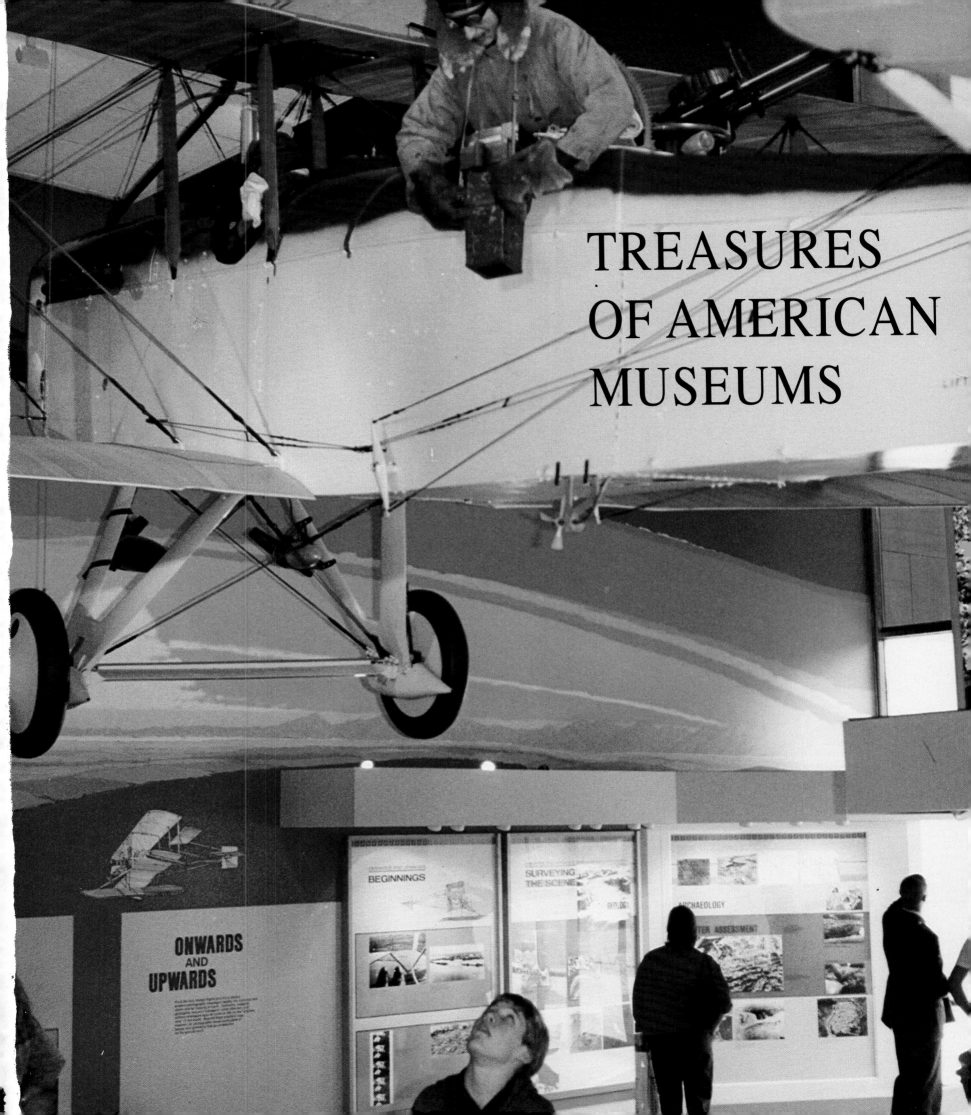

TREASURES
OF AMERICAN
MUSEUMS

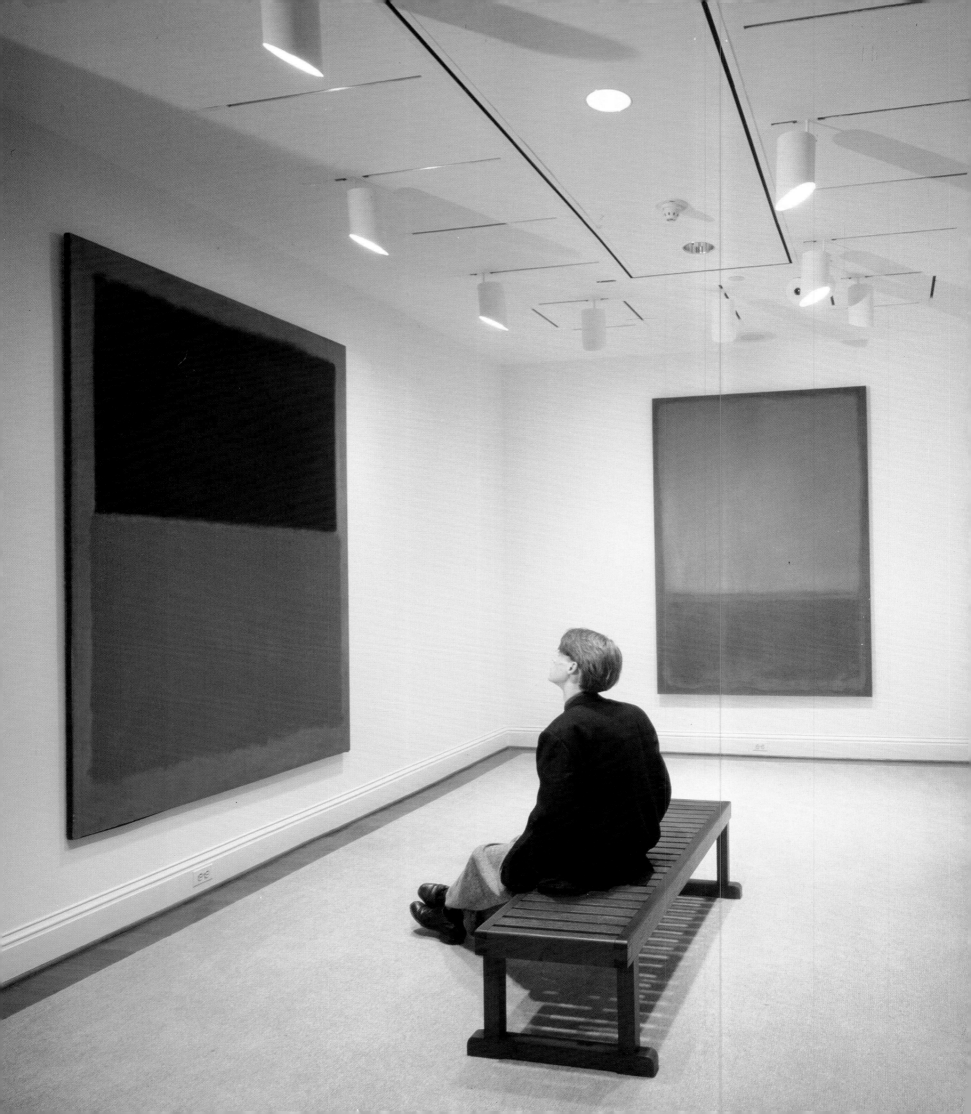

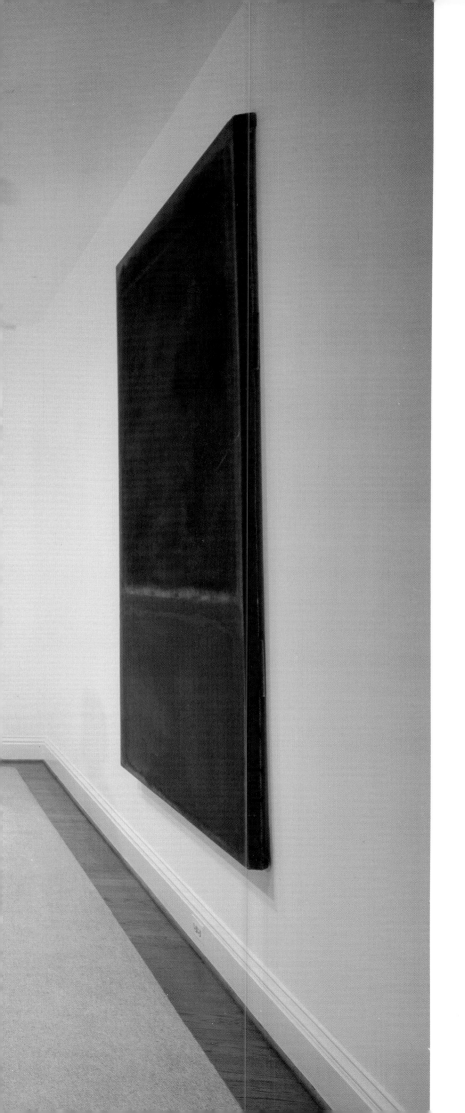

TREASURES
OF AMERICAN
MUSEUMS

CHARLES MATHES

MALLARD
PRESS

An imprint of BBD Promotional Book Company, Inc.,
666 Fifth Avenue, New York, New York 10103

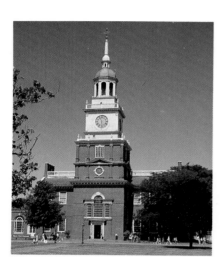
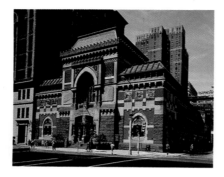
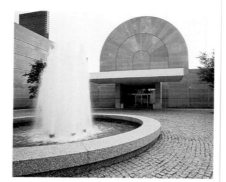
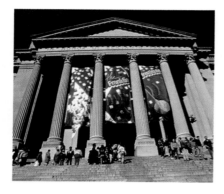
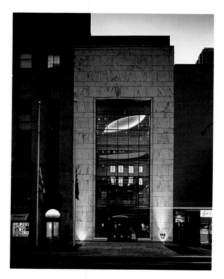

Acknowledgements

The producers of *Treasures of American Museums* gratefully acknowledge the assistance of the following individuals in creating this book:

Albright Knox Gallery of Art, Cheryl Orlick; American Advertising Museum, Alan Winson; American Museum of Natural History, Elizabeth Chapman, Carmen Collazo; American Museum of the Moving Image, David Schwartz, Barbara Marshall; Amon Carter Museum, William Harkins; The Art Institute of Chicago, Eileen Harakal, Paula Pergament; The Baltimore Museum of Art, Marge Lee, Jennifer Dyre; Buffalo Bill Historical Center, Shari Pullar; Center for Creative Photography, Nancy Solomon; Cincinnati Art Museum, Jane Durrell; Cincinnati Museum of Natural History, Susan Schultz; The Cleveland Museum of Art, Karen Ferguson; The Cleveland Museum of Natural History, Jan

McKay; Colonial Williamsburg Foundation, Catherine Grosfils; The Computer Museum, Gail Jenness, Liz Armbruster; The Corcoran Gallery, Judith Heisley; The Corning Museum of Glass, Clare Bavis; Country Music Hall of Fame and Museum, Linda Ludwig-Blackwood, Chris Skinker, Lisa Eubank; Dallas Museum of Art, Melanie Wright, Diane Pratt; The Denver Art Museum, Lora Witt, Cynthia Nakamura; Denver Museum of Natural History, Kelly Ladyga, Amy Martin; Detroit Institute of Arts, Margaret DeGrace, Kay Young; Field Museum of Natural History, Jim Lowers, Sherry DeVries, Nina Cummings, Mark Alvey, Erin O'Donnell; The Fine Arts Museums of San Francisco, Linda Jablon, Robin Koltenuk; The Franklin Institute Science Museum, ZeeAnn Mason, Allison Lewis; Freer Gallery of Art, Smithsonian Institution, Lavida Emory; The Frick Collection, Deborah Charleton, Francine Alessi; Gene Autry Western Heritage

Museum, Mary Ellen Nottage; The Heard Museum, Mary Brennan; Henry Ford Museum & Greenfield Village, Lori Ann Dick, Bill Northwood; The Hertzberg Circus Collection and Museum, David Leamon; High Museum of Art, Sue Deer; Hirshhorn Museum and Sculpture Garden, Smithsonian Institution, Sidney Lawrence; Houston Museum of Fine Arts, Karyn Galetka, Mary Christian, Celeste Adams; The Huntington, Lisa Blackburn, Peggy Bernal; The Indianapolis Motor Speedway Hall of Fame Museum, Ron McQueeny, Pat Jones, Martha Powell; Indianapolis Museum of Art, Mona Slaton, Andrea Badger, Betsy Brown; International Museum of Photography at George Eastman House, Eliza Benington; Isabella Stewart Gardner Museum, Karen Haas; The J. Paul Getty Museum, Andrea Leonard, Lori Starr; Janet Diederichs & Associates, Inc., Kate Mitchell; The John and Mable Ringling Museum of Art, Pat

Buck; Kennedy Space Center, Spaceport USA, Tom Blair, George Meguiar; Kimbell Art Museum, Wendy Gottlieb; Los Angeles County Museum of Art, Pamela Jenkinson; The Metropolitan Museum of Art, Mary Doherty, Beatrice Epstein; Milwaukee Public Museum, Kara Wagner, Debra Lyn Zindler; The Minneapolis Institute of Arts, Muriel Morrisette; Museum of Fine Arts, Boston, Mary Sluskonis, Linda Patch; The Museum of Modern Art, Jennifer Carlson, Richard Tooke, Leslie Conner; The Museum of Natural Science, Houston, Terrell Falk, Mike Olsen; Museum of New Mexico, Beverly Becker, Joyce Spray; The Museum of Science and Industry, Pat Kennedy; National Air & Space Museum, Smithsonian Institution, Helen Morrill, Patricia Graboske; National Automobile Museum, Timothy Woods; National Baseball Hall of Fame and Museum, William Guilfoile; National Cowboy Hall of Fame and Western

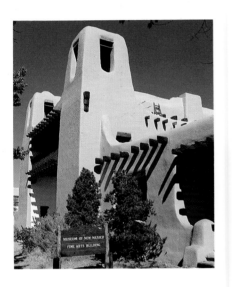

The West 186

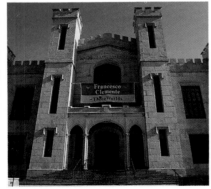

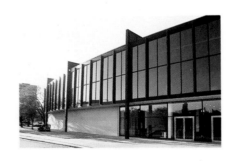

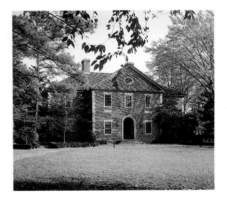

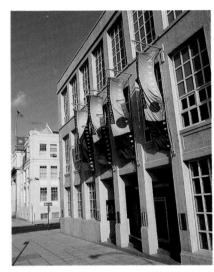

Heritage Center, Dana Sullivant; National Museum of American Art, Smithsonian Institution, Marjorie Byers, Kimberly Cody, Bob Johnston; National Museum of Natural History, Smithsonian Institution, Tom Harney, Chip Clarke; National Museum of Transport, Jane Jensen; The National Museum of Women in the Arts, Ramona Gremillion, Stephanie Skestos; The National Portrait Gallery, Smithsonian Institution, Michele Przypyszny, Sue Ann Kendall; The Nelson-Atkins Museum of Art, Gina O'Neal; New Mexico Museum of Natural History, John Arnold, Ron Behrmann Photography; Norton Simon Museum, Lori Hunt; Pennsylvania Academy of the Fine Arts, Anne Broussard; Philadelphia Museum of Art, Carrie Stavrakos, Sondra Horrocks; The Phillips Collection, Kristin Krathwohl, Ignacio Moreno; Phoenix Art Museum, Margaret Fries; Pima Air Museum, Thomas Swanton; Pro Football Hall of Fame, Donald Smith, Pete Fierle; San Diego Museum of

Art, Lucy Schwab, Mardi Snow; Seattle Art Museum, Jacci Thompson Dodd, Heather McLeland, Helen Abbott; The Smithsonian Institution, Lilas Wiltshire, Linda St. Thomas; Solomon R. Guggenheim Museum, Samar Qandil, Heidi Rosenau; Sterling and Francine Clark Art Institute, Rosalie Buckley; The St. Louis Art Museum, Kay Porter; Thomas Gilcrease Institute of American History and Art, Paula Hale Eliot Toy & Miniature Museum, Marcia Shepherd; Virginia Museum of Fine Arts, Suzanne Hall, Richard Woodward, Howell Perkins; Wadsworth Atheneum, Raymond Petke, Jennifer Huget, Monique Shira; Walker Art Center, John Hall, Adrienne Wiseman, Karen Gysin; The Walters Art Gallery, Howard White; The Western Reserve Historical Society, Ann Grube; Winterthur, Pat McNichol; Worcester Art Museum, Gretchen Harris.

First page National Air and Space Museum, Smithsonian Institution, Washington, D.C.
Previous pages The Rothko Room, The Phillips Collection, Washington, D.C.
These pages (l. to r.) Henry Ford Museum & Greenfield Village; Pennsylvania Academy of the Fine Arts; The Franklin Institute Science Museum; Dallas Museum of Art; Terra Museum of American Art; The Museum of New Mexico; Wadsworth Atheneum; The Museum of Fine Arts, Houston; The Abby Aldrich Rockefeller Folk Art Center; The American Museum of the Moving Image.

AN M&M BOOK

Treasures of American Museums was prepared and produced by M & M Books, 11 W. 19th Street, New York, New York 10011.

Project Director & Editor Gary Fishgall
Editorial Assistants Maxine Dormer, Ben D'Amprisi, Jr.; *Copyediting* Phil Alkana; *Proofreading* Shirley Vierheller.
Design Binns and Lubin
Separations and Printing Regent Publishing Services Ltd.

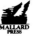

An imprint of BDD Promotional Book Company, Inc., 666 Fifth Avenue, New York, New York 10103

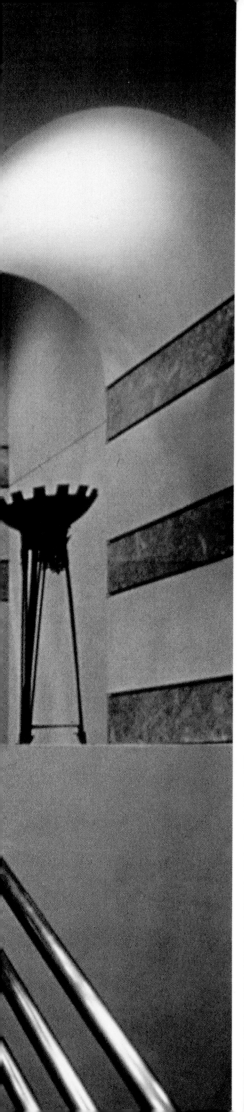

INTRODUCTION

America has become a nation of collectors.

Unlike Europe, however, where museums were formed around royal collections that had been amassed over centuries, our great institutions were founded only after the Civil War. It is a testimony to the zeal and commitment of these pioneering institutions that by the turn of the century grand palaces were being built in many American cities to house burgeoning collections of artistic, historic, scientific, and cultural artifacts.

Unfortunately, for many years these riches were largely ignored. Museums remained primarily a preoccupation of the elite, thought of by the general public as places patronized only by dusty academics and unwilling school children.

Then in the 1960s something happened.

Perhaps it was the Kennedy administration's commitment to art and culture. Perhaps the nation was just growing up. In any event, museums stopped rivaling libraries as places of quiet and contemplation. In fact it often became necessary to stand in a line just to get in.

Bold new museum buildings and additions suddenly began sprouting up in cities all over the country; cultural and artistic treasures began to be presented in fresh new ways

THE ST. LOUIS MUSEUM OF ART, ST. LOUIS, MISSOURI.

featuring hands-on exhibits and theatrical lighting; even reproductions of articles from major institutions in the form of post cards, catalogs, and other items became a $100-million-dollar business. In the 1970s, spurred by "blockbuster" shows like that featuring the treasures of King Tutankamen, museum attendance exceeded the one-billion-visitors-per-year mark for the first time.

Today there are over 6,700 institutions listed in the American Association of Museums' Official Museum Directory, but no one knows what the actual total is. More things are being collected by more institutions and seen by more people than ever before in history, and there doesn't seem to be any end in sight. Estimates suggest that five or six new museums are being formed per week—and not merely in the familiar categories.

In a nation as diverse as the United States it is somehow fitting that the definition of what should be included in a museum has been stretched to the limit. There are now museums devoted to agriculture, apothecary, architecture, bottles, buttons, butterflies, clocks, coins, comedy, costumes, crime, dentistry, electricity, fire-fighting, fish, furniture, guns, lumber, medicine, mining, musical instruments, pharmacology, scouting, stamps, theater, tools, toy trains, typography, whaling, woodcarving, and of

course wax figures—to name just a few areas.

This book concentrates on some of the largest, best-known American museums of art, natural history, science and technology, transportation, and sports, as well as some institutions representing categories uniquely their own. The featured collections range from great paintings and sculpture to country music recordings and meteorites.

What, after all, is worth preserving? Most people would now agree that paintings by Vincent van Gogh are treasures, although during his lifetime the artist never sold a canvas. But what of a 75-million-year-old lizard skeleton? Or a 350-ton steam locomotive? Or the Yankee Stadium locker used by both Joe DiMaggio and Mickey Mantle?

Happily, someone thought all these things and many equally unusual were worth saving, and America and her citizens are the richer for it.

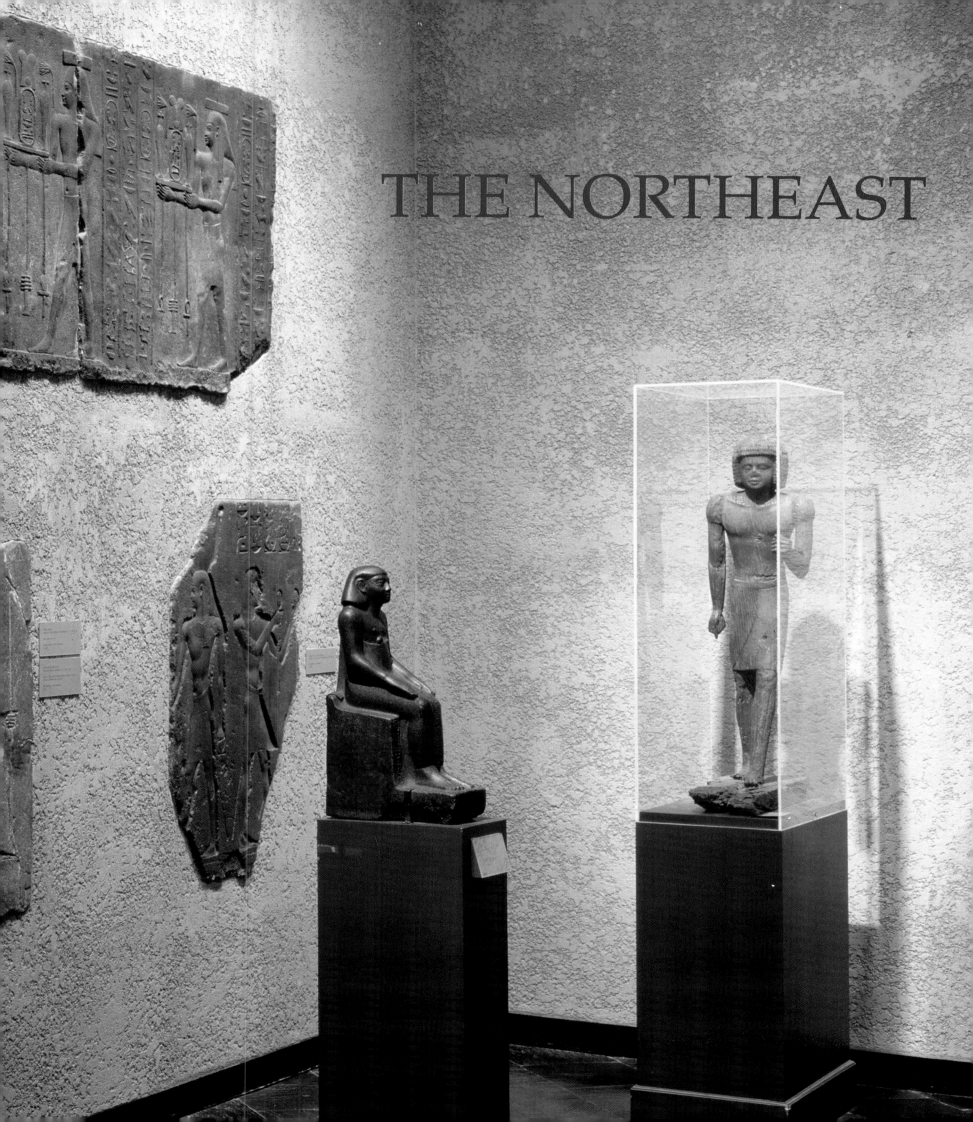

THE NORTHEAST

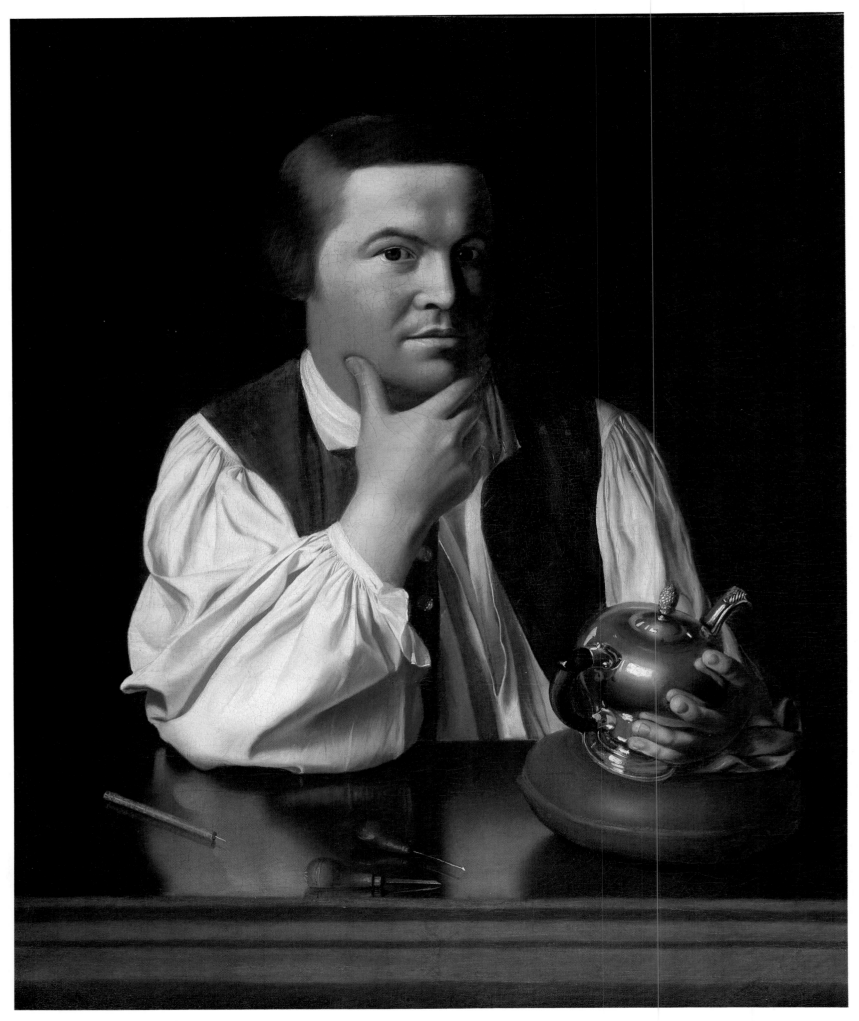

1 JOHN SINGLETON COPLEY *Paul Revere*

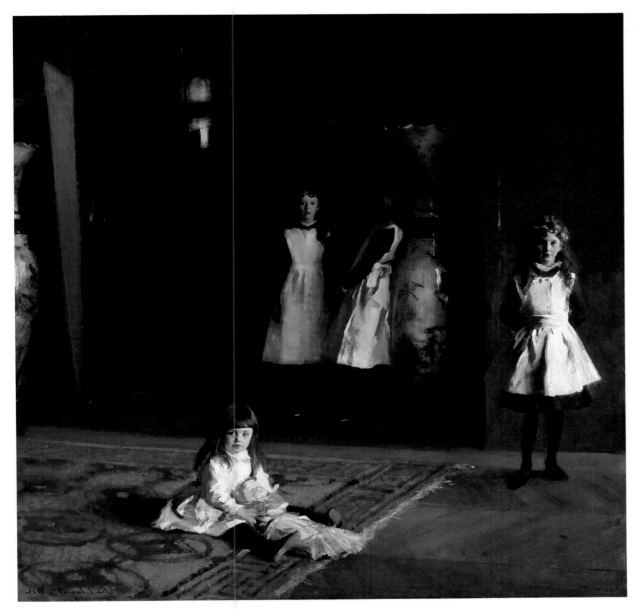

2 JOHN SINGER SARGENT *The Daughters of Edward D. Boit*

Museum of Fine Arts Boston

BOSTON, MASSACHUSETTS

One of the country's great institutions, the Museum of Fine Arts Boston was founded in 1870 and moved into its present neoclassical building on the Fenway in 1909. New wings were added over the years until the present structure, rising around two central enclosed courtyards, was completed in 1981 by I. M. Pei's bold new West Wing.

Today the Museum of Fine Arts encompasses more than 250,000 square feet of exhibition space, and its vast collection ranges from Egyptian Old Kingdom sculpture equalled only by examples in the Cairo Museum to the paintings on the very cutting edge of modern art.

Particularly well-known is the collection of Asian art—the world's single most comprehensive survey—housed in the Asiatic Wing galleries, which were reinstalled in 1982. One of the three most important collections of Islamic art in the United States is also on display here.

More than 700 paintings from the museum's outstanding European and American collections hang in the Robert Dawson Evans Galleries for Paintings, which were completely restored in 1986. Among the artists represented here are El Greco, Peter Paul Rubens, Nicolas Poussin, Rembrandt, J. M. W. Turner, John Singleton Copley (Copley's portrait of Paul Revere was the gift of the sitter's descendents), Gilbert Stuart, Jean-François Millet, and John Singer Sargent. Of particular note is the museum's extensive Impressionist and Post-Impressionist collection, which includes world-renowned works by Pierre Auguste Renoir, Edgar Degas, Vincent van Gogh, Paul Gaugin, and 38 works by Claude Monet.

The museum also features notable collections of silver, furniture, and decorative arts, classical art, musical instruments, prints, drawings, photographs, textiles, costumes and several period rooms.

3 UNKNOWN *Amphora*

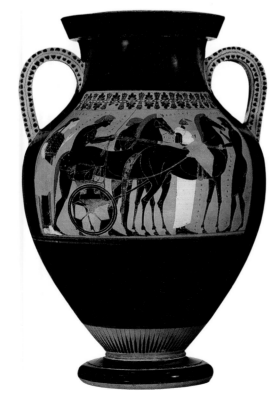

1 American, 1768–1770, Oil on canvas, Gift of Joseph W. William B. and Edward H.R. Revere, 30.781.

2 American, 1882, Oil on canvas, Gift of Mary Louise Boit, Florence D. Boit, Jane Hubbard Boit, and Julia Overing Boit, in memory of their father, Edward Donley Boit, 19.124.

3 Greek, Attic, c. 540 B.C, Clay, Henry Lillie Pierce Residuary Fund Bartlett Collection, 63.952.

4 Japanese, 1763, Hanging scroll, Charles Main Hoyt Fund.

5 Spanish, n.d., Rape of the Sabine Women, Juliana Cheney Edwards Collection, Tompkins Collection, and Fanny P. Mason Fund in Memory of Alice Thevin, 64.709.

6 French, 1897, Oil on canvas, Tompkins Collection, 36.270.

7 Flemish, 1435, Oil and tempera on panel, Gift of Mr. and Mrs. Henry Lee Higginson, 93.153.

8 Egyptian, Dynasty IV, 2599–1571 B.C., Slate schist, Harvard MFA Expedition, 11.1738.

9 Northern Indian, late 16th–early 17th century, Knotted pile (senna knot); cotton warp and weft, Gift of Mrs. Frederick L. Ames in the name of Frederick L. Ames, 93.1480.

10 Chinese, Northern Chi' to Sui Dynasties, Northern stoneware with Celadon glaze, Keith McLeod Fund, 1986.339 a, b.

11 French, 1876, Oil on canvas, 1951 Purchase Fund, 56.147.

12 Italian, n.d., Oil on canvas, 1948 Fund and Otis Norcross Fund, 48.499.

Preceding pages:
THE WALTERS ART GALLERY,
BALTIMORE MARYLAND

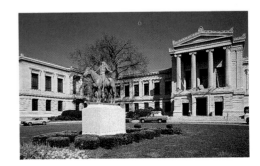

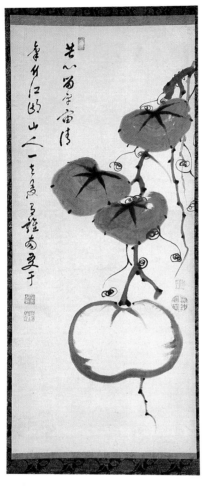

4 HO JAKUCHU *Chinese Melons*

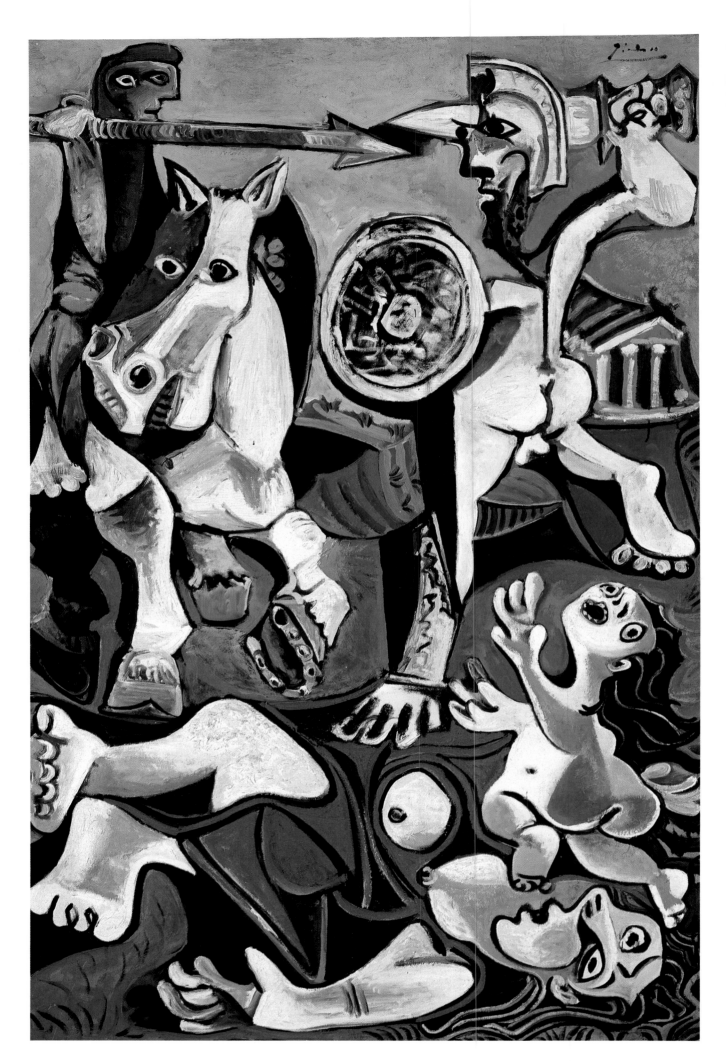

5 PABLO PICASSO
Rape of the Sabine Women

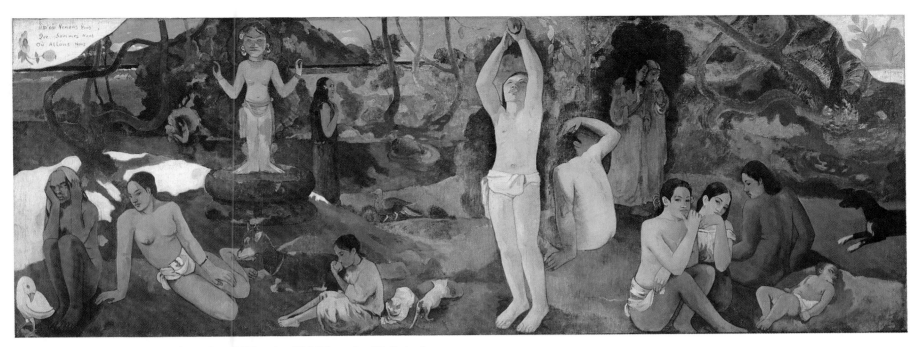

6 PAUL GAUGUIN *Where Do We Come From? What Are We? Where Are We Going?*

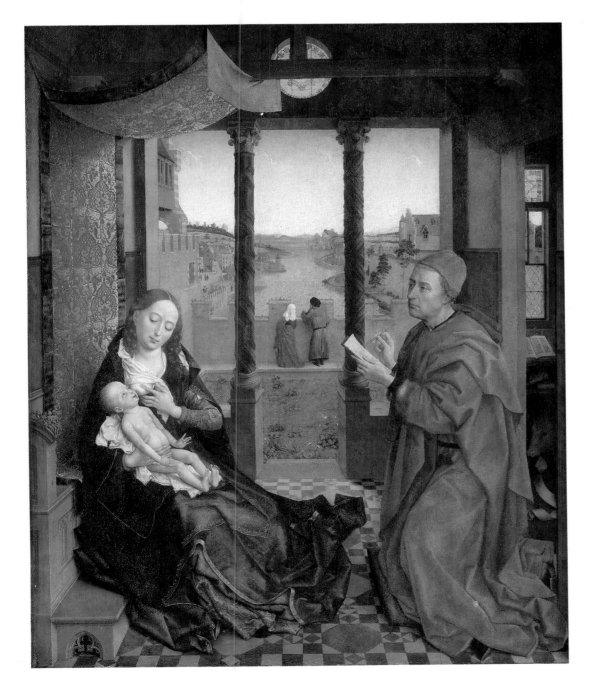

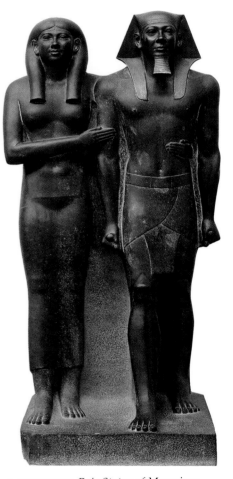

8 UNKNOWN *Pair Statue of Mycerinus and His Queen*

7 ROGIER VAN DER WEYDEN
St. Luke Painting the Virgin

13

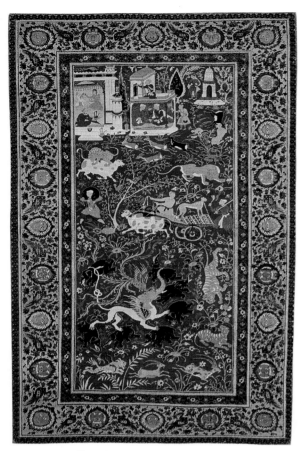

9 MUGHAL *Carpet*

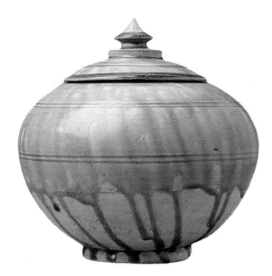

10 UNKNOWN *Globular Jar with Cover*

11 CLAUDE MONET *La Japonaise*

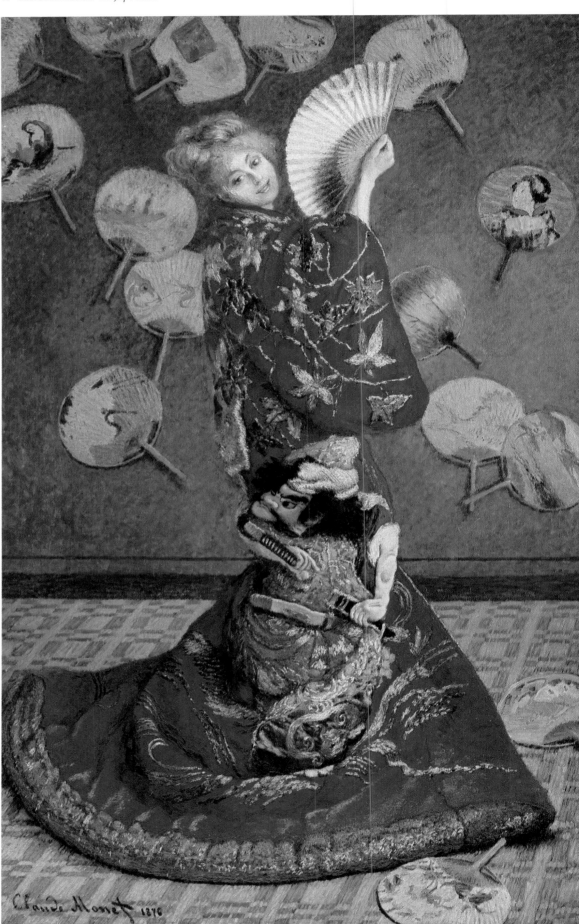

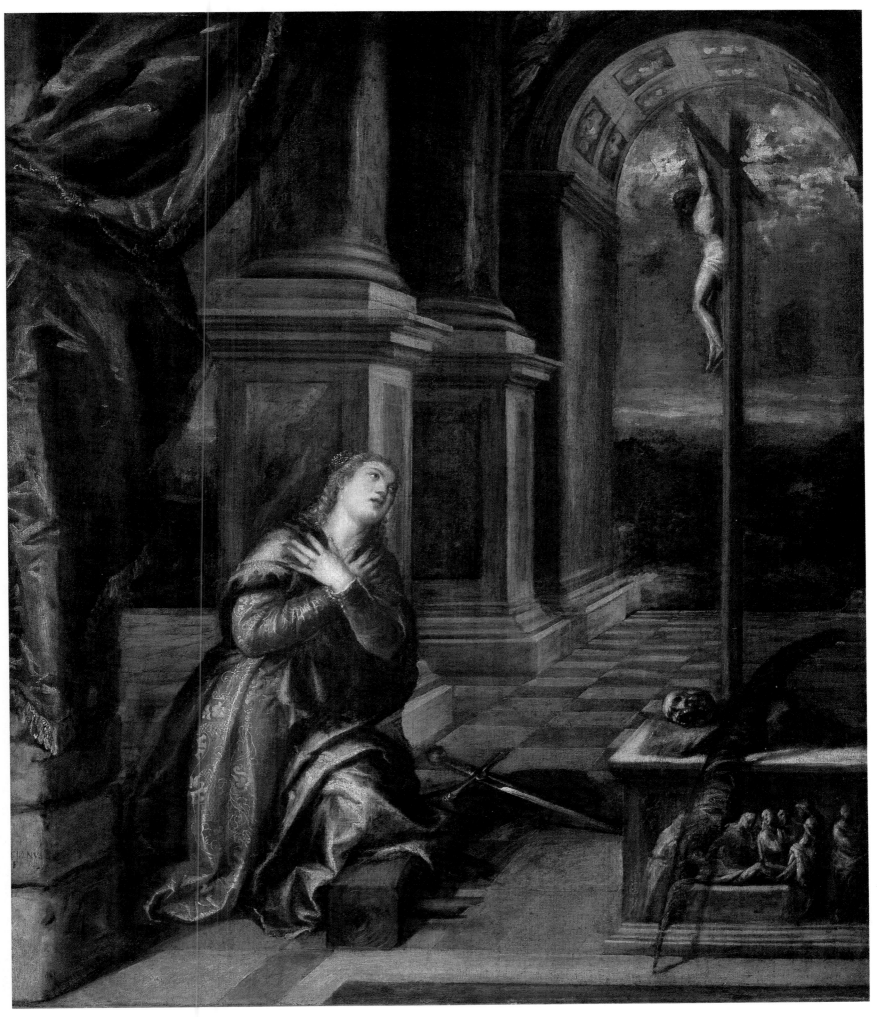

12 TITIAN *St. Catherine of Alexandria at Prayer*

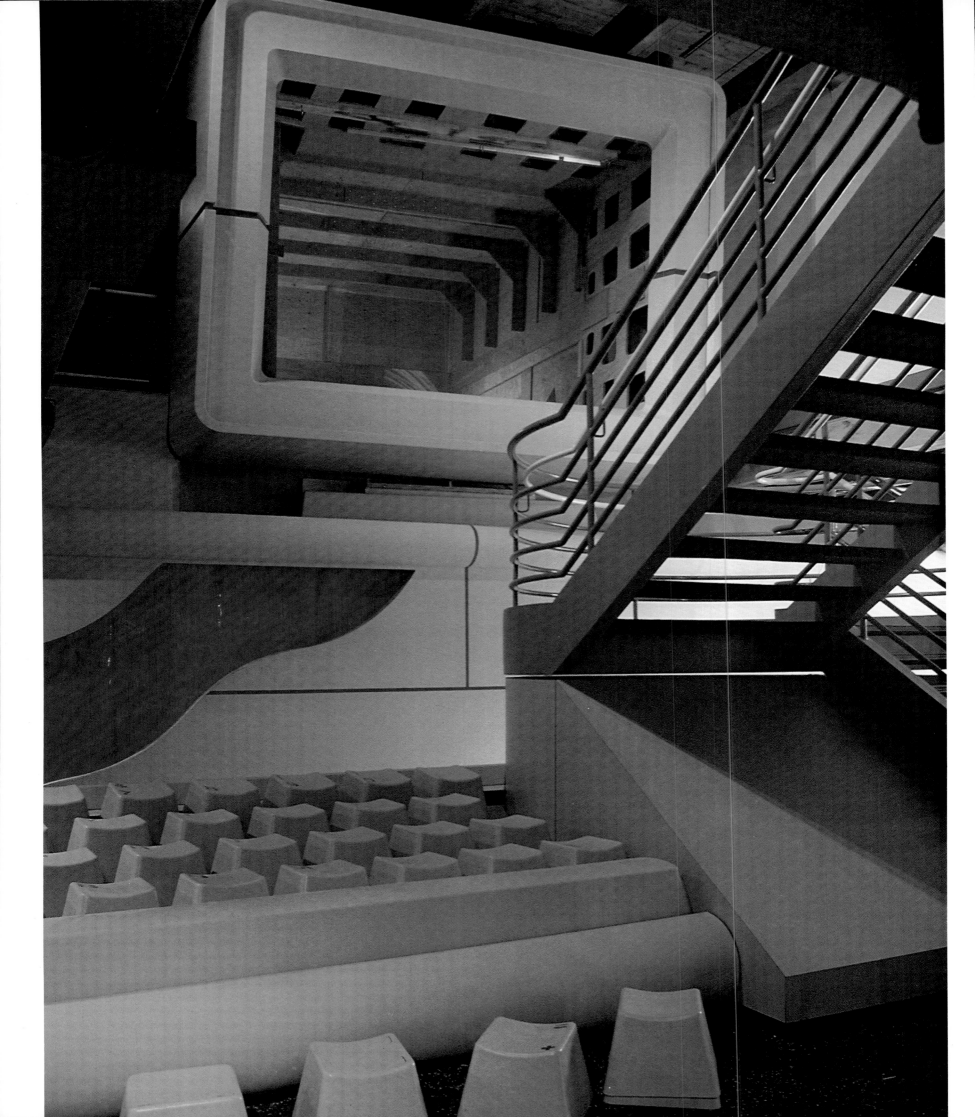

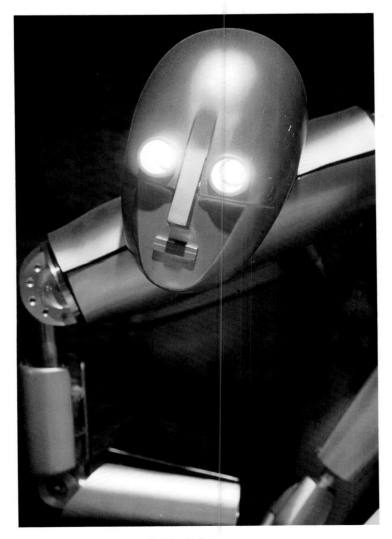

1 MARK FRIEDMAN *Robotic Page-turner*, 1986

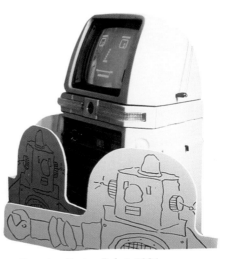

4 *Denning Sentry Robot*, 1986

The Computer Museum

BOSTON, MASSACHUSETTS

This 53,000-square foot museum on Boston's waterfront opened in 1984 and features the largest collection of historical computers and robots in existence. It is the world's only museum devoted to computers and their impact on society.

The museum's 1,500 artifacts, 1,000 photographs, and 400 videotapes and films document the evolution of computers from early mechanical devices to the cutting edge of today's technology. Displays include a "Smart Machines" gallery that demonstrates artificial intelligence and robotics, and a new historical exhibit entitled "Milestones of a Revolution: People and Computers," a dramatic chronicle of the evolution of computing that uses interactive computers, artifacts, and videos. The milestones range from a 1930s punch-card machine that shows how the federal government initially performed data processing to a Univac I to today's personal computers. Also featured are the microprocessors that pervade everyday life in objects such as a VCR, a microwave oven, and an answering machine. The museum also houses a resource center full of interactive exhibits and a gallery devoted to the expanding field of image processing and computer graphics.

Perhaps the most exciting of the museum's 75 interactive exhibits is the new 5,300-square-foot "Walk-through Computer." This is a working model of a desktop computer, blown up to 50 times its normal size. Visitors can actually walk past the 108-square-foot monitor, the 25-foot keyboard, and a six-foot-tall floppy disk into the two-story exhibit and see how a computer works. Giant disk drives spin and pulsing lights simulate the flow of data between the computer and its peripherals. The computer's microprocessor, as true to life as 100 experts and 25 institutions and corporations from three countries could make it, is visible through many viewports magnified 500 times.

2 MAXELL CORPORATION *Golden Robot*

3 WALK-THROUGH COMPUTER (UNDER CONSTRUCTION)

The Isabella Stewart Gardner Museum

BOSTON, MASSACHUSETTS

Isabella Stewart Gardner, a wealthy American socialite, formed with her husband one of the country's first great collections of old master paintings. In 1903 the true scope of this remarkable woman's vision became apparent when Mrs. Gardner, who was by then a widow, opened to the public the Venetian-style Renaissance palace that she had designed herself to house her collection.

Everything about the Gardner Museum still reflects the taste and sensibility of its founder. Mrs. Gardner believed that art should be displayed not by chronology or by country, but in a manner that would fire the imagination. The more than 2,000 objects in her museum are still as she arranged them—an ancient Chinese vessel was placed beneath a portrait by the Spanish artist Francisco Zurbarán, an Egyptian sculpture among Graeco-Roman marbles. Many art treasures remain unlabeled to allow visitors to respond to the works themselves.

Although the collection includes furniture, textiles, tapestries, mosaics, drawings, sculptures, and prints, the museum is best known for its magnificent paintings, some of which noted art critic Bernard Berenson helped Mrs. Gardner acquire. Represented artists include Giotto, Fra Angelico, Masaccio, Piero della Francesca, Sandro Botticelli, Raphael, Peter Paul Rubens, Jan Vermeer, Rembrandt, and Titian. There are also numerous works by John Singer Sargent and James Whistler, both friends of Mrs. Gardner, and portraits by Edouard Manet and Edgar Degas. *The Terrace, St. Tropez* was the first painting by Henri Matisse to enter an American museum.

The cloisters, loggias, and courtyards of the Gardner Museum have always been an ideal setting for music. Paderewski and Nellie Melba performed here early in the century, and the museum continues to present more than 100 concerts annually, featuring well-known musical artists.

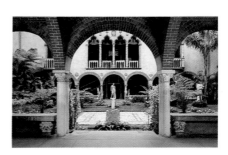

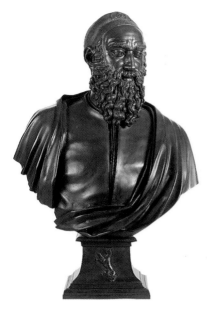

1 BENVENUTO CELLINI *Bindo Altoviti*

1 Italian, c. 1550, Bronze.
2 Italian, c. 1513, Oil on panel.
3 American, 1882, Oil on canvas.
4 Dutch, 1629, Oil on panel.

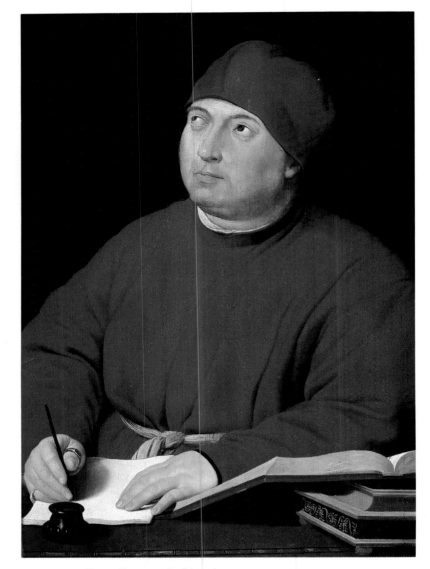

2 RAPHAEL *Count Tommaso Inghirami*

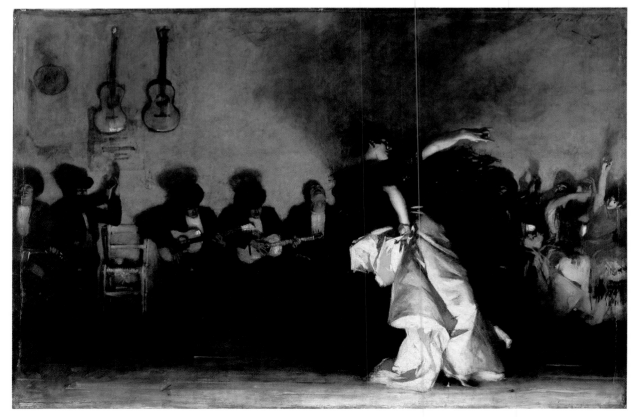

3 JOHN SINGER SARGENT *El Jaleo*

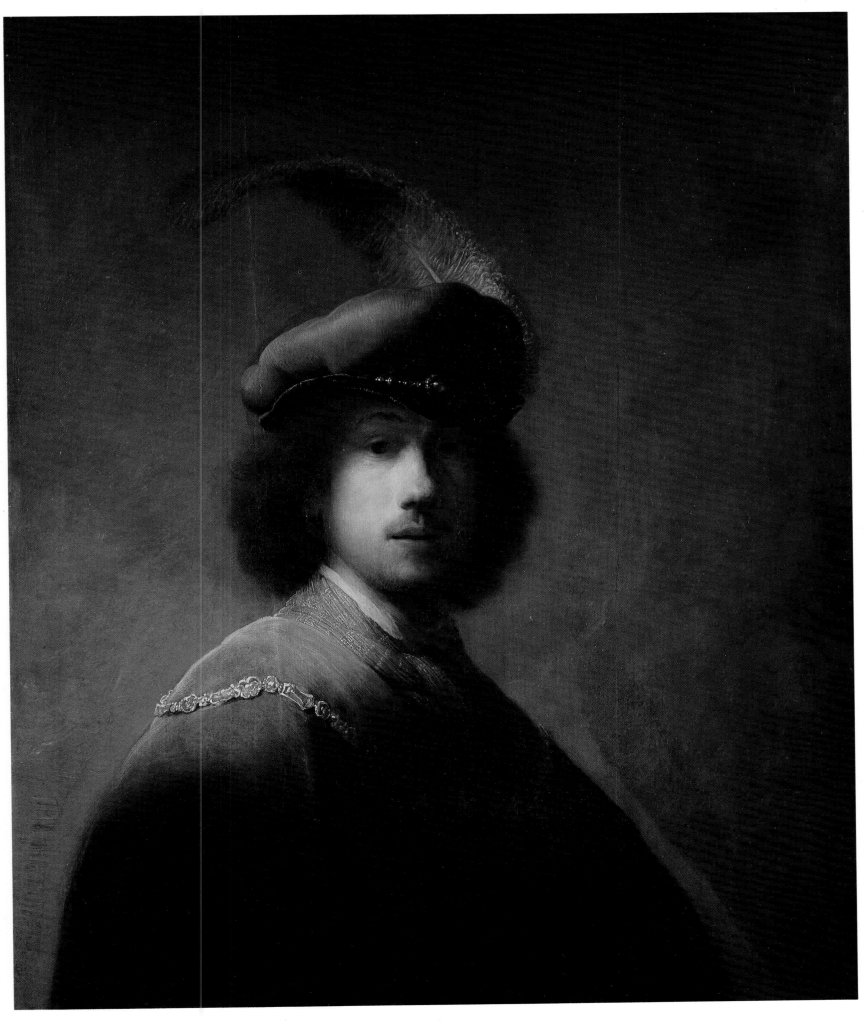

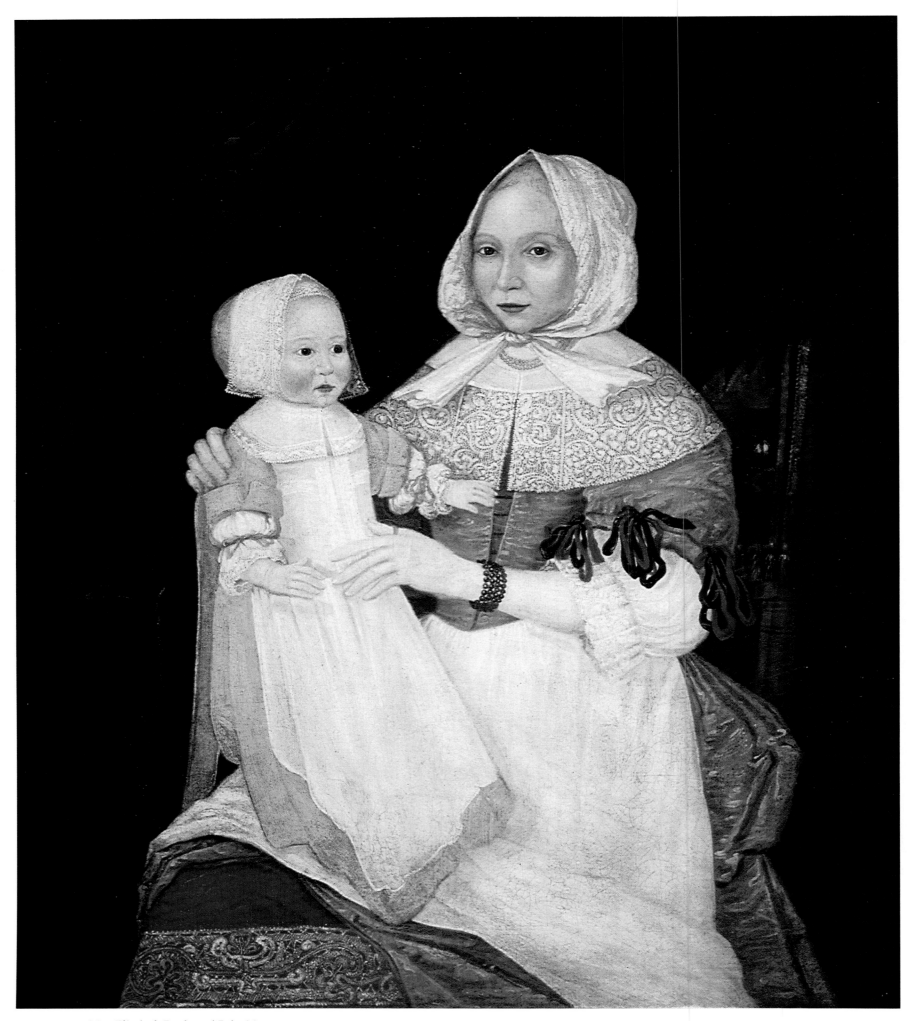

1 UNKNOWN *Mrs. Elizabeth Freake and Baby Mary*

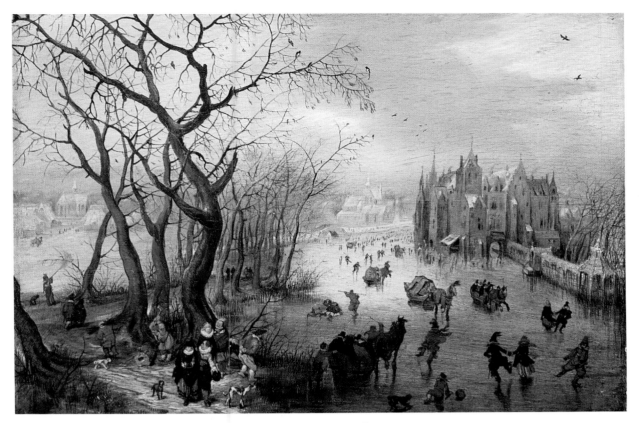

2 ADRIAEN VAN DE VENNE *Winter Landscape with Skaters Near a Castle*

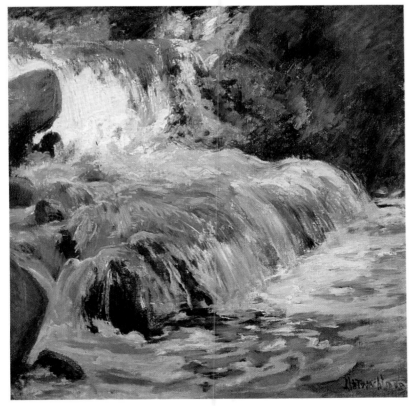

3 JOHN HENRY TWACHTMAN *The Waterfall*

The Worcester Art Museum

WORCESTER, MASSACHUSETTS

With 25,000 objects and 188,000 square feet of space, the Worcester Art Museum is among the largest and most admired cultural institutions in the New England area.

The museum was founded in 1896. Its collection, spanning 50 centuries of humanity's creative heritage, is displayed in chronologically arranged galleries of paintings, sculpture, decorative arts, photographs, drawings, and prints.

The museum's holdings in American art are particularly strong. Though the artist has never been identified, the museum's double portrait of *Mrs. Freake and Baby Mary* and companion image, *Mr. John Freake*, are considered two of the finest examples of 17th-century American portraiture in existence. John Singleton Copley, Charles Willson Peale, Childe Hassam, John Singer Sargent, and James Whistler are among the many other American artists represented here. The museum holdings also include the Goodspeed collection of over 3,000 early American prints and the first gallery in the world devoted to the permanent display of American portrait miniatures.

The museum's strong collection of European paintings features masterworks by Raphael, Andrea del Sarto, El Greco, J. M. W. Turner, Thomas Gainsborough, and the major French Impressionists, as well as a particularly impressive collection of 17th-century Dutch landscapes, still lifes, genre scenes, and portraits by artists like Rembrandt, Jan Steen, and Jacob van Ruisdael.

Ten mosaics from the second to sixth centuries A.D., excavated from the Roman city of Antioch, are displayed in the museum's Renaissance Court. A 12th-century vaulted Romanesque chapter house, originally part of a French monastery, has also been reconstructed here.

Eastern art, antiquities, and contemporary painting and sculpture round out the collection.

1 American, ca. 1671–1674, Oil on canvas.
2 Dutch, 17th century, oil on canvas.
3 American, 19th century, Oil on canvas.
4 Roman, 2nd century A.D., Bronze.

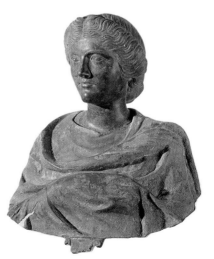

4 ANTONINE *Bust of a Roman Lady*

The Sterling and Francine Clark Art Institute

WILLIAMSTOWN, MASSACHUSETTS

Located in a community of 8,000 people, 2,000 of whom are students at Williams College, the Sterling and Francine Clark Art Institute draws 125,000 visitors each year—an impressive testimony to the quality and charm of this friendly, intimate museum.

Robert Sterling Clark, grandson of a founder of the Singer Sewing Machine Company, was 35 years old before he purchased his first work of art, but he made up for lost time in the ensuing years, assembling a very personal, idiosyncratic collection. He eventually decided to share his substantial holdings with the public and chose Williamstown because of his family's long association with Williams College and because of the beauty of the area. The Clark Art Institute opened in a classical white marble building in 1955, shortly before Sterling Clark's death. A 1973 red granite addition brought the museum's gallery space to 24,000 square feet.

The museum is best known for its works by the French Impressionists, notably Pierre Auguste Renoir, who is represented by over 30 canvasses. There are also paintings by Camille Pissarro, Alfred Sisley, and Claude Monet and nine sculptures by Edgar Degas. In addition, Clark acquired the works of the Academic painters, against whom the Impressionists had rebelled, picking up canvasses by Adolphe Bouguereau, Jean-Léon Gérôme, and Sir Lawrence Alma-Tadema when they were out of fashion and inexpensive.

The Clark Art Institute also features significant pictures by Barbizon artists Jean-François Millet and Jean-Baptiste Camille Corot and by American painters Winslow Homer, Mary Cassatt, and Frederic Remington. There are numerous works by the older masters as well, including a rare panel painting by Piero della Francesca, and portraits by Hans Memling and Jan Gossaert.

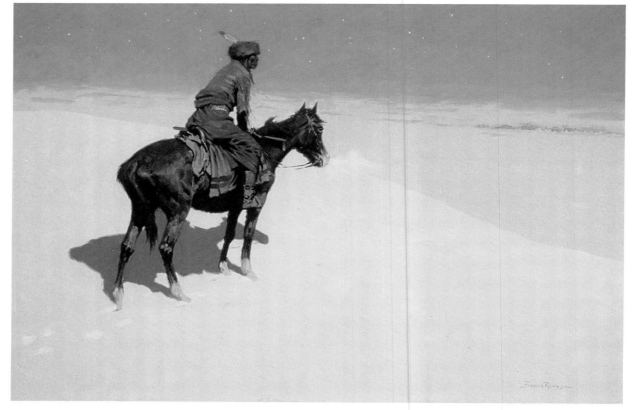

1 FREDERIC REMINGTON *The Scout: Friends or Foes*

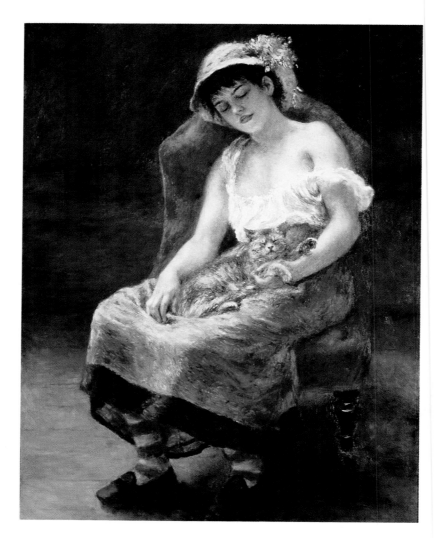

3 PIERRE-AUSTUSTE RENOIR *Sleeping Girl with a Cat*

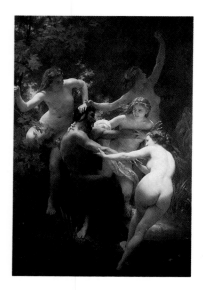

2 WILLIAM ADOLPHE BOUGUEREAU *Nymphs and Satyr*

1 American,1900-1905, Oil on canvas.

2 French, 1873, Oil on canvas.

3 French, 1880, Oil on canvas.

4 French, c. 1857–1858, Oil on paper mounted on canvas.

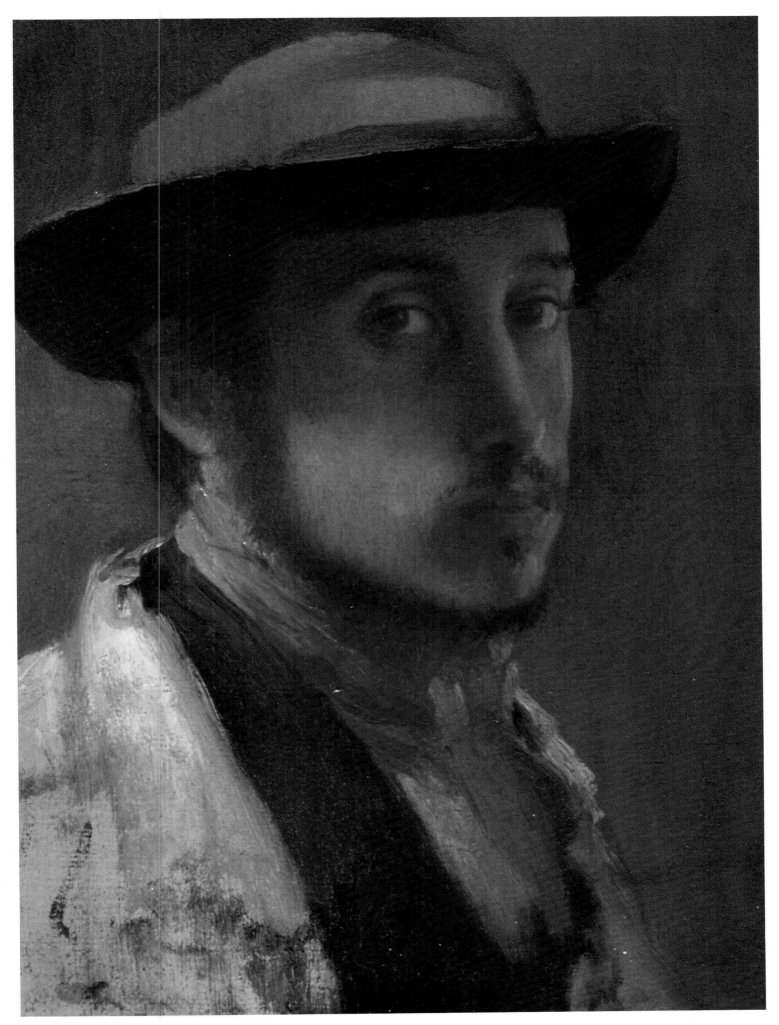

4 EDGAR DEGAS *Self-Portrait*

The Wadsworth Atheneum

Founded in 1842, the Wadsworth Atheneum is America's oldest continuously operating public art museum. Housed in five buildings spanning a century-and-a-quarter of architectural styles, the collection ranges from Greek and Roman masterpieces to the most contemporary of modern art.

J. Pierpont Morgan, Jr., elevated the Atheneum to international status in 1917 when he donated more than 1,300 objects from his late father's famous collection, including the largest assemblage of Meissen porcelains outside of Europe. Morgan later gave the museum the Wallace Nutting Collection of 17th-century furniture and decorative arts, the most renowned collection of its kind.

It was A. Everett "Chick" Austin, Jr., however, director from 1927 to 1944, who helped define the Atheneum's role among American institutions, building important collections of Baroque, Impressionist, American, and Modern art, as well as introducing performances and other art forms such as dance, film, and photography to the museum world.

Under Austin's direction, the Atheneum presented America's first exhibition of Italian Baroque art, its first show on Surrealism, and its first major Picasso retrospective. In 1933 the museum also sponsored George Balanchine's emigration to America and later presented the first performances of his American ballet company.

While the collection includes major oils by Frans Hals, Caravaggio, Francisco Zurburán, Tintoretto, Peter Paul Rubens, Claude Monet, Pierre August Renior, and Vincent van Gogh, the Atheneum's curators have always made it a special point to collect contemporary art. Philanthropist Daniel Wadsworth himself accumulated canvases by the then contemporary painters of the Hudson River school, among them Thomas Cole, Frederic Church, and his wife's uncle, John Trumbull.

1 CARAVAGGIO *Ecstasy of Saint Francis*

24

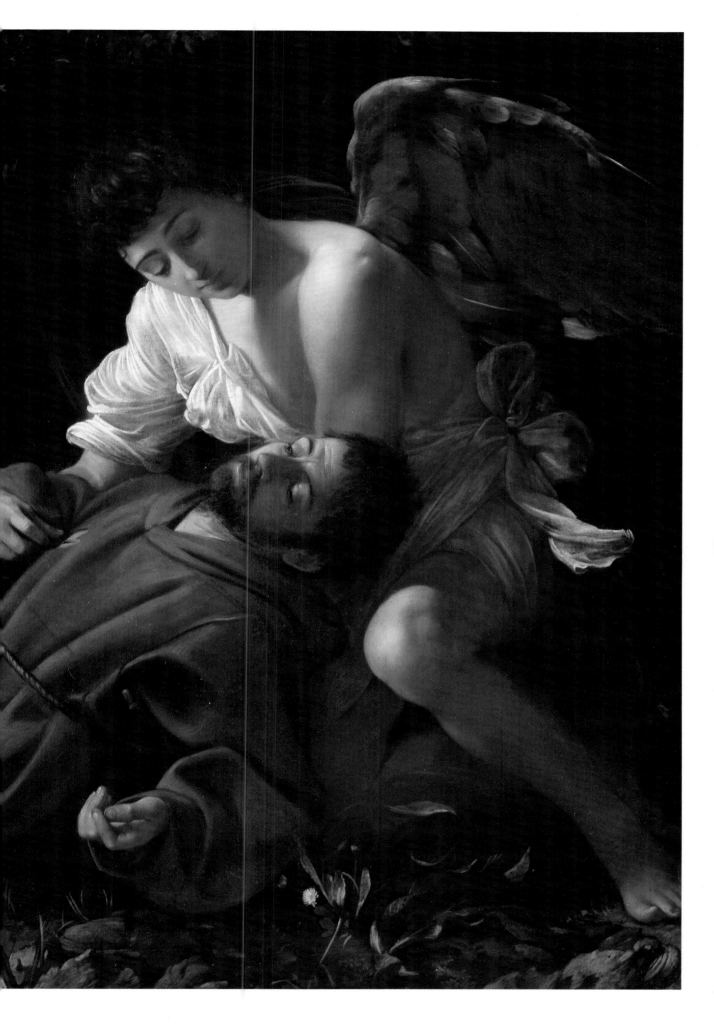

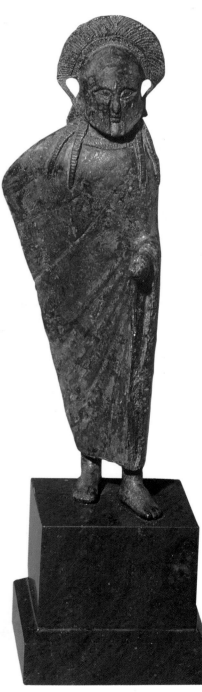

2 UNKNOWN *Draped Warrior*

3 JOHN SLOAN *Hairdresser's Window*

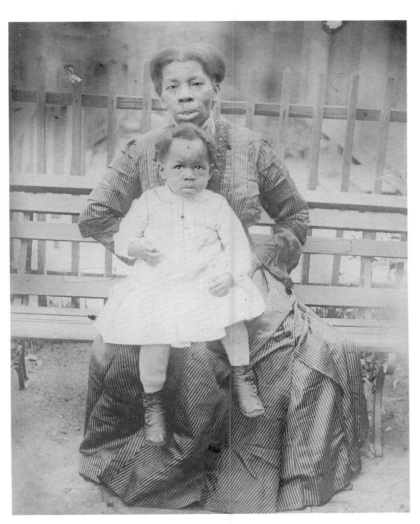

4, UNKNOWN *Grandmother with Granddaughter in Lap*

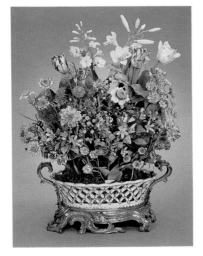

5 MEISSEN *Oval Basket*

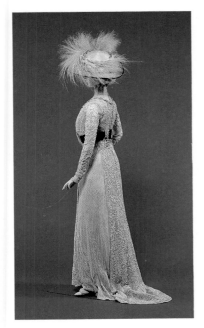

6 PAQUIN *Afternoon Dress*

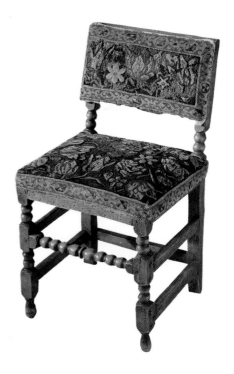

7 BOSTON, MASSACHUSETTS *Side Chair*

1 Italian, c. 1594, Oil on canvas, Ella Gallup Sumner and Mary Catlin Sumner Collection.

2 Greek, 510–500 B.C., Bronze, J. Pierpont Morgan Collection.

3 American, 1907, Oil on canvas, Ella Gallup Sumner and Mary Catlin Sumner Collection.

4 American, c. 1890, Photograph, Amistad Foundation.

5 German, c. 1750, Hard-paste porcelain, J. Pierpont Morgan Collection.

6 French, 1908, Linen, cotton, and silk.

7. American, 1660–1690, Wallace Nutting Collection, Gift of J. Pierpont Morgan.

8 American, 1964, Oil on canvas, Gift of Susan Morse Hilles.

8 ROBERT RAUSCHENBERG *Retroactive I*

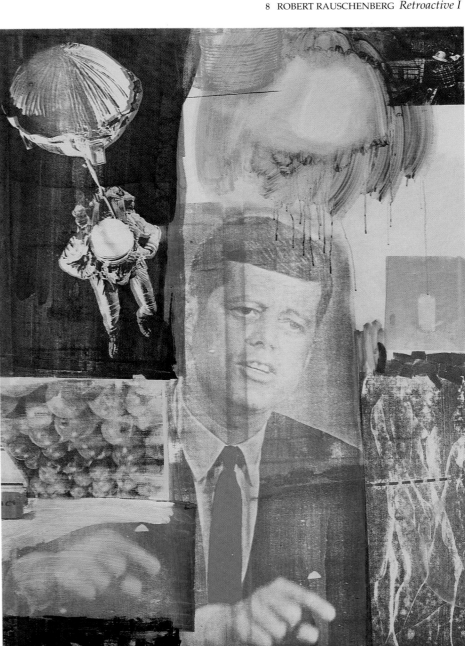

The Albright-Knox Art Gallery

BUFFALO, NEW YORK

Inside the 1905 Greek revival building of the Albright-Knox Art Gallery is a collection representing one of the world's foremost surveys of international painting and sculpture of the last 50 years.

The Albright-Knox's parent organization—the Buffalo Fine Arts Academy—was founded in 1862, making it the sixth-oldest arts organization in the United State. Anna Pavlova danced in the gallery's sculpture court in 1914, and Sarah Bernhardt performed at the opening of an exhibition two years later.

While the museum boasts Impressionist masterpieces, a wide range of Italian, Dutch, French, and Flemish old masters, a fine suite of 18th- and 19th-century American artists, and an exceptional group of English paintings, more than one-half of its 6,000-piece collection dates from after 1945.

The Albright-Knox's stunningly successful foray into the field of modern art is largely due to the vision and generosity of patron Seymour Knox. In the late 1950s and early 1960s, Knox and museum director Gordon M. Smith made acquisitions that determined the museum's present reputation as an outstanding center for art of the 20th century.

The list of painters and sculptors with major works on display here reads like a history of modern art: Arshile Gorky, Willem de Kooning, Mark Rothko, Jackson Pollock, Helen Frankenthaler, Philip Guston, David Smith, Francis Bacon, Alberto Giacometti, Jasper Johns, Robert Rauschenberg, Frank Stella, and Roy Lichtenstein. The museum also has 33 paintings by Clyfford Still, the largest public collection of the works of this reclusive Abstract Expressionist.

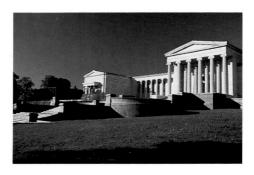

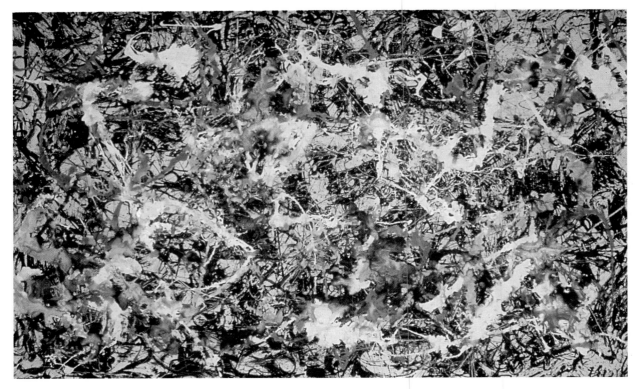

1 JACKSON POLLOCK *Convergence*

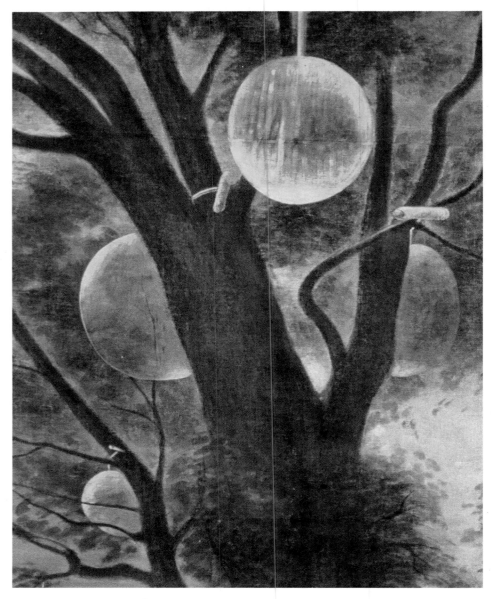

2 FRANCESCO CLEMENTE *Son*

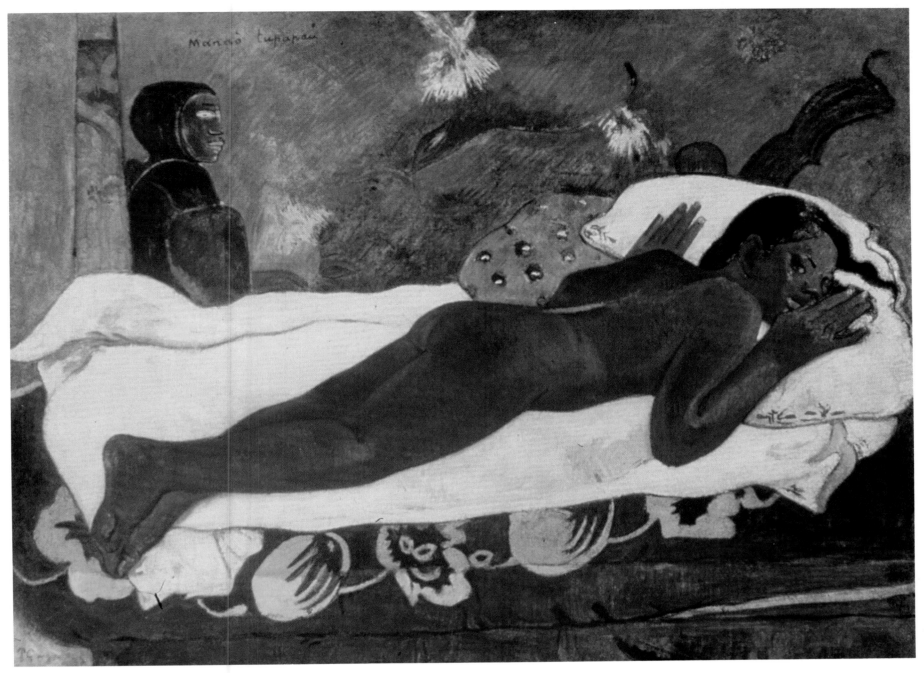

3 PAUL GAUGUIN *The Spirit of the Dead Watching*

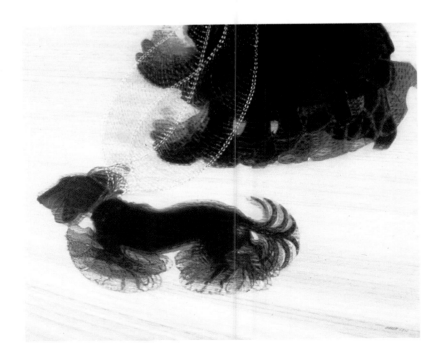

4 GIACOMO BALLA *Dynamism of a Dog on a Leash*

1 American, 1952, Oil on canvas.
2 Italian, 1984, Oil on linen.
3 French, 1892, Oil on burlap mounted on canvas.
4 Italian, 1912, Oil on canvas.

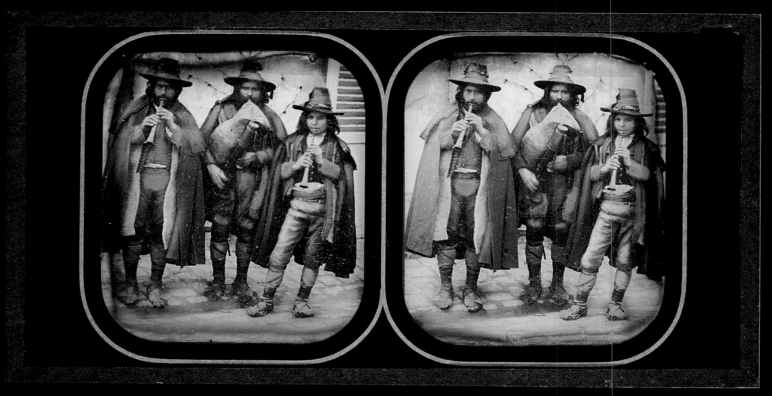

1 UNKNOWN *Street Flutists*

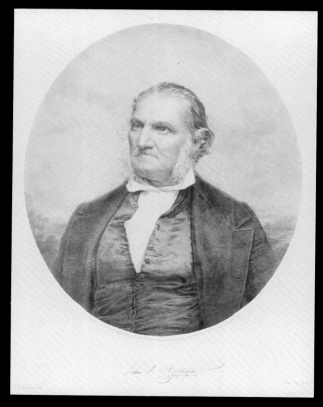

2 FRANCOIS D'AVIGNON *John James Audubon*

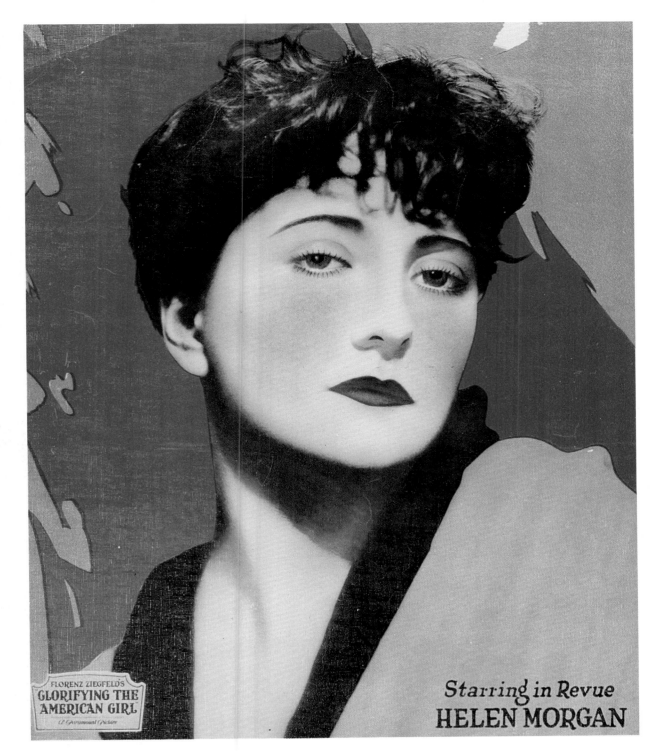

3 LOBBY CARD *Glorifying the American Girl*

George Eastman was the founder of the Eastman Kodak Company and the father of amateur photography. His 50-room, 35,000-square-foot home in Rochester, New York, first opened to the public in 1949 as a photography museum (In 1980, it was renamed the International Museum of Photography at George Eastman House.). In 1989, the collection moved into its own state of the art study center and exhibition space—a three-level, 73,000-square-foot building adjacent to Eastman's mansion. Also in 1989, the house and its formal gardens were restored to their formal grandeur, opening to the public in 1990.

Today holdings of the International Museum of Photography at George Eastman House include the world's finest collection of still photography—nearly 600,000 prints and negatives representing more than 8,000 international photographers from 1839 to the present. Louis Daguerre, William Henry Fox Talbot, Alexander Gardiner, Alfred Stieglitz, Ansel Adams, Lewis Hine, and Edward Steichen are but a few of the photographic artists represented.

The museum also features a renowned motion picture collection, including 7,000 titles and 3 million publicity stills, posters, and celebrity portraits; more than 11,000 cameras and related items, such as an 1838 Giroux Daguerreotype camera, the world's first commercially marketed instrument; and the world's most comprehensive film and photography library, 27,000 volumes, many of them rare and unique. Finally the museum includes four rotating exhibits of rare original photographs and North America's first hands-on photo Discovery Room, where visitors can create their own images and view demonstrations of photographic technology.

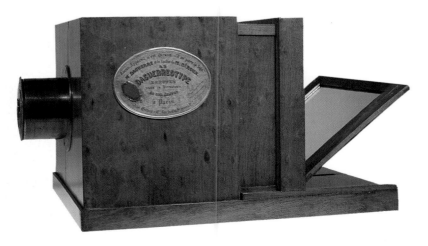

1 French, c. 1852, Stereo daguerreotype with applied color, Print Collection.
2 French, 1850, Lithograph after a daguerreotype by Matthew Brady, Richard and Ronay Meschel Library.
3 Paramount Famous Lasky Corp., 1929, Film Collection, Paper archives.
4 French, 1839, Technology Collection.

4 GIROUX DAGUERREOTYPE CAMERA

The Corning Museum of Glass

CORNING, NEW YORK

The Corning Museum in New York's famous Finger Lakes region houses the world's premier collection of glass and glassmaking. There are over 25,000 objects on display in the museum's stunning new building completed in 1980, and the 50,000-volume Rakow Library is the world's principal research center of this ancient art.

The museum examines 35 centuries of humanity's experience with glass—from prehistoric tools and weapons chipped from volcanic obsidian to the elegant creations of the great European masters to the visionary pieces of today's studio glass artists.

Thirteen milestones in the history of glassmaking are displayed in the museum's "Masterpiece Columns." These include ancient works like the Corning Ewer, a wafer-thin-1000-year-old Persian vessel, and the head of Amenhotep II, one of the earliest known portraits in glass, as well as modern works like the annual Rakow Commission, created each year by an outstanding contemporary artist. Another 200 major objects complete the masterpiece gallery, while adjacent galleries include 1,500 pieces in separate theme cases. The remainder of the collection is presented in study cases and there are also different special exhibitions each year.

In addition to the museum, the Corning Glass Center includes the "Hall of Science and Industry"—a tribute to the wonders of modern glass technology, from the tiny optical fibers that are revolutionizing communications to the first casting of the 200-inch mirror for the Palomar Mount telescope, one of the largest glass pieces ever made—and the Steuben Factory, makers of the glass treasures of tomorrow.

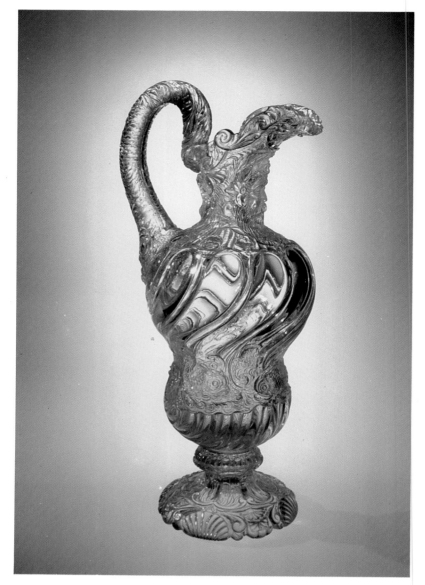

1 WILLIAM FRITCHE *Ewer*

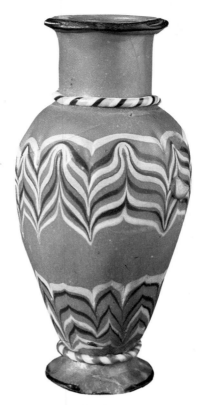

2 UNKNOWN *Bottle*

1 British, 1886, Glass with rock crystal style of engraving.
2 Egyptian, c. 1450–1350 B.C., Core-formed glass.
3 French, c. 1900, Glass with colored and wheel-engraved decoration.
4 American, 1905, Leaded glass.

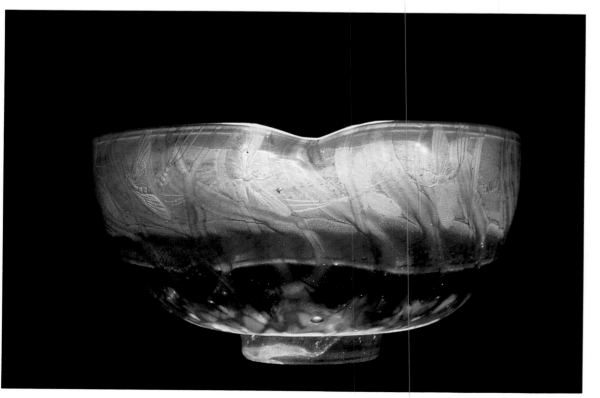

3 WORKSHOP OF ÉMILE GALLÉ *Bowl*

32

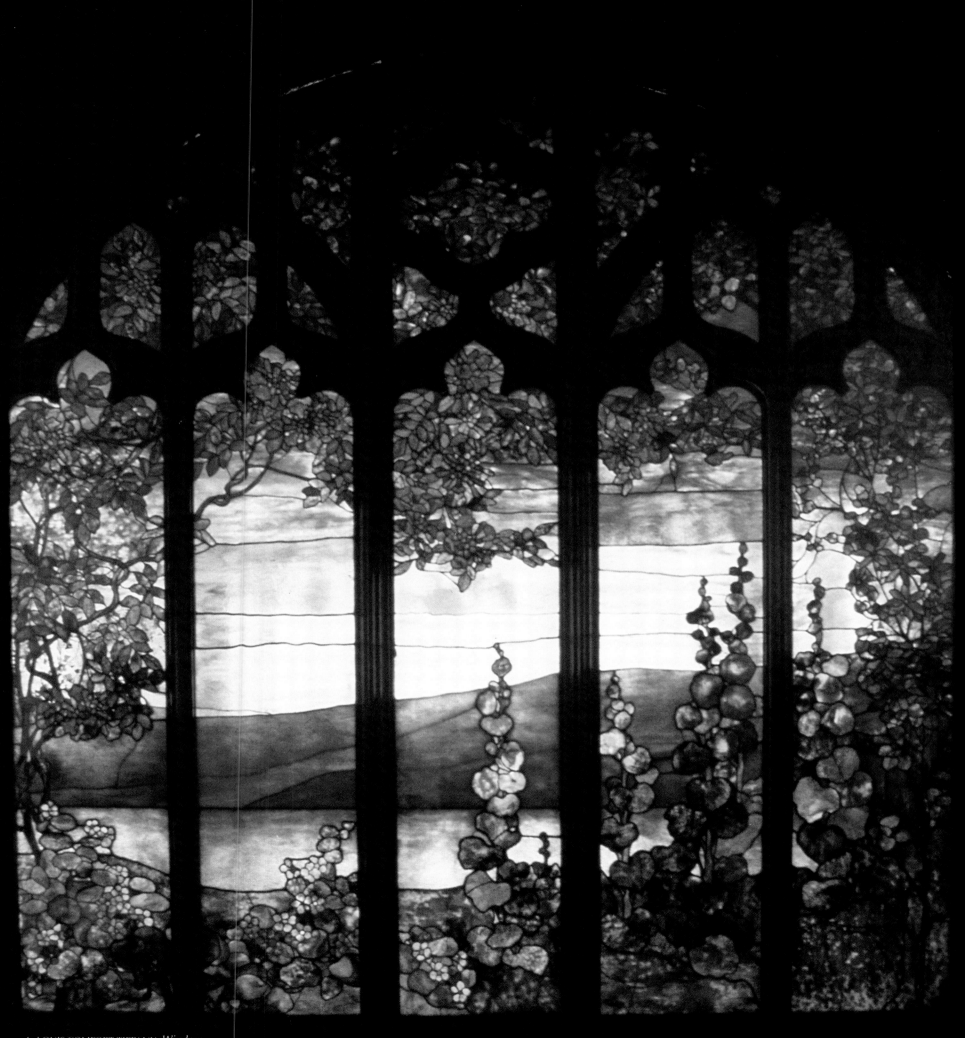

4 LOUIS COMFORT TIFFANY *Window*

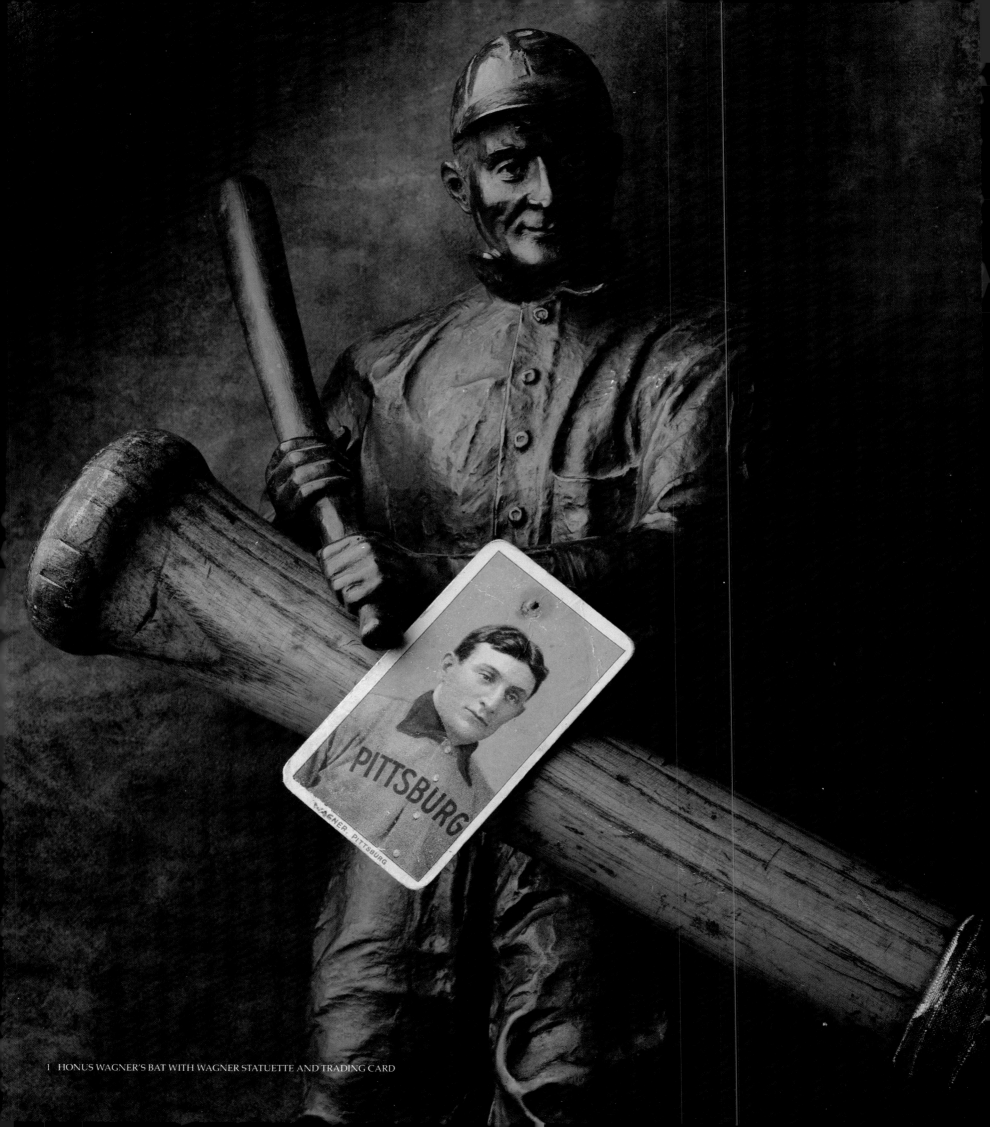

1 HONUS WAGNER'S BAT WITH WAGNER STATUETTE AND TRADING CARD

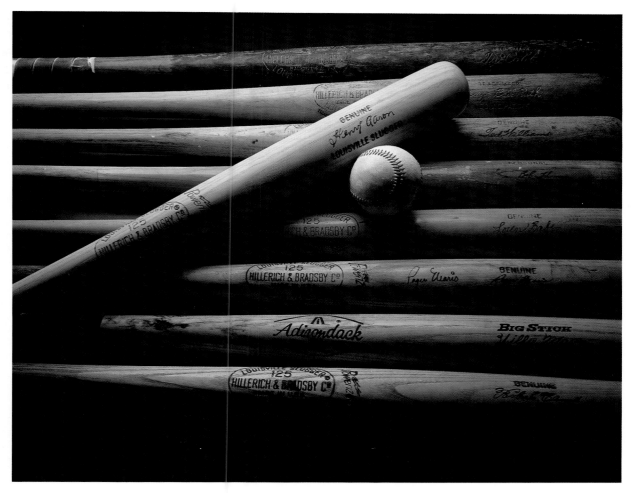

2 BATS USED BY (BOTTOM TO TOP) ROBERTO CLEMENTE, WILLIE MAYS, ROGER MARIS, LOREN BABE, BOB THOMSON, TED WILLIAMS, BABE RUTH, AND TY COBB.

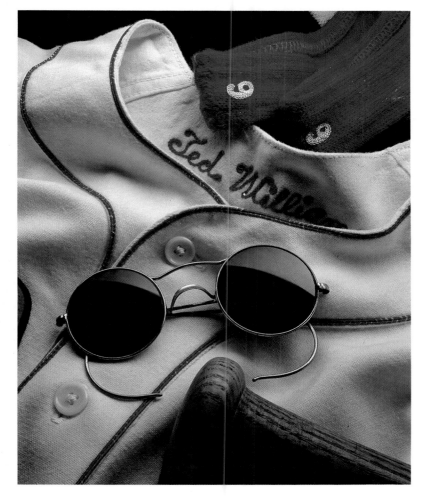

3 TED WILLIAMS' UNIFORM, LEGGINGS, SUNGLASSES, AND BAT.

4 BABE RUTH'S UNIFORM, BAT, AND BALL.

The photographs of the artifacts are by Terry Hefferman Inc.

National Baseball Hall of Fame and Museum

COOPERSTOWN, NEW YORK

The Baseball Hall of Fame, where over 200 of the sport's immortals are now enshrined, was established in 1939 in the very town where Abner Doubleday was said to have devised the game exactly 100 years before.

Life-size wood carvings of Babe Ruth and Ted Williams greet the more than 350,000 fans who come to Cooperstown each year to visit the recently expanded and renovated shrine. While the heart of the museum is the chapel-like Hall of Fame Gallery where baseball's greats are honored, there are a variety of rooms and displays spotlighting various aspects and players of the game.

In the Cooperstown Room, the history and development of baseball is traced. The "Great Moments Room" features a carefully selected montage of memorable events in the sport's history as well as the work of artists like Norman Rockwell. Touch-screen computers in the "IBM Hall of Fame Sports Gallery" allow visitors to obtain information on any enshrinee.

On the museum's second floor there are over 1,000 artifacts and photographs chronicling the 150 years of baseball history, plus displays on the All-Star Game, women in baseball, the early Negro leagues, world tours, and men who made outstanding contributions to the game.

In the "Ballparks Room" on the third floor, actual dugout benches, grandstand seats, and turnstiles can be seen. Here, too, are lockers that once belonged to Joe DiMaggio, Lou Gehrig, Stan Musial, and Honus Wagner; other unusual collections relating to the sport; and the "World Series Room," where dozens of magic Octobers are re-created.

The museum's new wing features a 200-seat movie theatre, more collections of baseball paraphernalia, and exhibits including one on how bats are made and another interactive IBM display that can answer questions about the game's all-time record holders.

The Frick Collection

NEW YORK, NEW YORK

In 1913 Pittsburgh industrialist Henry Clay Frick built a mansion on New York's Fifth Avenue to house his small but exquisite collection of paintings, sculpture, furniture, porcelains, enamels, rugs, silver, prints, and drawings.

Upon his death in 1919, Frick bequeathed both the collection and the residence to a private corporation for the purpose of establishing a public gallery after the death of his widow. The mansion opened to the public in 1935. Today, visitors can stroll through these intimate rooms, carefully preserved in their original luxurious states, and view many outstanding works of art from the 13th to 19th centuries.

A sense of history and an appreciation of style are evident everywhere in the Frick. One small room is devoted to eight François Boucher paintings commissioned by Madame de Pompadour. The dining room is decorated with 18th-century English portraits by William Hogarth, George Romney, and Joshua Reynolds and Thomas Gainsborough's *The Mall in St. James Park*. The living room features Giovanni Bellini's stunning *St. Francis In the Desert*, *St. Jerome* by El Greco, and portraits by Titian and Hans Holbein. Even the elegant hallways are filled with the Frick masterpieces, including J. A. D. Ingres' *Comtesse d'Haussonville*, and Jan Vermeer's luminous *Officer and Laughing Girl*.

Several rooms were built expressly as galleries, and here can be found wonderful paintings by Rembrandt, Bronzino, Diego Velázquez, Francisco Goya, Anthony Van Dyck, Georges de La Tour, and J. M. W. Turner to name but a few. Four large portraits by James Whistler are also on display as is the life-sized terra cotta figure of *Diana the Huntress* by Houdon. For a brief respite from the museum's many masterpieces, visitors are invited to linger in the Frick's delightful central court.

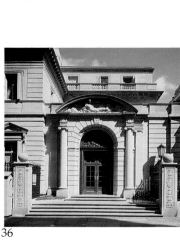

1 HANS HOLBEIN THE YOUNGER *Thomas Cromwell*

1 Dutch, n.d., Oil on panel.
2 Italian, c. 1480, Tempera and oil on poplar panel.
3 Dutch, c. 1655, Oil on canvas.
4 Italian, 1516, Oil on canvas.

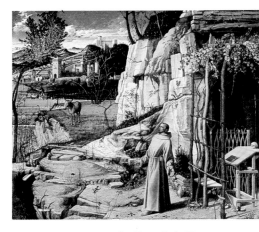

2 GIOVANNI BELLINI *St. Francis in Ecstasy*

3 REMBRANDT *The Polish Rider*

36

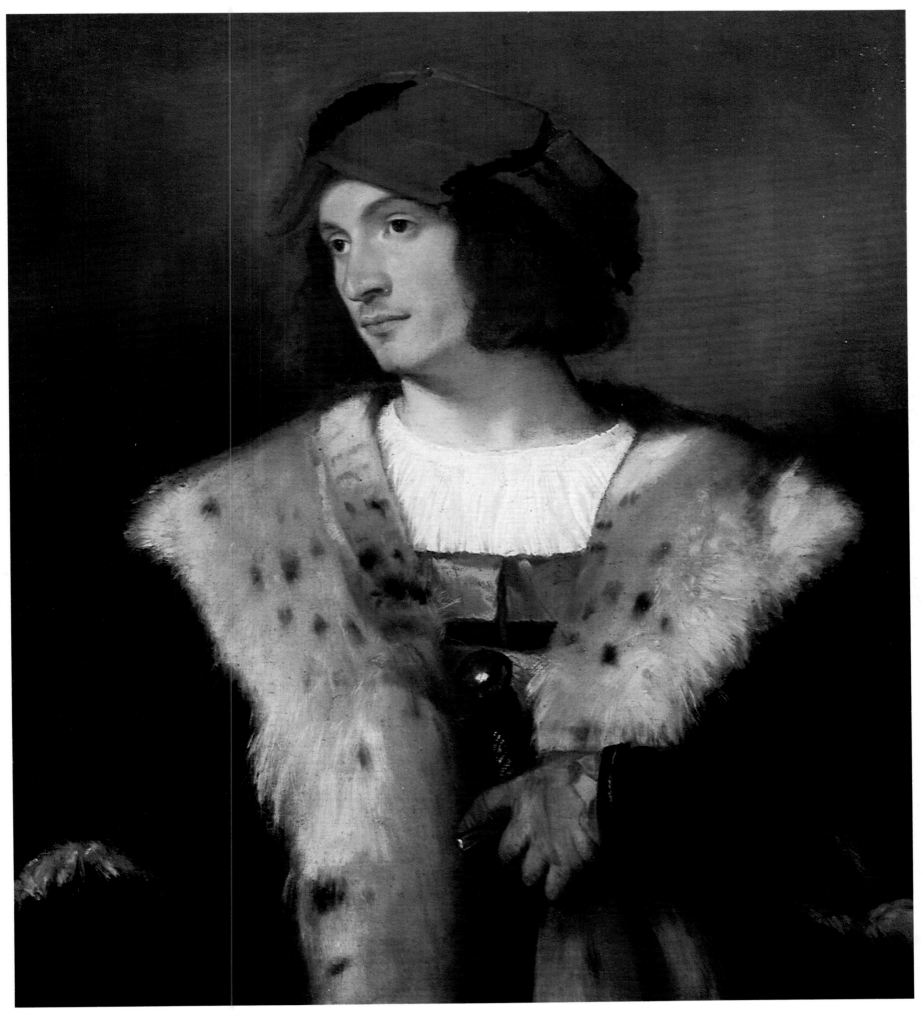

4 TITIAN *Man with a Red Hat*

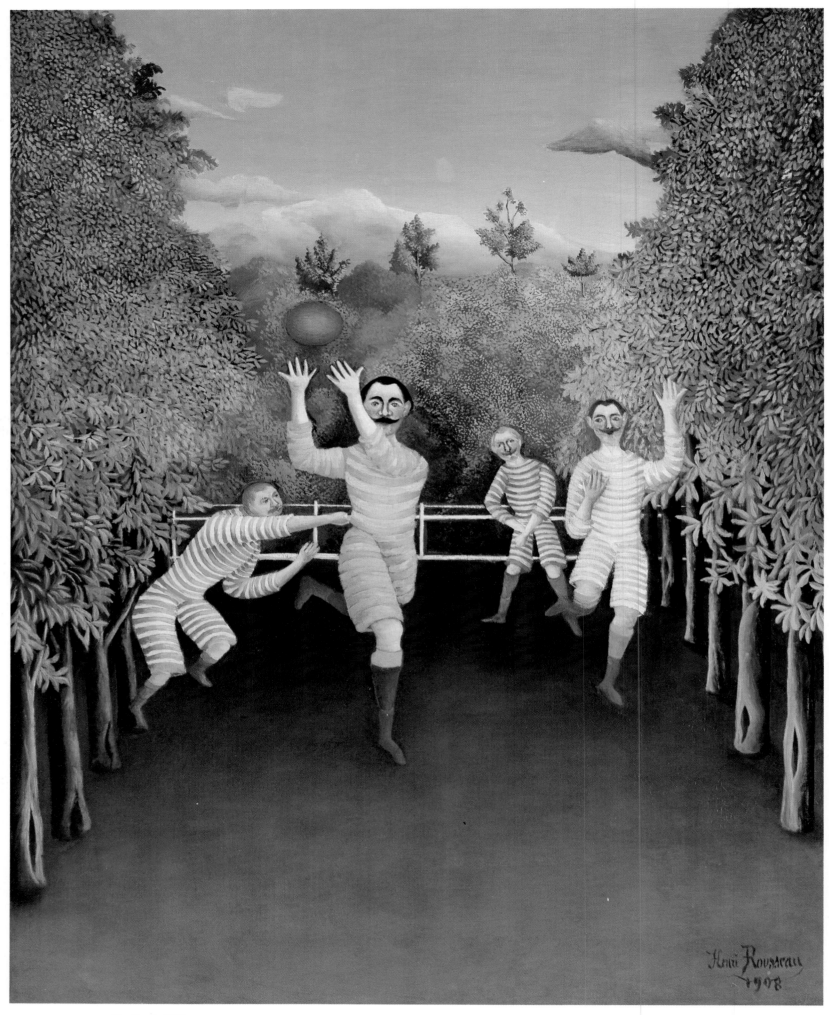

1 HENRI ROUSSEAU *The Football Players*

The Solomon R. Guggenheim Museum

NEW YORK, NEW YORK

Solomon Guggenheim, who built an American mining empire, originally exhibited his collection of modern art in his apartment at New York's Plaza Hotel. In 1939 his Museum of Non-Objective Painting opened in rented rooms and later occupied a six-story mansion. It was not until 1959, however, that the Solomon R. Guggenheim Museum—as the museum had been renamed—moved to its permanent home and captured the world's attention.

That permanent home was Frank Lloyd Wright's famous poured-concrete landmark on New York's Fifth Avenue, across from Central Park. This unique structure with its 25,000 square feet of airy exhibit space along a spiraling ramp originally caused consternation among local residents, but it has become so accepted, that the recent museums renovation came under strict public scrutiny lest anything detract from Wright's original design. Gallery space has been expanded by 50 percent, allowing the Justin K. Thannhauser collection of Impressionist and early modern works to be displayed in the small rotunda of the original building, a space previously not open to the public. More of Solomon Guggenheim's collection of Kandinskys and Légers, Chagalls and Moholy-Nagys, Delaunays and Feiningers can also be presented.

Over the years this permanent collection, which still gives the museum its keel and direction, has been enlarged with paintings and sculpture by such European masters as Paul Klee, Pablo Picasso, Constantin Brancusi, Alberto Giacometti, and Joan Miro, and Americans like Jackson Pollock, David Smith, and Frank Stella. The 1990 acquisition of more than 300 works from the Panza collection has greatly strengthened the museum's holdings of minimalist art from the 1960s and 1970s. Examples of this acquisition view at the museum in 1992.

1 French, 1908, Oil on canvas, FN 60.1583.
2 Swiss, 1947, Bronze, wire, rope, and steel, FN 66. 1807.
3 Russian, 1926, Oil on canvas, Gift Solomon R. Guggenheim, 1941, FN 41.283.
4 Russian, 1923/24, Oil on canvas, Gift Solomon R. Guggenheim, 1937, FN 37.446.
All photographs by David Heald.

2 ALBERTO GIACOMETTI *Nose*

3 VASILY KANDINSKY *Several Circles*

4 MARC CHAGALL *Green Violinist*

The American Museum of Natural History

NEW YORK, NEW YORK

Founded in 1869, its cornerstone laid by Ulysses S. Grant, the American Museum of Natural History was never intended to be a local or regional institution, but a national center for the scholarship and teaching of the natural sciences and anthropology. A Romanesque revival landmark sprawling across several New York City blocks and including 38 major exhibition halls, a planetarium, and a research library, it long ago fulfilled its destiny and is today the largest natural history museum in the world.

It is impossible to talk about the museum's dioramas, habitats, and life-sized exhibits without using superlatives. The largest dinosaur collection in existence can be found here. So can the largest collection of mammal fossils, the largest collections of birds, and one of the largest planetarium computer automation systems.

The museum also features extensive exhibits covering anthropology and human evolution. The African collection, the Margaret Mead Hall of Pacific Peoples, the artifacts representing the peoples of Asia and the Indians of Middle and South America—all are among the finest in existence.

The American Museum's spectacular collection of minerals, gems, and meteorites includes the largest meteorite on display anywhere (a 68,000-pound chunk of iron and nickel), the world's largest star sapphire (the 563 carat Star of India donated by financier J. P. Morgan), and three moon rocks. Perhaps most remarkable of all is what is not on display. Carefully catalogued and stored in areas not open to the public is the bulk of the museum's collections and the lifeblood of its research mission—some 36 million specimens.

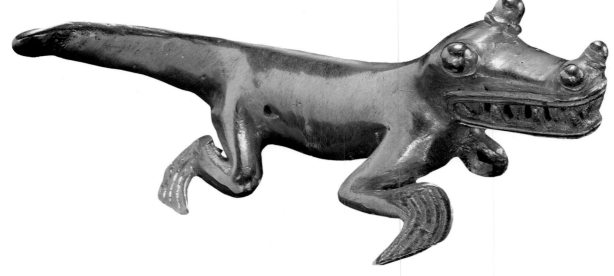

1 CHIRIQUI, PANAMA *Gold alligator pendant*

3 SAPPHIRE
The Star of India

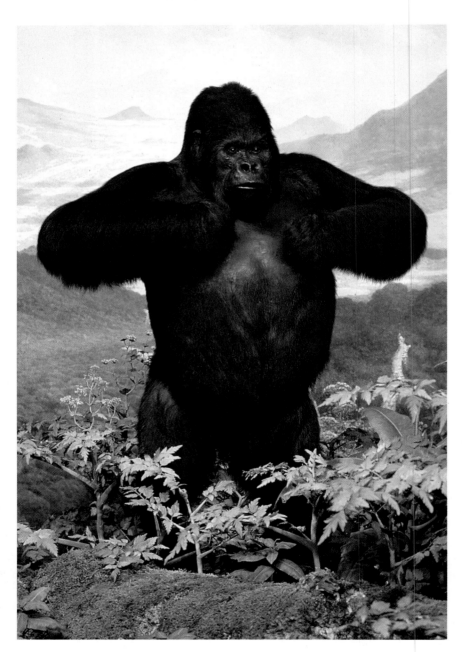

2 AFRICAN *MALE GORILLA*

4 BENIN *Bronze face mask*

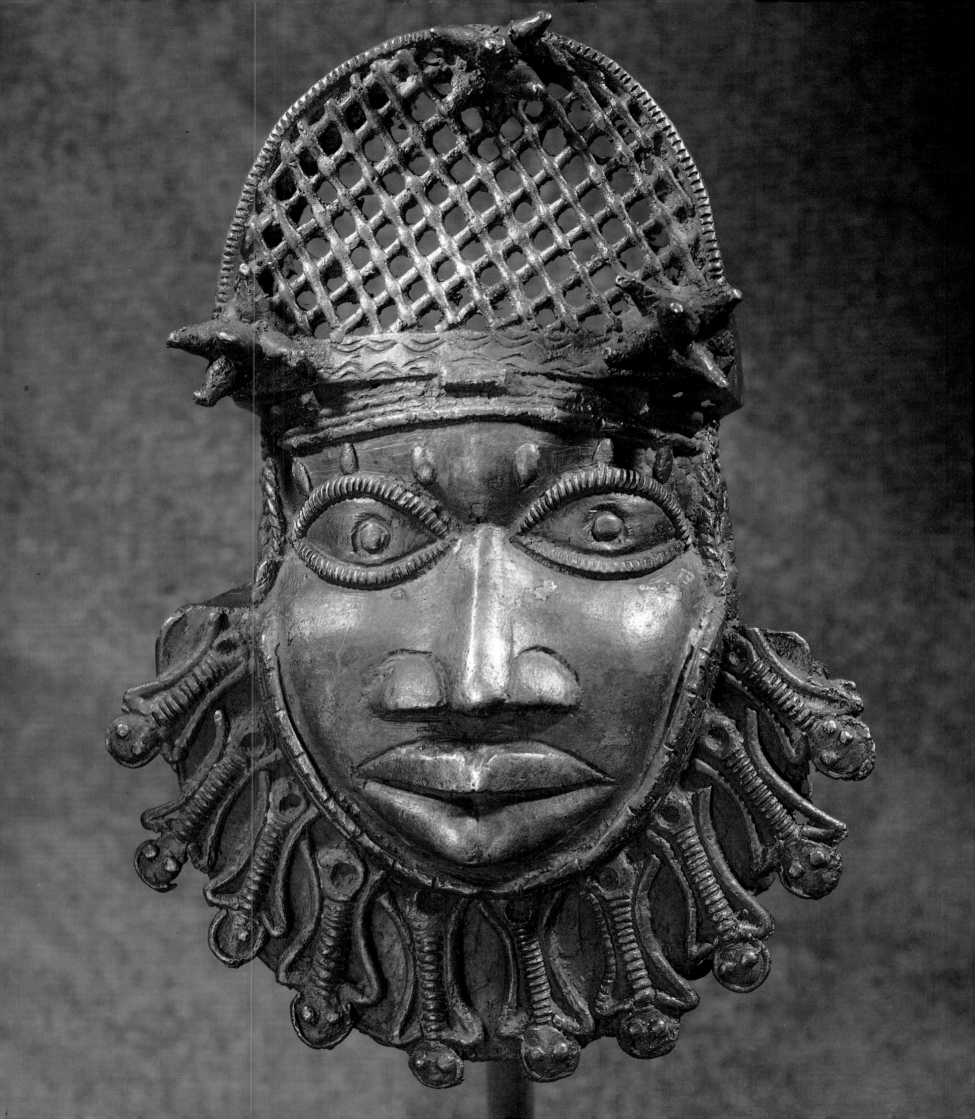

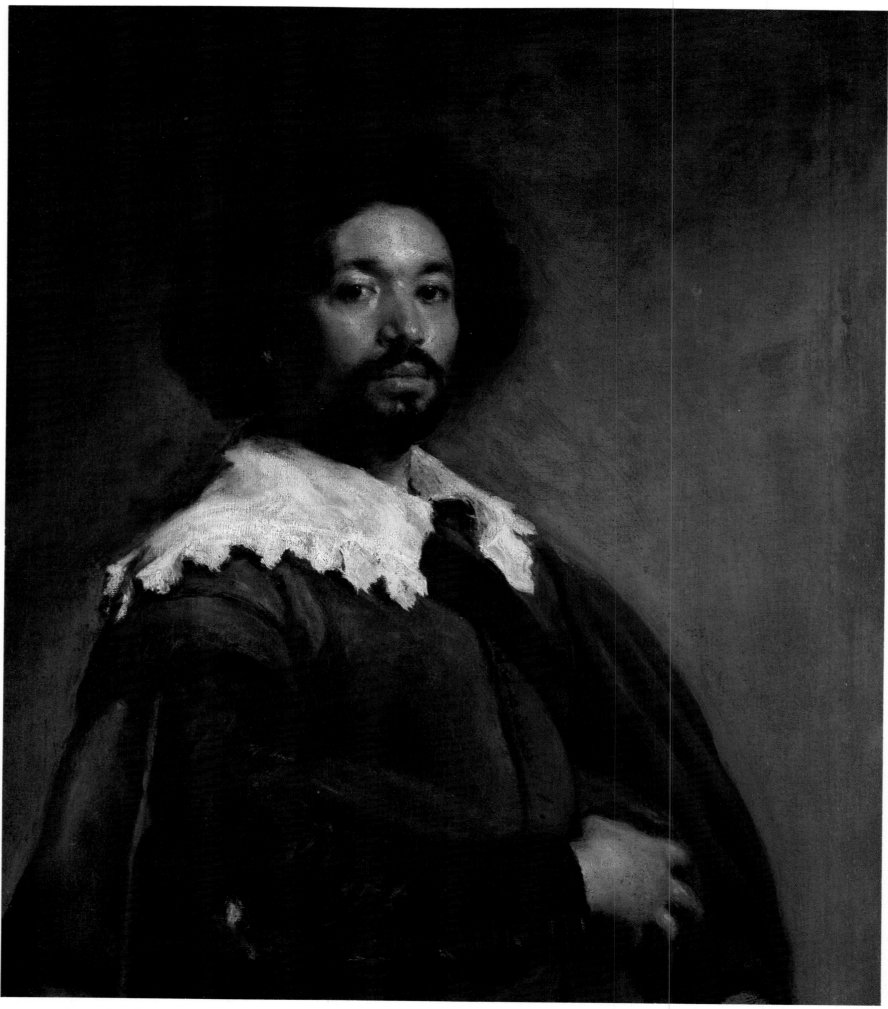

1 DIEGO VELÁZQUEZ *Juan de Pareja*

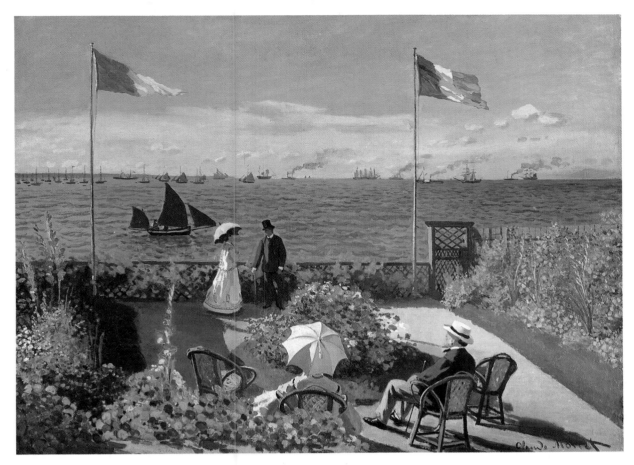

2 CLAUDE MONET *Terrace at Sainte-Addresse*

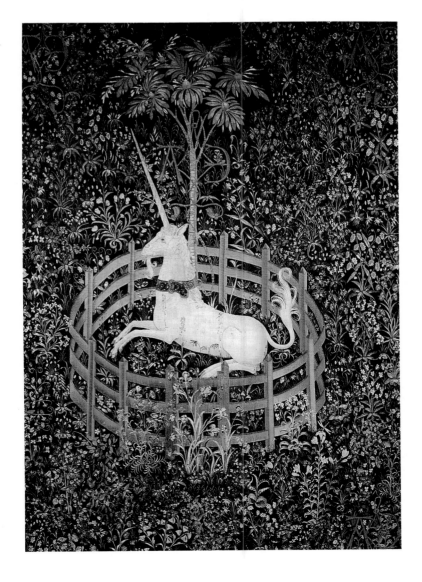

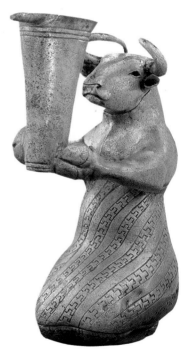

3 UNKNOWN *Kneeling bull holding vessel*

4 UNKNOWN *The Hunt of the Unicorn: The Unicorn in Captivity*

The Metropolitan Museum of Art

NEW YORK, NEW YORK

The Metropolitan Museum of Art is one of the world's great museums with more than two million works spanning virtually every culture and era in the 5,000-year history of art. Over four million visitors annually come to see the Met's collection, several hundred thousand pieces of which are on display at any one time.

It is impossible to avoid superlatives when discussing the museum's more than 240 galleries in 19 major curatorial areas. Of particular note are the Egyptian Wing, which features a renowned collection, and the American Wing, which houses perhaps the most impressive collection of American paintings, sculpture, and decorative arts in the world. Separate wings are devoted to the Robert Lehman Collection of Old Masters, 19th-century French painting, and European decorative arts, and the museum's stunning collection of primitive art.

Many instantly recognizable canvases can be found in the museum's 3,000-item European Painting collection, and the Department of European Sculpture and Decorative Arts has 60,000 works dating from the Renaissance to the early 20th century.

The museum also has extensive collections in Greek and Roman art; arms and armor; Islamic art; musical instruments; 20th-century art; Medieval art (much of it housed at the Cloisters in Upper Manhattan); Ancient and Near Eastern art; costumes; drawings, prints and photographs; and Asian art.

The Metropolitan Museum of Art was founded in 1870 and moved to its present site in New York's Central Park in 1880. The museum's familiar beaux-arts façade and Great Hall were designed by Richard Morris Hunt at the turn of the century, and the side wings, completed in 1906, were by McKim, Mead, and White. Several new wings designed by Roche, Dinkeloo and Associates have been completed since 1975.

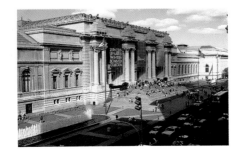

43

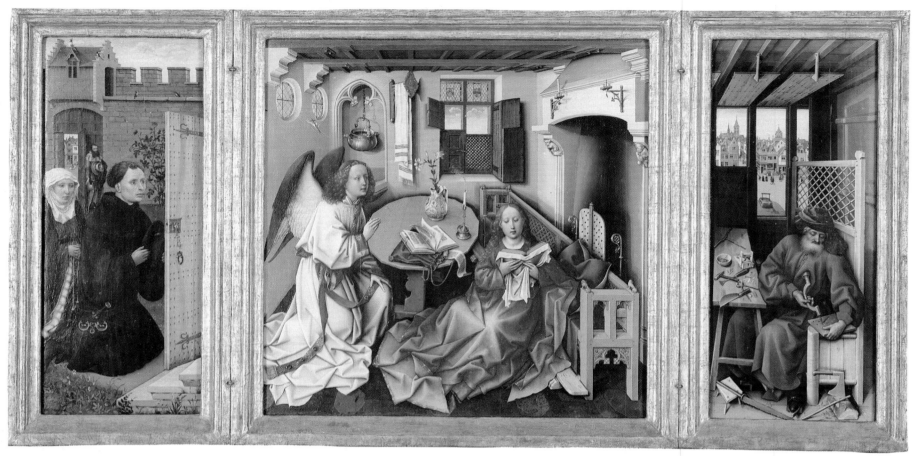

5 ROBERT CAMPIN *Triptych of the Annunciation*

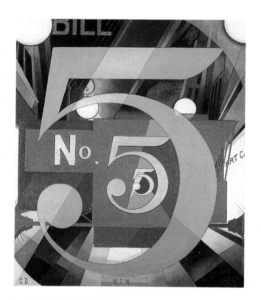

6 CHARLES DEMUTH
I Saw the Figure 5 in Gold

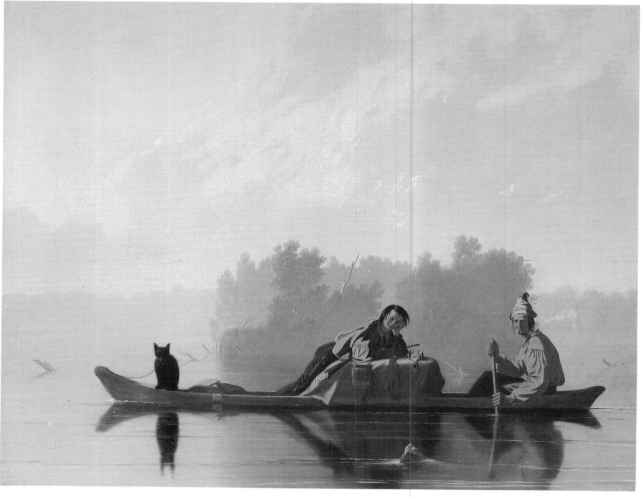

7 GEORGE CALEB BINGHAM *Fur Traders Descending the Missouri*

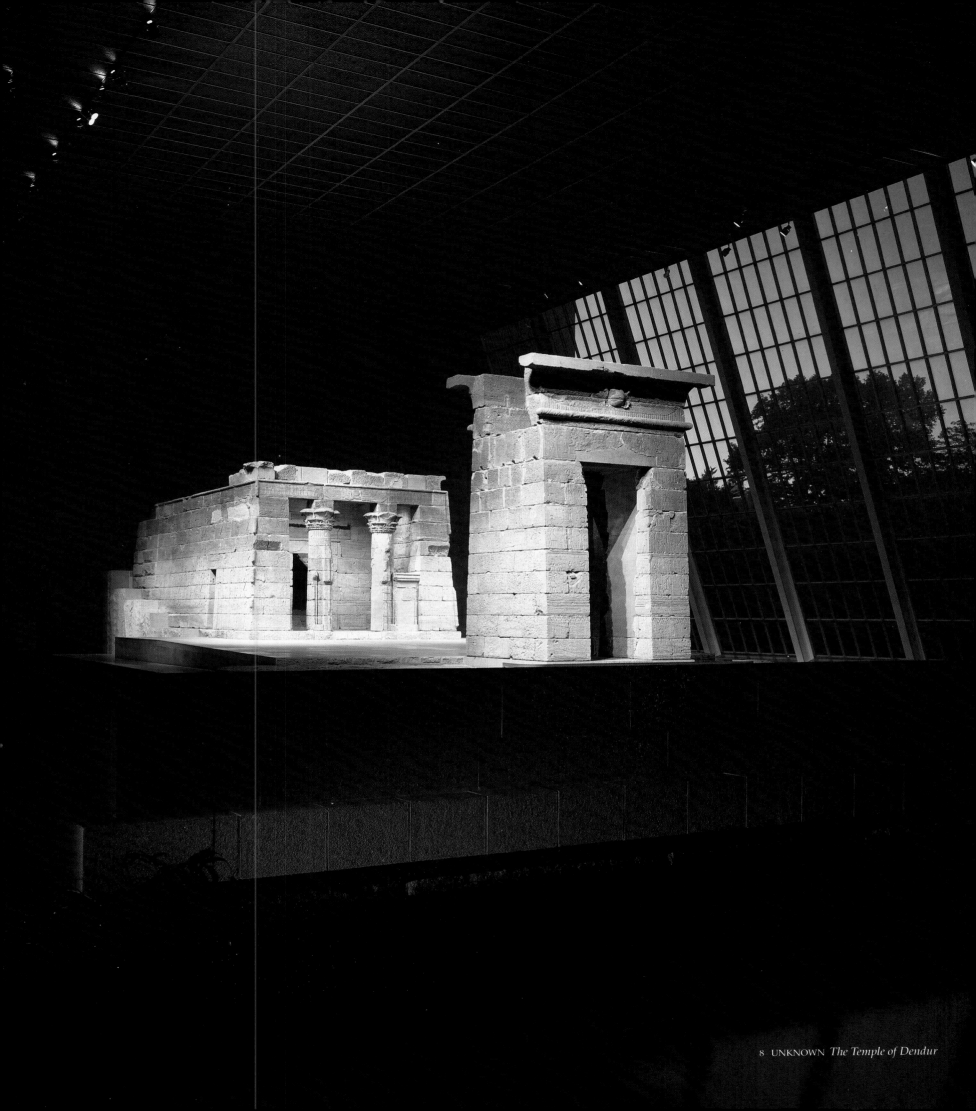

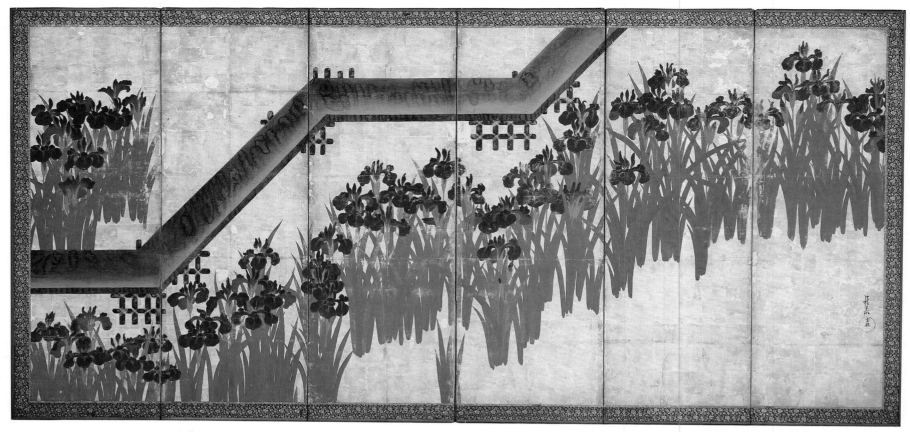

9 OGATA KORIN *Iris and Bridge*

1 Spanish, c. 1650, Oil on canvas, Fletcher Fund, Rogers Fund, and Bequest of Miss Adelaide Milton de Groot (1876-1967), by exchange, supplemented by gifts from friends of the Museum, 1971.86.

2 French, 1867, Oil on canvas, Purchased with special contributions and purchase funds given or bequeathed by friends of the Museum, 67.241.

3 Iranian, Proto-Elamite period, c. 2900 B.C., Silver, Purchase, Joseph Pulitzer Bequest, 66.173.

4 Franco-Flemish, c. 1500, Silk, wool, silver and silver-gilt threads, Gift of John D. Rockefeller, Jr., The Cloisters Collection, 37.80.6.

5 Flemish, c. 1425–1428, Oil on wood, The Cloisters Collection, 56.70.

6 American, 1928, Oil on composition board, The Alfred Stieglitz Collection, 49.59.1

7 American, c. 1845, Oil on canvas, Morris K. Jesup Fund, 33.61.

8 Egyptian, 1st century B.C., Architecture, Given to the United States by Egypt in 1965, awarded to the Metropolitan Museum of Art in 1967 and installed in the The Sackler Wing in 1978, 68.154.

9 Japanese, 19th century, Six-panel screen: one of a pair, Paint and gold on paper, Louisa E. McBurney Gift Fund, 53.7.2.

10 Greek, Attic, c. 490 B.C., Terracotta, Fletcher Fund, 56.171.38.

11 Nigerian, Early 16th century, Ivory, iron, copper, The Michael C. Rockefeller Memorial Collection, Gift of Nelson A. Rockefeller, 1978.412.323, Photograph by Schecter Lee.

12 Dutch, 1653, Oil on canvas, Purchased with special funds and gifts of friends of the Museum, 61.198.

10 ATTRIBUTED TO THE BERLIN PAINTER *Amphora*

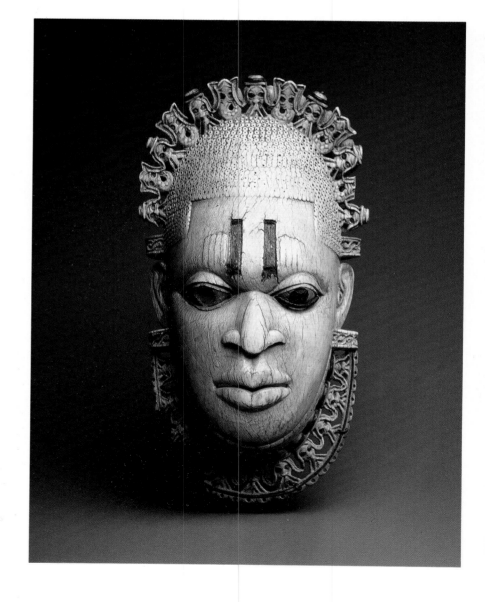

11 BENIN KINGDOM *Pendant Mask*

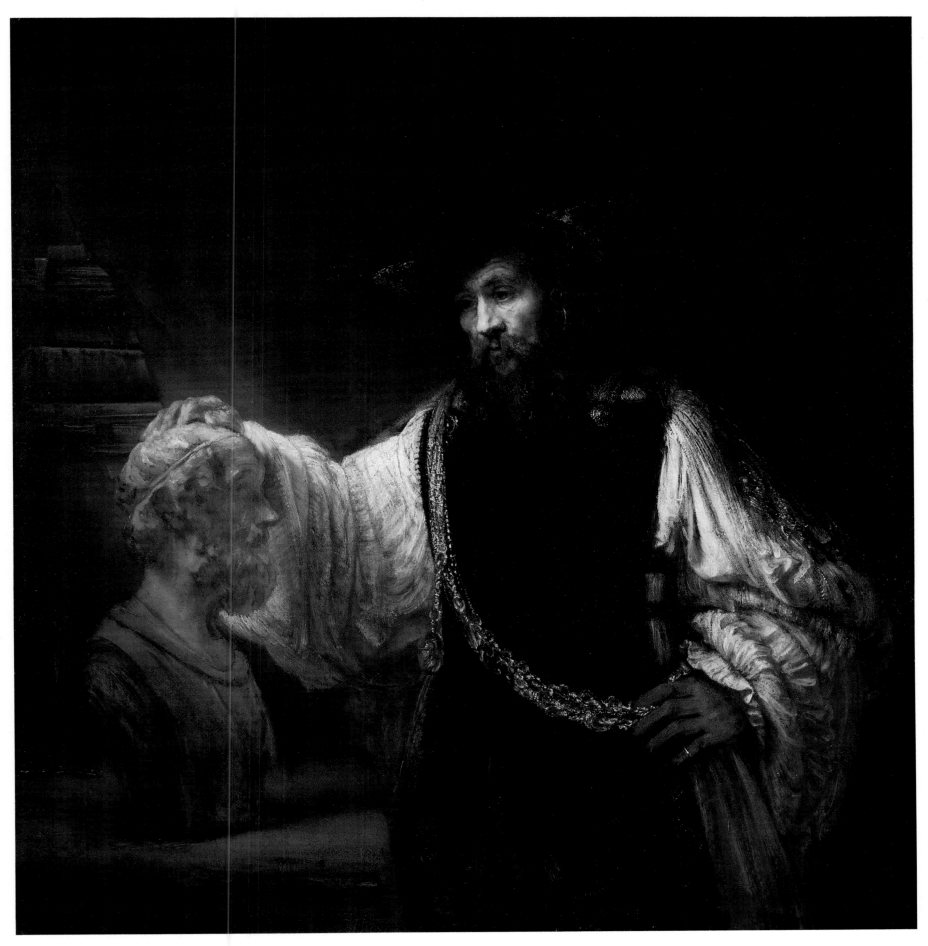

12 REMBRANDT *Aristotle with a Bust of Homer*

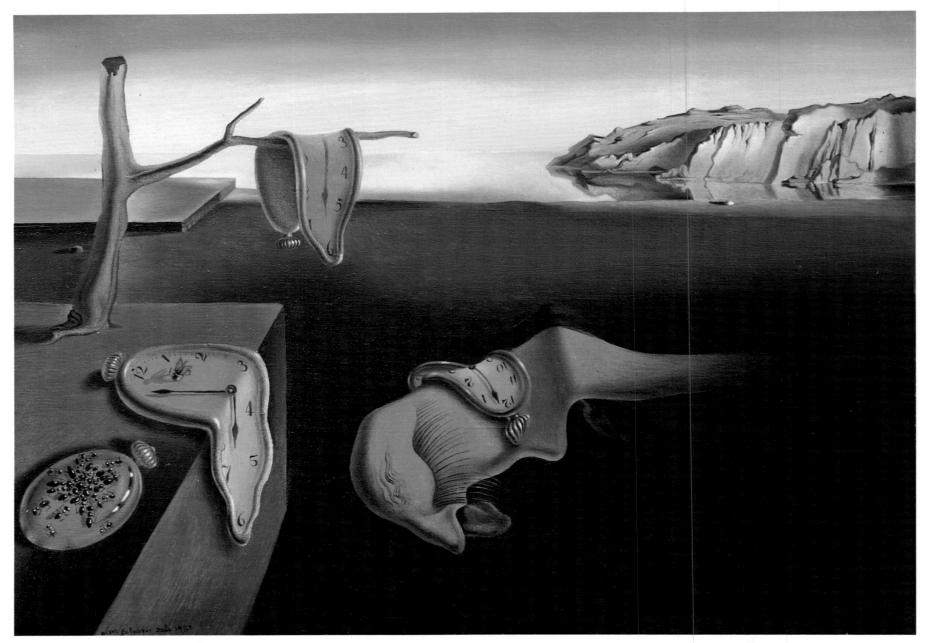

1 SALVADOR DALI *The Persistence of Memory*

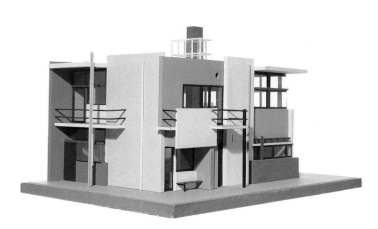

2 GERRIT RIETVELD *Schroder House, The Netherlands (model)*

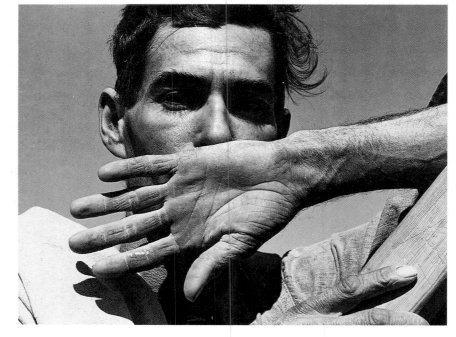

3 DORTHEA LANGE *Migratory Cotton Picker, Eloy, Arizona*

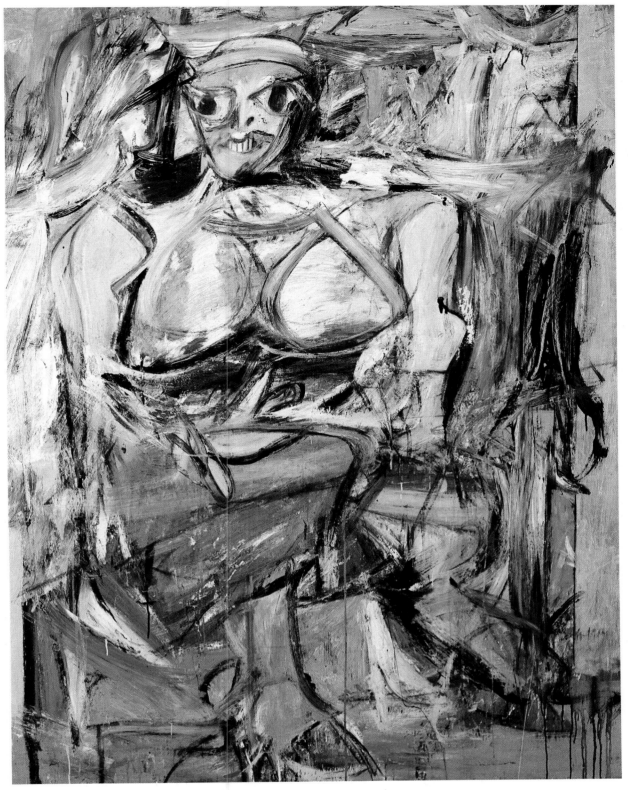

4 WILLEM DE KOONING *Woman I*

The Museum of Modern Art

NEW YORK, NEW YORK

In 1929, a group of progressive individuals felt the need to provide a home for contemporary art. Under the leadership of art scholar Alfred Barr, the institution they founded, the Museum of Modern Art (MoMA), has grown into one of the world's most comprehensive surveys of 20th-century works.

MoMA's 1939 International-style building, designed by Philip Goodwin and Edward Durell Stone, was augmented by two new wings, completed in 1964 by architect Philip Johnson. In 1979 a major renovation and construction effort designed by Cesar Pelli more than doubled MoMA's gallery space.

The museum's collection of over 100,000 objects includes works by virtually every important artist of the last 100 years. Constantly changing displays of contemporary art present recent work by emerging artists.

Salvador Dali's famous *The Persistence of Memory* is in the collection, as is Henri Matisse's *Dance*, Piet Mondrian's *Broadway Boogie-Woogie*, Andrew Wyeth's *Christina's World*, Andy Warhol's *Gold Marilyn Monroe*, and Jackson Pollock's *One*. Representative works of Pablo Picasso's entire prolific career can be found here, including the landmark *Les Demoiselles d'Avignon*.

MoMA also devotes permanent gallery space to the exhibition of its drawings, photographs, and illustrated books and prints. On display too are architectural models by such noted figures as Mies van der Rohe, Le Corbusier, and Frank Lloyd Wright. The museum's collection of innovatively designed objects—one of its most popular attractions—includes household appliances, posters, and even a helicopter. As many as four film programs—ranging from foreign animation to Hollywood classics—are screened daily in the museum's two theaters.

1 Spanish, 1931, Oil on canvas, Given anonymously.

2 Dutch, 1924, Plywood and glass, Gift of Phyllis B. Lambert.

3 American, 1940, Gelatin-silver print, Gift of the Photographer.

4 Dutch, 1950–1952, Oil on canvas, Purchase.

5 Spanish, Begun May, reworked July 1907, Oil on canvas, Acquired through the Lillie P. Bliss Bequest.

6 French, 1910, Oil on canvas, Gift of Nelson A. Rockefeller.

7 Dutch, 1942–1943, Oil on canvas, Given anonymously.

8 Italian, 1913, Bronze (cast 1931), Acquired through the Lillie P. Bliss Bequest.

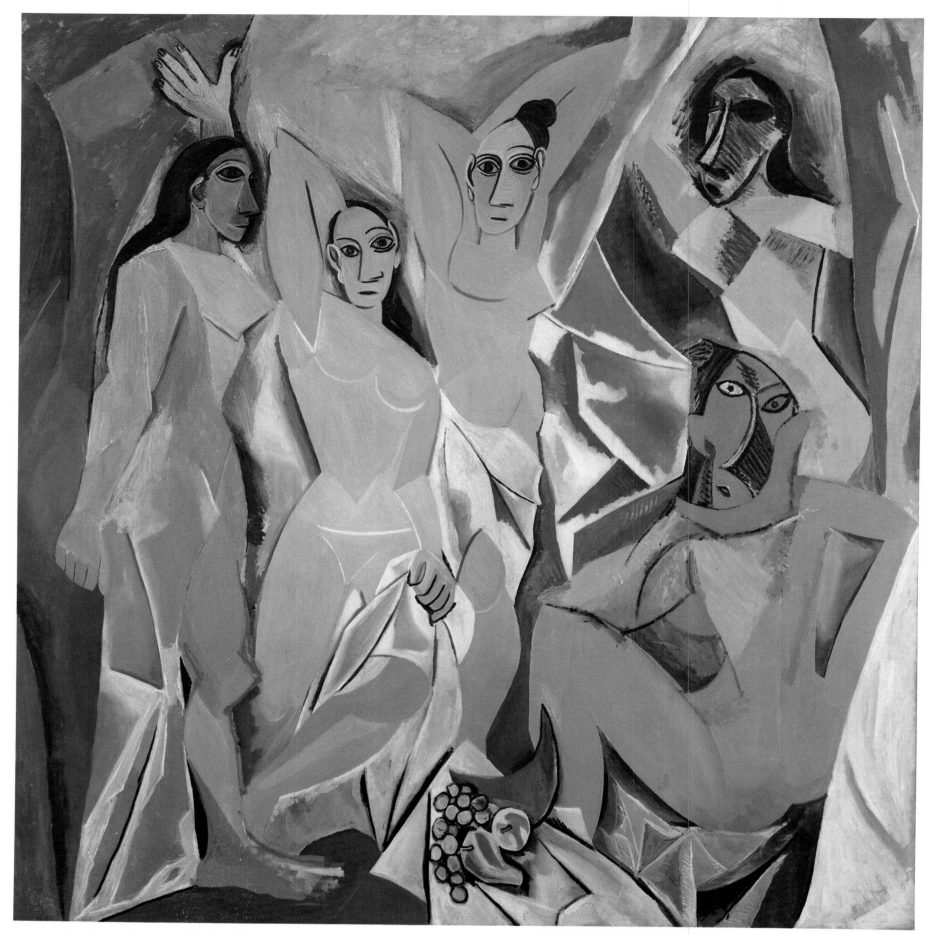

5 PABLO PICASSO *Les Demoiselles d'Avignon*

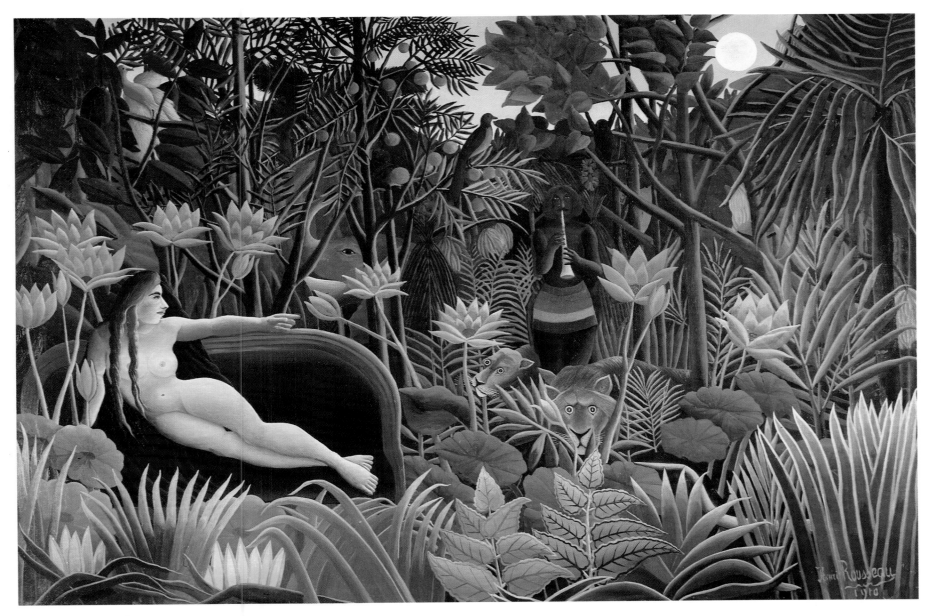

6 HENRI ROUSSEAU *The Dream*

7 PIET MONDRIAN *Broadway Boogie Woogie*

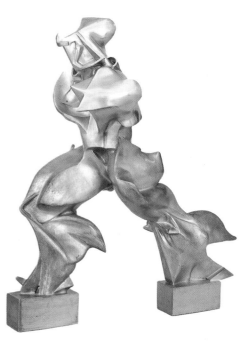

8 UMBERTO BOCCIONI
Unique Forms of Continuity in Space

The American Museum of the Moving Image

ASTORIA, NEW YORK

This 50,000-square-foot $15-million institution in Astoria, Queens, was once the home of Paramount Pictures and is the nation's only museum devoted to the art, history, and technology of motion pictures, television, and video.

The museum, founded in 1988, does not preserve films or tapes, but rather is devoted to the material culture of the moving images that have become such a part of 20th-century life. Its collection of over 70,000 artifacts dating from the age of Edison to the age of Spielberg includes props, costumes, technical apparatus, marketing materials, production designs and models, photographs, and licensed merchandise—everything from Mickey Mouse watches and lunch boxes inspired by films and TV shows to Joan Crawford's white-tiered ball dress from *Letty Lynton*. (Macy's sold 300,000 copies of this dress).

The museum's permanent display, "Beyond the Screen: Producing, Promoting and Exhibiting Motion Pictures and Television," features a "Magic Mirror" where visitors can see how they would look as Axel Foley, Eddie Murphy's character in *Beverly Hills Cop*, or as Scarlett O'Hara in *Gone with the Wind*. There are also displays that illustrate how the movies and television are created and others that celebrate the professionals who make it all happen. Works commissioned by leading video artists complement the presentation. Items from the permanent collection rotate approximately every six months, and visitors may find anything from video arcade games to costume sketches to star portraits on display. There are also special exhibitions, as well as two advanced screening rooms where more than 500 programs—silent films, Hollywood classics, TV documentaries, and even the latest experimental videos—are shown annually.

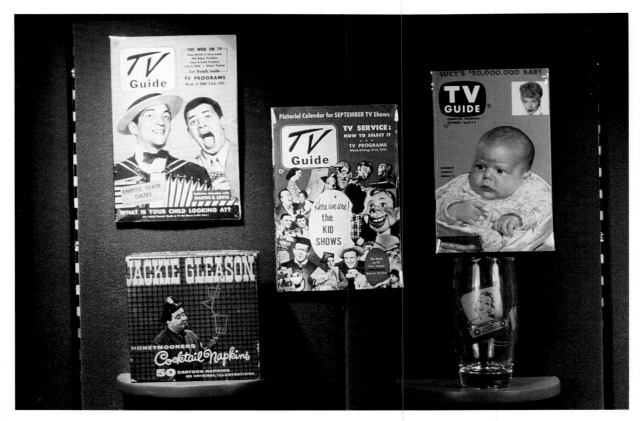

1 ARTIFACTS OF THE TELEVISION AGE

2 FILM PROJECTOR, c. 1910

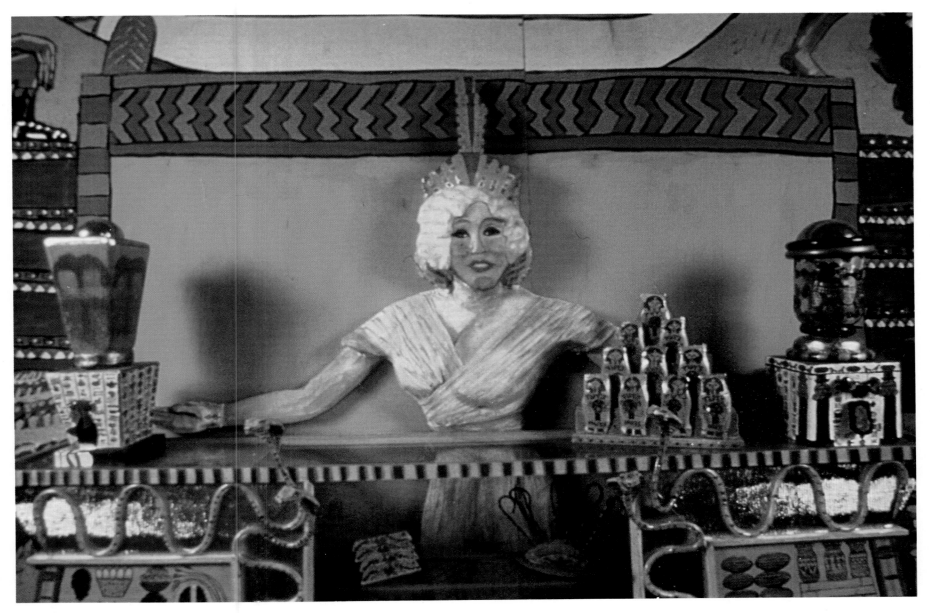

3 RED GROOMS AND LYSIANE LUONG *Mae West*, DETAIL FROM *Tut's Fever*

4 TONY WALTON SET MODEL FOR *Death of a Salesman* (1985 version)

3 JAMES EARLE FRASER
Benjamin Franklin

4 FOUCAULT PENDULUM

The Franklin Institute Science Museum

PHILADELPHIA, PENNSYLVANIA

The Franklin Institute for the Promotion of the Mechanic Arts was founded in 1824 to document the careers and preserve the artifacts of such pioneers of American science as Benjamin Franklin, Samuel F. B. Morse, Thomas Edison, and the Wright brothers. The present Franklin Institute Science Museum, established in 1933, is the custodian of this rich legacy and one of the nation's leading museums of science and technology.

The recently renovated 300,000-square-foot museum is comprised of five major components, linked together by an interactive computer, the most extensive of its kind.

The Futures Center, a 90,000 square-foot new addition completed in 1990, is the first museum dedicated to the ideas and forces that will shape life in the 21st century. Permanent exhibits highlight the technology involved in such areas as computers, space travel, energy, fiber optics, health, new materials, and the environment.

The Science Center is the main section of the museum, featuring scores of displays and hands-on exhibits, a practice that the Franklin Institute pioneered. Visitors can try everything from composing tunes on a music synthesizer to tapping out messages in Morse code. Also included are a walk-through model of a human heart; the Baldwin 60,000—a 350-ton, 101-foot-long steam locomotive; flight simulators and a jet trainer; and two reflection telescopes in the largest public observatory in the United States.

The Institute's four-story Tuttleman Omniverse Theater features a revolutionary motion picture system that surrounds the viewer with images. The 79-foot wide screen is among the largest in the country.

The 350-seat Fels Planetarium is the nation's second-oldest, but the technology is state of the art, thanks to the DIGISTAR projector installed in 1989.

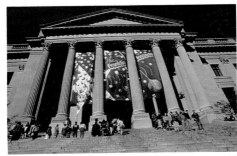

The Philadelphia Museum of Art

PHILADELPHIA, PENNSYLVANIA

Founded in America's centennial year, 1876, the Philadelphia Museum of Art moved into its striking, 435,600-square-foot Greco-Roman building in 1928. Today it is the nation's third-largest museum with a collection of more than 300,000 objects spanning 25 centuries.

American art is among the Philadelphia museum's particular strengths. The world's largest collection of paintings by Thomas Eakins is here, as well as works by Thomas Sully, Winslow Homer, and 86 canvasses by Mary Cassatt. Five portraits by Charles Willson Peale in the Powel Room—one of the museum's many American period rooms—picture furniture that is actually on display in the room. The museum also has a large collection of Pennsylvania German and Shaker pieces, as well as extensive displays of silver, glass, and porcelain.

Celebrated holdings in Asian arts include not just paintings and artifacts, but an entire stone Hindu temple from India and a Japanese tea house and garden.

Early European decorative arts, including Gothic sculpture and stained glass, center around a 12th-century French cloister. The Renaissance is captured in paintings by such masters as Fra Angelico, Agnolo Bronzino, and Titian. Later European painters range from Nicolas Poussin, Peter Paul Rubens, and Giambattista Tiepolo to all the major French Impressionists. There are also period rooms indicative of 18th- and 19th-century France and England.

Finally, there is 20th-century art. The museum's outstanding holdings features paintings by Pablo Picasso, Georges Braque, and Henri Matisse; sculpture by Constantin Bracusi; the world's finest collection of works by Marcel Duchamp; and contemporary creations by Jasper Johns, Robert Rauschenberg, and Cy Twombley, whose ten-panel painting, *Fifty Days at Iliam*, takes up an entire room.

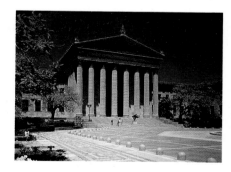

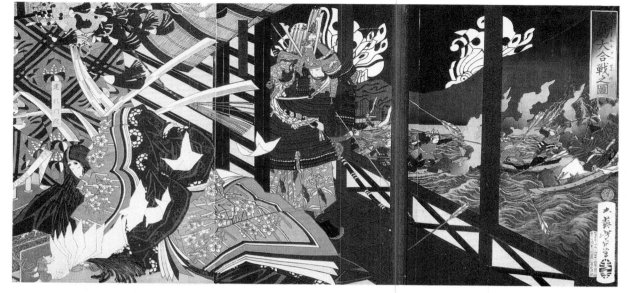

1 TSUKIOKA YOSHITOSHI *The Great Battle of Yshima*

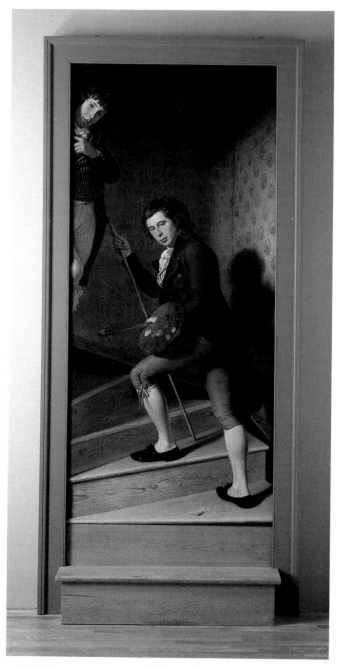

3 CHARLES WILLSON PEALE *Staircase Group*

2 CONSTANTIN BRANCUSI *The Kiss*

1 Japanese, 1881, Color woodcut, Purchased with funds contributed by the E. Rhodes and Leona B. Carpenter Foundation.

2 Rumanian, c. 1912, Limestone, Louise and Walter Arensberg Collection.

3 American, 1795, Oil on canvas, The George W. Elkins Collection.

4 Spanish, 1921, Oil on canvas, A.E. Gallatin Collection.

5 French, 1906, Oil on canvas, Purchased: W.P. Wilstach Collection.

6 French, 1638–1640, Oil on canvas.

7 American, c. 1775-60, Mahogany, red cedar, pine, poplar, Purchased with the Walter H. Annenberg Fund for Major Acquistions, with supporting funds from the Henry P. McIlhenny Fund in memory of Frances P. McIlhenny, funds contributed by H. Richard Dietrich, Jr., and other private donors by contribution and exchange.

8 American, 1912, Oil on canvas, Louise and Walter Arensberg Collection.

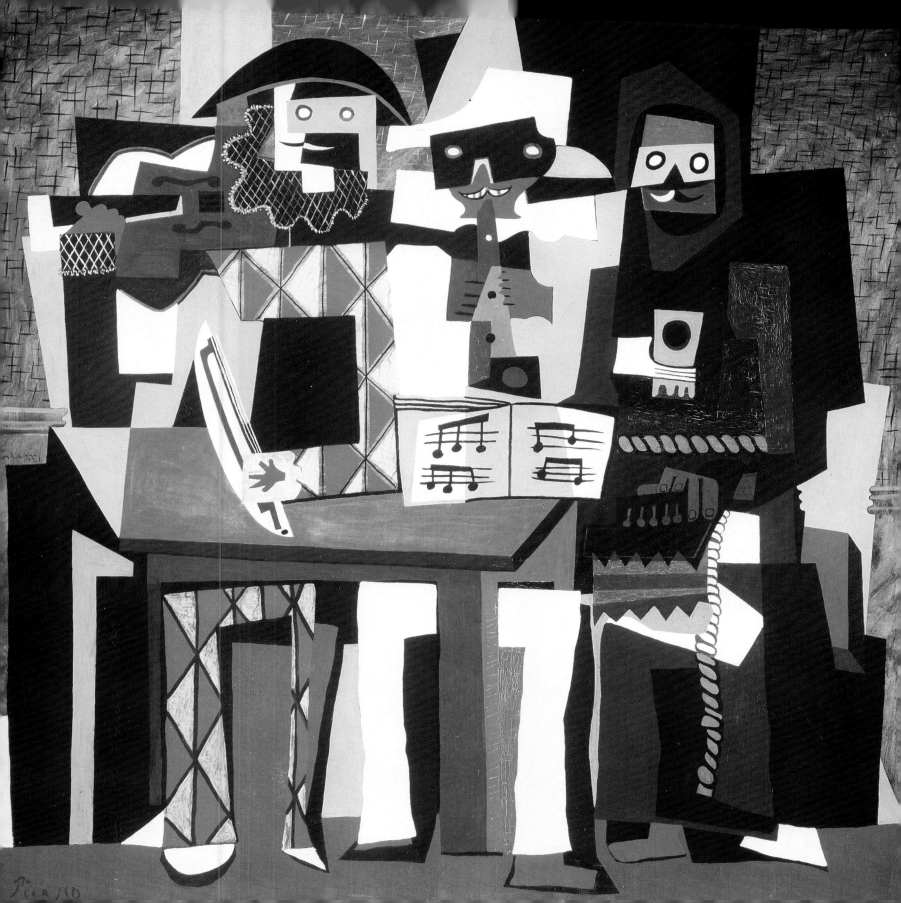

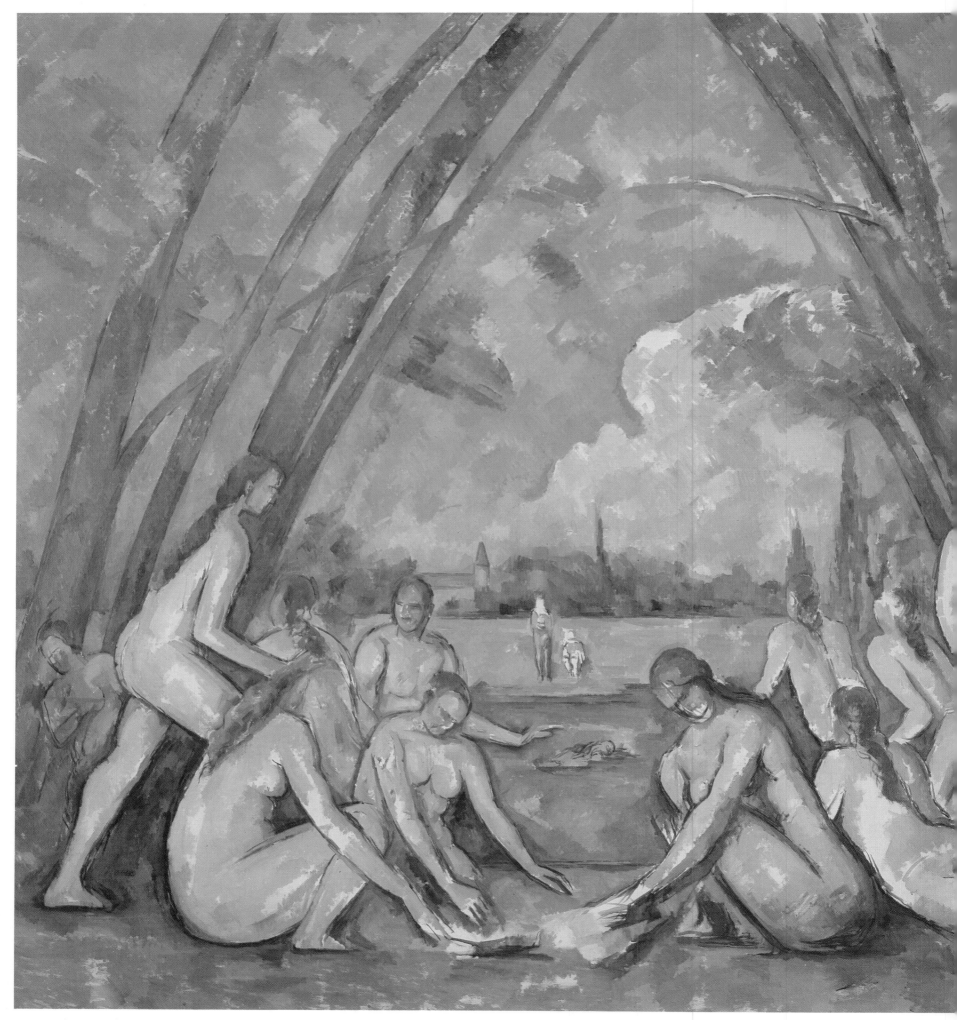

5 PAUL CÉZANNE *The Large Bathers*

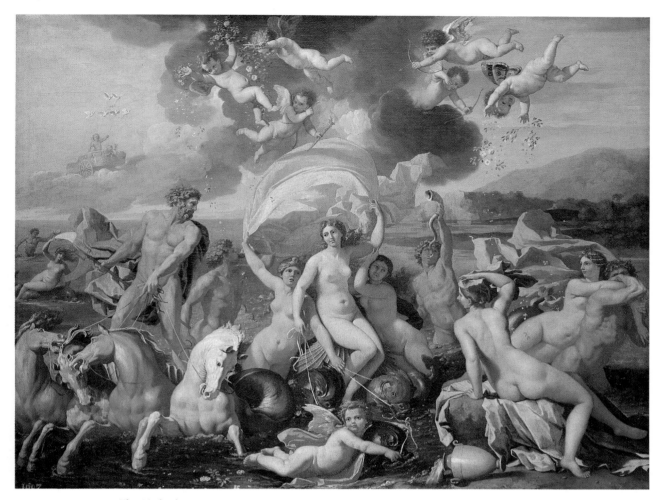

6 NICOLAS POUSSIN *The Birth of Venus*

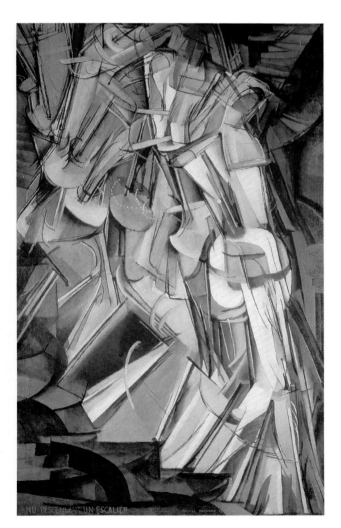

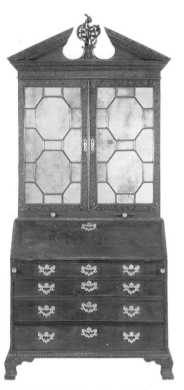

7 UNKNOWN *Secretary Bookcase*

8 MARCEL DUCHAMP
Nude Descending a Staircase No. 2

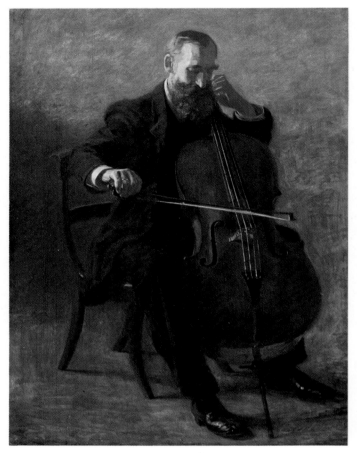

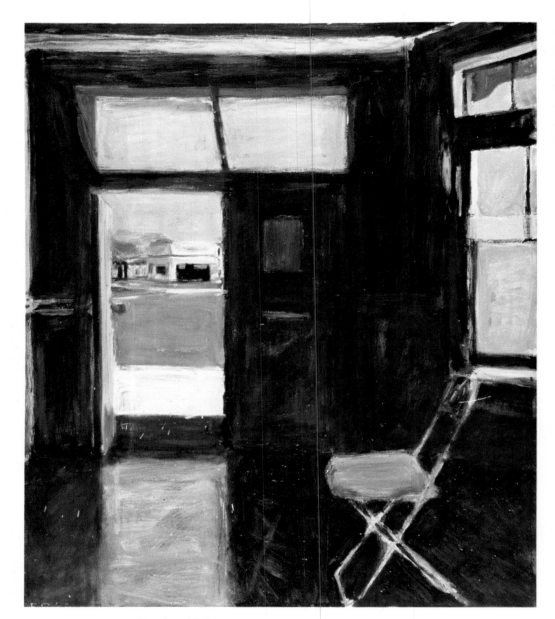

1 THOMAS EAKINS *The Cello Player*

2 RICHARD DIEBENKORN *Interior with Doorway*

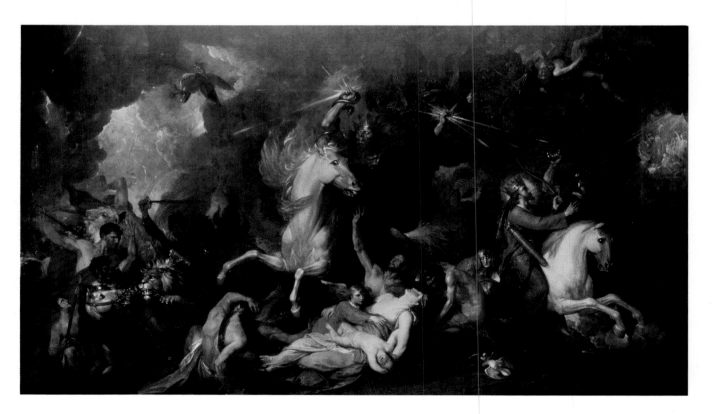

3 BENJAMIN WEST
Death on the Pale Horse

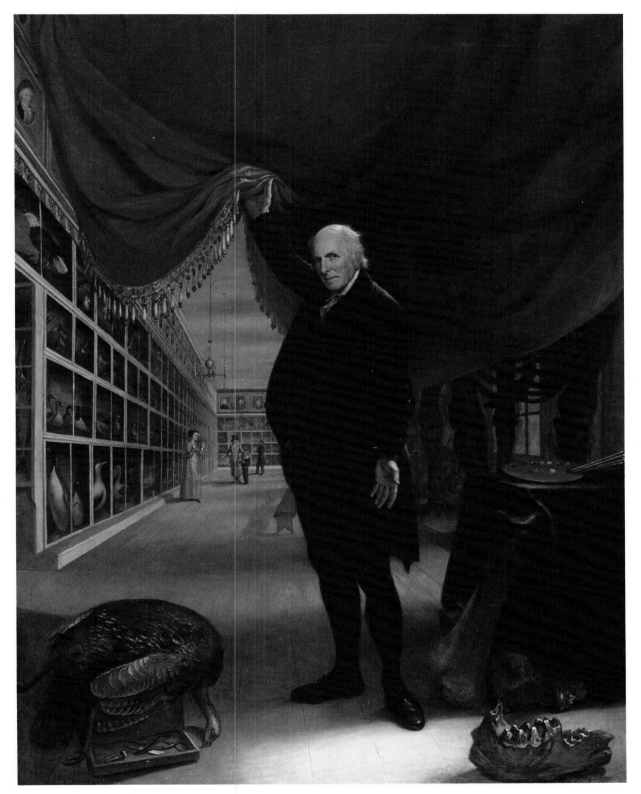

4 CHARLES WILLSON PEALE *The Artist in His Museum*

Pennsylvania Academy of the Fine Arts

PHILADELPHIA, PENNSYLVANIA

Founded in 1805, the Pennsylvania Academy of the Fine Arts is the nation's oldest art institution, housing both a renowned school and a collection of American art dating from the mid-18th century to the present. Its historic landmark building, completed in 1876 and fully restored 100 years later, is one of the nation's outstanding models of Victorian architecture. A pastiche of historical styles, it features Venetian Gothic colors and materials, Gothic arches and tracery, a French Mansard roof, Mooresque moldings, a Greek frieze, rustic Renaissance stonework, Byzantine tiles, medieval corbels, American Indian rug patterns, and stylized leaves and flowers.

Many of the important artists displayed in the academy's 18,000 square feet of galleries—Thomas Cole, Mary Cassatt, and John Sloan to name but a few—were once students here. Others, such as Thomas Sully, Charles Willson Peale, and Thomas Eakins were on the faculty. Altogether, the academy's museum features 1,800 paintings, 400 sculptures, 14,000 works on paper, and hundreds of manuscripts, photographs, and sketches.

There are portraits by John Singleton Copley, members of the Peale family, and Gilbert Stuart; genre paintings by William Sidney Mount and Henry Inman; and landscapes by Jasper Cropsey and Martin Johnson Heade. Impressionist canvases by Childe Hassam and John Twachtman are balanced by the realism of John Frederick Peto, the Ash Can School, and Thomas Hart Benton. Contemporary artists range from Philip Pearlstein and George Segal to Robert Motherwell, Louise Nevelson, and Nancy Graves.

1 American, 1896, Oil on canvas.
2 American, 1962, Oil on canvas.
3 American, 1817, Oil on canvas.
4 American, 1822, Oil on canvas.

Winterthur Museum and Gardens

WINTERTHUR, DELAWARE

Originally the home of Henry Francis du Pont, Winterthur opened in 1951 as a museum for Mr. Du Pont's collection of 89,000 objects made or used in America between 1640 and 1860—the largest and finest collection of American decorative arts in the world.

The museum, originally a three-story Greek revival structure built in 1839, was augmented in 1929, 1959, and 1969 to accommodate the growing collection, and to provide conservation facilities, a research library, and flexible exhibition space. A new building is scheduled for completion in 1993.

This is not a conventional museum with galleries and display cases. Furniture, textiles, paintings, prints, pewter, silver, ceramics, clocks, glass, needlework, and brass are presented in 196 period room settings. Visitors are guided through the collection on intimate reserved tours for small groups of four to six people. The collection begins at about 1640 with rooms from Ipswich and Essex, Massachusetts, and Oyster Bay, Long Island, and ends about 1840 with ornate Empire-style rooms from New York and Georgia.

The quality of the collection is as extraordinary as its quantity. There is Chippendale furniture by Newport cabinet makers John Townsend and John Goddard, a set of six silver tankers by Paul Revere, a New York settee by Duncan Phyfe, John Trumbull's portrait of *George Washington at Verplanck's Point*, German earthenware, and Chinese export porcelain, including a 66-piece dinner service made for George Washington.

Winterthur's library includes over 70,000 volumes, as well as half a million manuscripts, microfilms, periodicals, and photographs covering American arts from colonial days to the 1920s. The museum's garden, almost 1,000 acres in the scenic Brandywine Valley, contains a vast collection of native and exotic plants have color throughout the year.

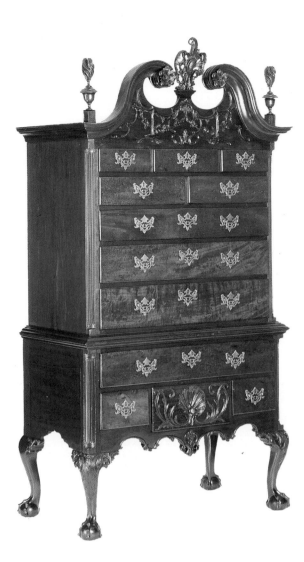

1 PHILADELPHIA, PENNSYLVANIA
High chest

1 American, 1765–1780, Mahogany.
2 American, 1666–1699, Silver.
4 American, dated October 29, 1783, May 9, 1794, Silk embroidery on canvas.

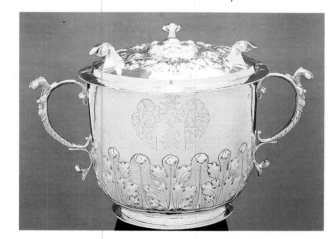

2 JURIAN BLANCK, JR
Two-handled cup with cover

3 WARRINGTON COUNTY, NORTH CAROLINA *Montmorenci Stairhall*

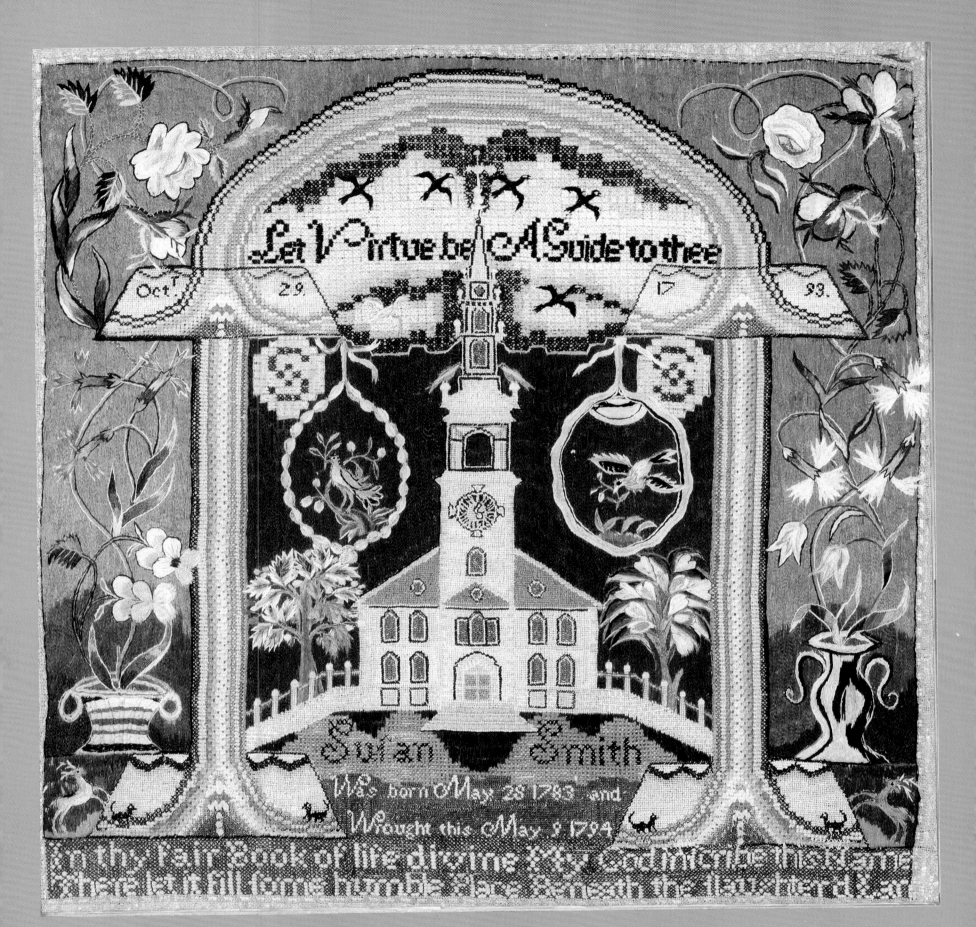

4 SUSAN SMITH *Sampler*

The Baltimore Museum of Art

BALTIMORE, MARYLAND

Established in 1914, the Baltimore Museum of Art features a collection of more than 100,000 works of art with unique strengths in several different areas.

What is perhaps the museum's most remarkable collection was bequeathed by Dr. Claribel and Miss Etta Cone. These sisters traveled throughout Europe beginning at the turn of the century with their friend Gertrude Stein, who introduced them to Pablo Picasso and Henri Matisse and inspired their passionate interest in modern art. The Cone Collection includes works by Vincent van Gogh, Pierre Auguste Renoir, and Paul Gauguin, but it is the Picassos and the Matisses that attract visitors from around the world. Indeed, Matisse's glorious *Pink Nude* is probably the museum's most popular and most famous image.

In addition to French paintings and sculpture of the late 19th and 20th centuries, the museum also has a significant and growing collection of modern and contemporary art including works by Frank Stella, Jackson Pollock, Andy Warhol, and Jasper Johns, as well as one of the nation's ten most distinguished collections of prints and drawings. There is a collection of English sporting art as well as an outstanding American Wing featuring furniture, decorative arts, and Maryland period rooms. There are major holdings in African and Oceanic art, and the museum's sculpture garden is one of the largest in the United States. In 1988 the museum made the largest purchase in its history—700 extraordinary 20th-century vintage photographs that comprise one the country's most important resources, the Dalsheimer Collection .

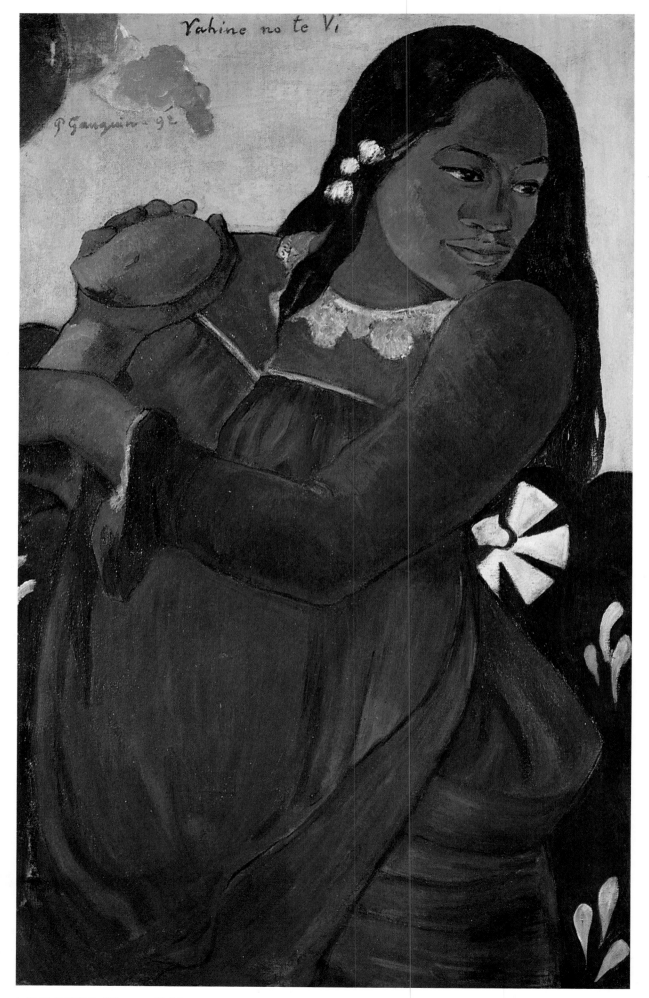

1 PAUL GAUGUIN *Woman with Mango*

2 HENRI MATISSE *Painter in the Olive Grove*

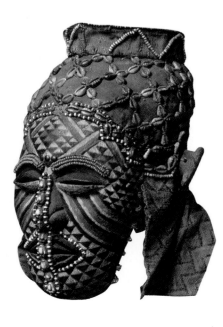

(FAR LEFT)
3 TONY SMITH *Spitball*

(LEFT)
4 KUBA *Female Mask*

1 French, 1892, Oil on canvas, The Cone Collection, formed by Dr. Claribel Cone and Miss Etta Cone of Baltimore, MD., BMA 1950.213.

2 French, 1923–early 1924, Oil on canvas, The Cone Collection, formed by Dr. Claribel Cone and Miss Etta Cone of Baltimore, MD., BMA 1950.239.

3 American, 1961, Steel painted black, Gift of Robert and Ryda H. Levi, Baltimore, BMA 1985.193.

4 Zaire, 19th century, Wood, metal, fiber, beads, cowrie shells, paint, cotton, and raffia cloth, Gift of Alan Wurtzburger, BMA 1954.145.77.

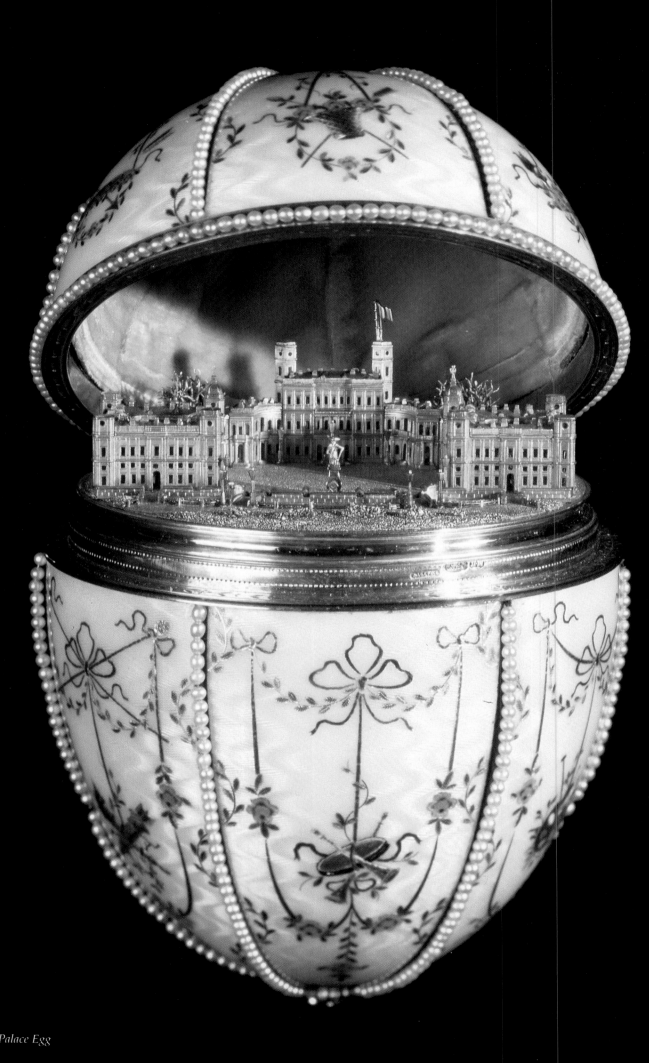

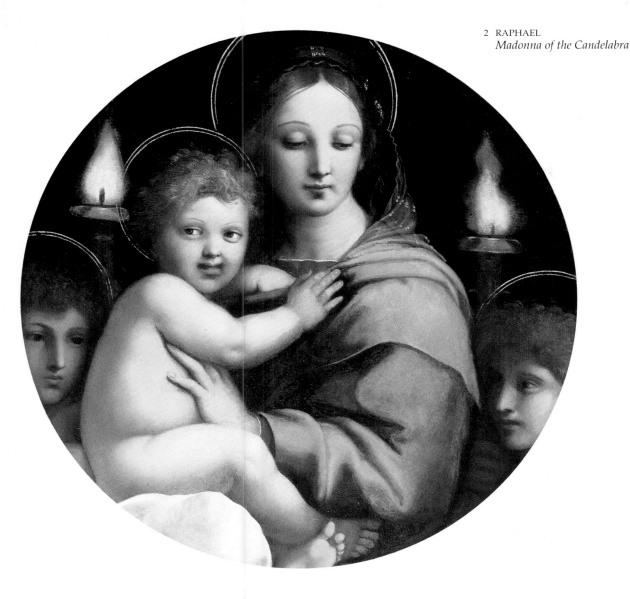

2 RAPHAEL
Madonna of the Candelabra

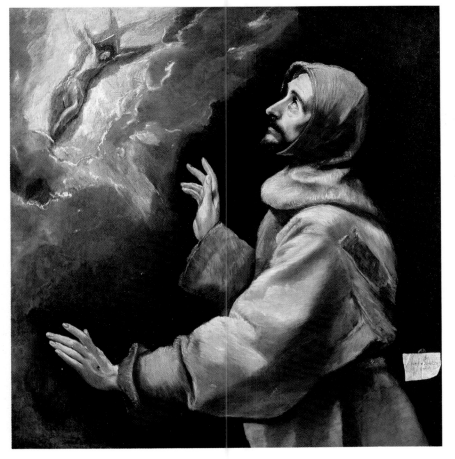

3 EL GRECO
St. Francis Receiving the Stigmata

1 Russian, ca. 1902, Gold *quatre couleur, guilloché*; opalescent enamel, pearls, diamonds.

2 Italian, n.d., Oil on panel.

3 Greek, n.d., Oil on canvas.

4 Italian, n.d., Oil on canvas.

5 Greek, c. 325–317 B.C., Marble.

6 Italian, n.d., Oil on panel.

7 French, 1903–1904, Ivory, enamel, diamonds.

8 Flemish, c. 1475, Oil on panel.

The Walters Art Gallery

BALTIMORE, MARYLAND

When Henry Walters bequeathed his gallery and art collection to the city of Baltimore upon his death in 1931, it was regarded as one of the greatest acts of cultural philanthropy in American history.

The collection had been started by Henry's father, William Walters, a Baltimore railroad magnate. Beginning with the works of local artists, William's tastes eventually expanded to encompass canvases by French painters like Jean-François Millet, Jean-Baptiste-Camille Corot, and Honoré Daumier, whom he commissioned to do a famous series of watercolors.

It was Henry Walters, however, who transformed the family collection into one of the finest in private hands in America, a treasure trove of 22,000 works ranging from the artifacts of ancient Egypt to the paintings of European Old Masters to early 20th-century decorative arts.

The two Walters' interests were both sophisticated and diverse. The medieval collection is one of the museum's central strengths, featuring early Christian, Romanesque, Gothic, migration period, and Byzantine art The museum's rare manuscript collection is second only to that of the Morgan Library. The Peachbloom Vase is considered the finest example of this type of Ming glaze in existence.

Among the collection's paintings are masterpieces by such artists as Bronzino, Raphael, Giovanni Lorenzo Bernini, Anthony Van Dyck, Edouard Manet, Claude Monet, and many others.

Only 20 percent of the Walters' holdings could be displayed until the completion of a huge new wing in 1974. Renovations throughout the 1980s have brought the museum into its present jewel-like perfection, and a new museum to display 1,000 pieces of Asian art from the Walters' 7,000-piece collection opened in 1991.

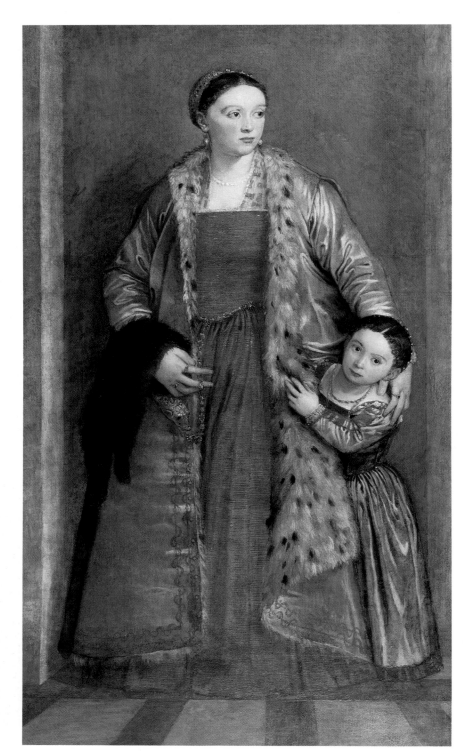

4 PAOLO VERONESE *Portrait of Countess Livia da Porto Thiene
and her Daughter Porzia*

5 UNKNOWN *Bearded Head*

6 BICCI DI LORENZO AND ASSISTANTS *The Annunciation*

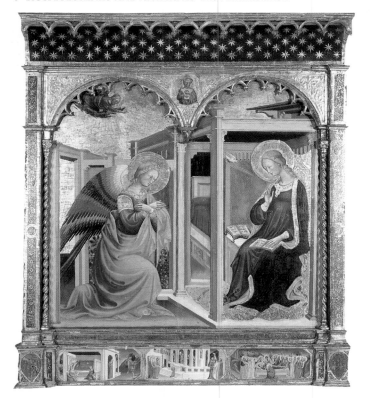

7 RENÉ LALIQUE *Orchid Comb*

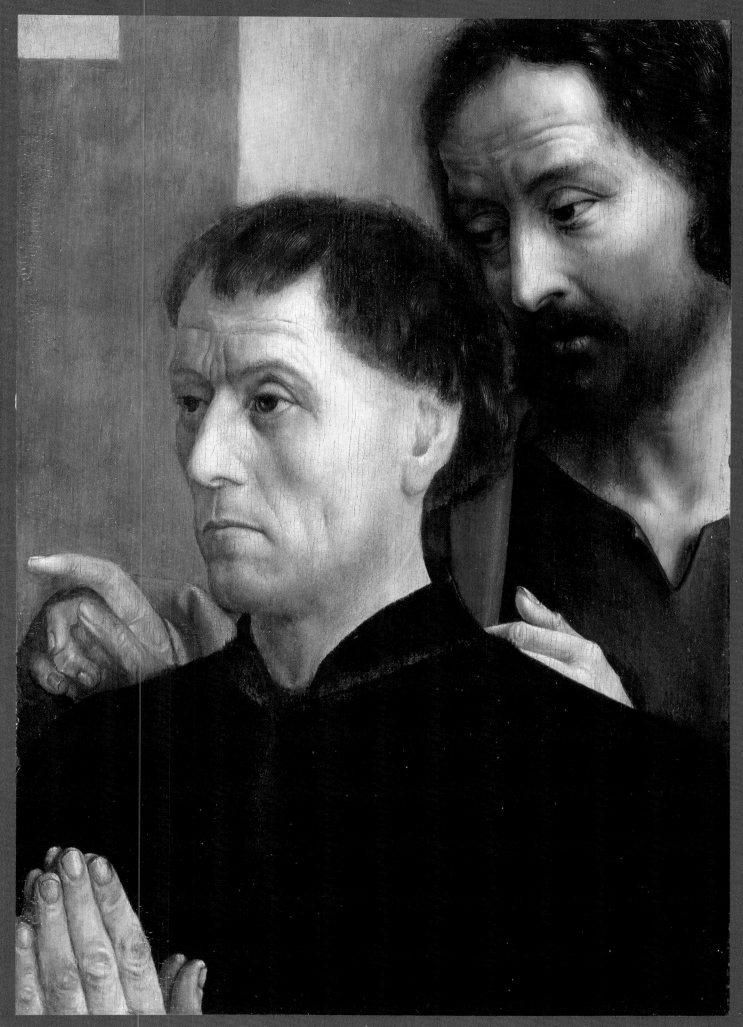

8 HUGO VAN DER GOES *Donor with St. John the Baptist*

THE SOUTHEAST

The Smithsonian Institution

WASHINGTON, D.C.

The Smithsonian Institution is the world's largest museum complex, an unrivaled collection of museums and galleries, the National Zoo, and research facilities.

Of the nine Smithsonian buildings on Washington's Mall, the "Castle," completed in 1855, is the oldest. It is the administrative center of the complex and the most recognizable symbol of "the Nation's Attic."

The National Air and Space Museum, housing everything from Charles Lindbergh's "Spirit of St. Louis" to John Glenn's space capsule, is the most visited museum in the world, with about 9 million visitors annually.

The National Museum of Natural History's collection of over 118 million items documents humanity and its environment. The National Museum of African Art is the country's only museum focusing solely on the art and culture of Africa. Though the Freer Gallery of Art has James Whistler's famous "Peacock Room," it is devoted primarily to Asian art, as is the newly completed Arthur M. Sackler Gallery. The National Museum of American History features a trove of American memorabilia including the original star-spangled banner. The Arts and Industries Building features the machines of the Victoria era. The Hirshhorn Museum and Sculpture Garden is devoted to contemporary art.

Other Smithsonian museums include the National Museum of American Art, which shares space with the National Portrait Gallery; the Anacostia Museum devoted to African-American history; and the Cooper Hewitt Museum—the Smithsonian's National Museum of Design—which is located in New York City.

Preceding pages:
THE JOHN AND MABLE RINGLING MUSEUM OF ART, SARASOTA, FLORIDA.

72

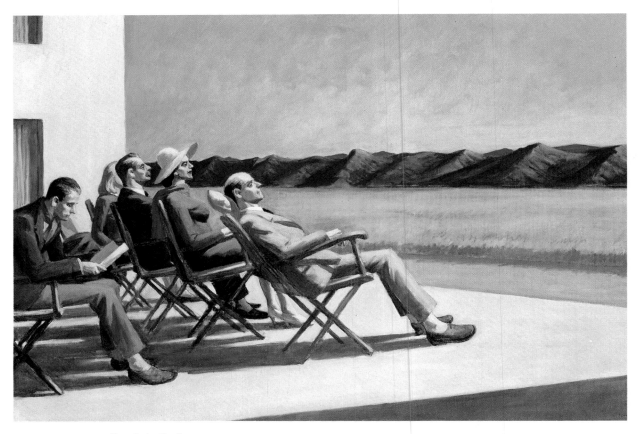

1 EDWARD HOPPER *People in the Sun*

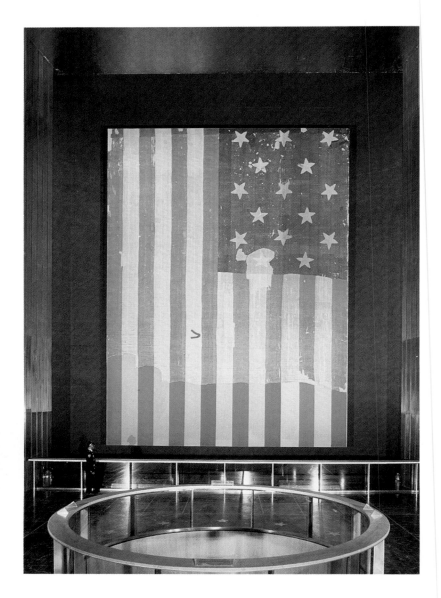

2 THE ORIGINAL STAR SPANGLED BANNER

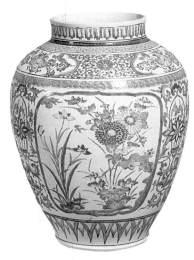

3 UNKNOWN *Jar*

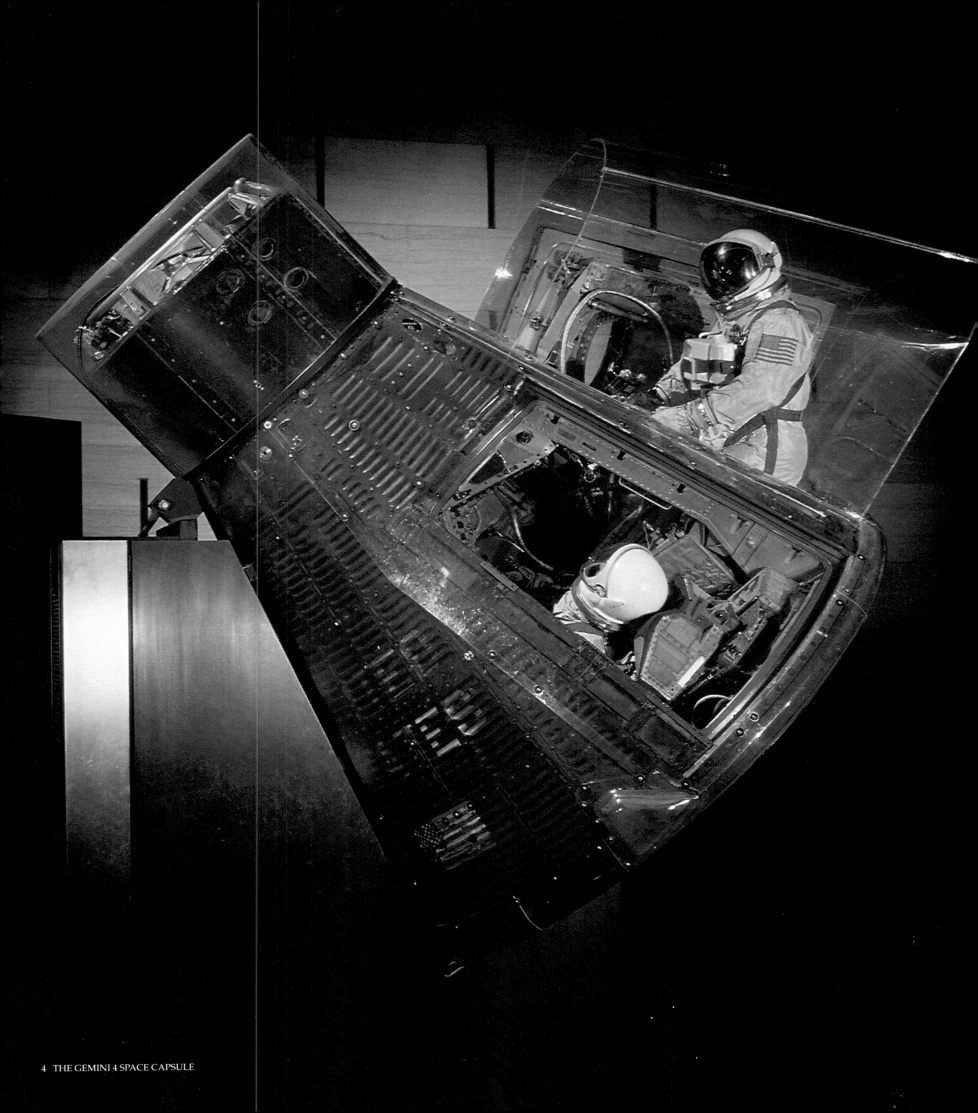

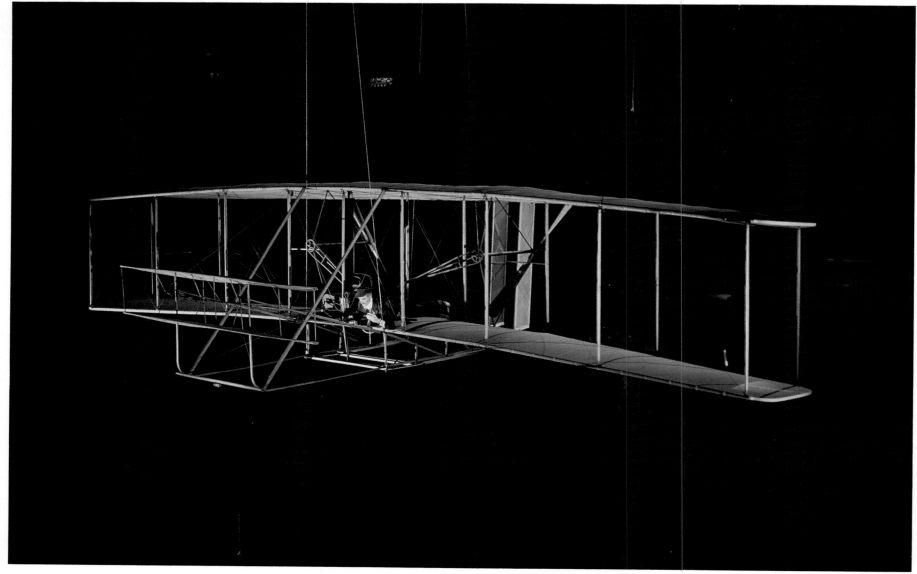

5 THE WRIGHT 1903 FLYER

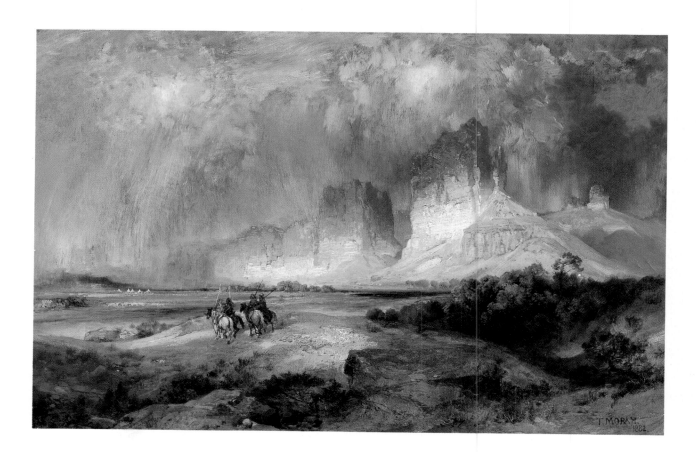

6 THOMAS MORAN *Cliffs of the Upper Colorado River, Wyoming Territory*

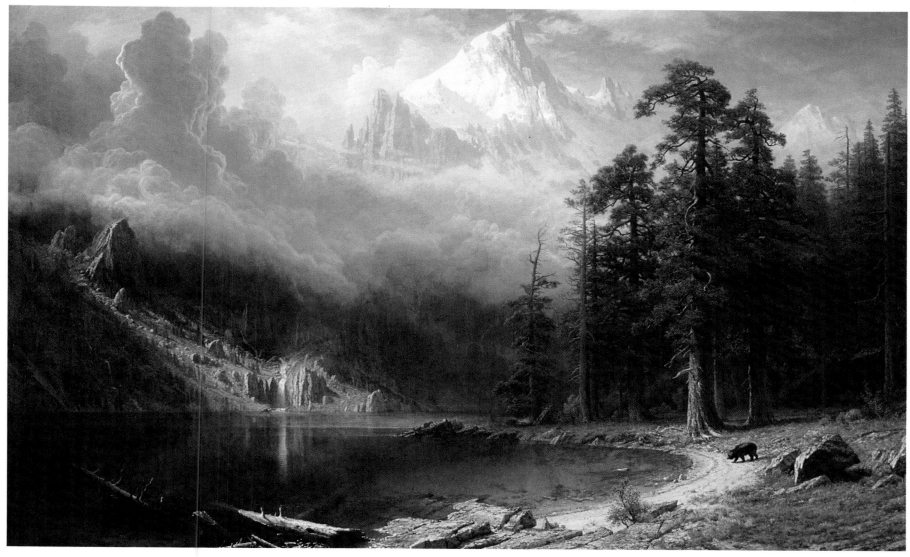

1 ALBERT BIERSTADT *Mount Corcoran*

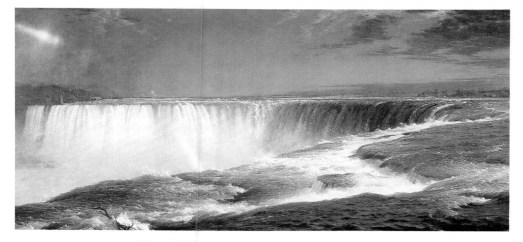

2 FREDERICK E. CHURCH *Niagara Falls*

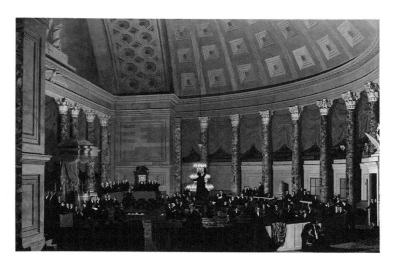

3 SAMUEL F. B. MORSE *The Old House of Representatives*

10 JO DAVIDSON *Gertrude Stein*

11 RUBY SLIPPERS FROM THE FILM
The Wizard of Oz

12 A MOTHER GRIZZLY BEAR AND HER CUBS

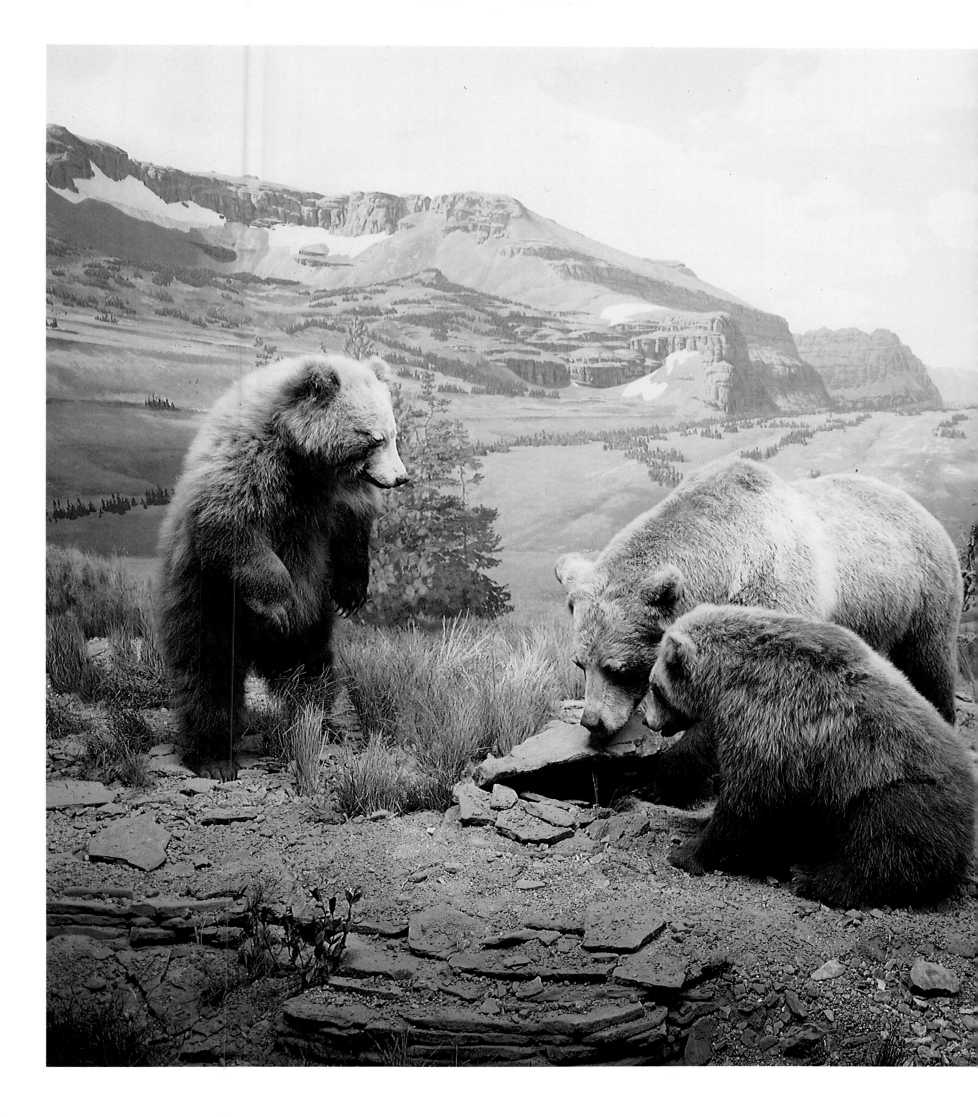

7 MORRIS LOUIS *Point of Tranquility*

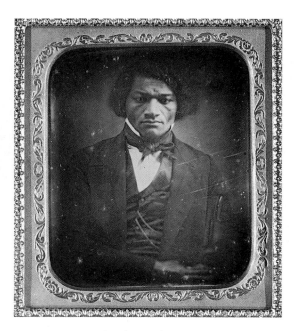

8 UNKNOWN *Frederick Douglass*

9 THE HOPE DIAMOND

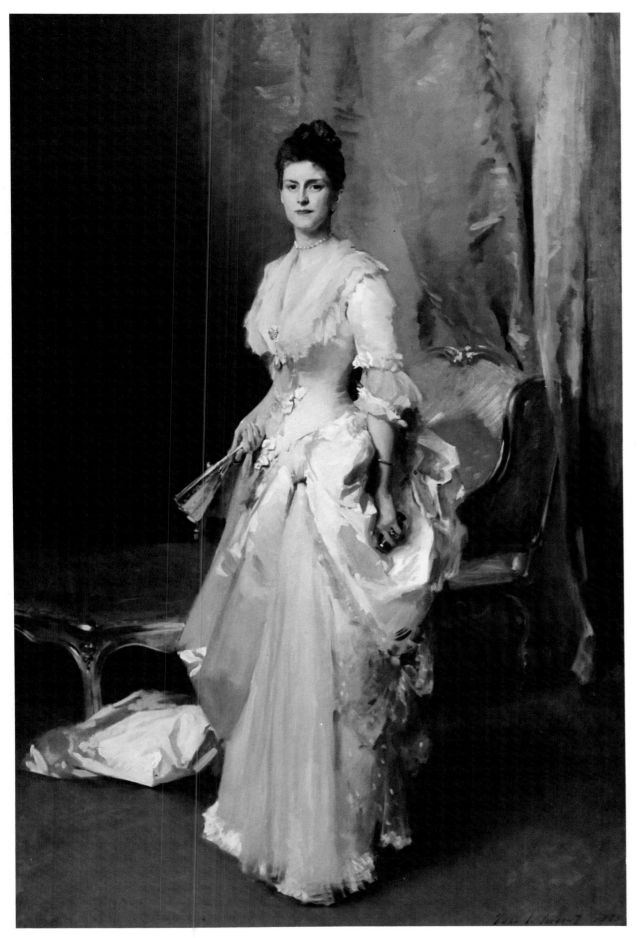

4 JOHN SINGER SARGENT *Mrs. Henry White*

1 American, 1875–1877, Oil on canvas.
2 American, 1857, Oil on canvas.
3 American, 1822, Oil on canvas.
4 American, 1883, Oil on canvas.

The Corcoran Gallery of Art

WASHINGTON, D.C.

Founded by District of Columbia banker and philanthropist William Wilson Corcoran in 1869, this privately funded museum—the first art museum in the nation's capital—features one of the oldest and finest collections of American art, as well as a small but impressive collection of European masters.

Housed in an 1897 Beaux Arts building, the Corcoran's holdings include more than 11,000 works in all media.

Frederick Church's *Niagara* is perhaps the best known of the museum's Hudson River School landscapes, which also include paintings by Albert Bierstadt, Thomas Cole, and John F. Kensett. Other strengths in the American collection include genre paintings by William Sydney Mount and his contemporaries, as well as portraits by John Singer Sargent, Thomas Eakins, and Mary Cassatt. Twentieth-century works include examples of Abstract Expressionism, Pop art, and Minimalism.

The Corcoran's European holdings are made up of two individual collections. The William A. Clark Collection, housed in a 1927 addition to the museum, is noted for Dutch, Flemish, and French Romantic art. It includes paintings by Rembrandt, Meindert Hobbema, Aelbert Cuyp, Honoré Daumier, and Edgar Degas, as well as a number of landscapes by the Barbizon painters. The Walker Collection consists of French painting of the late 19th and early 20th centuries with notable canvases by Pierre Auguste Renoir, Claude Monet, Gustave Courbet, and Camille Pissarro. This wing also houses the 18th-century Grand Salon from the Hotel D'Orsay in Paris.

The Corcoran Gallery presents a wide variety of temporary exhibitions each year. And a four-year art college founded in 1890—the only one in the Washington metropolitan area—operates in conjunction with the museum.

The National Museum of Women in the Arts

WASHINGTON, D.C.

Wilhelmina and Wallace Holladay became enamored of the work of women artists while visiting European museums. Upon returning to the United States, however, they found that many important women artists were unknown here, and nowhere was there a museum or library specifically dedicated to women's contributions to art. So in 1981 Wilhelmina Holladay decided to start one.

Today the National Museum of Women in the Arts features more than 1,200 works by 400 women artists from 28 countries in a permanent collection that dates from the Renaissance to the 20th century. There is also a Library and Research Center focusing on women in art, a 200-seat auditorium, a schedule of annual special exhibitions, and educational programming. In its short life the museum has attracted membership support of nearly 100,000 individuals and organizations—the third largest in the world.

Strolling through the elegant galleries of the museum's newly restored home— a 1907 Renaissance Revival building a few blocks from the White House— many visitors are struck for the first time with the full extent of women's contributions to art.

Some of the names are familiar— Georgia O'Keeffe, Mary Cassatt, Rosa Bonheur, and Helen Frankenthaler. Others are a delightful discovery, like Vatican painter Lavinia Fontana, Elizabeth Vigee-Lebrun (court painter for Marie Antoinette), and Rachel Ruysch, Rembrandt's contemporary whose flower paintings sold for more than his during their lifetimes. The NMWA also has several important special collections, including over 100 pieces by 18th century women silversmiths as well as the botanical and zoological prints of Maria Sibylla Merian.

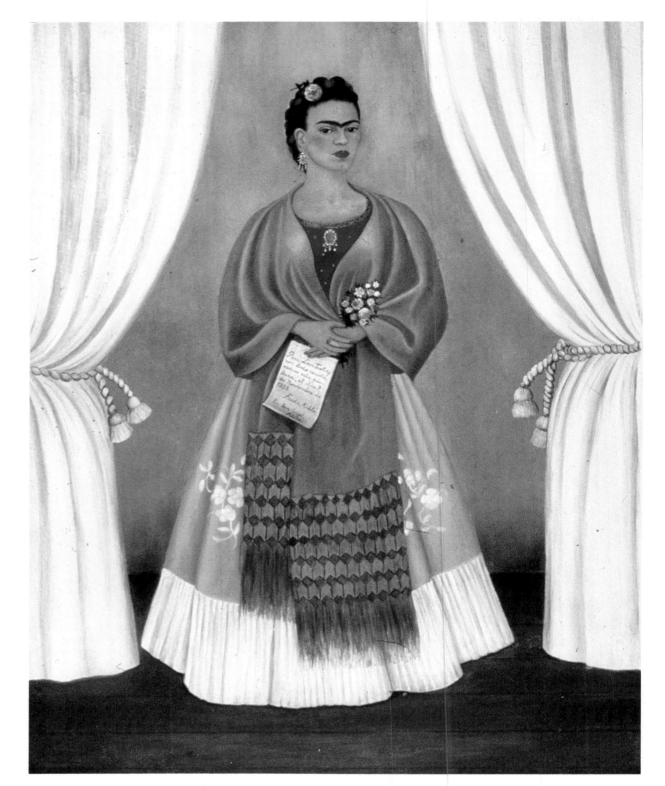

1 FRIDA KAHLO *Between the Curtains (Self-Portrait dedicated to Trotsky)*

1 Mexican, 1937, Oil on board, Gift of Honorable Clare Boothe Luce.

2 Flemish, n.d., Oil on panel, Gift of Wallace & Wilhelmina Holladay.

3 American, 1951, Gelatin Silver print, Gift of Helen Cumming Ziegler.

4 French, c. 1890, Bronze, Gift of Wallace and Wilhelmina Holladay.

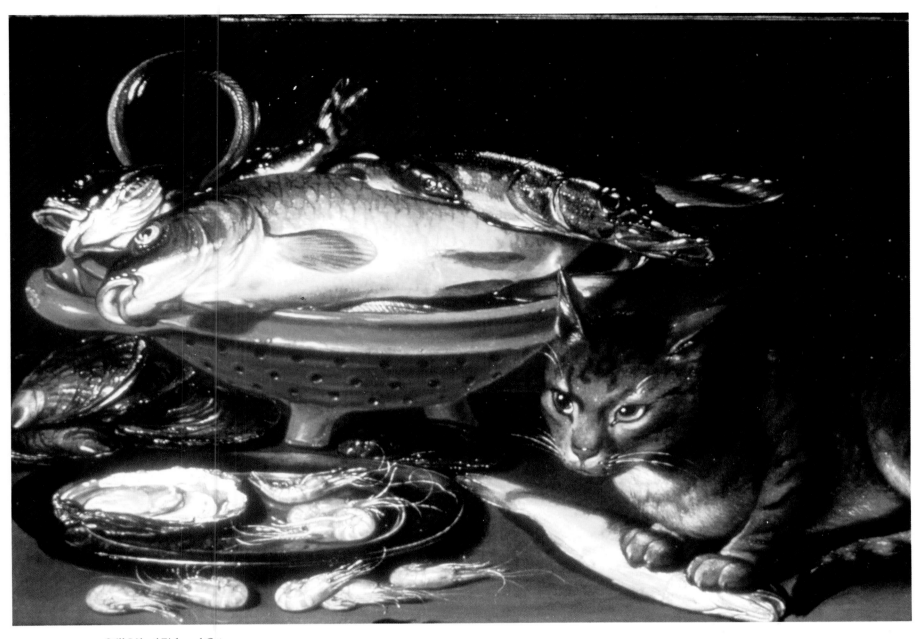

2 CLARA PEETERS *Still Life of Fish and Cat*

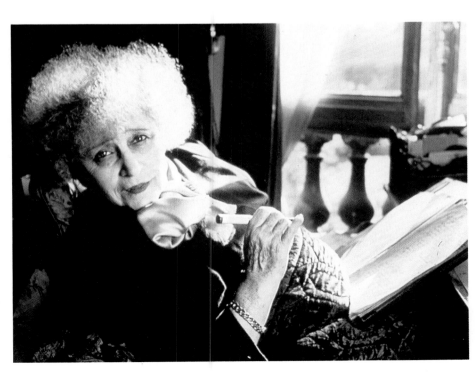

3 LOUISE DAHL WOLFE *Colette*

4 CAMILLE CLAUDEL
Young Girl with a Sheaf of Wheat

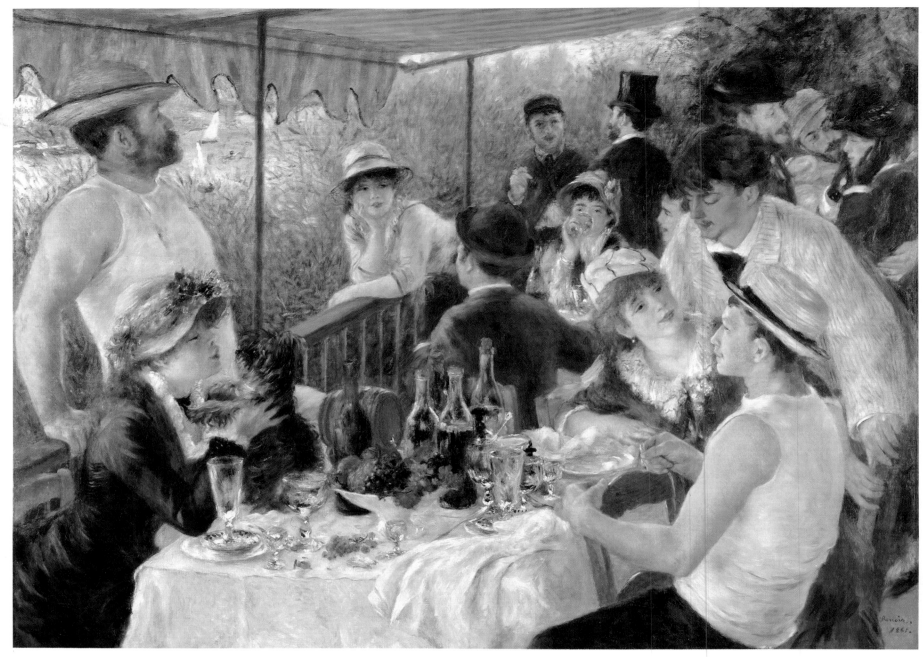

1 PIERRE AUGUSTE RENOIR *The Luncheon of the Boating Party*

(RIGHT)
2 PIERRE BONNARD *The Palm*

(FAR RIGHT)
3 GEORGIA O'KEEFFE *Pattern of Leaves*

1 French, 1881, Oil on canvas.
2 French, 1926, Oil on canvas.
3 American, c. 1923, Oil on canvas.
4 American, 1953, Oil on canvas.

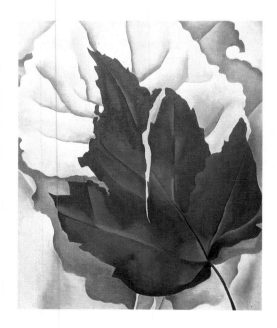

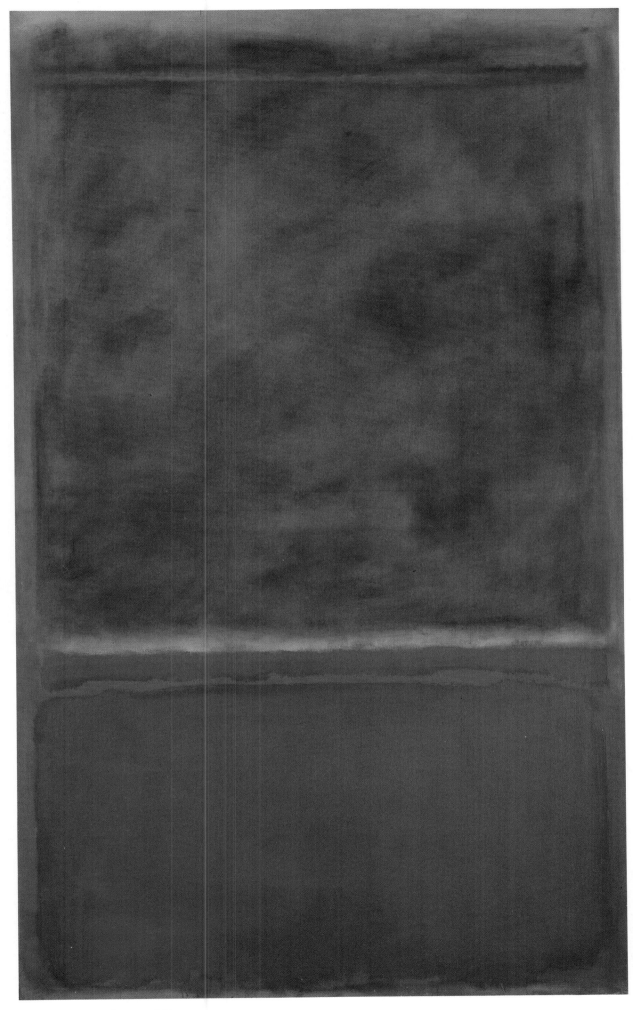

4 MARK ROTHKO *Green and Maroon*

The Phillips Collection

WASHINGTON, D.C.

Duncan Phillips, the grandson of one of the founders of the Jones and Laughlin Steel Company, was an art collector of unusual discrimination, prescience, and generosity. In 1921 he opened two rooms of his home near Dupont Circle in Washington, D.C. as the first museum of modern art in the United States. By the time of his death in 1966, the Phillips Collection had become one of the finest small museums in the world.

The charm of the Phillips can be credited not only to the unerring taste with which the collection was assembled, but to the intimacy and style of its presentation. In a pleasant, home-like setting, visitors can take advantage of numerous couches and chairs to enjoy masterpieces like Pierre Auguste Renoir's *Luncheon of the Boating Party* and individual rooms full of Bonnards and Rothkos. The museum's Sunday afternoon concerts have been a feature of Washington cultural life since 1941.

Paintings are still grouped into visually telling combinations, as Duncan Phillips preferred, rather than by dates or styles. Because the founder envisioned his collection as "a museum of modern art and its sources," there are works by old masters like El Greco and Francisco Goya in among the Cezannes and van Goghs, the Braques and the Klees, the O'Keeffes, and the Doves (Phillips was the first important collector of Arthur Dove's work and his foremost patron for 20 years).

Less than one-quarter of the museum's 2,500 works can be displayed at one time, even after a $7.8 million renovation and the reopening of the Goh Annex in 1989, but then Duncan Phillips wanted his successors to keep the collection alive by frequent rearrangements. Indeed he was repositioning paintings to show off their best qualities even from his deathbed.

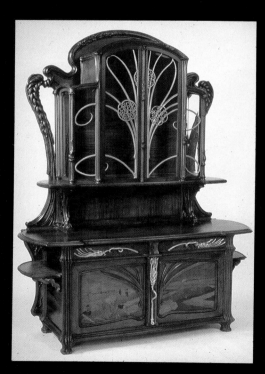

1 ÉMILE GALLÉ *Sideboard*

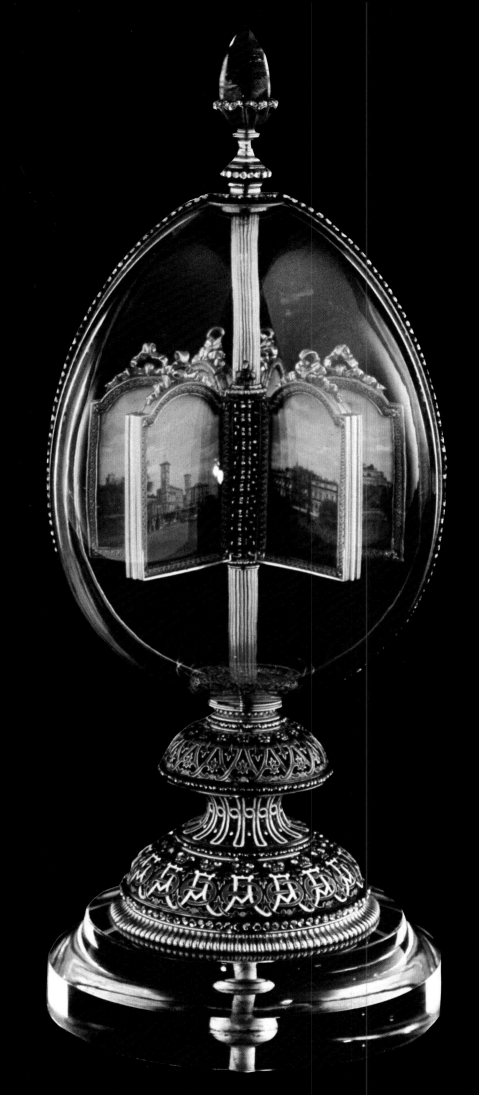

2 FABERGÉ *Imperial Easter Egg*

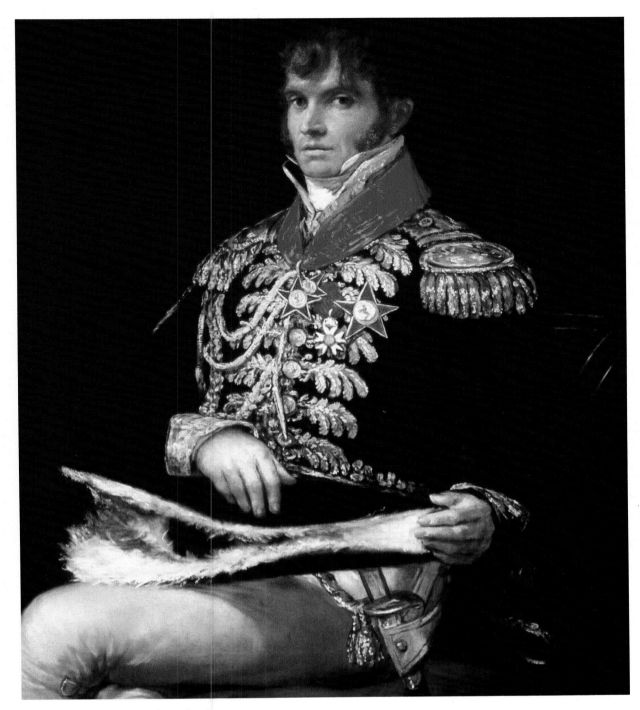

3 FRANCISCO GOYA *General Nicolas Guye*

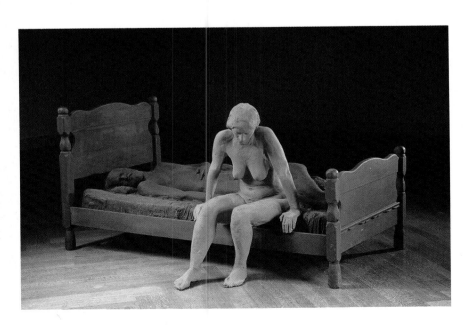

4 GEORGE SEGAL
Blue Girl On Black Bed

The Virginia Museum of Fine Arts

RICHMOND, VIRGINIA

Founded in 1936, the Virginia Museum of Fine Arts was the nation's first state-supported art museum and statewide arts network. With the opening of its new West Wing in 1985, the museum once again demonstrated success in combining public commitment with inspired private support.The monumental addition brings together two superb and diverse collections.

From Mr. and Mrs. Paul Mellon, the museum received a stunning collection of French Impressionist and post-Impressionist paintings and drawings, and a collection of British sporting art was given by Mr. Mellon. The Mellon galleries also house important American paintings and exquisite works by famed jewelry designer, Jean Schlumberger.

The Sydney and Frances Lewis Collection of Late 19th- and Early 20th-Century Decorative Arts encompasses Art Nouveau, Art Deco, and Modernism, and includes important pieces by Émile-Gallé, Louis Comfort Tiffany, and Eileen Gray. Also given by the Lewises was their vast collection of contemporary art, which includes works from the 1950s through the 1980s by artists such as Franz Kline, Andy Warhol, and Richard Estes.

These treasures of the new West Wing join the broad panorama of world art possessed by the Virginia Museum, which includes collections of Egyptian, Greek, and Roman art; Medieval and Byzantine art; European paintings, sculpture, and tapestries from the Renaissance to the early 20th century; and American paintings, sculpture, furniture, and decorative arts. The museum also features one of the largest collections of Fabergé jewels outside of the Soviet Union as well as one of the country's most significant collections of Indian and Himalayan art. Important holdings of Chinese and Japanese art, pre-Columbian art, and African art complete the museum's encyclopedic spectrum of collections.

5 VINCENT VAN GOGH *Field at St. Remy*

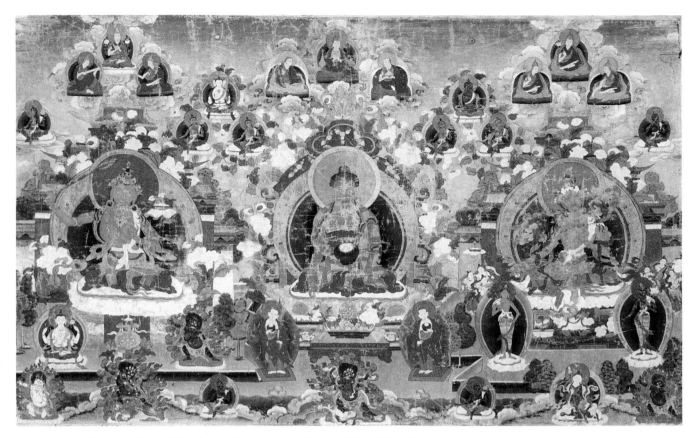

6 UNKNOWN *Thanka of the Buddha flanked by Arapacana Manjurshi and Green Tara*

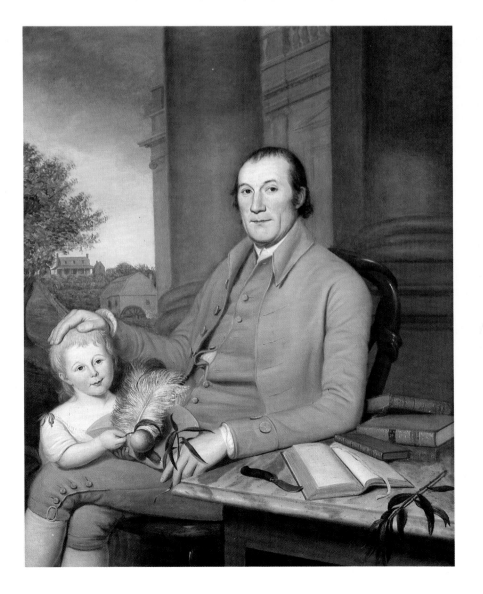

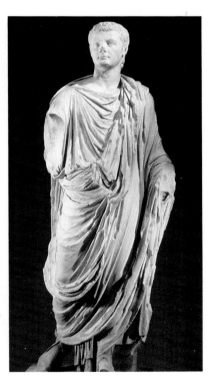

8 UNKNOWN *Caligula*

7 CHARLES WILLSON PEALE
William Smith and his Grandson

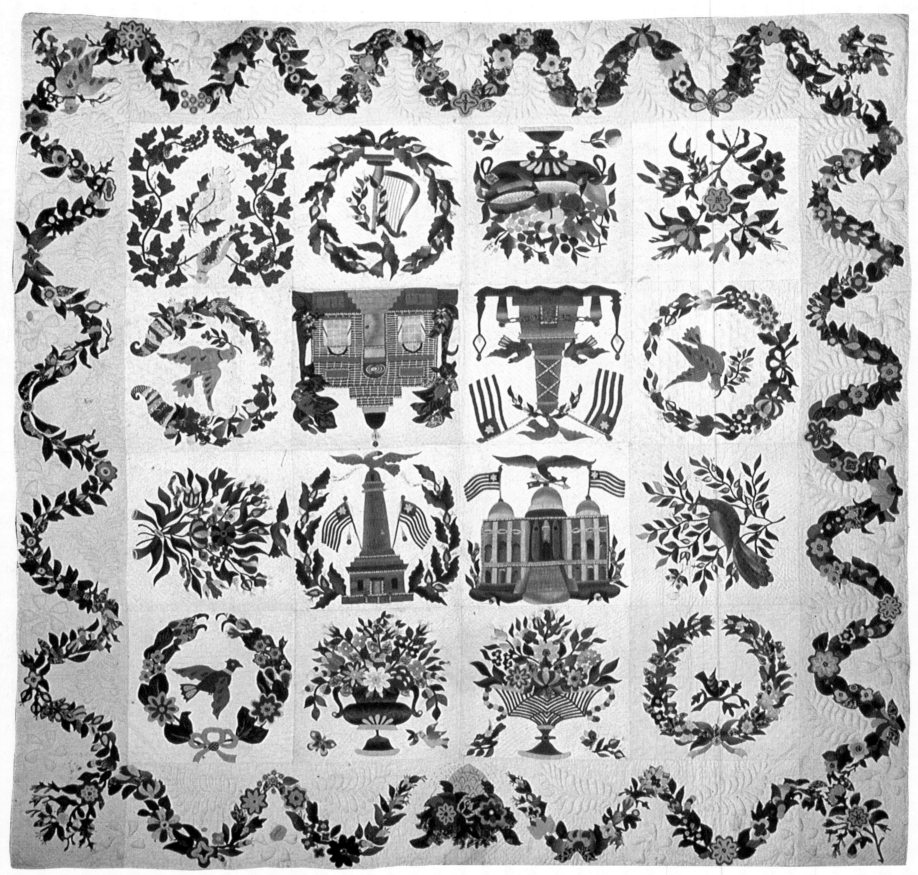

1 UNKNOWN *Baltimore Album Quilt*

1 American, c. 1850, quilt, 76.609.6

2 Possibly South Carolina, possibly 1790–1800, Watercolor on laid paper, 35.301.3.

3 Possibly Pennsylvania, c. 1810–1830, Oil on canvas, 31.100.1.

4 c. 1870, Butternut (head and body) and eastern white pine (arms and book), 31.701.5

(RIGHT)

2 UNKNOWN *The Old Plantation*

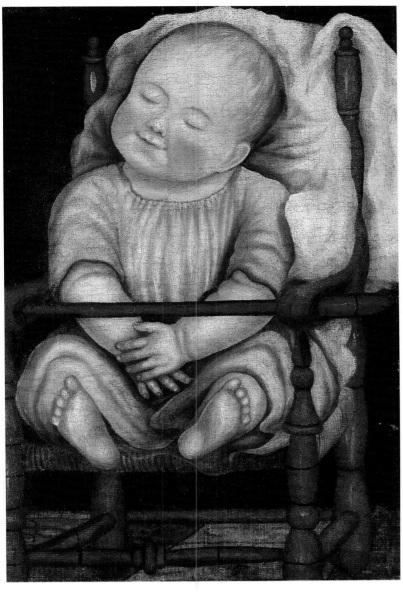

3 UNKNOWN *Baby in Red Chair*

4 UNKNOWN *The Preacher*

The Abby Aldrich Rockefeller Folk Art Center

WILLIAMSBURG, VIRGINIA

When completed in June 1992, the 19,000-square-foot addition to the Abby Aldrich Rockefeller Folk Art Center will triple the exhibition space of this preeminent collection of American folk art from the 18th to the 20th centuries.

More than 2,600 objects now make up the collection, which was begun by Mrs. John D. Rockefeller in the 1920s. At that time folk art objects like weathervanes, portraits by untrained artists, and primitive sculptures were at best considered curiosities.

Mrs. Rockefeller assembled over 400 examples of folk art, and in 1939 donated the principal part of her collection to Colonial Williamsburg, the pre-Revolutionary War capital of Virginia, which her husband, John D. Rockefeller, Jr., had been restoring to its 18th-century appearance. When a permanent home for the collection opened in Colonial Williamsburg in 1957, it was the nation's first folk art museum.

Everything at the museum was created by an artist or craftsman untutored in the rules and formulas of academic art. Among the objects on display at the museum are portraits, landscapes, still lifes, frakturs (German letter style utilized by immigrants to decorate documents), shop signs, pottery, needlework, quilts and coverlets, carvings, decoys, whirligigs, and toys.

The collection also features the largest number of paintings by Edward Hicks owned by any institution, 15 portraits spanning the career of Ammi Phillips, drawings by Lewis Miller, and works by Erastus Salisbury Field, Joseph Hidley, Charles Peale Polk, and Wilhelm Schimmel, now celebrated artists whose works Mrs. Rockefeller was among the first to collect.

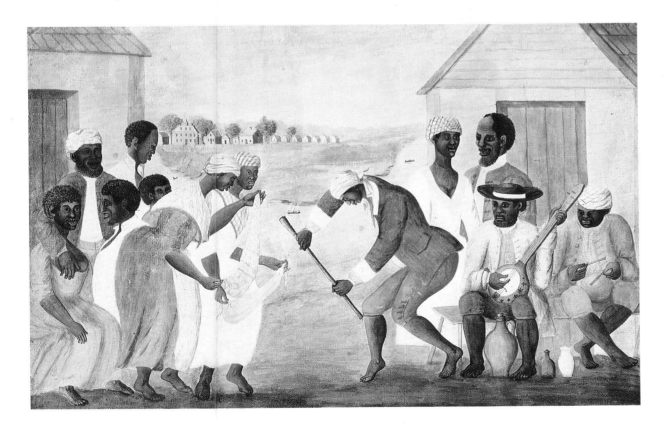

The Country Music Hall of Fame and Museum

NASHVILLE, TENNESSEE

Chartered in 1964, the Country Music Hall of Fame celebrates the great performers of country music. Since the doors opened 1967, more than eight million visitors have come here to honor the more than 50 artists inducted into the Hall of Fame and to see what was the first and is still the largest institution dedicated to a unique American art form.

Located on Nashville's famous "Music Row," the 20,000-square-foot Hall of Fame and Museum houses more than 3,000 artifacts relating to the history of country music—the world's most extensive collection. Included are 20th-century, American-made stringed instruments; broadcast and recording equipment; and Thomas Hart Benton's last mural, *The Sources of Country Music*.

Custom-designed stage costumes and other objects relating to the personal lives and professional careers of important country music artists are also featured. Some of the more popular items include Willie Nelson's *Red Headed Stranger* costume; more than 100 items documenting the career of Johnny Cash; the original song manuscripts of such hits as K. T. Oslin's "80s Ladies," and Holly Dunn's "Daddy's Hands"; and Elvis Presley's "Solid Gold" Cadillac.

There is also a library and media center that houses more than 150,000 recordings (the largest collection of country recordings in the world), 35,000 photographs, and over 1,500 films, videos, and audio tapes. The Country Music Foundation, which governs the Hall of Fame and Museum, also operates two historic sites: RCA's historic Studio B, Nashville's oldest recording studio and Hatch Show Print, which was the major mid-South printer of entertainment posters and handbills. The Foundation also sponsors an oral history project, community outreach programs, and a publishing program—all designed to preserve America's country music heritage.

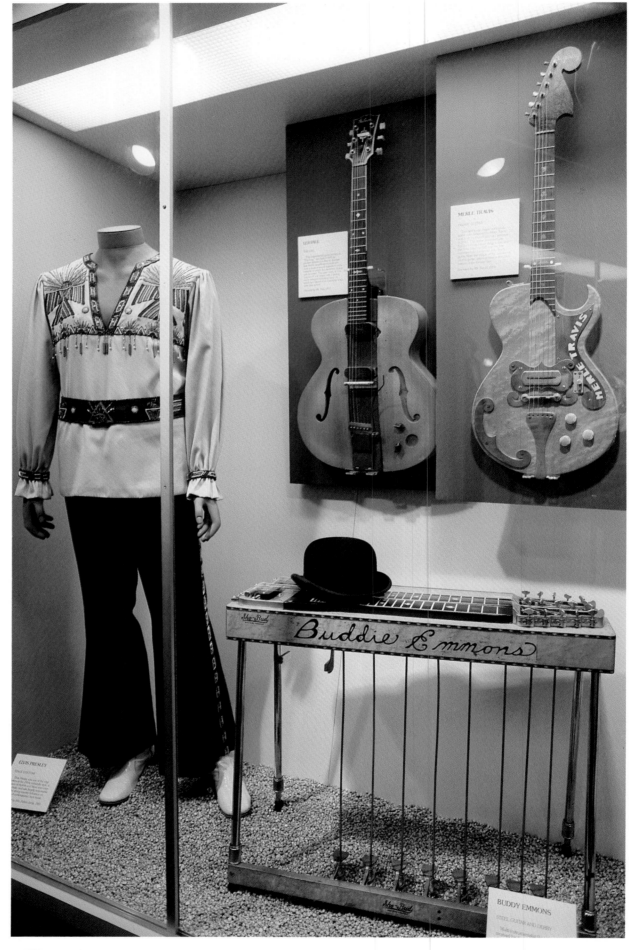

1 DISPLAY CASE FEATURING ELVIS PRESLEY'S COSTUME, LES PAUL'S GUITAR (LEFT), AND MERLE TRAVIS' GUITAR.

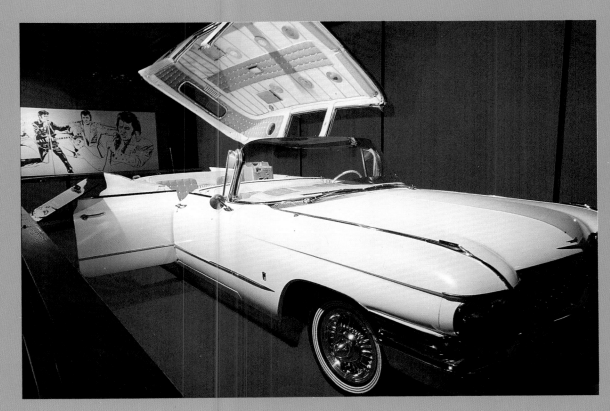

2 ELVIS PRESLEY'S GOLD CADILLAC

3 WURLITZER 1015 JUKE BOX, 1947

4 VINTAGE MICROPHONE FROM WSM RADIO

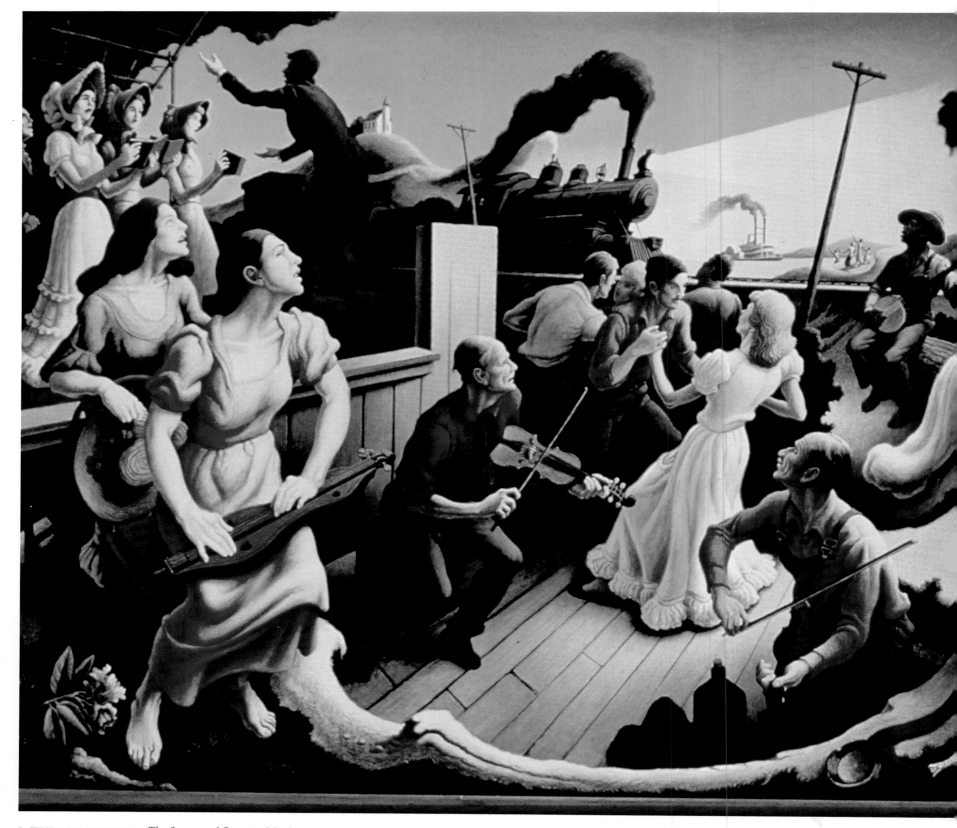

5 THOMAS HART BENTON *The Sources of Country Music*

5 American, 1974/75, Oil on canvas.
Photos 1, 2, 3, 6 and exterior by Alan Briere.

6 RESONATOR GUITAR (DETAIL)

8 HATCH SHOW LETTERPRESS POSTER FOR
MINNIE PEARL

7 WYNONNA AND NAOMI JUDD'S STAGE COSTUMES, 1987

The High Museum of Art

ATLANTA, GEORGIA

In 1983 the High Museum of Art moved into its new home—a stunning 135,000-square-foot work of modern art designed by architect Richard Meier. The stark white building with its piano-curved reception pavilion and four-story atrium tripled the museum's previous space and won such internationally prestigious honors as the American Institute of Architects' Honor Award and the Pritzker Architecture Prize. The museum's membership, attendance, and income have also all increased dramatically since the opening.

The High's external growth reflects Atlanta's increasing commitment to the arts in recent decades. The museum was founded in 1926, but its permanent collection, which now includes some 8,200 objects, has more than doubled in size in just the past ten years.

The museum now boasts strong permanent collections of 19th-century American paintings and contemporary works. The 150-piece Virginia Carroll Crawford Collection of American Decorative Arts has drawn critical acclaim while the Samuel H. Kress Foundation has enhanced the museum's European collection with Italian paintings and sculpture from the 14th to 18th centuries, including works by such masters as Giovanni Bellini, Vittore Carpaccio, and Giovanni Battista Tiepolo.

The Uhry Print Collection, established in 1955, contains important works by French Impressionists, German Expressionists, and 20th-century American artists. The museum's collection of sub-Saharan African art has become an important regional center of study, and the photography collection has grown to more than 2,700 images.

The High Museum is part of the Robert W. Woodruff Arts Center, which also includes the Atlanta Symphony, the Alliance Theatre Company, and the Atlanta College of Art.

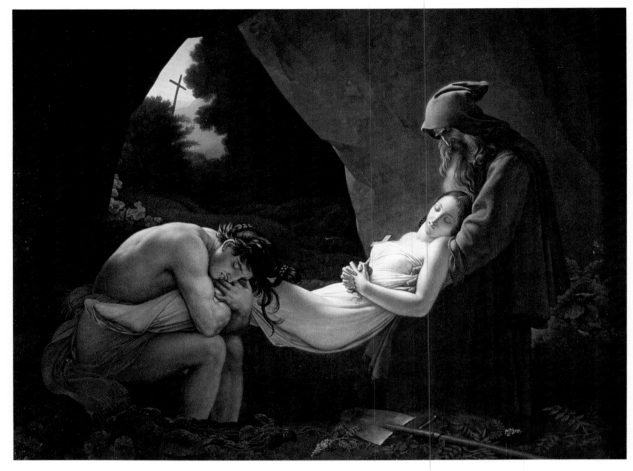

1 ANNE-LOUIS GIRODET-TRIOSON *The Funeral of Atala*

1 French, c. 1811, Oil on canvas.
2 American, 1856, Marble.
3 French, 1903, Oil on canvas.
4 American, 1968, Acryllic on canvas.

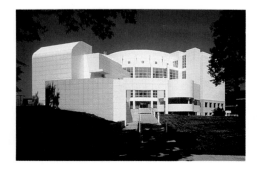

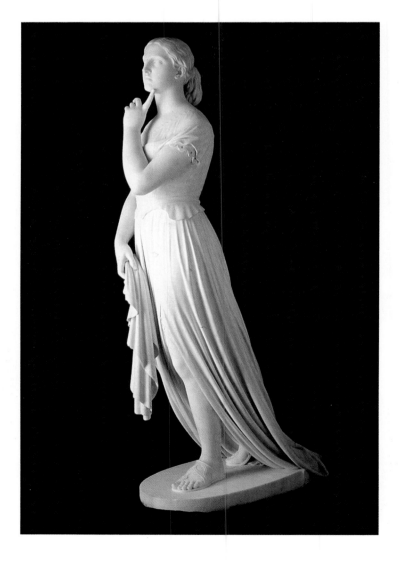

2 HIRAM POWERS *La Penserosa*

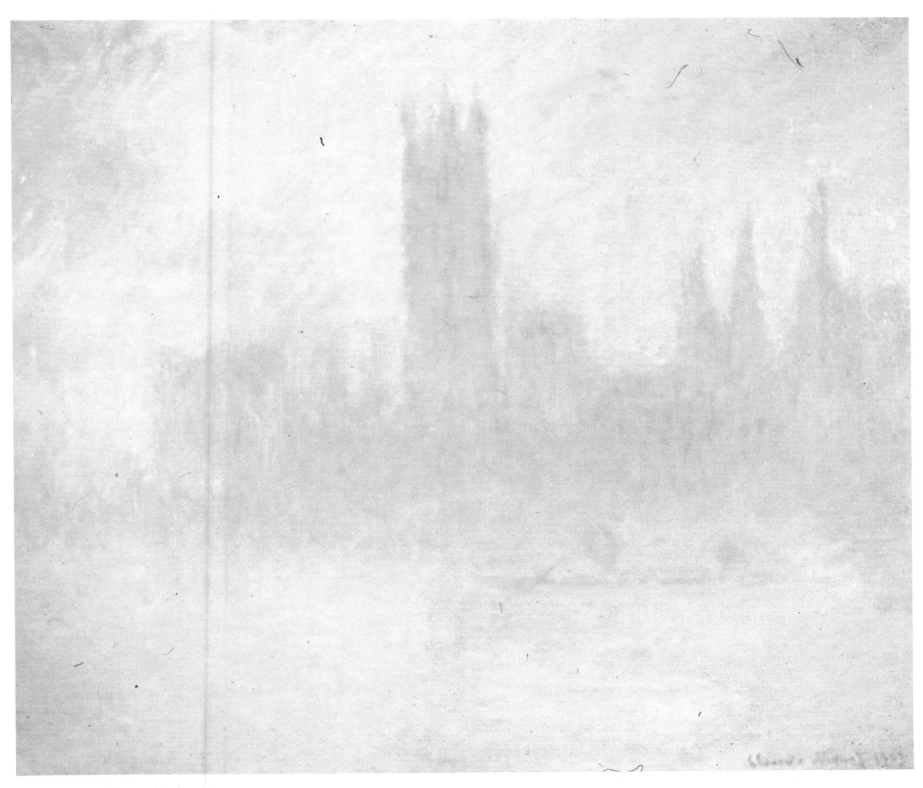

3 CLAUDE MONET *Houses of Parliament*

4 FRANK STELLA *Manteneia I*

1 PIERO DI COSIMO *The Building of a Palace*

2 PIETRO BERRETINI (PIETRO DA CORTONA) *Hagar and the Angel*

3 PETER PAUL RUBENS *Portrait of the Archduke Ferdinand*

The John and Mable Ringling Museum Of Art

SARASOTA, FLORIDA

John Ringling, the railroad and circus magnate, bequeathed his private museum, his art collection, and his 38-acre estate fronting Sarasota Bay to the people of Florida upon his death in 1936. Today, the John and Mable Ringling Museum of Art consists of over 10,000 objects, including important old master paintings, numerous statues, and various works of decorative arts.

The museum and Ringling's Italianate mansion, Ca' d'Zan (Venetian dialect for House of John), were built during the roaring twenties at a cost of over $5 million and are an eclectic collection of architectural styles ranging from Venetian Gothic to Florentine and Italian Renaissance. Architectural elements collected by the Ringlings in Europe are incorporated in the design.

The collection includes important paintings by Lucas Cranach the Elder, Nicolas Poussin, Frans Hals, Anthony Van Dyck, and other masters. There is also a superlative group of works by Peter Paul Rubens, and the museum's Italian Baroque paintings—Ringling's special love—are among the rarest and most celebrated in the country. One of the museum's unique and most famous features is the Asolo Theatre, an Italian court playhouse from Cornaro Castle in Asolo, Italy, reassembled here in the 1950s. With its three tiers of rococo boxes arranged in a horseshoe, it is a living illustration of Baroque theater design, presenting films and lectures. Although John Ringling did not include any circus art or artifacts in his bequest, the museum's first director fittingly converted the estate's garage into galleries which now house a fine collection of circus wagons, costumes, and memorabilia.

1 Italian, c. 1515–1520, Oil on canvas.
2 Italian, 1637/1638, Oil on canvas.
3 Flemish, 1635, Oil on canvas.
4 Italian, 16th century, Majolica.

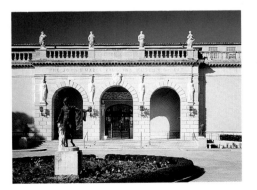

4 FAENZA *Two-Handled Drug Vase*

Kennedy Space Center Spaceport USA

KENNEDY SPACE CENTER, FLORIDA

S paceport USA opened in 1966 as the Visitor Center of NASA's John F. Kennedy Space Center. It received its formal name in 1985, and today this 70-acre complex of orientation buildings and outdoor attractions offers visitors a unique perspective on America's space programs, past, present, and future.

The Galaxy Center houses the Twin Galaxy and IMAX theaters, where special feature presentations relating to spaceflight are shown. Also here are scale models of the Hubble Space Telescope and Space Shuttle, as well as the NASA Art Gallery, which features more than 250 paintings and sculptures commissioned by NASA, including works by Andrew Wyeth, Wilson Hurley, Bob McCall, and Robert Rauschenberg.

Some of the numerous attractions and exhibits at the Gallery of Space Flight include the Gemini 9 Spacecraft; the space suit astronaut David Scott wore on the Gemini 8 mission; the actual Apollo spacecraft that docked with the Russian Soyuz during the historic 1975 cooperative space flight; full-sized models of the Viking spacecraft that landed on Mars in 1976, the Lunar Rover, and the Russian Soyuz space craft; a scale model of the Saturn V Moon Rocket; and an actual moon rock.

The Rocket Garden at Spaceport USA features historic rockets and other equipment from each stage of America's space program, including an authentic Saturn 1B, like those used in the first manned Apollo launch and the three Skylab missions; a Mercury Redstone; and a scale model of the Lunar Landing Module.

In Spring 1991 an Astronauts Memorial was completed. It is dedicated to the 14 American astronauts who have lost their lives in the line of duty. Two-hour bus tours of Launch Complex 39 at Kennedy Space Center are also available from Spaceport USA.

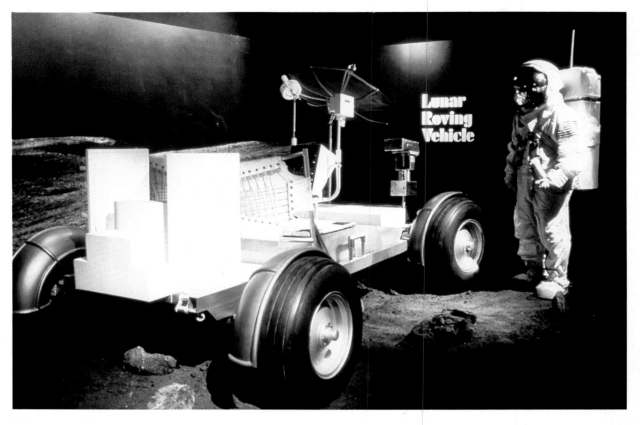

1 LUNAR ROVER VEHICLE

2 LORI McCAY
With the Spirit of Daedalus

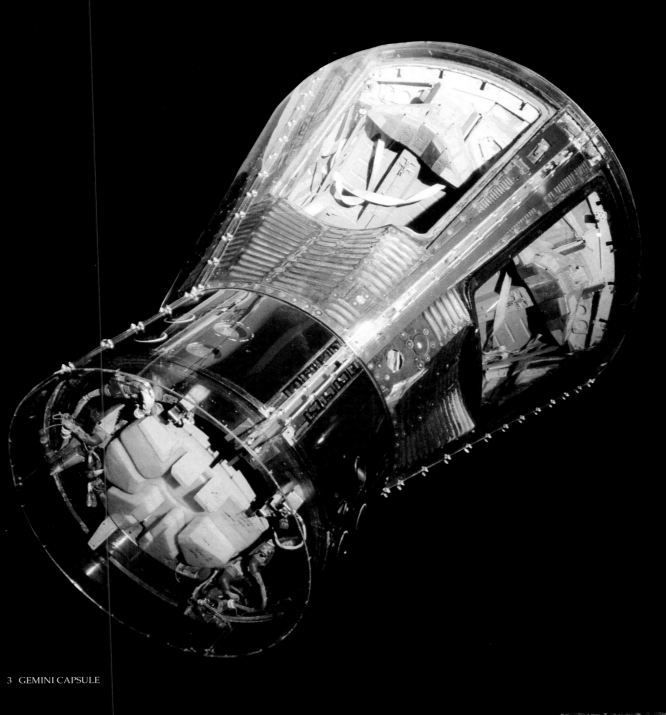

3 GEMINI CAPSULE

2 American, 1985, Watercolor.

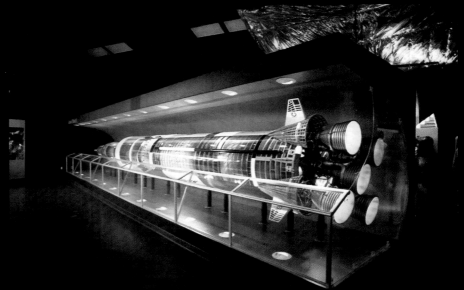

4 SATURN V ROCKET

1 ANDRE DERAIN *The Turning Road, L'Estaque*

2 EDWARD STEICHEN *Trees, Long Island*

The Museum of Fine Arts, Houston

HOUSTON, TEXAS

With more than 27,000 works in its collection, the Museum of Fine Arts, Houston, ranks as one of the largest and most outstanding art institutions in the Southwest.

The museum first opened to the public in 1924 under the auspices of the Houston Art League. Cullinan Hall, designed by famed architect Ludwig Mies van der Rohe, was built in 1958. The Brown Pavilion Galleries, which house European art to the early 20th century, opened in 1974, completing Mies' masterplan for the museum.

The entire spectrum of world cultures from antiquity to the present is represented here. Highlights include the Straus Collection of Renaissance and 18th-century art and the Beck Collection of Impressionist and Post-Impressionist paintings. There are also galleries devoted to American painting, 20th-century painting, Far Eastern art, photography, and the art of Africa, Oceania, and the Americas. The Lillie and Hugh Roy Cullen Sculpture Garden, created by internationally renowned sculptor Isamu Noguchi, provides a serene setting for selected pieces from the museum's permanent collection.

In 1957 Houston philanthropist Ima Hogg donated her collection of American paintings and decorative arts from 1670 to 1870 to the museum, along with her 28-room mansion, Bayou Bend, and its 14 acres of gardens. The Bayou Bend collection, which now includes over 4,700 works, is located five minutes from downtown Houston. It opened to the public in 1966, its conversion from home to museum personally supervised by Miss Hogg.

3 CHARLES WILLSON PEALE *Self-Portrait with Rachel and Angelica Peale*

4 DOGON *Ceremonial trough*

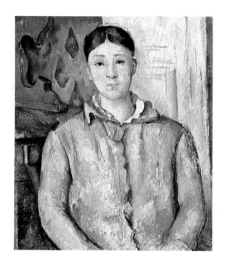

5 PAUL CÉZANNE
Madame Cézanne in Blue

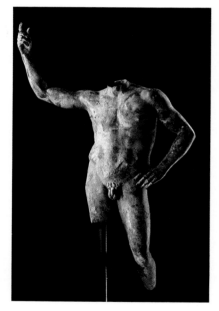

6 UNKNOWN *Portrait of a Ruler*

1 French, 1906, Oil on canvas, The John A. and Audrey Jones Beck Collection, 74.138.

2 American, 1905, Carbon photograph on base of silver paint, Museum purchase with funds provided by the Long Endowment for American Art and the Sarah Campbell Blaffer Foundation, 86.1.

3 American, c. 1790, Oil on canvas, The Bayou Bend Collection, gift of Miss Ima Hogg, B.60.49.

4 Mali, 1720–1820, Wood, Gift of D. and J. de Menil, 64.11.

5 French, 1885–1887, Oil on canvas, The Robert Lee Blaffer Memorial Collection, gift of Sarah Campbell Blaffer, 47.29.

6 Roman, Severan period, c. 200–225 A.D., Bronze, Gift of D. and J. de Menil in memory of Conrad Schlumberger, 62.19.

7 Italian, c. 1524/25, Oil on canvas, transferred from panel, The Samuel H. Kress Collection, 61.79.

8 American, c. 1855, American tulip wood, northeast white pine, black walnut, marble, Museum purchase with funds provided by Anaruth and Aron S. Gordon, 83.46.

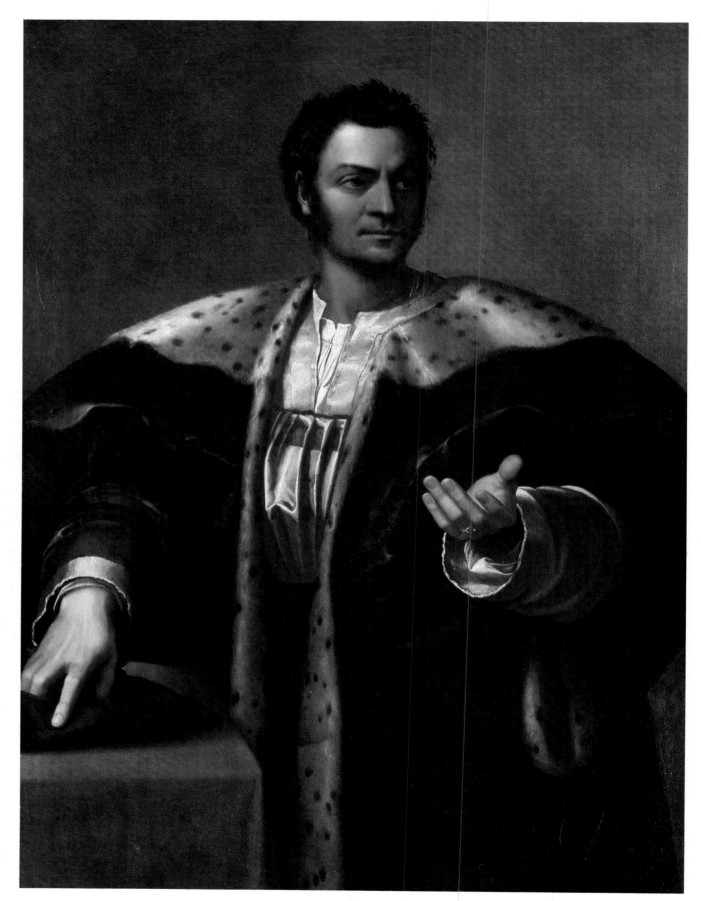

7 SEBASTIANO DEL PIOMBO *Portrait of Anton Francesco Degli Albizzi*

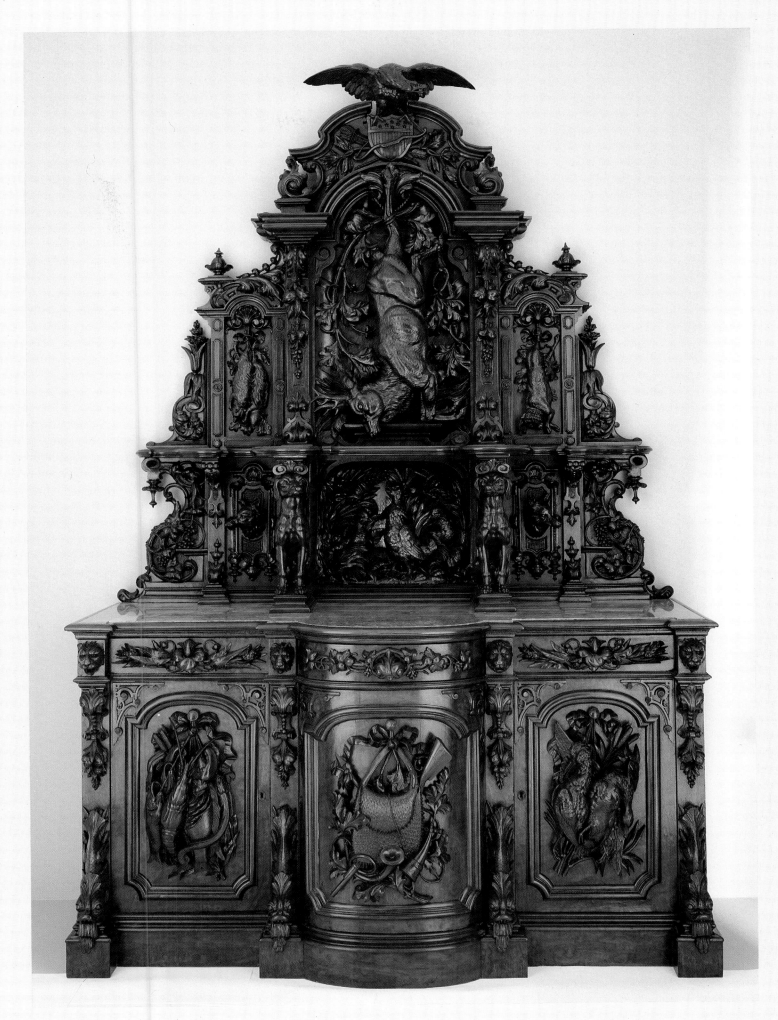

8 UNKNOWN *Sideboard*

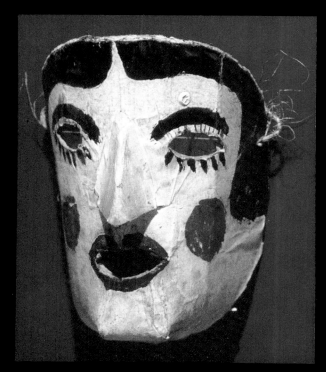

1 UNKNOWN *Mask*

2 BUTTERFLY

3 Mexico, 100 B.C.–A.D. 600, Turquoise.

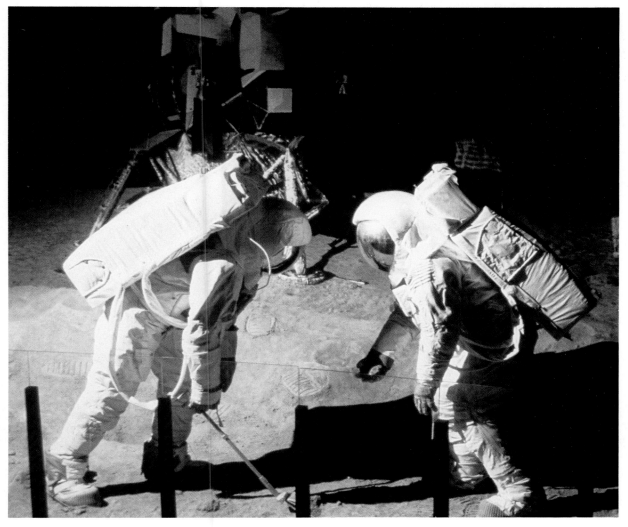

3 MOONWALK DIORAMA

4 SERANDITE AND ANALCIME (*Silicate-Triclinic*)

Houston Museum of Natural Science

HOUSTON, TEXAS

The Houston Museum of Natural Science is the city's most popular museum with an annual attendance of 1.8 million visitors in 1990.

Founded in 1909, the 162,000-square-foot complex is divided into three parts: the museum, the Wortham IMAX Theatre, and the Burke Baker Planetarium.

The museum consists of 18 galleries devoted to various areas of the natural sciences. There are extensive displays of dinosaur remains, shells, space science, Native American artifacts, health sciences, and Texas wildlife. The Cullen Gallery of Earth Science features the six million dollar, world-class Sams Collection of Gems and Minerals, housed in total darkness except for the spectacularly lit cases. The Weiss Hall of Petroleum Science and Technology is one of the largest exhibits on the subject in the United States. There is also the Discovery Place, filled with hands-on interactive exhibits.

In the 402-seat Wortham IMAX Theatre, the world's most advanced motion picture system provides an exceptional experience as images of unsurpassed clarity are projected onto a screen ten times larger than that of a conventional movie theater and enhanced with six-track stereo sound.

The 50-foot, 232-seat domed Burke Baker Planetarium presents astronomical programs with a recently-installed Digistar starfield projector, one of only a handful in operation. Every space shuttle astronaut is trained in starfield identification at this facility.

The museum also operates the George Observatory, an exact replica of the 36-inch 10-ton research telescope at the Kitt Peak National Observatory in Arizona and the largest professional telescope open to the public.

The Hertzberg Circus Collection

SAN ANTONIO, TEXAS

Harry Hertzberg was a San Antonio lawyer, civic leader, and state senator. He was also his era's most active collector of circus memorabilia. When he died in 1940, he left his entire collection to the San Antonio Public Library, and upon its dedication in 1942, the Hertzberg Circus Collection, housed at the library's downtown annex, became one of three public collections in America devoted to circus history.

The collection features circus memorabilia ranging from an ornate parade wagon built in 1902 for the Gentry Bros. Circus to an entire miniature circus built by ringmaster Harry Leska Thomas to exactly duplicate the tented railroad troupes of the 1920s and 1930s. The collection also possesses a coach that impresario P. T. Barnum had built for his famous midget, General Tom Thumb, in 1843. Additional artifacts include a blade box (in which a side show "rubber girl" would attempt to evade being skewered), the trapeze bar on which the Mexican-American Alfredo Codona perfected his triple somersault, and an extensive collection of clown and animal figurines. The newest exhibit is Clown Alley, which presents a historical approach to clowning and to key figures in clown history.

Also among the highlights of the Hertzberg collection are nearly 1,000 posters from famous circuses and circus attractions. These posters range from the earliest surviving color circus poster, a 8' x 10' advertisement for the R. Sands & Co. Hippoferaean Arena of 1849 to such 20th-century acts as animal trainer Clyde Beatty and the wire-walking Wallendas.

The collection also includes 1,000 books, 300 broadsides (handbills), over 100 illustrated booklets, more than 100 scrapbooks, 140 pieces of 19th-century sheet music, plus numerous songsters, prints, programs, route books, journals, manuscripts, paintings, and photographs—all relating to the circus.

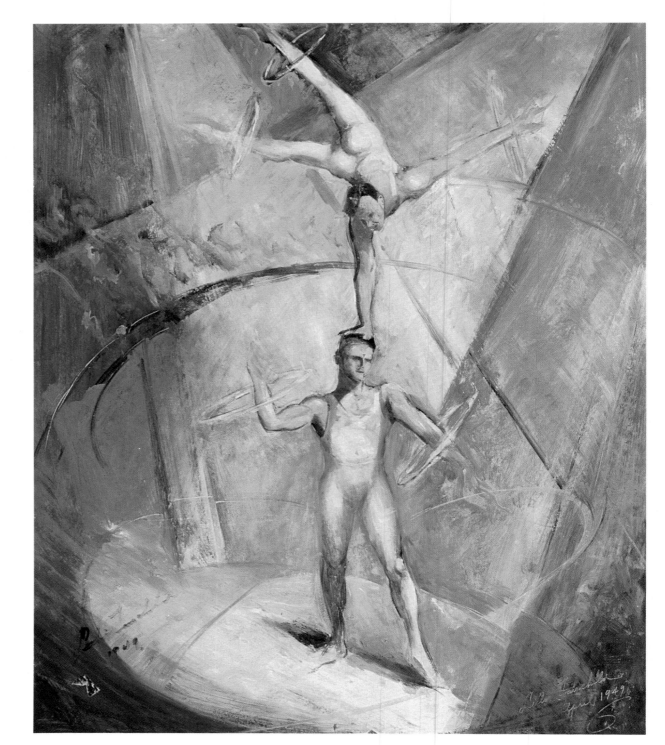

1 LESLIE FAIRCHILD *Acrobat*

2 TOM THUMB'S CARRIAGE

3 "TOTO," AN 18TH-CENTURY
MECHANICAL CLOWN

1 American, 1949, Oil on canvas.

4 MINATURE CIRCUS

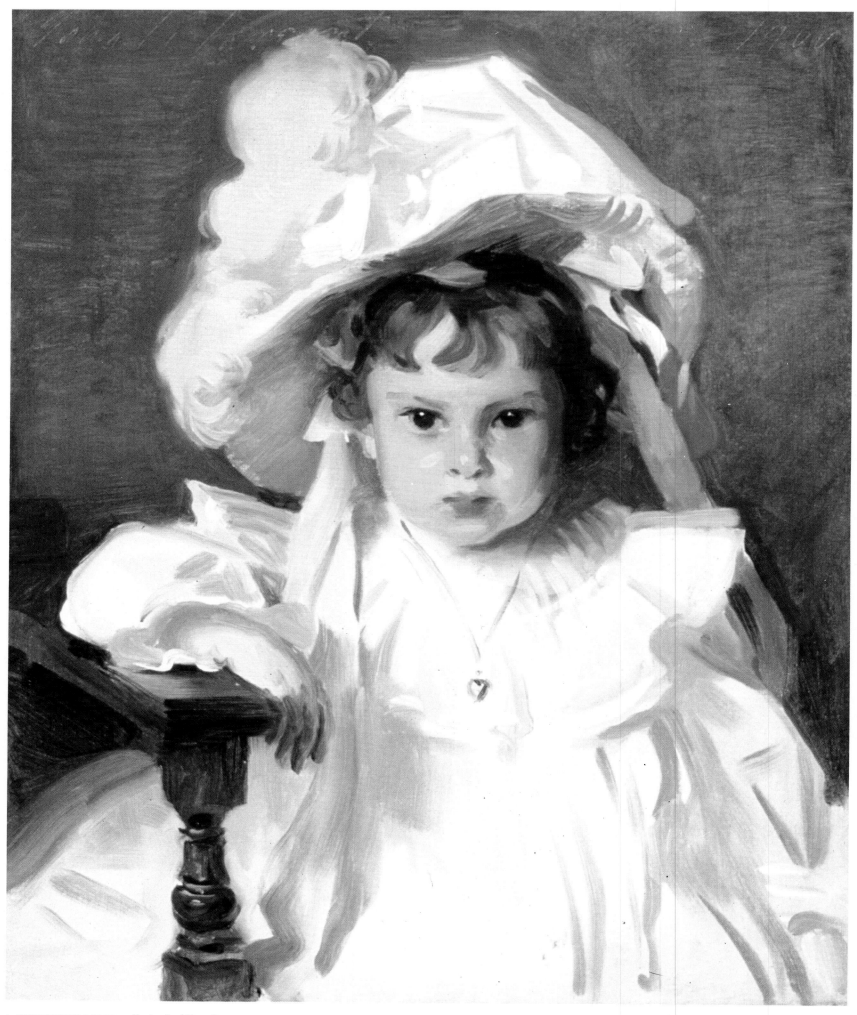

1 JOHN SINGER SARGENT *Portrait of Dorothy*

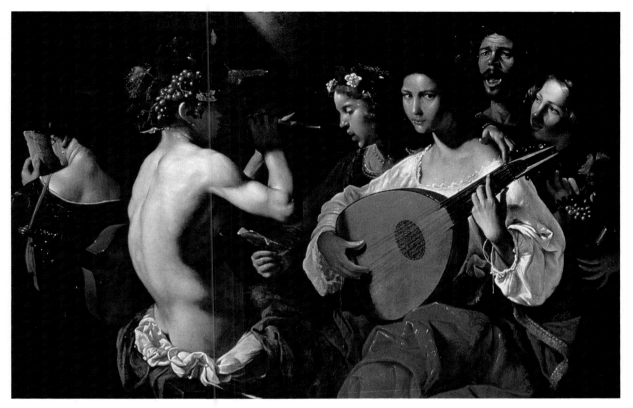

2 PIETRO PAOLINI *Bacchio Concert*

3 PIET MONDRIAN *Windmill at Blaricum*

1 American, c. 1900, Oil on canvas, Leland Fikes Foundation, Inc.

2 Italian, c. 1625–1630, Oil on canvas, the Hoblitzelle Collection.

3 Dutch, 1908, Oil on canvas.

4 American, 1893, Silver, The Eugene & Margaret McDermott Fund.

4 TIFFANY & COMPANY *Water pitcher*

Dallas Museum of Art

DALLAS, TEXAS

In January, 1984 the Dallas Museum of Art moved into a 210,000-square-foot structure with a 40-foot-tall central barrel vault. Though the new building, designed by Edward Larrabee Barnes, tripled the museum's previous space, plans were announced in December 1988 for a 50 percent expansion.

The museum's collection is clearly growing. Presently it encompasses more than 15,000 works, showing greatest strength in the areas of pre-Columbian art, African sculpture, textiles, decorative arts, and post-World War II American art.

The 16-inch "Eccentric Flint," a Mayan representation of a canoe carrying a deceased king to the underworld, is considered the world's foremost object in its class. Textiles range in date from about 550 B.C. to the present and include examples from South, Central, and North America, the countries of the Pacific rim, and the American Southwest. Large modern sculptures by Claes Oldenburg and Ellsworth Kelly are featured prominently in the new building.

American painting of the 18th and 19th centuries is an area growing in importance at the museum. Represented artists range from Charles Willson Peale and Thomas Sully to Albert Bierstadt and Frederic Church (whose masterpiece, *The Icebergs*, is on display). The museum's holdings in European paintings (including an exceptional collection of Mondrians), Native American objects, prints, drawings, and photographs are also emerging in significance.

Finally, the Wendy and Emery Reves Collection features major Impressionist paintings, porcelain, carpets, furniture, metalwork, and glass all housed in a re-creation of several rooms from the Reves' French villa. Other examples of decorative arts at the museum include impressive holdings in American furniture and one of the nation's finest collections of English and American silver.

The Amon Carter Museum

FORT WORTH, TEXAS

Newspaper publisher Amon Carter had a dream—that his superb 400-piece collection of the works of Frederic Remington and Charles M. Russell would one day form the basis of an art museum for his beloved city of Fort Worth. Though he did not live to see it, Carter's dream has been more than realized.

Since the 1961 opening of its International Style building by Philip Johnson, the museum has had two additions (also designed by Johnson) and still the collection continues to grow. It now includes over 6,400 paintings, watercolors, prints, and sculptures, reflecting the complete evolution of American painting.

Beginning with landscapes from the 1820s, including works by painters from the Hudson River School like Thomas Cole and Frederic Edwin Church, the collection progresses through luminist paintings and *trompe l'oeil* still lifes to American Impressionism and modernism.

There are many outstanding works on display, including Augustus Saint-Gaudens' sculpture *Diana*, originally owned by architect Stanford White; wonderful paintings of children by Winslow Homer and Eastman Johnson; William Merritt Chase's harmonious *Idle Hours* and Childe Hassam's *Flags on the Waldorf*; the abstractions of Marsden Hartley, John Marin, and Georgia O'Keeffe; and Grant Wood's famous *Parson Weems' Fable* that pictures the six-year-old George Washington (but with an instantly recognizable adult face from Gilbert Stuart's famous Athenaeum portrait), admitting that he chopped down the cherry tree.

The Amon Carter's photography collection began with Dorothea Lange's gift of her portrait of Charles Russell in 1961. Today it consists of more than one-quarter of a million prints and negatives and is one of the major repositories of American photography.

1 WINSLOW HOMER *Crossing the Pasture*

1 American, 1828, Oil on canvas.
2 American, c. 1850, Dauguerreotype Courtesy Laura Gilpin Collection.
3 American, c. 1872, Oil on canvas.
4 American, 1889, Oil on canvas.

2 UNKNOWN *(California Forty-Niner)*

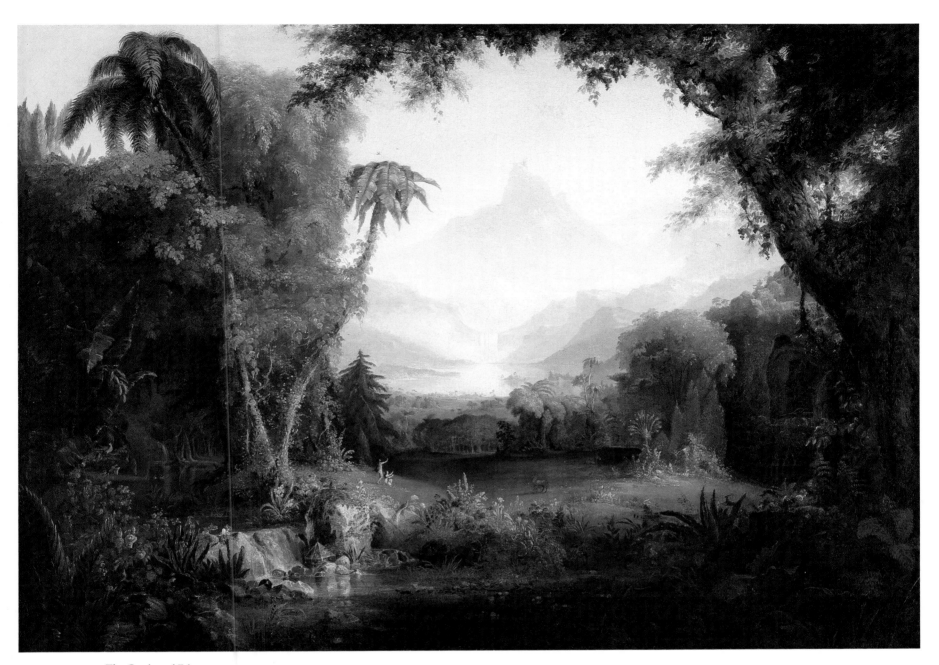

3 THOMAS COLE *The Garden of Eden*

4 FREDERIC REMINGTON *A Dash for the Timber*

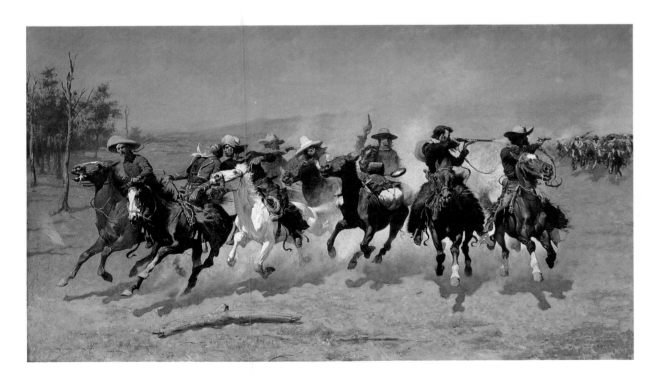

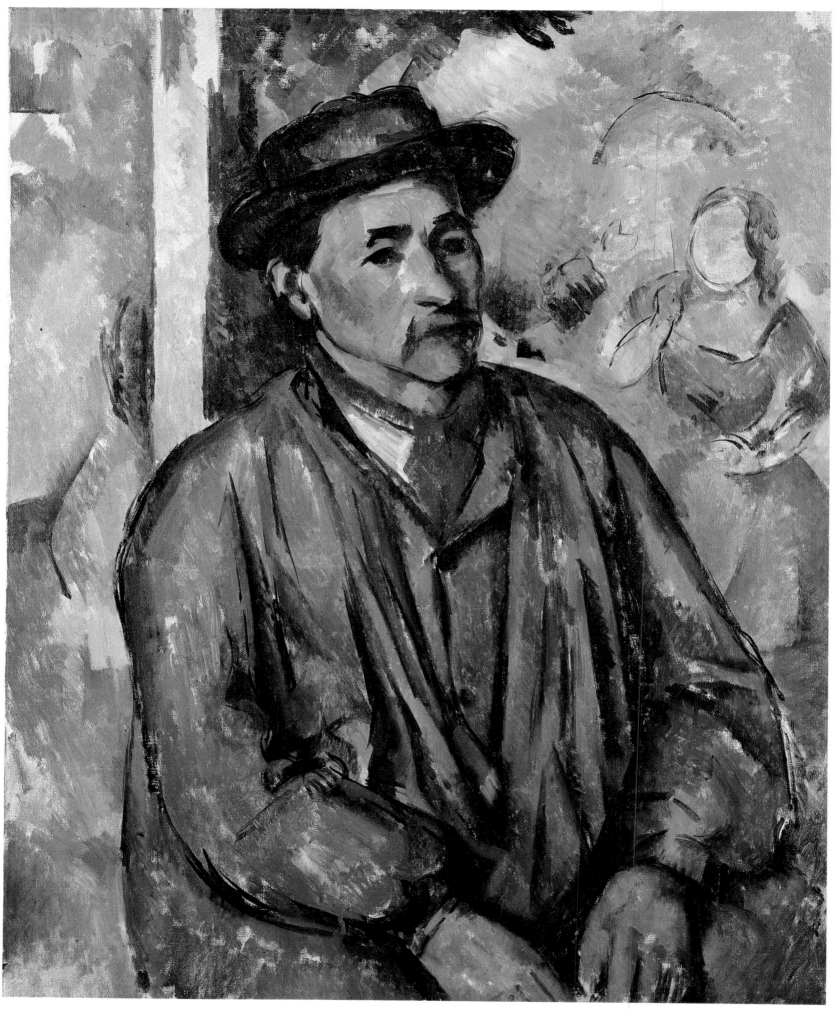

1 PAUL CÉZANNE *Man in a Blue Smock*

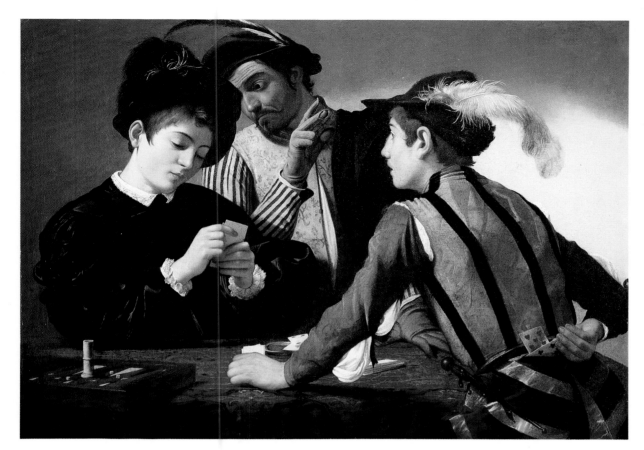

2 CARAVAGGIO *The Cardsharps*

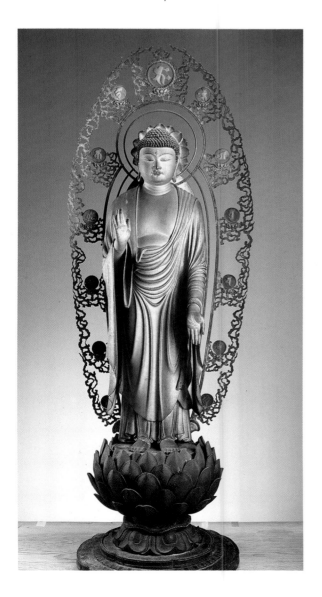

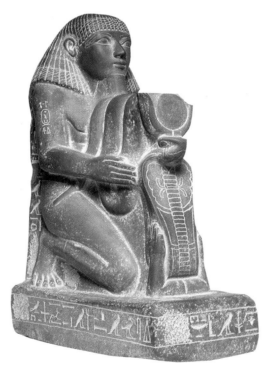

3 UNKNOWN *Kneeling Statue of Senenmut*

1 French, c. 1895–1897, Oil on canvas.
2 Italian, c. 1594–1595, Oil on canvas.
3 Egypt, 18th Dynasty, c. 1490 B.C., Schist.
4 Japanese, c. 1210, Gilt and lacquered wood

4 ATTRIBUTED TO KAIKEI *Standing Shaka Buddha*

Kimbell Art Museum

FORT WORTH, TEXAS

By any standard, the Kimbell Art Museum is one of the best small museums in America. Established by entrepreneur Kay Kimbell, the museum first opened its doors in 1972 in one of the finest facilities for the public display of art in the world. The building, a series of 16 open concrete vaults that won the American Institute of Architect's highest award, was designed by famed Philadelphia architect Louis I. Kahn and was the last building completed under Kahn's personal supervision.

The museum's stunning collection ranges from antiquity to the early 20th century and includes works from ancient Egypt, Asia, Mesoamerica, and Africa, but it is in the area of Western European painting that the Kimbell truly distinguishes itself.

The museum's outstanding holdings include Duccio's *The Raising of Lazarus*, Fra Angelico's *Saint James Freeing Hermogenes*, Georges de La Tour's *The Cheat with the Ace of Clubs*, as well as the recently discovered *Cardsharps* by Caravaggio, one of the most important old master paintings to emerge in decades. The collection also features major portraits by Tintoretto, Diego Velázquez, Rembrandt, and El Greco as well as important works by Giovanni Bellini, Andrea Mantegna, Titian, Peter Paul Rubens, Nicolas Poussin, Francisco Goya, and Jacques-Louis David. The major movements of the 19th- and 20th-century are also represented in paintings by Gustav Courbet, Eugene Delacroix, Édouard Manet, Claude Monet, Henri Matisse, and Pablo Picasso, among others.

The Kimbell is the only museum in the Southwest with a substantial collection of Asian arts, featuring a stunning assemblage of Japanese screens and hanging scrolls, Chinese paintings, and sculptures from India, Southeast Asia, China, and Japan.

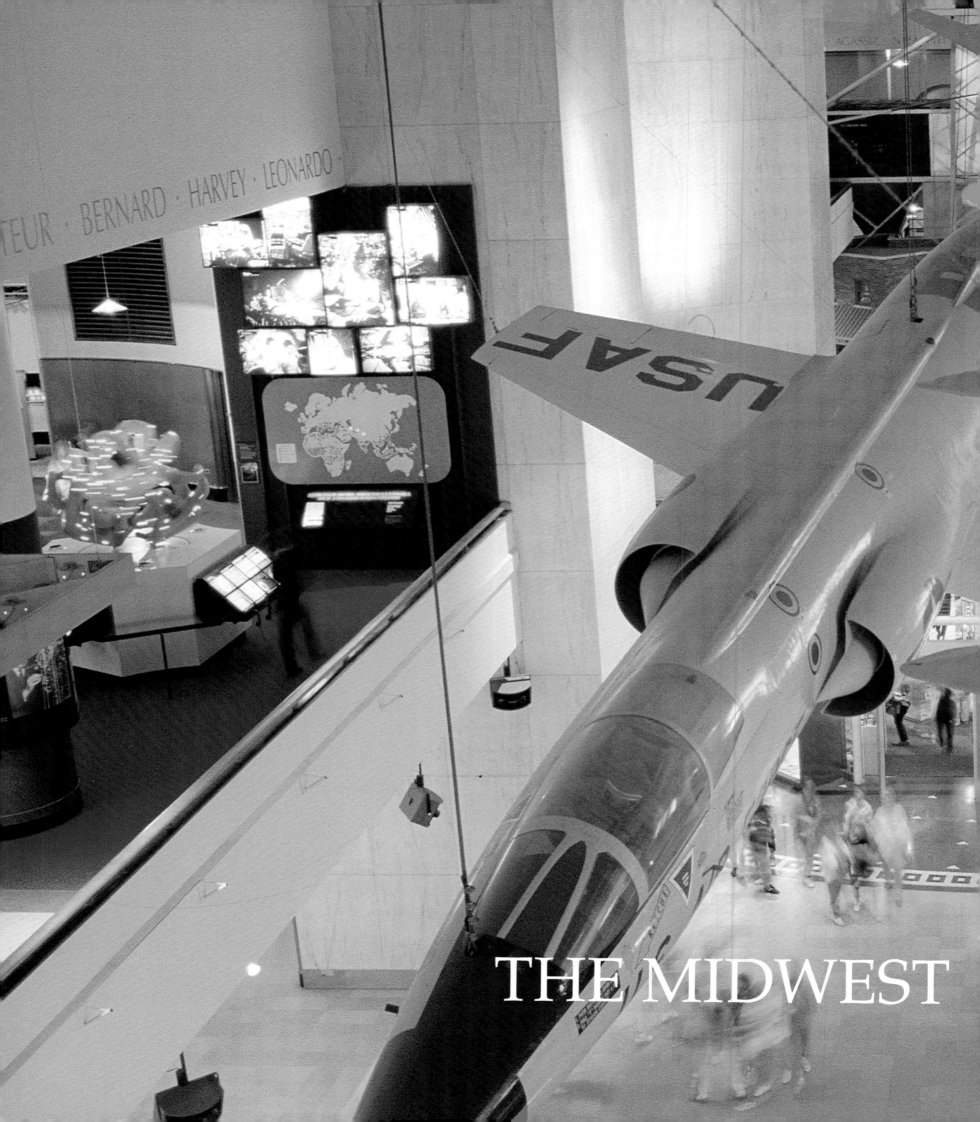

THE MIDWEST

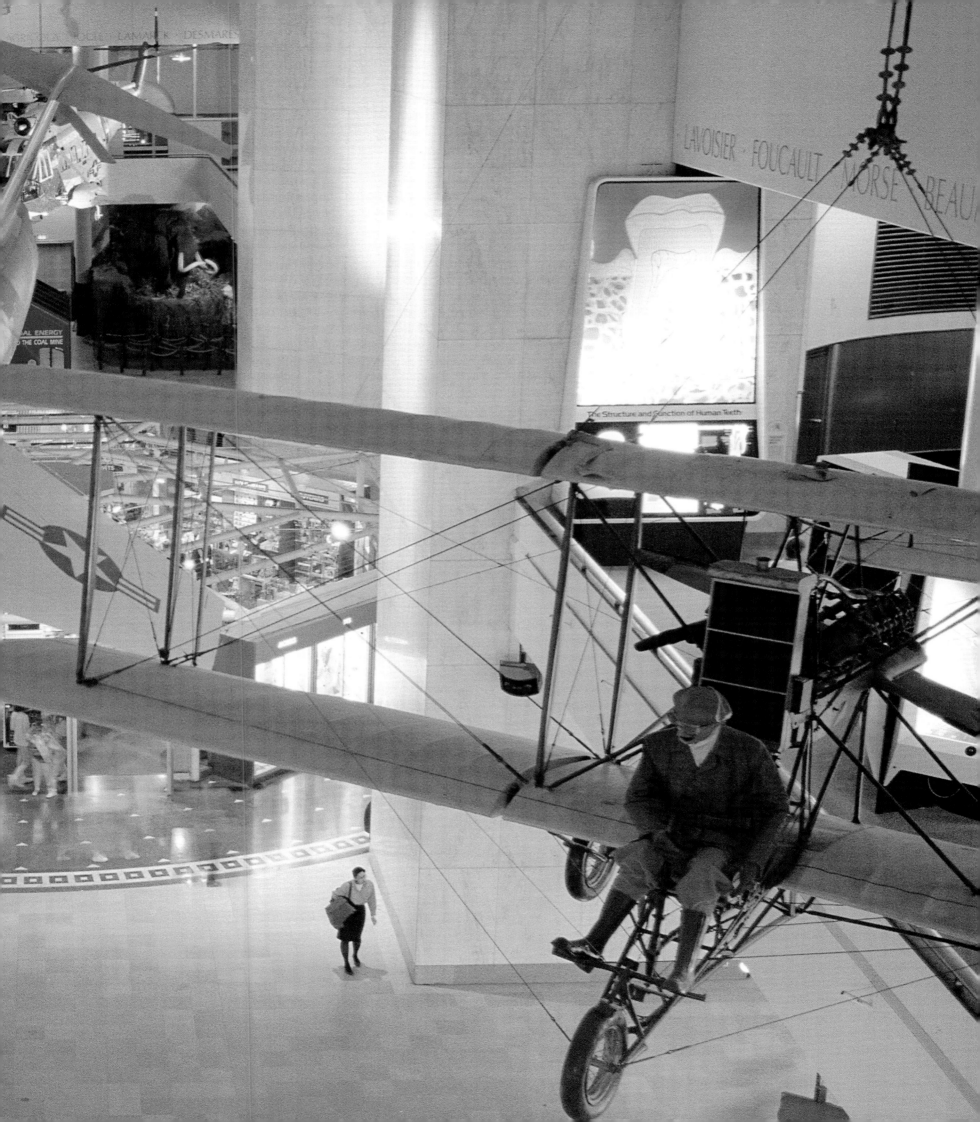

The Pro Football Hall of Fame

CANTON, OHIO

The Pro Football Hall of Fame was created in 1963 to honor America's great professional football players. Today it has grown into an unusual 51,000-square-foot, four-building complex, filled with educational displays and memorabilia.

A seven-foot bronze statue of Jim Thorpe, the great American Indian athlete, guards the entrance to the Exhibition Rotunda, where pro football history is traced from its origins in 1892 to the present day. Mementoes, including a complete uniform from pro football's earliest indoor game in 1902, are displayed here as well as exhibits honoring all of the pro teams and individual greats like Johnny Unitas, Eric Dickerson, and Walter Payton.

The "Pro Football Art Gallery" displays the winning entries from each of the hall's annual contests. The "Adventure Room" features colorful exhibits on various subjects including African-Americans in pro football and the history of the All-Star Game. The "Super Bowl Room" includes picture stories of all the games, plus the Vince Lombardi Trophy awarded to the winning team after each January classic and replicas of each of the Super Bowl Rings.

The "Enshrinement Galleries and Mementoes Room" form the core of the museum. Here, members of the Pro Football Hall of Fame are honored in statues, videos, and exhibits. Mementoes include such treasures as Y. A. Tittle's battered helmet, Joe Namath's New York Jets jersey, and even the ice tongs Red Grange used while working his way through college.

Each year a 31-man Board of Selections made up of outstanding sports writers elects a new class of Hall of Famers. To merit election, a candidate must receive approximately 82 percent of the vote.

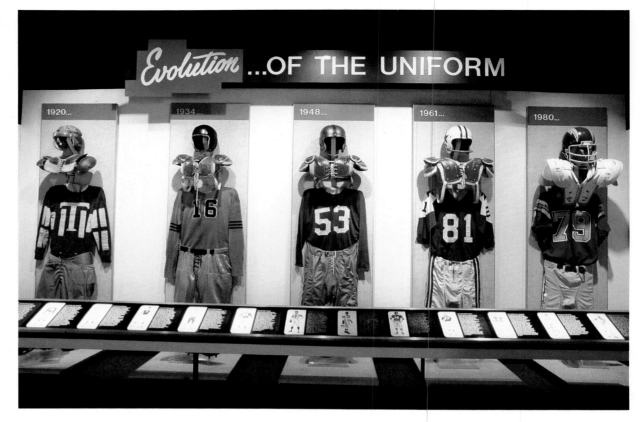

1 THE *EVOLUTION OF THE UNIFORM* EXHIBIT

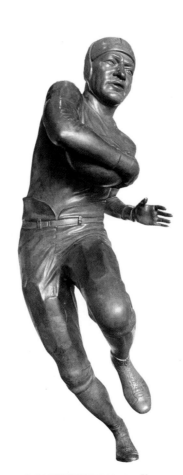

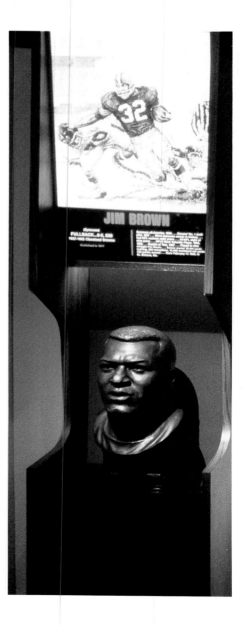

2 JACK WORTHINGTON *Jim Thorpe, 1963 Inductee*

3 JACK WORTHINGTON *Jim Brown 1971 inductee*

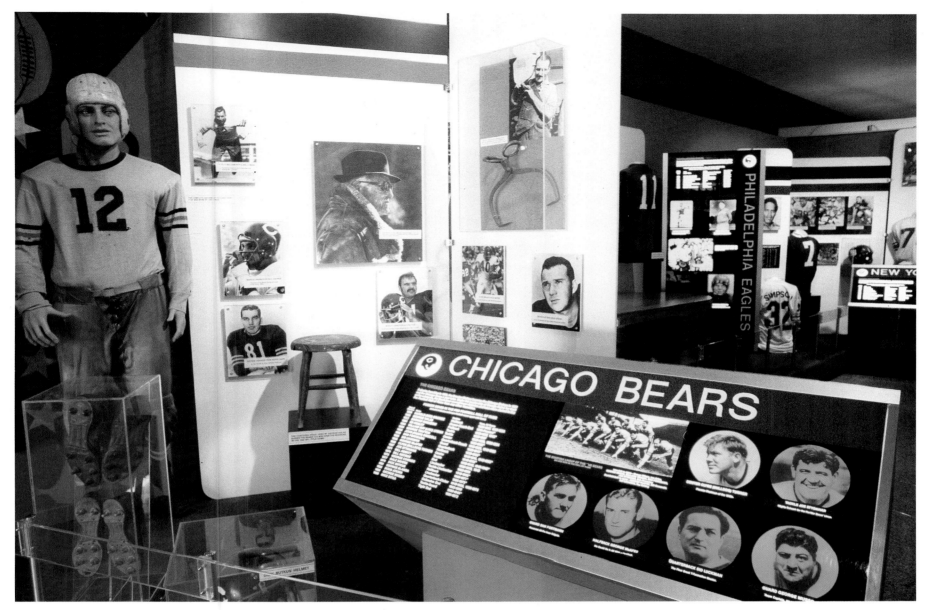

4 THE *TEAM MEMENTOS* EXHIBIT

5 DOAK WALKER'S SHOE

6 GREEN BAY PACKERS PLAYERS' BENCH

Photos 1, 2, 3, 4 and the exterior by Alan Briere.

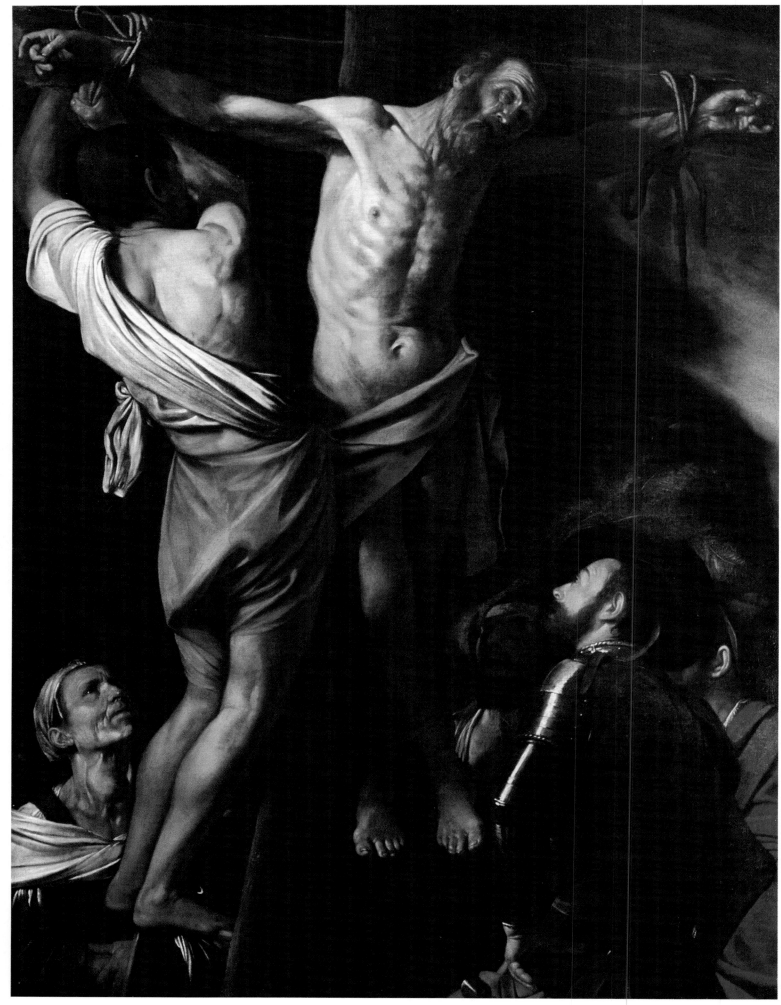

1 CARAVAGGIO *The Crucifiction of St. Andrew*

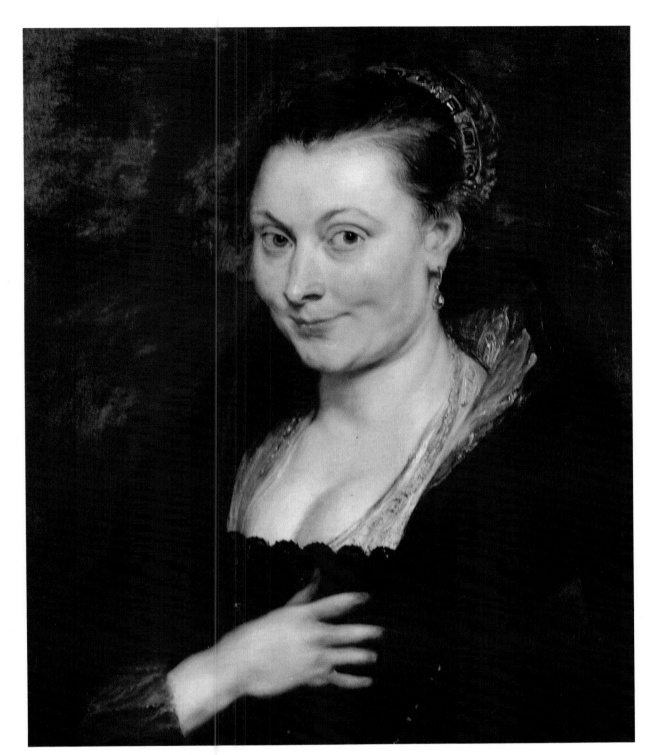

2 PETER PAUL RUBENS *Portrait of Isabella Brant*

The Cleveland Museum of Art

CLEVELAND, OHIO

The Cleveland Museum of Art is one of America's major art museums, celebrated for both the enormous range and the exceptional quality of its collection.

Housed in an elegant neoclassical building whose marble steps lead down to sculptured gardens and a jewel-like lagoon, the museum first opened to the public in 1916. A 1958 addition doubled gallery space and a three-story wing designed by Marcel Breuer and Hamilton Smith was added in 1970. The museum's holdings—over 50,000 works—represent a chronological progression of the history of Western art from ancient Egypt, Greece, and Rome to the present, and a similarly comprehensive representation of the arts of Asia.

The paintings collection includes works by a host of old masters and modern artists, some represented by their most important canvases. There are portraits attributed to Rembrandt, J. M. W. Turner's famous *Burning of the Houses of Parliament*, El Greco's *Christ on the Cross with Landscape*, and Picasso's *La Vie*, the largest and most complex painting of his Blue Period, as well as ten of his other works. The museum's exceptional collection of the Impressionists and Post-Impressionists includes, among others, three Cézannes, five Monets, four Renoirs, three outstanding van Goghs, and five superior works by Degas.

Aside from its paintings, the Cleveland Museum is also known for its decorative arts, its arms and armor, and for its strong collections of the arts of India, Southeast Asia, Africa, and the pre-Columbian Americas. The museum also has one of the United States' largest and most important Medieval European collections and its Far Eastern collection is widely regarded as one of the finest outside of Asia.

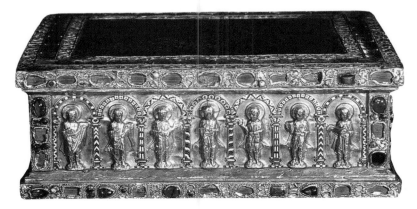

3 UNKNOWN *Portable Altar Front*

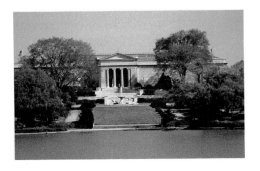

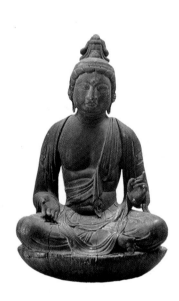

4 UNKNOWN
Nikko, the Sun Bodhisattva

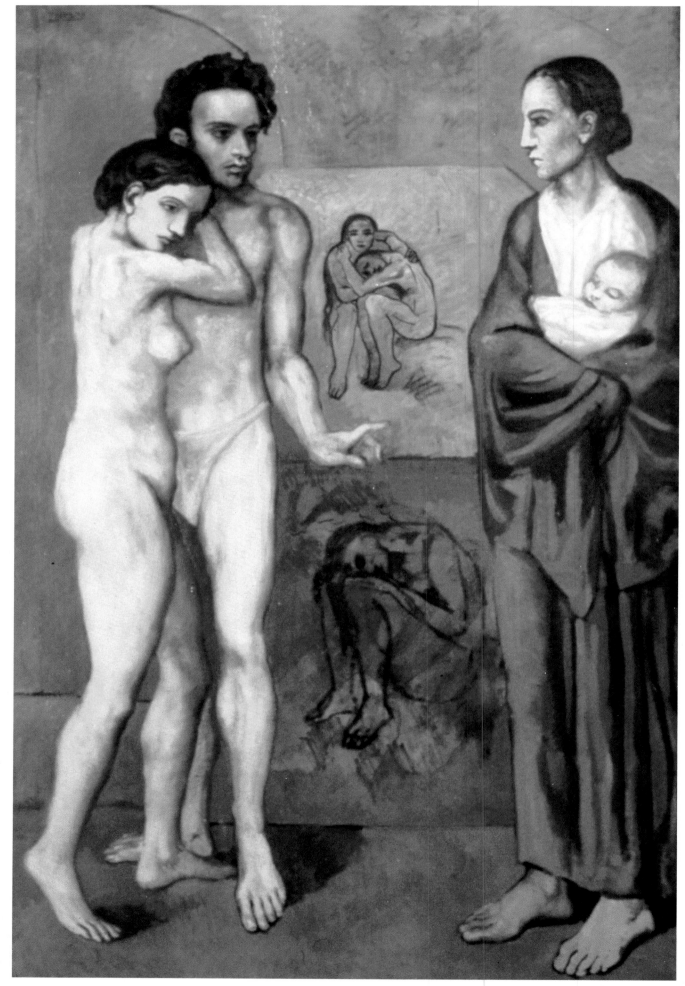

5 PABLO PICASSO *La Vie*

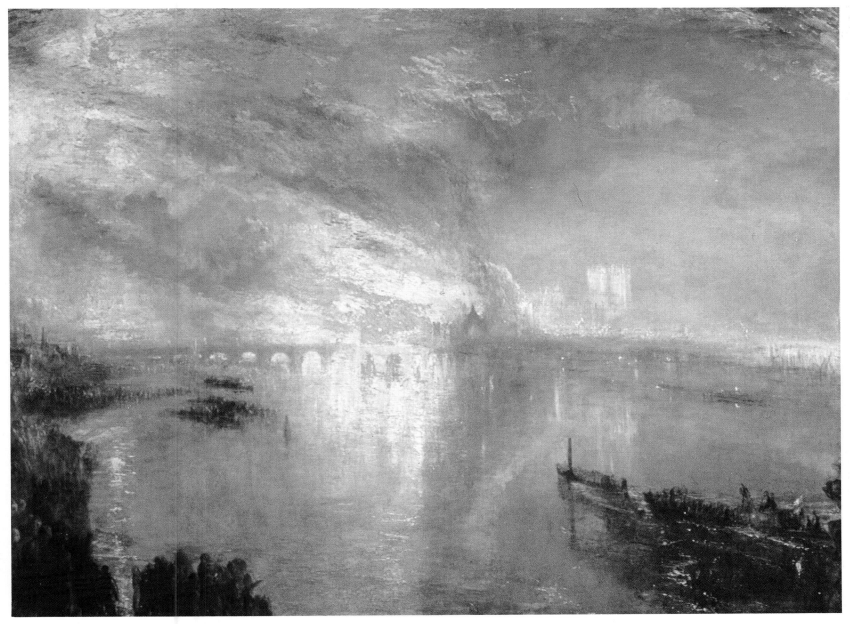

6 J. M. W. TURNER *Burning of the Houses of Parliament*

(FAR LEFT)
7 PIERRE AUGUSTE RENIOR
Mlle. Romaine Lacaux

(LEFT)
8 DIEGO VELÁZQUEZ *Portrait of the Jester Calabazas*

The Western Reserve Historical Society

CLEVELAND, OHIO

Founded in 1867, the Western Reserve Historical Society offers a fascinating glimpse at the history of Cleveland and of a 3.5-million-acre area surrounding the city — once the state of Connecticut's "Western Reserve." The society's history museum in University Circle, Cleveland's cultural center, occupies approximately 65,000 square feet in two Italian-Renaissance-style mansions built in the early 20th century.

The museum's far-ranging holdings totaling about 100,000 objects are displayed in 18 period rooms and include fine furniture, decorative arts (including an extraordinary collection of Ohio glass), and nearly 7,000 paintings by such artists as Howard Chandler Christie, Albert Bierstadt, and *Spirit of '76*-artist Archibald Willard, who is represented by 38 canvases. The museum also possesses what is perhaps the finest collection of articles relating to Napoleon Bonaparte outside of France, as well as a world-class costume collection covering the years from 1750 to the present and numbering nearly 25,000 items.

A separate wing was opened in 1963 to house the Frederick C. Crawford Auto-Aviation Museum. This collection—one of the country's finest—now includes over 150 classic and antique automobiles, as well as four aircraft, assorted bicycles, motorcycles, and transportation memorabilia. A new library building, opened in 1984, includes 225,000 volumes, 180,000 prints and photographs, and 5 million manuscripts.

In addition to its University Circle museum, the Western Reserve Historical Society operates several historical sites in Northeastern Ohio: Lawnfield is the 30-room Victorian mansion of President James A. Garfield; Shandy Hall was home to the Harper family from 1815 to 1935 and is indicative of the changing character of family life in the Western Reserve; and Hale Farm and Village is a living history museum of life in rural Ohio in the mid–1800s.

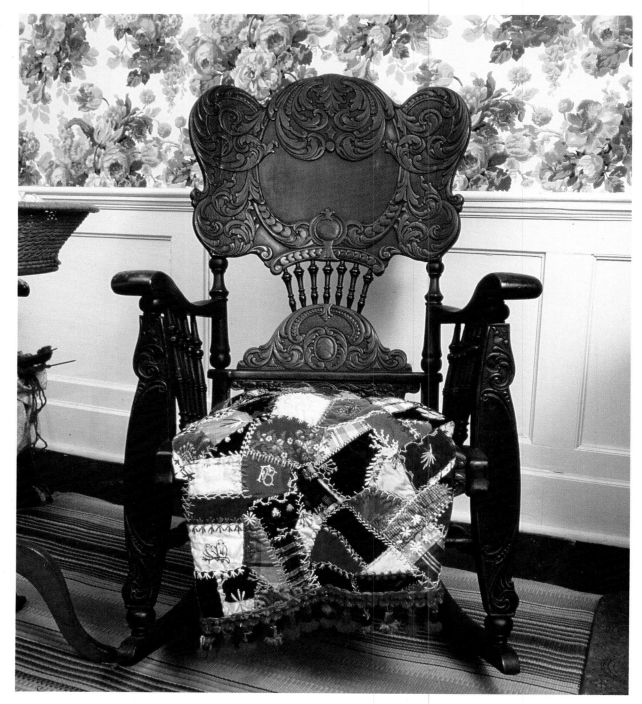

1 SEARS, ROEBUCK CO *Crest-back rocking chair*

2 PACQUA *Tobacco pouch*

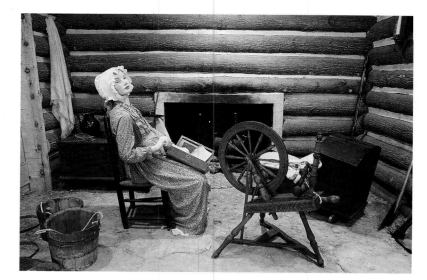

3 CABIN INTERIOR

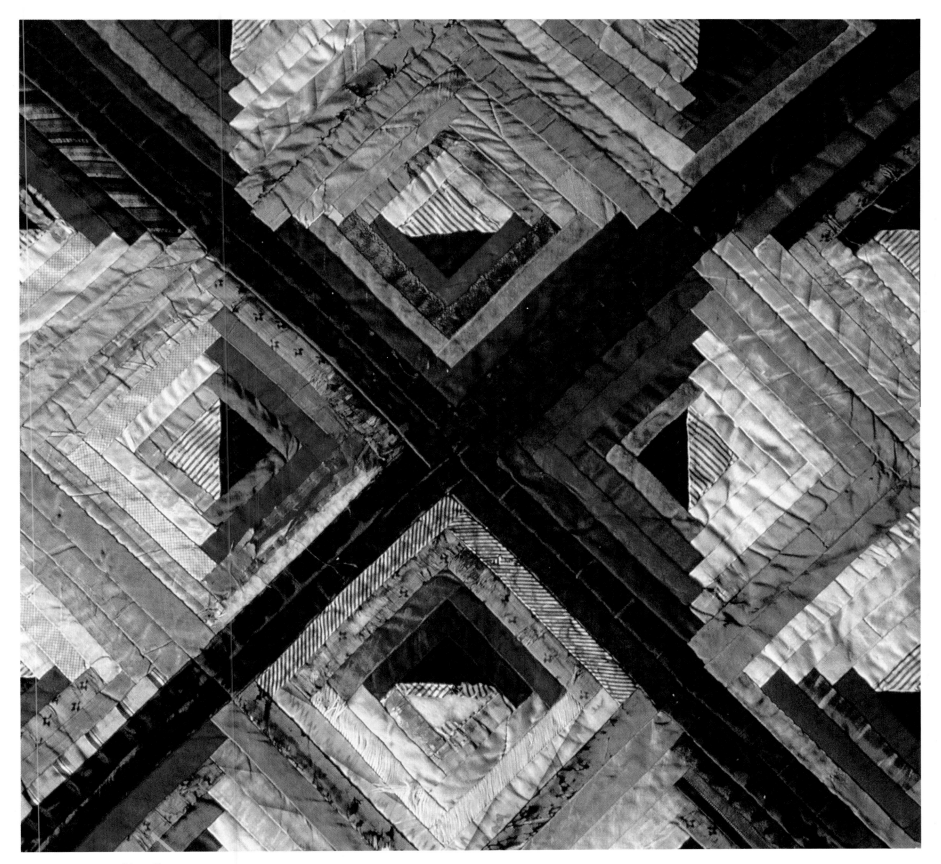

4 UNKNOWN *Log cabin quilt*

5 LOUIS COMFORT TIFFANY *Stained glass window*

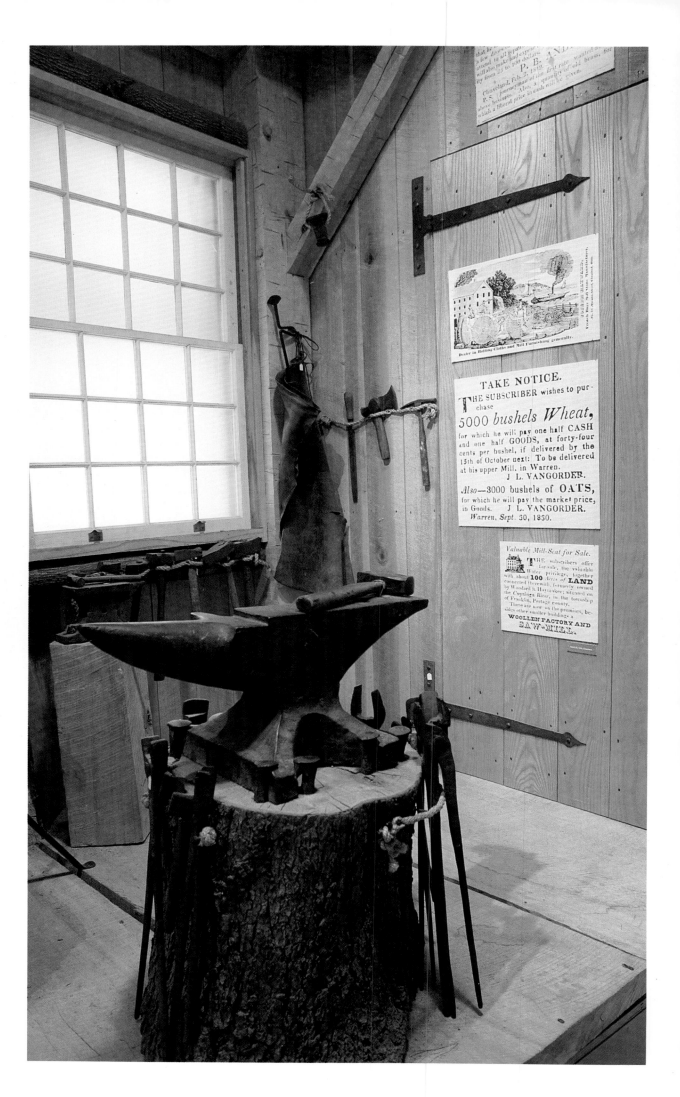

6 BLACKSMITH SHOP

7 FOX, NEW YORK–PARIS
Visiting Dress

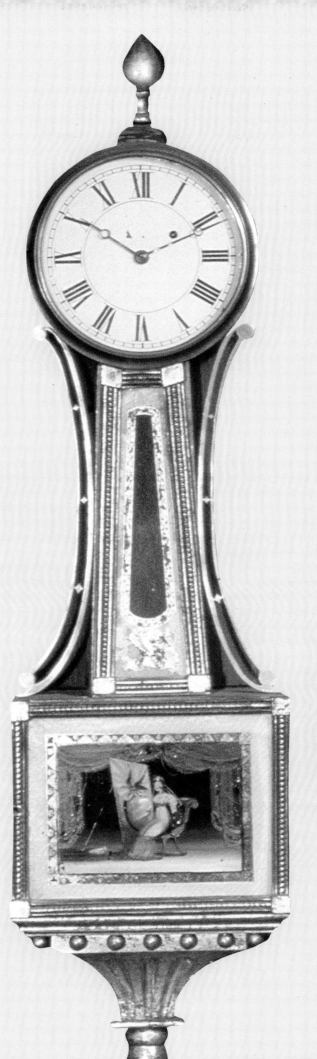

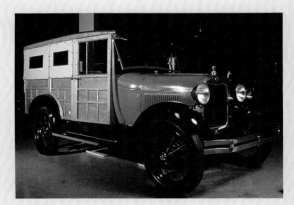

9 1929 FORD STATION WAGON

8 ATTRIBUTED TO LEMUEL CURTIS *Presentation banjo clock*

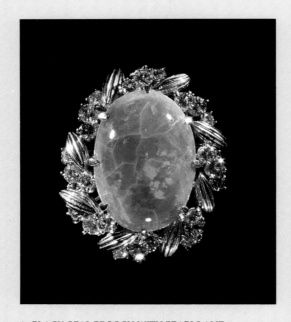

1 BLACK OPAL BROOCH WITH PEARLS AND
 DIAMONDS, PLATINUM SETTING

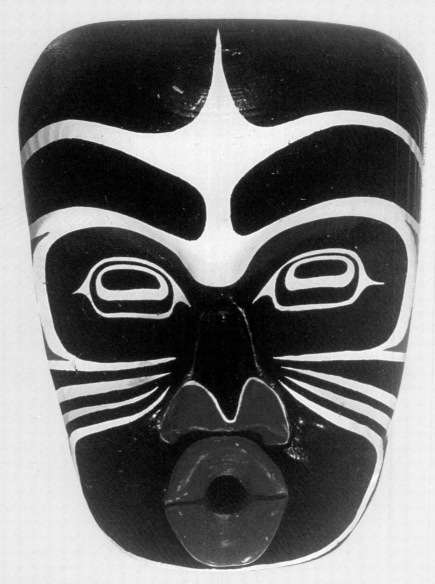

2 BRITISH COLUMBIA *"Dsonoqua" Mask*

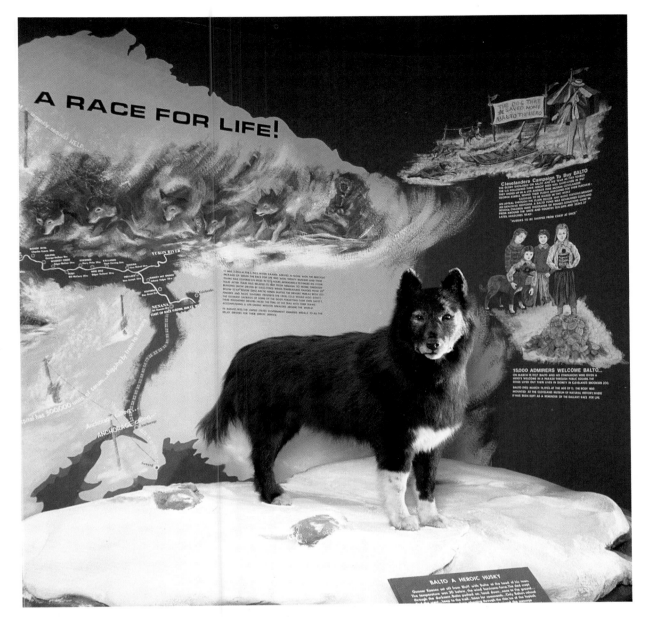

A RACE FOR LIFE!

3 THE *RACE FOR LIFE* EXHIBIT

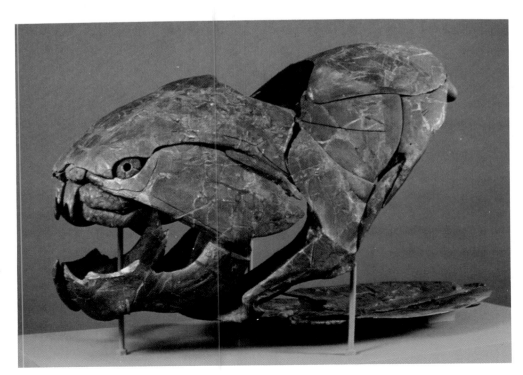

4 DUKLEOSTEUS

2 Canadian, 1959, Wood.

The Cleveland Museum of Natural History

CLEVELAND, OHIO

The Cleveland Museum of Natural History, Ohio's oldest and largest institution of its kind, was incorporated in 1920, but its roots stretch back to the 1830s when naturalists living in the area began meeting with each other.

The museum's present building in Cleveland's University Circle area, the city's cultural center, was dedicated in 1958. A 1972 addition and a new wing completed in 1989 have increased space to a total of 210,000 square feet.

The museum's collections, containing more than one million objects, present the natural sciences and humanity's relationship to the earth in a fascinating chronological display, starting with the beginning of time and extending to the ecological changes that are currently taking place.

The remains of Lucy, the oldest, most complete hominid, are on display at the museum, as is a notable collection of opals and colored diamonds, and North America's oldest known boat. In addition, there is an extensive exhibit devoted to the natural history of Ohio.

The museum, however, is best known for its dinosaurs. It is the only natural museum in Ohio to display dinosaur fossils. The renowned paleontological display includes the only skull of Nanotyrannus lancensis—the "pygmy tyrant"—on display anywhere in the world. Also featured are a 75-foot-long full reconstruction of Haplocanthosaurus delfsi, the oldest sauropod in North America; the oldest shark skeleton found anywhere in the world; and the fossil remains of Dunkleosteus terrelli, an ancient armored sea monster that swam in the inland waters located around Cleveland 360 million years ago.

The museum's focus is not entirely earthbound. It maintains the Ralph Mueller Planetarium and Observatory and conducts numerous astronomy programs for schools and the public. The observatory is equipped with a $10\frac{1}{2}$-inch telescope.

The Cincinnati Art Museum

CINCINNATI, OHIO

Nestled within the greenery of Eden Park on a cliff overlooking the city, the 70,000 square feet of gallery space in the Cincinnati Art Museum— one of the Midwest's oldest cultural institutions— offer a dynamic and distinguished collection spanning 5,000 years of art history.

Founded in 1881, the museum possesses impressive depth in a number of unexpected areas—like its collection of Gainsboroughs, one of the largest in the United States. There are also important holdings in American paintings, art pottery, and Native American art.

The museum's Near Eastern collection contains unique Nabataean sculpture as well as particularly rare Islamic ceramics and artwork from the 12th and 13th centuries. European paintings and sculptures include such masterpieces as Andrea Mantegna's *A Queen Disputing with a Philosopher* and Vincent van Gogh's *Undergrowth with Two Figures*. There are also extensive collections of prints and decorative arts.

Cincinnati's costume collection is one of the oldest in the nation, begun, like the museum's extraordinary African collection, in the late 19th century when few other museums were active in these areas.

The museum has had considerable success in the organization of important temporary exhibitions. In 1959 the Lehman Collection, now housed in its own wing at New York's Metropolitan Museum of Art, was presented for the first time in this country at the Cincinnati Art Museum.

A decade later, CAM organized the first laser art exhibition and more recently it presented unprecedented loan exhibitions from the Tower of London's arms and armor collection and from Munich's distinguished Alte Pinakothek.

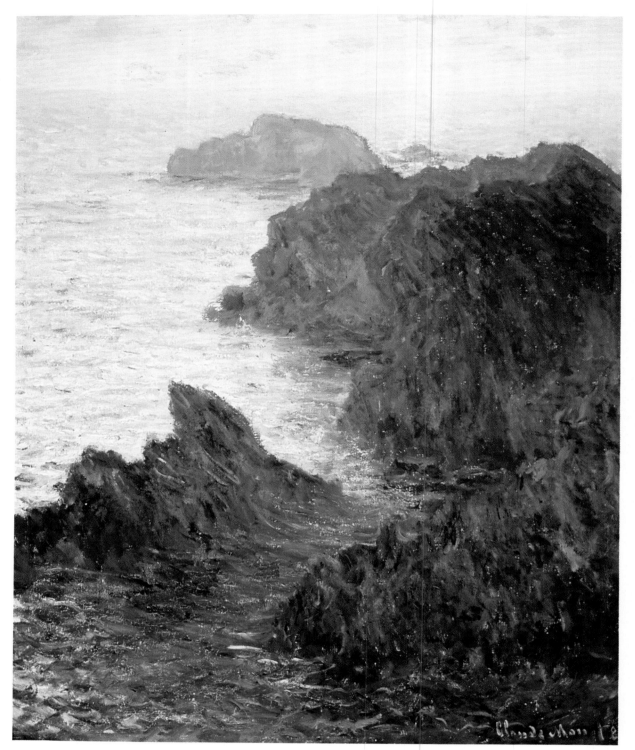

1 CLAUDE MONET *Point De Rochers A Port-Goulphar*

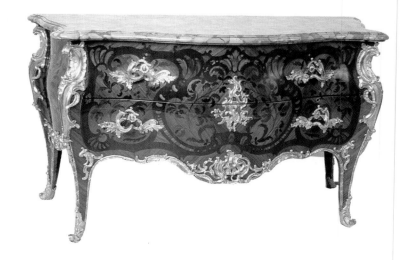

2 JEAN-PIERRE LATZ *Commode*

1 French, 1886, Oil on canvas.

2 French, c. 1745–1749, Marquetry of tulip wood and other woods on oak, marble top, bronze trim.

3 Italian, c. 1551, Oil on canvas.

4 Egypt, XIX Dynasty, Limestone.

5 Italian, 1920, Yellow silk, velvet.

6 Persian, 2nd half 16th century, Wool pile on cotton and silk foundation.

7 Turkish, Iznik ware, late 16th century, Earthenware.

8 American, 1985, Acrylic on canvas, silkscreen image.

(RIGHT)
3 BRONZINO *Eleanor of Toledo and Her Son Ferdinand*

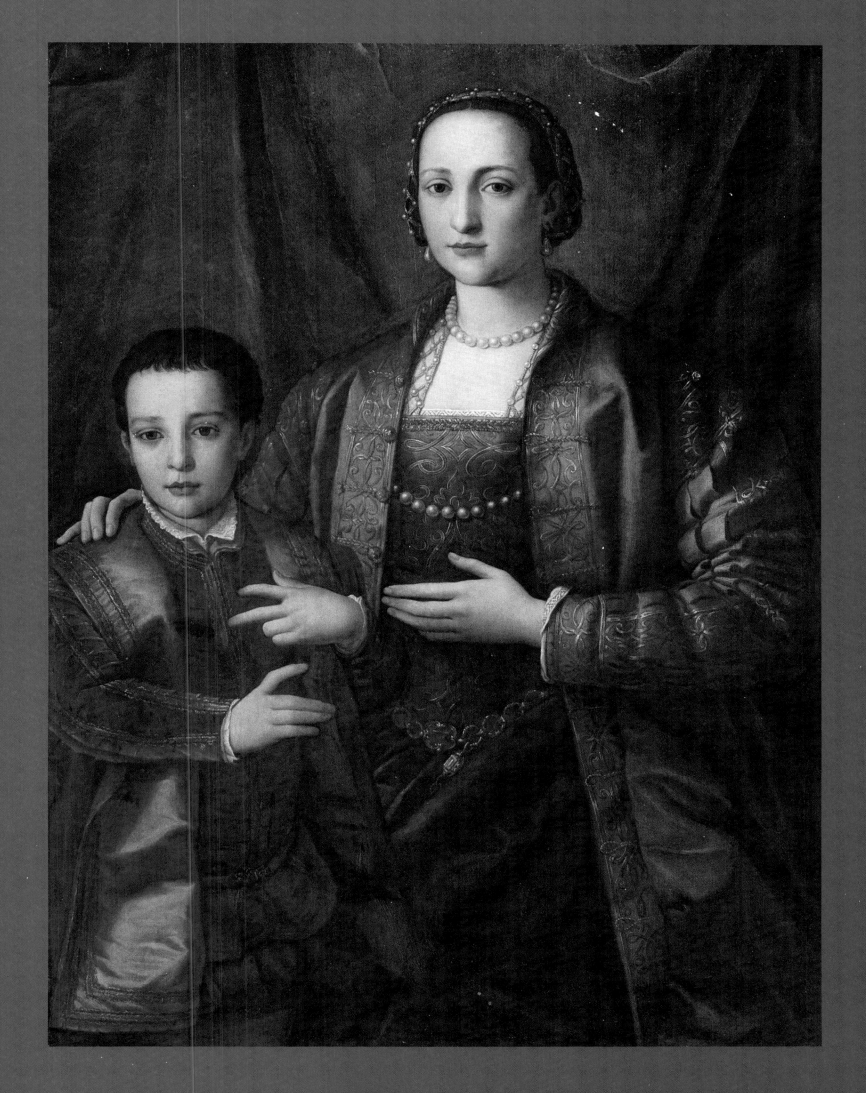

4 UNKNOWN *Relief of Seti*

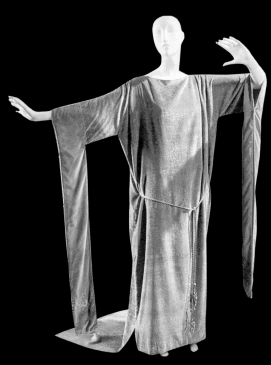

5 M. M. GALLENGA *Tea Gown*

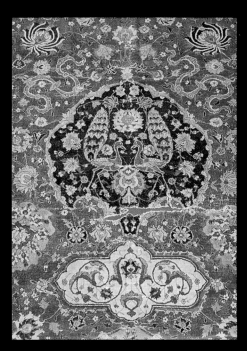

6 UNKNOWN *Fragment of a Heral Medallion Rug (detail)*

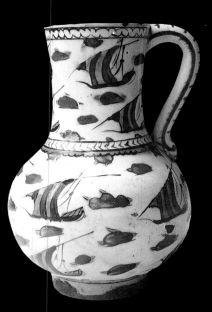

7 UNKNOWN *Pitcher*

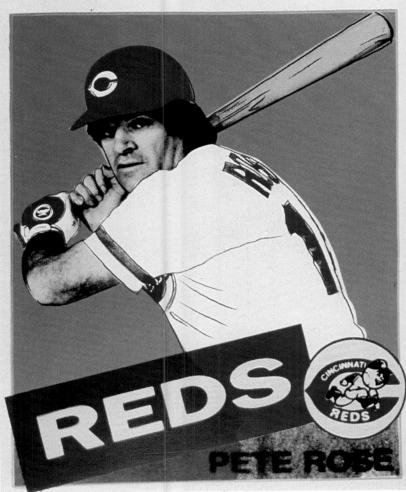

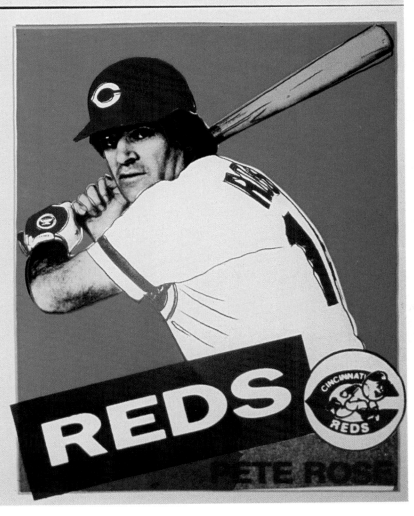

The Cincinnati Museum of Natural History

CINCINNATI, OHIO

The Cincinnati Museum of Natural History is one of the 15 largest natural history museums in the United States. With a history stretching back more than 150 years, it is also the oldest scientific institution in continuous operation west of the Alleghenies. John James Audubon, the famous naturalist and painter of birds, was the first salaried employee of the museum's predecessor, the Western Museum Society.

In 1990 the museum moved to the new Museum Center at Cincinnati's historic 500,000-square-foot Union Terminal, which also houses the Cincinnati Historical Society Museum and the Robert D. Lindner Family OMNIMAX Theatre, where the wonders of the natural world are projected in eye-opening clarity on a 260-degree domed screen—the only one of its kind in Ohio.

The museum features exhibits that explore the world and the geological history of Ohio. Of particular note are the Children's Discovery Center, a hands-on area where youngsters can learn about the environment and the workings of the human body; "Dinamation: Return of the Giants," the country's largest display of robotic dinosaurs; "Cincinnati: The Pleistocene Legacy," a step back 19,000 years into the Ohio Valley of the Ice Age; "The Cavern," a simulated Kentucky limestone cave complete with a live bat colony; and "Treasures of the Tar Pits," focusing on the famous La Brea tar pits in Los Angeles that became the final resting place of a number of species.

The building that the museum previously occupied has been renovated into a state-of-the-art facility now used for research activities and to house a multimillion-item study collection.

1 NEW GUINEA *Roof finial*

2 ROBOTIC DINOSAUR

3 ROBOTIC DINOSAUR

4 NATIVE AMERICAN *Puma Shell Gorget*

1 Charles and Dorette Fleischmann Collection.
4 Late Woodland period, 10th century.
5 Charles and Dorette Fleischmann Collection.

5 NEW GUINEA *Lug from Slit Gong Drum*

1 NINO PISANO *Madonna and Child*

2 PIETER BRUEGEL THE ELDER
The Wedding Dance

The Detroit Institute of Arts

DETROIT, MICHIGAN

Situated on park-like grounds in Detroit's Cultural Center, the 600,000-square-foot Detroit Institute of Arts is the largest municipally owned museum in the United States. The DIA—as it is called—was founded in 1884, and its collection of some 55,000 works is one of the country's most comprehensive.

The collection is divided into eight major departments: Ancient Art (one of the few U.S. collections with master-pieces from virtually every Mediterranean, Near Eastern, and Islamic culture); Asian Art; African, Oceanic, and New World Cultures; Graphic Arts; American Art (a renowned collection that includes such masterpieces as *Cotopaxi* by Frederic Church, James Whistler's *Nocturne in Black and Gold: The Falling Rocket*, and *Promenade* by Maurice Prendergast); European Painting (including *The Visitation* by Rembrandt and one of Vincent van Gogh's stunning self-portraits); European Sculpture and Decorative Arts; and 20th Century Art (one of the nation's largest public collections).

One of the museum's particular strengths is its wealth of Dutch and Flemish paintings, which includes such world renowned works as *The Wedding Dance* by Pieter Bruegel the Elder and *Saint Jerome in His Study* by Jan van Eyck. The museum also has one of the leading U.S. collections of German Expressionist paintings and the third-largest holdings of Italian Renaissance works outside of Europe. North America's most important fresco is perhaps the DIA's *Detroit Industry* by Diego Rivera, which covers the walls of the museum's central courtyard.

The DIA's Performing Arts Department, which supervises the largest array of historical puppets in the United States, is also the home of the Detroit Youtheatre, the country's largest center of professional entertainment for young people.

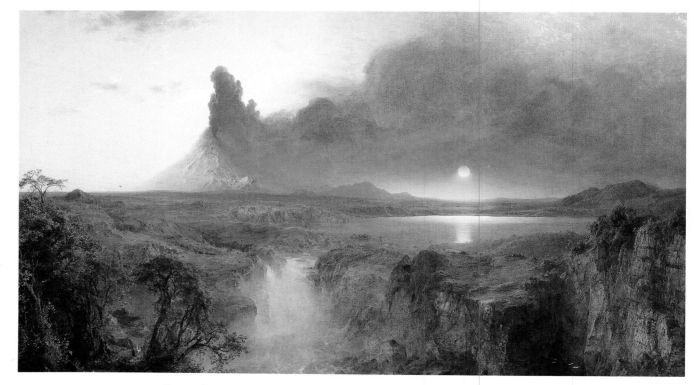

4 FREDERIC EDWIN CHURCH *Cotopaxi*

3 EMIL HANSEN NOLDE
Portrait of the Artist and His Wife

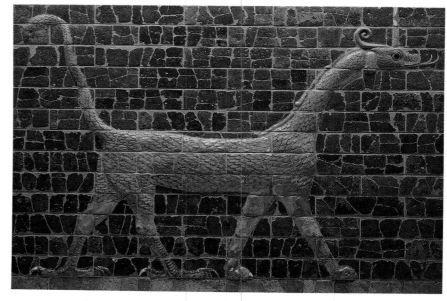

6 UNKNOWN *Ishtar Gate, Dragon of Marduk*

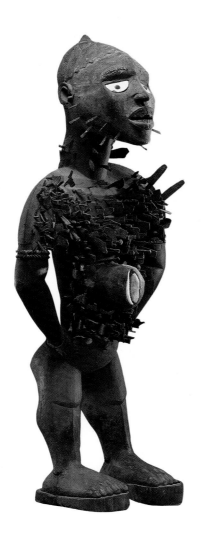

5 WESTERN KONGO *Nail figure*

1 Italian, 1250/1260, Marble with traces of poly-chromy and gilt, Gift of Mr. and Mrs. Edsel B. Ford, 27.150.

2 Flemish, c. 1566, Oil on panel. City of Detroit Purchase, 30.374.

3 German, c. 1932, Watercolor. Bequest of Robert H. Tannahill, 70.323.

4 American, 1862, Oil on canvas, Founders Society Purchase with funds from Mr. and Mrs. Richard A. Manoogian, Robert H. Tannahill Foundation Fund, Gibbs-Williams Fund, Dexter M. Ferry, Jr. Fund, Merrill Fund and Beatrice W. Rogers Fund.

5 African, 1875–1900, Wood, screws, nails, blades, cowrie shells, and other material.

6 Neo-Babylonian, c. 604–562 B.C., Terracotta. Founders Society Purchase, 31.25.

7 Chinese, 13th century, Ink and colors on paper, Founders Society Purchase, General Membership and Donations Fund, 29.1.

8 German, 1919, Oil on canvas Gift of Curt Valentin in memory of the artist on the occasion of Dr. Valentine's 60th birthday, 40.58

7 QIAN XUAN *Early Autumn*

8 ERNST LUDWIG KIRCHNER *Winter Landscape in Moonlight*

1 THE *AUTOMOBILE IN AMERICAN LIFE EXHIBIT*

2 THOMAS EDISON'S MENLO PARK LABORATORY

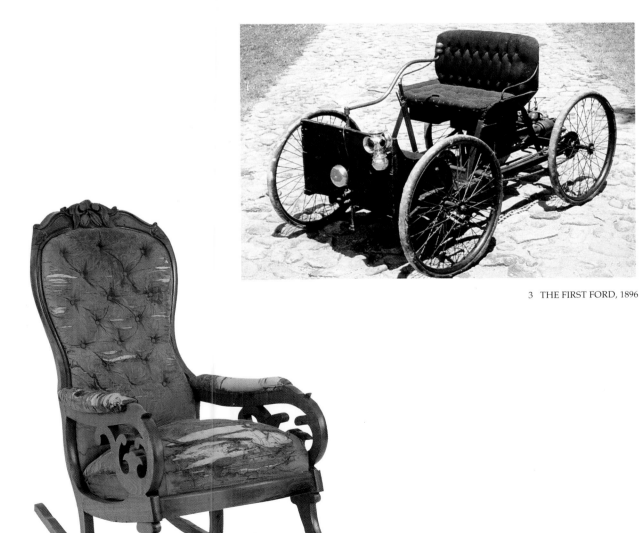

3 THE FIRST FORD, 1896

4 THE CHAIR IN WHICH LINCOLN WAS ASSASSINATED

Henry Ford Museum & Greenfield Village

DEARBORN, MICHIGAN

Henry Ford Museum & Greenfield Village is an unsurpassed repository of the technological changes that transformed America from an agrarian society to an urban industrialized nation over the past 300 years. Founded by Henry Ford in 1929, it is one of the largest museum complexes in the country, stretching over 93 indoor and outdoor acres.

The indoor museum is divided into seven areas. In the transportation section, the focus is on the "Automobile In American Life," a multimedia presentation that features a world-renowned auto collection and such roadside landmarks as a complete 1940's Texaco service station and a 1946 diner. "Communications" includes exhibits from telegraph to television, as well as the world's most extensive collection of printing machinery.

There is a staggering display of farm tools and machinery in "Agriculture"; a colossal accumulation of machinery in "Industry" (including the largest existing collection of steam engines); household furnishings from 1600 to modern times in "Domestic Life"; music boxes, phonographs, radios, and television sets in "Leisure and Entertainment"; and an "Activities Center" where the past comes alive through demonstrations and interactive exhibits.

Henry Ford acquired some 80 structures—including several of major historical significance—and relocated them to create Greenfield Village. Included are Thomas Edison's Menlo Park laboratory, the bicycle shop where the Wright brothers designed and built their first airplane, and the house where Noah Webster wrote his dictionary.

Altogether the collections here total more than one million artifacts, plus another 25 million books, prints, photographs, and manuscripts. Not surprisingly, Henry Ford Museum & Greenfield Village has become the most visited indoor/outdoor museum complex in North America.

Indianapolis Museum of Art

INDIANAPOLIS, INDIANA

The Indianapolis Museum of Art is one of the oldest museums in the country. Although it has been in existence since 1883, it has only been at its present location since 1970 and only known by its present name since 1969.

Today the museum's collection occupies four of the institution's five pavilions within a 152-acre botanical garden. The fifth pavilion houses one of the oldest civic theaters in the United States.

The four-story Mary Fendrich Hulman Pavilion designed by famed architect Edward Larrabee Barnes was completed in 1990, expanding the museum's exhibition space by 80 percent. It houses the 1,400-piece Eiteljorg Collection of African Art, considered to be one of the most comprehensive collections of its kind in the nation, as well as gallery space for special exhibitions and the museum's fine Italian, Dutch Baroque, Impressionist, and Post-Impressionist works.

The 227,410-square-foot Krannert Pavilion, completed in 1970 and renovated in 1989, features Asian, ethnographic, and classical art, as well as 18th-through 20th-century European and American paintings and sculpture.

The Clowes Pavilion, featuring a two-storied atrium courtyard surrounded on three sides and on both levels by cloisters, houses important old master paintings including works by Caravaggio, Peter Paul Rubens, and Rembrandt. The pavilion's J. M. W. Turner Collection is one of the largest and most comprehensive collections of the artist's paintings and watercolors in the world.

The Lilly Pavilion of Decorative Arts maintains the elegance of an 18th-century French home and showcases two centuries of English, continental, and American furniture, silver, and ceramics.

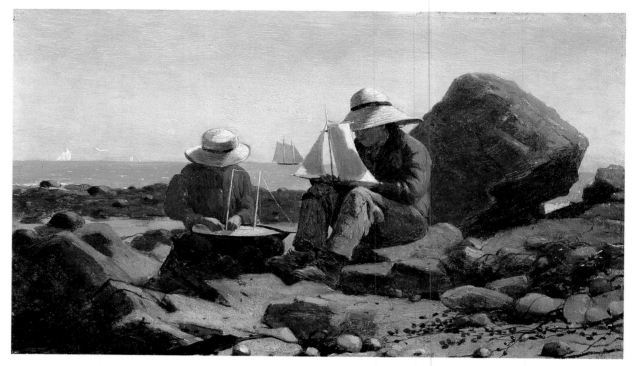

1 WINSLOW HOMER *The Boat Builders*

2 GEORGIA O'KEEFFE
Pelvis with the Distance

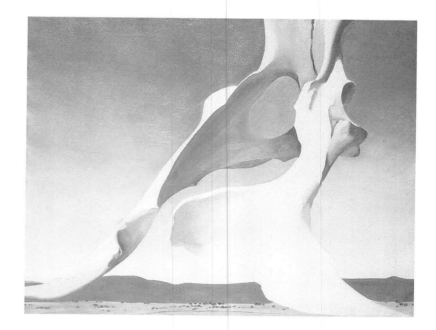

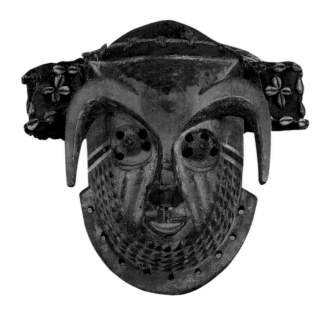

1 American, 1873, Oil on panel, Martha Delzell Memorial Fund, 54.10.

2 American, 1943, Oil on canvas, gift of Anne Marmon Greenleaf in memory of Caroline Marmon Fesler, 77.229.

3 Central African (Zaire), Early 20th century, Wood, pigment, cloth, fiber, cowrie shells, Gift of Harrison Eiteljorg.

4 Greek, c 1610–1614, Oil on canvas, The Clowes Fund Collection.

5 Dutch, 1889, Oil on canvas, Gift of Mrs. James W. Fesler in memory of Daniel W. and Elizabeth C. Marmon, 44.74.

6 Indonesian, 19th century, Cotton plain weave embroidered with shells and beads, Eliza M. and Sarah L. Niblack Collection, 33.682.

7 Tang dynasty, 8th century, Glazed earthenware, Gift of Mr. and Mrs. Eli Lilly, 60.75.

8 Flemish, c. 1622, Oil on panel, The Clowes Fund Collection.

140

3 KUBA *Face Mask*

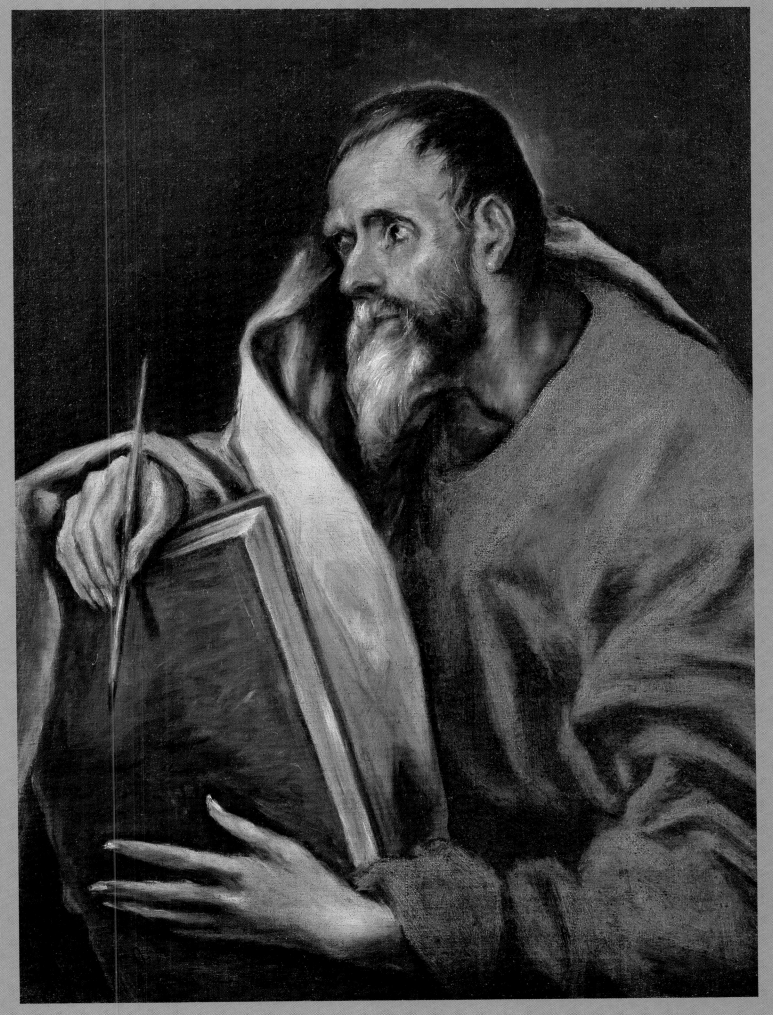

4 EL GRECO *St. Luke*

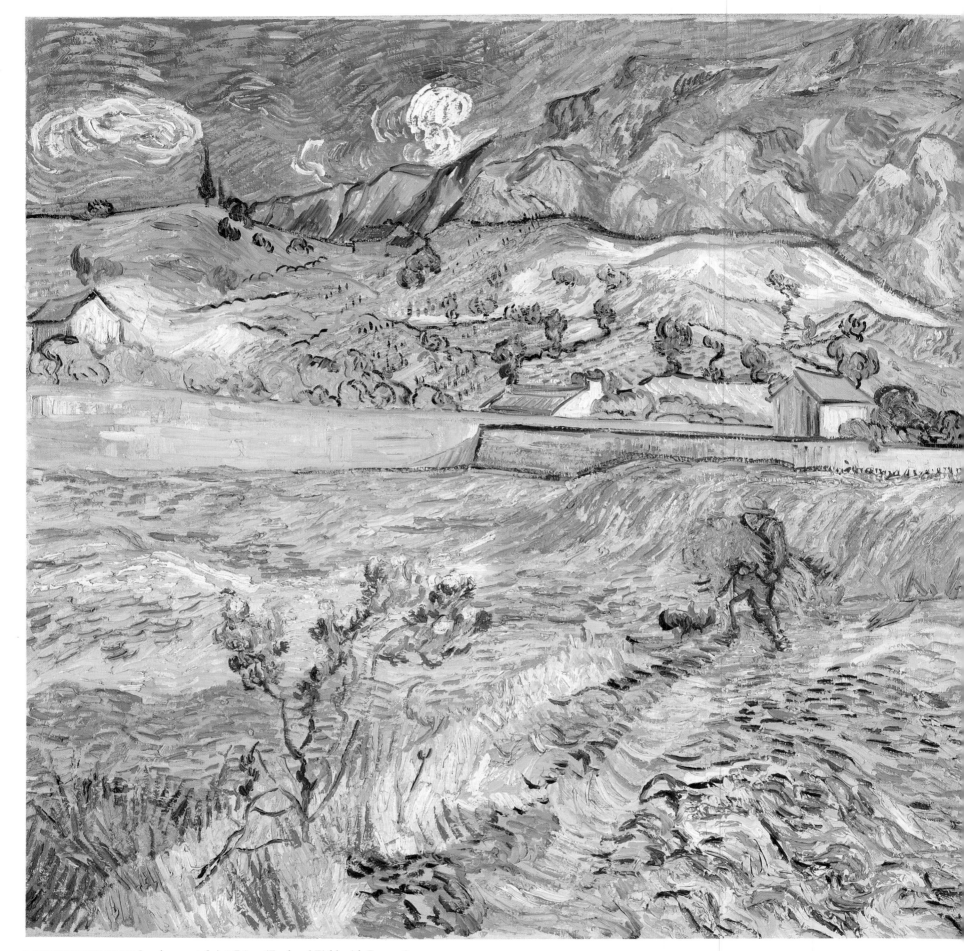

5 VINCENT VAN GOGH *Landscape at Saint-Rémy (Enclosed Field with Peasant)*

6 SUMBA *Woman's Wrapper*

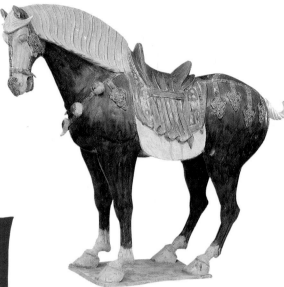

7 UNKNOWN *Horse*

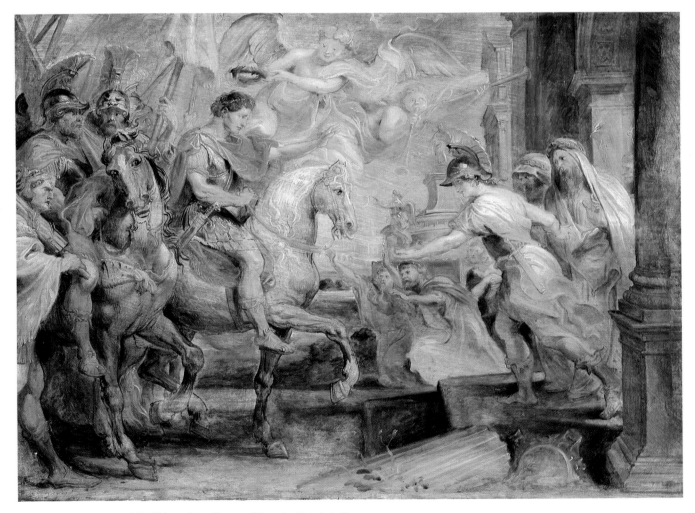

8 PETER PAUL RUBENS *The Triumphant Entry of Constantine into Rome*

143

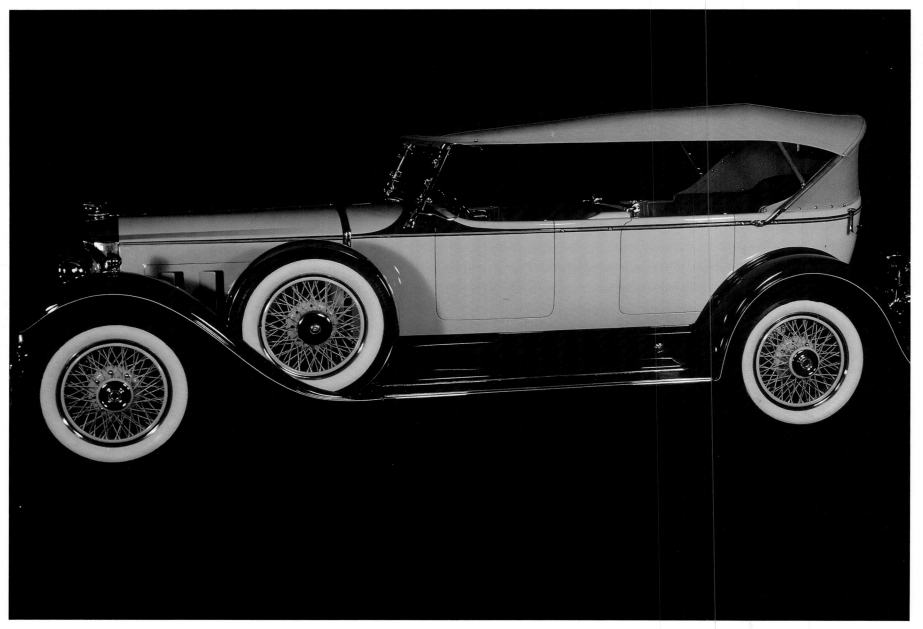

1 ROSCOE TURNER'S PACKARD, 1930S

2 FLOYD DAVIS AND MAURI ROSE'S NOC-OUT HOSE
 CLAMP SPECIAL

3 BELOND EXHAUST SPECIAL

2 1941 Indy winner
3 1957 Indy winner.
4 1963 Indy winner.
5 1977 Indy winner.
6 1950 Indy winner.
All photos courtesy of Ron McQueeney.

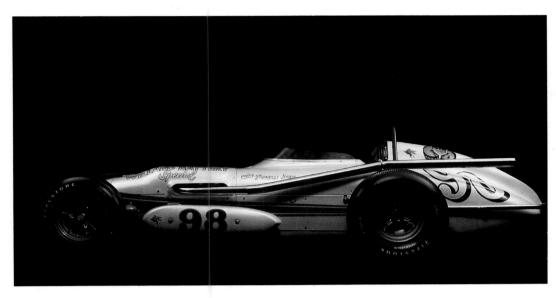

4 PARNELLI JONES' AGAJANIAN WILLARD BATTERY SPECIAL

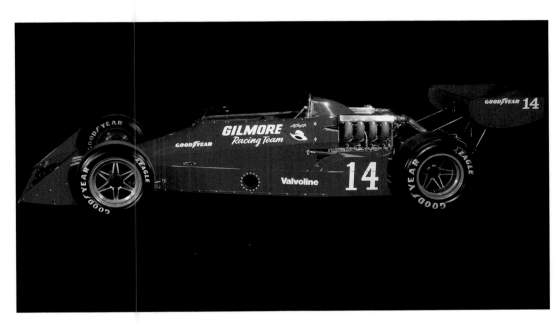

5 A.J. FOYT'S GILMORE RACING SPECIAL

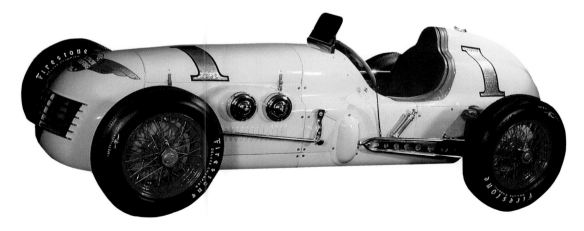

6 JOHNNY PARSONS' THE WYNNS FRICTION PROVING SPECIAL

The Indianapolis Motor Speedway Hall of Fame Museum

INDIANAPOLIS, INDIANA

Each Memorial Day America's passion for automobiles reaches its peak as 33 turbo-charged racers explode onto the track at the Indianapolis Motor Speedway for the Indianapolis 500. The Speedway Hall of Fame Museum, established in 1956, preserves the heritage of this great event.

Since 1976 the museum has occupied a 96,000-square-foot, light-filled modern building within the confines of the Speedway Oval. It features trophies (including some designed by Tiffany as well as Rudolf Caracciola's entire 175-piece collection); paintings by artists like Robert Peak, Peter Helck, James Dietz, and Leroy Neiman; an audio-visual presentation on the history of motor racing; and even a display of helmets dating back to 1911. But it is the cars that people come to see—a rotating collection of over 200 vehicles that capture the excitement, the style, and the spirit of the Indianapolis 500.

More than 30 winning Indy Cars—sleek aerodynamic wonders averaging 2½ miles to the gallon and capable of speeds in excess of 200 mph—are on display here, representing 36 victories. Even the names sound fast: Ray Harroun's 1911 Marmon Wasp, the Boyle Maserati (Wilbur Shaw 1939–1940), the Blue Crown Spark Plug Special (Mauri Rose 1947–1948), A. J. Foyt's 1977 Coyote, and the 1922 Duesenberg #12 Murphy Special, the only car ever to win both the Indianapolis 500 and the French Grand Prix.

Also included in the museum's collection are a number of antique and classic passenger cars, many of which were built in Indiana at the turn of the century, as well as one-of-a-kind vehicles like the 1957 Corvette SS prototype, which was instrumental in the development of the present day Corvette and was the centerpiece of the 1987 Monterey Historic Automobile Races.

The Milwaukee Public Museum

Founded in 1882, the Milwaukee Public Museum has always been an innovative leader. It was here in 1890 that Carl Akeley, known as the father of modern taxidermy, created the world's first diorama, a lifelike display of animals in their natural habitat. The world's first museum outreach program was pioneered here in 1888 and the country's first instructional program using live animals took place here in 1903. The museum, with its present 348,000 square feet of space, is still recognized as an international leader in institutional exhibit design.

In the museum's popular "Streets of Old Milwaukee," visitors step back 100 years into a world of old-fashioned stores and cobblestone streets. There is a "European Village" featuring detailed reconstructions of houses from 33 different cultures, as well as a life-size display of dinosaurs and a spectacular two-story tropical rain forest.

Among the museum's more than 4.3 million specimens is the world's largest dinosaur skull, a Torosaurus specimen measuring nine feet long and eight feet across; one of the world's finest collections of contemporary American Indian costumes; a significant pre-Columbian collection of miniature figures from Mexico; the most outstanding collection of East African artifacts in the U.S.; and the largest collection of typewriters in the world.

Well-known for its research activities, the museum is the leader in the use of nondestructive techniques to study mummies, including X-rays and CAT scans, and is currently conducting a dinosaur census that may provide information on why these giant reptiles became extinct.

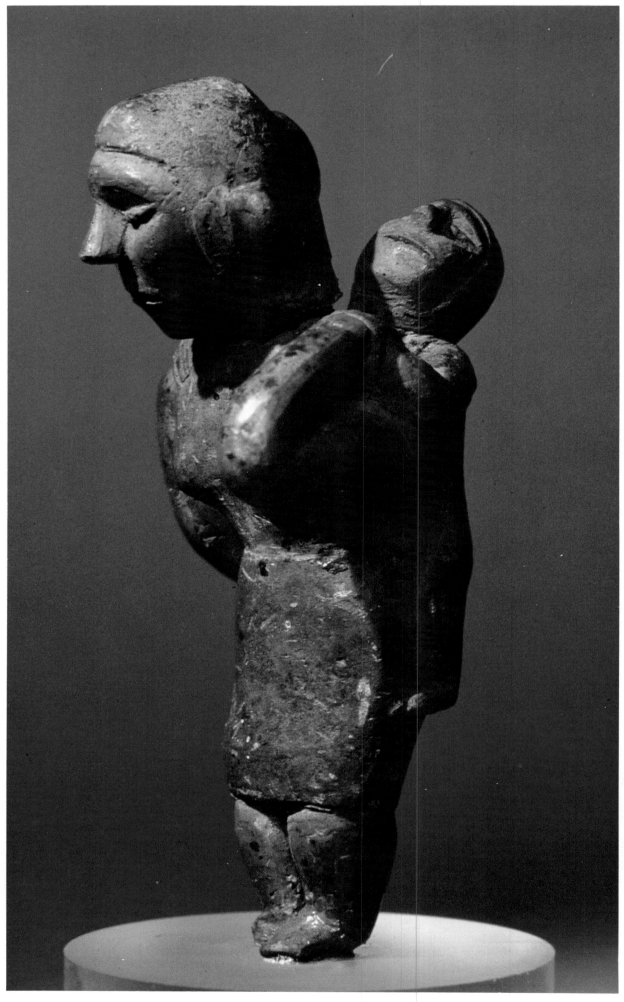

1 HOPEWELL CULTURE *Mother and child*

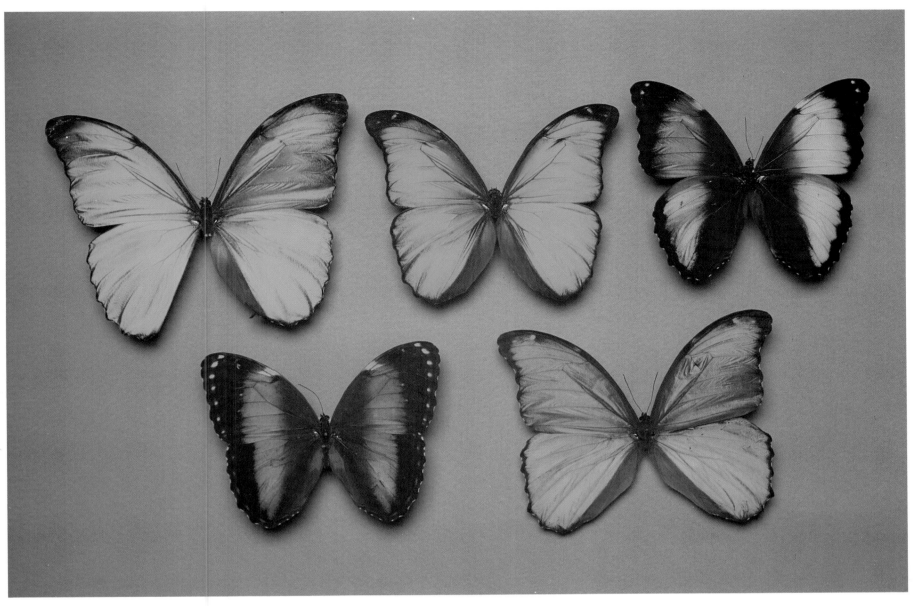

2 BUTTERFLIES OF THE GENUS *MORPHO*

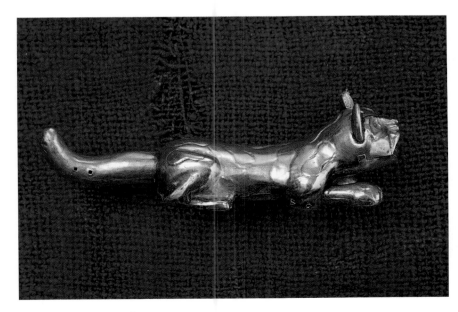

3 MOCHICA CULTURE *Jaguar*

4 UNKNOWN *Stein*

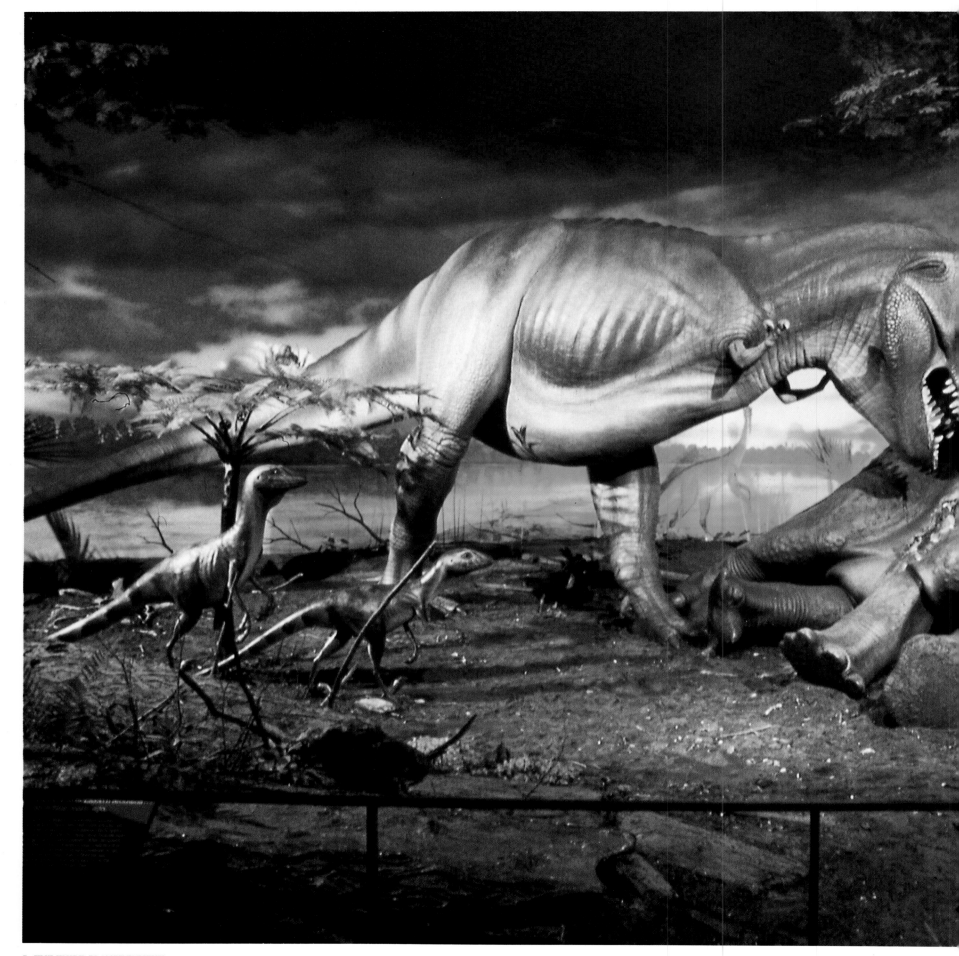

5 THE *THIRD PLANET* EXHIBIT

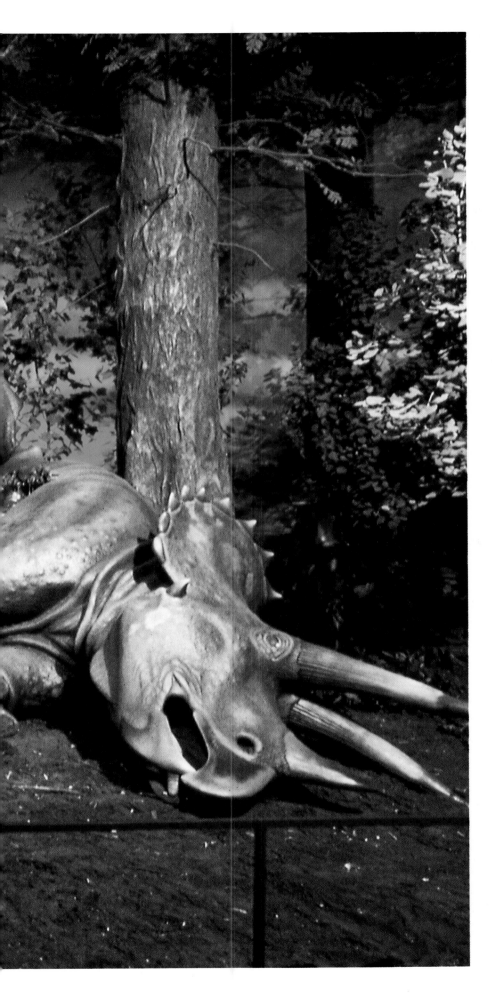

6 TERRITORIAL HOWLER MONKEY

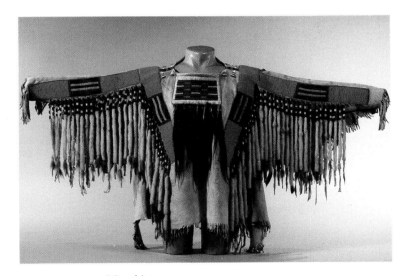

7 CROW INDIAN *War shirt*

1 Native American, 150–400 A.D., Fired clay.
3 Peru, 400–100 B.C., Gold (hollow sheet).
4 Italian, late 19th century, Pottery.
7 Native American, c. 1900, Buckskin, beads, ermine tails, hair.

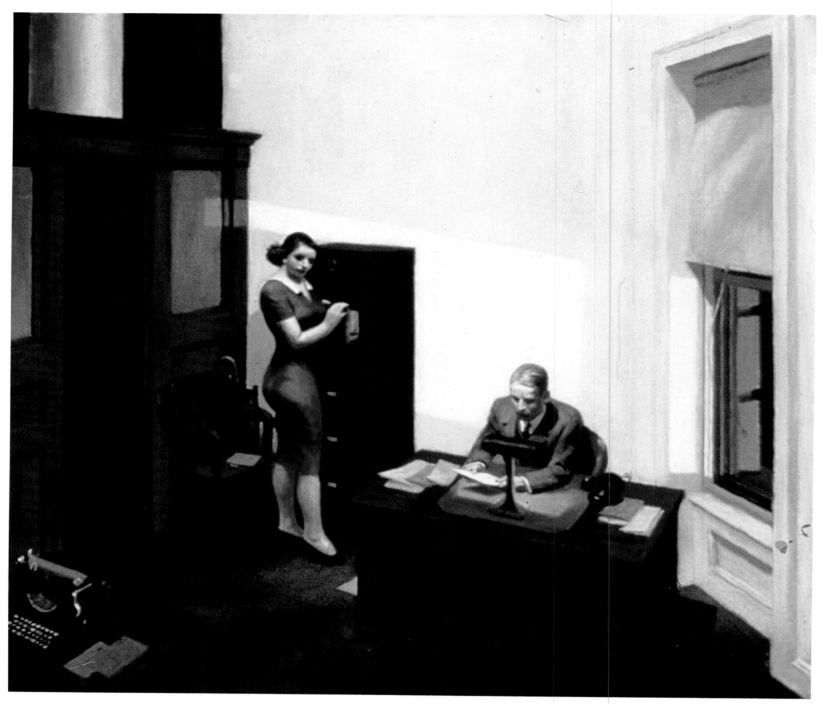

1 EDWARD HOPPER *Office at Night*

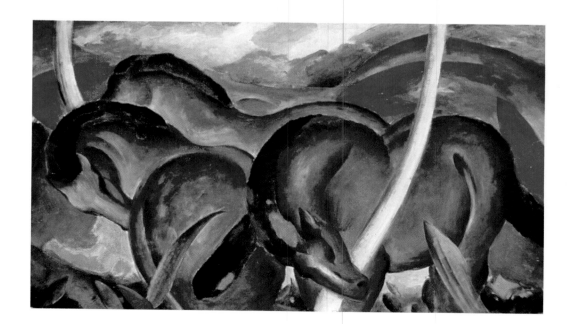

2 FRANZ MARC *The Large Blue Horses*

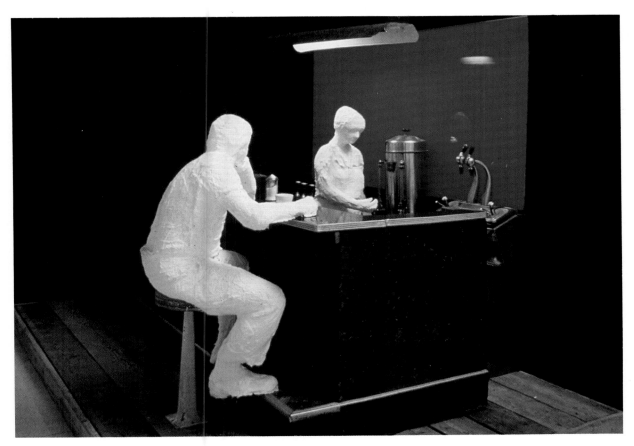

3 GEORGE SEGAL *The Diner*

1 American, 1940, Oil on canvas.
2 German, 1911, Oil on canvas.
3 American, 1964–1966, Plaster, wood, formica.
4 American, 1946, Oil on canvas.

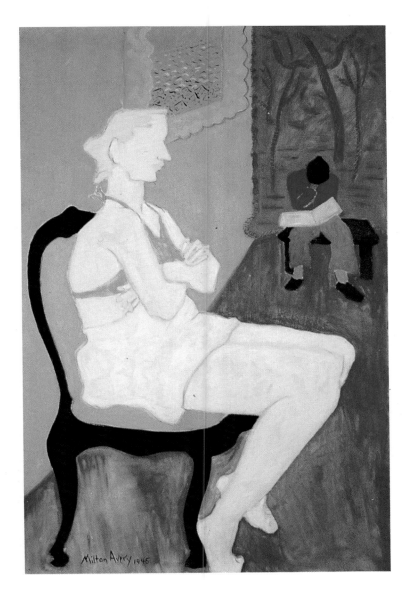

4 MILTON AVERY *Seated Blonde*

Walker Art Center

MINNEAPOLIS, MINNESOTA

The Walker Art Center, founded in 1879 by lumber baron Thomas Barlow Walker, is not large. The museum's 1971 building, even after a 1984 expansion, features just 30,000 square feet of exhibition space, and its permanent holdings of almost 6,000 pieces are dwarfed by many larger collections.

Still, the *New York Times* has called the Walker "one of the finest museums for the display of modern art in the nation," and indeed, when it comes to 20th-century American and European art — particularly Abstract Expressionism, Pop art, Social Realism, Modernism, Minimalism, New Image painting, and recent neo-Expressionism — the museum seems far larger than the sum of its parts.

Alexander Calder, Jim Dine, Mark Rothko, David Hockney, and Andy Warhol are all strongly represented in the permanent collection, as is the cartoon art of Roy Lichtenstein. The Walker also has more than 300 Jasper Johns prints, making it the only museum containing the complete range of Johns' graphic imagery.

More than one million visitors have enjoyed the Minneapolis Sculpture Garden since its opening in September 1988 adjacent to the Walker. The 38 pieces in this 7 1/2-acre park represent every style from the archetypal organic abstraction of Henry Moore's *Reclining Mother and Child* to the social realism of George Segal's *Walking Man*. Claes Oldenburg and Coosje van Bruggen's spectacular *Spoonbridge and Cherry*—a gigantic gray spoon with a cherry in its bowl spanning a free form pond — is the garden's focal point and is quickly becoming a new symbol for the Twin Cities.

The Minneapolis Institute of Arts

MINNEAPOLIS, MINNESOTA

The Minneapolis Institute of Arts was founded in 1915 in a neoclassical building designed by McKim, Mead, and White. Today, additions by the Japanese architect Kenzo Tange enable the institute to display major portions of its more than 80,000 items spanning the entire history of world art.

The institute's painting collection includes such notable canvasses as Rembrandt's *Lucretia*, Nicolas Poussin's *The Death of Germanicus*, and Rene Magritte's *Les Promenades d'Euclide*, as well as major works by Francisco Goya, Pierre Bonnard, Vincent van Gogh, and Edgar Degas, among others. Sculpture ranges from masterpieces of the ancient Egyptian, Greek, and Roman eras (including the marble sculpture *Doryphoros* by Polykleitos, widely regarded as the greatest example of Hellenistic sculpture in America) to modern masterpieces by Constantin Brancusi, Alexander Calder, Pablo Picasso, Henri Matisse, and Henry Moore.

The Minneapolis Institute of Art also has fine collections of Asian, African, Oceanic, and Native American arts; one of the nation's largest collections of prints and drawings; an important textile collection; an impressive selection of French decorative arts; one of the first museum photography collections in the country; and important English and American silver including the 1793 Templeman Tea Service by Paul Revere. With its classical column motif symbolizing the philosophic foundations of the new nation, the Templeman Service is one of the silversmith-patriot's finest works and one of the few matched silver tea sets that have survived intact from the period.

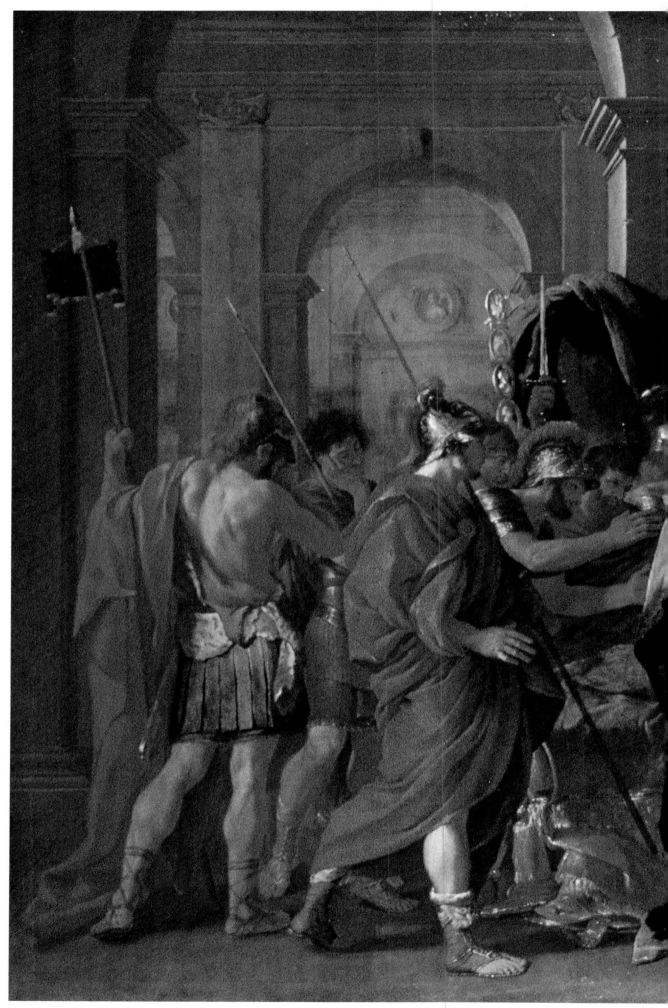

1 NICOLAS POUSSIN *The Death of Germanicus*

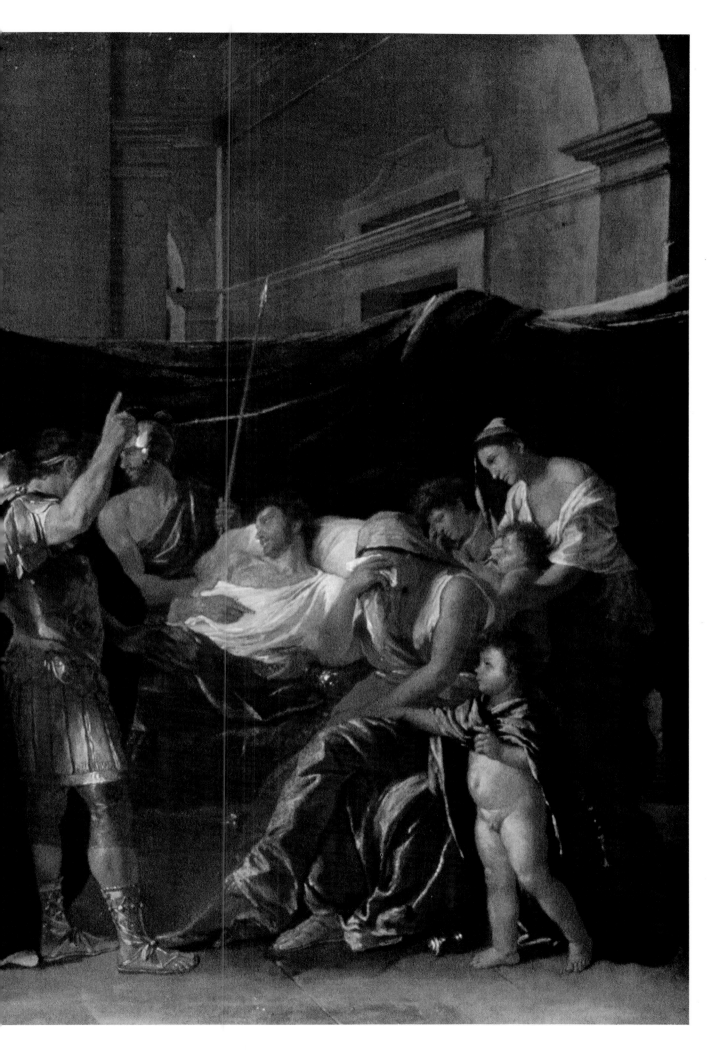

2 UNKNOWN *Doryphoros*

1 French, 1627, Oil on canvas, William Hood Dunwoody Fund.

2 Roman after a 5th century B.C. Greek original, 120–50 B.C., Marble, The John R. Van Derlip Fund and gift of Bruce B. Dayton, an anonymous donor, Mr. and Mrs. Kenneth Dayton, Mr. and Mrs. W. John Driscoll, Mr. and Mrs. Alfred Harrison, Mr. and Mrs. John Andrus, Mr. and Mrs. Judson Dayton, Mr. and Mrs. Stephen Keating, Mr. and Mrs. Pierce McNally, Mr. and Mrs. Donald Dayton, Mr. and Mrs. Wayne MacFarlane and others.

3 American, 1988, Mixed media on paper. Gift of Ruth and Bruce Dayton, Cargill and Donna MacMillan, and the John R. Van Derlip Fund, 1990.

4 American, 1948, Gelatin silver print, William Hood Dunwoody Fund and gift of funds from Mr. and Mrs. Judson Dayton.

5 Papua, New Guinea, 19th century, Wood and pigments, Gift of Regis Corporation.

6 German, 1945, Oil on canvas, Gift of Mr. and Mrs. Donald Winston.

7 Spanish, 1820, Oil on canvas, Ethel Morrison Van Derlip Fund.

8 Chinese, n.d. Bronze, Bequest of Alfred F. Pillsbury.

3 JIM DINE *San Marco with Meissen Figure and the Buddha*

5 NEW IRELAND
*Standing Figure with
Panpipes*

4 FREDERICK SOMMER *Livia*

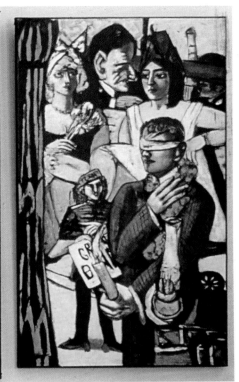

6 MAX BECKMANN *Blindman's Buff: Triptych*

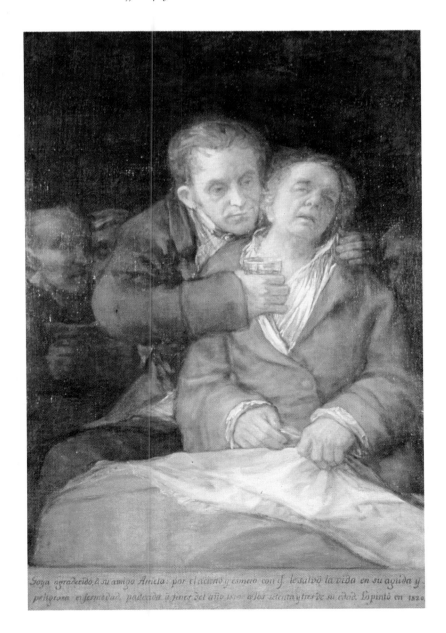

8 YIN OR E. CHOU
Wine vessel in owl shape

7 FRANCISCO GOYA *Self-Portrait with Dr. Arrieta*

1 UNKNOWN *Mask*

2 UNKNOWN *Masks*

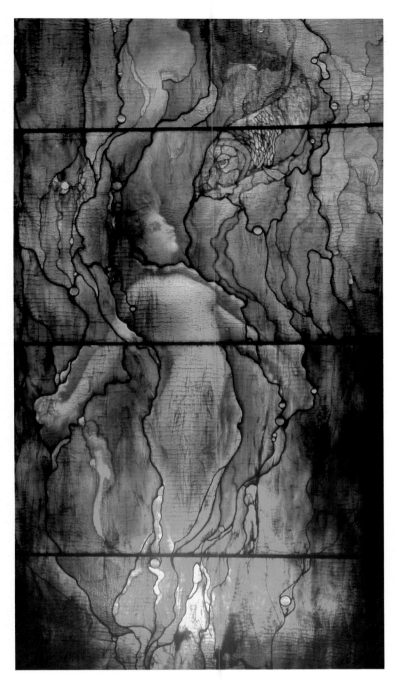

3 LOUIS COMFORT TIFFANY *Window*

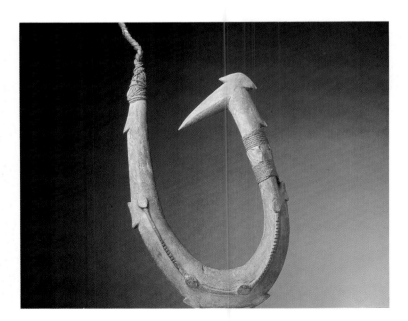

4 UNKNOWN *Ceremonial fish hook*

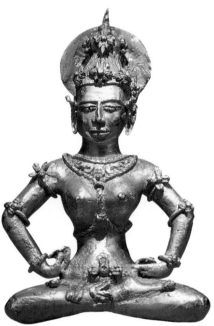

5 UNKOWN *Agusan figure*

1 Egyptian, 332–30 B.C, Wood and carton-
nage with gilded face, Neg. # 110661c, Photo-
graph by Ron Testa.

2 Melanesian, ca. 1911, (left to right) Coconut
fiber, gummy pitch; hollowed out tree fern,
coconut fiber, gummy pitch, tusks; wood,
fiber, boar's tusk, A. B. Lewis Collector (first
two), Neg. #111267c, Photograph by John
Weinstein.

3 American, n.d., Stained glass, Gift of Frank
G. James, Palo Alto, CA, Neg. # Geo, Photo-
graph by Ron Testa and Diane Alexander
White.

4 Polynesian, Early 19th century, Wood, Neg.
#111265.2c, Capt. A. W. Fuller Collection, Pho-
tograph by John Weinstein.

5 Filipino, 14th century or earlier, Gold, Neg.
#109935c, Photograph by Ron Testa and Diane
Alexander White.

Photograph of exterior by Ron Testa,
GN84157-AS.

Field Museum of Natural History

CHICAGO, ILLINOIS

Field Museum of Natural History is one of the great institutions of its kind in the world, with over 19 million artifacts and specimens and more than 879,000 square feet of space spanning five floors.

The museum was founded in 1893, thanks to a gift from department store mogul Marshall Field, to create a permanent home for the extraordinary collections assembled in Chicago that year for the World's Columbian Exposition.

The museum's research programs encompass the traditional disciplines of anthropology, botany, geology, and zoology. Its public exhibitions, however, have shifted from conventional displays to an innovative three-pronged strategy of introductory exhibits, major thematic exhibits, and resource centers, which the museum hopes will lead it into the 21st century.

Introductory exhibits include "Families at Work," which focuses on the ways that animals and humans raise their young, and "Sizes," an exploration of how factors like gravity affect the extent to which living things can grow.

Major thematic exhibits—large environmental and experiential presentations—illustrate the story of a culture, the history of part of the world, or the evolution of some form of life. Cross-disciplinary presentations like "Inside Ancient Egypt," "Travelling the Pacific," and "Pacific Spirits" allow visitors to gain insight into the cultural context of artifacts and objects. A major exhibit on the animal kingdom is scheduled to open in 1993 and will feature an interactive "nature walk."

Resource centers, like the Webber Resource Center for the Native Cultures of the Americas and the planned Animal Resource Center, are comfortable, in-depth learning environments where curious museum goers can peruse books, and videotapes, and study collections, photographs, and other materials.

The Art Institute of Chicago

CHICAGO, ILLINOIS

The Art Institute of Chicago is one of America's great art museums with a vast collection of over 300,000 items and a physical plant exceeding 843,000 total square feet. Established in 1879, the museum is organized into ten curatorial departments.

European Paintings range from the Middle Ages to 1900 and include some of the finest canvasses on view in America by such artists as Peter Paul Rubens, Rembrandt, El Greco, and Pierre Auguste Renoir. Georges Seurat's pointillist masterpiece *Sunday Afternoon on the Island of La Grande Jatte* is on display here.

European Decorative Arts and Classical Art features 30,000 objects, with particular strength in French and English silver, continental glass, and furniture of the past three centuries. This department also maintains the 68 exquisite miniature rooms by Mrs. James Ward Thorne and the Arthur Rubloff Paperweight Collection (774 on view).

The museum's Asian Arts Department is one of the most comprehensive in the country with over 35,000 objects. The Buckingham collection of Japanese woodblock prints and the Chinese bronzes are among the finest in the world.

American Arts features a vast array of decorative arts and renowned paintings, including Mary Cassatt's *The Bath*, and John Singer Sargent's elegant portrait of *Mrs. George Swinton*.

Every significant movement in America and Europe is included in the Twentieth Century Painting and Sculpture Department. Grant Wood's famous icon *American Gothic* is here, along with works by Pablo Picasso, Marc Chagall, Anselm Keifer, and Ed Paschke. There are also impressive holdings in the departments responsible for textiles; prints and drawings (including examples by Albrecht Dürer, Francisco Goya, and Rembrandt); architecture; photography; and the arts of Africa, Oceania, and the Americas.

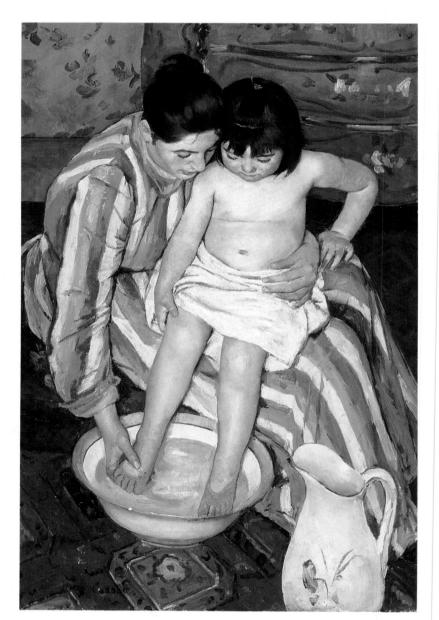

1 MARY CASSATT *The Bath*

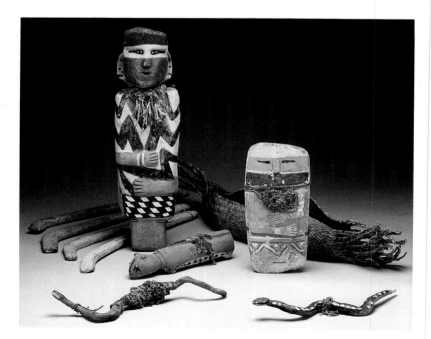

2 MIMBRES CULTURE *Cache of Ritual Figures*

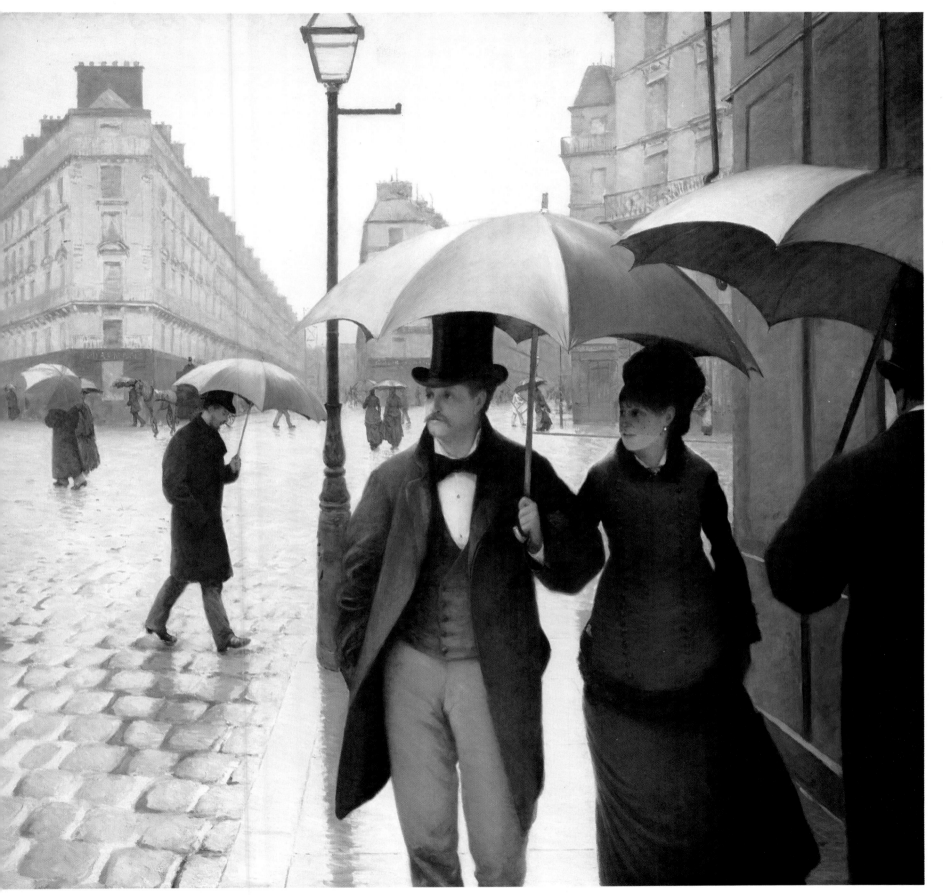

3 GUSTAVE CAILLEBOTTE *Paris, A Rainy Day*

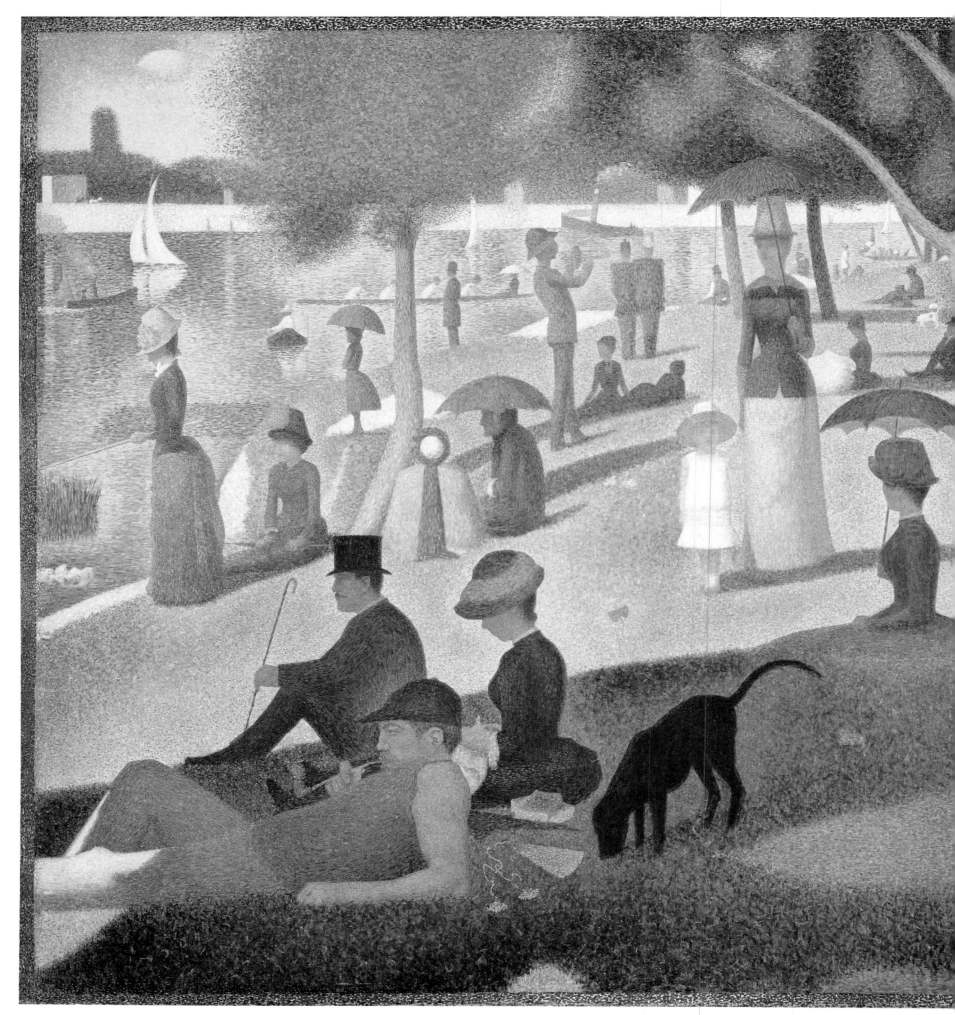

4 GEORGES SEURAT *Sunday Afternoon on the Island of La Grande Jatte*

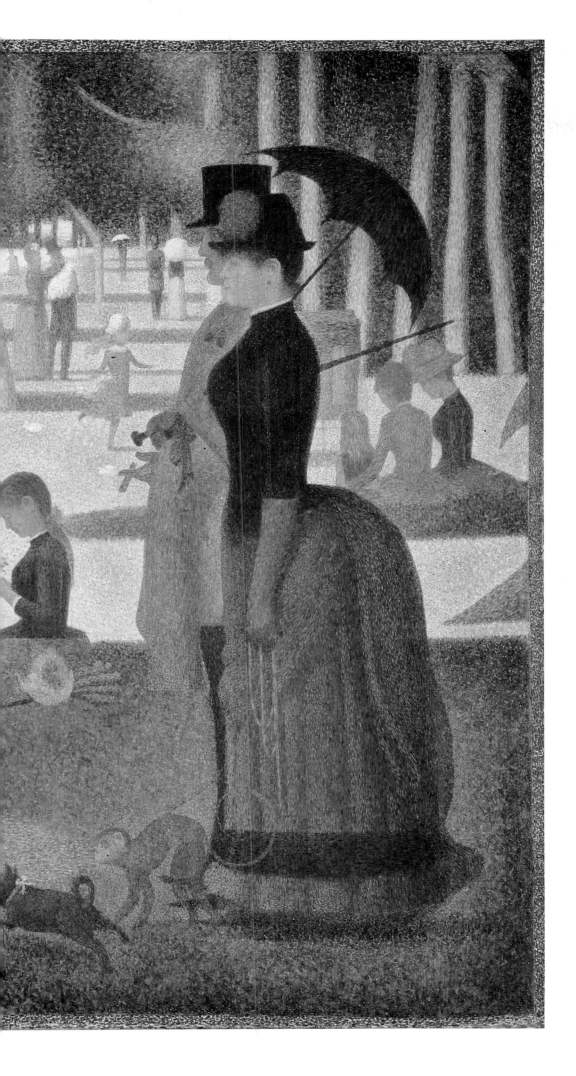

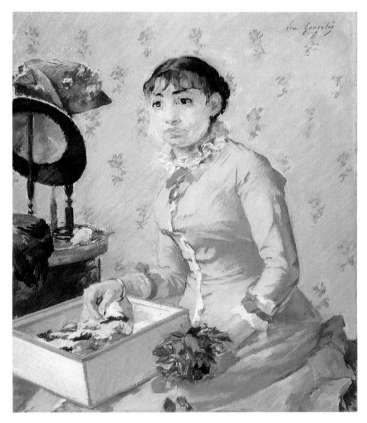

5 EVA GONZALES *The Milliner*

6 FRANCESCO MOCHI
Bust of a youth (St. John the Baptist)

7 FRANÇOIS BOUCHER *Boy Holding a Carrot*

8 EVA HESSE
Hang-Up

9 EL GRECO *The Assumption of the Virgin*

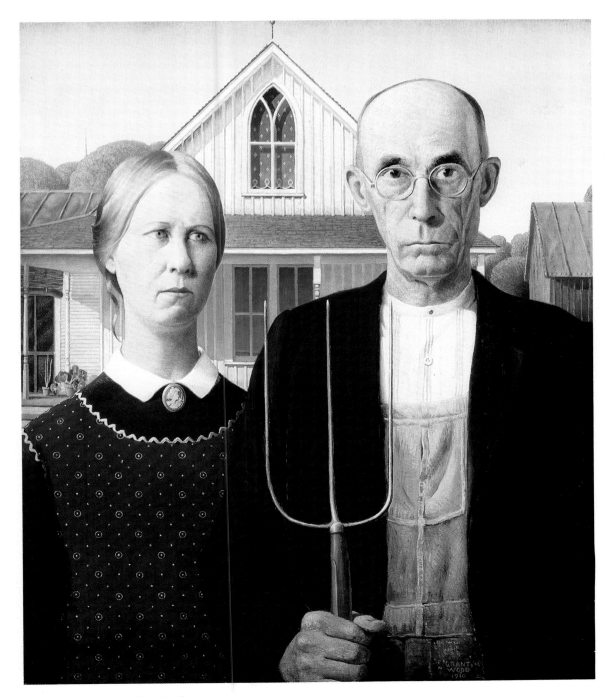

10 GRANT WOOD *American Gothic*

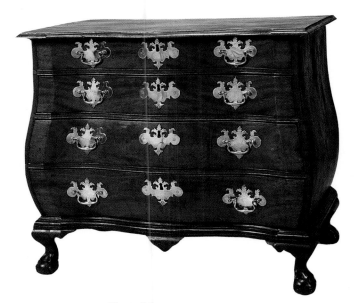

11 BOSTON AREA *Chest of drawers*

12 SUZUKI HARUNOBU *Autumn Wind: The Poet Bunya no Yasuhide, "The Six Celebrated Poets"*

1 American, 1891/92, Oil on canvas, Robert A. Waller Fund, 1910.2

2 Native American, c. 1150–1400, Wood, stone, cotton, feathers, fiber, black, blue, yellow, red, and white earth pigments, Major Acquisitions Centennial Fund Income, 1979.17a-k.

3 French, 1876/77, Oil on canvas, Charles H. and Mary F. S. Worcester Collection, 1964.336.

4 French, 1884–1886, Oil on canvas, Helen Birch Bartlett Memorial Collection, 1926.224.

5 French, c. 1877, Gouache and pastel on canvas, Lewis Larned Coburn Memorial Collection, 1972.362.

6 Italian, c. 1630, Marble on variegated black marble socle, Restricted gift of Mrs. Harold T. Martin; Departmental Funds; Major Acquisitions Centen-

nial Endowment, 1989, Photograph by Robert Hashimoto.

7 French, n.d., Pastel, Helen Regenstein Collection, 1971.22.

8 German, 1965/66, Acrylic on cloth over wood and steel, Gift of Arthur Keating and Mr. and Mrs. Edward Morris by exchange, 1988.130.

9 Greek, 1577, Oil on canvas, Gift of Nancy Atwood Sprague in memory of Albert Arnold Sprague, 1906.99.

10 American, 1930, Oil on beaver board, Friends of American Art Collection, 1930.934.

11 American, 1770–1795, Mahogany with white pine, The Helen Bowen Blair Fund, 1979.499.

12 Japanese, c. 1766, Woodblock print, Clarence Buckingham Collection, 1925.2124.

The Museum of Science and Industry

CHICAGO, ILLINOIS

Chicago's Museum of Science and Industry is the world's largest and—with an annual 4 million visitors annually—the world's most popular museum devoted to contemporary science and technology. It is also the city's number one tourist attraction.

Founded by Sears-Roebuck tycoon Julius Rosenwald, the museum opened in 1933. Its 75 exhibit halls are housed in one of the finest existing examples of classical revival architecture in America—the 14-acre reconstructed Fine Arts Building of the 1893 World's Columbian Exposition. A 1986 addition—the 36,000-square-foot Henry Crown Space Center—features spaceships, lunar models, and the world's most advanced projection system, the Omnimax Theatre.

There are some 2,000 permanent and temporary exhibit units on display, covering subjects ranging from yesterday's firefighters and bicycles to the farms and energy systems of the future. Many of the exhibits are interactive, an approach that the Museum of Science and Industry helped to pioneer.

Just a few of the many attractions include the U-505, an actual German submarine captured during World War II; a 16-foot-walk-though model of a pulsating human heart; "Colleen Moore's Fairy Castle," complete with electricity, running water, and over 1,000 tiny treasures from around the world; extensive collections of historic aircraft, trains, and automobiles; a Foucault pendulum; a famous collection of dolls; a tiny circus consisting of hundreds of hand-carved miniatures; a reproduction of an actual coal mine; a collection of antique typewriters; and a full-sized cobblestone street from 1910.

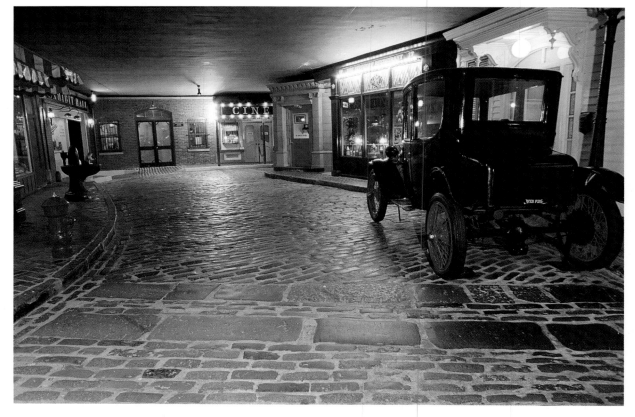

1 THE *YESTERDAY'S MAIN STREET* EXHIBIT

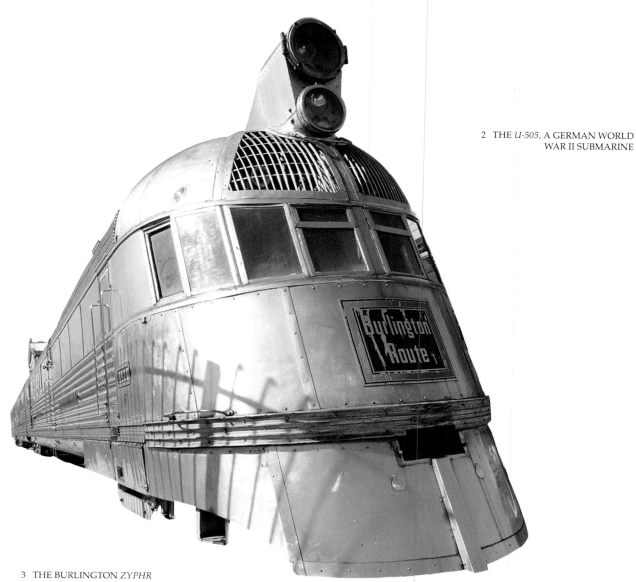

2 THE *U-505*, A GERMAN WORLD WAR II SUBMARINE

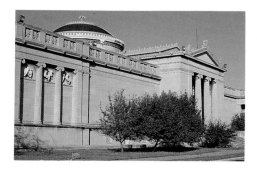

3 THE BURLINGTON *ZYPHR*

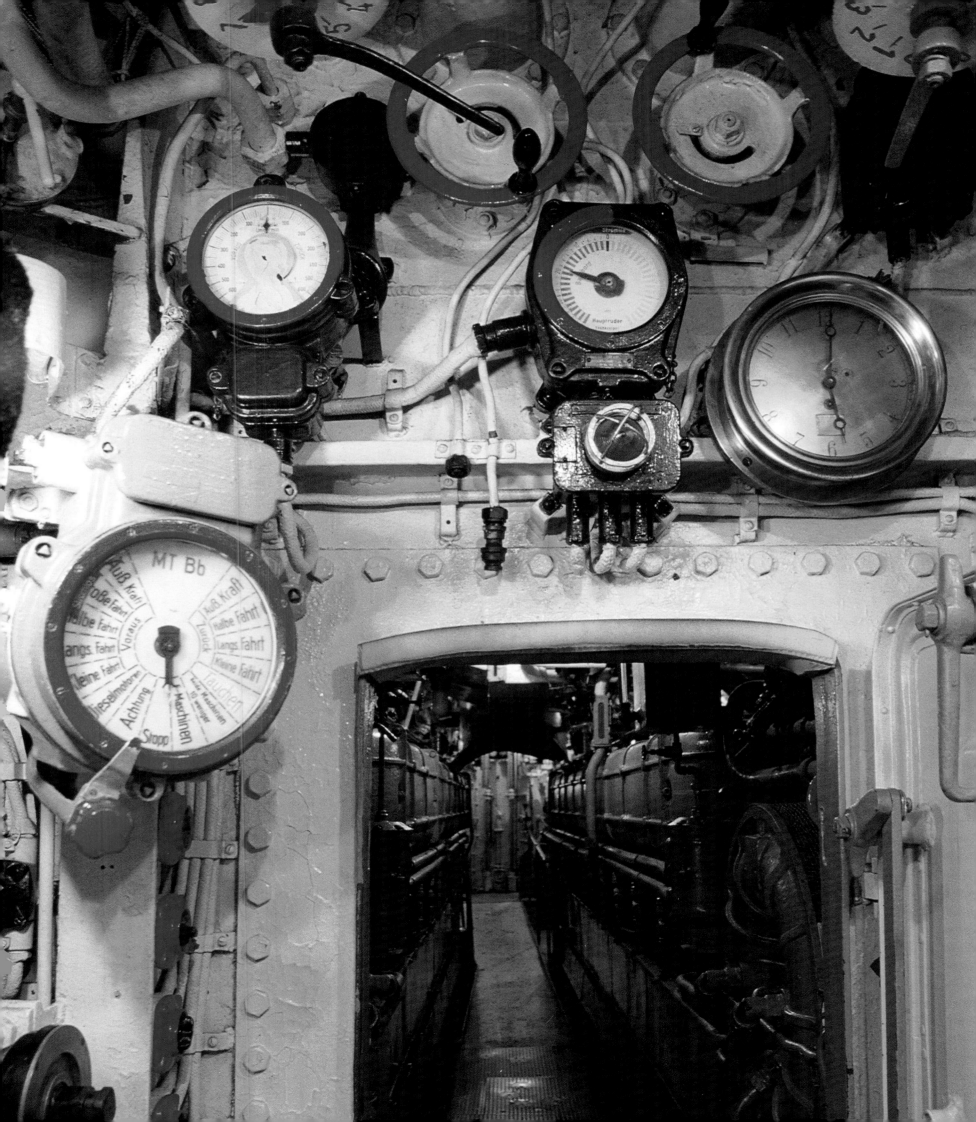

4 GIANT FEMALE ANATOMICAL FIGURE

5 MODEL OF THE HUMAN BRAIN

6 WALK-THROUGH MODEL OF
A HUMAN HEART

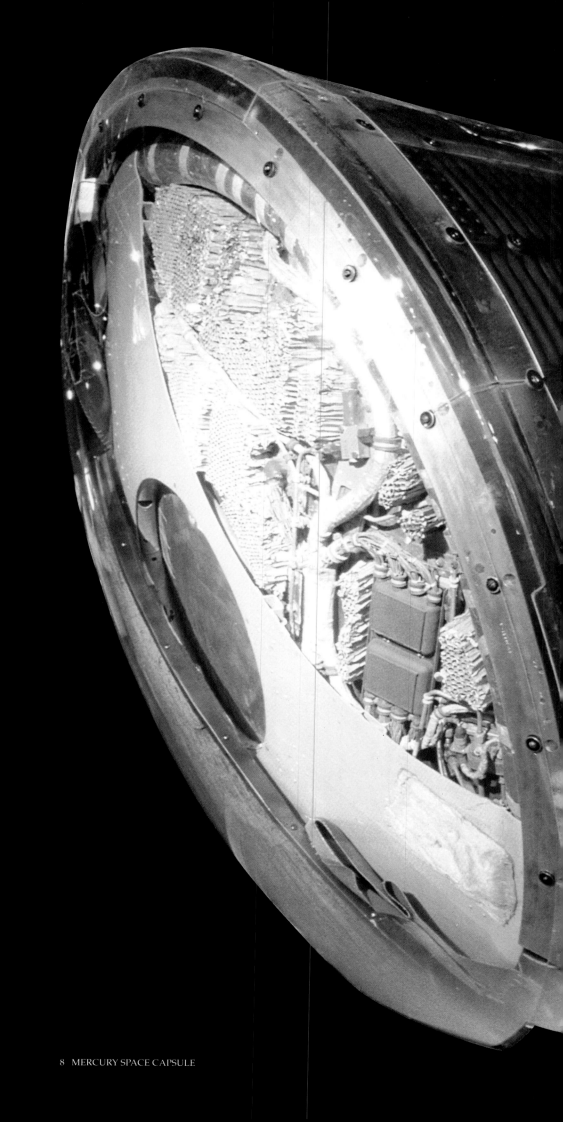

8 MERCURY SPACE CAPSULE

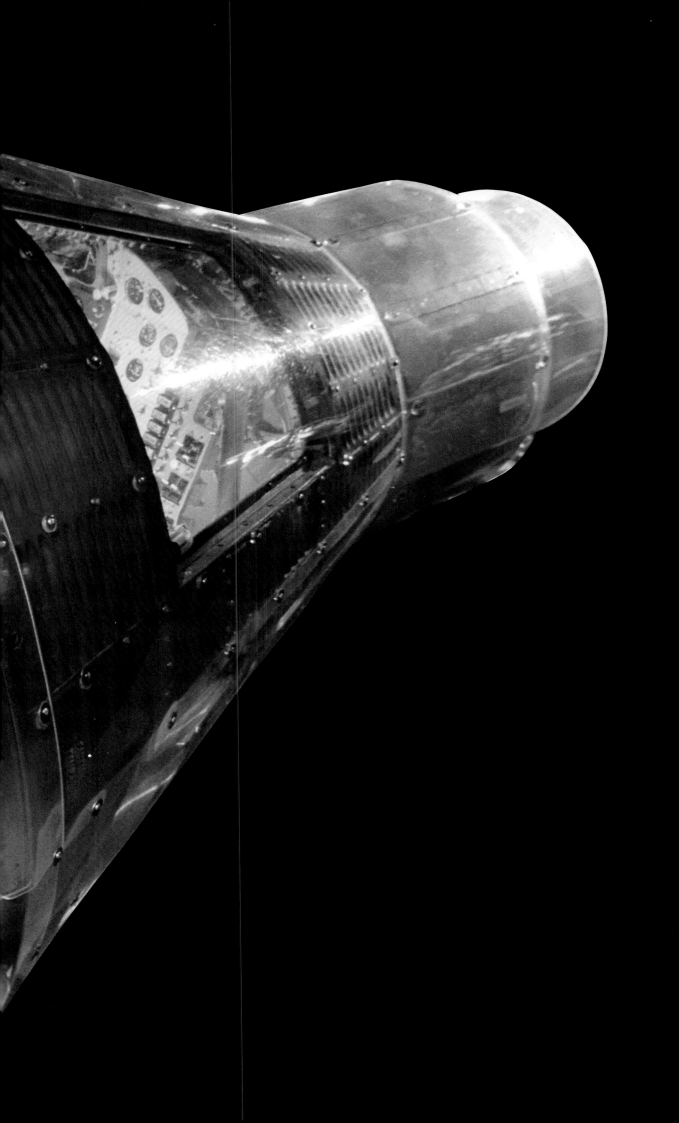

7 MOON ROCK

1 JAMES WHISTLER *Note in Red: The Siesta*

1 American, 1882–1883, Oil on panel, Daniel J.
Terra Collection, 44.1982.

2 American, 1873, Gouache and watercolor on
paper, Daniel J. Terra Collection, 6. 1982.

3 American, 1930, Watercolor, Daniel J. Terra Col-
lection, 11.1981

4 American, 1866, Oil on canvas, Daniel J. Terra
Collection, 5.1983.

2 WINSLOW HOMER *Three Boys on the Shore*

3 JOHN MARIN *Brooklyn Bridge*

4 SANFORD ROBINSON GIFFORD *Hunter Mountain, Twilight*

Terra Museum of American Art

CHICAGO, ILLINOIS

Located in an award-winning 1987 building in the heart of Chicago's Magnificent Mile, Terra Museum of American Art, founded by industrialist Daniel J. Terra in 1980, contains one of the world's preeminent collections of American art.

Among the more than 800 works in the museum's permanent collection can be found many of the country's finest examples of American Impressionism and Luminism, as well as paintings from the 1700s to the present day. Among the celebrated canvases on display here are Samuel F. B. Morse's *Gallery of the Louvre* and George Caleb Bingham's *Jolly Flatboatmen No. 2.*

Also represented in the collection are such artists as John Singleton Copley, Fitz Hugh Lane, Martin Johnson Heade, James Whistler, Winslow Homer, Mary Cassatt, John Singer Sargent, William Merritt Chase, Childe Hassam, Maurice Prendergast, Stuart Davis, Charles Sheeler, Marsden Hartley, Edward Hopper, Joseph Stella, and Andrew Wyeth.

Because it is dedicated to preserving and cultivating an understanding of American art, Terra Museum sponsors a wide range of educational programs, special exhibitions, and touring shows. A recent schedule included "Morgan Russell: A Retrospective," "Winslow Homer in Gloucester," "Gertrude Stein: The American Connection," "African American Artists, 1880–1987," "Selections from the Evans-Tibbs Collection," "An American Collection: Painting and Sculpture from the National Academy of Design," and "John La Farge: Watercolors and Drawings."

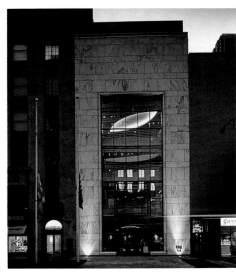

The National Museum of Transport

ST. LOUIS, MISSOURI

The National Museum of Transport features perhaps the world's most comprehensive collection of rail power, as well as examples of other means of transportation including automobiles, buses, trucks, aircraft, horse-drawn vehicles, and riverboats.

The museum was founded by a group of historically minded citizens in 1944 to save an 1880 mule-drawn streetcar from the scrap heap. As the collection grew, the museum acquired 39 acres along the right of way of the historic Missouri Pacific Railroad, including the two historic Barrett Tunnels—the first such tunnels west of the Mississippi River when they were built from 1851 to 1853. In 1979 administration of the museum passed to the St. Louis County Parks and Recreation Department, which has continued acquiring and preserving artifacts from the nation's transportation heritage.

The museum's yards now contain 65 locomotives representing 150 years of American railroad history. Visitors can compare tiny steam engines of Civil War vintage with the monster Union Pacific "Big Boy" of the 1940s (the largest locomotive used in regular service anywhere in the world), and the streamlined diesels and electrics of the post-World War II years. The museum's holdings also include the entire Purdue Collection of locomotives, featuring the "Eddy Clock" and a B & O "Davis Ten Wheeler."

As the National Museum of Transport continues to evolve, more emphasis is being placed upon attractive presentations of various modes of transportation. New exhibits will illustrate the importance of every type of vehicle from animal-powered carriages to spacecraft, from the museum's Douglas DC-3 aircraft to its "Bobby Darin Dream Car."

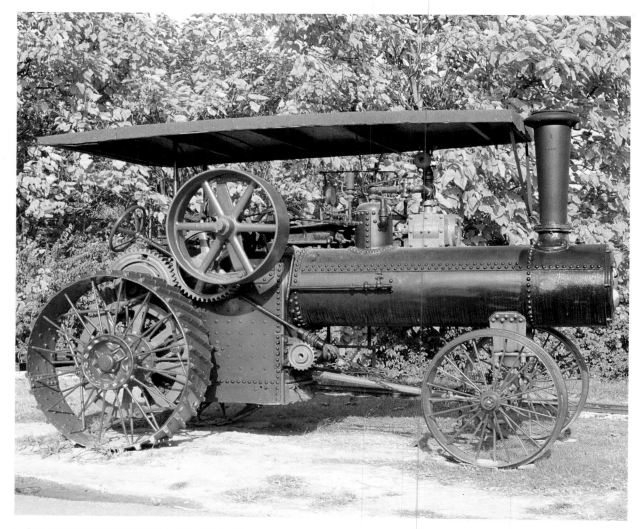

1 CASE TRACTION ENGINE (STEAMTRACTOR), 1911

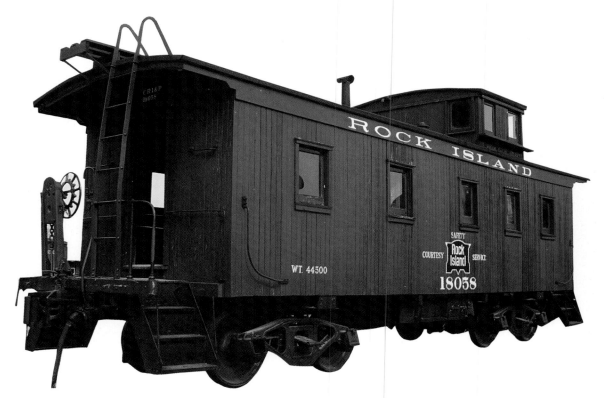

2 ROCK ISLAND CABOOSE, 1904

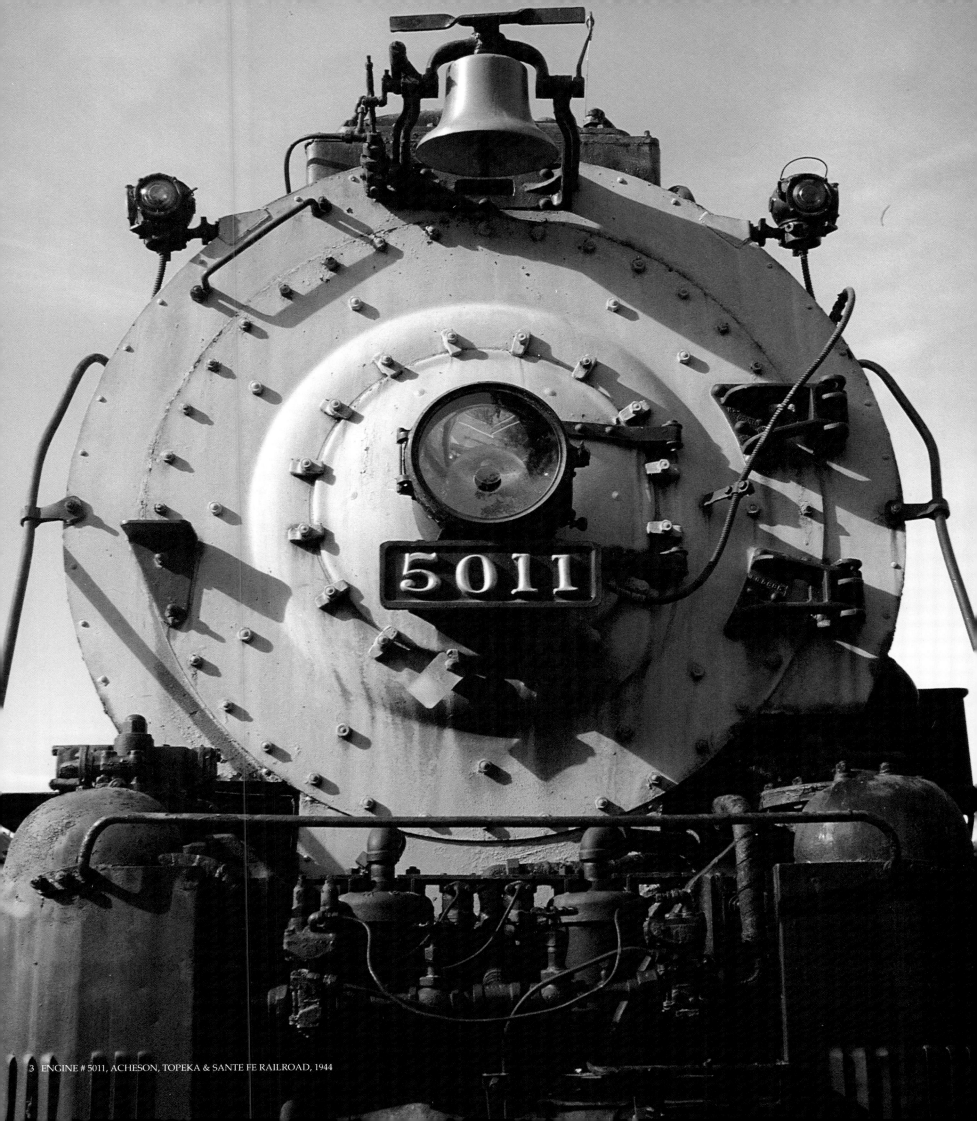

3 ENGINE # 5011, ACHESON, TOPEKA & SANTE FE RAILROAD, 1944

4 COVERED WAGON, C. 1900

5 THE DOUGLAS C-47A "GOONEY BIRD," 1946

6 GRAVITY GAS PUMP, C. 1920s

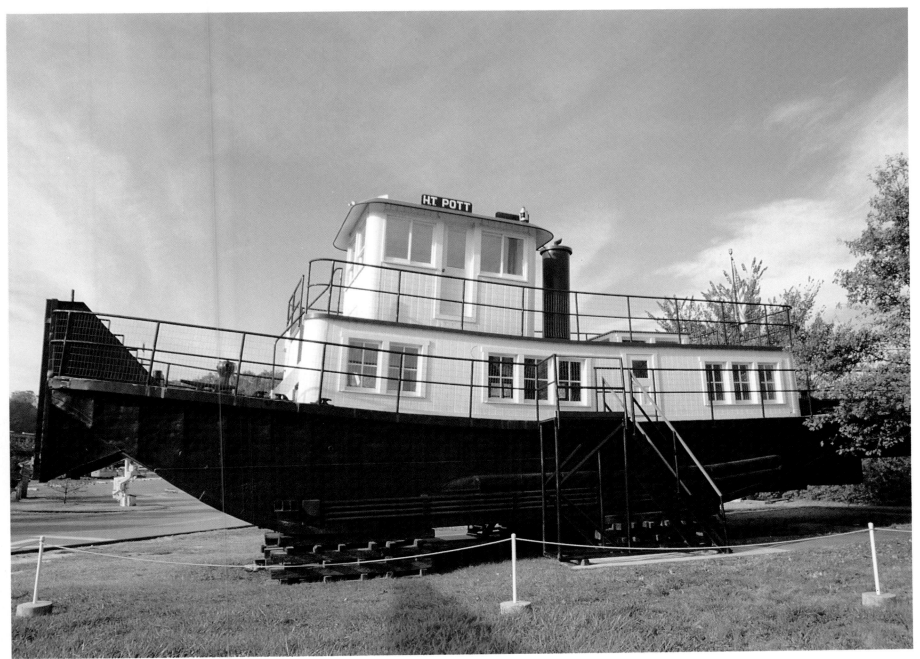

7 THE *H.T. POTTS* TUG BARGE, 1932

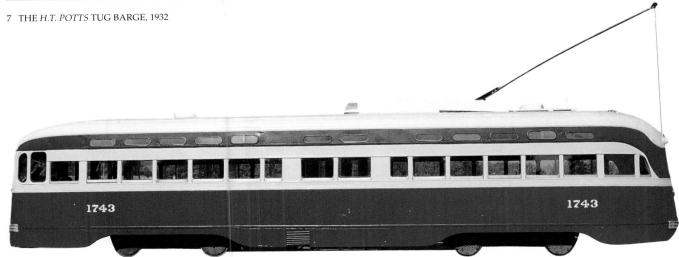

8 ELECTRONIC STREETCAR

Photographs by Lynn Radeka

The St. Louis Art Museum

ST. LOUIS, MISSOURI

The only permanent structure designed for the famous 1904 World's Fair, the St. Louis Art Museum's beaux arts building in Forest Park enjoys the same pristine elegance that it did when it was built. The museum's West Wing, recently renovated in a 13-year, $32-million project, houses the Decorative Arts galleries and some of the finest period rooms in the country.

Although it is not one of the country's largest museums, the quality of its 35,000-work collection is indisputable. In scope, it ranges from ancient Egyptian treasures to the most modern of masterpieces. Of particular note is the museum's historical commitment to collecting works by living artists.

Some highlights of the museum's holdings include classical Greek, Roman, and Asian sculpture; important canvases by Rembrandt, Hans Holbein the Younger and Frans Hals; a masterful altarpiece, *Madonna and Child With Saints* by Piero di Cosimo; Giorgio Vasari's dramatic painting of *Judith and Holofernes*; George Caleb Bingham's famous *Jolly Flatboatmen in Port*; *The Bathers with a Turtle* by Henri Matisse, which John Russell of the *New York Times* has called "one of the most important 20th-century paintings in the country"; Auguste Rodin' s exquisite white Carrara marble sculpture, *Vespair*; a remarkable silver bowl made by Tiffany to commemorate the silver anniversary of an Anheuser and a Busch; William Glackens' lovely *Young Woman In Green*; Anselm Kiefer's monumental painting, *Burning Rods*; and Liu Cai's *Fish Swiming Amid Falling Flowers*, a silk scroll from 12th-century China.

Thanks to the generosity and vision of the late department store owner, Morton D. May, the St. Louis Art Museum holds two particular collections ranked among the best in the world—one focusing on pre-Columbian works, the other on German Expressionism. May also gave the museum an outstanding collection of the art of every Pacific culture between Indonesia and Hawaii, as well as pieces from South America and even Alaska.

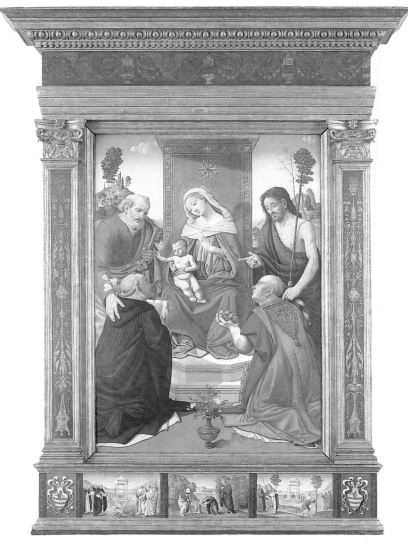

1 PIERO DI COSIMO *The Madonna and Child Enthroned with St. Peter and St. John the Baptist, St. Dominic and St. Nicholas*

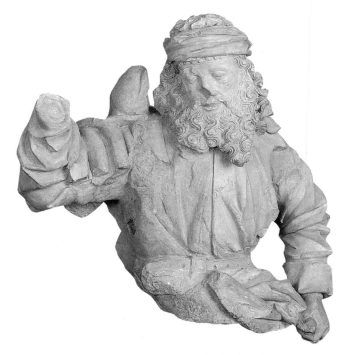

2 UNKNOWN *St. Christopher*

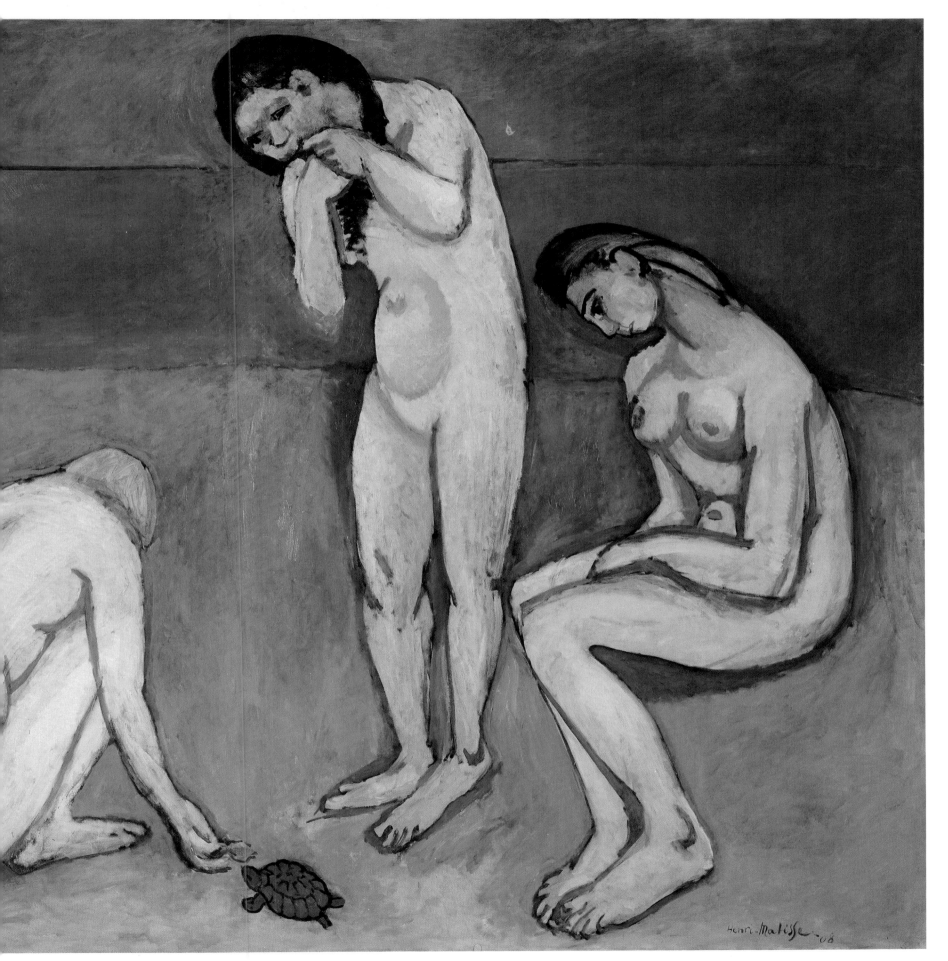

3 HENRI MATISSE *Bathers with a Turtle*

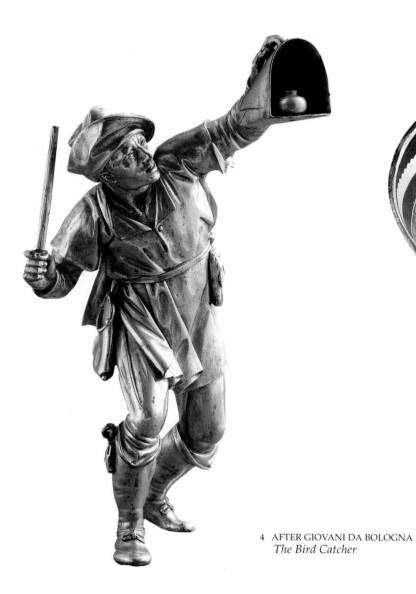

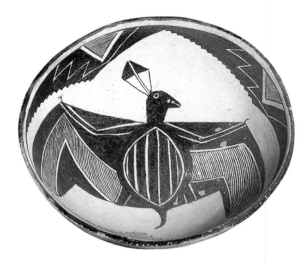

5 MIMBRES CULTURE *Bowl with Bat Design*

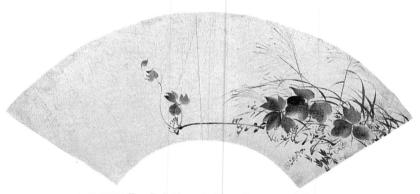

4 AFTER GIOVANI DA BOLOGNA
The Bird Catcher

6 ZESHIN *Fan Painting: Autumn Leaves and Grasses*

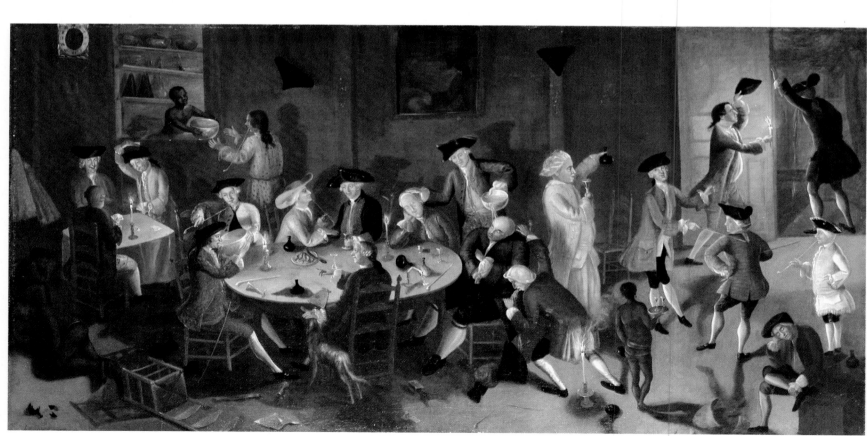

7 JOHN GREENWOOD *Sea Captains Carousing in Surinam*

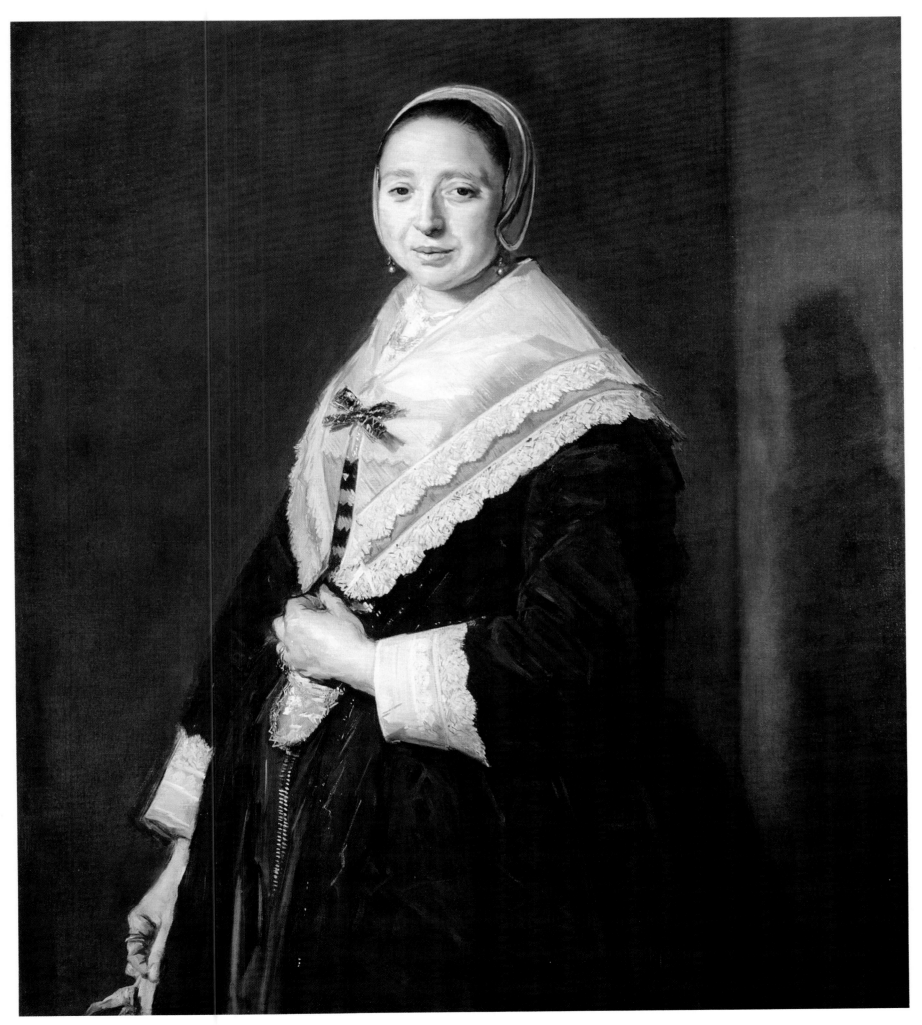

8 FRANS HALS *Portrait of a Lady*

1 UNKNOWN *Fashion Dolls*

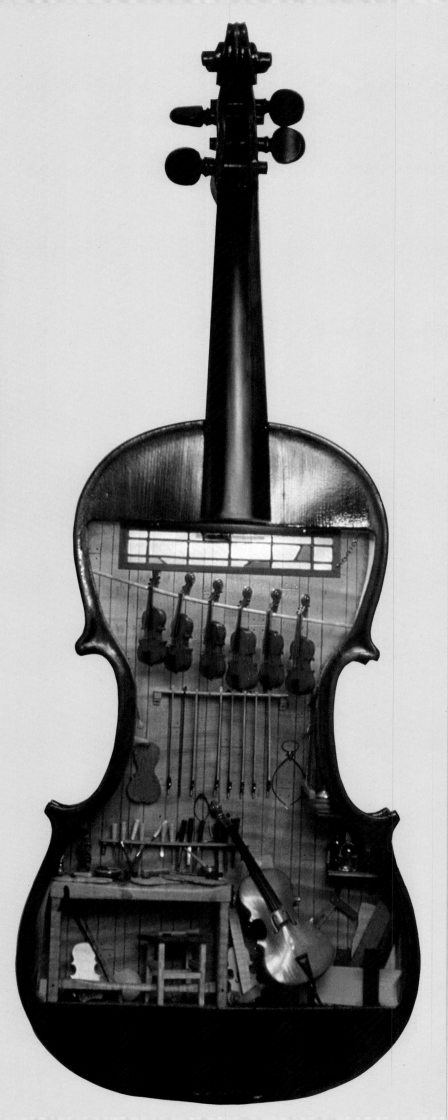

1 French, c. 1860, Bisque with glass eyes and human hair wigs.

2 American, 1942, Wood.

3 American, 1927, Wood with wood and marbleized paper pillars.

4 German, 1870, Painted wood frame and cupboard, lithograph floor and wallpaper.

2 W. FOSTER TRACY *Violin Maker's Shop*

The Toy and Miniature Museum of Kansas City

KANSAS CITY, MISSOURI

The violins are strung with human hair and can actually be played. A full silver service completes the Federal-period table setting, but a magnifying glass may be necessary to see the hallmarks. There's a Gypsy caravan made of match sticks, perambulators no bigger than postage stamps, even a Lilliputian replica of Buckingham Palace.

The elegant mansion that houses the Toy and Miniature Museum of Kansas City has more than 100 dollhouses and exact-to-scale miniature rooms full of tiny objects of wonder and delight, as well as German model kitchens and farms, animal menageries, toy soldiers, peep shows, cast iron fire equipment, and much more.

Mary Harris Francis and Barbara Marshall founded the museum in 1982 to share their private treasures with the public. With over 500,000 items now on display in 24,000 square feet, the museum is the only one of its kind in the Midwest and is considered one of the world's best.

The building has recently undergone a colorful renovation, but it is difficult to imagine how one could improve on wonders like a dollhouse styled as a French chateau and big enough for a child to climb into or the tiny Noel Thomas house, complete with spider webs in the attic, moss in the gutters, and a pie cooling on the window sill.

There is even a room full of Noah's arks, playthings created during Victorian times when children were only allowed to amuse themselves with biblical toys on the Sabbath. The mural in the ark room features a very stylish Noah indeed—his knit robe has, of course, not one but *two* alligators!

3 UNKNOWN *Replica of St. Vincent's Cathedral, Los Angeles*

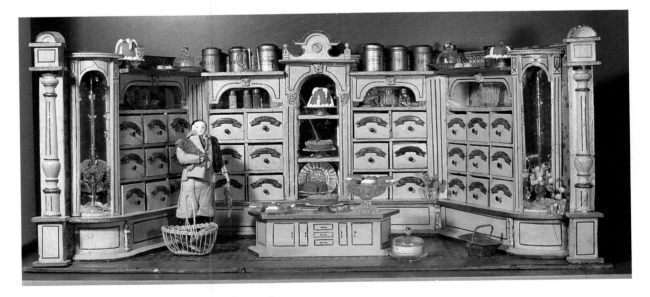

4 CHRISTIAN HACKER *Toy German grocery/sweet shop*

179

1 HENRY MOORE *Large Interior Form*

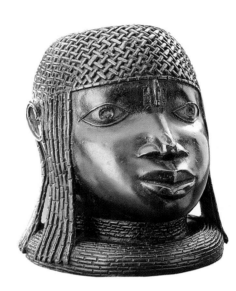

3 BENIN KINGDOM
Memorial Head of an Oba

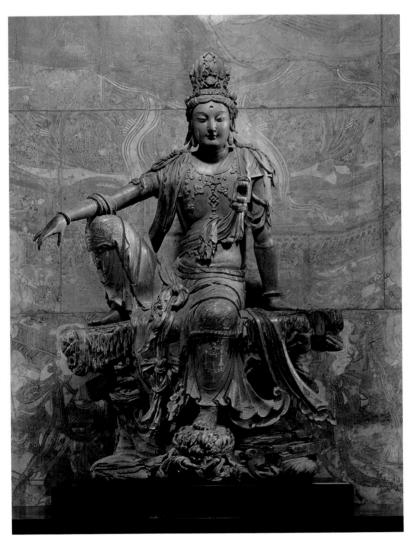

The Nelson-Atkins Museum of Art

KANSAS CITY, MISSOURI

Housed in a handsome neoclassical building built in the 1930s, the 30,000-piece collection of the Nelson-Atkins Museum of Art features master-works spanning a broad spectrum of countries and centuries.

Endowed by legacies from newspaper publisher William Rockhill Nelson and from Mary Atkins, a reclusive former school teacher, the museum's renowned collections of European and American paintings include important works by Peter Paul Rubens, Rembrandt, Edgar Degas, Pierre Auguste Renoir, Vincent van Gogh, Frederic Church, Winslow Homer, Thomas Eakins, and many others. Caravaggio's stellar *St. John the Baptist* is here—one of only seven original works by the artist in the United States. So is Raphaelle Peale's well-known visual pun, *Venus Rising from the Sea—A Deception (After the Bath)*, a painting of a painting largely covered by a cloth. The museum's collection of French paintings from Nicolas Poussin to Claude Monet is particularly rich.

Besides oils, the Nelson-Atkins also boasts a superb collection of Egyptian sculpture, the 1,100-piece Burnap Collection of English pottery, and the Starr Collection of miniatures.

In 1989 the Henry Moore Sculpture Garden opened on 17 acres adjoining the museum. The 12 monumental bronze sculptures on display here are the largest such collection in the United States, but they are only part of the nearly 60 pieces by Moore on long-term loan to the museum by the Hall Family Foundations.

Of all its treasures, the Nelson-Atkins is best known for its collection of Oriental art, one of the country's best thanks to the connoisseurship of Laurence Sickman. As *New York Times* art critic John Russell said in 1983, "It is difficult not to regard (the Chinese galleries) as one of the finest single curatorial achievements in museum history."

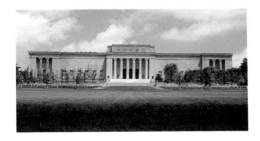

4 UNKNOWN *Seated Guanyin*

The Thomas Gilcrease Institute of American History and Art

TULSA, OKLAHOMA

The Thomas Gilcrease Institute of American History and Art houses the world's finest and most comprehensive collection of the arts of the American West, featuring more than 10,000 paintings, prints, drawings, and sculptures by some 400 artists from colonial time to the present. It also includes 90,000 rare manuscripts, documents, and maps, and 250,000 anthropological artifacts, among them many works of Native American cultures, ancient and modern.

Thomas Gilcrease, the museum's founder, built his oil fortune on land allotted to him at the age of nine by the federal government because of his mother's Creek Indian blood. After touring Europe, Gilcrease began to see the need for a repository for the art, history, and culture of his beloved American West. He opened his museum to the public in 1949 and, when he suffered financial reversals in 1955, the city of Tulsa agreed to purchase the collection. Later, Gilcrease deeded the land and buildings to the city, along with oil royalties designed to provide for the museum's continued maintenance.

All the great artists of the American West are represented here. There are 57 works by Frederic Remington, 88 by Charles Russell, and 1,063 by William R. Leigh, to name but a few. There are also such fascinating pieces of history as the oldest existing letter from the New World, written by Christopher Columbus' son in 1512, and a certified copy of the Articles of Confederation, as well as important works by other non-Western American artists like John James Audubon, Winslow Homer, James Whistler, and Thomas Eakins.

Thomas Gilcrease's legacy is so significant in its depth and scope that only 20 percent of the collection can be displayed at any one time, despite a 1987 expansion and renovation that brought the museum's size to nearly 128,000 square feet.

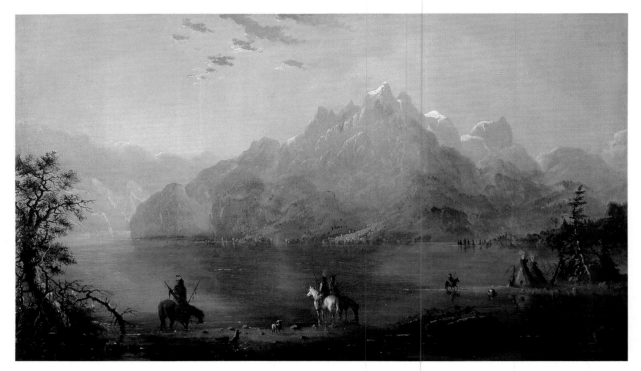

1 ALFRED JACOB MILLER *Indians on Green River*

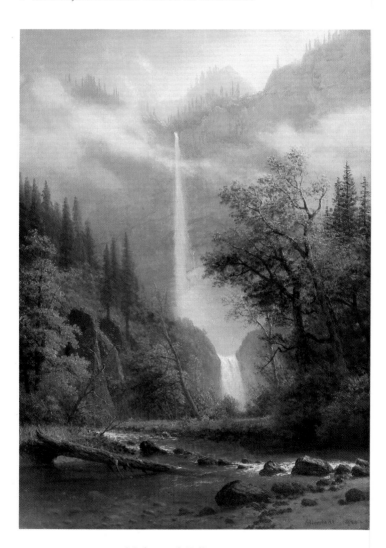

2 ALBERT BIERSTADT *Multnomah Falls*

3 CHARLES M. RUSSELL
Meat's Not Meat 'Til it's in the Pan

1 American, n.d., Oil on canvas.
2 American, 1893, Oil on canvas.
3 American, 1915, Oil on canvas.
4 American, 1765., Oil on canvas.

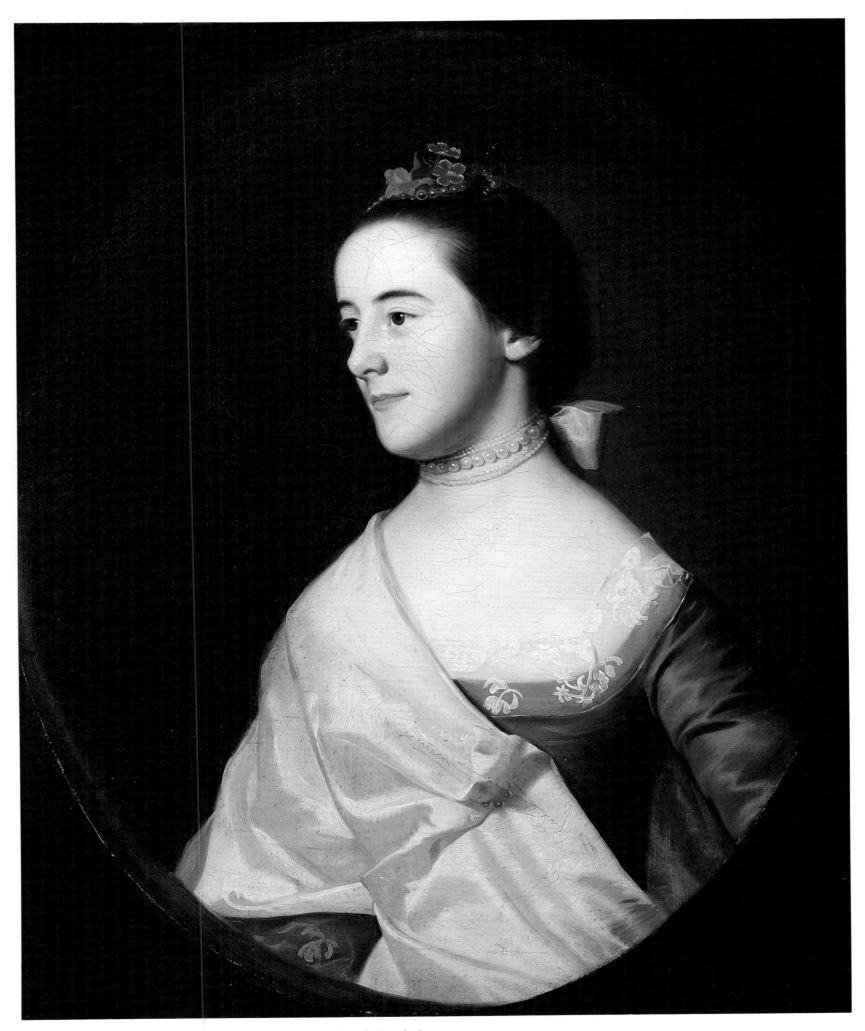

4 JOHN SINGLETON COPLEY *Portrait of Mrs. John Apthorp, née Hannah Greenleaf*

1 CARL WIMAR *Buffalo Hunt*

1 American, 1860, Pastel on canvas.
3 American, 1867, Oil on canvas.
4 American, 1917, Bronze.

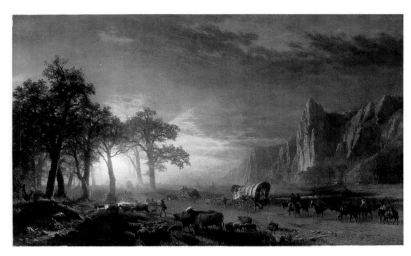

2 RE-CREATION OF U.S. MARSHAL'S OFFICE

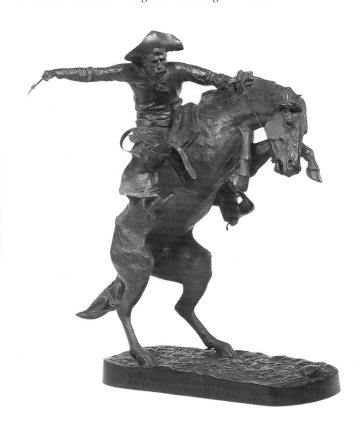

3 ALBERT BIERSTADT *Emigrants Crossing the Plains*

4 FREDERIC REMINGTON
Bronco Buster

The National Cowboy Hall Of Fame And Western Heritage Center

OKLAHOMA CITY, OKLAHOMA

Conceived by Kansas City industrial-ist Chester A. Reynolds, the National Cowboy Hall of Fame and Western Heritage Center opened in 1965 in a unique structure designed to resemble pioneer tents on the prairie. The museum, which extends over 37 scenic acres on Oklahoma City's Persimmon Hill, offers visitors a number of different perspectives from which to view the American West.

The historical West is evident in classic paintings by such world-renowned masters as Albert Bierstadt, Charles M. Russell, Charles Schreyvogel, and William R. Leigh. The collection also features the 18-foot-high original plaster sculpture, *End of the Trail*, by James Earle Fraser (perhaps the most widely copied image in American Western Art), as well as a fine selection of bronzes by Frederic Remington, including the only casting of *Buffalo Signal*. There are also galleries where visitors can step inside an authentic sod house, walk through a gold mine, and acquaint themselves with such typical Western artifacts as a stagecoach, a chuck wagon, a telegraph office, and, of course, a saloon.

The modern West is represented by contemporary artists whose work is exhibited in two spacious galleries that also house temporary and traveling exhibits.

Finally, there are shrines honoring the accomplishments of Westerners in three separate areas. The Rodeo Hall of Fame immortalizes in portraits, displays, and memorabilia legendary ropers and riders. The Western Performers Hall of Fame honors actors like Walter Brennan, Ben Johnson, Slim Pickens, the cast of *Gunsmoke*, and John Wayne, who donated Kachina dolls and movie memorabilia for a permanent display. The Hall of Great Westerners recognizes men and women—including Ronald Reagan—who have made outstanding contributions to the nation's Western heritage.

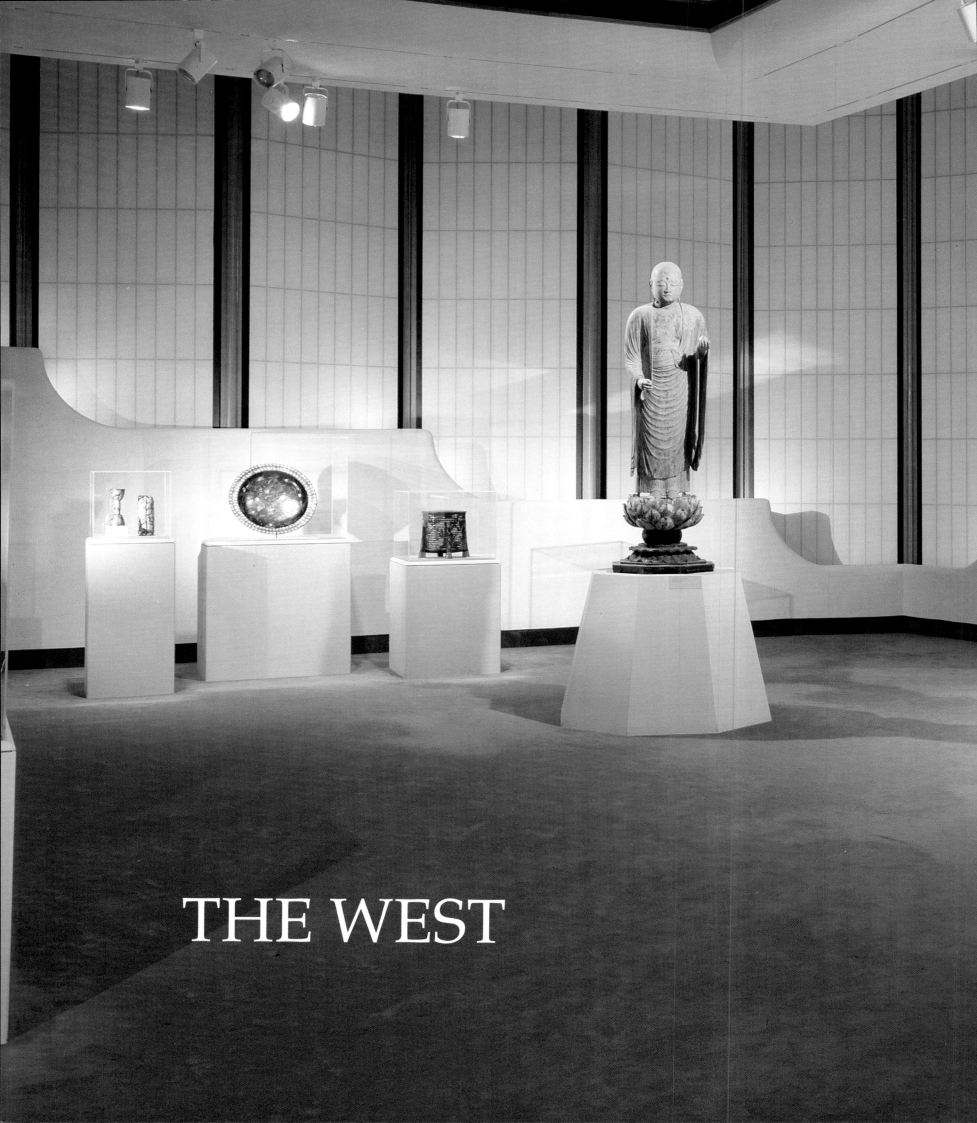

THE WEST

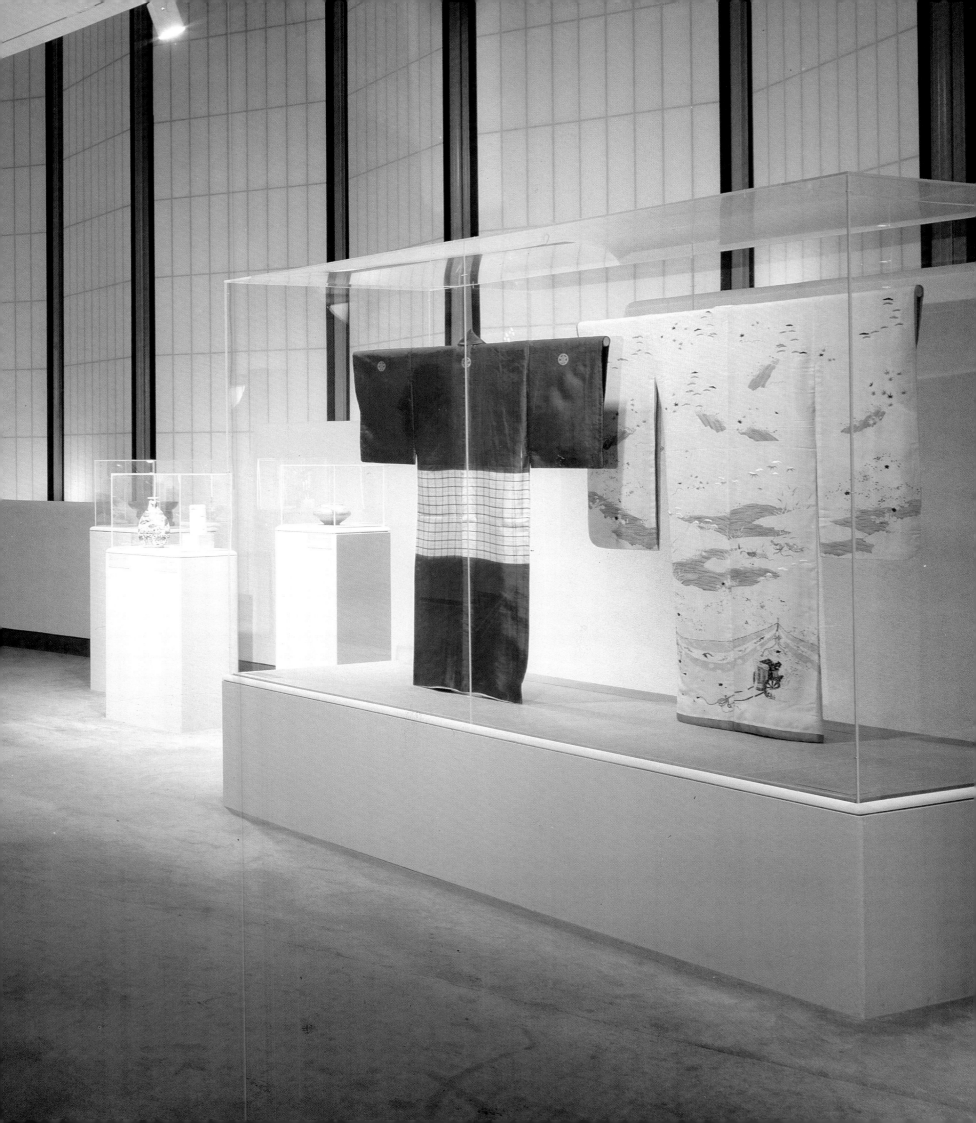

The Denver Art Museum

DENVER, COLORADO

For the last half century the Denver Art Museum has dedicated itself to building a collection representative of all major historic periods and cultures for the benefit of the residents of the Rocky Mountain area.

The museum was founded in 1893, but had no single permanent home until what was later called the Otto and Cile Bach Wing was constructed in 1954. The Bach Wing still houses the museum's Modern and Contemporary Department, the Bayer Archive, and a gallery featuring artists from the region.

Most of the 35,000-object collection, however, is contained in a 1971 twin tower designed by James Sudler and Gio Ponti. This nine-level, 210,000-square-foot landmark is clad in tiles specially developed by Corning Glass and is itself considered a work of art. It is also the largest art museum between Kansas City and the West Coast and one of the major museums built in the United States in recent decades.

Although it is not as comprehensive as some American museums, Denver's collection is considered outstanding in several areas. The museum's holdings of Native American art is certainly one of the world's finest and was also the first to be selected and displayed as art rather than anthropological artifacts. The Textiles and Costumes Department, the museum's second largest department with over 8,000 objects, includes everything from Chinese silks to American quilt and samplers. There are also noteworthy collections of pre-Columbian, Spanish colonial, American, Contemporary, and Asian art.

An extensive renovation and expansion program is planned for the museum's centennial, which will include a 113,000-square-foot new wing on the site of the existing Bach Wing.

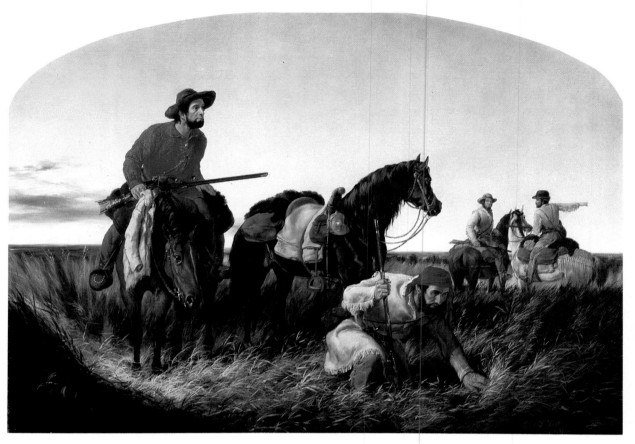

1 ARTHUR FITZWILLIAM TAIT *Trappers at Fault, Looking for Trail*

2 UNKNOWN *Hemis Kachina*

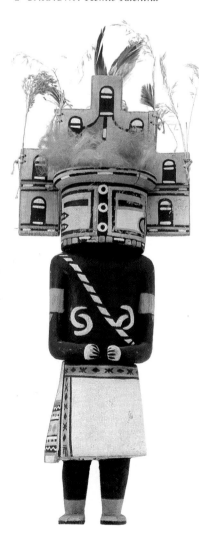

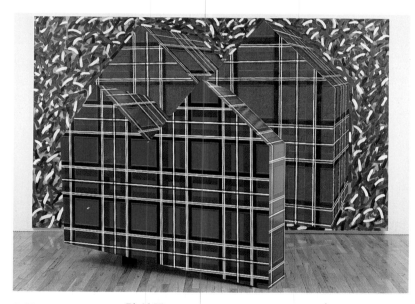

3 JENNIFER BARTLETT *Plaid House*

1 British, 1852, Oil on canvas.
2 Hopi, 1920s, Wood, feathers.
3 American, 1985–1989, Oil on canvas, enamel on wood, photo: D. James Dee.
4 Indian, Tanjore district(?), Late Chola period, 13th century, Bronze.

Preceding pages:
THE PAVILLION FOR JAPANESE ART,
THE LOS ANGELES COUNTY MUSEUM OF ART,
LOS ANGELES, CALIFORNIA.

1 MAYA *Ceramic figure*

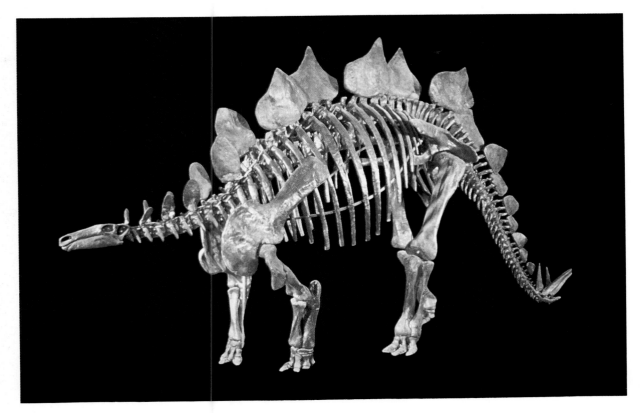

2 STEGOSAURUS

Denver Museum of Natural History

DENVER, COLORADO

Set against the spectacular backdrop of the Rocky Mountains, the Denver Museum of Natural History is the largest institution of its kind between Chicago and the West coast, hosting nearly 1.4 million annual visitors in its 480,000-square-foot facility.

The museum was founded in 1900 and first opened its doors to the public eight years later. In 1968, Gates Planetarium was completed; it offers a variety of star and laser light shows. The Phipps IMAX Theatre, featuring a screen 4½ stories tall and 6½ stories wide and one of the largest and most sophisticated movie projection systems in the world, opened in 1983. A 187,000-square-foot expansion was completed in 1987.

In addition to the museum's Dinosaur Hall, Crane American Indian Hall, Coors Mineral Hall, and featured exhibits relating to the ecology of Colorado, there are nearly 90 life-sized dioramas featuring animals of the Americas, Africa, Australia, and the South Pacific in their natural environments.

The museum's nearly 400,000 zoological, paleontological, geological, and anthropological artifacts includes one of the finest U.S. collections of assembled fossil mammal skeletons; an intricate tundra exhibit containing 1.5 million reproduced leaves; a large collection of minerals and gemstones including a 10,558-carat faceted Brazilian topaz; one of the finest collections of crystallized leaf gold in the world; the only assembled fin whale skeleton in the Rocky Mountain area; an outstanding Native American collection of over 12,000 items; and a full-sized replica of the feared Tyrannosaurus Rex.

The Denver Museum of Natural History presents an active schedule of changing exhibitions, and its outreach program brings perspectives on the natural world to more than 220,000 children annually.

3 "TAM'S BABY," COLORADO'S LARGEST GOLD NUGGET

4 MOOSE AND CARIBOU (DIORAMA)

The Buffalo Bill Historical Center

CODY, WYOMING

The very personification of the American West, William F. "Buffalo Bill" Cody was one of the most famous men in the world at the turn of the last century, honored by Congress (with the Medal of Honor) and foreign rulers alike. Today the Historical Center named for him in the town that he founded preserves the Western heritage, art, and philosophy that Buffalo Bill stood for.

The center has four distinct parts. The Buffalo Bill Museum is devoted specifically to Cody and his exploits—Pony Express rider at the age of 14, legendary Indian scout, and Wild West Show impresario. Here the great showman's story is recaptured in photos and personal memorabilia.

The Whitney Gallery of Western Art houses an important collection of the works of artists and sculptors of the American West from 1825 to the present. The gallery includes not only important canvasses and bronzes, but the actual studio collections, installed in replica environments, of two of the West's premier artists, W. H. D. Koerner and Frederic Remington.

The new Cody Firearms Museum contains a diverse sampling of arms from all over the world as well as an incomparable assemblage from the Winchester Repeating Arms Company and its predecessors.

The traditional gifts bestowed on Bill Cody by Native Americans forms the basis of the 43,000-square-foot Plains Indian Museum. The special relationship that Buffalo Bill enjoyed with American Indians says a great deal about the man and his understanding of the West. "Every Indian outbreak that I have ever known," Cody wrote as early as 1878, "has resulted from broken promises and broken treaties by the government."

1 Plains Indian, n.d., Grizzly bear and leather.
2 American, 1881, Oil on canvas.
3 American, 1905, Oil on canvas.
4 French, 1889, Oil on canvas.

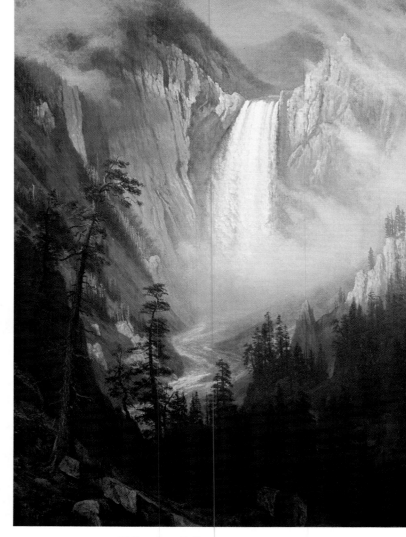

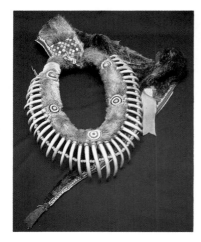

1 SAUK-FOX TRIBE *Bearclaw necklace*

2 ALBERT BIERSTADT *Yellowstone Falls*

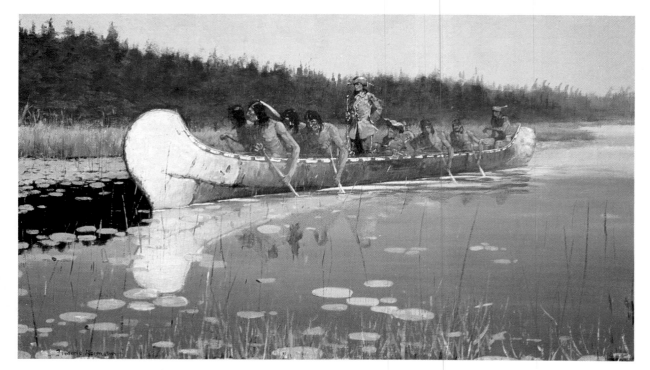

3 FREDERIC REMINGTON *Radisson and Groseilliers*

192

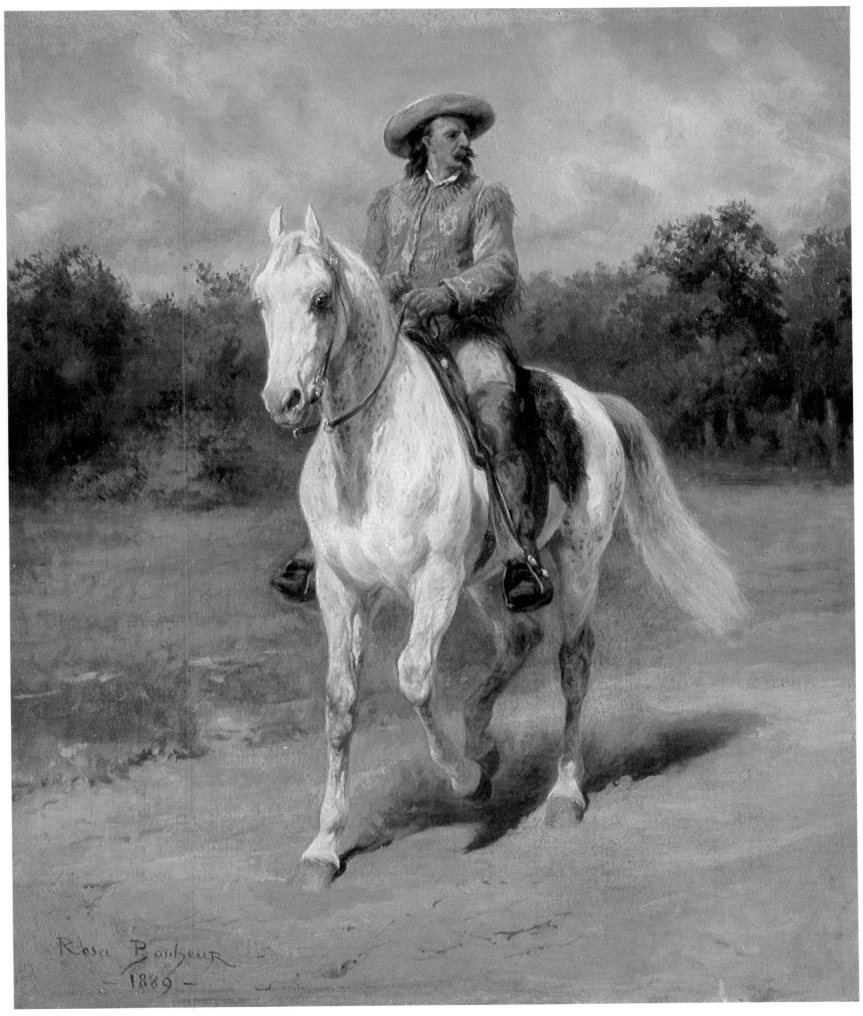

4 ROSA BONHEUR *Colonel William F. Cody*

1 GEORGIA O'KEEFFE *In the Patio II*

2 DOLLS IN A MARKET SCENE

3 UNKNOWN *Ferris Wheel (toy)*

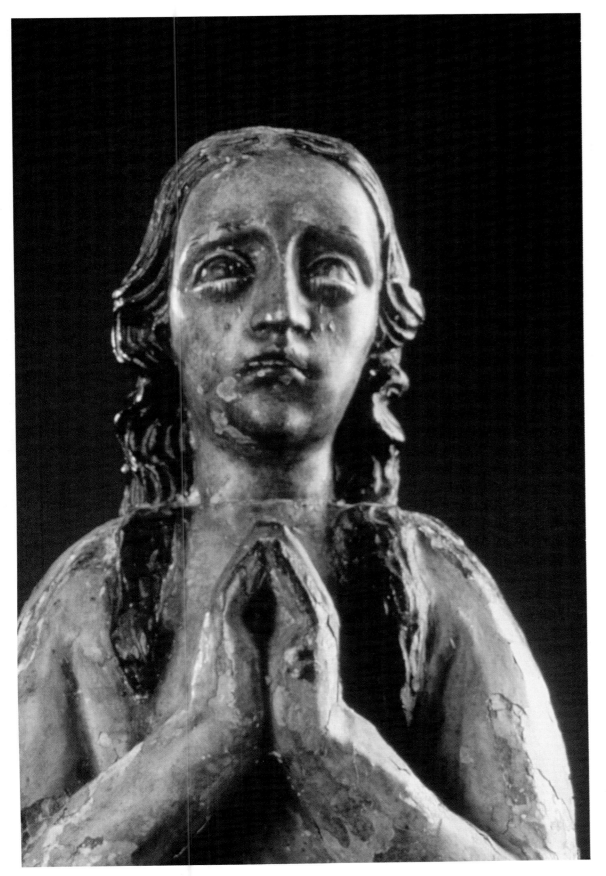

4 UNKNOWN *Lone soul in Purgatory (detail)*

1 American, 1948, Oil on canvas.

2 Multiple artists, c. 1960, Primarily painted ceramic, The Girard Foundation Collection, Museum of International Folk Art, Photo by Mark Schwartz.

3 Greek, c. 1960, Paint and wood, the Alexander Girard Collection, Museum of International Folk Art.

4 Guatamalan, 18th century, Paint on wood, Collection of the International Folk Art Foundation, Photo by Blair Clark.

The Museum of New Mexico

SANTA FE, NEW MEXICO

Founded in 1909 by the territorial government, the Museum of New Mexico is not one but a family of four museums, plus numerous other cultural institutions, all serving the people of the Southwest.

The Palace of the Governors was originally built by Spanish settlers in 1609, making it the oldest continuously occupied government building in the United States. It opened to the public as a museum in 1911 and today displays a 17,000-object collection illuminating the area's history.

The Museum of Fine Arts, focusing on 20th century American art with an emphasis on Southwest works, opened in 1917 and underwent a renovation and expansion in 1980. Among its 8,000 works of art are paintings by Georgia O'Keeffe, Marsden Hartley, and John Marin and photographs by Laura Gilpin.

The Museum of International Folk Art was established in 1953. Its collection, exceeding 125,000 items from over 100 nations, is the largest of its kind in the world. A separate wing housing items reflecting America's Hispanic heritage opened in 1989.

The Museum of Indian Arts and Culture, built in 1987, features more than 50,000 objects relating to the native peoples of the Southwest, ranging from a 151-foot-long hunting net made in 1,100 A.D. to a bridle belonging to the Apache chief Cochise to the first black-on-black pot fired by Maria Martinez. Also featured are the collections of the Laboratory of Anthropology, activated 60 years ago.

In addition to its four museums, the Museum of New Mexico includes five historic state monuments.

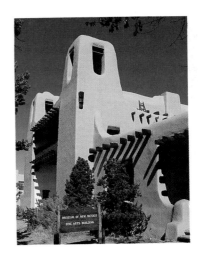

New Mexico Museum of Natural History

ALBUQUERQUE, NEW MEXICO

This new museum, established in 1980, first opened to the public in 1986 in a 100,000-square-foot building near Albuquerque's picturesque Old Town and already attracts more than 300,000 visitors annually.

The museum features exhibits like "Origins"—a walk through the evolution of the universe—and a 14-foot by 22-foot relief map of the earth with earthquakes and volcanic eruptions highlighted by 2,500 fiber-optic elements. The overall focus of the exhibit areas, however, is on the natural history of New Mexico and the Southwest.

The "Age of Giants" re-creates the environment of New Mexico during the Jurassic period and includes such dinosaurs as the 50-foot-long Camarasaurus and four rhamphorhyncoid pterosaurs. "New Mexico's Seacoast" features a living arboretum of trees similar to those that grew in the area 75 million years ago and the unique Borden "Evolator," which simulates a 38-million year journey through geologic history. In the "Age of Volcanos," visitors walk through what appears to be an active volcano with hissing steam vents and flowing magma. In "New Mexico's Ice Age," the Pleistocene epoch is re-created with reconstructed skeletons of local mammals, including mammoths, camels, dire wolves, and sabre-toothed tigers. "The Living Landscape" focuses on the recent ecology of the Southwest—recent meaning over the past 10,000 years. Even the museum's landscaping features the New Mexico environment with 200 tons of indigeinous rocks and 80 native plant species.

In addition to the permanent exhibits, the museum features a state-of-the-art Iwerks Dynamax Theater, an active schedule of changing exhibits, and the Naturalist Center—a hands-on activity room especially designed for children.

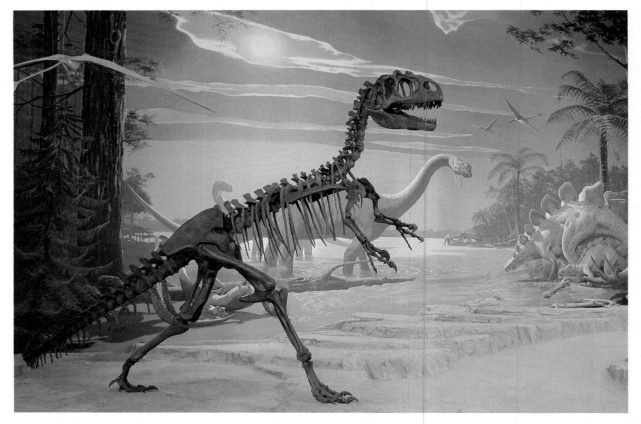

1 ALLOSAURUS, *AGE OF GIANTS* EXHIBIT

Photographs courtesy of Ron Behrmann.

2 FOSSIL FISH IN SANDSTONE

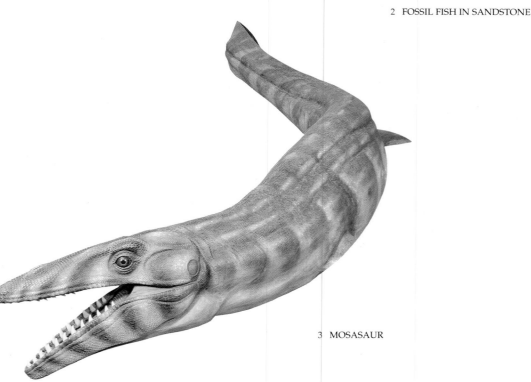

3 MOSASAUR

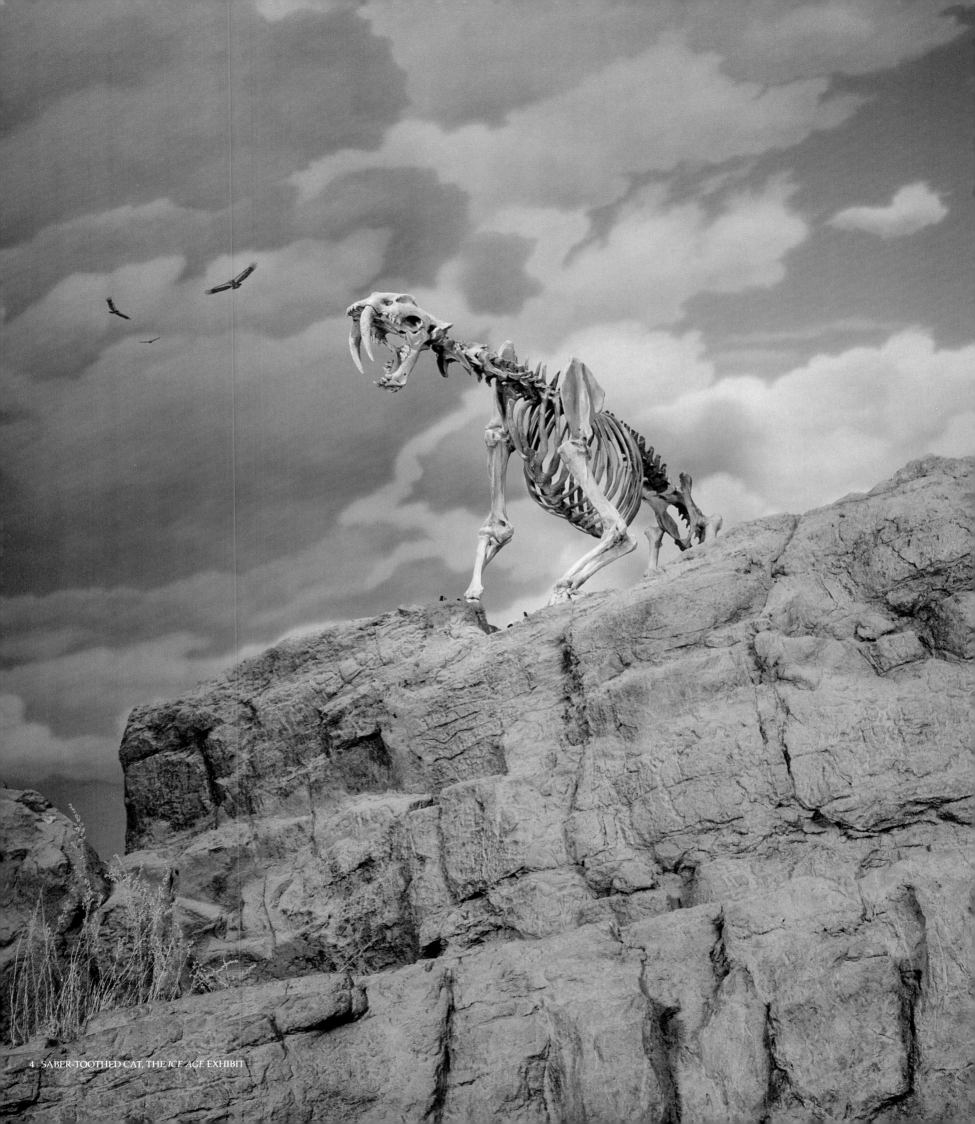

Center for Creative Photography

TUCSON, ARIZONA

The Center for Creative Photography at the University of Arizona at Tucson is a unique research museum where members of the public can view one of the world's leading photographic collections unhampered by traditional museum constraints.

The collection, which moved into the center's new 55,000-square-foot facility in 1989, consists of more than 50,000 matted fine photographic prints representing more than 1,400 photographers. There are also several dozen major photographic archives housed here, including those of Ansel Adams, Richard Avedon, Wynn Bullock, Harry Callahan, Louise Dahl-Wolfe, Andreas Feininger, Aaron Siskind, W. Eugene Smith, Paul Strand, and Edward Weston. The center's library includes over 11,000 volumes and over 500 hours of videotaped interviews with and lectures by noted photographers and historians.

While gallery space is devoted to items from the permanent collection and traveling exhibits, visitors here are not limited to seeing what is on display. Anyone may sign up for a print-viewing appointment and select virtually anything from the collection or the archives that he or she wishes to see, resulting in a personalized experience of this wonderful resource for each individual.

1 EDWARD WESTON *Nautilus Shells*

2 ANSEL ADAMS *Moonrise over Hernandez, New Mexico*

3 W. EUGENE SMITH *Tomoko Uemura Bathed by Her Mother*

1 American, ca. 1947, Kodachrome.
2 American, 1941, Gelatin silver print.
3 American, 1971–1975, from the series Minamata, Japan, Gelatin silver print.
4 American, 1980, Gelatin silver print.

4 RICHARD AVEDON *Tom Stroud, oil field worker*

Pima Air Museum

TUCSON, ARIZONA

Eighty years of aviation history are chronicled in the aircraft of the Pima Air Museum. Opened during America's bicentennial celebration in 1976, the 30-acre museum now features nearly 200 planes, some representing models that cannot be seen anywhere else.

Most of the aircraft at Pima had a military mission. The Boeing B-17 Flying Fortress and the B-29 Superfortress, awesome heavy bombers of World War II, stand in silent dignity here. The Grumman F-9 Cougar, which fought in Korea, is also represented, as is the McDonnell F101 Voodoo, which saw action in Viet Nam. Visitors can see for themselves why ground crews in the more than 14 different countries where the Lockheed F104D Starfighter was used had to fit the plane's razor-thin wings with felt caps during servicing to protect themselves.

There are other craft at Pima, too, planes that recall turning points in aviation history: a 1903 Wright brothers flyer; the North American X-15, which broke speed record after speed record; and the Lockheed 10A Electra, the type of craft used by Amelia Earhart in her ill-fated attempt to fly around the world in 1937.

In 1986 the Pima Air Museum began operating the Titan Missile Museum in nearby Green Valley, Arizona, the only intercontinental ballistic missile complex in the world open to the public. The installation consists of an actual Titan II Missile silo previously assigned to the 390th Strategic Missile Wing. Of the 54 Titan sites that were once on active alert in the United States, all have been destroyed except this one, which remains a symbol of a fearful time that no American wishes to revisit—except at a museum.

2. THE CONSOLIDATED B-24J "LIBERATOR," 1940s

3 THE "BUMBLE BEE," 1984

6 THE COLUMBIA XJL–1, 1946

7 TITAN II MISSILE, 1963–1987

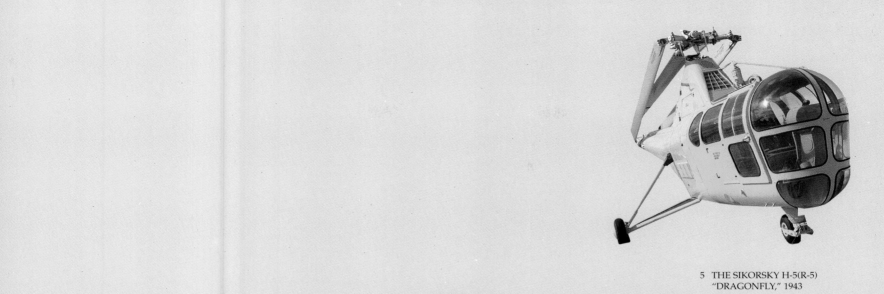

5 THE SIKORSKY H-5(R-5) "DRAGONFLY," 1943

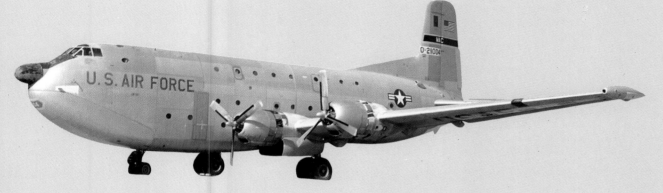

4 THE DOUGLAS C-124C "GLOBEMASTER," 1950–1955

8 PHOENIX MISSILE (REAR), 1986–1990S, AND MAVERICK MISSILE, 1972

Photographs by Lynn Radeka.

Phoenix Art Museum

PHOENIX, ARIZONA

Phoenix is a young, rapidly growing city and its art museum is also young and growing. The museum opened in 1959 and reached its present size of 75,000 square feet six years later. Although it is already the major fine arts institution in the Southwest, the Phoenix Art Museum is currently planning a renovation and expansion that will more than double its facilities.

In its short life, the Phoenix Art Museum has assembled a notable collection of more than 18,000 pieces. The Roy Wayland Gallery of Western Art includes superb works that focus on the unique landscape and history of the American West. There are galleries devoted to decorative arts, American and European portraiture, Asian arts, and to major artists of the 19th and 20th century, including the best-known Impressionists. Miniature rooms created by Mrs. James Ward Thorne beautifully replicate historic American and European interiors. The Arizona Costume Institute—one of only a handful of costume collections in the country—features exquisite clothing and accessories spanning more than 200 years, including creations of major 20th-century designers.

The museum began to receive national recognition in 1984 when it organized a major touring exhibition of the great Mexican muralist, Diego Rivera, which included nearly 80 works never before seen in this country. After the Rivera exhibit traveled to New York City, the young museum began putting a great deal of emphasis on its exhibition schedule, creating bigger and more important shows. Phoenix Art Museum now presents more than 25 exhibitions each year and has achieved critical acclaim for the exhibitions it organizes, like the recent "Frank Lloyd Wright Drawings," a major retrospective of the architect's work.

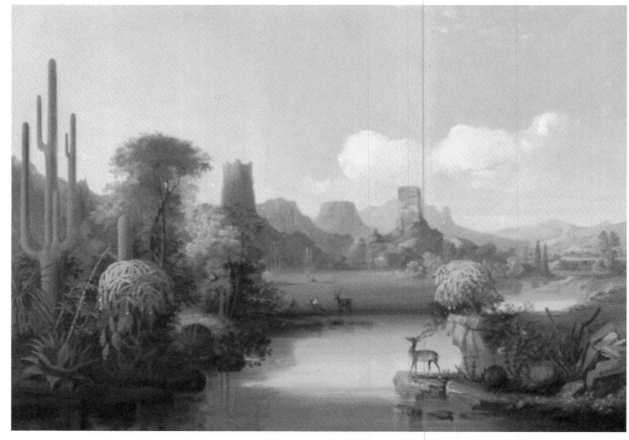

1 JOHN MIX STANLEY *Chain of Spires Along the Gila River*

1 American, 1855, Oil on canvas.
2 American, 1986, Bronze.
3 American, 1945, Black rayon crepe.
4 Mexican, 1938, Oil on panel.

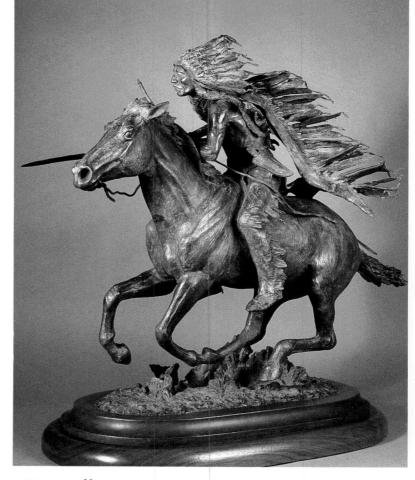

2 JOE BEELER *Vengeance*

3 ADRIAN *Evening gown*

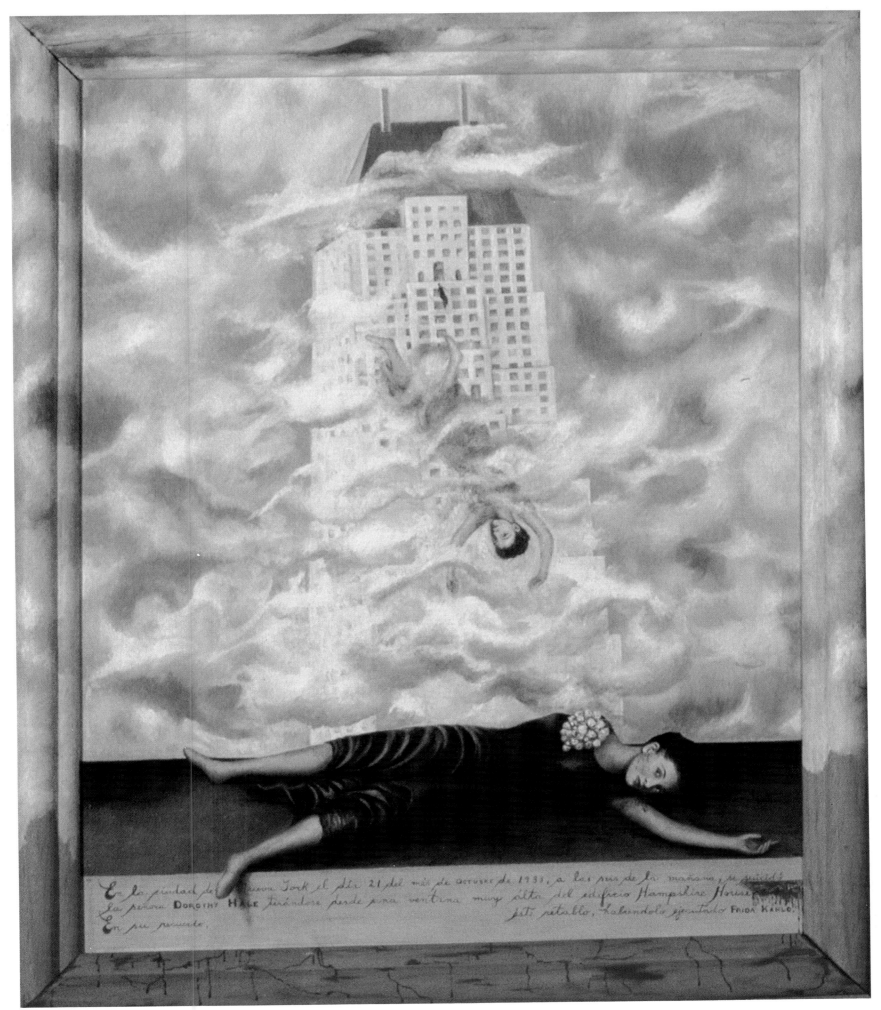

4 FRIDA KAHLO *Suicide of Dorothy*

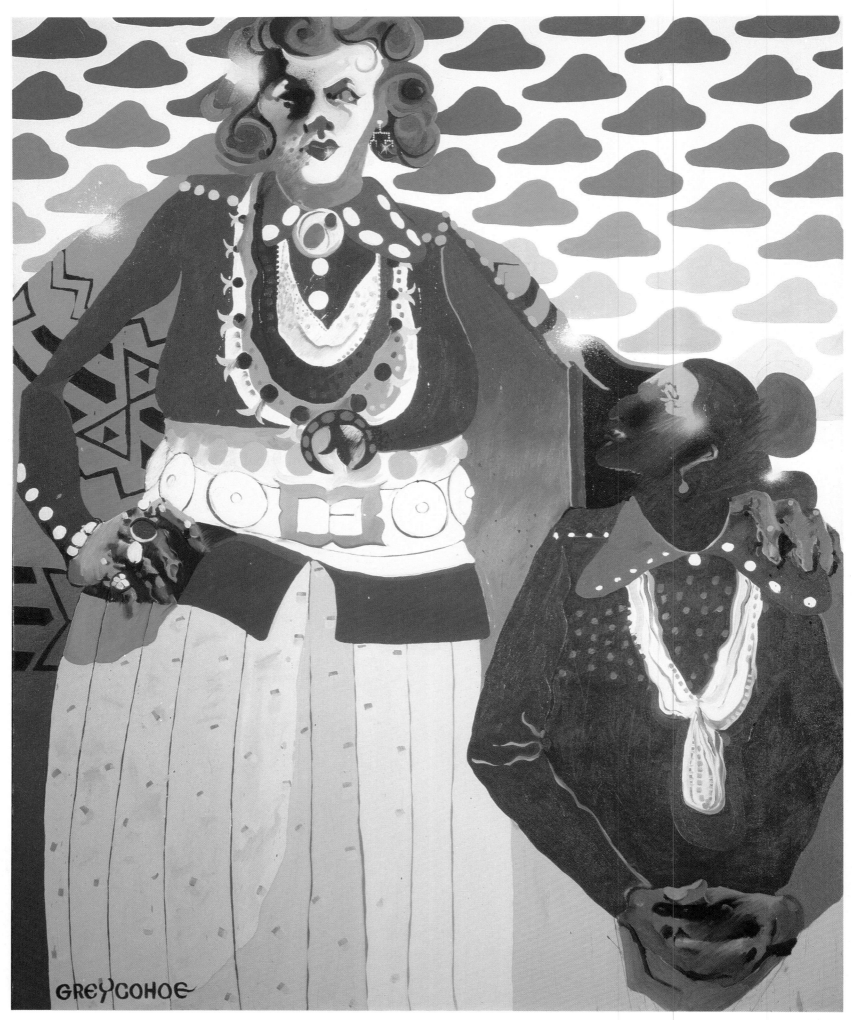

1 GREY COHOE *Tall Visitor at Tocito*

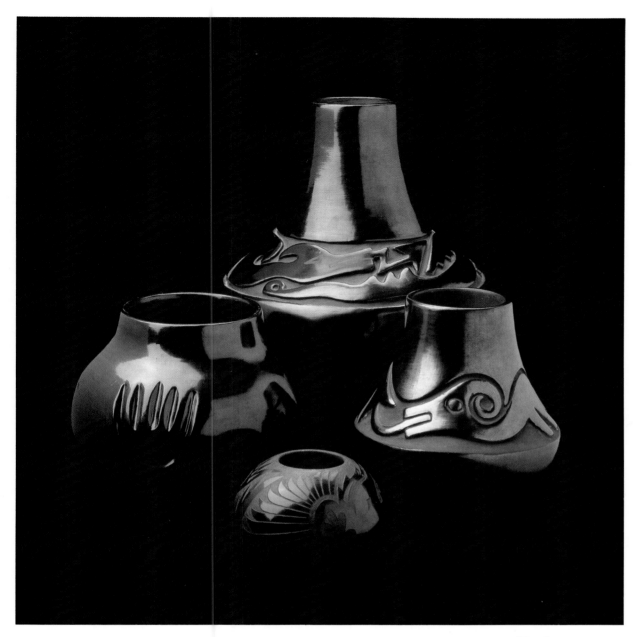

2 (CLOCKWISE FROM TOP) ROSE GONZALES, JOSEPH LONE WOLF, TERESITA NARANJO, MARGARET TAJOYA *Vessels*

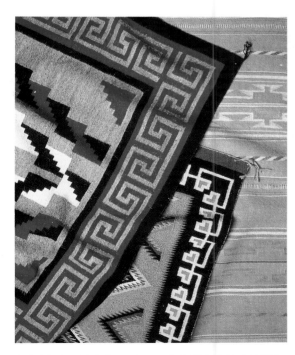

3 (TOP TO BOTTOM) ALICE BEGAY, DEE ETSITTY, LOTTIE THOMPSON *Native American textiles*

4 WHITE BEAR FREDERICS *Kachina Doll*

1 American, 1981, Acrylic
2 Americans, n.d, Blackware.
3 Americans,1950s–1970s. wool.
4 American, n.d.. Cotton wood.

The Heard Museum

PHOENIX, ARIZONA

Dwight and Maie Bartlett Heard moved from Chicago to Phoenix in 1894. Almost immediately they became interested in the culture of the Southwest and began collecting Native American artifacts. As their business interests in real estate development and newspapers grew, so did their collection, which the Heards ultimately decided to open as a public resource.

Shortly after Mr. Heard's death in 1929, the Heard Collection was installed in a two-story Spanish Colonial building with a central courtyard. The collection has grown substantially since then through gifts and legacies, and today is recognized internationally as an important center of learning about the Native Americans of the Southwest.

The museum's holdings include more than 1,000 pieces of Navajo silver jewelry, as well as superb Hopi and Zuni works; 1,300 textiles, 700 of which are Navajo weavings; 3,500 ceramics by peoples of the Southwest, ranging from prehistoric to modern pieces; 600 examples of beadwork and quillwork; 2,500 baskets by Native Americans cultures west of the Mississippi; 1,200 kachina dolls, including the collections of Barry Goldwater and the Fred Harvey Company, and 2,500 paintings, sculptures, and other works by Native American artists.

The museum features two permanent exhibits. "Native Peoples of the Southwest," one of the most extensive exhibits of its kind in North America, covers the history of Native Americans of the Sonoran Desert, the Southwestern Uplands, and the Colorado Plateau. "Old Ways, New Ways" is a state-of-the-art, hands-on exhibit that was designed especially for families. It features the cultures of Northwest Coast Tsimshian, Southwest Zuni, and the Great Plains Kiowa.

The museum also features artifacts by peoples of Mexico, Central and South America, Africa, and the Pacific.

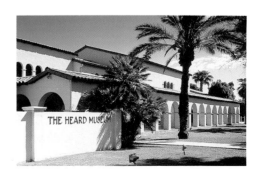

The National Automobile Museum

RENO, NEVADA

Hotel and casino owner Bill Harrah started collecting automobiles in 1948 with the purchase of a 1911 Maxwell and a Ford Model T. By the time of his death in 1978, Harrah's collection had become one of the nation's foremost. More than 200 antique, classic, and special interest cars, most of which come from Harrah's collection, have now found a unique home in the nation's largest automobile display space—the 105,000-square-foot National Automobile Museum in downtown Reno, Nevada.

The museum opened in 1989 in a building reminiscent of car design, complete with rounded corners, chrome stripping, and panels painted with the popular 1950s automobile color "heath fire mist." Inside, visitors can enjoy a multimedia presentation tracing the development of the automobile, four authentic street scenes representing each quarter of the 20th century, and costumed interpreters who help make the various eras of automotive history come alive.

The collection itself—the most comprehensive public display of cars in the Western hemisphere—includes such classics as an 1892 Philion steam carriage; the futuristic 1934 Dymaxion; a 1913 Stutz Bearcat; the rare 1938 Phantom Corsair; the original 1907 Thomas Flyer, winner of "The Great Race," in 1908 from New York to Paris; and one of the 49 Tuckers that are still roadworthy today.

The museum also possesses a number of automobiles that are famous because of their association with celebrities: the black 1949 Mercury featured with James Dean in the movie *Rebel Without A Cause*; Al Jolson's V-16 1933 Cadillac All Weather Phaeton; a 1973 Cadillac Eldorado Coupe belonging to Elvis Presley; Frank Sinatra's 1961 Ghia; and finally Jack Benny's humble 1923 Maxwell, which the comedian used in his casino stage shows in the 1960s.

1 1911 FORD MODEL T

2 1933 V-16 CADILLAC ALL WEATHER PHAETON OWNED BY AL JOLSON

3 1936 DESOTO CAB

4 1936 MERCEDES BENZ 500K SPECIAL ROADSTER

1 LUCA SIGNORELLI *Coronation of the Virgin*

2 MANUEL NERI
Escalieta No. 5

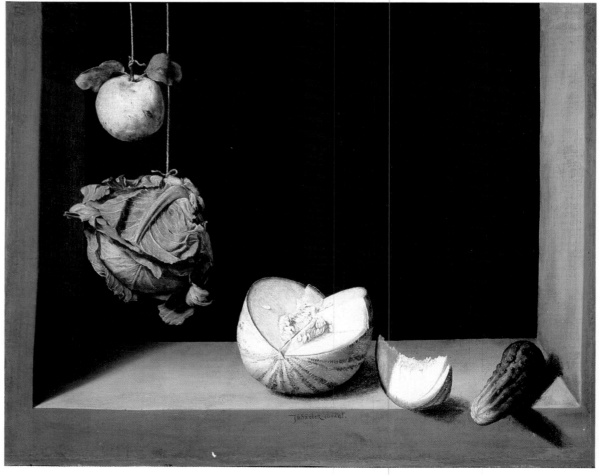

3 FRAY JUAN SANCHEZ COTAN *Quince, Cabbage Melon and Cucumber*

4 JOAQUIN SOROLLA Y BASTIDA *My Daughter Maria at La Granja (Girl in White)*

The San Diego Museum of Art

SAN DIEGO, CALIFORNIA

Located in Balboa Park, the San Diego Museum of Art occupies a distinctive two-story, Spanish-style building housing a collection of 15,000 objects ranging from the Egyptian and pre-Columbian periods to the present.

The museum is perhaps best known for its sophisticated collection of Italian Renaissance and Spanish Baroque paintings. Highlights of the museum's Italian holdings include works by Carlo Crivelli, Canaletto, Luca Signorelli's lunette for the Filippini Altarpiece, and the only undisputed work by Giorgione in America. El Greco, Francisco Zurbarán, and Francisco Goya are just a few of the Spanish artists represented.

Paintings by such artists as Peter Paul Rubens, Frans Hals, Jean-Auguste-Dominique Ingres, Claude Monet, Henri Matisse, and Max Beckmann round out the museum's European collection. There are also more than 100 graphics by Henri Toulouse-Lautrec, and a noteworthy group of paintings, including works by René Magritte, Salvador Dali, and Giorgio de Chirico.

American paintings include works by Raphaelle Peale, George Inness, Thomas Eakins, Georgia O'Keeffe, Frank Stella, and folk artist Ammi Phillips.

The comprehensive Asian collections include displays of earthenware vessels, stoneware and pottery figurines, archaic jade, decorative lacquerware, porcelain, cloisonné, and ceremonial swords and sword guards. In addition, the museum was the beneficiary of two recent gifts— the internationally prominent Binne Collection of 1,400 Indian miniatures made between 1138 to the present and 33 major works of contemporary California art. The latter, a gift of the Frederick R. Weisman Art Foundation Collection, is now on permanent view in the new Frederick R. Weisman Gallery for California Art.

The J. Paul Getty Museum

MALIBU, CALIFORNIA

One of the most unusual arts institutions anywhere is that named for oil baron J. Paul Getty. One of the world's wealthiest men when he died, Getty endowed the museum so richly that few others can compete against it in its areas of interest, which parallel the founder's own eclectic tastes.

The museum building is a recreation of the Villa dei Papiri, a Roman country house which stood on the bay of Naples, and which was buried when Mt. Vesuvius erupted in 79 A.D. Modern bronze casts of some of the villa's original statues stand in the museum's lush gardens.

The Getty has an outstanding collection of Greek and Roman antiquities spanning the period from 2500 B.C. to 300 A.D., including a limestone and marble Aphrodite, the bronze *Victorious Athlete*, and an interesting group of cycladic sculptures. The collection of drawings includes more than 200 works by artists from the Renaissance to Impressionism. The collection of European paintings from the 14th to the 19th centuries includes many important works, such as the recently acquired Van Gogh *Irises*, which broke all auction records when it was sold to its previous owner in 1987 for $53.9 million. The museum also features European illuminated manuscripts, decorative arts from various periods, European and American photography, and European sculpture from the Renaissance to the end of the 19th century.

The musuem is one of several programs sponsored by the J. Paul Getty Trust, a private operating foundation. Upon the trust's completion of the J. Paul Getty Center in Los Angeles—presently scheduled for 1996—the museum will move its collections, except its antiquities, to the new site. At that point, the Malibu villa will become the only museum in the United States exclusively devoted to Greek and Roman art.

1 VINCENT VAN GOGH *Irises*

2 UNKNOWN *Cult Statue of a Goddess (Aphrodite?)*

3 ANDRE-CHARLES BOULLE (ATTRIBUTED TO) AND JEAN VARIN (MEDALLIONS AFTER) *Cabinet on stand*

1 Dutch, c. 1888, Oil on canvas, 90.PA.20.

2 Greek, 425–400 B.C., Limestone and marble, 88.AA.76.

3 French, c. 1675–1680, Oak veneered with ebony, pewter, tortoiseshell, brass, ivory, horn, and many stained woods; lignum vitae drawers; painted and gilded wood; bronze mounts, 77.DA.1.

4 Italian, 1537–1538, Oil (or oil and tempera) on panel transferred to canvas, 89.PA.49.

5 Italian, 1495–1505, Tempera on canvas, 85.PA.417.

6 Dutch, c. 1637, Red chalk heightened with white chalk on paper, 81.GB.27.

7 Dutch, 1627, Oil on canvas, 84.PA.5.

8 Greek, Late 4th century B.C., Bronze, 77.AB.30.

4 JACOPO PONTORMO *Portrait of Cosimo De' Medici*

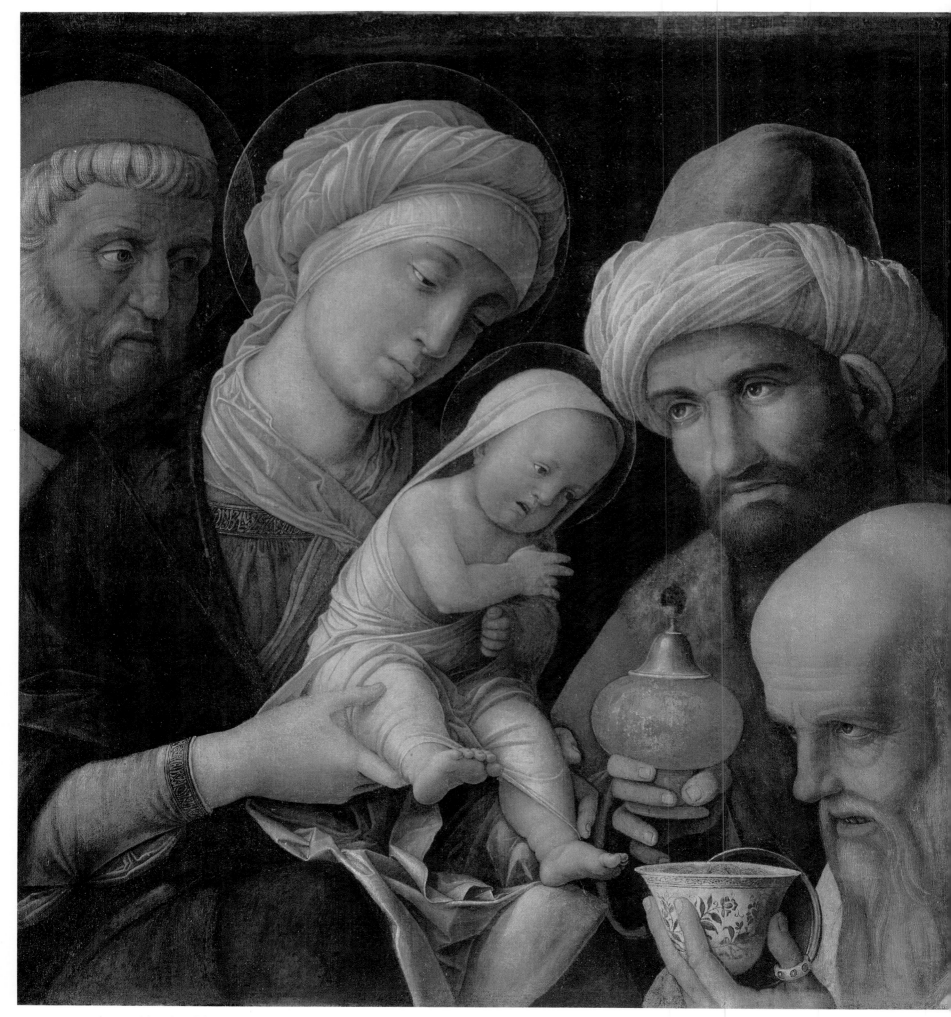

5 ANDREA MANTEGNA *Adoration of the Magi*

6 REMBRANDT *Nude Woman with a Snake as Cleopatra*

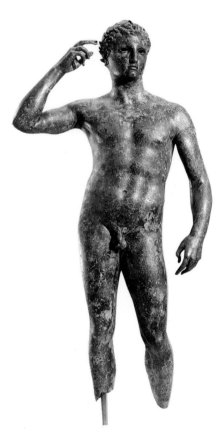

8 UNKNOWN *Victorious Athlete*

7 HENDRICK TER BRUGGHEN
Bacchante with Ape

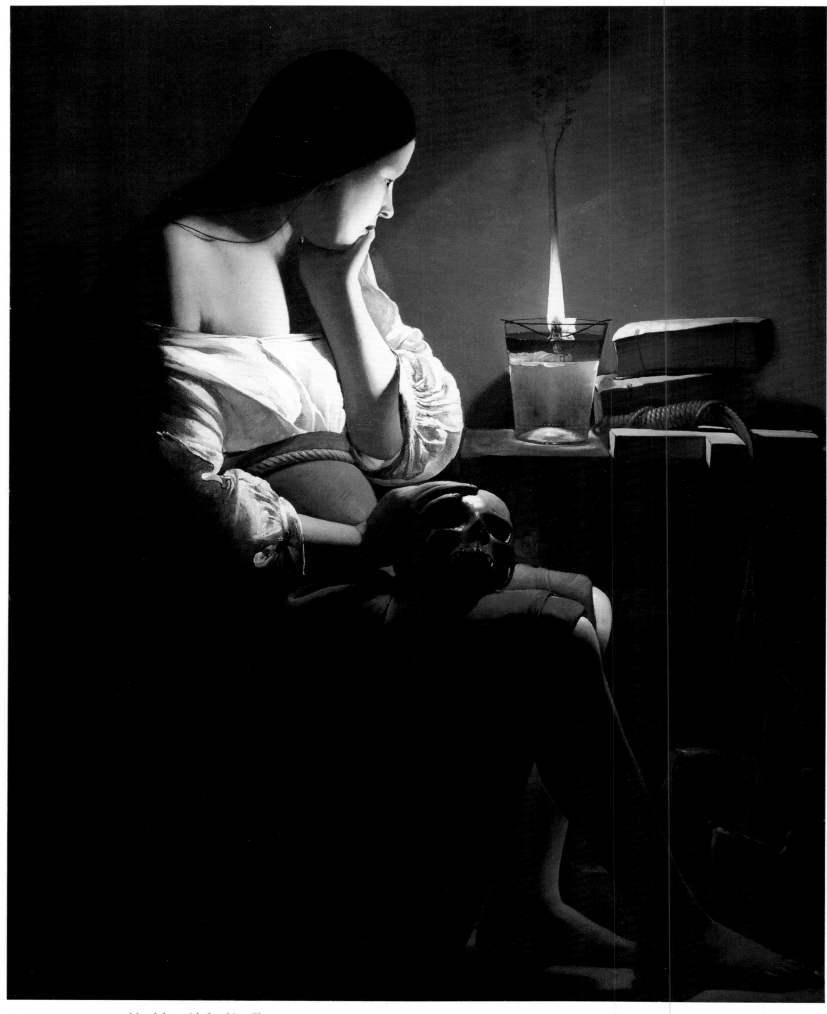

1 GEORGES DE LA TOUR *Magdalen with Smoking Flame*

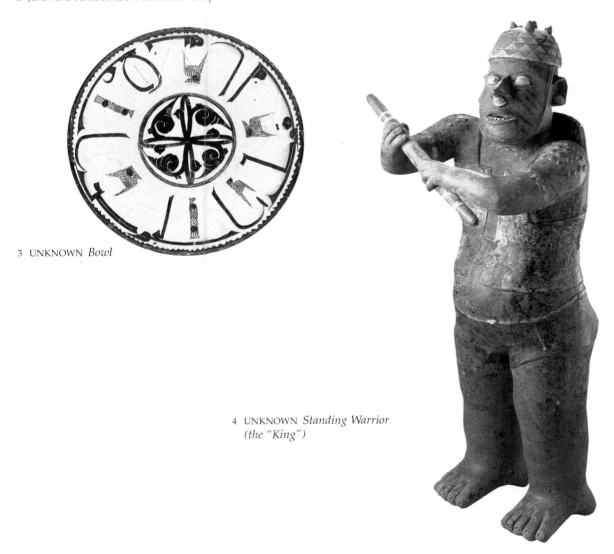

2 JEAN-BAPTISTE SIMEON CHARDIN *Soap Bubbles*

3 UNKNOWN *Bowl*

4 UNKNOWN *Standing Warrior*
(the "King")

Los Angeles County Museum of Art

LOS ANGELES, GALIFORNIA

The 500,000-square-foot, five-building complex that comprises the Los Angeles County Museum of Art contains one of the major art collections in the United States. Originally part of the Los Angeles County Museum of Science, History and Art, LACMA branched out on its own in 1965 and has recently completed an extensive program of additions and renovations.

The Ahmanson Building houses most of the museum's varied holdings, which total more than 250,000 works. Here can be found one of the world's most renowned collections of Indian and Southeast Asian art, as well as the museum's strong holdings in European painting, sculpture, and decorative arts, including Georges de la Tours' stunning *Magdalene with Smoking Flame*, Rembrandt's *The Raising of Lazarus*, and Jean-Baptiste Chardin's *The Soap Bubbles*. The Ahmanson building also contains the Far Eastern collection; American painting and sculpture; costumes and textiles; pre-Columbian art; and ancient and Near Eastern art.

Twentieth-century art is the focus of the Robert O. Anderson Building, which opened in 1986. Among the more than 300 works on display here are Georges Braque's *Still Life With Violin*, David Hockney's *Mulholland Drive: The Road to the Studio*, and Anselm Kiefer's sculpture, *The Book*.

The 1988 Pavilion for Japanese Art houses the museum's extensive Japanese holdings, including a major collection of netsukes and what is considered the most outstanding assemblage of Edo-period paintings in the Western world. This is the only building outside of Japan exclusively devoted to Japanese art.

Rounding out the complex, the Hammer Building houses special exhibitions and the museum's collections of prints, drawings, and photographs. The Leo S. Bing Center contains the museum's two theaters.

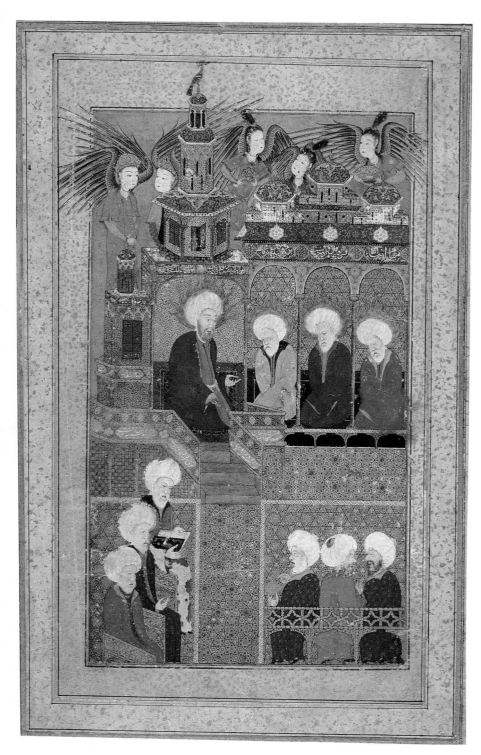

5 UNKNOWN *The Prophet Muhammad with His Companions*

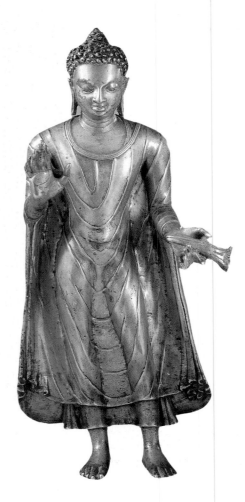

7 DAOJI (SHITAO) *Album of Landscapes (leaf 2 of 8)*

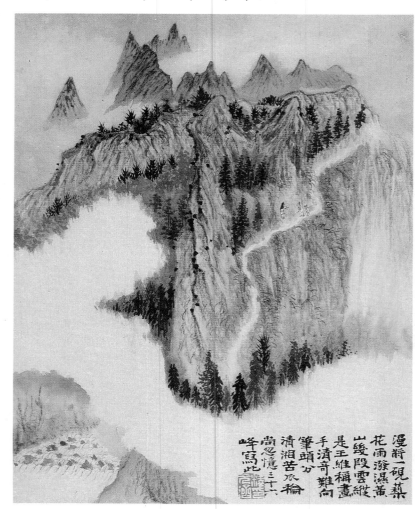

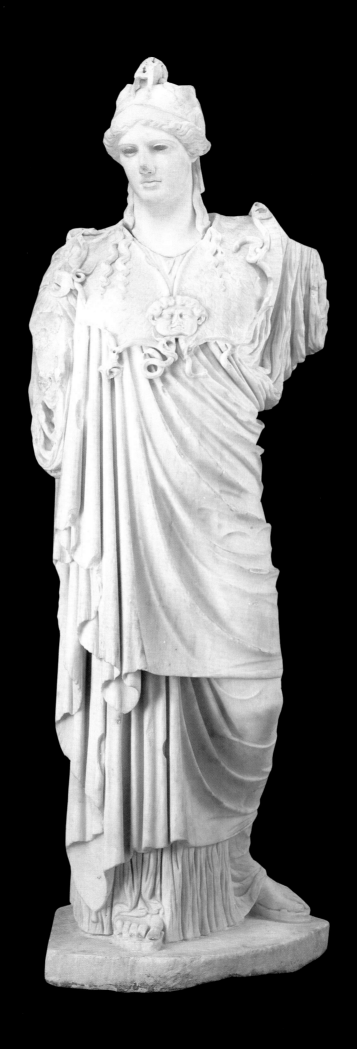

9 DAVID HOCKNEY *Mulholland Drive: The Road to the Studio*

10 UNKNOWN *Archangel Raphael*

11 UNKNOWN *Siva as the Lord of Dance (Nataraja)*

1 French, c. 1640, Oil on canvas, Gift of the Ahmanson Foundation.

2 French, after 1739, Oil on canvas, Gift of the Ahmanson Foundation.

3 Northeastern Iranian or western Turkestani, 9th–10th century, Underglaze painted ceramic, The Nasli M. Heeramaneck Collection, gift of Joan Palevsky.

4 Mexican, c. 100 B.C.–A.D. 300, Ceramic with red slip, yellow, white, and black paint, The Proctor Stafford Collection, purchased with funds provided by Mr. and Mrs. Allan C. Balch.

5 Turkish, c. 1558, Ink, opaque watercolor, and gold on paper, The Nasli M. Heeramaneck Collection, gift of Joan Palevsky

6 Indian, late 6th century, Copper alloy with color, Gift of the Michael J. Connell Foundation.

7 Chinese, Qing dynasty, 1694, Ink and color on paper.

8 Roman after a Greek original of the late 5th century B.C., 2nd century A.D., Marble, WIlliam Randolph Hearst Collection.

9 British, 1980, Acrylic on canvas, Purchased with funds provided by the F. Patrick Burns bequest.

10 Italian, about 1600, Polychromed and gilded wood, Gift of Anna Bing Arnold.

11 Indian, about 950, Copper alloy, Given Anonymously.

12 American, 1890, Oil on canvas, Frances and Armand Hammer Purchase Fund.

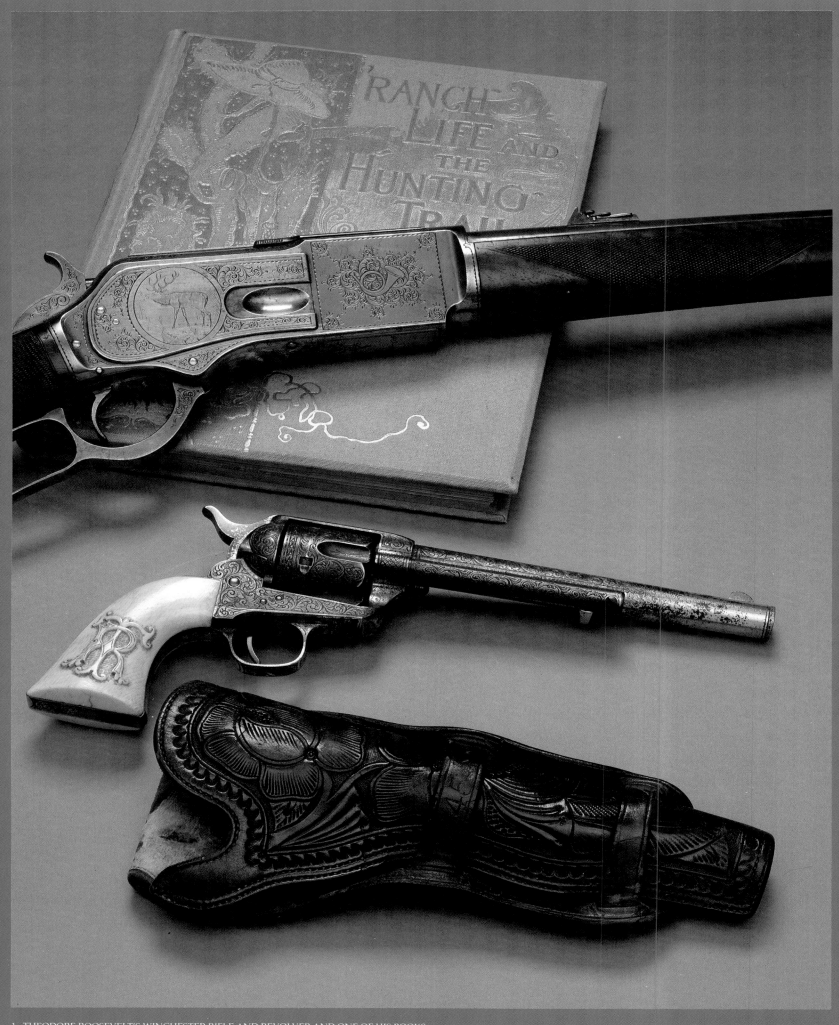

1 THEODORE ROOSEVELT'S WINCHESTER RIFLE AND REVOLVER AND ONE OF HIS BOOKS.

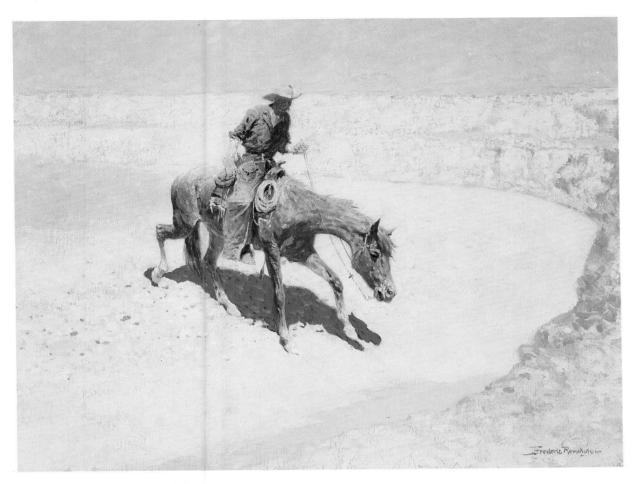

2 FREDERIC REMINGTON *Waterhole*

2 American, c. 1905, Oil on canvas.
3 New Mexican, 1830–1840, Cottonwood and natural pigment.
4 American, 1875, Oil on canvas.
7 Plains Indian, 1890, Brain-tanned leather, seed beads.

3 THE SANTO NINO SANTERO *Santo of San Antonio*

The Gene Autry Western Heritage Museum

LOS ANGELES, CALIFORNIA

Cowboy star Gene Autry founded this museum in 1984 to preserve artifacts of the West, to record the history of frontier life, and to chronicle how America's mythic image of the Old West evolved.

The museum's Spanish-Mission-style, 140,000-square-foot building in Griffith Park opened in 1988, featuring a collection of more than 16,000 objects, including paintings by many of the great artists of the West, a superb collection of firearms, and artifacts belonging to everyone from Teddy Roosevelt to the Lone Ranger.

The focal points of the museum are its seven "Spirit" galleries developed in association with Walt Disney Imagineering. "The Spirit of Discovery" features articles of those who settled in the West going back to prehistoric times. "The Spirit of Opportunity" tells of the lure that brought the hardy pioneers across the plains, displays the possessions they traveled with, and depicts the story of their expectations compared to the reality they found. "The Spirit of Conquest" shows how the environment was mastered through varying means of transportation and communication, and how the region's different cultures came into conflict. "The Spirit Of Community" considers the social and economic structure of the West, as well as the issue of law and order. Featured is an 1880s saloon, and Wyatt Earp's pencil diagram of the incident at the O.K. Corral.

One of the most recognized and enduring images of the West is featured in "The Spirit of the Cowboy," which includes an extensive collection of saddles, branding irons, and other tools of the cowpuncher's trade. "The Spirit of Romance," which houses the museum's permanent collection of important paintings and sculpture, reveals how the West began to take on mythical dimensions in the 19th century. Finally, "The Spirit of Imagination" shows how movies, TV, radio, and books create their own fictional view of the American West.

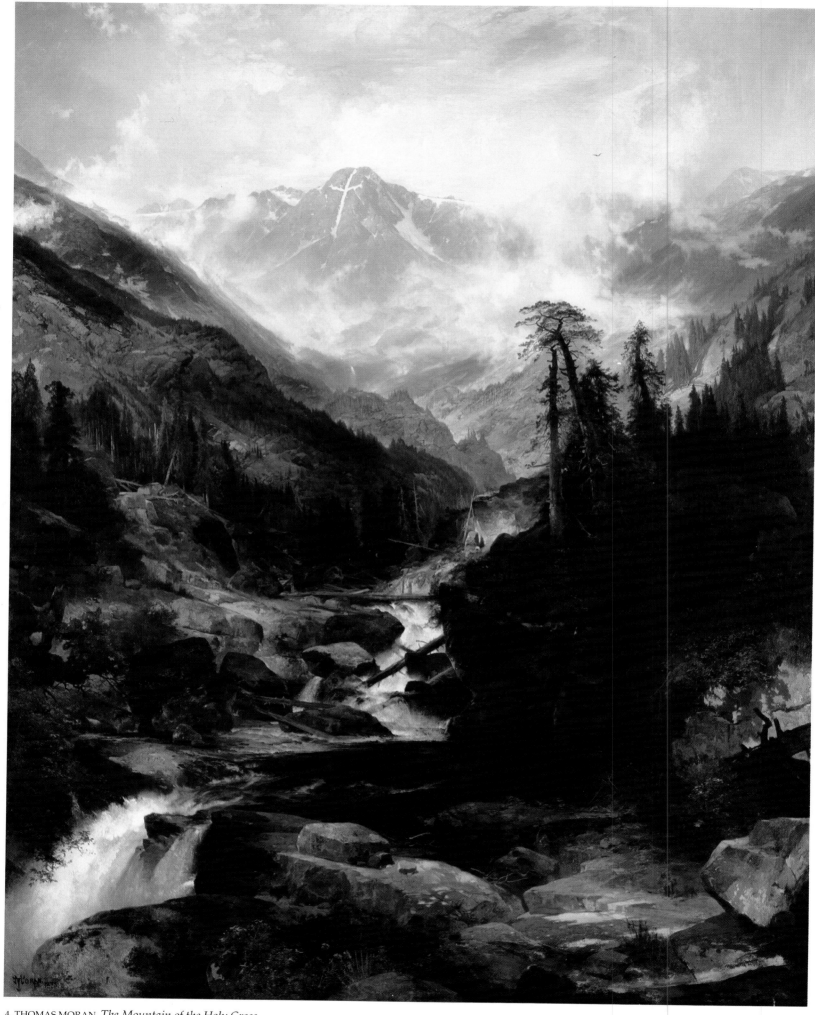

4. THOMAS MORAN *The Mountain of the Holy Cross*

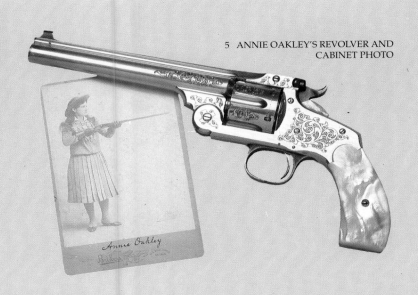

5 ANNIE OAKLEY'S REVOLVER AND
CABINET PHOTO

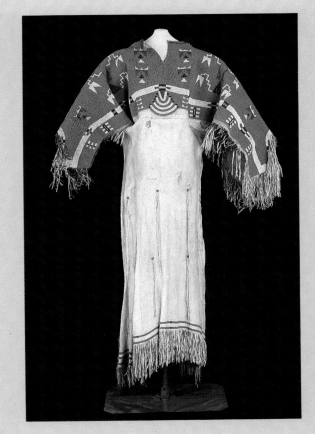

7 SIOUX DRESS, 1890

6 BUDWEISER POSTER, C. 1903.

8 CALIFORNIA VAQUERO SADDLE, C. 1860

The Huntington

SAN MARINO, CALIFORNIA

The Huntington is not one great institution but three: a renowned art collection, a spectacular botanical garden, and one of the world's foremost research libraries.

The Huntington Art Gallery, originally the residence of founder Henry E. Huntington, features the most comprehensive and distinguished collection of 18th- and 19th-century British art outside of London. In the main gallery alone is probably the finest group of full-length British portraits anywhere—Thomas Gainsborough's *Blue Boy* and Thomas Lawrence's *Pinkie* to name but two. The Arabella D. Huntington Memorial Collection includes Renaissance paintings and 18th-century French decorative arts, while the Virginia Steele Scott Gallery of American Art, which opened in 1984, features the works of such artists as Mary Cassatt, Edward Hopper, and John Singer Sargent.

The Huntington Botanical Gardens covers 150 acres and features over 14,000 different kinds of plants. There are 15 principal gardens, ranging from a traditional Japanese garden to the 12-acre desert garden that comprises one of the largest outdoor collections of mature cacti and succulents in the world. The Huntington Library, devoted to the study of British and American history and literature, contains nearly 2.5 million manuscripts and 336,000 rare books. The Library's Ellesmere Chaucer and Gutenberg Bible are often on display as are items from the Huntington collection of early Shakespeare editions—unsurpassed by the holdings of any other library.

Each year nearly 2,000 scholars from throughout the world undertake research projects here, and half a million members of the public come to enjoy the fabulous gardens and art treasures.

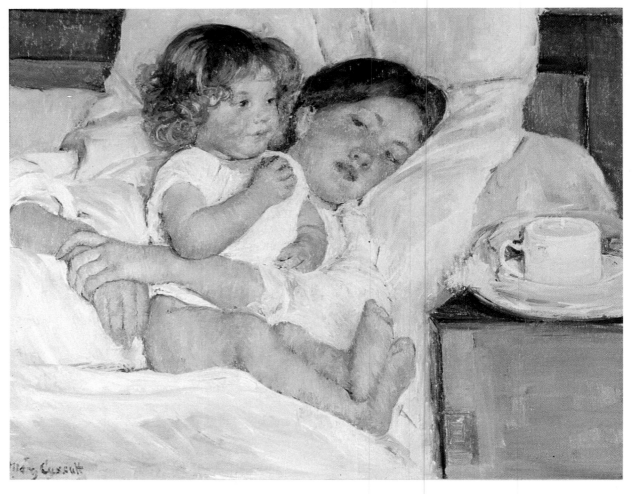

1 MARY CASSATT *Breakfast in Bed*

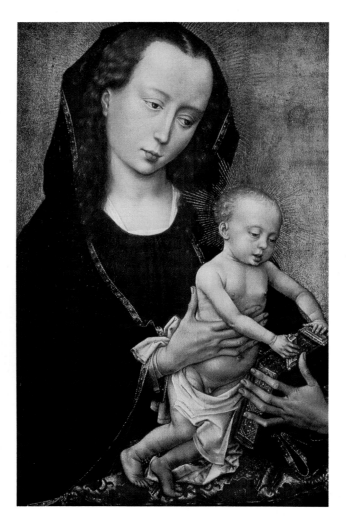

2 ELLESMERE MANUSCRIPT OF CHAUCER'S *The Canterbury Tales*

3 ROGER VAN DER WEYDEN *Madonna and Child*

1 American, 1897, Oil on canvas.
3 Flemish, 15th century, Oil on panel.
4 British, 1770, Oil on canvas.

226

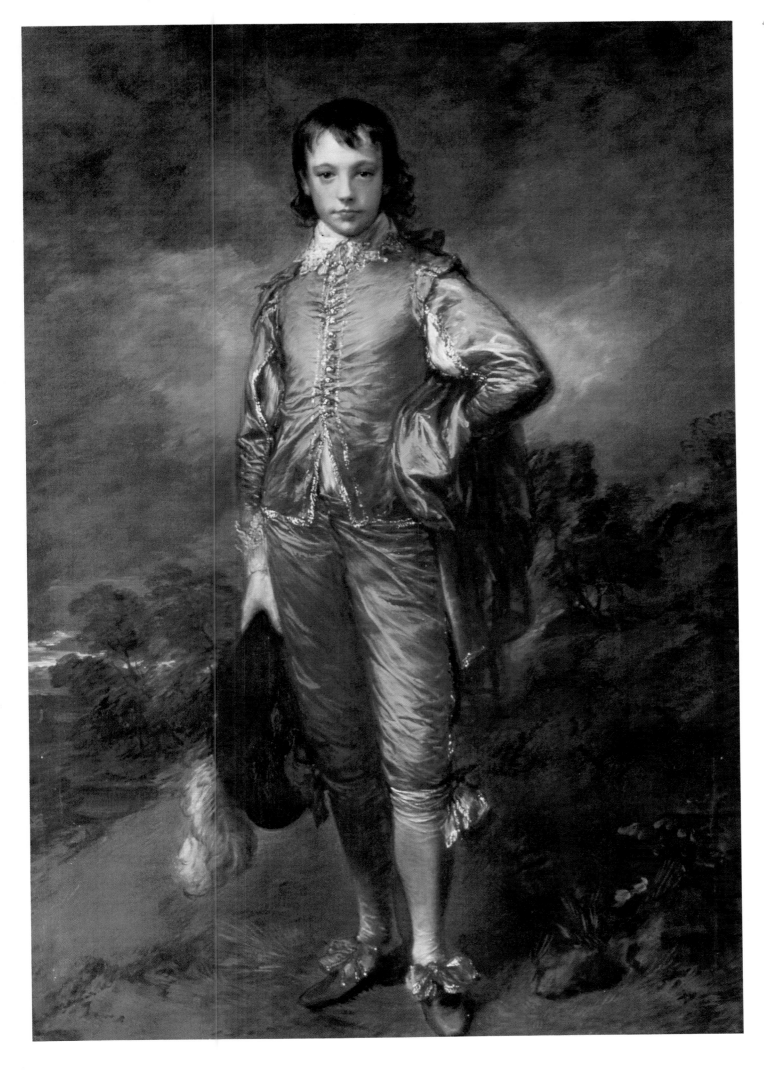

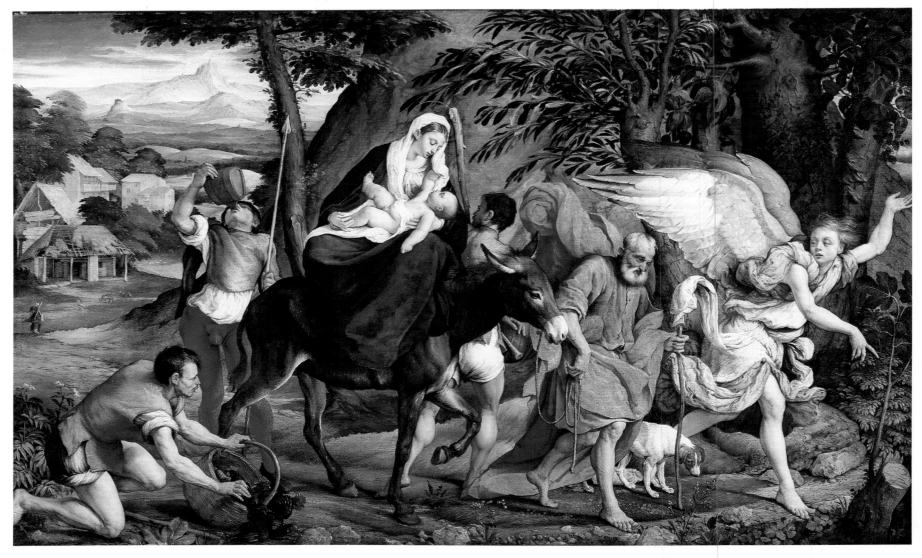

1 JACOPO BASSANO *The Flight into Egypt*

1 Italian, c. 1544/45, Oil on canvas.
2 French, 1884/85, Bronze.
3 Dutch, c. 1645–1650, Oil on canvas.
4 Spanish, 1633, Oil on canvas.

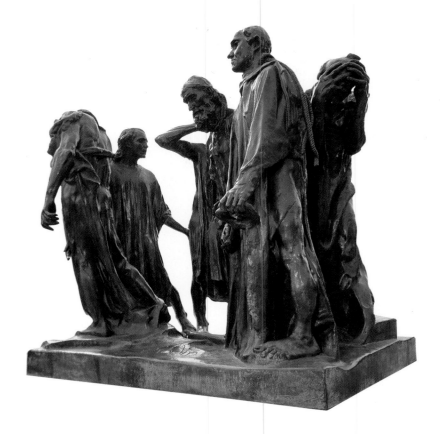

2 AUGUSTE RODIN *The Burghers of Calais*

The Norton Simon Museum of Art

In 1974 Norton Simon, the industrialist and philanthropist, came to the aid of the ailing 85,000-square-foot Pasadena Art Museum. The museum, originally founded in 1924 as the Pasadena Art Institute, had moved into a new building in 1969 and featured an exclusively contemporary collection. By contrast, the reorganized and remodeled museum served as a showcase for Simon's own internationally recognized collection of European paintings from the Renaissance to the 20th century.

The Norton Simon is a quiet, scholarly place fitting harmoniously into its environs. About 1,000 of the museum's 11,650 objects are regularly on view in 30 chronologically arranged galleries. Featured are masterpieces by some of the greatest names in the history of art, including Jacopo Bassano's *Flight Into Egypt*; Francisco Zurbarán's *Still Life with Lemons, Oranges, and a Rose*; Rembrandt's *Portrait of the Artist's Son, Titus*; Vincent Van Gogh's *The Mulberry Tree*; and Pablo Picasso's *Woman With Book*.

Other celebrated old masters represented here include Raphael, Sandro Botticelli, Peter Paul Rubens, Antoine Watteau, Jean-Honoré Fragonard, and Francisco Goya. There are also outstanding Impressionist and Post-Impressionist paintings, as well as 20th-century works including those of the German Expressionists. The museum also features sculptures by such artists as Auguste Rodin, Aristide Maillol, and Henry Moore, and a unique set of Edgar Degas' original master bronzes.

An outstanding assemblage of sculpture from India and Southeast Asia spanning 2,000 years complements the presentation of Western art.

3 REMBRANDT *Portrait of the Artist's Son, Titus*

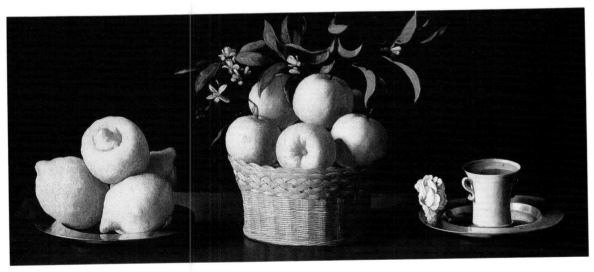

4 FRANCISCO DE ZURBARAN *Still Life with Lemons, Oranges and a Rose*

229

The Fine Arts Museums of San Francisco

SAN FRANCISCO, CALIFORNIA

The two institutions that comprise the Fine Arts Museums of San Francisco are both identified with the great symbol of the Bay City, the Golden Gate.

The M. H. de Young Memorial Museum in Golden Gate Park features an outstanding textile collection and works from Africa, Oceana, and the Americas, but its real strength lies in its holdings in American art. There are now 21 galleries of the nation's art at the de Young, stretching from colonial times to the present and featuring decorative arts, paintings, sculpture, silver, and folk arts. Virtually all the great names of American art are represented here, craftspeople as well as artists. There are portraits by Gilbert Stuart and John Singer Sargent, landscapes by Frederic Church and Albert Bierstadt, furniture by John Henry Belter, and silver by Paul Revere. Special note should be made of the extraordinary group of eye-tricking still lifes by turn-of-the-century *trompe l'oeil* artists William M. Harnett, John F. Peto, and John Haberle.

The California Palace of the Legion of Honor, set against the spectacular backdrop of the Golden Gate Bridge, is one of the most dramatic museum buildings in the nation, adapted from the Hôtel de Salm in Paris where Napoleon established his Legion d'Honneur. The galleries here chronicle European art (except British) from the Middle Ages to the 20th century and include extraordinary works by masters like Georges de La Tour, El Greco, Rembrandt, Jean-Honoré Fragonard, and the Impressionists, as well as one of the world's finest collections of Rodin's sculpture.

Both museums have recently undergone gallery renovations and both feature continually changing exhibitions.

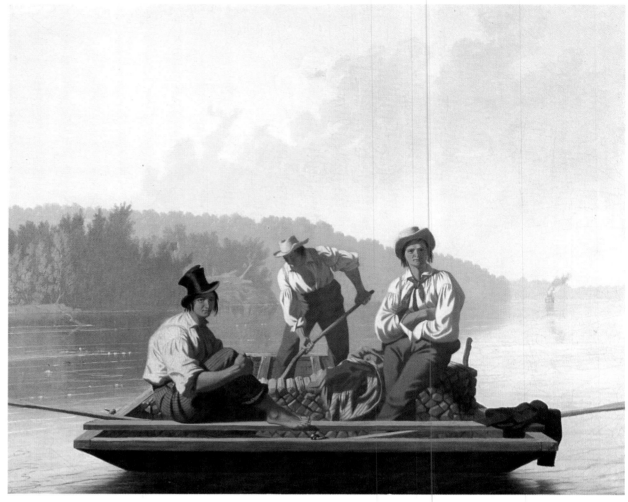

1 GEORGE CALEB BINGHAM *Boatmen on the Missouri*

THE M. H. DE YOUNG MEMORIAL MUSEUM

2 AUGUSTE RODIN *Thinker*

3 WILLIAM MICHAEL HARNETT *After the Hunt*

4 PAUL CÉZANNE *The Rocks in the Park of the Chateau Noir*

THE CALIFORNIA PALACE OF THE
LEGION OF HONOR

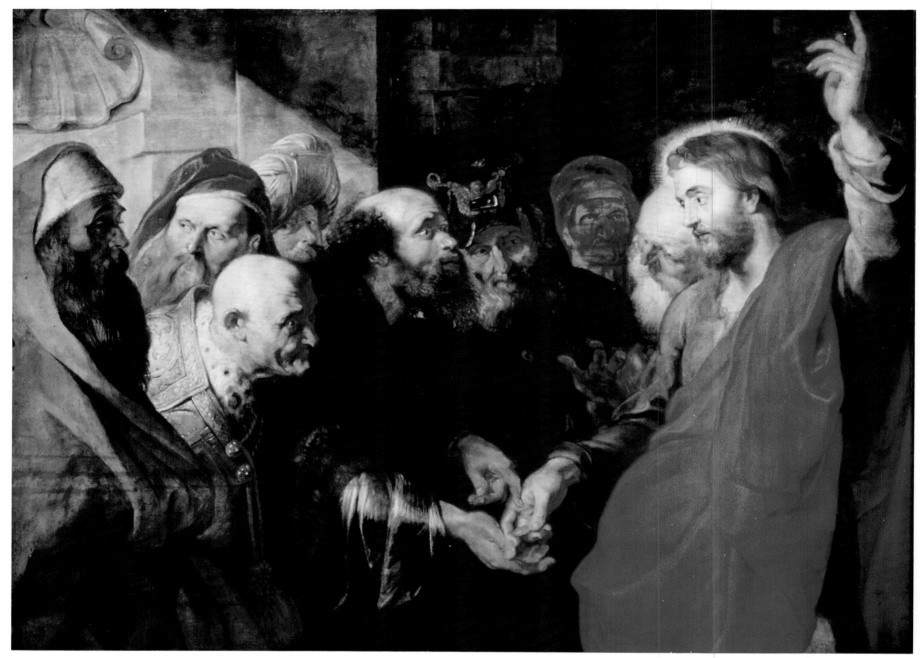

5 PETER PAUL RUBENS *The Tribute Money*

6 THOMAS ANSHUTZ *The Ironworkers' Noontime*

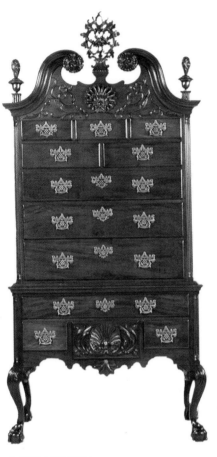

8 PHILADELPHIA
High Chest of Drawers

1 AD FOR THE NEW HAVEN RAILROAD, 1942

2 AD FOR UNEEDA BISQUITS, C. 1899

3 AD FOR MARLBORO CIGARETTES, BEFORE 1954

4 SIGN FOR BUSTER BROWN SHOES, 1904–1915

The American Advertising Museum

PORTLAND, OREGON

Dedicated in 1986, the American Advertising Museum is the world's only museum exclusively devoted to the history and culture of advertising. Its comprehensive collection of American advertising and advertising artifacts was assembled through contributions and loans from advertisers, ad agencies, the media, private collections, and museums including the Smithsonian Institute.

The museum's exhibitions include a gallery of print ads illustrating the evolution of advertising since the 15th century; continuously playing radio ads and classic television commercials; a fascinating display on specialty advertising, which shows how calendars and other novelty items (like Coca Cola serving trays) helped turn the names of some companies into household words; displays of outdoor advertising like the neon signs for Greyhound's "Running Dog" and Mobil's "Flying Red Horse," as well as an original set of Burma Shave signs; and exhibits explaining the importance of trademarks and showing how advertising campaigns are created.

There is also a section devoted to advertising's "all-time best" as determined by industry polls conducted by the trade journal, *Advertising Age*. Here, visitors can see print ads and storyboards from such famous campaigns as those for Volkswagen, Alka Seltzer, Hathaway Shirts, Marlboro, Rolls Royce, and Schweppes.

The museum also sponsors special exhibitions, which have included "Original Art from Nabisco's Cream of Wheat Advertising, 1900–1930"; "The Classic Santa: Original Art from Coca-Cola, 1932–1964"; and "Claymation: From Mind to Motion" featuring filmmaker Will Vinton's California Raisins.

The museum's 2,200-volume library is complemented by a manuscript collection of national advertising campaigns and a collection of rare books.

Seattle Art Museum

SEATTLE, WASHINGTON

Thanks in part to the largest successful bond levy for an art museum in the United States, the Seattle Art Museum recently opened a new 155,000-square-foot, $60-million-dollar building in downtown Seattle—famed architect Robert Venturi's first museum design.

The museum was founded in 1933 in Seattle's Volunteer Park, a lush hilltop expanse designed by the firm of Frederick Law Olmstead. Today its permanent collections include more than 18,000 objects, ranging from ancient Egyptian sculpture to contemporary American paintings.

The museum's original building is currently under renovation and will reopen in 1992 as the permanent home of the museum's internationally renowned collections of Asian art.

The Japanese collection is one of the top five in the United States, containing numerous important ceramics, textiles, lacquerware, scroll paintings, screens, and sculpture. The museum has many examples of fine Korean ceramics and decorative arts. Its Chinese collection numbers more than 2,500 objects in a wide variety of media including ritual bronzes, ceramics, and a superb assemblage of jade.

In 1981 the Seattle Art Museum acquired the 2,000-piece Katherine White Collection, one of the nation's finest assemblages of African sculpture, masks, and textiles.

A strong regional collection of over 1,000 paintings, drawings and sculpture includes important work of artists of the Northwest School, with particular emphasis on Morris Graves and Mark Tobey.

Other areas covered in the museum include European paintings, sculpture, and decorative arts; the work of Northwest Native Americans; prints and photographs; and modern art.

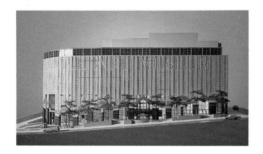

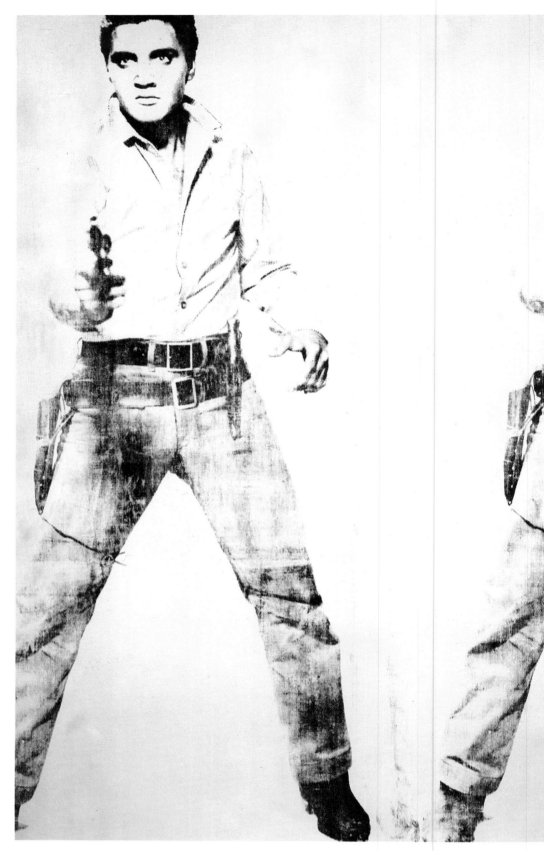

1 ANDY WARHOL *Double Elvis*

1 American, 1963, Acrylic on canvas, silkscreen, Purchased with funds from the National Endowment for the Arts, PONCHO, and the Seattle Art Museum Guild, 76.9.1.

2 American, 1854, Oil on canvas, Gift of Mrs. Paul C. Carmichael, 65.80, Photograph by Paul Macapia.

3 Nigerian, 16th century, Ivory, Katherine White Collection, 81.17.493, Photograph by Paul Macapia.

4 Japanese, Edo period, early 17th century, Eugene Fuller Memorial Collection, 36.21, Photograph by Paul Macapia.

236

2 FREDERICK CHURCH *Landscape*

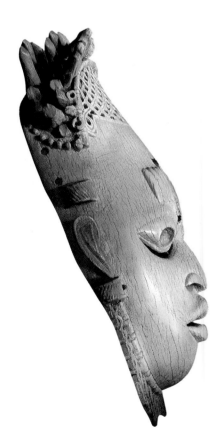

4 UNKNOWN *The Hundred Black Crows*

3 BENIN *Belt Mask*

ADDITIONAL INFORMATION

The Northeast

Albright Knox Art Gallery, *pp. 28-29*
1285 Elmwood
Buffalo, New York 14222
(716) 882-8700

American Museum of Natural History, *pp. 40-41*
Central Park West at 79th Street
New York, New York 10024
(212) 769-5000

American Museum of the Moving Image, *pp. 52-53*
35th Avenue at 36th Street
Astoria, New York 11106
(718) 784-4520

The Baltimore Museum of Art, *pp. 64-65*
Art Museum Drive
Baltimore, Maryland 21218
(301) 396-7101

The Computer Museum, *pp. 16-17*
300 Congress Street
Boston, Massachusetts 02210
(617) 426-2800

The Corning Museum of Glass, *pp. 32-33*
1 Museum Way
Corning, New York 14830
(607) 937-5371

The Franklin Institute Science Museum, *pp. 54-55*
20th Street and Benjamin Franklin Parkway
Philadelphia, Pennsylvania 19130
(215) 448-1200

The Frick Collection, *pp. 36-37*
1 East 70th Street
New York, New York 10021
(212) 288-0700

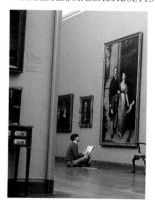

WORCESTER ART MUSEUM,
WORCESTER, MASSACHUSETTS

International Museum of Photography at George Eastman House, *pp. 30-31*
900 East Avenue
Rochester, New York 14607
(716) 271-3361

Isabella Stewart Gardner Museum, *pp.18-19*
280 The Fenway
Boston, Massachusetts 02115
(617) 566-1401

The Metropolitan Museum of Art, *pp. 42-47*
1000 Fifth Avenue
New York, New York 10028
(212) 535-7710

Museum of Fine Arts, Boston, *pp. 10-15*
465 Huntington Ave.
Boston, Massachusetts 02115
(617) 267-9300

The Museum of Modern Art, *pp. 48-51*
11 West 53rd Street
New York, New York 10019
(212) 708-9400

National Baseball Hall of Fame and Museum, *pp. 34-35*
P.O. Box 590 (Main Street)
Cooperstown, New York 13326
(607) 547-9988

Pennsylvania Academy of the Fine Arts, *pp. 60-61*
118 North Broad Street
Philadelphia, Pennsylvania 19102
(215) 972-7600

Philadelphia Museum of Art, *pp. 56-59*
Benjamin Franklin Parkway
Box 7646
Philadelphia, Pennsylvania 19101-7646
(215) 763-8100

Solomon R. Guggenheim Museum, *pp. 38-39*
1071 Fifth Avenue
New York, New York 10003
(212) 727-6200

Sterling and Francine Clark Art Institute, *pp. 22-23*
225 South Street
Williamstown, Massachusetts 01267
(413) 458-9545

Wadsworth Atheneum, *pp. 24-27*
600 Main Street
Hartford, Connecticut 06103
(203) 278-2670

The Walters Art Gallery, *pp. 66-69*
600 North Charles
Baltimore, Maryland 21201
(301) 396-9000

Winterthur, *p. 62-63*
Route 52
Winterthur, Delaware 19735
(302) 888-4600

Worcester Art Museum, *pp. 20-21*
55 Salisbury Street
Worcester, Massachusetts 01609
(508) 799-4406

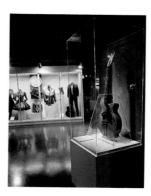

THE COUNTRY MUSIC HALL OF
FAME AND MUSEUM,
NASHVILLE, TENNESSEE

The Southeast

Abby Aldrich Rockefeller Folk Art Center, *pp. 88-89*
P.O. Box C
Williamsburg, Virginia 23187
(804) 220-7671

Amon Carter Museum, *pp. 110-111*
3501 Camp Bowie Boulevard
Fort Worth, Texas 76017
(817) 738-1933

The Corcoran Gallery, *pp. 78-79*
17th Street and New York Avenue, Northwest
Washington, D.C. 20006
(202) 638-3211

Country Music Hall of Fame and Museum, *pp. 90-93*
4 Music Square East
Nashville, Tennessee 37203
(615) 256-1639

Dallas Museum of Art, *pp. 108-109*
1717 North Harwood Street
Dallas, Texas 75201
(214) 922-1200

The Hertzberg Circus Collection & Museum, *pp.106-107*
210 Market Street
San Antonio, Texas 78205
(512) 299-7810

High Museum of Art, *pp. 94-95*
1280 Peachtree Street Northeast
Atlanta, Georgia 30309
(404) 892-3600

Houston Museum of Natural Science, *pp. 104-105*
1 Hermann Circle Drive
Houston, Texas 77030
(713) 639-4600

Kimbell Art Museum, *pp. 112-113*
3333 Camp Bowie Boulevard
Fort Worth, Texas 76107
(817) 322-8451

The Museum of Fine Arts, Houston, *pp. 100-103*
P.O. Box 6826
Houston, Texas 77265-6826
(713) 639-7300

The National Museum of Women in the Arts, *pp. 80-81*
1250 New York Avenue
Washington, D.C. 20005
(202) 783-5000

The Phillips Collection, *pp. 82-83*
1600 21st Street, Northwest
Washington, D.C. 20009
(202) 387-2151

The John and Mable Ringling Museum of Art, *pp. 96-97*
5401 Bayshore Road
Sarasota, Florida 34243
(813) 355-5101

The Smithsonian Institution, *pp. 72-77*
1000 Jefferson Drive, Southwest
Washington D.C. 20560
(202) 357-1300

Spaceport USA, *pp. 98-99*
TWRS
Kennedy Space Center, Florida 32899
(407) 452-2121

Virginia Museum of Fine Arts, *pp. 84-85*
2800 Grove Avenue
Richmond, Virginia 23221
(804) 367-0800

The Midwest

The Art Institute of Chicago, *pp. 158-163*
Michigan Avenue at Adams Street
Chicago, Illinois 60603
(312) 443-3600

Cincinnati Art Museum, *pp. 128-131*
Eden Park Drive
Cincinnati, Ohio 45202
(513) 721-5204

Cincinatti Museum of Natural History, *pp. 132-133*
1301 Western Avenue
Cincinatti, Ohio 45203
(513) 621-3889

The Cleveland Museum of Art,
pp. 118-121
11150 East Boulevard
Cleveland, Ohio 44106
(216) 421-7340

The Cleveland Museum of Natural History, *pp. 126-127*
1 Wade Oval Drive, University Circle
Cleveland, Ohio 44106
(216) 231-4600

The Detroit Institute of Arts,
pp. 134-137
5200 Woodward Avenue
Detroit, Michigan 48202
(313) 833-7900

Field Museum of Natural History,
pp. 156-157
Roosevelt Road at Lake Shore Drive
Chicago, Illinois 60605
(312) 922-9410

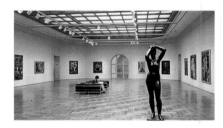

THE ST. LOUIS ART MUSEUM,
ST. LOUIS, MISSOURI

Thomas Gilcrease Institute of AmericanHistory and Art,
pp. 182-183
1400 Gilcrease Institute Road
Tulsa, Oklahoma 74127
(918) 582-3122

Henry Ford Museum & Greenfield Village, *pp. 138-139*
20900 Oakwood Boulevard
Dearborn, Michigan 48121
(313) 271-1620

Indianapolis Museum of Art,
pp. 140-143
1200 West 38th Street
Indianapolis, Indiana 46208
(317) 923-1331

The Indianapolis Motor Speedway Hall of Fame Museum, *pp. 144-145*
4790 West 16th Street
Indianapolis, Indiana 46222

(317) 241-2500

The Milwaukee Public Museum,
pp. 146-147
800 West Wells Street
Milwaukee, Wisconsin 53233
(414) 278-2702

The Minneapolis Institute of Arts,
pp. 152-153
2400 Third Avenue
Minneapolis, Minnesota 55404
(612) 870-3046

The Museum of Science and Industry, *pp. 164-167*
57th Street and Lakeshore Drive
Chicago, Illinois 60637
(312) 684-1414

National Cowboy Hall of Fame and Western Heritage Center,
pp. 184-185
1700 Northeast 63rd Street
Oklahoma City, Oklahoma 73111
(405) 478-2250

National Museum of Transport,
pp. 170-173
3015 Barrett Station Road
St. Louis, Missouri 63122
(314) 965-8007

The Nelson-Atkins Museum,
pp. 180-181
4525 Oak Street
Kansas City, Missouri 64111
(816) 561-4000

Pro Football Hall of Fame,
pp. 116-117
2121 George Halas Drive Northwest
Canton, Ohio 44708
(216) 456-8207

The St. Louis Art Museum,
pp. 174-177
1 Fine Arts Drive, Forest Park
St. Louis, Missouri 63110
(314) 721-0067

Terra Museum of American Art,
pp. 168-169
666 North Michigan Avenue
Chicago, Illinois 60611
(312) 664-3939

Toy & Miniature Museum,
pp. 178-179
5235 Oak Street
Kansas City, Missouri 64112

(816) 333-1396

Walker Art Center, *pp. 150-151*
Vineland Place
Minneapolis, Minnnesota 55403
(612) 375-7600

The Western Reserve Historical Society, *pp. 122-125*
18025 East Boulevard
Cleveland, Ohio 44106
(216) 721-5727

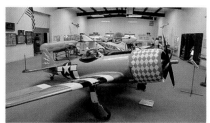

THE PIMA AIR MUSEUM,
TUSCON, ARIZONA

The West

American Advertising Museum,
pp. 234-235
9 Northwest Second Avenue
Portland, Oregon 97209
(503) 226-0000

Buffalo Bill Historical Center,
pp. 192-193
720 Sheridan Avenue
Cody, Wyoming 82414
(307) 587-4771

Center for Creative Photography,
pp. 198-199
843 East University Boulevard
Tucson, Arizona 85721
(602) 621-7968

The Denver Art Museum,
pp. 188-189
100 West 14th Avenue
Denver, Colorado 80204
(303) 575-2793

Denver Museum of Natural History,
pp. 190-191
2001 Colorado Boulevard
Denver, Colorado 80205
(303) 322-7009

Gene Autry Western Heritage Museum, *pp. 222-225*
4700 Zoo Drive
Los Angeles, California 90027
(213) 667-2000

The Heard Museum, *pp. 206-207*
22 East Monte Vista Road
Phoenix, Arizona 85004
(602) 252-8840

The Huntington, *pp. 226-227*
1151 Oxford Road
San Marino, California 91108
(818) 405-2125

The J. Paul Getty Museum,
pp. 212-215
17985 Pacific Coast Highway
Malibu, California 90265
(213) 459-7611

Los Angeles County Museum of Art,
pp. 216-221
5905 Wilshire Boulevard
Los Angeles, California 90036
(213) 857-6111

The Fine Arts Museums of San Francisco, *pp. 230-233*
California Palace of the Legion of Honor
34th Avenue and Clement Street
San Francisco, California 94121
(415) 863-3330

Museum of New Mexico,
pp. 194-195
113 Lincoln Avenue
Santa Fe, New Mexico 87501
(505) 827-6451

New Mexico Museum of Natural History, *pp. 196-197*
1801 Mountain Road, Northwest
Alburquerque, New Mexico 87194
(505) 841-8837

Phoenix Art Museum, *pp. 204-205*
1625 North Central Avenue
Phoenix, Arizona 85004
(602) 257-1880

Pima Air Museum, *pp. 202-203*
6000 East Valencia Road
Tucson, Arizona 85906
(602) 574-0462

National Automobile Museum, *pp. 208-209*
10 Lake Street South
Reno, Nevada 89501
(702) 333-9300

Norton Simon Museum, *pp. 228-229*
411 West Colorado Boulevard
Pasadena, California 91105
(818) 449-6840

San Diego Museum of Art,
pp. 210-211
1450 El Prado, Balboa Park
San Diego, California 92102
(619) 232-7931

Seattle Art Museum, *pp. 236-237*
1400 East Prospect Street
Seattle, Washington 98112
(206) 625-8900

DEEP IN THE HEART

BLAZING A TRAIL FROM EXPANSION TO WORLD SERIES

BILL BROWN *and* MIKE ACOSTA

With an Introduction by President George H. W. Bush

bright sky press

HOUSTON, TEXAS

bright sky press
HOUSTON, TEXAS

2365 Rice Blvd., Suite 202
Houston, Texas 77005

10 9 8 7 6 5 4 3 2 1

Library of Congress Cataloging-in-Publication Data

Brown, Bill, 1947-
Houston Astros : deep in the heart / Bill Brown and Mike Acosta;
foreword by former President George H.W. Bush.
pages cm
ISBN 978-1-939055-08-8
1. Houston Astros (Baseball team)--History. I. Acosta, Mike. II. Title.

GV875.H64B76 2013
796.357'64097641411--dc23 2012051258

Editorial Direction, Lucy Herring Chambers
Creative Direction, Ellen Peeples Cregan
Design, Marla Y. Garcia

Printed in Canada through Friesens

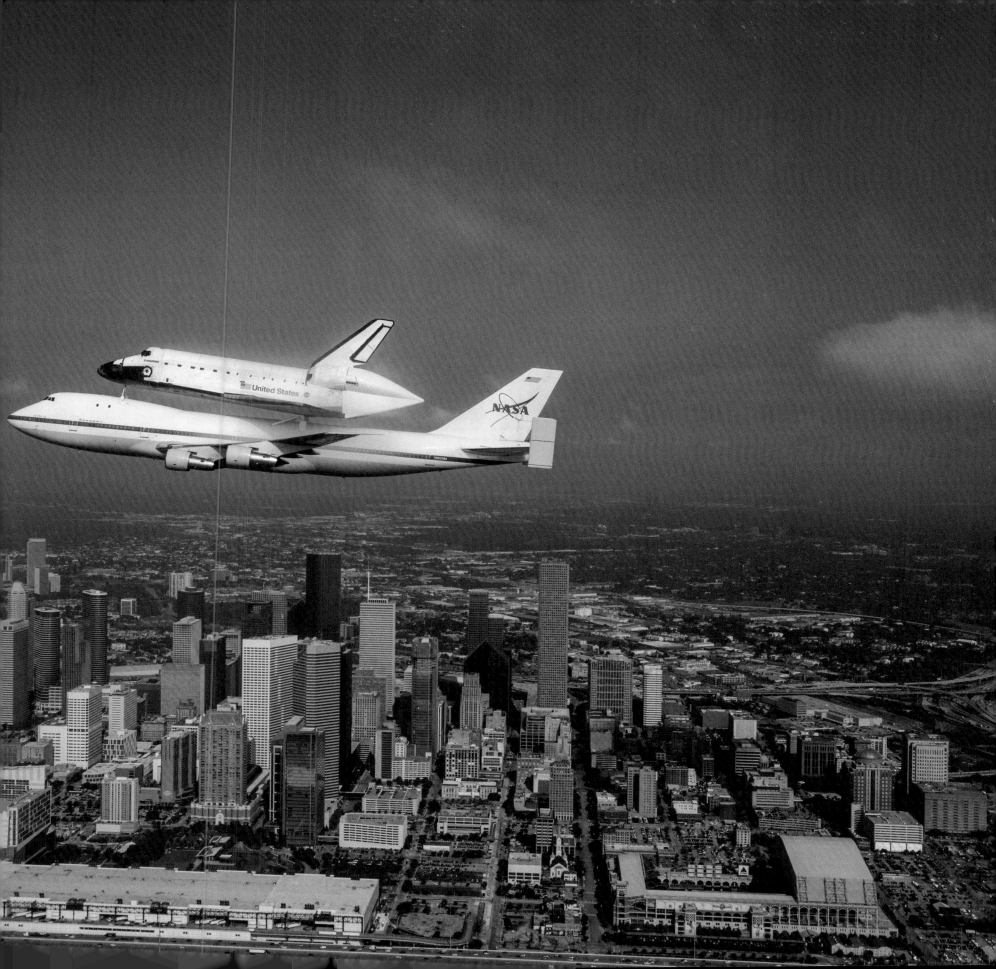

LET'S GO
☆ ASTROS

THE LOYAL FANS of Houston who have spent countless hours following the Buffs, the Colt .45s and the Astros have been a major part of the growth of the city and its quality of life. Houston has achieved a strong national identity and its citizens are valued as achievers who have rolled up their sleeves and earned their place in the world. This book is for them, with gratitude for their hospitality.

CONTENTS

THE FIRST
PITCH

LIKE ANY MARRIED COUPLE, BARBARA AND I haven't always agreed on everything through the years—baseball included. For example, back in college there was a scurrilous rumor going around that your author here was a good defensive first baseman, but not so hot as a hitter. All these years later, I am not at all certain I share that assessment, but Barbara—who kept score for just about every game I played in college—maintains there is truth to it.

Despite the great pain that still causes, I believe the Astros' "Kiss Cam" has often documented that I still love my bride of 68 years.

We may not agree on college baseball stats from the 1940s, but from the moment the Astros arrived in Houston in the early 1960s, Barbara and I have been devout fans when our "career paths" would allow—and that's why we are so pleased that Bill Brown has decided to publish this retrospective look at a great franchise and its history. If, like us, you feel the great joy and pride our team has given us since its inception is hard to put in words, well, Bill does the hard work for us all.

So to all our fellow Astros fanatics: Sit back, relax, and enjoy a special and exciting ride. See you out at the ballpark!

PRESIDENT GEORGE H. W. BUSH

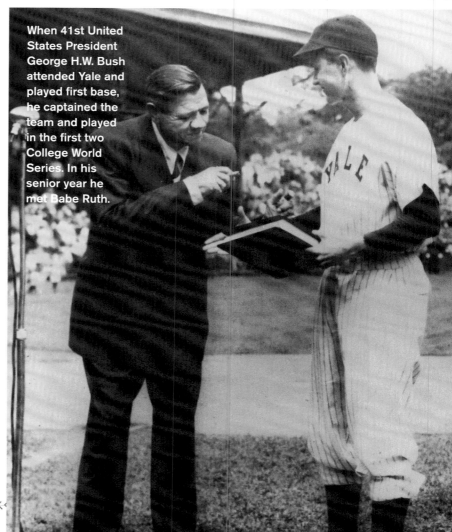

When 41st United States President George H.W. Bush attended Yale and played first base, he captained the team and played in the first two College World Series. In his senior year he met Babe Ruth.

TAKING THE
FIELD

AS THE HOUSTON ASTROS AND CHICAGO WHITE SOX LINED UP ON THE FOUL LINES for Game 1 of the 2005 World Series at U.S. Cellular Park in Chicago, it was the pinnacle of achievement for the Astros. In the 44th year of their existence, at last they had reached every team's dream—to play in the World Series.

Lined up on the field for the player introductions before Game 1, Jeff Bagwell thought, "I can't believe that we're one of the last two teams left. After you play your whole career, all the stuff that I went through with rehab and shoulder surgeries and all that, to come back that year and pinch hit." He added, "It was a little bittersweet that I couldn't be out there full time and I still wasn't the player that I used to be. But it was a great time for the city. People were going crazy. There's just something about when you get down to those last two teams."

The Astros' journey began in different times, with a unique blend of personalities you're about to meet. You'll meet Bob Aspromonte, Joe Niekro, Art Howe, Larry Dierker and other major contributors. You'll discover the importance of the Astrodome and experience the buildup to the first playoff appearance in 1980.

You'll relive the long development from 1962 to the first playoff team in 1980 and that year's near miss on a World Series bid. You'll travel through another near miss in1986. Then the bumpy road takes you through an era with four playoff appearances in five years from 1997 to 2001. And, after another close call in 2004, the triumphant march in 2005 from tombstones to champagne.

In the last 50 years, the Big Show has been a part of the Houston lore that fans and players love to remember. As the club looks to the next 50 years, Mike Acosta and I have gathered the legends, the images and the memories that the next generation of baseball fans will need to understand this often underdog but always inspirational team. The 2013 season's logos and uniforms hark back to the colors of the past, and it seems like the perfect time to reflect on where we've been.

Enjoy the journey!

BILL BROWN

THE BIRTH OF BASEBALL IN HOUSTON

CHAPTER 1

HOUSTON'S FIRST MAJOR LEAGUE TEAM ARRIVED IN 1962, BUT ITS BASEBALL tradition began more than a century earlier. The first Houston Base Ball Club was formed a short time after the state of Texas seceded from the Union in 1861. A meeting to form the club reportedly was held over J. H. Evans' store. The players agreed to report to Academy Square, a vacant field between San Jacinto, Caroline, Capitol and Rusk streets at five o'clock Monday, Wednesday and Friday mornings for "field exercise." Little is known about baseball during this era, but there was enough enthusiasm for America's pastime that teams from Houston and Galveston traveled to play each other.

The first organized game in the area took place April 21, 1868. The Houston Stonewalls blasted the Galveston Robert E. Lees 34-5. According to one report, the game—billed as a "state championship game," though there were no formal leagues—attracted more than 1,000 people on San Jacinto Day at the San Jacinto Battleground, where Texas won its independence from Mexico on another April 21, 32 years earlier. Other teams, with names like the Lambs and the Red Stockings formed, as did a pre-Negro League team called the Six Shooter Jims. Finally, in 1889, after becoming a professional club, the Houston Babies became the first champions of the Texas League.

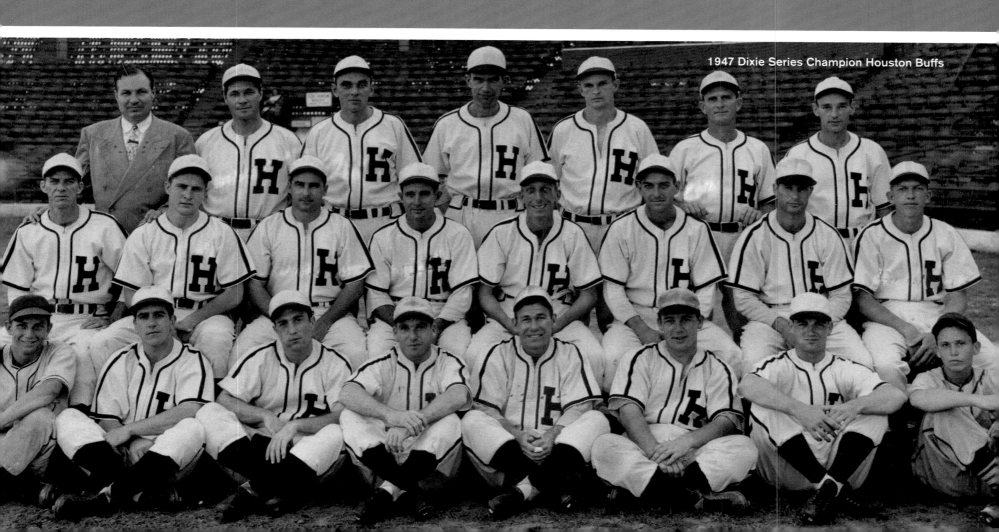

1947 Dixie Series Champion Houston Buffs

According to the latest research, the name "Buffaloes" was first applied to the Houston baseball club a few years before the turn of the century. It stuck for more than five decades, as the fan-base in Houston rapidly expanded. In 1901, news of the oil gusher at Spindletop in East Texas spread around the world, and fortune seekers headed for Houston. The Houston population mushroomed from 44,633 in 1900 to more than 900,000 in the early '60s when the city finally got its Major League franchise and the Buffs made way for the Colt .45s and eventually the Astros.

The St. Louis Cardinals owned the Buffs from the early 1920s through 1958. Cardinals General Manager Branch Rickey convinced owner Sam Breadon to purchase the Buffs with the intent of building a farm system. Prior to that time, Major League clubs purchased players from minor league clubs if they had not been under contract to a Major League organization. Almost 40 years later, Rickey would return as a major force in bringing Houston a Major League team.

The Buffs won or tied for 17 Texas League pennants. They moved into 11,000-seat Buff Stadium on St. Bernard Street (later Cullen Boulevard) in 1928 and set up shop in a $400,000 facility. Close to the University of Houston, it was considered a state-of-the-art ballpark by minor league standards and it featured a Spanish-style tiled roof entryway. Buff Stadium became known as a pitcher's park, measuring 344 feet to the left field line, 434 to center and 323 to right with 12-foot walls.

Houston loved the Buffs. The team developed such stars as Dizzy and Paul Dean, Joe Medwick, Pepper Martin, Ken Boyer, Enos Slaughter, Howie Pollet, Harry Brecheen, Red Schoendienst, Vinegar Bend Mizell, Frank Mancuso and Solly Hemus. In 1946, after working his way up from parking lot attendant, Allen Russell took over as president of the Buffs. Russell was a tireless promoter, and he presided over Texas League titles in 1947 and 1951. From 1946 until 1953 the team outdrew the St. Louis Browns of the American League more than once, including a 1948 draw of 401,282.

As the post-World War II boom began to change America with easy air travel and increased leisure time, baseball was ready for growth. After serving in the war, George Kirksey arrived in Houston. Knowing the town's background of professional baseball success, he began to develop a plan to bring Major League Baseball to the city. A former wire service sportswriter, Kirksey had many connections

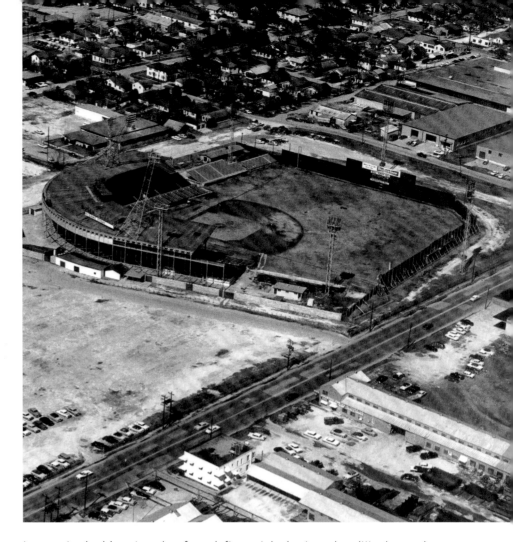

in sports. In Houston, he found financial clout and political punch as well.

In 1957, with the goal of bringing Major League Baseball to southeast Texas, Kirksey formed a syndicate that included Texaco heir Craig Cullinan, prominent local businessman William Kirkland, millionaire oilman R. E. "Bob" Smith and his partner, former mayor Judge Roy Hofheinz. Financed by Cullinan, members of the group visited several Major League cities to try to coax a team into moving to Houston. They were told repeatedly to get a stadium before talks could begin in earnest.

In a special session in 1957, the state legislature approved the use of public money for building stadiums subject to voter approval and established the Harris County Parks Commission. In 1958 an $18 million bond issue was introduced for the Harris County sports complex, and the Houston Sports Association—formed by this initial leadership group—applied for admission into the National League. Houston was primed for a big league ball club.

The persuasive Hofheinz was *"just unbelievable in his oratory,"* according to Gene Elston, the Colt .45s' first play-by-play voice who found himself mesmerized by Hofheinz' speeches. *"He could get you excited over anything,"* said catcher Hal Smith. *"I think he was born ahead of his time,"* said broadcaster Rene Cardenas. *"He was ahead of the whole world."*

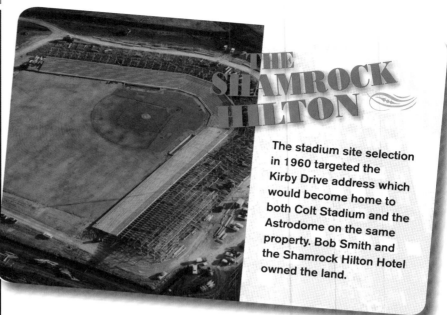

THE SHAMROCK HILTON

The stadium site selection in 1960 targeted the Kirby Drive address which would become home to both Colt Stadium and the Astrodome on the same property. Bob Smith and the Shamrock Hilton Hotel owned the land.

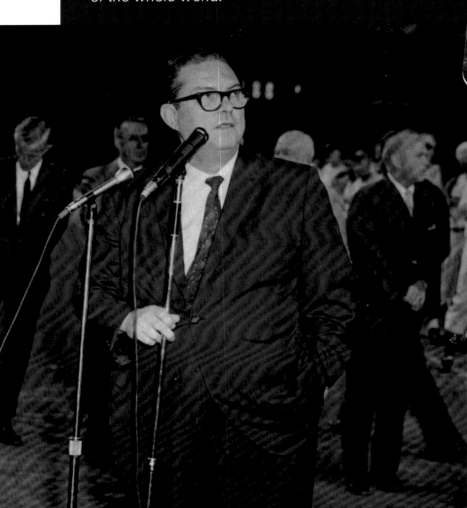

Roy Hofheinz was a visionary who had been a state legislator at age 22, a Harris County judge at 24 and mayor of Houston at 40. He had researched development of a large indoor shopping center and wanted to apply it to the concept of a sports complex. He owned extensive acreage in the downtown area.

Despite the country's readiness for more baseball, the committee that Major League Baseball had formed in 1957 to study expansion had been ignored. From the 1890s until 1955, the westernmost Major League market had been St. Louis. When the Brooklyn Dodgers moved to Los Angeles and the New York Giants moved to San Francisco for the 1958 season, baseball's borders expanded dramatically. But there still was no team in the South or Southwest. The decision makers were slow to embrace the idea of Major League Baseball in a southern market.

New York Mayor Robert Wagner reacted to the loss of the Dodgers and Giants by forming a four-man committee to bring the National League back to New York City. He appointed lawyer William Shea, for whom Shea Stadium was later named, as chairman. Eventually, they announced the formation of the Continental League. Joan Payson, a former minority owner of the Giants who bitterly regretted their move to San Francisco, joined the effort, as did the Houston group.

Together, they named Branch Rickey president in 1959 and put forth a plan to compete with the Major Leagues for talent and fans. Rickey gave the group credibility with his stature in the game. He established the first farm system and his judgment in selecting Jackie Robinson to break the color barrier in Major League Baseball in 1947 with the Brooklyn Dodgers stamped him as a giant of the sport.

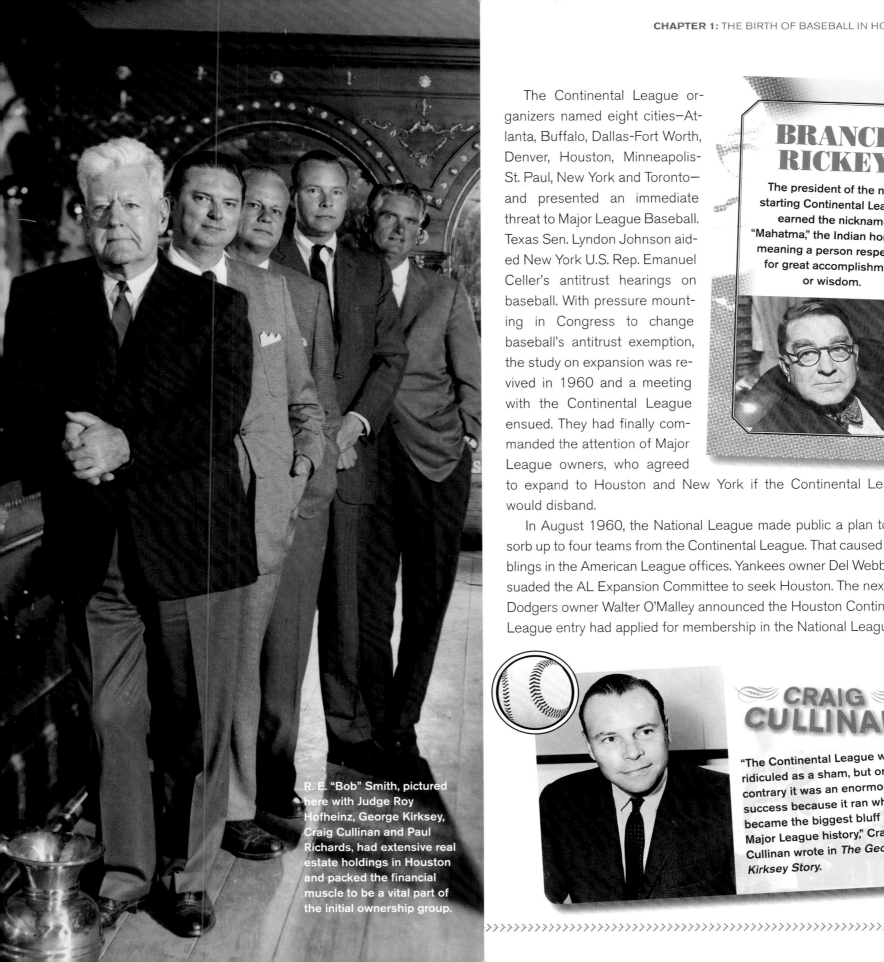

The Continental League organizers named eight cities—Atlanta, Buffalo, Dallas-Fort Worth, Denver, Houston, Minneapolis-St. Paul, New York and Toronto—and presented an immediate threat to Major League Baseball. Texas Sen. Lyndon Johnson aided New York U.S. Rep. Emanuel Celler's antitrust hearings on baseball. With pressure mounting in Congress to change baseball's antitrust exemption, the study on expansion was revived in 1960 and a meeting with the Continental League ensued. They had finally commanded the attention of Major League owners, who agreed to expand to Houston and New York if the Continental League would disband.

In August 1960, the National League made public a plan to absorb up to four teams from the Continental League. That caused rumblings in the American League offices. Yankees owner Del Webb persuaded the AL Expansion Committee to seek Houston. The next day, Dodgers owner Walter O'Malley announced the Houston Continental League entry had applied for membership in the National League.

BRANCH RICKEY

The president of the non-starting Continental League, earned the nickname "Mahatma," the Indian honorific meaning a person respected for great accomplishment or wisdom.

R. E. "Bob" Smith, pictured here with Judge Roy Hofheinz, George Kirksey, Craig Cullinan and Paul Richards, had extensive real estate holdings in Houston and packed the financial muscle to be a vital part of the initial ownership group.

CRAIG CULLINAN

"The Continental League was ridiculed as a sham, but on the contrary it was an enormous success because it ran what became the biggest bluff in Major League history," Craig Cullinan wrote in *The George Kirksey Story.*

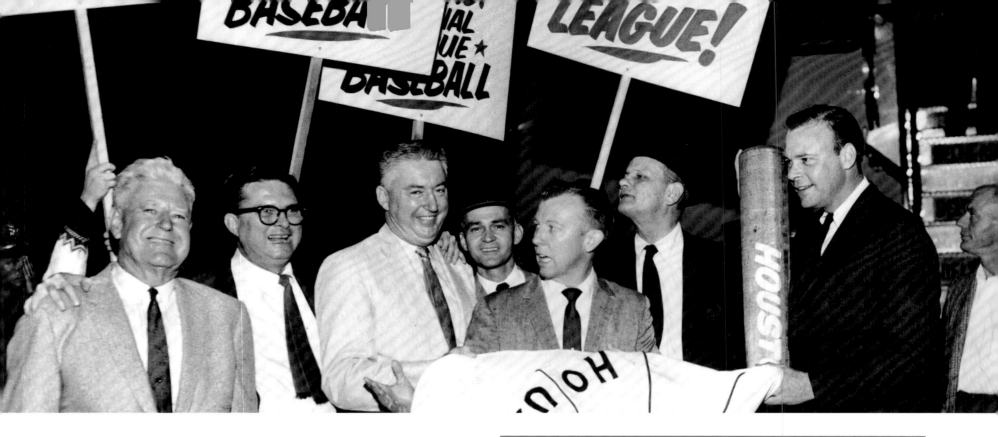

The day Bill Mazeroski hit the winning home run in the 1960 World Series to send the Pittsburgh Pirates off to a celebration after beating the New York Yankees, the National League office confirmed the rumor that Houston was joining the National League. Cullinan, who had chosen the National League as Houston's preference, was elected president of the Houston Sports Association and Kirksey became executive vice president. Four days later, October 17, 1960, the official announcement came that Houston and New York were in line for celebrations of their own. They each would begin play in the National League in 1962.

As 1962 began, despite political conflict brewing with Cuba, baseball in Houston got under way smoothly. Alan Shepard became the first U.S. man in space in Freedom 7. The Manned Spacecraft Center, later to be named the Lyndon B. Johnson Space Center, opened in the Clear Lake area south of downtown Houston on July 4, 1962. Clear Lake had been a sparsely populated area of rice farms used for cattle grazing, and the National Aeronautics and Space Administration was about to turn it into a sprawling, futuristic hub for space travel. The space program and the Houston baseball team were headed toward a close relationship that would last for decades.

BUD ADAMS

Another member of the Houston ownership group, Bud Adams, provided more of its "new money" identity. Adams, owner of the Houston Oilers, had extensive oil and real estate interests and had been a major player in the creation of the American Football League. In 1960, his Oilers drafted Heisman Trophy winner Billy Cannon from LSU and offered him $110,000 after the NFL Los Angeles Rams offered $10,000. Adams packed the financial foundation to bring the National Football League a major competitor, and Major League Baseball owners were worried that he could present the same threat to their monopoly.

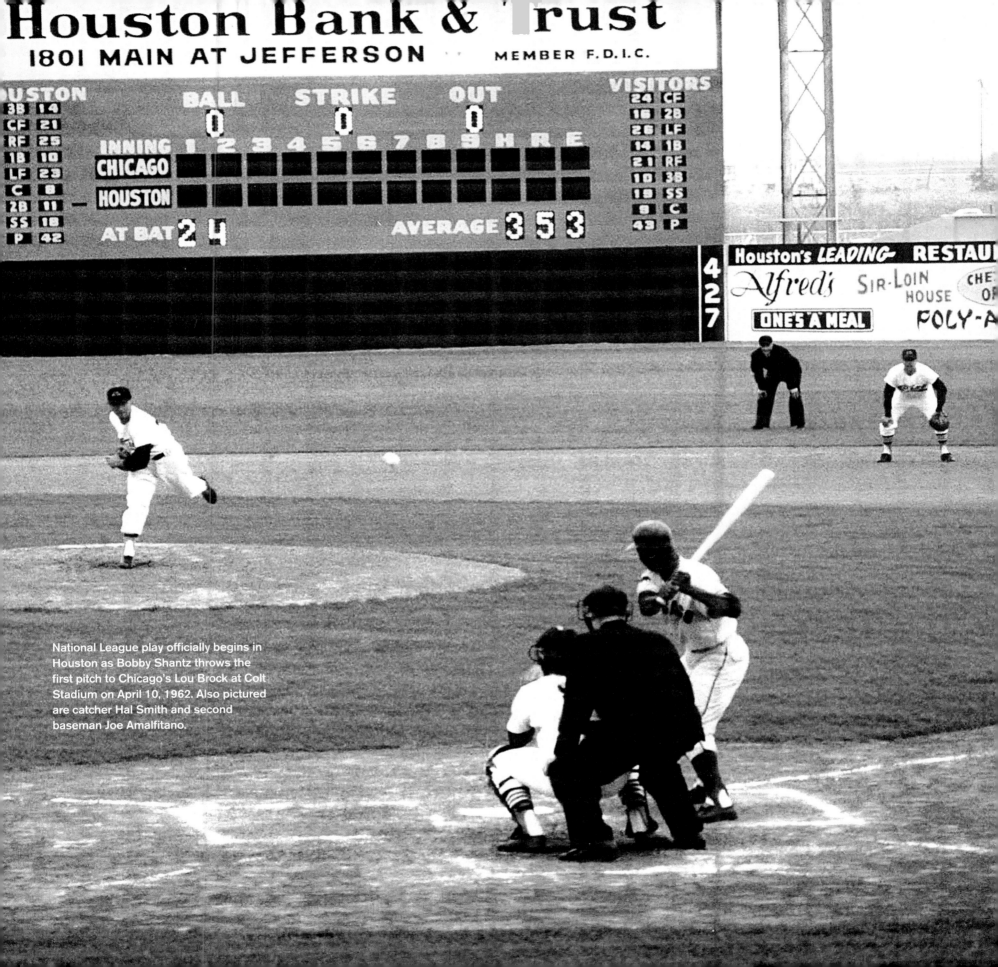

National League play officially begins in Houston as Bobby Shantz throws the first pitch to Chicago's Lou Brock at Colt Stadium on April 10, 1962. Also pictured are catcher Hal Smith and second baseman Joe Amalfitano.

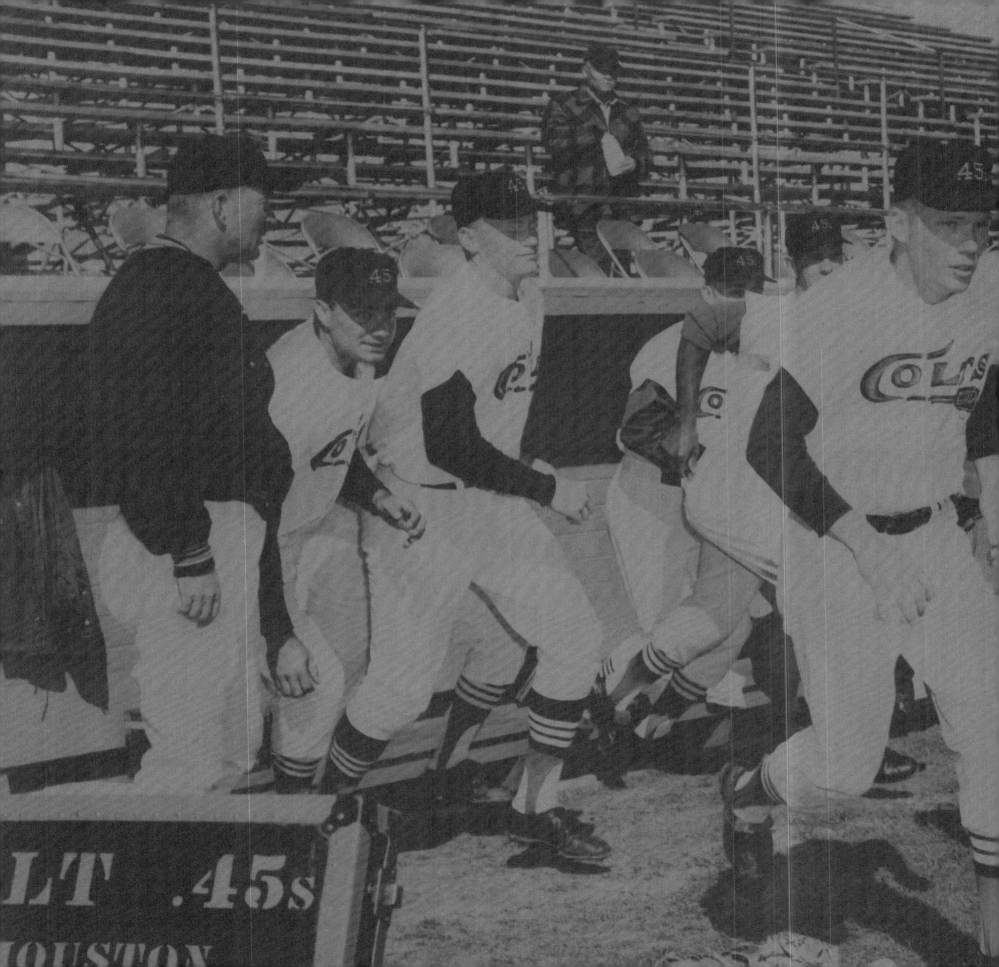

THE HOUSTON
COLT.45s

CHAPTER2

1962-1964

ONCE HOUSTON HAD A FRAN-chise, it was time to build a team. Gabe Paul was hired in 1960 as the first general manager. He brought Tal Smith with him from Cincinnati. Bill Giles also joined the organization. Paul lasted about six months before resigning to join the Cleveland Indians. His successor, Paul Richards, was a native Texan, from Waxahachie. Although he was managing the Baltimore Orioles, Richards was hired as general manager before the 1961 season in an illegal arrangement that was kept secret.

Richards had managed in the American League from 1951 to 1961. He had developed a reputation as an innovator and earned the nickname "The Wizard of Waxahachie." In an era when managers relied on home runs to get on the board, Richards focused on pitching, good defense, speed and stolen bases to create runs—a strategy now known as "small ball."

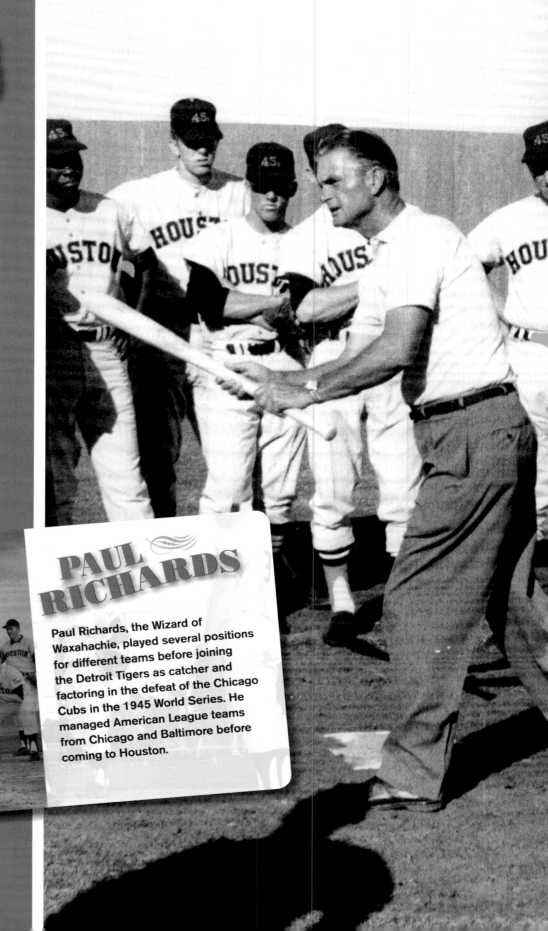

PAUL RICHARDS

Paul Richards, the Wizard of Waxahachie, played several positions for different teams before joining the Detroit Tigers as catcher and factoring in the defeat of the Chicago Cubs in the 1945 World Series. He managed American League teams from Chicago and Baltimore before coming to Houston.

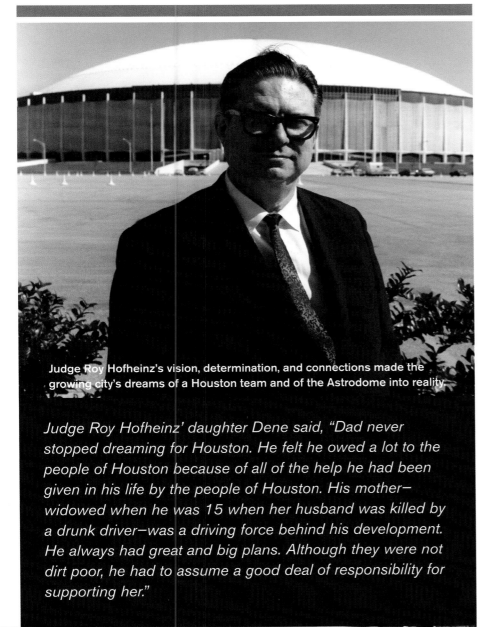

Judge Roy Hofheinz's vision, determination, and connections made the growing city's dreams of a Houston team and of the Astrodome into reality.

Judge Roy Hofheinz' daughter Dene said, "Dad never stopped dreaming for Houston. He felt he owed a lot to the people of Houston because of all of the help he had been given in his life by the people of Houston. His mother—widowed when he was 15 when her husband was killed by a drunk driver—was a driving force behind his development. He always had great and big plans. Although they were not dirt poor, he had to assume a good deal of responsibility for supporting her."

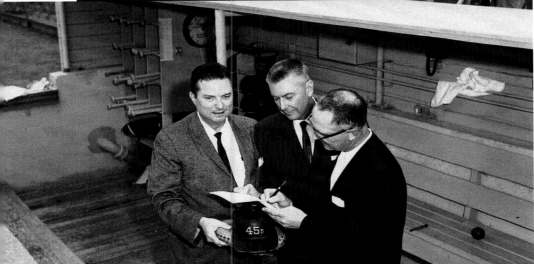

In 1961, the Colt .45s started their organization with their purchase of the Buffs. Harry Craft stayed in town after managing the Buffs to become the Colt .45s' first skipper. After the 1961 season, the expansion draft brought the Colt .45s and the New York Mets their first established players. Houston selected shortstop Eddie Bressoud first and traded him to Boston for Don Buddin. The team then drafted Bob Aspromonte, Bob Lillis, Roman Mejias, Jim Umbricht, Joey Amalfitano, Dick Farrell, Hal Smith, Al Spangler and Bobby Shantz among others.

DON BUDDIN

Shortstop Don Buddin came to the Colt .45s in a trade for their first draft pick, Eddie Bressoud. Replaced at shortstop by Bob Lillis, his contract was waived to the Tigers before the season was out.

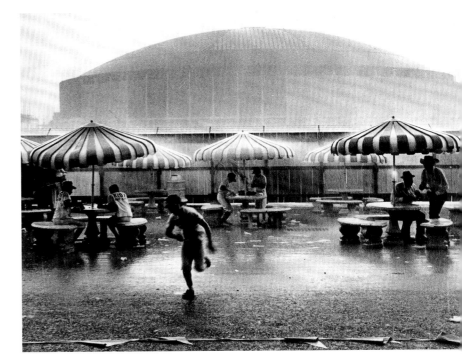

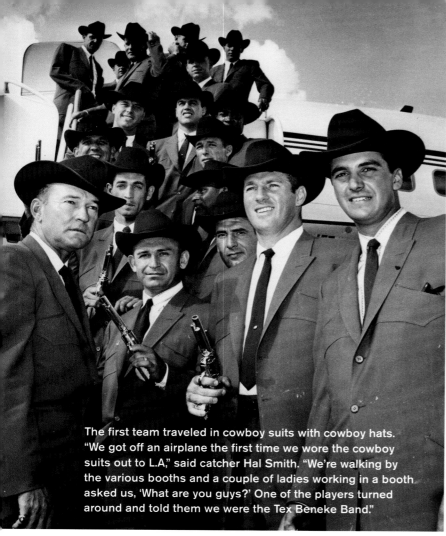

The first team traveled in cowboy suits with cowboy hats. "We got off an airplane the first time we wore the cowboy suits out to L.A.," said catcher Hal Smith. "We're walking by the various booths and a couple of ladies working in a booth asked us, 'What are you guys?' One of the players turned around and told them we were the Tex Beneke Band."

The Colt .45s won the Cactus League Championship during their first spring training.

FIRST SPRING TRAINING

The Houston owners, hoping to create a spring training boomtown, decided to hold the Colt .45s' first spring training in Apache Junction, Arizona, at the new Geronimo Park. In the first inning of the first exhibition game in 1962, Al Heist stepped in a hole and injured his ankle. His career ended later that season. Undeterred, the Colt .45s won their first Cactus League exhibition title for spring training games in Arizona.

Geronimo Park at Apache Junction, 1962.

COLT STADIUM

Delays in the plans to open 1962 in the Astrodome caused the HSA to build temporary Colt Stadium. The outdoor stadium went up in just five months. The pastel colored seats reflected Judge Hofheinz' love of colorful sports stadiums. There was no roof over the grandstand.

THE WIZARD OF WAXAHACHIE AT WORK

GM Paul Richards ordered the Colt Stadium lights dimmed and the grass grown as high as possible. The hitters had issues with the high grass at Colt Stadium. Norm Larker got so frustrated that he once brought a lawnmower to the park and cut the grass. Richards also taught his pitchers the slip pitch. "I thought it was a great changeup," said Bob Bruce. "You shoved it way back in the palm and you gripped it real tight with your middle finger and your thumb. You almost threw it like you threw a forward pass. It kind of slipped out and that's why they called it a slip pitch."

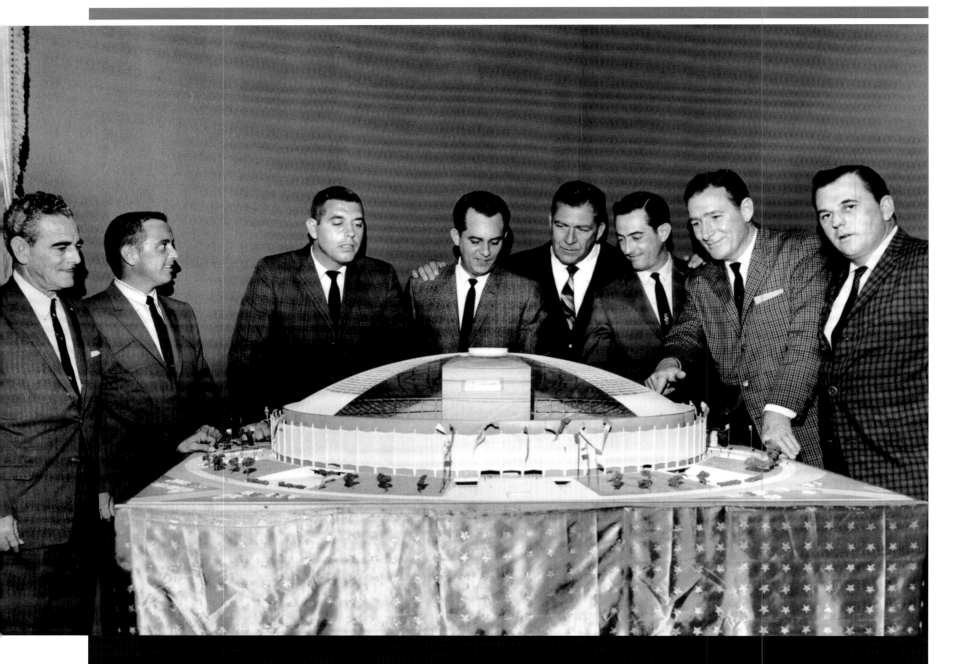

The Houston baseball club has always been ahead of the curve serving a diverse market. Pictured around the model Dome is the Colt.45s' broadcast team, which brought the games to both English-and Spanish-speaking fans. From left to right: Orlando Sanchez-Diago (broadcaster, Spanish), Skipper Johnson (engineer, Spanish), Gene Elston (broadcaster, English), Rene Cardenas (broadcaster, Spanish), Al Helfer (broadcaster, English), Bob Green (engineer, English), Loel Passe (broadcaster, English) and Bob Boyne (producer).

Major League Baseball in Houston had a wildly successful opening series in 1962 with the Colt .45s sweeping the Chicago Cubs in a three-game series at Colt Stadium. Veteran southpaw Bobby Shantz won the opener 11-2 with a five-hit complete game. Despite the Opening Day gem, Shantz was traded to St. Louis in May 1962 for Carl Warwick.

Third baseman Bob Aspromonte led off the bottom of the first with the first Houston hit. Hal Smith was the first Houston player to hit a home run. Outfielder Roman Mejias blasted a pair of three-run homers with an enthusiastic crowd of 25,271 welcoming the team to Houston.

The home attendance of 924,456 in 1962 was very close to the population of Houston. By the time Harry Craft's Colt .45s finished 64-96 and in eighth place in a 10-team National League, ahead of the Cubs and Mets, they had gained respect as an organization.

CARL WARWICK

"We beat the Giants on the next to last day of the season to knock them out of first place, which was one of our big accomplishments," recalled Carl Warwick. That was a part of a season-ending road trip that included two wins at Los Angeles in games started by Don Drysdale and Sandy Koufax.

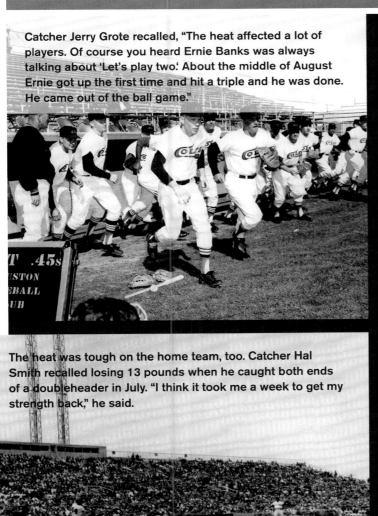

Catcher Jerry Grote recalled, "The heat affected a lot of players. Of course you heard Ernie Banks was always talking about 'Let's play two.' About the middle of August Ernie got up the first time and hit a triple and he was done. He came out of the ball game."

The heat was tough on the home team, too. Catcher Hal Smith recalled losing 13 pounds when he caught both ends of a doubleheader in July. "I think it took me a week to get my strength back," he said.

THE HEAT IS ON

Because of the extreme heat, Sunday games were played at night for the first time in Major League Baseball in 1963 in Houston. During one June doubleheader in 1962, 78 people and one umpire sought medical attention.

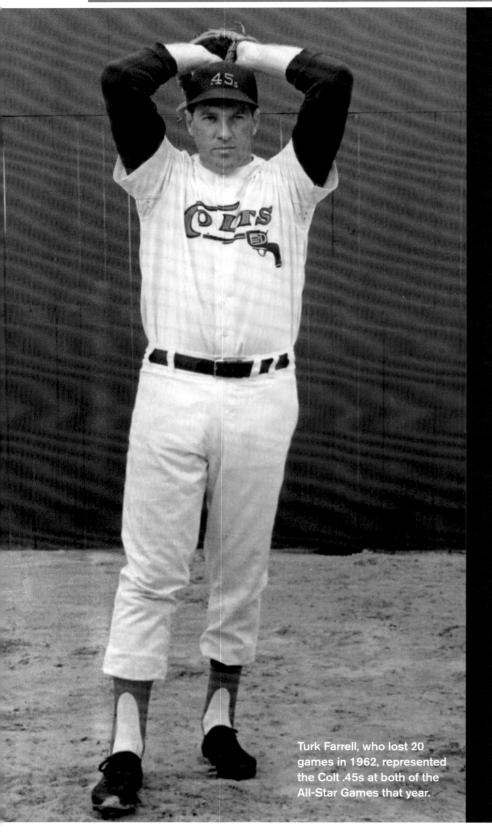

Turk Farrell, who lost 20 games in 1962, represented the Colt .45s at both of the All-Star Games that year.

DICK FARRELL

A hard-throwing 6'4" right-hander, Dick "Turk" Farrell was purchased from the Dodgers for $125,000 in the expansion draft pool when the Colt .45s were being stocked. Out of boredom during Spring Training at Apache Junction, he sometimes shot rabbits with a .22 pistol on his morning walk through the desert. He bagged four that first spring. He also borrowed Bob Aspromonte's brand new red Oldsmobile and took it hunting, returning it covered with dirt and with snakes slithering around in the back seat.

Farrell had been a reliever for the Phillies and Dodgers, making All-Star in 1958. He became Houston's first All-Star in 1962, allowing a home run to Rocky Colavito in the All-Star Game. As a lack of run support turned his record into 10-20 in 1962, Farrell still went seven innings or more 23 times. He pitched 12 scoreless innings Aug. 6 against Cincinnati and the Reds' Bob Purkey matched his first 10 zeroes. The relievers decided the game, with Reds pitcher Johnny Klippstein homering off Don McMahon in the 13th for a 1-0 win. Farrell compiled a 25-inning scoreless streak that first year. But alas, the Colt .45s scored only one run for him during that streak! He lost 2-1 on the final day of the season on Willie Mays' 47th home run of the year.

The hard luck pitcher sported a 3.02 ERA and pitched 241 innings that season. He went 14-13 the next year with the same ERA. Farrell led or tied for the club lead in wins in three of the first four years of the franchise. He became an All-Star again in 1964, getting off to a 10-1 start. Again in 1965 he achieved All-Star status. He left the Astros in 1967 at age 33 with a 53-64 record in Houston.

John Paciorek made the most of his only Major League game. Paciorek collected three singles and two walks, scored four runs and drove in three in five plate appearances in his only game Sept. 29, 1963. He was just 18. He had signed as an amateur free agent. A bad back ended his career. But on the final day of the 1963 season, he had a day to remember. He kept trying to make it back, playing in the minors until 1969.

In 1963, younger players claimed jobs. With 19-year-old Rusty Staub, 21-year-old Jim Wynn, 21-year-old Ernie Fazio and 22-year-old John Bateman playing key roles, older players such as Pete Runnels and Johnny Temple, both 35, were moved out.

By the end of the year, the youth movement was going full bore. The Colt .45s made history by fielding a team of all rookies September 27 against the New York Mets. Even though the Colt .45s lost 10-3, they displayed their organizational expertise at finding talent. The average age of the starters that day was 19 years and four months, and four of them went on to be All-Stars.

At the end of the '63 season, the Colts were 66-96 and in ninth place.

Jay Dahl was 17, making him one of the youngest pitchers in Major League history. He had signed earlier in 1963 and made only that one Major League appearance, lasting 2.2 innings and allowing five earned runs. In 1964 he returned to the low minors but was sidelined by a bad back. In 1965, he started 5-0 for the Salisbury, N.C. affiliate of the Astros and pitched the team into first place in his last appearance. He was killed in an auto accident June 20 at age 19.

JAY DAHL

1963
ALL-ROOKIE
LINE UP

The Colt .45s made history on September 27, 1963 when they fielded a team of nine rookies.

L to R: Sonny Jackson, Joe Morgan, Jim Wynn, Rusty Staub, Aaron Pointer, Brock Davis, Glenn Vaughan, Jerry Grote and Larry Yellen. Yellen was replaced by Jay Dahl at the last minute because he was observing a religious holiday.

The Colt .45s opened their third season with heavy hearts. Pitcher Jim Umbricht died of cancer just before Opening Day at age 33. His uniform number 32 was retired. It was the first number to be retired by the club in a ceremony on April 12, 1965.

Luman Harris (left), whose career was tightly associated with Paul Richards, took over from Craft as skipper for the final 13 games in 1964, finishing 5-8. Craft was fired after a 191-280 record, jettisoned like a first-stage rocket after launch. The liftoff had been acceptable, but the Astrodome years would bring the Houston team a new focus and higher expectations.

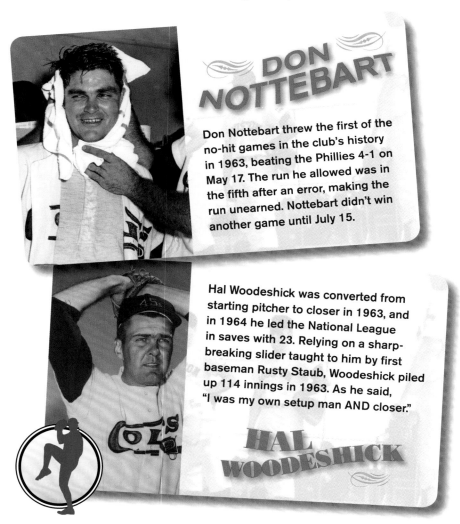

DON NOTTEBART

Don Nottebart threw the first of the no-hit games in the club's history in 1963, beating the Phillies 4-1 on May 17. The run he allowed was in the fifth after an error, making the run unearned. Nottebart didn't win another game until July 15.

Hal Woodeshick was converted from starting pitcher to closer in 1963, and in 1964 he led the National League in saves with 23. Relying on a sharp-breaking slider taught to him by first baseman Rusty Staub, Woodeshick piled up 114 innings in 1963. As he said, "I was my own setup man AND closer."

HAL WOODESHICK

Ken Johnson was the first Major League pitcher to lose a nine-inning no-hitter. He dropped a heartbreaking 1-0 game to Cincinnati on April 23, 1964 when the Colt .45s made two errors in the ninth inning, allowing Pete Rose to score. Johnson made one error on a bunt by Rose; usually flawless second baseman Nellie Fox made the other on a Vada Pinson grounder allowing the only run to score. Fox apologized to Johnson after the game for his error, but Johnson accepted blame for his own miscue.

"It's a helluva way to get into the books, isn't it?" said Johnson. Johnson started 0-5 in 1962, pitching well but getting only four runs from his teammates in five games.

In 1963, the Colt .45s had a "Runs for Johnson" night. Women who brought nylon stockings with runs in them got 75 cents off the price of a ticket. But Jim Bunning of the Phillies threw a one-hitter and Johnson lost 4-0. 1964 saw Johnson 11-17 with a 2.65 ERA.

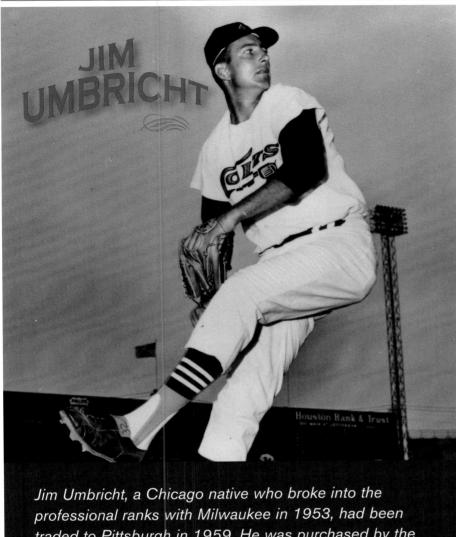

JIM UMBRICHT

Jim Umbricht, a Chicago native who broke into the professional ranks with Milwaukee in 1953, had been traded to Pittsburgh in 1959. He was purchased by the Colt .45s for $50,000 in 1961 in the National League player pool expansion draft. He opened 1962 as an original Colt .45 and was one of the top relief pitchers in the National League, finishing 4-0 with a 2.01 ERA that year. He then made a remarkable comeback after cancer surgery in March 1963 and compiled a 4-3 record with a 2.61 ERA in 1963.

Umbricht died in early April 1964. The morning after his funeral, a small plane swooped low over the Astrodome construction site and Ed Umbricht scattered the ashes of his brother over the site. "The Astrodome is Jim's headstone," said Ed.

BOB BRUCE

Bob Bruce threw the first pitch for the franchise in the Spring Training opener at Geronimo Park. Bruce, who was obtained in a December 1961 trade with Detroit, developed into a 15-game winner in 1964 with a 2.76 ERA. Bruce blanked the Dodgers 1-0 in a 12-inning shutout in the Colt Stadium finale that year.

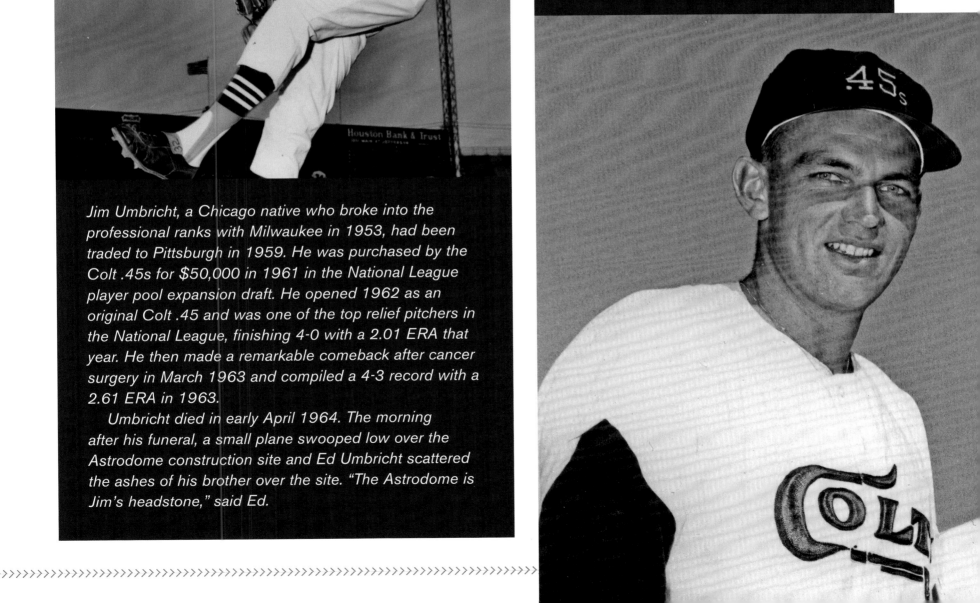

BOB ASPROMONTE

Bob Aspromonte was an early Houston mainstay. A handsome bachelor who collected the first hit and first grand slam for the franchise, Aspromonte had been obtained in the expansion draft for $75,000 from the Dodgers. The second player chosen by Houston, he set a National League record in 1962 for consecutive errorless games by a third baseman with 57.

Aspromonte said, "At age 21, Harry Craft was like a father image to me. I had a little hot temper and would bang my helmets around. He would get alongside me and say, 'I don't want you to do that because your next at-bat is going to be affected by what you just did.'"

The 1964 club MVP, Aspromonte smashed six of the club's first nine grand slams. That club record stood until 2011. The club moved into the Astrodome in 1965. "I was hitting fifth that year," said Aspromonte. "They thought I could hit some home run balls in the Astrodome but it was too big for me. The ball would not carry. But I did hit the first home run in the Astrodome by an Astro. And then I hit the first grand slam in the Astrodome." Bob was one of the original group of inductees into the Astros Walk of Fame in 2012.

BOB ASPROMONTE & BILL BRADLEY

In July of '62, Bob Aspromonte met a 9-year-old youngster from Arkansas named Bill Bradley. Bradley had been struck by lightning and blinded at his Little League game. He was flown to Houston's Methodist Hospital and Aspromonte visited him. Bradley asked him to hit a home run that night. Aspromonte delivered with a blow off Stu Miller in a 3-2 loss to the Giants.

In 1963 Bradley returned in June for more surgery and again he requested a long ball from Aspro. This time Aspromonte ripped a 10th-inning grand slam off Lindy McDaniel for a 6-2 win over the Cubs. The fans exploded and lifted Bradley in the air as Aspro circled the bases. He headed for Bradley in the stands to celebrate the moment Aspromonte refers to as "divine intervention."

In July, the dreamer and the deliverer connected a third time with spectacular results. This time Bradley had a tall order: Aspromonte was hitting .198 and was mired in a 1-for-21 slump. But the slugging third sacker belted yet another grand slam, this one in a seven-run first inning off Tracy Stallard of the Mets. Bradley's eyesight had been restored and he could see the blast.

In 1964, after several more eye operations, Bradley was able to return to the playing field himself. Aspromonte opened his mail and read newspaper clippings from an Arkansas paper detailing a no-hitter pitched by a 12-year-old boy. Attached was a note from the pitcher: "Here's one for you, Bob. Your biggest fan, Bill Bradley."

After his playing career ended, Aspromonte himself was blinded in his right eye when a car battery exploded in his face. He required several surgeries to restore his sight. This time Bradley visited him and reassured him.

Bill Bradley (left) with Bob Aspromonte

ASTRODOME CLUB

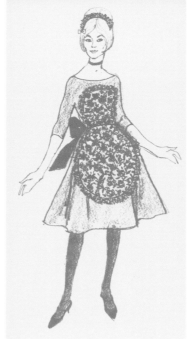

A wild-west theme prevailed in Colt Stadium. "Triggerettes" guided patrons to their seats, parking attendants wore orange Stetsons and employees in The Fast Draw Club dressed in old-style saloon attire. This flamboyancy continued in 1965 with themed clubs and restaurants throughout the Astrodome. Custom outfits drawn up by Houston designer Evelyn Norton Anderson outfitted employees. Behind the outfield wall was a German-style beer garden called the Domeskeller and the Countdown Cafeteria behind home plate showed a historical progression beginning with Roman Gladiators. "Blast-off" girls helped serve the line of patrons. The Trailblazer Restaurant, located behind first base on the sixth floor Loge Level, celebrated man's greatest accomplishments in the midst of dark wood panels and accented red walls. In the Astrodome Club, which extended from just to the left of home plate to the left field foul pole on the fifth level, season ticket holders enjoyed a 100-foot bar, a 90-foot perimeter bar and a five-course meal in various dining rooms. Ninth floor Skybox ticket holders had exclusive access to the Sky Dome Club behind home plate, where dinner was served in a Japanese-themed steakhouse. The Sky Dome Club's outer space decor was illuminated by black lights. Patrons sat in "invisible" chairs and gray tempered windows gave a clear view of southwest Houston. Around the Astrodome, "Space-ettes" showed fans to their seats, while "Earthmen" manicured the playing field and "Space Finders" assisted in the massive 20,000-spot parking lot.

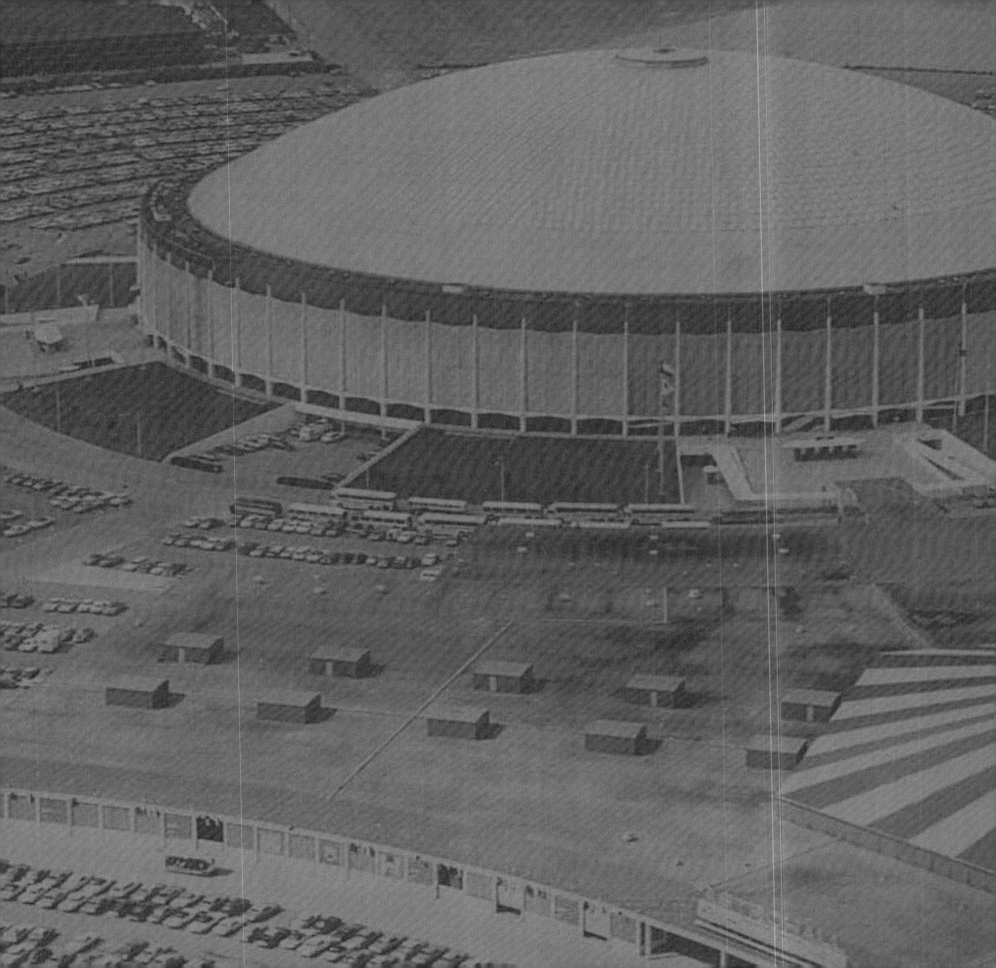

SPACE AGE
BASEBALL

CHAPTER 3

WITH A NEW STADIUM set to open in 1965, Judge Roy Hofheinz was seeking a new identity for the team. He consulted with some of the NASA astronauts about honoring them by giving the team the nickname "Astros," and they embraced the idea. Once the team was christened, the domed stadium rising from the prairie south of town became the Astrodome, another striking symbol of Houston's spectacular growth and can-do spirit.

The new logo incorporated a space theme of orbiting baseballs around the Astrodome.

Spanish language broadcaster Rene Cardenas remembers Hofheinz telling him, **"GET ON IT. TELL THE WHOLE WORLD HOW IT IS AND IF YOU NEED TO SPEND MONEY, DO IT."**

THE EIGHTH WONDER OF THE WORLD

Judge Hofheinz realized his dream in 1965 when the Astrodome opened as the "Eighth Wonder of the World." Hofheinz said, "We are building something that will set the pattern for the 21st century. It will antiquate every other structure of this type in the world. It will be an Eiffel Tower in the field."

The scoreboard was more than four stories tall, 474 feet wide, with 50,000 light bulbs and more than 1,200 miles of wiring. The display for an Astro home run was a particular delight for Houston fans and an irritant for opposing pitchers who allowed the homers.

Hofheinz conceived the 45-second display himself, including a cowboy roping a steer and two cowboys blasting pistols with the bullets ricocheting off various points of the scoreboard. The scoreboard cost a reported $2 million.

The playing field was 25 feet below street level to limit the vertical travel required by fans. Some 6,600 tons of air conditioning cooled the building. Houston fans began a long tradition of enjoying their games in air-conditioned comfort.

Hofheinz's dream stadium captivated fans and players alike. "It was like the city of Houston came alive," said Astros outfielder Rusty Staub. "It was incredible. It was spectacular."

Journalist Mickey Herskowitz was dazzled. "No one had ever been in a baseball facility that had color except for the billboards. But somewhere along that first year (1965), you could go to any city in the world, London or Paris for example, and if somebody asked where you were from and you said Houston, they would know about the Astrodome. People forget the impact the Astrodome had. It was so unique it didn't just change baseball—it changed architecture. It was the first time really on that scale that we brought the outside indoors."

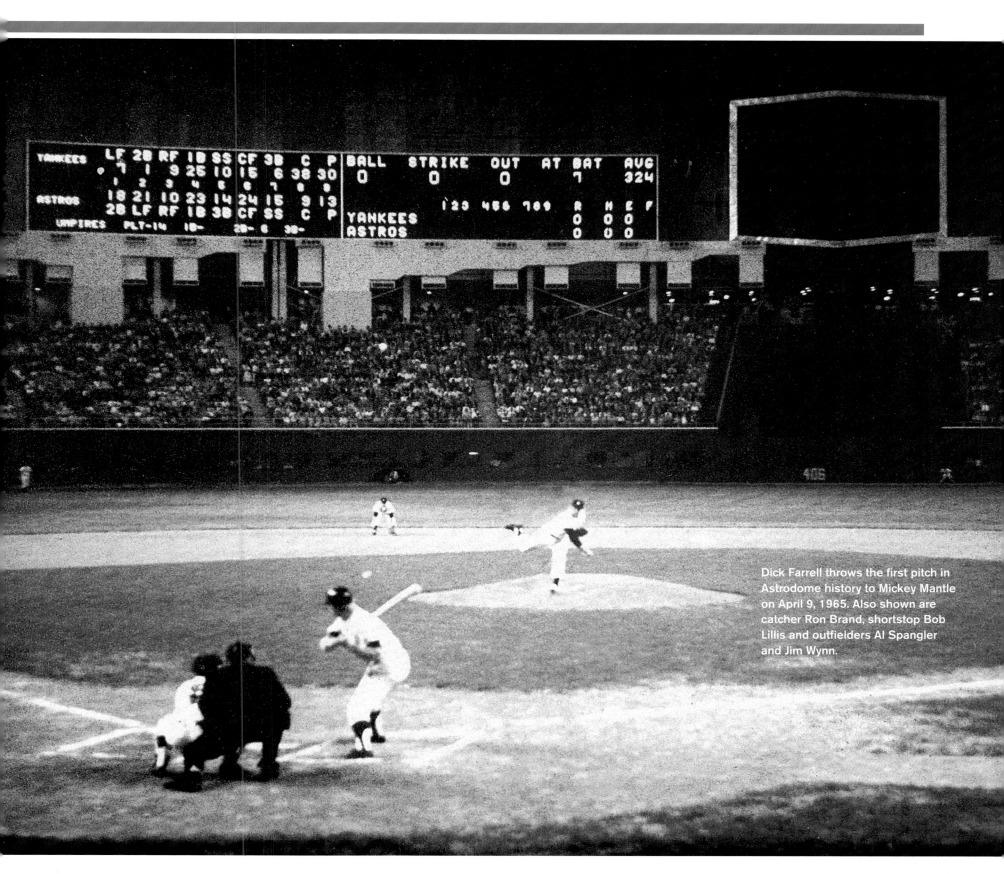

Dick Farrell throws the first pitch in Astrodome history to Mickey Mantle on April 9, 1965. Also shown are catcher Ron Brand, shortstop Bob Lillis and outfielders Al Spangler and Jim Wynn.

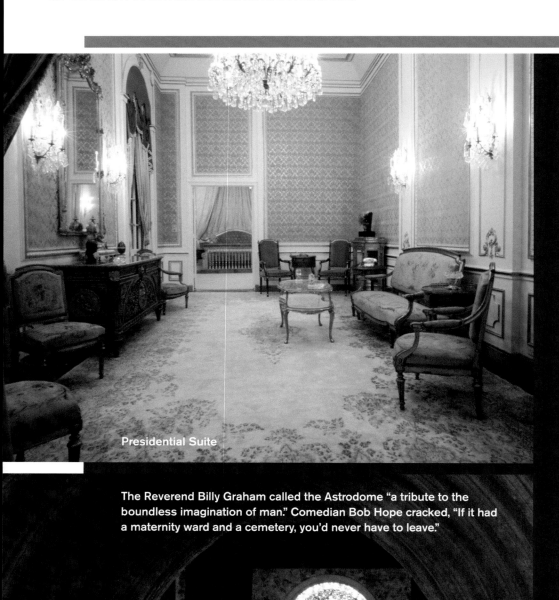

Presidential Suite

The Reverend Billy Graham called the Astrodome "a tribute to the boundless imagination of man." Comedian Bob Hope cracked, "If it had a maternity ward and a cemetery, you'd never have to leave."

HOFHEINZ'S VISION: SKY BOXES AND SKY LIGHTS

There were 53 luxury Sky Boxes along the upper rim of the stadium. Each suite came with a different design motif named after Hofheinz's world travels. Hofheinz had his own special office in the Astrodome with private quarters.

The 4,596 translucent Lucite roof panels in the Astrodome allowed sunlight to filter the necessary light for the specially selected Tifway 419 Bermuda grass field to grow. It was a stunning architectural breakthrough, but the players lost the baseballs against the glare. According to Jimmy Wynn, in one early Dome game, all three outfielders lost fly balls.

Larry Dierker pitched an intrasquad game in the afternoon before the first exhibition game. As he recalls, "You couldn't catch a fly ball because of the way the roof was in the Dome. I had pretty good hop on my fastball that day and I was getting a lot of popups and fly balls, but the fielders couldn't catch any of them. And I thought, 'Oh no. I'm going to get sent to the minors now because Major League players can't catch popups.' But of course, they were smarter than that and that didn't make any difference, so I made the team anyway."

Although Joe Morgan hit a home run in a later exhibition to set off the Astrodome scoreboard for the first time, the glare problem from the Lucite panels needed to be addressed quickly. Club officials tried color-dyed baseballs for a day exhibition game, but they didn't work.

"Never fear," said Hofheinz. "I will not be the first man to call a game on account of sunshine."

He announced that the skylights would be painted with a translucent acrylic coating over a three-day period at a cost of $20,000. That process had an immediate effect on the grass. It died.

The grass field became barer and the dirt was spray painted green, which stained the baseballs. Baseball had historically been played on grass. For the Eighth Wonder of the World to be the successful ballpark that Hofheinz envisioned, he would have to find a way to produce grass without direct sunlight.

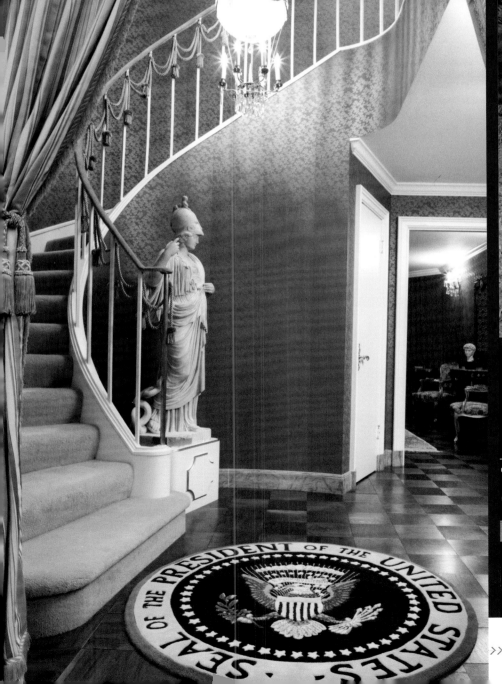

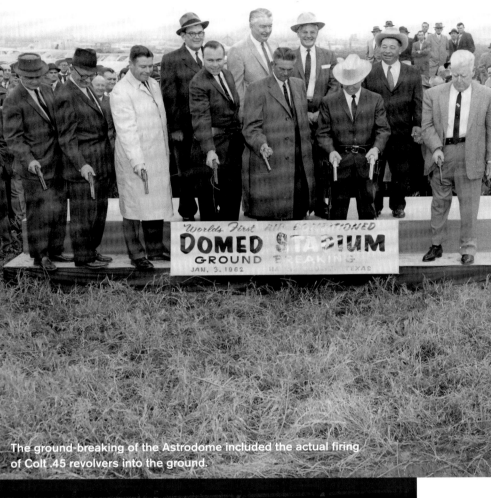

The ground-breaking of the Astrodome included the actual firing of Colt .45 revolvers into the ground.

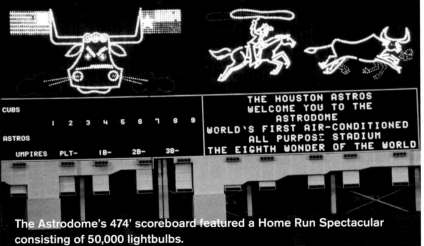

The Astrodome's 474' scoreboard featured a Home Run Spectacular consisting of 50,000 lightbulbs.

Years of work had paid off, and the franchise, the team name and the new stadium were securely in place. One question remained for Hofheinz and the Houston Sports Association: How would the stadium suit baseball games?

The first game, an exhibition game against the Yankees, took place on April 9, 1965. With President Lyndon B. Johnson on hand and astronauts throwing baseballs to Astros, the ceremonial first pitch honors went to Texas Governor John Connally.

Mickey Mantle bounced a leadoff single off Turk Farrell. Mantle later hit the first home run. Catcher Ron Brand's triple in the third off Mel Stottlemyre was the first Houston hit. A Nellie Fox game-winning hit in the 12th made the night a complete success for Houston, 2-1.

The official National League Opener in the Astrodome arrived April 12. The Philadelphia Phillies shut out the Astros 2-0 with Chris Short going the distance to beat Bob Bruce. Dick Allen hit the first regular season home run in the Astrodome. Later that month—on April 24 off Pittsburgh's Vern Law—Bob Aspromonte became the first Astro to blast a long ball in the Dome.

Eager fans poured into the futuristic baseball palace. June 25, 1965, on the 38th home date, the 1 million mark in home attendance was reached. The 2 millionth fan passed through the turnstiles Sept. 14. Despite a losing record, the Astros ranked second in National League attendance their first season in the Astrodome.

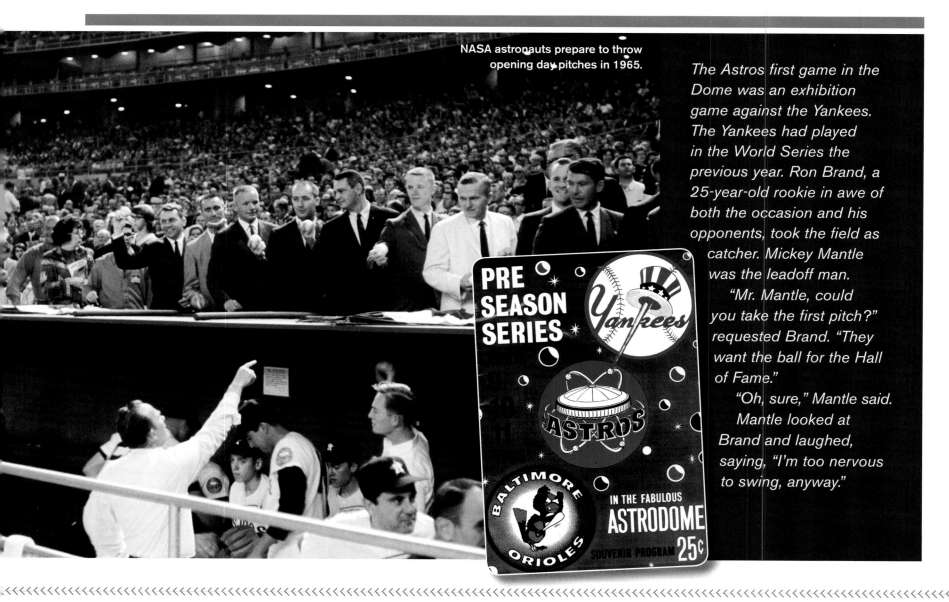

NASA astronauts prepare to throw opening day pitches in 1965.

PRE SEASON SERIES

The Astros first game in the Dome was an exhibition game against the Yankees. The Yankees had played in the World Series the previous year. Ron Brand, a 25-year-old rookie in awe of both the occasion and his opponents, took the field as catcher. Mickey Mantle was the leadoff man.

"Mr. Mantle, could you take the first pitch?" requested Brand. "They want the ball for the Hall of Fame."

"Oh, sure," Mantle said. Mantle looked at Brand and laughed, saying, "I'm too nervous to swing, anyway."

BALTIMORE ORIOLES

IN THE FABULOUS ASTRODOME

SOUVENIR PROGRAM 25¢

The longest game that occurred in the Astrodome was against the Mets. The Astros won 1-0 in 24 innings in 1968 in the Astrodome. After six hours and six minutes of baseball, Mets shortstop Al Weis allowed Bob Aspromonte's bases-loaded grounder to roll between his legs at 1:37 a.m., allowing Norm Miller to score from third.

After the problems he had encountered with the grass in the Astrodome, Judge Hofheinz decided to revisit the idea of an artificial surface that had been considered and rejected during the stadium's construction phase. Hofheinz decided that the synthetic turf, now being called "AstroTurf," would be installed in the infield and in foul territories for the first exhibition game of 1966. New grass and new soil were laid down in the outfield. After only one year in the Astrodome, Hofheinz revolutionized the sport again. The entire project came in under budget—at $17.5 million.

The first game played on a complete AstroTurf field was July 19, 1966. Turk Farrell beat the Phillies 8-2 with a complete game and belted a three-run homer. The Astros continued to rack up milestones in their new home. Eddie Mathews, who joined the club after a brilliant career with the Braves, got his 500th career home run July 14, 1967 at San Francisco off Juan Marichal. Mathews became the seventh player ever to reach that plateau.

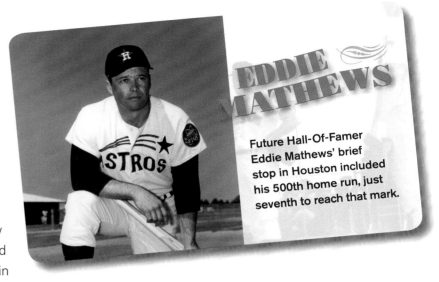

Future Hall-Of-Famer Eddie Mathews' brief stop in Houston included his 500th home run, just seventh to reach that mark.

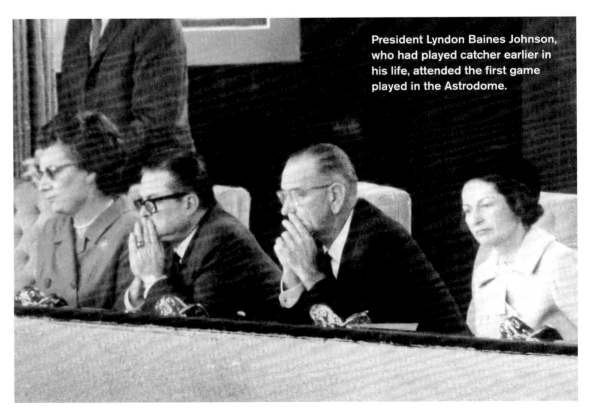

President Lyndon Baines Johnson, who had played catcher earlier in his life, attended the first game played in the Astrodome.

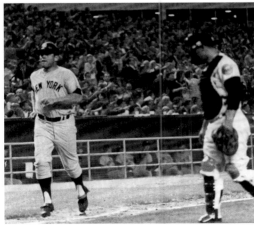

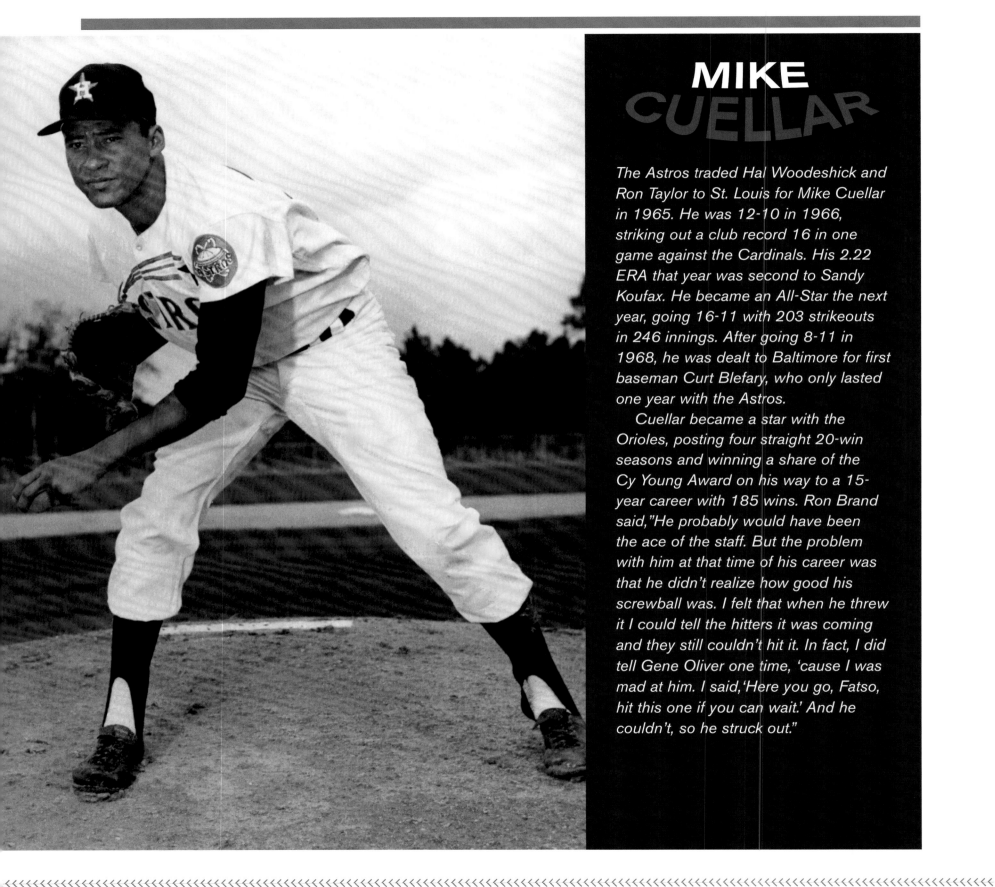

MIKE CUELLAR

The Astros traded Hal Woodeshick and Ron Taylor to St. Louis for Mike Cuellar in 1965. He was 12-10 in 1966, striking out a club record 16 in one game against the Cardinals. His 2.22 ERA that year was second to Sandy Koufax. He became an All-Star the next year, going 16-11 with 203 strikeouts in 246 innings. After going 8-11 in 1968, he was dealt to Baltimore for first baseman Curt Blefary, who only lasted one year with the Astros.

Cuellar became a star with the Orioles, posting four straight 20-win seasons and winning a share of the Cy Young Award on his way to a 15-year career with 185 wins. Ron Brand said,"He probably would have been the ace of the staff. But the problem with him at that time of his career was that he didn't realize how good his screwball was. I felt that when he threw it I could tell the hitters it was coming and they still couldn't hit it. In fact, I did tell Gene Oliver one time, 'cause I was mad at him. I said,'Here you go, Fatso, hit this one if you can wait.' And he couldn't, so he struck out."

RUSTY STAUB

Rusty Staub, who grew up in Louisiana, signed a six-figure contract in 1962. Paul Richards had rushed to New Orleans before Hurricane Carla arrived so he could sign Staub for $113,000 before Staub could agree to terms with one of the other 19 clubs scouting him. After one minor league season, Staub ran off a torrid stretch of hitting in 1963 Spring Training and made a huge leap to the Colt .45s for Opening Day.

"So when I thought I was going back to the minor leagues," said Staub, "they called me in the office and said, 'We've changed our minds. You're gonna stay with the ball club.' I was shocked. I was very pleased. They said, 'You're gonna play right field.' They had just traded Roman Mejias for Pete Runnels and he won the AL batting title once or twice and was supposed to be the first baseman. What could I say? I had to borrow an outfielder's glove and they played me in right field."

At age 19, Staub became the club's Opening Day right fielder, batting cleanup. He belted his first Major League homer that year, off Cy Young Award winner Don Drysdale. Recalling those heady times Staub said, "Some of the players resented the bonus money I got, and the publicity. I was ready for the game, but not for the life."

When General Manager Spec Richardson traded Staub to Montreal for slugger Donn Clendenon and Jesus Alou before the 1969 season, Houston Post *writer Mickey Herskowitz wrote, "It was like giving up a child for adoption." Making the trade worse, Clendenon retired rather than come to Houston. Commissioner Bowie Kuhn demanded the trade be restructured rather than voiding the deal. The Astros received Jack Billingham, Skip Guinn and $100,000 instead of Clendenon.*

Like Joe Morgan, Staub achieved greater heights after he left Houston. He finished a 23-year career with 2,716 hits and 1,466 RBI.

"I thought he was probably the smartest hitter I ever played with," Ron Brand said of Staub.

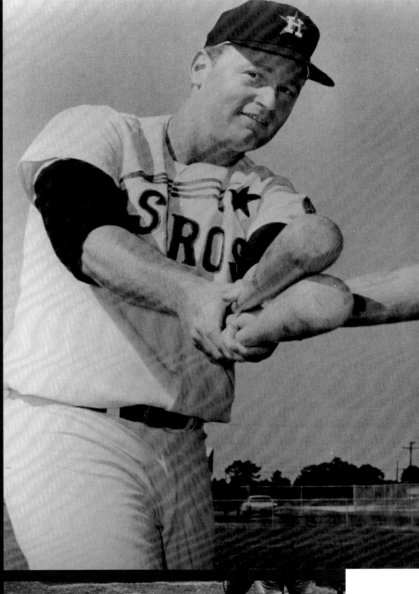

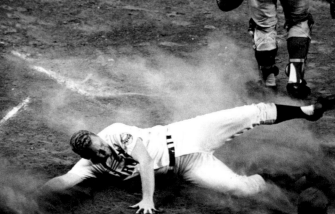

LARRY DIERKER

In the final year of the Colt. 45s, before the June draft, a 17-year-old pitcher from California became the target of a bidding war. Seventeen clubs vied for the young hurler. The Colts won the bidding and signed Larry Dierker for $55,000.

Sept. 22, 1964, in his Major League debut on his 18th birthday, he whiffed Willie Mays and Jim Ray Hart in the first inning at Colt Stadium. In 1966, when he was still only 19, he beat Sandy Koufax at Dodger Stadium 3-0. Dierker threw eight perfect innings at Shea Stadium that same year and wound up losing 1-0 in the ninth. In 1969 he became the club MVP and an All-Star, winning 20 and completing 20 games. He lost a no-hitter with two outs in the ninth against Atlanta on a Felix Millan infield hit. He finally threw a no-hitter July 9, 1976 against Montreal. Fans that night got free beer and enjoyed the fifth no-hitter in the franchise's history.

"Foamer nights" rewarded fans with free beer if an Astro pitcher struck out a hitter while a particular scoreboard light was on. "Somebody told me that after the Pete Mackanin strikeout everybody headed for the beer stands and that some people didn't realize there was a no-hitter going on," said Dierker. "So they would go up to get their beer and then drink it in line. They were drinking for two or three innings and missed the no-hitter."

Those fans missed a steady diet of Dierker fastballs to the Expos. "I had lost an earlier no-hit bid on an infield hit in the ninth," he said. "So I wanted to get them to hit the ball in the air and I was up 6-0, throwing nothing but fastballs. It was an unbelievable rush of adrenaline—that's what I remember more than anything."

That no-hitter occurred on his wedding anniversary. "For some reason or other I got a bottle of champagne and put it in the refrigerator that day," he said. "After the game was over and by the time I got showered all my teammates were gone…and when I went up there the only one who was still there was my wife, Judy. So we went home and when we got there we had a bottle of champagne waiting."

The team offered a thousand dollar bonus for his pitching that night. He knew the team was in receivership and said, "Hey, you guys are bankrupt. I'm not. Go ahead and keep the money. Pitching a no-hitter is a good enough reward for me."

He still holds club records for starts, innings and complete games in a career and single season records for innings (305) and complete games (20), numbers which seem unreachable today.

After his days on the diamond, Dierker worked in the front office and became a broadcaster in 1979. His analytical mind led to his selection as the club's manager in 1997. He served until 2001, devoting more than 40 years of service to the Astros. Inducted to the Texas Baseball Hall of Fame in 1993, he added Texas Sports Hall of Fame honors in 1999. Recognizing his career achievements, the Astros retired his number 49 jersey in 2002. In 2004, he was named one of Houston's 38 greatest sports legends. He returned to the television booth in 2005 and has written "My Team" and other baseball books.

JOE MORGAN

Joe Morgan moved rapidly through the Houston system and made his Major League debut in September 1963. But on the way, he ran into a major challenge. As an 18-year-old African-American playing in Durham, N.C. in 1963, Morgan felt the sting of racial slurs and threats. When the team went on the road, he had to stay in separate hotels with no air conditioning in the African-American part of town.

The pressures of the situation caused him to pack his equipment to go home, crying in frustration and anger. Walt Matthews, a 28-year-old white player and coach on the team, made sure badgering fans left him alone. Matthews "was kinda like a rock" to Morgan. "As a young player," Morgan said, "I wanted to be like Walt." By 1966, Joe Morgan became an All-Star. He was the first Houston non-pitcher to reach that stature, offering a 5'7" explosive package of speed and power.

Morgan said he signed with the Colt .45s because after a college game, scout Bill Wight told him "You're a really good player." Other scouts called him a good little player. His unique hitting style featured a "chicken flap," which was recommended by teammate Nellie Fox to keep his elbow higher as he waited for the pitch. The Astrodome hampered Morgan's production as a hitter and he clashed with Manager Harry Walker, as did many players. Morgan's talents were still well recognized, though. As an Astro, he scored 100 runs twice and stole 40 bases three times. He homered twice in one game off Sandy Koufax at the Dome and set the club record with six hits in a game at Milwaukee.

"You have the best eye in baseball," teammate Ron Brand told Morgan. "Use it. Take advantage of it." Brand

recalled, "People didn't talk about on base percentage that much then, but this guy could walk 100 times, score 100 runs, drive in 100 runs, steal 60 bases and hit 20 homers. What kind of an offensive threat is that?"

General Manager Spec Richardson parted with Morgan, the club MVP in 1970, in a blockbuster 1971 trade with Cincinnati. Morgan said, "I wasn't happy at the time because I'd played in Houston through the struggles and I wanted to be there when they had a good team." Looking back, he put it in perspective: "I've often said that Houston taught me how to play the game and in Cincinnati I put it all together. I hit 14 home runs in 1965, which was a good number in the first year of the Astrodome. And I stole 49 bases one year. The difference was if I drew a walk, stole second and never scored in Houston and we lost, nothing was made of it."

Morgan flourished in a Reds' uniform, winning consecutive Most Valuable Player awards in 1975 and 1976. The fans of Houston welcomed him back in 1980 and he contributed to the Astros' first Western Division title. In 1990 he became a Hall of Famer.

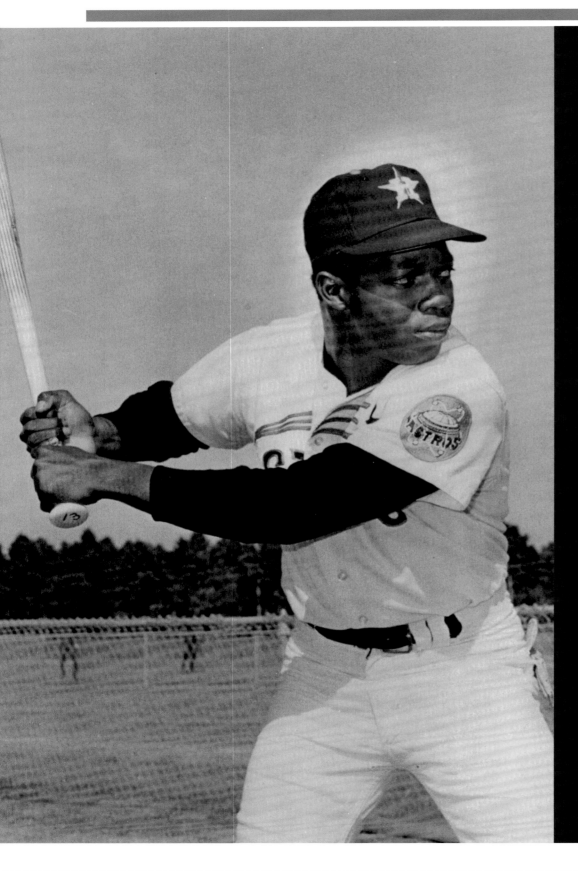

JIMMY WYNN

Jimmy Wynn was another athlete who helped the Astros attain respectability in the early years. Wynn was born in Cincinnati and grew up a few blocks from Crosley Field. "Frank Robinson would come driving by in a pink Thunderbird convertible on Colerain Avenue," said Wynn. "I used to race home from school and say hi to Frankie and Vada Pinson and that's how I got to know them and the rest of the ballplayers. I was always behind left field catching baseballs." Years later, when the Astros were at the Reds, Wynn clubbed a monstrous home run all the way onto I-75, bouncing among the passing cars. As the story went, it stopped rolling on Colerain Avenue, not far from his boyhood home.

Wynn had originally signed with Cincinnati, but Houston drafted him from the Reds. He made his Major League debut in 1963 as shortstop and took his first hit off Bob Friend. "I almost got killed in Pittsburgh with the infield playing in when Roberto Clemente hit a line drive to me," said Wynn. "I did not get my glove up in time and the ball hit me and continued on out into center field, about 90 feet."

The Houston club liked the way Wynn went back on fly balls, and he became a center fielder. Wynn, however, wasn't so sure about that idea. "Every day at noon at old Colt Stadium, I was ordered to come there and take 200 fly balls for a solid two weeks in order to become a center fielder. In that heat! And then turned around and played a ball game that night."

The sweltering workouts paid off. By the next year, he was a center fielder who connected for an Opening Day home run. In 1965, he was the club MVP with 22 home runs. In 1966 he blasted a home run out of Connie Mack Stadium in Philadelphia, clearing a tall billboard and the stadium's roof. And, in 1967 he became the first Astro to belt three home runs in a game at the cavernous Astrodome. Houston sportswriter John Wilson dubbed Wynn the "Toy Cannon," and that name stuck.

An All-Star in 1967, Wynn wanted to do more base stealing. The team discouraged that thought. "The guys on the team used to tell me to relax and swing the bat because they needed me to be strong so they could be strong," said Wynn. "It was a lot of pressure on me, but I enjoyed it up to a point. But this is a team game—not just one guy."

He told Richardson he wanted to spend his entire career with the Astros, but he received a phone call from Richardson asking him to waive his contractual rights and approve the trade to the Dodgers. He reluctantly did so because he felt the Astros didn't want him. After the 1973 season Wynn was traded to Los Angeles for pitcher Claude Osteen. "We were on the verge of having a very, very good ballclub," said Wynn. "After a while I guess management got to a point of saying, 'We need to get some ballplayers in here other than these young guys,' and that's exactly what they did." When The Toy Cannon left Houston, he had set club records for home runs in a career (223) and a season (37), RBI in a season (107), walks in a season (148) and runs in a season (117).

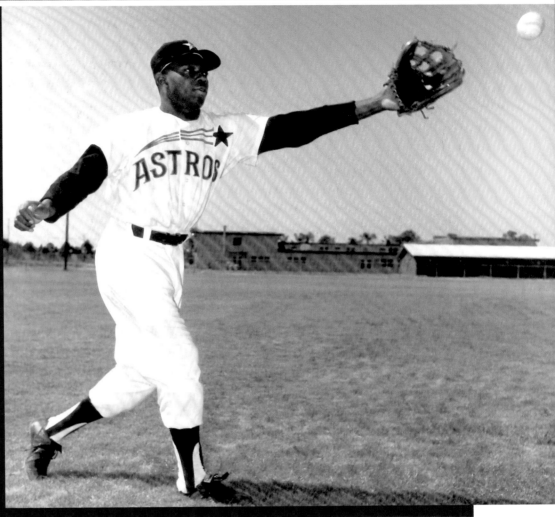

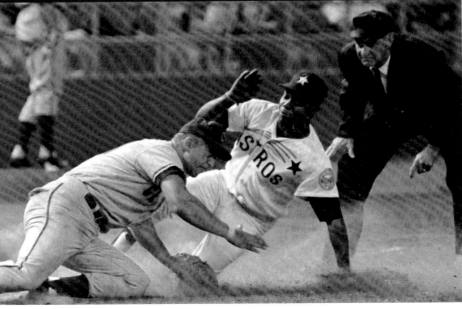

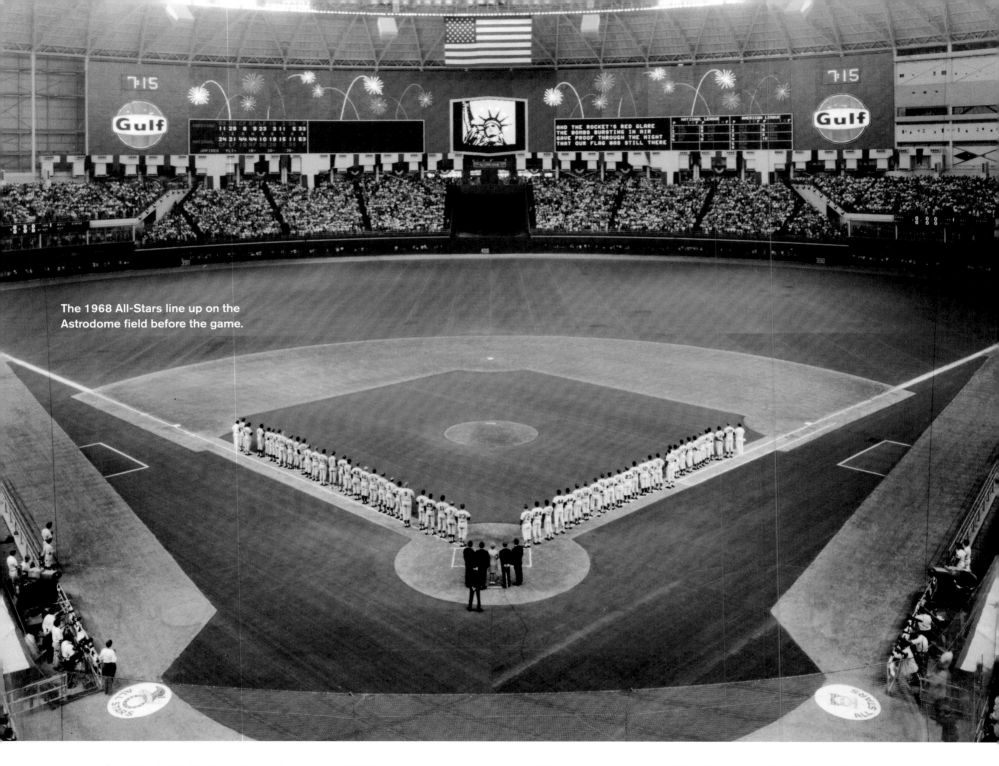

The 1968 All-Stars line up on the Astrodome field before the game.

On July 9, 1968, Houston entertained 48,321 at the Astrodome for its first All-Star Game. It was the first All-Star Game played indoors and also the first on artificial turf. In the "Year of the Pitcher," the National League won a pitching-dominated game when Willie Mays scored the only run in the first on a double play ball hit by Willie McCovey. The two squads produced only eight hits all night.

After seven seasons of finishing no better than eighth place in a 10-team National League, 1969 brought expansion, divisional play, the first non-losing season (81-81) and a fifth-place finish. As the '70s arrived, the focus would shift from establishing indoor baseball to establishing winning baseball.

50 YEARS OF UNIFORMS

In a 1961 name-the-team contest for the first Major League team in Texas, Houstonian William Neder had the winning submission. The original Colt .45's uniform, complete with its signature smoking pistol, gave way in 1965 to the shooting star design when the team's name changed to the Astros. It is believed that many of the remaining Colt .45's jerseys were destroyed by order of owner Roy Hofheinz. Since 1965, every Astros uniform has had a signature star either across the chest or on the sleeve.

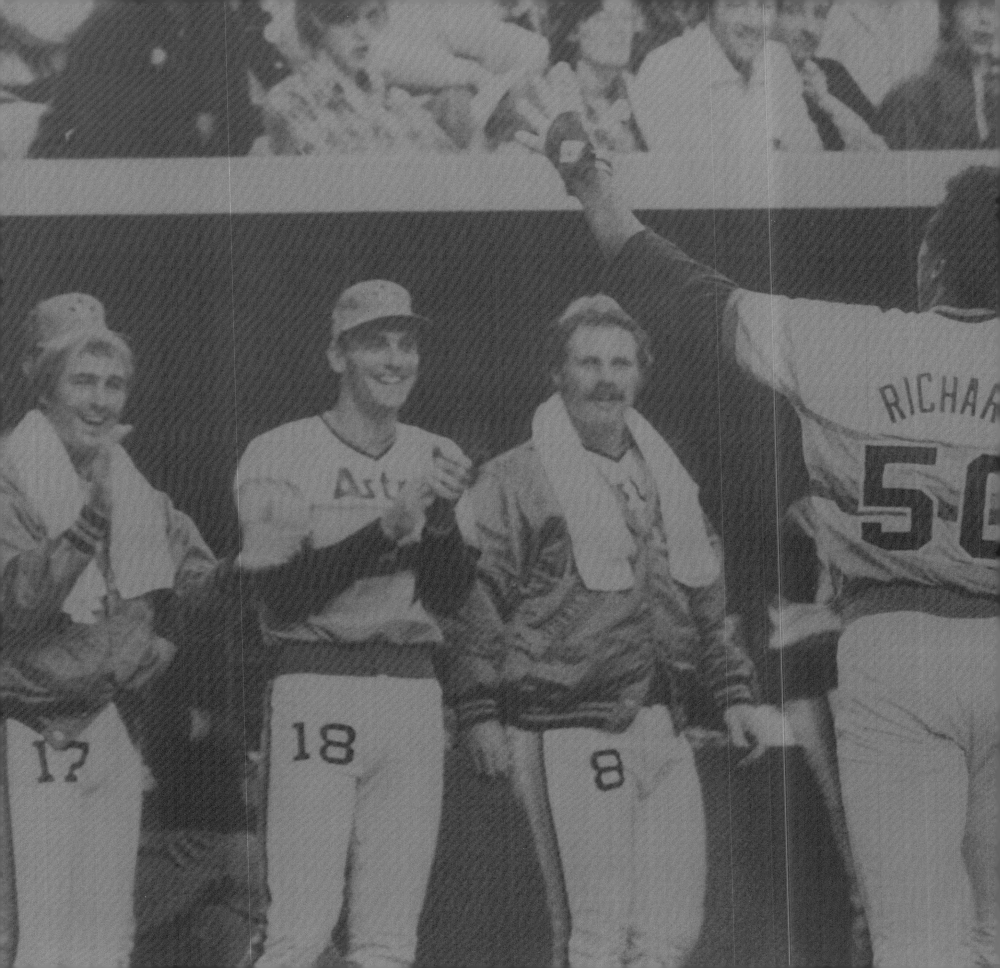

ORANGE
SLICES

CHAPTER 4

AS THE '70S BEGAN, THE Astros were no longer the young expansion club they were in the '60s. Their uniforms evolved just as their lineups did. In 1971, Houston switched to an orange cap and orange lettering instead of navy blue. Bigger sartorial changes were yet to come.

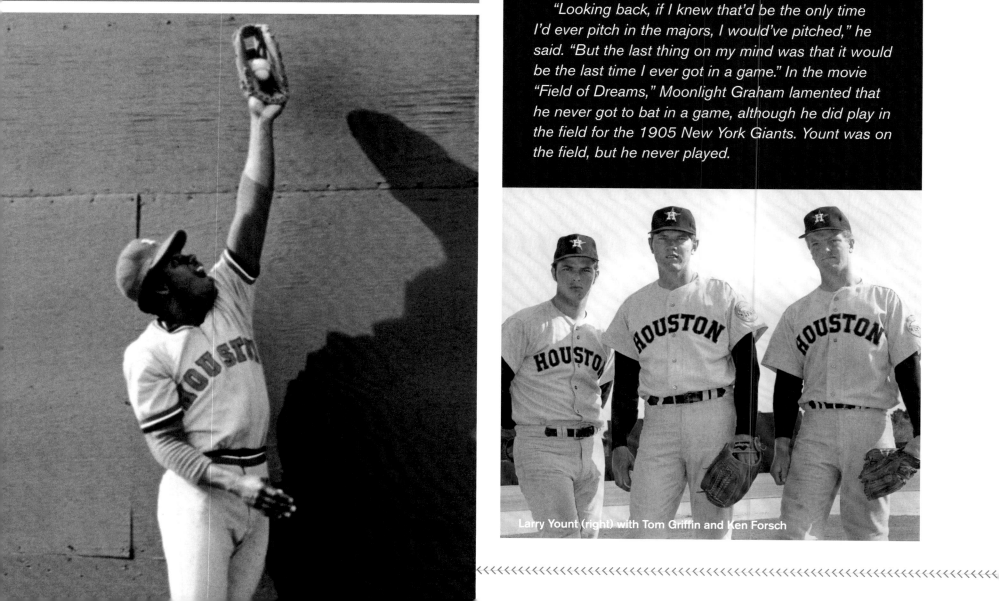

SHORTEST APPEARANCE

On Sept. 15, 1971, Hall of Famer Robin Yount's older brother Larry was called out of the Astros' bullpen to make his Major League debut. While warming up, Larry still felt the right elbow pain he had been feeling in the bullpen. He was unable to continue. Despite not throwing an official pitch, Yount had made an appearance. Yount's pitching line included all zeroes. And he never appeared in another Major League game.

"Looking back, if I knew that'd be the only time I'd ever pitch in the majors, I would've pitched," he said. "But the last thing on my mind was that it would be the last time I ever got in a game." In the movie "Field of Dreams," Moonlight Graham lamented that he never got to bat in a game, although he did play in the field for the 1905 New York Giants. Yount was on the field, but he never played.

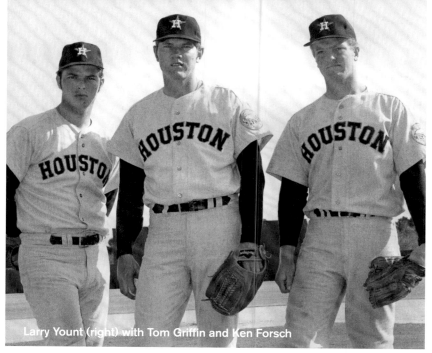

Larry Yount (right) with Tom Griffin and Ken Forsch

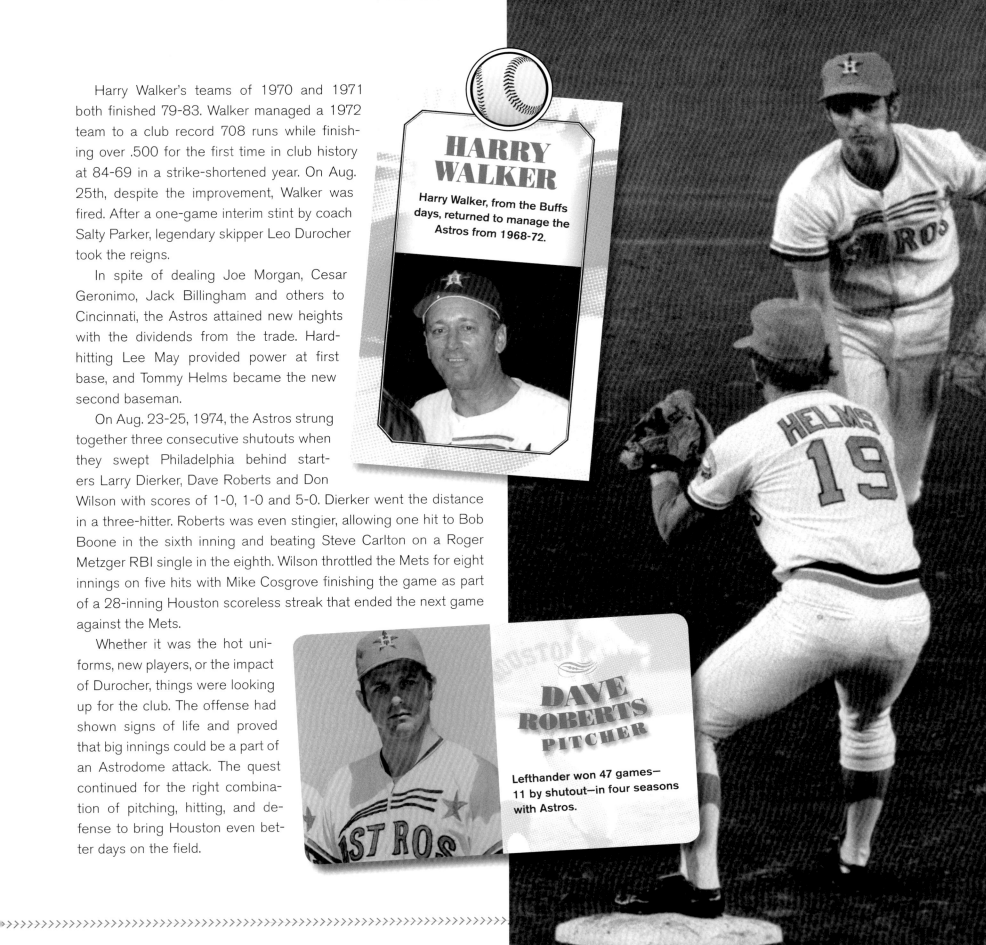

Harry Walker's teams of 1970 and 1971 both finished 79-83. Walker managed a 1972 team to a club record 708 runs while finishing over .500 for the first time in club history at 84-69 in a strike-shortened year. On Aug. 25th, despite the improvement, Walker was fired. After a one-game interim stint by coach Salty Parker, legendary skipper Leo Durocher took the reigns.

In spite of dealing Joe Morgan, Cesar Geronimo, Jack Billingham and others to Cincinnati, the Astros attained new heights with the dividends from the trade. Hard-hitting Lee May provided power at first base, and Tommy Helms became the new second baseman.

On Aug. 23-25, 1974, the Astros strung together three consecutive shutouts when they swept Philadelphia behind starters Larry Dierker, Dave Roberts and Don Wilson with scores of 1-0, 1-0 and 5-0. Dierker went the distance in a three-hitter. Roberts was even stingier, allowing one hit to Bob Boone in the sixth inning and beating Steve Carlton on a Roger Metzger RBI single in the eighth. Wilson throttled the Mets for eight innings on five hits with Mike Cosgrove finishing the game as part of a 28-inning Houston scoreless streak that ended the next game against the Mets.

Whether it was the hot uniforms, new players, or the impact of Durocher, things were looking up for the club. The offense had shown signs of life and proved that big innings could be a part of an Astrodome attack. The quest continued for the right combination of pitching, hitting, and defense to bring Houston even better days on the field.

HARRY WALKER

Harry Walker, from the Buffs days, returned to manage the Astros from 1968-72.

DAVE ROBERTS PITCHER

Lefthander won 47 games—11 by shutout—in four seasons with Astros.

DON WILSON

A dominant pitcher born in Louisiana and raised in Southern California, 6'2" righthander Don Wilson signed with the Astros at age 19 in 1964 and reached the Major Leagues in 1966. He became one of the standouts of the pitching staff and won 104 games in nine years, with a 3.15 ERA. He won 16 games twice and had six 200-inning seasons. In 1971, he was an All-Star as well as team MVP.

As a rookie, Wilson stopped Atlanta cold with a no-hitter June 18, 1967, whiffing 15. Wilson said he was "petrified" when he took the mound for the ninth inning of the 2-0 win, his second straight complete game. Manager Grady Hatton said, "I am amazed at the game he threw. He had thrown 155 pitches against San Francisco in his last start, and we had brought him back on three days rest. I was dying in the dugout–this is just too hard on a manager." Hank Aaron, who fanned three times, said, "It's young guys like this that make me want to retire."

Of all the teams the Astros played, it was the Reds who seemed to bring out the best in Wilson. He struck out 18 in a 1968 game at Crosley Field. In his second no-hitter at Cincinnati on May 1, 1969, the Astros were upset because they felt the Reds had taunted them during Jim Maloney's 10-0 no-hitter over Houston the previous night. Jimmy Wynn remembered, "What got Don irritated was that the Reds were laughing and howling and shouting at us during the game." The next day, when Wynn and Joe Morgan came into the clubhouse, they looked at Wilson and he was sitting in his locker. Wynn said, "I told Joe to tell everybody not to talk to Don, because Don was in a state of determination. And after he got the last guy, he wanted to go over and fight the Reds' manager, Dave Bristol. We had some hot contests against the Cincinnati Reds that year and Wilson hated Bristol."

Norm Miller recalled that Wilson charged off the mound toward the Cincinnati dugout and Bristol after the game. "We dragged him out into the old locker room and he tore the locker room apart," said Miller. Wilson polished off the Reds 4-0 in that game with 13 strikeouts.

Alongside Larry Dierker, Wilson was a mainstay of the pitching staff from the late '60s into the '70s. Wilson came close to a third no-hitter in one of the final games of his career. Walks and errors caused him to be removed for a pinch-hitter against the Reds when he trailed 2-1 despite eight no-hit innings. After Wilson died tragically by carbon monoxide poisoning, the Astros retired his uniform, number 40, on April 13, 1975.

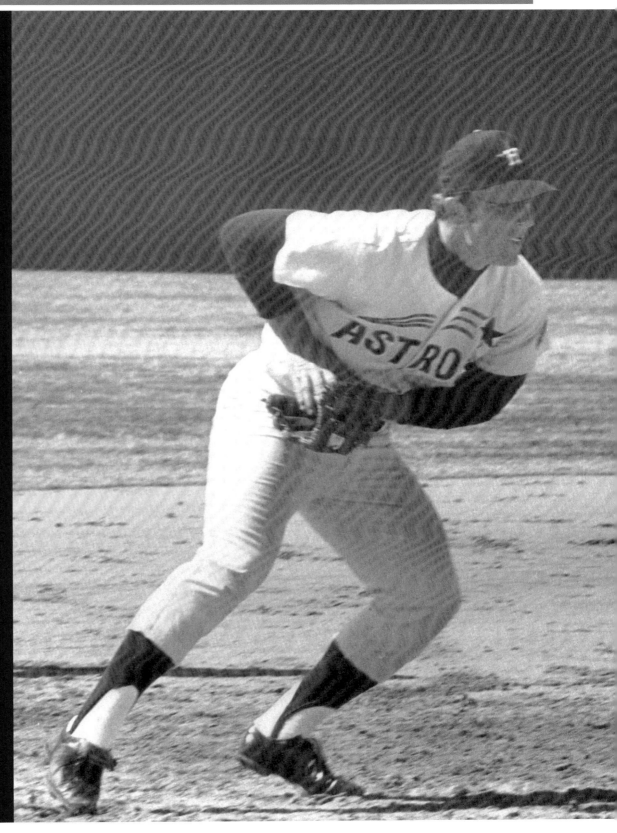

DOUG RADER

Third baseman Doug Rader, a homegrown product who signed in 1965 as a free agent after attending Illinois Wesleyan University, became a cornerstone of the teams of the early '70s. Rader, nicknamed the "Red Rooster," brought a red-headed, hard-nosed approach to the field. He compiled a career with Houston that would become a benchmark for third basemen to follow. He chased home 600 runs during his nine-year career in a Houston uniform, and he played 150 games or more during five seasons.

Winner of five straight Gold Gloves from 1970-74, Rader was often seen on the field with no glove at third base before the entrance gates opened, with an Astros' coach ripping ground balls off his chest and other parts of his body to prepare him for blocking balls when he didn't have time to use his glove. Behind the doors of the clubhouse, Rader shook up his teammates by hitting golf balls near their lockers as they dove to the floor in self-preservation. In 1975, when his offensive numbers slipped and he failed to win another Gold Glove, the Red Rooster was traded to San Diego.

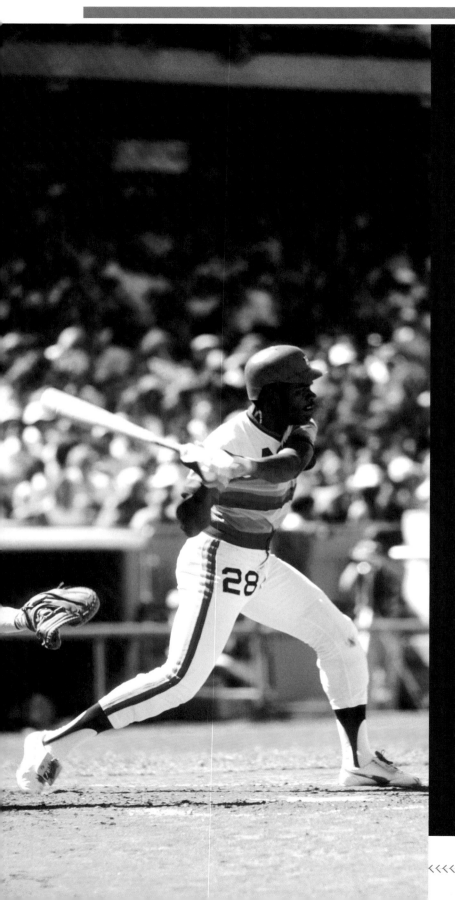

CESAR CEDENO

Pat Gillick and Tony Pacheco scouted and signed Cesar Cedeno in the Dominican Republic when he was just 16 years old. He moved swiftly through the minors, reaching the majors in 1970 when he was 19. For six consecutive seasons, from 1972-77, he stole 50 bases or more. In two of those seasons he joined the rare 20-50 club for home runs and steals. During his tenure with the Astros, Cedeno set club records for total bases, slugging percentage, and steals in one season as well as putouts by an outfielder. Cedeno won five Gold Gloves and was a National League All-Star four times. He hit for the cycle twice. "He was the next Willie Mays," said broadcaster Gene Elston, echoing Leo Durocher's sentiments.

Jimmy Wynn also recognized Cedeno's great talent, saying, "He could hit, he could throw, he could steal bases. But he did not want to play center field. And I had to go talk to him and tell him, 'You are the future of the ball club. They want you to play center field. Play center field and do the best that you can.' He wanted to play right field because his childhood hero was Roberto Clemente. I talked him into it and he decided to play center field and became a whale of a center fielder."

In 1978, Cedeno signed a 10-year contract for $3.5 million. Later that year he underwent surgery for a torn ligament in his right knee. Another body blow came his way in Game 3 of the NLCS in 1980 when he dislocated an ankle, requiring more surgery. In 1981, he was traded to the Reds for Ray Knight.

Enos Cabell agrees with the widespread opinion that Cedeno was the best athlete Houston developed. "One year, he was hitting .198 I think halfway through the season with 300-and-some at-bats. He hit .298 or .299 for the season. I've never seen anything like it. It was unbelievable. Every day he got two hits at least. And he was stealing bases, he was going crazy. I've never seen anybody play like that."

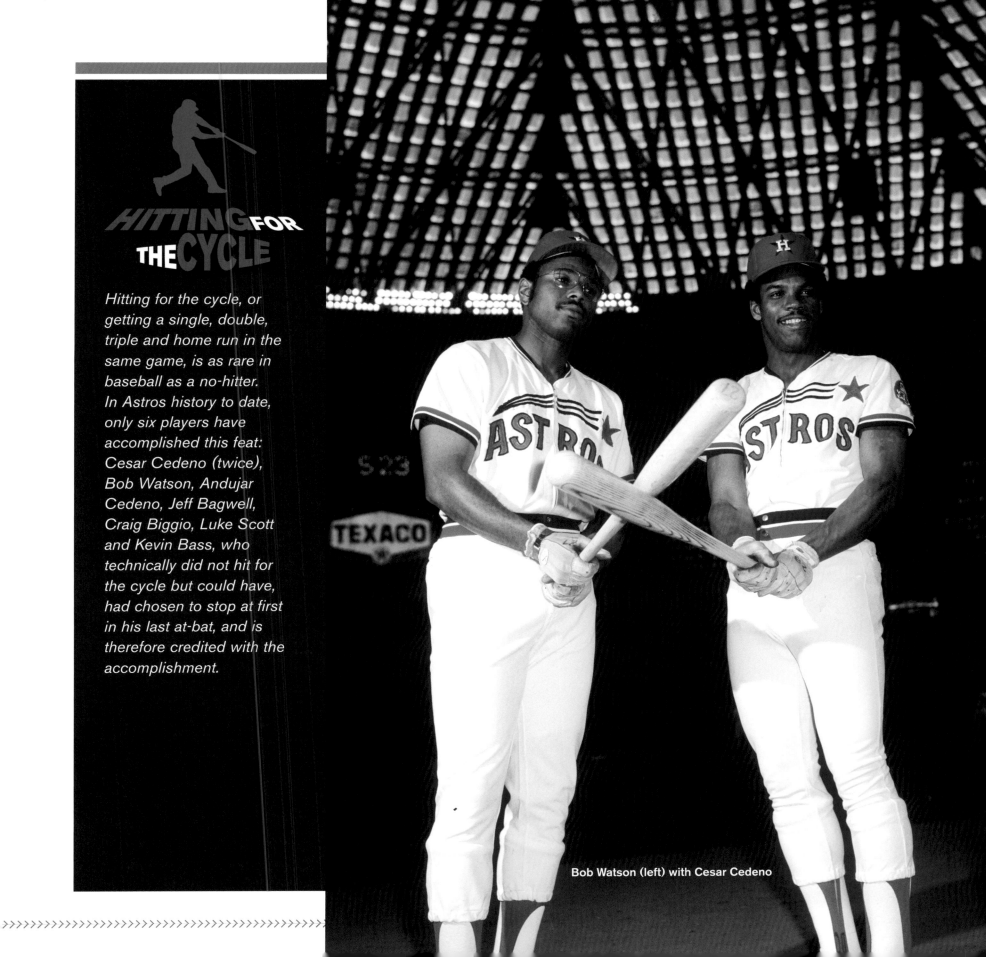

HITTING FOR THE CYCLE

Hitting for the cycle, or getting a single, double, triple and home run in the same game, is as rare in baseball as a no-hitter. In Astros history to date, only six players have accomplished this feat: Cesar Cedeno (twice), Bob Watson, Andujar Cedeno, Jeff Bagwell, Craig Biggio, Luke Scott and Kevin Bass, who technically did not hit for the cycle but could have, had chosen to stop at first in his last at-bat, and is therefore credited with the accomplishment.

Bob Watson (left) with Cesar Cedeno

BOB WATSON

Slugger Bob Watson served the club well in the Astrodome for 14 seasons. Watson remembered his days as an amateur in California, "When I graduated high school we couldn't come together on a contract so I went to junior college. I had a good year at junior college and hit .400 or whatever and scout Karl Kuehl signed me in the winter of '64, just before the Astros came into being."

As a catcher, Watson experienced a debilitating injury when a foul ball broke the tip off his right shoulder. After experimental surgery with three pins inserted into the shoulder, throwing became a painful chore, and he changed positions. He became a first baseman and outfielder and had "one good throw a day." Arriving in Houston in '66, Watson provided clutch hitting. He was an All-Star in '73 and '75. He had 100-RBI seasons in '76 and '77. In '86, he was voted first baseman on the All-Time Astros' Dream Team.

In addition to his awards and impressive stats, Watson earned some unique hardball honors. He became the first player to hit for the cycle in both leagues, in '74 for Houston and in '79 for Boston. Watson also scored what was believed at the time to be the one millionth run in history on May 4, 1975. Tootsie Roll Industries had sponsored a promotion to reward the player who scored the run with one million Tootsie Rolls®.

Watson recalled the legendary run. "Hey, to be real honest with you, the only reason I scored the run was we got rained out in San Francisco the day before," he said. "We played a doubleheader and started at noon. It was on the board up there how many runs

were needed to reach one million when our game started. It was on 10 by the time I got to the plate. John "The Count" Montefusco was pitching and it was down to two. He walks me on four pitches." Surprisingly, Watson stole second. The countdown to one million had reached one on all the stadium scoreboards. "He walks Jose Cruz on four pitches," continued Watson. "Now it's on one and I'm on second base. Like everybody else I'm watching. Now it gets to two balls on Milt May. On a 2-0 pitch he had to lay it in. Milt whacked it out of the ballpark. I started jogging and if it wasn't for the bullpen [in those days near the left field line right by third base] yelling, 'Run, run run...."

When the dust cleared, it turned out that at just the same time, in Cincinnati, Dave Concepcion had homered off Phil Niekro and was racing around the bases. Watson said, "Dave Concepcion hit the home run the same time Milt did. And he's low flying around the bases. So I take off in a sprint from third to home and I beat him by a second and a half or whatever it was. If the guys in the pen hadn't yelled, I would have jogged on in the way you normally do. And they robbed Davey of scoring the millionth run."

At 12:32:30 PDT, Watson scored the millionth run as Concepcion was rounding third in Cincinnati. Watson, whose children were allergic to chocolate, requested that the Tootsie Roll Industries send 500,000 Tootsie Rolls® to the Boy Scouts and 500,000 to the Girl Scouts. As part of the promotion, the Astros were awarded $10,000. Watson went on to play for the Red Sox, the Yankees and the Braves before joining Astros' management and becoming a factor in the '90s (see p. 126).

50 YEARS OF BASEBALLS

It has become commonplace to use baseballs with special logos to commemorate a special event or anniversary. Some of the most historic baseballs to be used by the Astros were from the 2005 World Series and featured the Fall Classic's logo in gold. The Enron Field logo was used in 2000 during the ballpark's inaugural season. The final regular season game played in the Astrodome included a special "35 Great Years" logo with the date of the game, October 3, 1999. The most historic baseball in Houston baseball history didn't have any special logos but may actually be the final out ball from Game 6 of the 2005 National League Championship Series. Houston's Dan Wheeler pitched to St. Louis hitter Yadier Molina, who flew out to right field where Jason Lane caught the ball, winning the NL Championship for the first time in franchise history. The ball was quickly secured by the Astros and was authenticated by Major League Baseball.

OFFICIAL BALL ★
WORLD SERIES
Allan H. Selig
COMMISSIONER

35 GREAT years 65-99

★ OCTOBER 3, 1999 ★

OFFICIAL
MAJOR LEAGUE BASEBALL

ENRON FIELD
INAUGURAL SEASON

★ OFFICIAL ★
MAJOR LEAGUE BASEBALL
Allan H. Selig
COMMISSIONER

RESPECT

THE MOST SIGNIFICANT CHANGE IN THE '70s took place in the front office. Tal Smith returned as general manager, and he hired Bill Virdon as manager. Their work together began to change the fortunes of the franchise.

Tal Smith had joined the club in 1961. He became vice president and director of player personnel in December, 1965. Foreshadowing the ways technology would revolutionize the creation of teams, he pioneered the development of computerized formats for scouting reports and other player data. During his first of three terms with Houston, Smith and his associates signed and developed more Major League players than any other team.

After leaving for two years to go with the Yankees, Smith returned to Houston in 1975 and hired Virdon to manage the Club. Their teamwork brought a new approach of acquiring and developing players who excelled in a style of play that was best suited for the Astrodome, emphasizing pitching, speed and defense.

The decade, marked by flashy uniforms, new ownership and the development of a game that would play in the Astrodome began to turn the stadium into the field of dreams that Hofheinz and his colleagues had envisioned when they went after the franchise.

A controversial rainbow uniform look for the 1975 Astros reflected the colorful garb of the era. The striped shades of orange, yellow and red on the chest behind a navy blue star and the similar stripes on the sleeves and pant legs were meant to look like the fiery trail of a rocket sweeping across the sky.

RAINOUT!

A unique "rain-in" on June 15, 1976 prevented the Astros and Pirates from playing their scheduled game. The players and staffs had made it to the Astrodome when heavy flooding hit Houston and prevented anyone else from joining them. Food was set up on tables on the playing field and uniformed personnel passed the time waiting until the flooding subsided. It was the only baseball postponement in the history of the Astrodome.

KEN FORSCH

Ken Forsch reached the majors in 1971 as a starter and reliever. He preferred to start. "The starters at that time were so good but we really didn't have any closers," said Forsch. "I went into that role for five or six years. And then Joe Sambito came into that role and I got an opportunity to get back into the rotation."

Forsch had made the club in Spring Training despite giving up 10 runs in one inning. Pitching coach Jim Owens went to the mound and was impressed that Forsch didn't want to come out of the game. "It was really a bizarre affair," said Forsch, remembering the game. "Denny Lemaster pitched the first five innings of that game—shutout ball. I went out and in my first warmup pitch—we had those old wool pants, and of course being a rookie you get anything they give you and they were so tight that I stretched out for my first pitch—and I ripped out the crotch from one knee to the other knee. Luckily there were no fans out there on Field 17 in Tampa. When Owens came out to get me he said, 'Anybody that's got guts enough to want to go out there, we'll give him a shot.'"

Forsch authored the earliest no-hitter in club history when he stopped Atlanta 6-0 at the Astrodome on April 7, 1979, in the first week of the season. He joined brother Bob, who had preceded him with a no-hitter in 1978, as the first brothers with no-hitters in the majors. Ken Forsch's came on an inauspicious day. He had pulled a hamstring in Spring Training and his left elbow was swollen from what the trainers thought might have been a spider

bite. His start that day was in doubt until the day before. He had a fever, and, as he recalls, Bill Virdon was going to scratch him. "I begged him to let me start," Forsch said. The only hard hit ball was a foul ball. With his effective sinker, Forsch got 15 ground ball outs with nine fly ball outs and three strikeouts, walking two and facing only 29 men.

Catcher Alan Ashby called that game, the first of three no-hitters he caught. Forsch was later presented with an orange Ford Mustang by Bill Odom of Ford Motor Credit Corp, which controlled the Astros when they were in receivership in the late 1970s.

Forsch spent 11 years with the Astros and had a career record of 78-81 with a 3.15 ERA. He made 421 appearances, starting 153 games and saving 50.

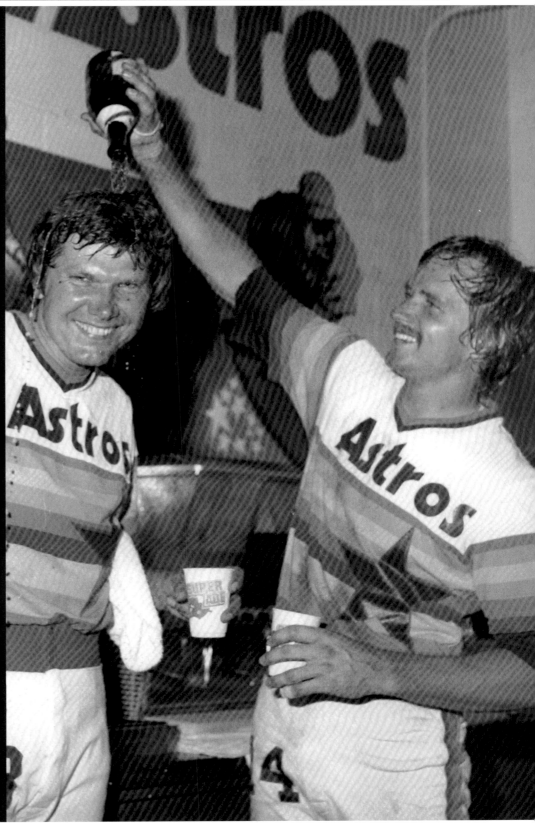

JOE NIEKRO

In 1979, Joe Niekro set a club record for wins in a season with 21. He had moved from a low cost acquisition in 1975 from Atlanta for $35,000 to a lynchpin of the pitching staff, piling up 263 innings that year. His Hall of Fame older brother Phil had learned the knuckleball from their father and relied heavily upon it for his success. But Joe, as Phil detailed, "threw the curve ball, the slider, the changeup and everything like that. He hung around quite a few years in the big leagues and I think maybe the hitters started figuring him out. He called me one day after he got traded for the fourth time and he said, 'That's it. I'm gonna hang 'em up.' And I said, 'What about the knuckleball?' He said, 'I've got it but nobody would ever let me throw it.' I said, 'Well, hey, that's all I've got and I'm still pitching. So think about that and if you need some help, my goodness, I'm here.'"

Joe Niekro parlayed the different approach into 144 wins with the Astros, setting the club record for wins in a career. Joe, by the way, hit his only career homer off brother Phil.

Broadcaster Dewayne Staats said, "Joe was as down-to-earth and salt-of-the-earth kind of guy as you could ever meet. There was no pretense about him. For a long time in his career he pitched in the shadow of his brother. And in fact when he had to pitch that playoff game in 1980, the night before he thought about it and articulated that he felt that might be his moment in the sun. Those brothers loved each other. Their parents agonized when

they had to pitch against each other. Joe had the greatest respect for Phil, as you would expect. But I think he seized that moment in that playoff game, realizing that it was 'put up or shut up' for him. His career really had been revived in Houston."

After Joe died of a brain aneurysm in 2006, his daughter Natalie started The Joe Niekro Foundation in 2007. Holding functions in the cities where Joe pitched, the foundation has raised more than $2 million for brain research, treatment and education. Natalie explained, "When I decided to start the foundation I really believed that it was Dad talking to me saying that you need to do this because it's a condition that's killing thousands of people every single year. I know that if he were here he would be doing this anyway on his own because he was just that type of person."

JOSE CRUZ

One of the best acquisitions in Astros history, "Cheo" was purchased from St. Louis after the 1974 season. He began a 13-year run with Houston that took his career to the upper echelons of the club's record books. Even though he had played with his younger brothers Tommy and Hector in St. Louis, he was happy to receive a call from G.M. Spec Richardson informing him of his acquisition by Houston.

When Jose Cruz left the club, he ranked as the franchise leader in hits, RBI, stolen bases, total bases and triples. He slashed 80 triples, which ranks him as the best in club history. He hit .300 six times in a Houston uniform.

Noted for his style, the four-time club MVP flexed his biceps in the batter's box when making himself comfortable and featured a high leg kick. He pranced to his position in left field like a high-strung stallion. He began running this way as a boy, after watching horses prance along the beach in Puerto Rico.

Cruz also developed a style of hitting which earned him the nickname "Chop Chop." He said, "I used to like it when the third baseman played me in at the Astrodome because I can hit the ball off the Astroturf over the third baseman's head for a double. Same way when I got a man at first base. I see the first baseman playing me in and I chopped it over his head for a double. I worked on that in

batting practice. I went to the ballpark with Tony Pacheco to hit the ball the opposite way and I came out a better hitter. A .300 hitter."

Public address announcer J. Fred Duckett drew out Cruz's last name when introducing him. The legendary Astrodome scoreboard spelled out "C-r-u-u-u-u-z" and the fans got in on the act, too.

"The first time he did it I thought they were booing me," said Cruz. "So I was wondering what I did wrong. I didn't make any errors. So I started listening again, and sometimes you can't tell whether it was 'boo' or 'Cruz'. It was pretty exciting for me. I was lucky that I was one of the favorites for the team."

It took some urging from Enos Cabell for Cruz to work up enough courage to have a talk with Bill Virdon about his playing time. Cruz said, "I talked to Bill and said, 'Listen Bill, I hit lefties just as good as right-handers.' He said, 'Oh, really? OK. Tomorrow, Steve Carlton pitches. You're playing tomorrow.' Maybe he thinks I was gonna back up. I say, 'I don't care. I'll play against anybody.' So I hit a home run against him. That was history. After that I played against everybody."

Jose Cruz's star continued to rise with the Astros through the next decade, and today, he still provides the club with his legendary style and expertise (see p. 92).

J.R. RICHARD

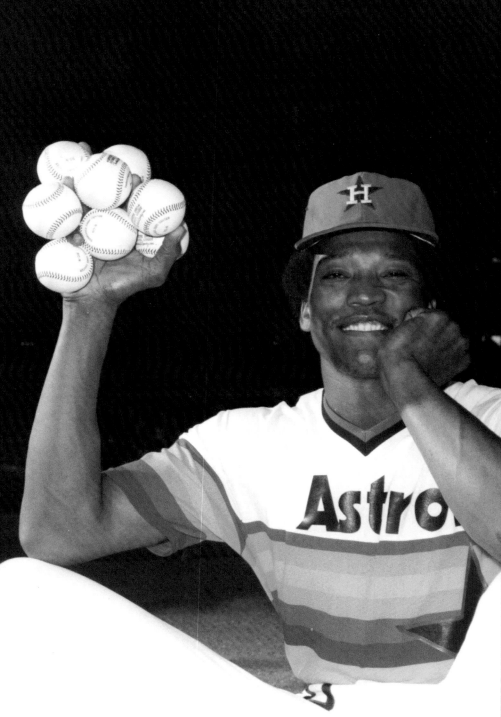

"He was special," said Joe Morgan. "I always thought that he was gonna be the best pitcher ever. [In 1980] I thought J.R. was on his way to being the best pitcher I'd ever seen."

J.R. Richard was a 6'8" high school basketball talent from Lincoln High School in Ruston, Louisiana, who reportedly passed on more than 300 scholarship offers to sign with the Astros in 1969. With an ERA of 0.00 in his senior year, he once hit four consecutive home runs in a game. He was the Astros' first choice. He went on to become one of only five pitchers in Major League history to have back-to-back 300-strikeout seasons.

Richard won 20 in 1976 and 18 for each of the next three years. In 1978 he became the first right-hander in the 20th century to strike out 300, with 303. In 1979 he surpassed that with 313–100 more than runner-up Steve Carlton.

In addition to his fastball, clocked in the upper 90s, his slider was a scary pitch for right-handed batters. He gained better command of his slider and reduced his walks from 4.6 per nine innings in 1978 to 3.0 in 1979, when he led the league in ERA (2.71). Allowing batting averages of .196 in 1978 and .209 in 1979, he was dominant.

By 1980, he had reached an even higher level and was on his way to his best season ever. Richard complained of shoulder stiffness and was taken out of two games but then rebounded to throw three consecutive shutouts. Then he left a game with a "dead arm," skipped a start and followed that with a bad outing. Nonetheless, he started the All-Star Game. He told the media that he was advised to take 30 days off, but later retracted that statement and kept pitching until leaving a game in July against Atlanta.

He experienced fatigue during a bullpen session and was placed on the disabled list. An exam revealed

a blockage in two arteries in his right arm. He was allowed to undergo supervised workouts. He was 10-4 with a 1.90 ERA when he collapsed during a workout at the Astrodome July 30, felled by a stroke that ended his career at age 30. Doctors performed surgery to remove blood clots from arteries in his neck. The batting average against him that year was .166. He had beaten the Dodgers for the 13th straight time early in the season.

Despite a comeback attempt, Richard's career ended with a 107-71 record and an ERA of 3.15. "After the stroke I had to relearn how to walk, speaking, talking, and all of that," Richard said. "We can all think on a hypothetical level what could have happened or what would have happened. But at the same time, after all this is said and done, I'm still here. I'm still alive. The sun is shining. Life is great."

"After about the third inning, they were pretty much beaten by him," Larry Dierker said of Richard's opponents. "Especially the right-handed hitters. I mean, Mays didn't want any part of that. When I think about J.R. Richard, I think about the most dominating right-handed pitcher I've ever seen. And I think about what could have been."

Richard was among the 2012 Walk of Fame induction class.

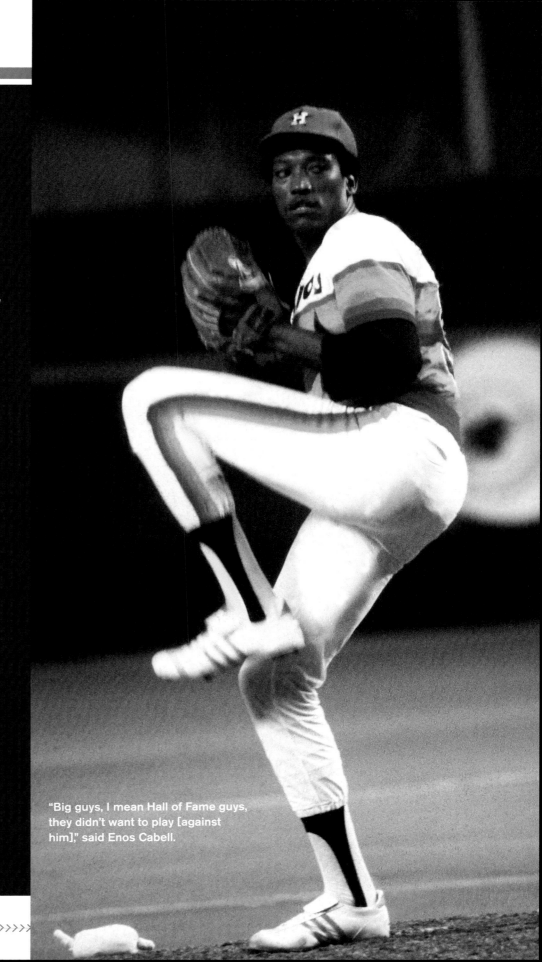

"Big guys, I mean Hall of Fame guys, they didn't want to play [against him]," said Enos Cabell.

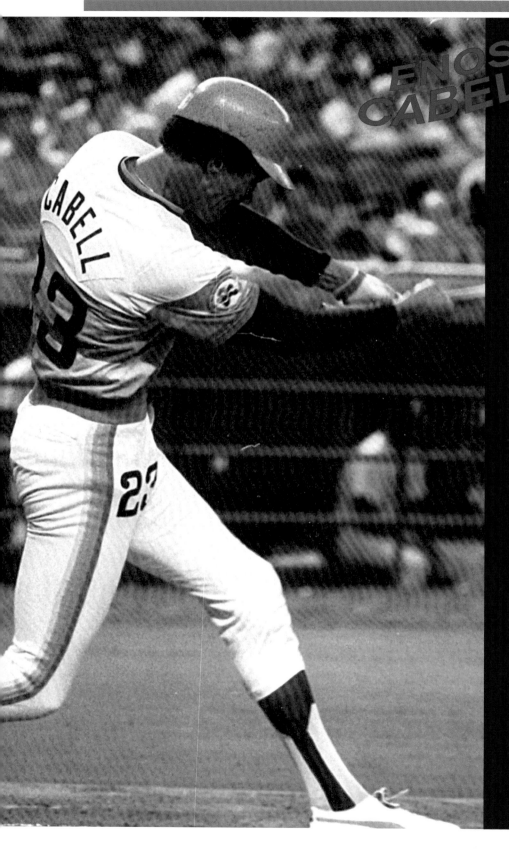

ENOS
CABELL

In the winter of 1974, Enos Cabell came to the Astros from Baltimore, in a trade involving Lee May. Cabell had requested a trade, because the talented Orioles were stocked at all the positions he played. In his eight years with the Astros, the 6'5" infielder hit .281 and stole 191 bases. He fit into an aggressive style of play. He was a hard-charging third baseman who took over the hot corner in 1976 after one season of playing multiple positions.

Cabell explained, "They traded most of the veterans that they could, and then we started playing younger players. I was one of those guys. Myself, Jose Cruz, Niekro—all of us got to play a lot more. Then we started adding people like Craig Reynolds, Alan Ashby. Terry Puhl came up. We brought up the kids—Joe Sambito, Dave Smith. I think I was 26 and I was one of the veterans on the team at that time. And Cedeno was already there."

Cabell took over at third from Doug Rader and was named team captain in the late '70s, wearing a uniform with "C" stitched on it. "I didn't do anything different and I don't think the guys expected me to do anything different," said Cabell of the responsibility. "If we had a meeting or something had to be said, usually I would say it and we would have it out right in the clubhouse, because we were changing the atmosphere of our team since we had lost for so long. It was just a change, I think, and we were tired of getting beat."

With a 1977 season with 101 runs scored, 36 doubles, 16 homers and 42 stolen bases, Cabell was named Astros MVP in 1978 after setting a club record at the time with 195 hits. He also played in all 162 games that year. He went on to be a big part of the 1980 Western Division Champions, and he has maintained a position with the Astros as a special assistant to the general manager, offering his input on players for evaluation by the front office.

BILL VIRDON

As the Astros positioned themselves for their first playoff year, they entrusted their improving organization to the managerial leadership of Bill Virdon. Just after returning to the Astros, Tal Smith hired Virdon, and the former Pittsburgh Pirate center fielder who had done a stint as the Pirates' manager took over the Astros in 1975.

When Virdon took over in Houston, the club had managed only one first division finish—in 1972 under Harry Walker. Virdon established firm discipline over the players. "He was a man's man," hitting coach Deacon Jones said of Virdon. "He demanded that players run hard for 90 feet to first base. He told them,'You will not chase fans away.' One night Cliff Johnson hit a popup and stood at home plate, getting mad as he watched the flight of the ball. He didn't run. We were screaming at him from the dugout to run, but he didn't. I looked at Bill and saw the veins popping out in his neck. After the game Bill told everybody but the next night's starting pitcher to meet at the ballpark at 10 o'clock in the morning. The next morning all the players went out to home plate and he made the players line up for practice swings and sprints up the first base line. He told them, 'Mr. Johnson is the reason you're doing this.' They ran hard to first for about half an hour and the workout ended."

Art Howe, a native of Pittsburgh, was excited about playing for Virdon. "The way he played the game was the way I always imagined myself playing," Howe said of Virdon. "He didn't say a whole lot. He was a disciplinarian. We were probably the best conditioned team in all of baseball. We used to run up and down the bayou including backwards and sideways."

Virdon had the longest tenure (seven years plus) and most wins (544) of any Houston manager. He managed 995 wins in his Major League career and was brought back to be rookie manager Larry Dierker's bench coach in 1997, continuing his legacy of teaching fundamentals and developing winning players.

Art Howe, a Pittsburgh native who was signed in his second try at a tryout camp by the Pirates in 1971, made his Major League debut in 1974 with the Pirates. After the 1975 season, he was traded to the Astros for Tommy Helms, in another of the insightful deals the Astros made. For seven years, Howe played as needed at all four infield positions for Houston.

In May of 1980, a Scott Sanderson pitch pierced through the shadows created by the roof of Olympic Stadium in Montreal and shattered Howe's jaw when he was late reacting. He wore a football type helmet to protect his broken jaw, which was wired shut. A few days after surgery, he was back as a pinch hitter.

Recalling the situation, he said, "The thing that was really difficult for me was breathing. I snipped a couple of those little rubber bands that kept my mouth closed so I could breathe when I ran. I pinch hit and struck out in my return. First time I ever struck out and got a standing ovation. That was nice." The batting helmet had a strip of plexiglass on the bottom, and Howe couldn't see the low pitch. "I never swung at a bad pitch down when I was wearing this thing," he said. "It was almost like a scope. The ball had to come right down the chute for me. I started hitting real well. My plate discipline improved. I lost 13 pounds on a liquid diet."

Howe's career spanned 11 Major League seasons. He played on the 1980 and 1981 playoff teams, hitting a home run in the 1981 Division Series. When he had a career day, driving in four in the 1980 one-game playoff at Los Angeles, he remembered a warning from the home plate umpire that helped him.

"I got a reprieve from Doug Harvey on the two-run homer. There were two outs and a man on second with a 1-2 count on me. Goltz threw that knuckle curveball that he was famous for. It froze me at the plate, to be honest with you. I thought it was strike three. But Harvey called it a ball. Joe Ferguson, our ex-teammate, was catching for the Dodgers. He jumped all over him and said, 'Doug, that's strike three!' And I stepped out of the box and looked back at Doug. Doug said, 'Artie, don't take that pitch again.' So I got back in there. Believe it or not, he threw the exact same pitch and I hit it out of the ballpark. And I'm coming across home plate and Ferguson is going crazy and I winked at Doug when I went by him."

Among Howe's accomplishments were hits in eight consecutive at-bats in 1980. He remembered leaving for a pinch hitter after his eighth straight hit when he was three for three in a game. He also set the club record at the time with a 23-game hitting streak in 1981.

"I was pretty hot," Howe recalled. "In the next game, when it ended, I pulled a hamstring running to first base on a squeeze bunt the first time up. No one really knew what the rules were then but the squeeze was a sacrifice. With no plate appearance I could have come out of the game and the streak would have been alive. No one seemed to know then, but I played. It hurt to swing every time after that. I was facing Tim Lollar the last time up and I remember everybody said, 'You can't walk.' So the count went to 3-2 and I fouled off about six pitches. I was swinging at balls over my head and I finally made an out. That was it. That's the only time in my life I just went up there hacking."

In 1989, Howe returned to manage the Astros for five years, finishing with a 392-418 record and helping the team transition from an older, veteran club through a rebuilding phase to a contending phase again. He later managed Oakland from 1996-2002 and the New York Mets in 2003 and 2004.

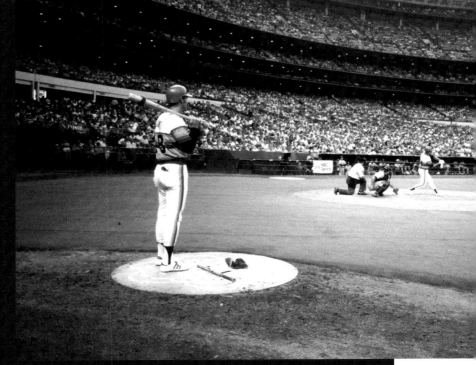

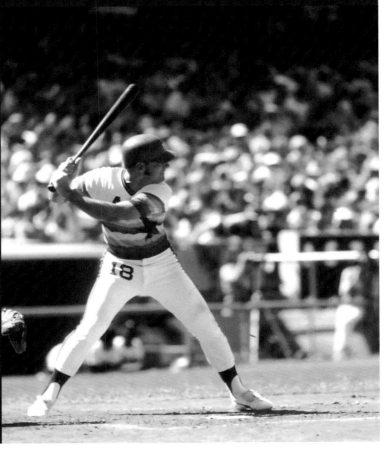

By May 10, 1979, when Montclair, New Jersey resident John McMullen purchased the Astros, the team had gotten off to an 18-13 start and was in a position to contend. Through wise management of limited resources, the Astros were a bargain for this former limited partner of George Steinbrenner in the Yankees' ownership. Three playoff teams in the 1980s would provide the first taste of success for an organization that had thirsted for it and would prove McMullen had made a sound investment.

JOHN McMULLEN

Like George Steinbrenner, his former limited partner in the Yankees' club, John McMullen built an estate with shipbuilding ventures and was ready to move to prominence in sports. A graduate of the U.S. Naval Academy, McMullen had served for 14 years with the U.S. Navy, retiring with the rank of Commander. His neighbor in New Jersey, Hall of Fame catcher Yogi Berra, later became an Astros' coach.

McMullen, who was passionate about playing golf and for a time owned the New Jersey Devils of the NHL, delegated operations of the team to those in Houston while spending much of his time in his home state. Known as a shrewd investor, he sold the Astros for several times his original investment. He also bought and sold Home Sports Entertainment, which televised Astros and Rockets games, at a rock bottom price and turned it over for a large profit.

50 YEARS OF CAPS

The first Astros cap seen in 1965's Spring Training had three variations: an orange block style "H" similar to the Houston Buffs; a more stylized orange version of the letter similar to the font used on the jerseys; and a solid orange star. For the regular season, this navy cap logo featured the orange star with a white block-style "H". The design was used until 1993, with an inverted variation on orange caps from 1971-1982. The 1994 season saw a new metallic gold shooting star that was modified to brick red when the Astros moved downtown in 2000. The 2013 season sees the return of the original Astros design, slightly modernized.

BIG
Dreams

CHAPTER6

FROM A 21-18 START ON MAY 25, 1980 the Astros reeled off 14 straight wins at home. Their outstanding home record of 55-26 that year epitomized their mastery of Astrodome baseball.

The Astros had battled the Dodgers most of the summer. After losing J.R. Richard to his stroke, they dropped five in a row. Vern Ruhle was chosen to join the starting rotation, and he went 7-2 during Richard's absence. With a deep bullpen, manager Bill Virdon could maneuver Joe Sambito, Frank LaCorte, Dave Smith and Joaquin Andujar in the late innings.

The Astros went to Los Angeles in early October with a three-game lead and three to play. But they lost all three. That left the Astros tied with the Dodgers and forced a one-game playoff in Los Angeles. Niekro went the distance on October 6 in a 7-1 victory at Chavez Ravine to secure the long-awaited playoff spot. It was his 20th win, the 163rd game of the season. When Dave Bergman fielded the final ground ball, Houston had avoided a bitter end and turned its energy toward the playoffs and Philadelphia.

The ramifications of losing the three games in Los Angeles would be felt very soon.

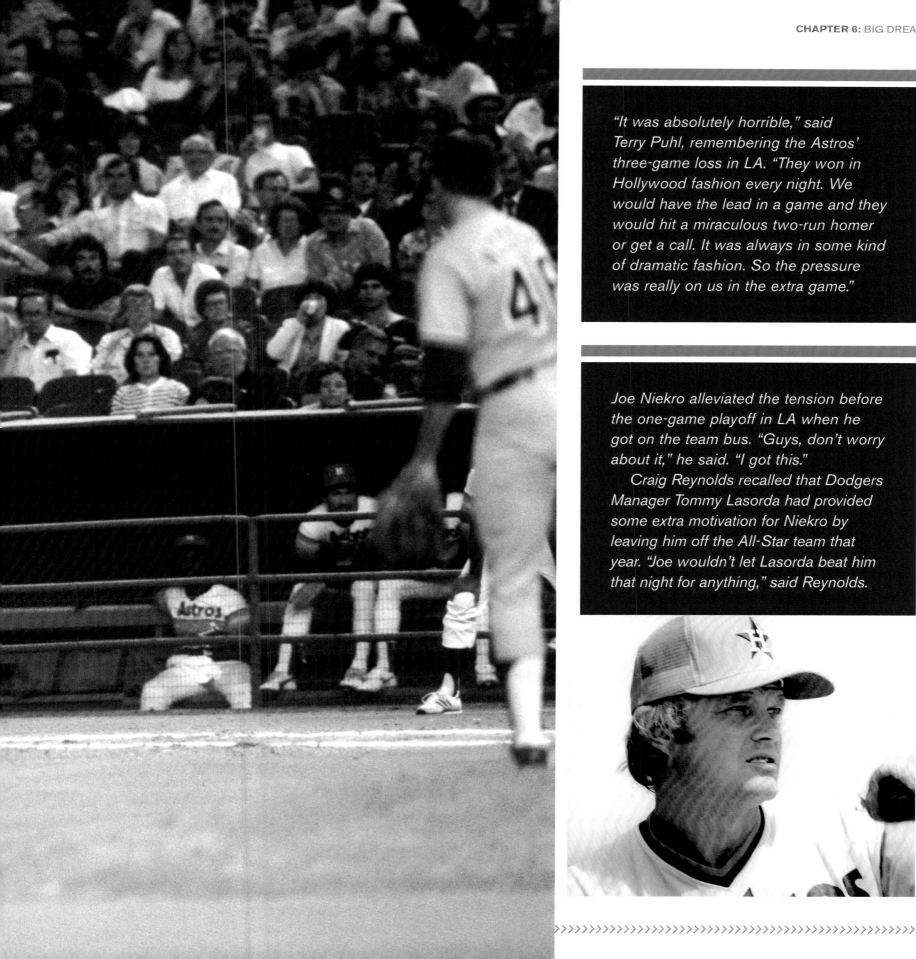

"It was absolutely horrible," said Terry Puhl, remembering the Astros' three-game loss in LA. "They won in Hollywood fashion every night. We would have the lead in a game and they would hit a miraculous two-run homer or get a call. It was always in some kind of dramatic fashion. So the pressure was really on us in the extra game."

Joe Niekro alleviated the tension before the one-game playoff in LA when he got on the team bus. "Guys, don't worry about it," he said. "I got this."

Craig Reynolds recalled that Dodgers Manager Tommy Lasorda had provided some extra motivation for Niekro by leaving him off the All-Star team that year. "Joe wouldn't let Lasorda beat him that night for anything," said Reynolds.

THE FIRST
PLAYOFFS

"Before the game in the clubhouse I wondered what was going to take place," said Alan Ashby, the catcher who would later morph into the Astros' broadcaster. "Would Bill Virdon have a meeting and would it be somber or **WOULD THERE BE ANGER OR ENCOURAGEMENT** *or what might go on? Jose Cruz wound up dancing on a table in limited attire, I'll put it that way, and everybody started cracking up. And we basically went from that danceoff by Jose Cruz onto the field laughing and it was just one of those days that erupted from that moment."*

The 1980 National League Championship Series was played between the Philadelphia Phillies and the Houston Astros from Oct. 7 to Oct. 12. Phillies' Manager Dallas Green later remembered the crowd noise at the Astrodome as the most deafening he ever encountered.

The Phillies grabbed the opener 3-1 in Philadelphia when Steve Carlton beat Ken Forsch with a two-run homer from Greg Luzinski in the sixth.

In **Game 2,** also played in Philadelphia, the Astros prevailed 7-4 in the 10th with Frank LaCorte the winner and Joaquin Andujar getting the save. Nolan Ryan and Dick Ruthven, the starting pitchers, both allowed two runs and the game went to the late innings tied. Jose Cruz singled with one out in the 10th to snap a 3-3 tie.

Joe Niekro dazzled the Phillies with 10 shutout innings in **Game 3.** Dave Smith got the win, 1-0 in 11, when Morgan tripled and Denny Walling drove in the run with a sacrifice fly. Walling's winning fly ball gave the Astros the win and a 2-1 lead in the series that put Houston within one game of its first World Series berth.

The Astros suffered another costly loss in **Game 3,** this time of 11-year veteran Cesar Cedeno. Cedeno tripped over first base in the sixth inning and had a compound dislocation of his right ankle, ending his season.

Another extra-inning game went to the 10th. The Phillies staved off elimination and captured **Game 4,** 5-3, in a contest that pushed even the umpires to their limits. In the fourth, Astros starter Vern Ruhle either trapped or caught a line drive with two on and then threw to first base, where Art Howe caught it and stepped on the base. Seeing the runner at second had run to third, Howe ran to second and stepped on that base as the umps ruled a triple play. But the Phillies protested and, after a long discussion with league officials, the umpires put the last runner back at second and ruled it a double play.

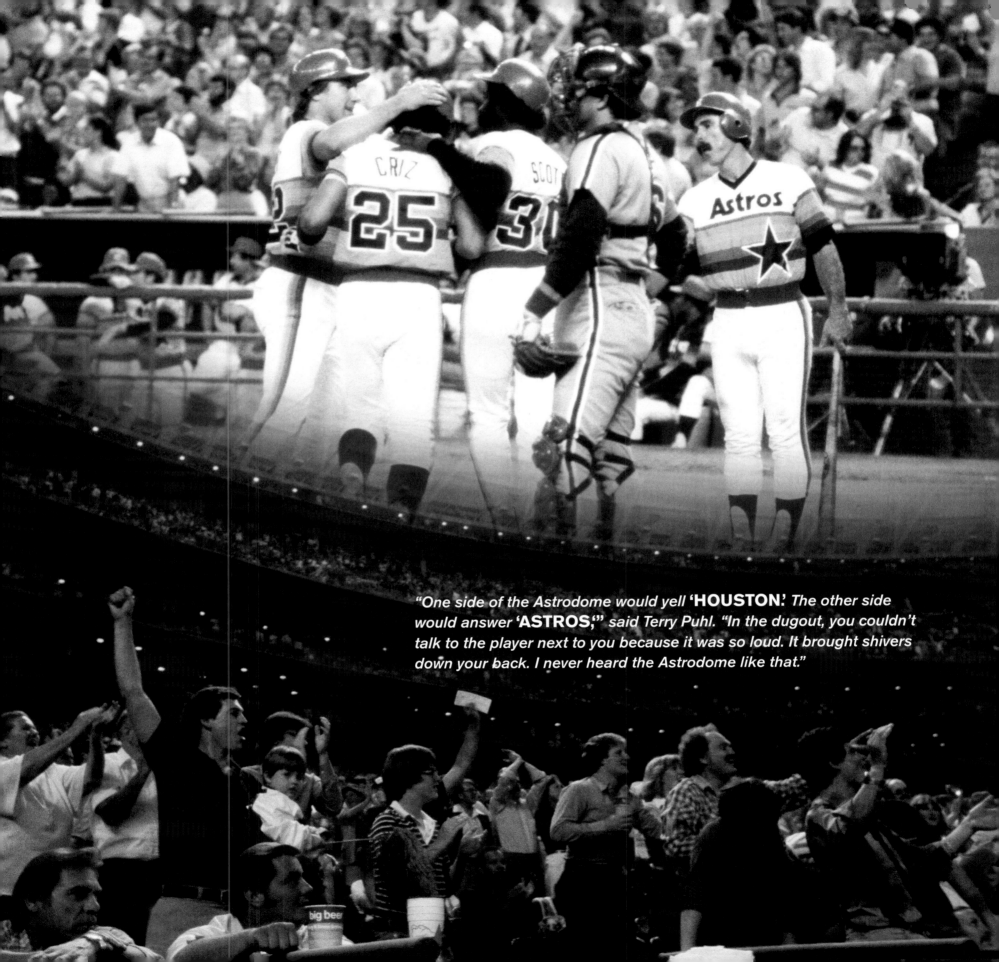

*"One side of the Astrodome would yell '**HOUSTON!** The other side would answer '**ASTROS,**'"* said Terry Puhl. *"In the dugout, you couldn't talk to the player next to you because it was so loud. It brought shivers down your back. I never heard the Astrodome like that."*

Denny Walling's sacrifice fly in Game 3 drove pinch runner Rafael Landestoy home for the winning run. "Walling was one of the best pinch hitters in the business, and in key situations when we had a chance to win I'd put him up there against anybody," said Virdon.

Walling knew what to expect. **"I HAD TWO STRIKES TO HIT, NUMBER ONE,"** he explained. "I was a believer that you could get two strikes in an at-bat. I kept it really simple. I knew the adversary. I watched how he was pitching Craig Reynolds and Terry Puhl and assumed he would pitch me the same way."

Philadelphia shortstop Larry Bowa recalled the challenge of facing Joe Niekro. "You couldn't sit on that pitch (the knuckleball). He had other pitches," Bowa said. "Phil ...you could sit on a knuckleball. That's all he threw. Joe had all that other stuff and **HE THREW HARD ENOUGH THAT YOU COULDN'T JUST SIT ON A KNUCKLEBALL.** He had a good move to first. You figure a guy with a knuckleball, you can steal. But it wasn't that easy. He was tough. Real tough."

With a 2-0 lead in the bottom of the sixth, Astros outfielder Gary Woods left third base too soon while tagging up on a fly ball to right fielder Bake McBride and was out on appeal at third base.

A World Series berth was just six outs away when the Phillies struck for three runs in the eighth for a 3-2 lead. Houston tied it in the ninth before Pete Rose of the Phillies scored the winning run in the tenth on a pinch double by Greg Luzinski, knocking over catcher Bruce Bochy at the plate.

In **Game 5,** the Astros appeared headed for a World Series meeting with Kansas City, leading 5-2 in the seventh inning at home with Nolan Ryan on the mound. Houston could have led by even more if two runners had not been thrown out at home on perfect relays.

The fourth extra-inning game of the series sent the Phillies to the World Series.

Ryan got his glove on a Bob Boone ground ball but deflected it and turned it into an infield hit. That hit was part of a five-run eighth inning. Greg Gross bunted for a hit. Pete Rose drew a walk, forcing Ryan out of the game.

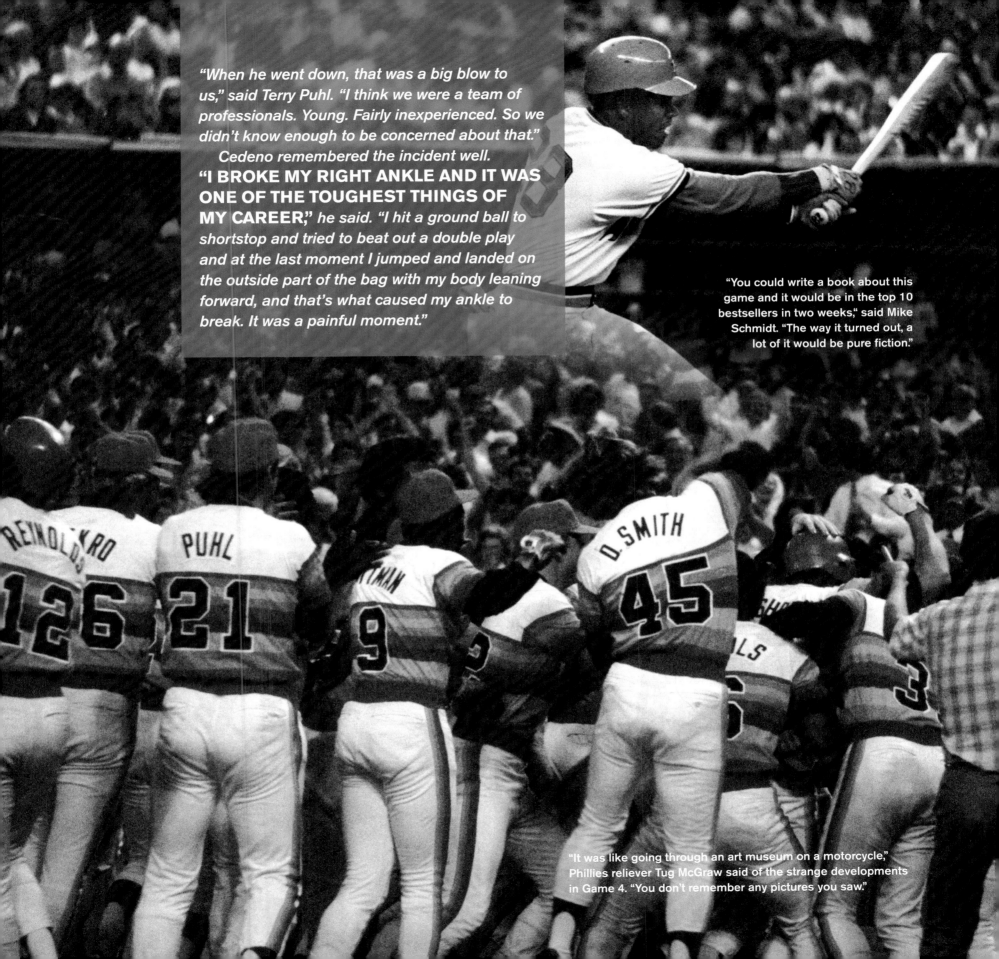

"When he went down, that was a big blow to us," said Terry Puhl. "I think we were a team of professionals. Young. Fairly inexperienced. So we didn't know enough to be concerned about that."

Cedeno remembered the incident well. **"I BROKE MY RIGHT ANKLE AND IT WAS ONE OF THE TOUGHEST THINGS OF MY CAREER,"** he said. "I hit a ground ball to shortstop and tried to beat out a double play and at the last moment I jumped and landed on the outside part of the bag with my body leaning forward, and that's what caused my ankle to break. It was a painful moment."

"You could write a book about this game and it would be in the top 10 bestsellers in two weeks," said Mike Schmidt. "The way it turned out, a lot of it would be pure fiction."

"It was like going through an art museum on a motorcycle," Phillies reliever Tug McGraw said of the strange developments in Game 4. "You don't remember any pictures you saw."

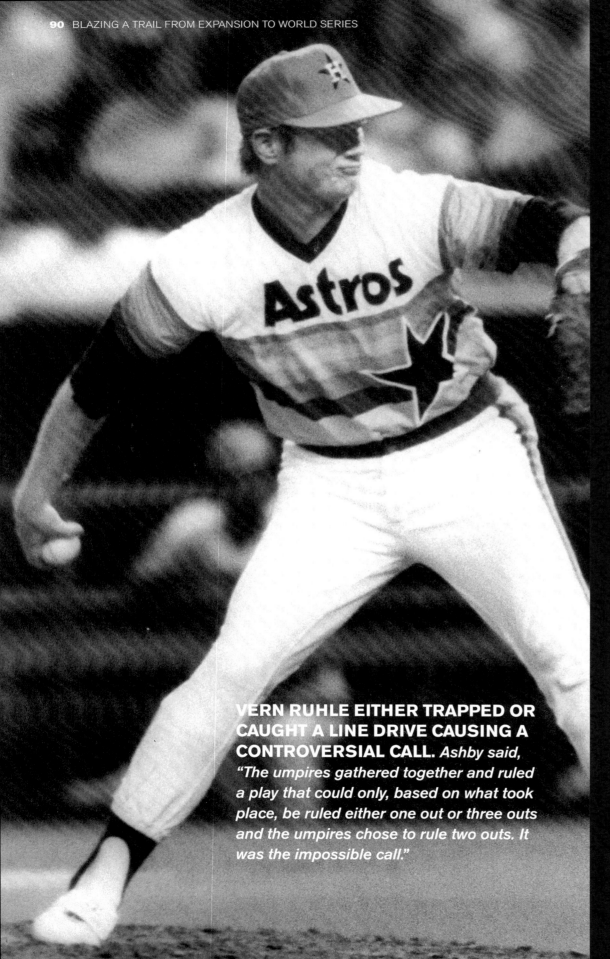

VERN RUHLE EITHER TRAPPED OR CAUGHT A LINE DRIVE CAUSING A CONTROVERSIAL CALL. *Ashby said, "The umpires gathered together and ruled a play that could only, based on what took place, be ruled either one out or three outs and the umpires chose to rule two outs. It was the impossible call."*

Ken Forsch was unable to stop the rally and the Phillies took the lead, 7-5. In the last of the eighth the Astros tied it on a Jose Cruz hit. But the Phillies won 8-7 in 10 innings when Garry Maddox sent the eventual winning run home with a two-out double off Frank LaCorte. The Astros lost a gut-grinding five-game series that featured four consecutive extra-inning games.

"I had broken a rib and separated some cartilage in my chest in the final game against the Dodgers," said Ashby. "I wasn't able to play the whole time and I was taking shots before the games just to be able to play when I did."

Craig Reynolds played on both the 1980 and 1986 playoff teams. "I still think the '80 team's the better team," said Reynolds. "People disagree with me but I think so. If we got the lead, that just opened the door for us to start doing stuff and it just put a lot of pressure on. That (fifth game against Philadelphia) was a great game, but that was a tough loss. I saw a lot of sad men after that game."

"I think it is still maybe the greatest League Championship Series of all time," said former Astros broadcaster Dewayne Staats.

Terry Puhl was brilliant in the series, hitting .526. "I remember specifically two things," he said. "My last at-bat, which was a line out in maybe the last inning of the last game, I probably hit the best ball I hit the whole series and Garry Maddox ran it down. I smoked that ball. That would have been an easy triple."

Puhl went 10 for 19 in the series even without that hit. "The other hit that I really remember was the one that at that time broke the record for most hits in a five-game NLCS that had been set by Pete Rose," he said. "I didn't have a clue that I was even close. Then I got down to first base and they flashed on the scoreboard, 'Terry Puhl has just set a new five-game NLCS record breaking the old mark set by Pete Rose.' Pete was the first baseman. Pete comes over to me and says, 'T.P., that's what records are for–they're made to be broken.' That was a special thing for him to say. It was just odd that he was right there after I broke his record."

After the final game, Joe Sambito went to Puhl at his locker in the clubhouse and said, "We've got some good young players here and we're gonna be back." Reality hit Puhl the following season. "Whoever thought that we would get the 'health bite' after that?" he said. "We lost Sambito and J.R. Richard and we took some serious hits. Those were All-Star players."

Puhl signed in 1973 as a non-drafted free agent. Scout Wayne Morgan revealed to Puhl years later that there was money left in the budget and he was signed as a "fill-in type player." He went on to a 14-year career with the Astros, hitting .281 with 217 stolen bases. When Puhl retired, he ranked second to Jose Cruz in games played in Houston. He was the all-time leader among Canadian-born Major League players in games played until Larry Walker passed his mark in 2001.

TERRY
PUHL

JOSE CRUZ
ON-GOING LEGEND

After becoming a fan favorite in the 1970s and proving his prowess at-bat, (p. 72) Jose Cruz was selected as an All-Star in '80 and '85. He played for both the '80 and '86 Division Champions. In 1980 he hit .400 in the NLCS against the Phillies and drove in four runs in the five games, delivering important runs in the clutch. He delivered a Game 2 RBI single in the 10th inning.

"They bring in a left-handed pitcher, Tug McGraw, and I get a base hit," said Cruz. "Then they walked me a lot of times with men on second base, maybe four or five times, and never pitched to me." Still, he tied Game 5, 7-7 in the bottom of the eighth inning with another clutch hit. Cruz also contributed defensively, leading National League left fielders in putouts five years in a row 1980-84.

Cruz, a native of Arroyo, Puerto Rico, is the only Astro who has been in uniform for all of the club's nine postseason appearances, three as a player. Although his uniform number 25 was retired in 1992, he wore it again as a first base coach for 13 seasons from 1997-2009 before becoming a special assistant to the general manager.

One of his sons, Jose Cruz Jr., was a first round draft choice of the Seattle Mariners after a college career at Rice University. Cruz has maintained his position with the Astros: He can be found on the field during batting practice sometimes and occasionally in the Spanish language radio broadcast booth.

After such a heartbreaking finish to 1980, the Astros put together another excellent season in 1981. Nolan Ryan led the NL in ERA that year with a 1.69 figure, going 11-5. The season was abbreviated by a work stoppage in the middle.

On the eve of the player's strike, June 9, Ryan dueled Pete Rose in Philadelphia. Rose was two hits away from breaking Stan Musial's National League record for career hits. The Astros were playing the Phillies in Philadelphia. Rose had predicted before the season that he'd get the record against Ryan. Rose led off the first with a single to center that tied the mark. Ryan determined that he would not be the pitcher to give up the record breaking hit that night. They squared off three more times that night and Ryan whiffed Rose all three times. Larry Dierker, who was broadcasting the game, called it one of the best one-on-one confrontations he had ever seen in all his years of broadcasting for the Astros.

In the second half of the '81 season, the Astros and Dodgers were running neck and neck when Ryan lit up the Astrodome on Sept. 26th with his fifth career no-hitter.

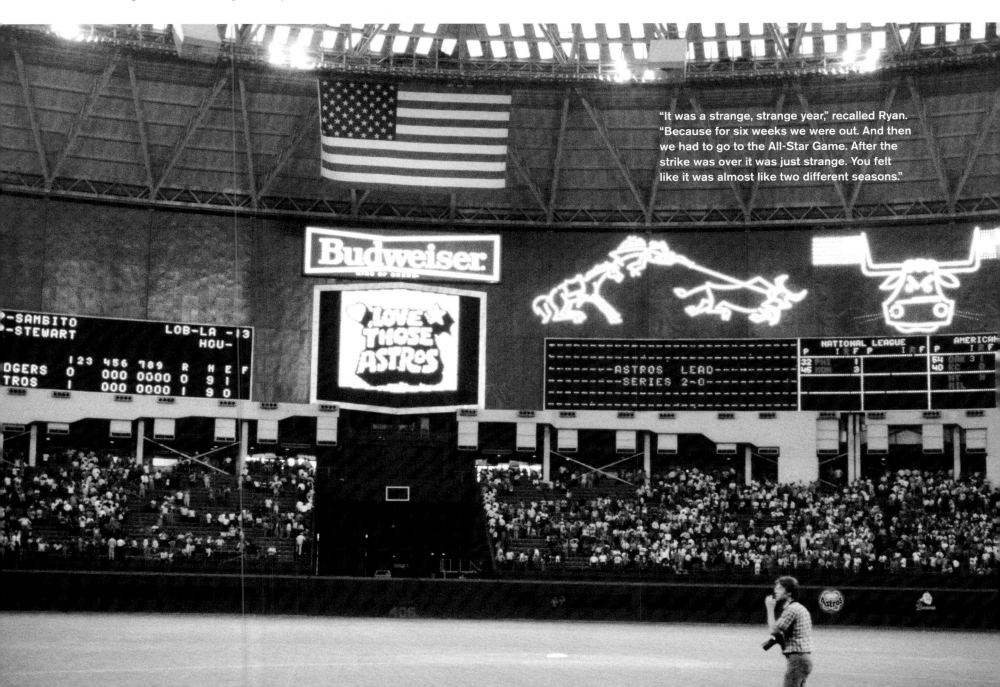

"It was a strange, strange year," recalled Ryan. "Because for six weeks we were out. And then we had to go to the All-Star Game. After the strike was over it was just strange. You felt like it was almost like two different seasons."

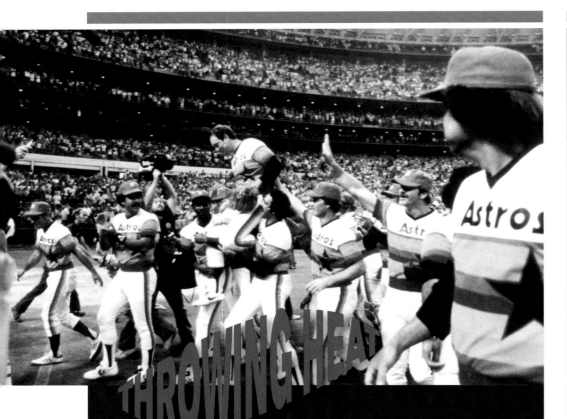

THROWING HEAT

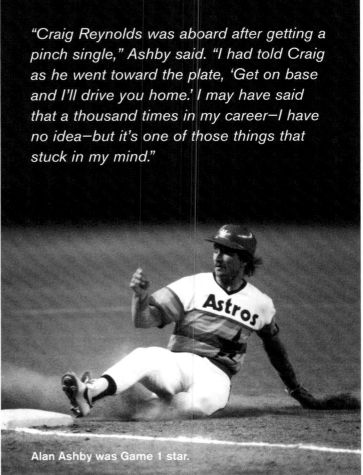

"Craig Reynolds was aboard after getting a pinch single," Ashby said. "I had told Craig as he went toward the plate, 'Get on base and I'll drive you home.' I may have said that a thousand times in my career—I have no idea—but it's one of those things that stuck in my mind."

Alan Ashby was Game 1 star.

Ryan remembered his fifth no-hitter in his autobiography Throwing Heat, *written with Harvey Frommer. "I struggled early, walking three batters in the first three innings," he said. "My fastball at the start was just average, but I knew I had a real good curveball that day. Twice before that season I had gone into the seventh inning with a no-hitter in progress only to lose it. My last no-hitter had been in 1975, when I was 28 years old. Now I was 34, and I was beginning to think that maybe I didn't have the stamina to get the fifth no-hitter.*

"It was just one of those games that it all came together and Terry Puhl made a catch in right center off Mike Scioscia. When the ball was hit I thought it was a base hit and Terry ran it down. You know, every no-hitter I've ever thrown I can look back and there was at least one play and sometimes two plays that put you in that position where you had a shot at throwing a no-hitter. That was the play in that game."

The 1981 season brought a second straight playoff opportunity for the Astros. After reaching the playoffs via a format that rewarded teams in first place when the strike began as well as teams that won the "second half" after the strike, the team met the Dodgers. The Astros built a 2-0 lead in this series, but again they lost in the maximum five games.

Nolan Ryan started the series and stopped the Dodgers 3-1 in the opener with a home run from Ashby off Dave Stewart. Walling again provided a game-winner, 1-0 in 11 innings with a bases-loaded pinch RBI single in Game 2 at the Astrodome. With the series moving to Los Angeles, Burt Hooton gave the Dodgers a 6-1 victory in Game 3. Then Fernando Valenzuela topped Ruhle 2-1 with both going the distance in Game 4. In the deciding game, former Astro Jerry Reuss blanked Houston 4-0.

KING OF K

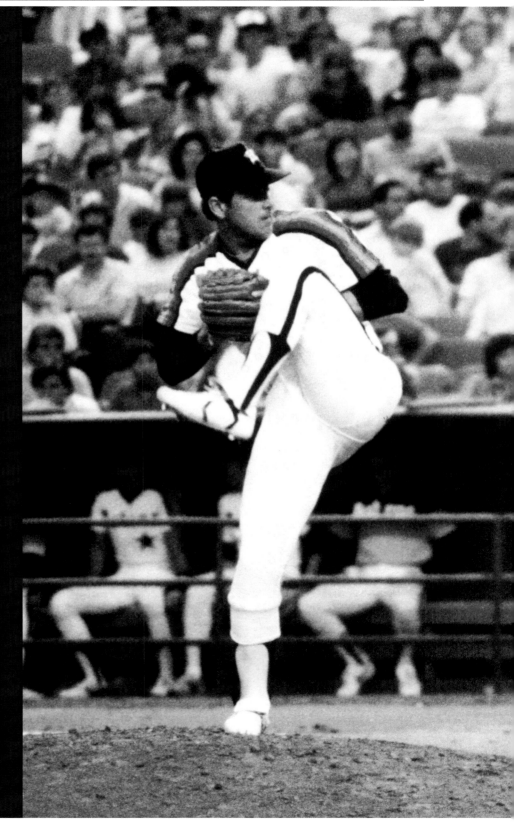

On April 27, 1983, Nolan Ryan whiffed Brad Mills in Montreal to break Walter Johnson's 56-year-old career strikeout mark of 3,508. Johnson's record was regarded at one time to be untouchable, in the category as Babe Ruth's career home run mark of 714.

Mills recalled the mood in the Expos' clubhouse before the game. "He was seven or eight (actually five) away from the record before that game," Mills said. "Our players were throwing money in a pool to see who would be the victim on the record breaking strikeout and guessing who would be the man. There was quite a bit of money in the pot.

"Tim Blackwell pinch hit before me and made an out. Then it was my turn to pinch hit. I wasn't sure where the strikeout number was because they did not have a countdown on the scoreboard at that time. The count went to 0-2 and he threw me a curve ball. I took it for a ball. I was a left-handed hitter and I was facing the Houston bench when I batted. I saw their players jumping up off the bench when they thought it was going to be called strike three. Then I knew I was the one. I was thinking, 'He's the Ryan Express. And he's known for his fastball. He just threw me a curveball and missed with it. He'll probably throw a fastball.' He threw another curve and I took it. The umpire called it strike three."

Mills recalled, "After that season I was traded to Houston. I was coming out of the clubhouse one day in Spring Training and Nolan was sitting on a bench waiting for somebody. We looked at each other and he said, 'It was outside, wasn't it?' After Nolan retired from the Rangers he flew me and my wife to Dallas for his retirement party. That was a classy move."

THE VOICES of THE ASTROS

In 1985 the Astrodome was 20 years old. Milo Hamilton (upper left), on the final leg of his Hall of Fame broadcast career, described events that year on the air. Hamilton received the Ford Frick Award for "major contributions to baseball" from the National Baseball Hall of Fame and Museum at Cooperstown, New York in '92 and retired as a broadcaster following the 2012 season. Gene Elston (upper right), the original voice of the Astros, joined Hamilton as a Ford Frick award winner in '96. Harry Kalas (bottom right) and Bob Prince (bottom left), other Frick winners, worked for the Astros as well.

"I knew we were a lot better than what people thought," said second baseman Bill Doran. "Nobody knew about Glenn Davis. Nobody knew about Kevin Bass. There were just a few things that took place that year that surprised everybody but the people who were involved in it."

After an 83-79 record in 1985, expectations were modest. Mike Scott anchored the starting rotation in 1986. Left-hander Bob Knepper, Ryan and rookie lefty Jim Deshaies were the other principals on a club that was widely expected to finish in fifth place in the NL West. But by early May the Astros were 17-10. General Manager Dick Wagner had hired St. Louis third base coach Hal Lanier to take over the underrated team in his rookie season as manager. Lanier used off-days in the schedule to ride a three-man rotation of Scott, Knepper and Ryan to a hot start.

"We came to the ballpark ready to play," said first baseman Glenn Davis. "We knew we weren't gonna just blow people away but we kind of fed off of that, what Billy was talking about. Other teams thinking that we weren't very competitive or that, hey, these guys aren't going anywhere. We were a very solid team. We were a close knit team."

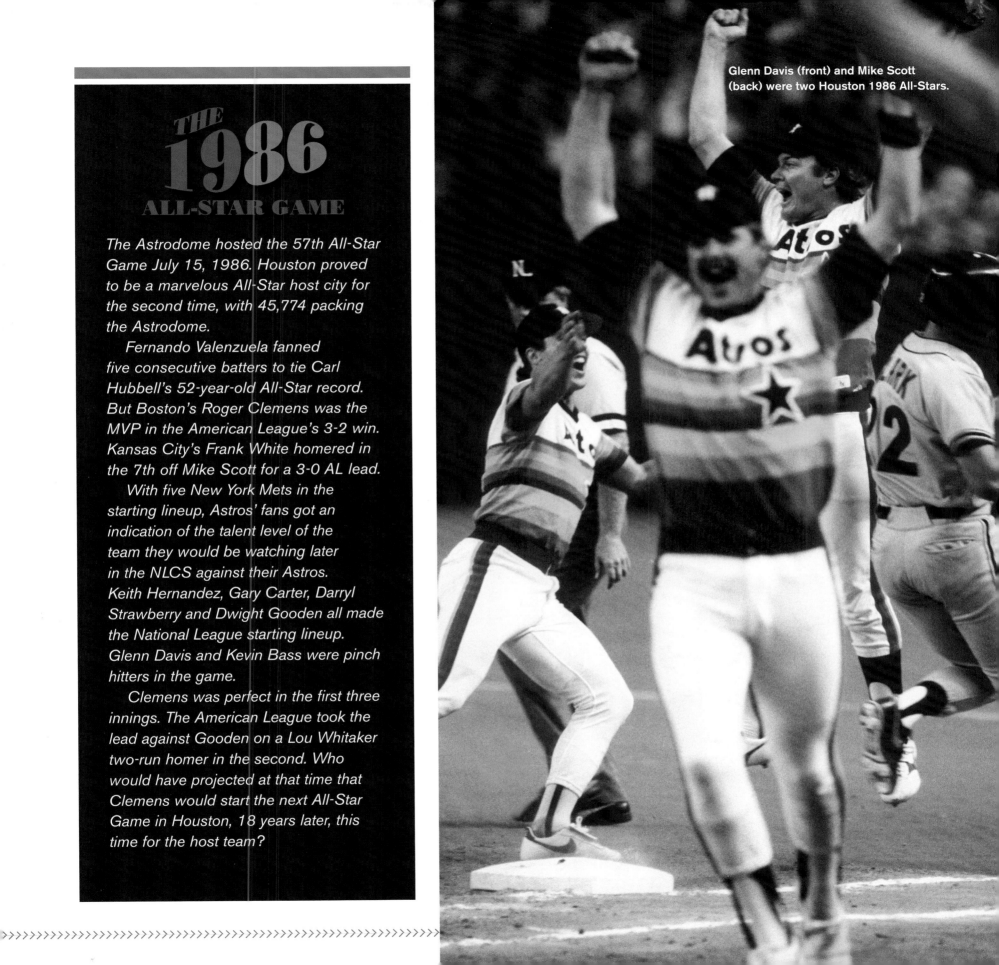

Glenn Davis (front) and Mike Scott (back) were two Houston 1986 All-Stars.

THE 1986 ALL-STAR GAME

The Astrodome hosted the 57th All-Star Game July 15, 1986. Houston proved to be a marvelous All-Star host city for the second time, with 45,774 packing the Astrodome.

Fernando Valenzuela fanned five consecutive batters to tie Carl Hubbell's 52-year-old All-Star record. But Boston's Roger Clemens was the MVP in the American League's 3-2 win. Kansas City's Frank White homered in the 7th off Mike Scott for a 3-0 AL lead.

With five New York Mets in the starting lineup, Astros' fans got an indication of the talent level of the team they would be watching later in the NLCS against their Astros. Keith Hernandez, Gary Carter, Darryl Strawberry and Dwight Gooden all made the National League starting lineup. Glenn Davis and Kevin Bass were pinch hitters in the game.

Clemens was perfect in the first three innings. The American League took the lead against Gooden on a Lou Whitaker two-run homer in the second. Who would have projected at that time that Clemens would start the next All-Star Game in Houston, 18 years later, this time for the host team?

The long-standing rivalry with the Dodgers was prominent in '86. In the Sept. 23 game against the Dodgers, Deshaies whiffed the first eight batters. Dodger skipper Tommy Lasorda then pinch hit for the pitcher with Larry See, who popped up to end the new Major League mark for consecutive strikeouts to begin a game. Deshaies had emerged as a fourth starter and 12-game winner to set a club rookie record.

The next day, Sept. 24, the Astros faced the Giants. Glenn Davis became the first Astro since Jimmy Wynn in 1969 to rip 30 homers in a season. In that same game, Ryan took a no-hitter to the seventh and gave up only a Mike Aldrete single in a combined one-hitter with Charley Kerfeld pitching the ninth.

The Sept. 25 clincher of the NL West was a special day. Mike Scott fired a 2-0 no-hitter at the Giants before 32,808. It was the only no-hitter in a clinching game in Major League history. Giants' skipper Roger Craig, who had taught Scott the split-fingered fastball that catapulted him into a different dimension of pitching, was victimized. Craig and other managers constantly showed baseballs thrown by Scott to the home plate umpires and charged that they were scuffed. That seemed to be about the only tactic they could think of to stop Scott.

The Mets were waiting in the National League Championship Series.

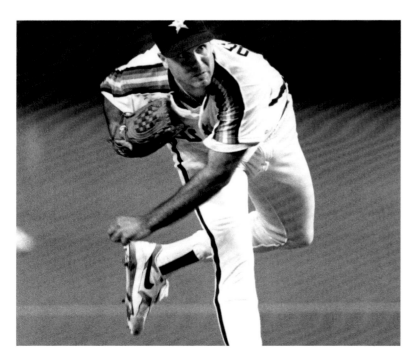

ROOKIE
PITCHING RECORD

"I guess when I got the seventh one we were getting close to clinching so there was all kinds of energy in the ballpark anyway," Deshaies recalled of his opening strikeouts in the Sept. 23 game against the Dodgers. *"The fans were going nuts. I was rubbing up the ball and the noise settled down a little bit. Then it spiked again. It grabs your attention. So I kind of turned and I looked and up on the scoreboard they posted an announcement: 'Jim Deshaies has just tied the modern record for consecutive strikeouts.' It's not a record you pay attention to or that anybody's aware of until it happens. So I was kind of, 'Wow.' That's the first time that I thought, 'This is really neat.' And then I got the next one. That's when the adrenaline really kicked in. That's when I really started to go for it.*

"I threw a two hitter. Nolan came out and threw eight innings of one-hit ball. I think he struck out 14. Charley pitched the ninth. And after the game I made a flippant comment to Ash (catcher Alan Ashby). 'Geez, you'd think Nolan could have let me have the limelight for more than one day,' I said. Ash said, 'I've got a feeling Scotty's gonna show you both up.' It's one of those stories you think, 'that's a bunch of bull.' But it's true. That's what he said. How do you show up a two-hitter and a one-hitter? There's only one way to do it."

Reflecting on those days, Deshaies said, *"I think being a young guy, I took pride in being associated with that pitching staff. To say I was in the same rotation as Ryan, Scott and Knepper—that meant a lot to me. I knew I was down the rungs of the ladder in that group. But for me, to be the young guy, it was pretty neat to be affiliated with those guys."*

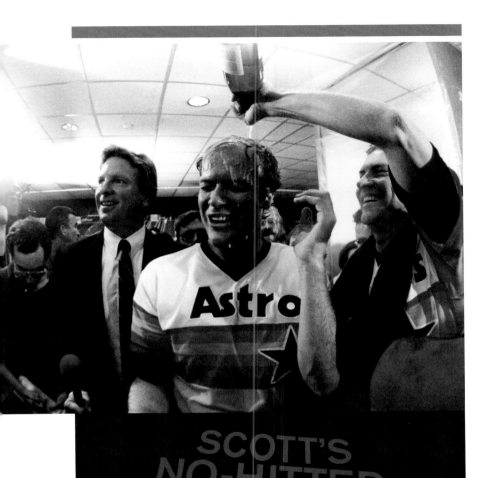

SCOTT'S NO-HITTER

CLINCHES NL WEST

Coach Matt Galante remembered the game clearly. "The no-hitter to me was…Mike walked a batter, hit a batter…and I was standing in the dugout talking to Denis Menke, one of our coaches," he said. "This is not a good day not to have good stuff," Galante said to Menke. "Then he winds up with a no-hitter and we clinch the division."

Denny Walling played a part in the no-hitter. "One of my biggest thrills was hitting a home run in a game when Scotty pitched his no-hitter," said Walling. "Juan Berenguer was blowing smoke in the high 90s. I got it up to right center field and it carried."

The 1986 Astros pitching staff allowed the fewest runs in the National League (569).

Five pitchers reached double digits in wins. The highest ERA among their top four starters was 3.34. They whiffed 1160 to lead the NL. They put together 19 shutouts among their 96 wins. Their pitching kept them in many of the games they won in their final at-bats. It was an exceptional group.

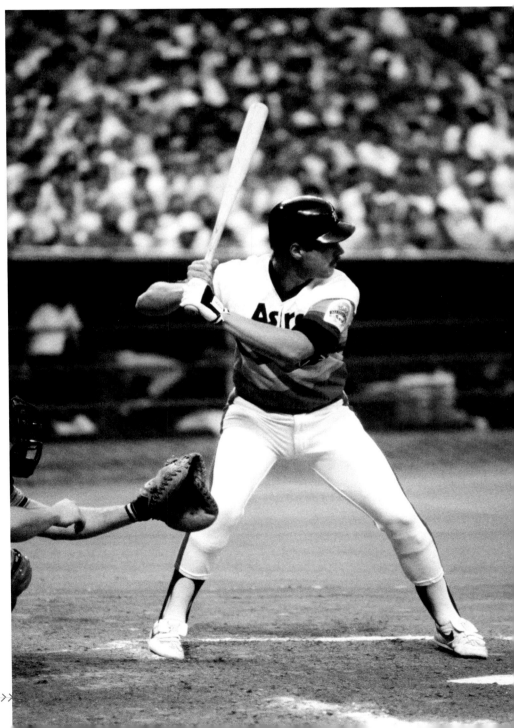

1986 NLCS

Game 1 Homer

Davis said of his homer to lead off the second inning, **"IT WAS JUST MAGIC.** It was just like Reggie Jackson. He had a phrase that home runs are accidents. It just happened. I was so pumped. There was so much adrenaline. It was my first playoffs in the big leagues."

Down, Not Out

Keith Hernandez recalled, "We were basically down every game in 1986 and **CAME BACK AND WON.** The only game we were really ahead we jumped on Nolan in Game 2. That was the game we had to have after losing Game 1 1-0 on the Davis home run."

In the 1986 National League Championship Series opener, Scott outpitched Dwight Gooden 1-0. The only run in Game 1 came on a Glenn Davis long ball at the Astrodome. The Mets bounced back in Game 2 to even the series behind Bobby Ojeda's complete game, 5-1. Mets outfielder Lenny Dykstra won Game 3 with a ninth inning two-run homer off Dave Smith.

In Game 4, Scott won for the second time in the series with a three-hitter, 3-1. His dominant pitching made an impact on the Mets' hitters, who were hoping they didn't have to face him in a Game 7.

A blown call in Game 5 led to New York taking a 2-1 decision in 12 innings. Then Bob Knepper made a 3-0 lead stand up for eight innings back in Houston for Game 6 before the Mets came back to tie it in the ninth.

Knepper Lets Loose

"He showed incredible emotion for Bob Knepper in a game," Terry Puhl remarked. "Probably that was to his benefit to have slowed-down metabolism working because of the environment. But he was animated and **PITCHED** as **MASTERFULLY** as he could."

Squeeze Play

"Hal Lanier in my opinion was probably **THE BEST STRATEGIST** as an Astro manager I played for," said outfielder Terry Puhl. "I think it was a case of the manager trying to get involved in the game. It kind of backfired, because if Ashby hits a sacrifice fly it's 4-0."

Hatcher Hits It Home

"That's probably the closest thing I'll ever do to get to heaven. Everything was in slow motion. I remember running around the bases and, if you can imagine this, I couldn't hear myself think. Probably **ONE OF THE GREATEST MOMENTS OF MY LIFE."**

It Doesn't Get Any Better Than This

Just before Hatcher's tying home run, Mets Manager Davey Johnson remembered, "With one out I was telling (pitching coach) Mel Stottlemyre, 'You're nervous as a cat. Relax, It doesn't get any better than this.' **AND BOOM!** *'Well, I take that back.'"*

Each club scored in the 14th, with Billy Hatcher's tying home run shaking the foul screen on the left field line and the noise rattling the rafters. The Mets struck for three in the 16th off Aurelio Lopez. Houston scored two runs in the bottom of the inning to close to within 7-6. Jesse Orosco, who surrendered the Hatcher long ball, stayed in the game for three innings and whiffed Kevin Bass with two on to end it.

The fans were kept riveted for four hours and 42 minutes. But in the end, there still was no World Series for yet another very good Houston playoff team. The Mets went on to beat the Red Sox in the World Series, leaving many Houston fans wondering what could have happened if Scott had faced the Mets in **Game 7.** For the third straight time the Astros reached the playoffs, the eventual World Champions eliminated them.

Hernandez went to the mound. "I told him if he threw a fastball we're gonna fight right here. It was to break the tension, number one. It was his third inning and he was gassed. Bass hitting righthanded was a high ball hitter and not a good down breaking ball hitter. Jesse had the big down breaking ball. It was a perfect matchup for Jesse to throw all sliders and that's all he did. And he struck him out and that won it.

"IT WAS THE GREATEST GAME I EVER PLAYED in my 17 years in Major League baseball. Because we went out there every inning in the bottom of the inning and if the Astros scored one run, you lose. Trying to catch them for 16 innings, and we played so deep into the night."

Two Sides of One Intense Game

Astros reliever Larry Andersen remembered being more nervous than he had ever been in a playoff game. "Once I got in the game I was like, 'What happened to my nerves?' Then after pitching three scoreless innings I came out and my legs were shaking in the dugout leaning over the railing. **IT WAS JUST SO INTENSE,**" he said.

So Close

Matt Galante observed, "Bass lined a bullet down the left field line and it missed being fair by maybe two inches. That would have won it, of course. **CAME SO CLOSE, YET SO FAR."**

Keith Hernandez also reflected on the series. "We got a great call (in Game 5) obviously on the double play here at Shea. It was not a double play and Nolan would have won that game. It changed the whole complexion of the series. There would have been a Game 7 and it would have been Mike Scott," he said.

Kevin Bass has vivid recollections. "The tying run was on second base and I think there was a man on third base," he said. "I'm sitting there watching all this form and it's almost like when you're playing golf and you think about your score. And you're about to shoot one of the best numbers that…and I'm thinking this is gonna be my destiny. I'm gonna go up and I'm gonna win this ballgame.

"Jesse Orosco is on the mound. I'm thinking, 'OK, I'm gonna get this base hit and we're gonna win this ballgame.' Or at least tie it. But I'm gonna do something great. And I'm thinking all this stuff. And I never think like that.

"And it never dawned on me that here's Jose Cruz, lefthanded hitter. He's gonna pitch around me. It was stupid. It was just a stupid, stupid at-bat. It goes down in history."

JOE SAMBITO

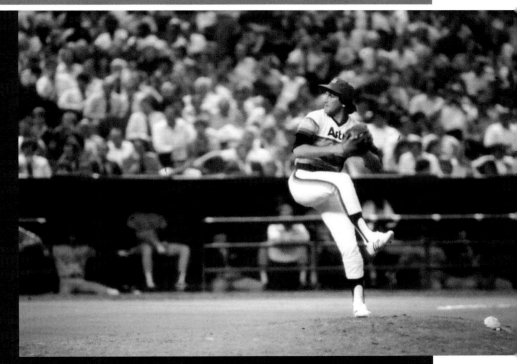

Joe Sambito, who was drafted in the 17th round in 1973, had never met Astros scout Earl Rapp when Rapp called to tell him he had been drafted. He knew many other scouts on a first name basis. Rapp had seen Sambito pitch once. On draft day, the other scouts worried about Sambito's arm. So did Sambito.

After he signed, he pitched one game and came out with his arm hurting. After a month layoff that first year, he never had arm problems again until his arm broke down in 1982.

Sambito was promoted to the majors in 1976. At the beginning of that season he wasn't deemed good enough to be in the Triple A club's starting rotation, so he became a reliever by choice. By 1979 he was well established as one of the top southpaw relievers in the majors. That year Sambito set a club record with 27 consecutive scoreless outings covering 40 innings.

Sambito replaced Forsch as the closer, which allowed Forsch to return to the rotation. Sambito remembers how he was used. "Closers back then, it was a little bit different in that they weren't into that one-inning job. You get a lead in the ninth, put the closer in. It just wasn't that way. I was used anywhere from the sixth to the ninth. And oftentimes coming in in the seventh or eighth with guys on base and the situation was right. You went to your guy then." He wound up his career with 72 saves.

"I was just so thankful for having the opportunity to live a dream," said Sambito, now a player agent. "And that's how I look at it. My whole life. How many people get a chance to live what they've always dreamed about?"

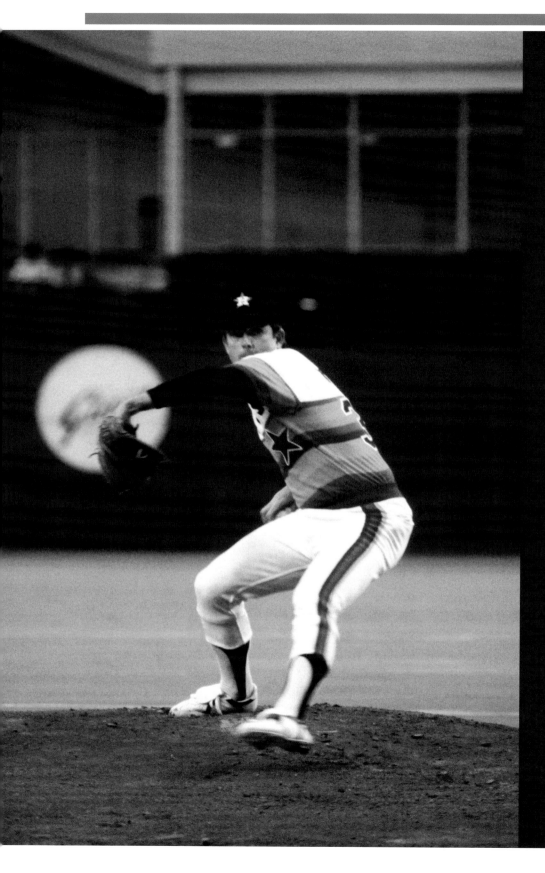

NOLAN RYAN

Nolan Ryan grew up in Alvin, Texas, south of Houston, and admired pitchers like Sandy Koufax while attending games at the Astrodome. He notched his first big league victory for the Mets against Houston and Larry Dierker in the Astrodome in 1968 with most of his family watching. Ryan and Dierker were both 21. Ryan was in the early stages of a Hall of Fame journey, exploding the career strikeout mark with 5,714 and the no-hitter record with seven.

His career really didn't develop until he was traded to the California Angels. His losing record with the Mets later made the Angels look brilliant for trading Jim Fregosi for him. He rolled up huge strikeout numbers and innings with the Angels, leading the league in strikeouts seven times and dominating American League hitters. When his free agent year arrived, he went 16-14 for the Angels to finish his eighth year with them. But Houston owner John McMullen made him the first million-dollar-per-year player in history and his nine-year Houston career began. Ryan signed a four-year, $4.4 million contract. Angels' GM Buzzy Bavasi said, "Ryan simply was asking for too much money. We'll just get two 8-7 pitchers to take his place."

In 1980 his 11-10 record with a 3.35 ERA gave the Astros a deep five-man rotation. But the lack of run support proved to be a precursor of his Astros years. As the years tumbled by, Ryan delivered for the Houston fans who marveled at his preservation of power in his 30s. He went 16-12, 14-9, 12-11, 10-12. Then in 1986 things came together behind the excellent pitching staff.

It wasn't easy for the pitchers. "When I got to Houston we just didn't score runs," Ryan recalled. "That was the bottom line. I knew that going in when I came there, but I came because of the impact it would have on my family. Being able to live at home year round and the kids being in one school and all that. So I knew that going in that was the tradeoff I was going to make. I just accepted it and it turned out we had enough pitching as a whole that we were able to be competitive.

"It was frustrating at times. But I knew everybody was doing their best and that's just the way it was."

The most frustrating season experienced by a Houston pitcher came in 1987 when Ryan was 8-16 despite leading the league in ERA (2.76) and strikeouts (270). He was the first pitcher to lead the league in those two categories and not win the Cy Young Award. The Astros put Ryan on a pitch count limit because of concerns about the condition of the ligament in his right elbow. That prevented him from pitching deep enough into some games to leave with a lead.

When the Houston years had ended, he was 106-94 with a 3.13 ERA. And he had the all-time strikeout lead with 1,866.

Ryan moved along through free agency to the Texas Rangers because McMullen wanted him to take a 20 percent pay cut. McMullen said, "We offered him the same contract as Mike Scott, and Mike Scott will win more games. He's a more important member of our team."

Ryan signed a two-year deal with Texas for $3.2 million. He wound up staying five years, compiling a 51-39 record including his 300th win while striking out an additional 939 batters and tossing two more of a record seven no-hitters. His last win came when he was 46 years old.

General Manager Al Rosen made what proved to be one of the best trades in Astros history in December of 1982 when he sent Danny Heep to the New York Mets for Mike Scott. Scott was 17-27 in a Mets' uniform with a 4.65 ERA and was fresh off a 7-13 season in 1982. The change of uniforms brought a major change in results when the Pepperdine University product went 10-6 in 1983 for Houston.

After sliding backwards in 1984, Scott came under the influence of former Houston pitching coach Roger Craig, who taught him to throw the split-fingered fastball. Luckily for the Astros, the splitter was Scott's ticket to stardom. "I threw pretty hard but I threw a slider and I threw a sinking fastball which almost did the same thing," Scott explained. "I needed to throw something offspeed. I wish I would have learned a regular changeup earlier in my career but I didn't. But that's what the split-fingered fastball did. The arm speed is the same as the fastball, and it's just hard for the hitters to pick up."

Leading the league in ERA (2.22), strikeouts (306) and innings (275) in 1986, Scott joined Richard as Houston's 300 strikeout men. He treated 32,808 fans to a no-hitter that clinched the NL West Sept. 25, 1986, fanning 13 and walking two. Craig, who then managed the Giants, was victimized by his former student.

He remembered a visit from batterymate Ashby late in the game. "We're gonna win this," Ashby told Scott. "And we're gonna win the

pennant. But let's not get crazy and throw a 2-0 fastball right down the middle."

After the season, Scott became Houston's first Cy Young winner, finishing 18-10. He also was MVP of the NLCS, a rarity for a player on the losing team, when he threw two complete games against the Mets. He thought his 1-0 win over Gooden in Game 1 was a better game than the no-hitter because, "It meant a lot more." He remembered a Glenn Davis diving play in the 14-strikout masterpiece.

"It just doesn't even feel right," Scott said of receiving the MVP for the championship series. "The Mets were over there celebrating and they call you into a dark little room and the guy hands you this trophy and we lost."

Scott won 110 games with the Astros.

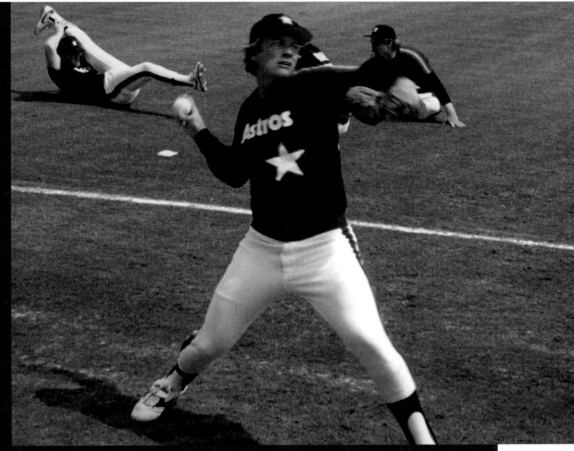

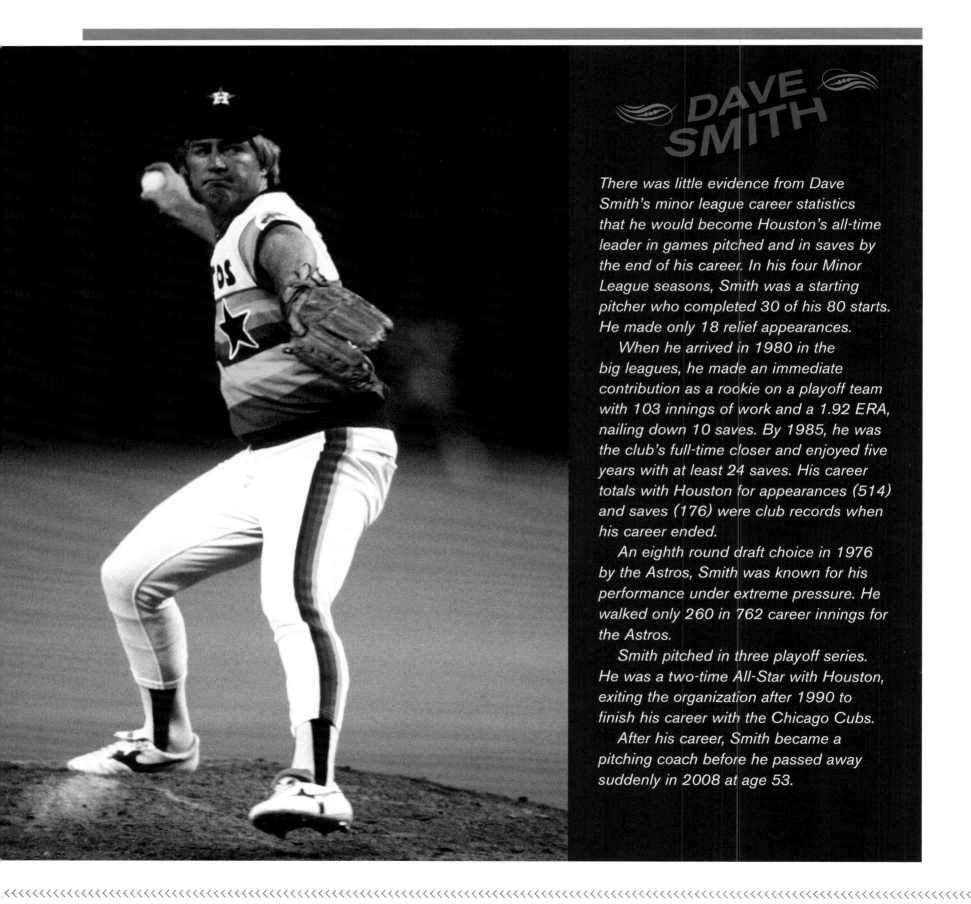

DAVE SMITH

There was little evidence from Dave Smith's minor league career statistics that he would become Houston's all-time leader in games pitched and in saves by the end of his career. In his four Minor League seasons, Smith was a starting pitcher who completed 30 of his 80 starts. He made only 18 relief appearances.

When he arrived in 1980 in the big leagues, he made an immediate contribution as a rookie on a playoff team with 103 innings of work and a 1.92 ERA, nailing down 10 saves. By 1985, he was the club's full-time closer and enjoyed five years with at least 24 saves. His career totals with Houston for appearances (514) and saves (176) were club records when his career ended.

An eighth round draft choice in 1976 by the Astros, Smith was known for his performance under extreme pressure. He walked only 260 in 762 career innings for the Astros.

Smith pitched in three playoff series. He was a two-time All-Star with Houston, exiting the organization after 1990 to finish his career with the Chicago Cubs.

After his career, Smith became a pitching coach before he passed away suddenly in 2008 at age 53.

ALAN ASHBY

When the Astros traded pitcher Mark Lemongello and two other players to Toronto after the 1978 season for switch-hitting catcher Alan Ashby, they were hoping to find a regular receiver for the first time since John Edwards in 1974. Ashby gave them a topflight catcher whose longevity was a bonus. His body of work in his 11 seasons was reflected in his selection as the starting catcher on the All-Time Astros 25-Man Roster in 2012.

Ashby caught three no-hitters and was a part of the 1980, '81 and '86 playoff teams whose offensive numbers are unmatched in club history among catchers. He later became a coach and broadcaster in his long tenure with Houston.

He hit a winning homer in Game 1 of the 1981 Division Series against the Dodgers and another big longball in the 1986 NLCS against the Mets. "You couldn't have a stronger dose of adrenaline than being able to play in the postseason. It was exactly what I desired. I enjoyed every moment of it until the Mets won," he said.

In his 11 years as a player with the Astros, Ashby hit .252 with 69 homers and 388 runs batted in. He played 965 games with Houston.

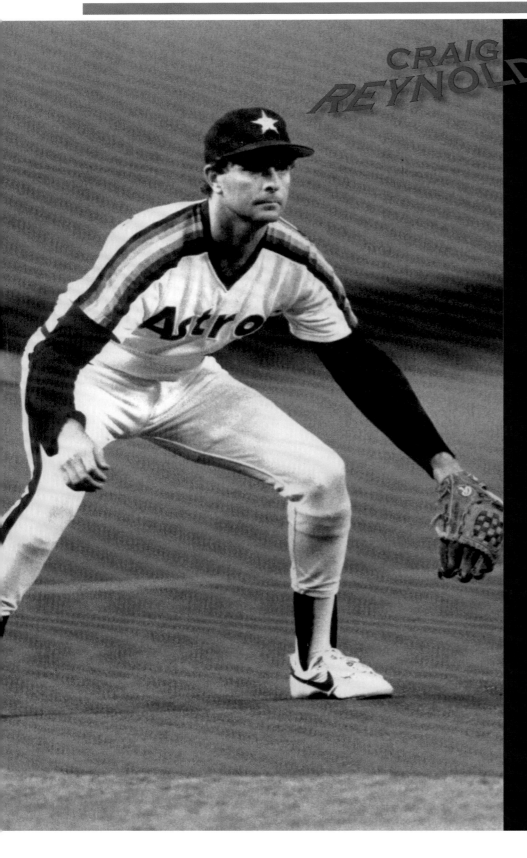

CRAIG REYNOLDS

Houston-born Craig Reynolds remembered attending Colt .45s and Astros games as a boy. Those who have known him might be surprised to know that at age 10 he yelled at catcher John Bateman, along with other players, "What are you doing?" He said, "I remember being the kind of kid I would want to look up at and punch as a player."

By the time he went to Reagan High School and then headed into professional baseball, he was more mild-mannered. A first round pick by Pittsburgh and an All-Star with Seattle, he joined Houston in a trade after the 1978 season for Floyd Bannister. Like Ashby, he set up shop for a contending team in his first year and stayed for a long time. Also like Ashby, he is regarded by many as the best to play for Houston at his position in the first 50 years of the franchise.

In his 11 years with the Astros, he showed a mastery of fundamentals. He was a dependable shortstop and an excellent bunter who led the league in sacrifice bunts three times. He remembered the intensity of the final game of the 1980 NLCS when he was a runner at first. Phillies first baseman Pete Rose told Reynolds it was a shame somebody had to lose the game. "They were leading then and I thought he was saying this game's over," said Reynolds. "I got mad. I said, 'This game's not over yet.' I kind of came back on him and I thought later that's not what he meant. He really meant it was a shame somebody's got to lose this game. He really meant that."

Reynolds hit .256 in his 11 Houston seasons and drove in 300 runs. He hit 65 triples, 12 to lead the league in 1981. He was a defensive leader on the field who was known for avoiding mistakes.

Reynolds was named the starting shortstop on the All-Time Astros 25-man Roster in 2012.

BILL DORAN

He was old school. Hard nosed. Ready to compete at the drop of a hat. Fearless on the double play. Sure handed. Seldom made mistakes. Speedy. Switch hitter with excellent speed. He could hit a homer and steal a base when the team needed. His statistics were very close to Joe Morgan's. But his name was Bill Doran.

Doran was an important member of the Astros' teams of the '80s, teaming with shortstops Craig Reynolds, Dickie Thon, Rafael Ramirez and others to provide excellent double play duos. Doran's troublesome back prevented him from continuing his career much longer after leaving Houston. He was traded to Cincinnati in 1990, leaving the second base position open for Craig Biggio a year later.

Drafted by the Astros in the sixth round in 1979, Doran moved from the high school fields in Cincinnati to Miami of Ohio at the collegiate level. He reached the Astros at age 24 in 1982, the first of his nine years in Houston. Doran was the Team MVP in 1985 and 1987. Here's how his Houston statistics compared to Morgan's in their years with the Astros only:

	Yrs.	Games	Hits	Runs	RBI	Steals
MORGAN	10	1032	972	597	327	219
DORAN	9	1165	1139	611	404	191

Doran remembered his mentors. "There was Phil Garner. And Art Howe always took me aside. Phil was the main guy. He pulled me aside and made sure I didn't stray. He was such a hard nosed guy. I remember Phil telling me my first year, 'Don't ever take a day off. Never admit that you can't play. Don't give in to an injury. As soon as you do it once it's easier to do it a second time. If they don't play you, they don't play you. Don't ever give in to the fact that that job is yours. Even if you're hurting, don't give in to it.'"

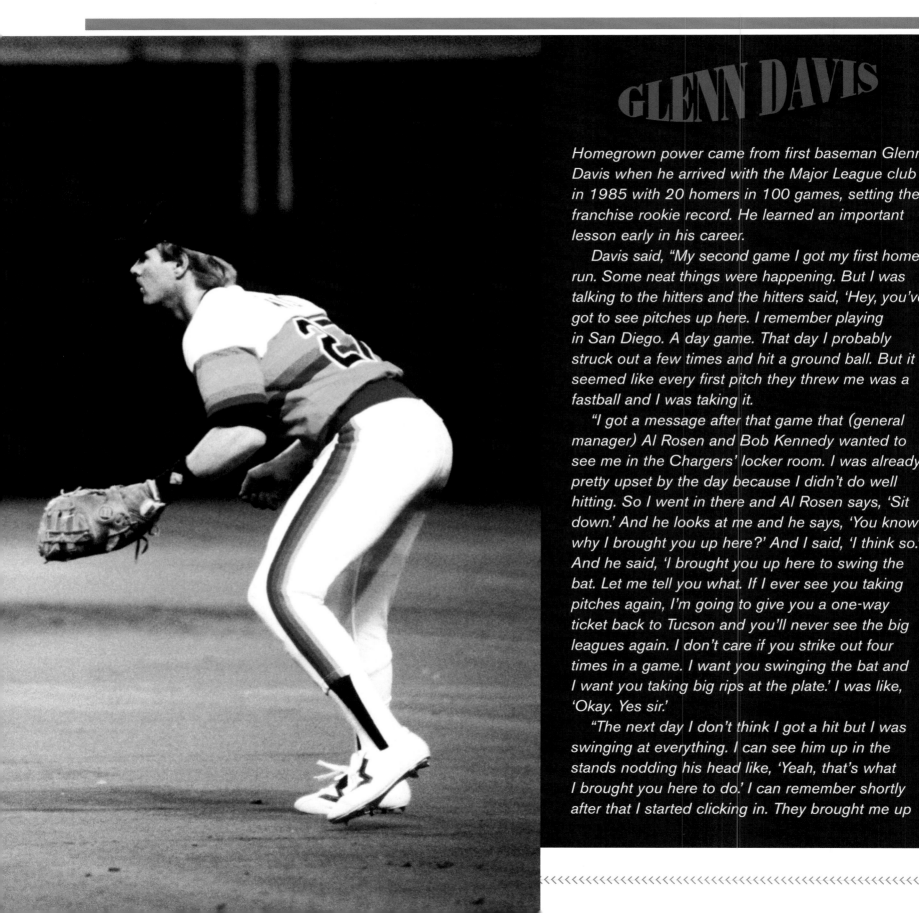

GLENN DAVIS

Homegrown power came from first baseman Glenn Davis when he arrived with the Major League club in 1985 with 20 homers in 100 games, setting the franchise rookie record. He learned an important lesson early in his career.

Davis said, "My second game I got my first home run. Some neat things were happening. But I was talking to the hitters and the hitters said, 'Hey, you've got to see pitches up here. I remember playing in San Diego. A day game. That day I probably struck out a few times and hit a ground ball. But it seemed like every first pitch they threw me was a fastball and I was taking it.

"I got a message after that game that (general manager) Al Rosen and Bob Kennedy wanted to see me in the Chargers' locker room. I was already pretty upset by the day because I didn't do well hitting. So I went in there and Al Rosen says, 'Sit down.' And he looks at me and he says, 'You know why I brought you up here?' And I said, 'I think so.' And he said, 'I brought you up here to swing the bat. Let me tell you what. If I ever see you taking pitches again, I'm going to give you a one-way ticket back to Tucson and you'll never see the big leagues again. I don't care if you strike out four times in a game. I want you swinging the bat and I want you taking big rips at the plate.' I was like, 'Okay. Yes sir.'

"The next day I don't think I got a hit but I was swinging at everything. I can see him up in the stands nodding his head like, 'Yeah, that's what I brought you here to do.' I can remember shortly after that I started clicking in. They brought me up

to hit the long ball. They wanted me to be aggressive."

Possessing the rare quality of legitimate Astrodome power, Davis ripped 31 homers of the team's 125 in 1986, driving in 101 runs of the team's 613. Twice in his career he belted three homers in a game.

The two-time All-Star averaged 30 homers over a four-year span from 1986-89. His power production stood out on a club without much power. "I was like Yogi Berra," said Davis. "With the Astros I was never, never gonna hit for average. Because pitchers started realizing once I started hitting those home runs, 'This guy's the real deal.' The game plan was, 'Whatever you do, do not let Davis beat you with a home run. Nobody else is gonna hit a home run. Let them hit a single. Let them hit a double.'

"So any time I got in a pressure situation or a key situation, they tried to keep the ball so far away from me that the only thing I could do… they didn't want me to extend my arms. The balls I hit were mostly balls out of the strike zone. That's the type of player I became. I had to manufacture, truly manufacture, runs for our team."

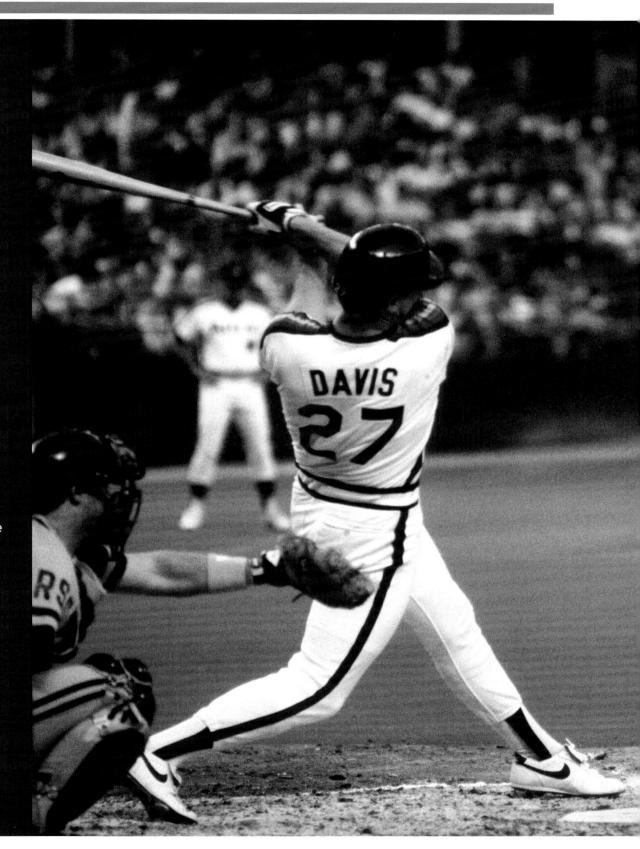

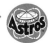

Three times in the playoffs in the 1980s, the Astros were on the verge of winning a postseason series. In 1980 they led the final two games, only to fall just short of the World Series. In 1986 they would have felt great about sending Scott to the mound in Game 7 if they had won Game 6 of the NLCS. Although they were within an eyelash of being champions, this era passed without a title.

KEVIN BASS

Kevin Bass joined the Astros from Milwaukee in a 1982 trade for Don Sutton. He remembered being in the Milwaukee clubhouse when Sutton arrived and asked him what he was doing there. Because of regulations at the time, Bass said he had to clear waivers and he was told the deal was not official yet. Even though he left a club that was headed to the World Series, he welcomed the chance to play every day in Houston.

"Looking back, it's a such a contrast from today," said Bass. "Back then it was one power guy built around a bunch of little scatter hitters and guys who made contact and run and hit and throw. But it was—I was behind Glenn. Glenn would hit fourth and I would hit fifth and I was his protection, being a switch hitter. That was fun. I saw such a contrast how they would pitch Glenn as opposed to how they would pitch me. You saw the fear oftentimes in pitchers because they didn't want to get hit by the long ball because he could go straightaway center, right field, he was definitely that power hitter. And that played into my strength. If you can remember I was a pretty good fastball hitter. I liked the ball hard. If you threw something hard, that just took all the guesswork out of it for me."

In two stops at Houston he hit .278 in 10 seasons and stole 120 bases while driving in 468 runs.

50 YEARS OF PATCHES

The first patch used on the Houston uniform was the Texas flag on the road jerseys of the Colt .45's from 1962-1964. The new "Atomic" logo, the first MLB logo to feature a team's stadium, became the uniform patch from 1965-1974. Over the years other patches have been used to celebrate various anniversaries. Special memorial patches were used in 1975 for pitcher Don Wilson and in 2003 when the Astros honored the lost crew of the Space Shuttle Columbia tragedy. Black armbands were worn in 1964 to honor pitcher Jim Umbricht and in 1989 in memory of Vivian Smith, the wife of franchise founding father R.E. "Bob" Smith and the First Lady of Houston baseball.

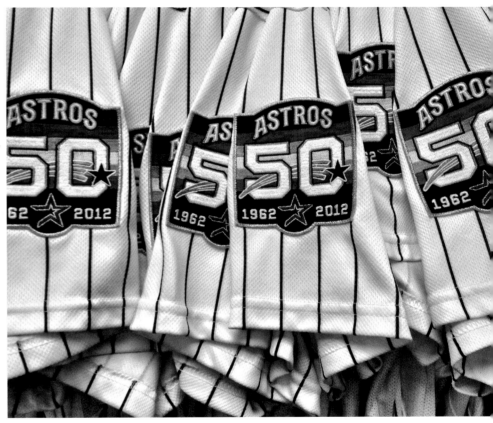

TEAM IN Transition

CHAPTER 7

AS THE 1986 PLAYOFF TEAM GREW OLDER AND FELL SHORT OF REPEATING ITS performance, aging veterans moved on. Nolan Ryan left for the Texas Rangers via free agency after the 1988 season; Bob Knepper left after 1989; Bill Doran and Larry Andersen were traded late in the 1990 season. Dave Smith and Glenn Davis departed the following winter. Injuries forced Mike Scott to retire in 1991.

Younger blood entered the picture in 1987 with Ken Caminiti, who debuted against the Phillies and was NL Player of the Week his first week in the majors. Caminiti tripled and homered in his first Major League game and went 7 for 14 in his first week. Craig Biggio was promoted to the majors in 1988 and claimed Ashby's catching job. Jeff Bagwell came in a trade late in 1990 for Andersen. Future All-Stars Steve Finley, Pete Harnisch and Curt Schilling joined the Astros in the Glenn Davis trade to add youth to the club in 1991.

ONE ENDLESS NIGHT

On a Saturday night, June 3, in 1989 at the Astrodome, the Astros and Dodgers played a 22-inning epic battle that took 7 hours and 14 minutes—the longest in National League history in terms of time. The Astros rewarded their fans who stayed, winning 5-4.

The wild game included seven shutout relief innings by the Dodgers' Orel Hershiser. The losing pitcher for Los Angeles was third baseman Jeff Hamilton. Fernando Valenzuela was playing first base at the end of the game. After a few short hours of rest, the Sunday afternoon game began at 1:05 p.m. Naturally, it too went extra innings, with the Astros winning in the 13th on a sacrifice fly by Mike Scott, who got the victory in relief.

General Manager Bill Wood, who engineered the rebuilding program, made the Bagwell trade and recalled, "When we got Bagwell in that trade and he went to the Instructional League, I got a phone call from Jimmy Johnson (coordinator of instruction). He said, 'You can't believe this kid Bagwell—his hitting ability. He looks even better than the praise he got from our scouts.' Then he got to Spring Training that year (1991) and Art Howe said, 'I've gotta find a spot for this guy.' Right away.'"

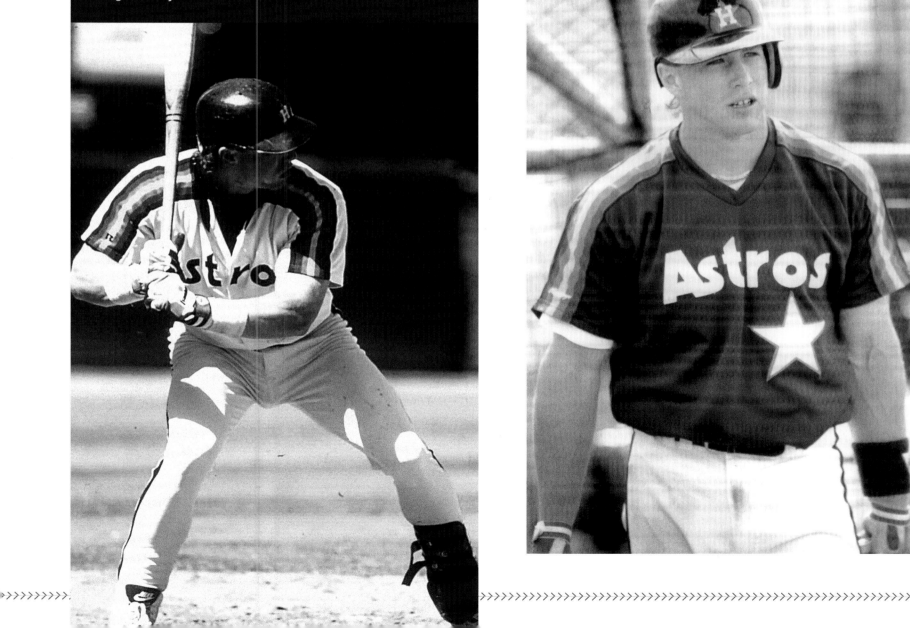

Jeff Bagwell was traded to Houston from Boston in 1990 for Larry Andersen. Bagwell had been a third baseman but was moved to first base because of the presence of Ken Caminiti at third. First base was open because Davis had been dealt to Baltimore. Harnisch moved into the Houston rotation. Schilling joined the late-inning relief corps, and Finley became the center fielder. By 1991, a full blown rebuilding program was under way with Art Howe as manager.

John McMullen put the Astros on the block after the 1991 season and started entertaining bids.

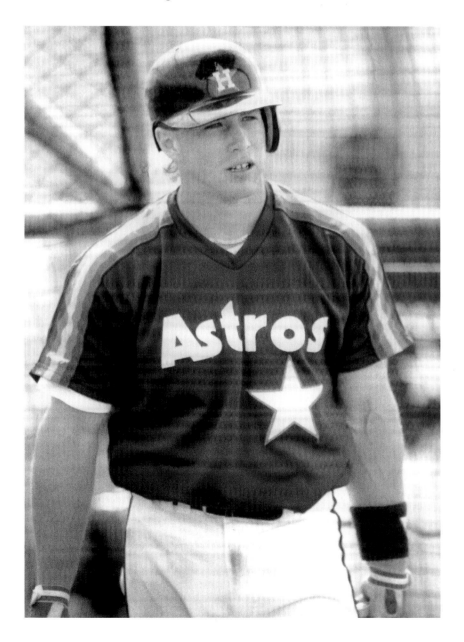

MILESTONES

1968-71, '74
This two-time All-Star was a master of the infield positions and also served as a coach.

DENIS MENKE

1971-78
1973's Gold Glove shortstop leads Houston shortstops in games played (1021).

ROGER METZGER

1981-87
Played second base and third base, coached and managed.

PHIL GARNER

1973-76, '89
Hit .314 as a rookie on way to a 17-year Major League career.

GREG GROSS

1981-87
In '83, this All-Star brought power, speed and arm strength to shortstop but was beaned by a Mike Torrez fastball.

DICKIE THON

1997-2004
Hit 44 homers in 2000 after development in Venezuelan Academy.

RICHARD HIDALGO

1990-95, '97
Developed by Houston, Gonzalez spent 7 of 19 years with Astros in his 354-home run career.

1996-2001
This versatile performer played at seven positions for six Houston seasons, including three trips to the playoffs.

2007-2011
This two-time All-Star was club MVP in 2010.

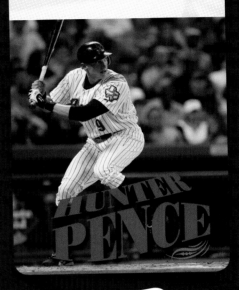

1996-98
Platooned at third base with .819 OPS for two playoff teams.

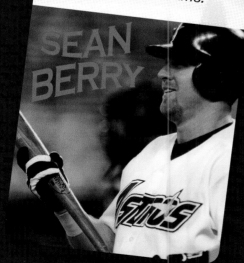

1991-2001
Holds the club record 24-game hitting streak over 50-day period in 2000. Eusebio hit .375 in postseason for four playoff teams.

2008-2011
Collected two Gold Gloves and two stolen base titles.

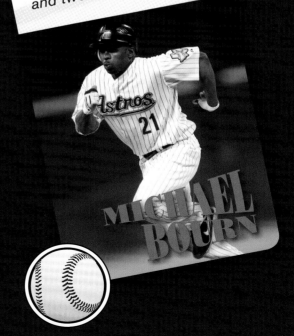

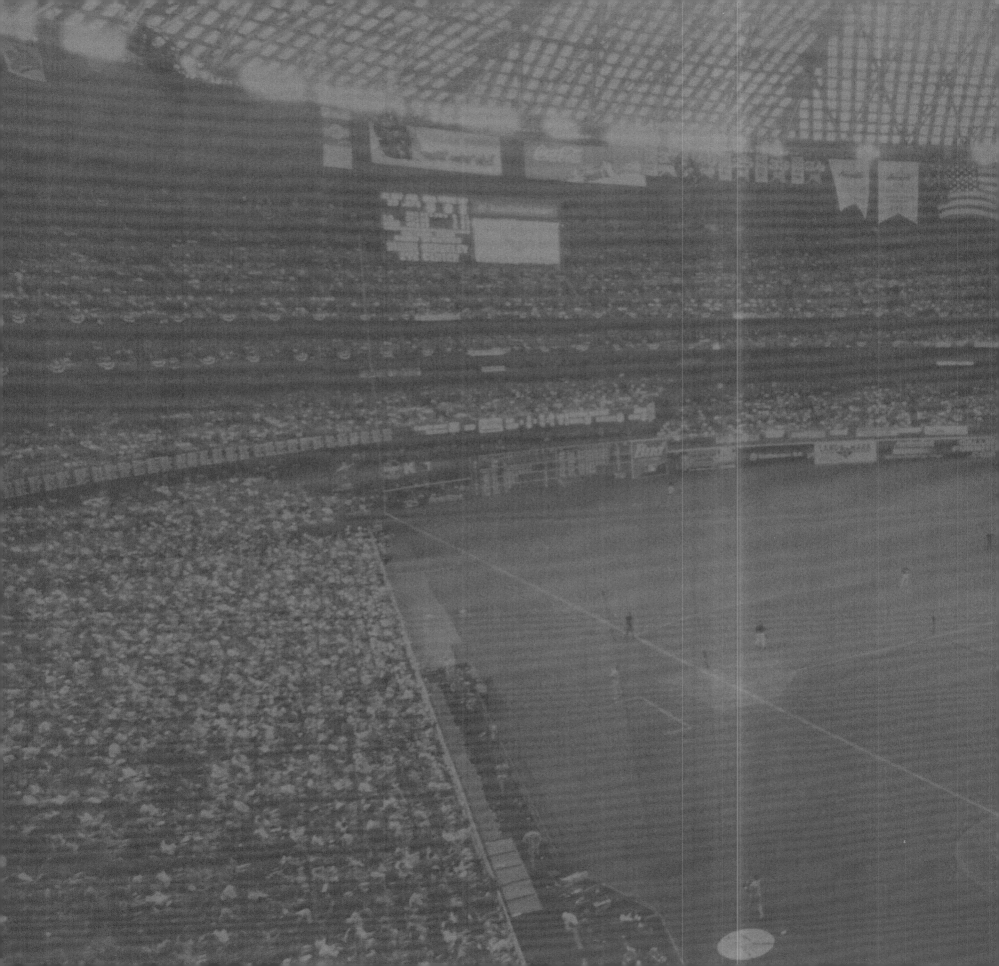

THE McLANE ERA

CHAPTER 8

WHEN DRAYTON McLANE STEPPED UP FROM A GROUP OF INTERESTED INVESTORS as a sole purchaser in 1992, he acquired a team that had quickly improved, finishing with a .500 season in 1992. McLane's reputation in Temple, Texas was impeccable, and he was a big supporter of Baylor University athletics. Reading about the new owner and seeing him immerse himself in the community, Houston fans embraced the change.

The Astros new owner immediately authorized major expenditures for free agent pitchers Doug Drabek and Greg Swindell. That created quite a stir, just as Nolan Ryan's free agent signing had in 1980. McLane discovered quickly that this ownership experience was far more public than he had known.

"The company, McLane Company, that I ran for over 30 years was owned by a family," McLane explained. "So it was large, 12 or 13 million dollars at the time. We had nine or ten thousand employees. But nobody had a clue who we were. When I bought the team they thought I was some country bumpkin from central Texas. You had no public exposure. I underestimated that."

Like Nolan Ryan, Doug Drabek cited returning to Texas as a major consideration in his decision to join the Astros. The native of Victoria, Texas who lived in The Woodlands north of Houston said, "I was going to get to be at home and see the kids go to school and it would be a comfortable situation. And also I knew a couple of guys on the team. But I also knew from playing them that I liked the way they played and I knew they had a good team."

Greg Swindell

The 1992 season marked a 16-game improvement over the previous year. With homegrown players Biggio, Caminiti, Luis Gonzalez, Scott Servais and Andujar Cedeno the young group stayed together despite a month-long road trip because of the Republican National Convention at the Astrodome. It was the longest road trip in modern baseball history. The Astros traveled to eight cities on a 26-game journey with a record of 12-14. Their sojourn began on July 27 in Atlanta before moving to Cincinnati, Los Angeles, San Diego, San Francisco, Chicago, St. Louis and Philadelphia.

In 1994, new manager Terry Collins took over. On the field, the Astros were breaking out. On their way to a 66-49 strike-shortened season they sported a powerful and speedy offense that overcame an 11-0 deficit in the biggest comeback in club history, overtaking the St. Louis Cardinals 15-12 July 19. The game featured an 11-run Houston sixth inning.

Biggio and Bagwell anchored Collins' team that was one-half game out of first place when the season ended. Both were All-Stars.

TERRY COLLINS

"Before I came to interview here I was on Jim Leyland's staff in Pittsburgh, and when I got the call to come interview I sat down with Jim," said Collins. "We sat down and talked about a lot of things including the Astros because he had seen them the previous three, four or five years. He talked about how this club had a real bright future.

"He said 'Make sure when you get there you stop talking about the future and talk about today.' And that was one of the first things I told our guys. I said, 'Look, I've been on the other side of the field for a couple of years and all you hear about is some day this team's going to be pretty good. Why not today? Why aren't we going to be good today?' And they were. They went out and played great in 1994. That's one of the best teams I've ever been around. I thought that coming in and letting them know what the other teams felt about them was something that needed to be said."

BOB WATSON RETURNS

After his playing days (see p. 60), Bob Watson left his job as bench coach of Oakland in 1988 to become assistant general manager of the Astros. When he rejoined the organization he recalled, "The biggest thing was they gave me a real good vote of confidence and told me and Dan O'Brien to go to Venezuela and sign some guys. I did that and we signed what, 40 guys? And out of those 40, I think 30 made it to the big leagues, if not with us with somebody else."

In 1993 Watson became the first African American general manager in Major League Baseball. Shortly after assuming the job, Watson traded for lefthanded pitcher Mike Hampton in December of 1993. Hampton went on to set the club record for wins in a season with 22 in 1999. As he described the deal with Seattle, "I had some guys that I played with who I knew and trusted from Woody Woodward to Lou Piniella. I knew that Lou had a short fuse and would give up on pitchers in a hurry. And I knew he liked the bats. And the thing was that Hampton was a power lefty, and I just thought that Eric Anthony was a guy who the big league lights had gotten to in the few short months he was in the big leagues. So I just said, hey, it would be good for him to have a change of scenery and I convinced Drayton to do this." That deal and others Watson made laid the groundwork for the Astros' playoff teams that would follow.

NL MVP

Bagwell became the first Astro to win NL MVP honors with club records for average (.368), home runs (39) and RBI (118). The MVP vote was unanimous for only the third time in NL history. He was hit by a pitch just before the Aug. 11 strike. Because the season was never resumed, the broken bone in his left hand did not deter him from leading the league in slugging percentage (.750), runs, extra base hits and total bases.

"Obviously we had the best player in the National League playing first," Collins said of Bagwell. "(We had) probably one of the top three other guys playing second (Biggio) and (third baseman) Ken Caminiti was in the middle of a huge season. I thought we were going to win. I really and truly did. I thought we were. I know Montreal had an outstanding club and if they were the best in the National League we were certainly the second best."

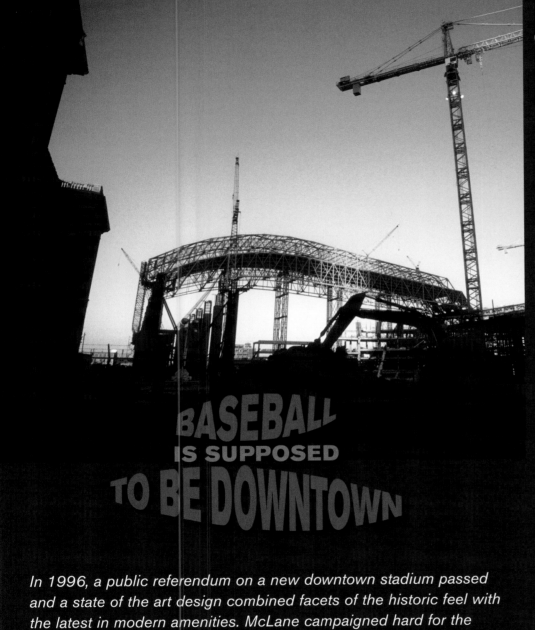

BASEBALL
IS SUPPOSED
TO BE DOWNTOWN

In 1996, a public referendum on a new downtown stadium passed and a state of the art design combined facets of the historic feel with the latest in modern amenities. McLane campaigned hard for the new stadium.

"Most people wanted to build it back at the Astrodome and I said, 'I'll not be part of it,'" said McLane. "It should be downtown. Baseball is supposed to be downtown."

The $248 million spent on this stadium with a retractable roof was one of the best bargains of all stadiums built around the country during this booming period of stadium construction.

Jeff Bagwell's 449 home runs in a Houston uniform rank number one. He stands atop the RBI list with 1,529 and is the all-time walk leader with 1,401. Most who watched his career agree that the Astrodome cost him many long balls. Traded by Boston for reliever Larry Andersen before the 1991 season, Bagwell came to his first Houston Spring Training as a third baseman. Ken Caminiti was anchored at third, but first base was open.

Manager Art Howe offered Bagwell a chance to make the club if he would move to first base. He learned the position in his last 10 days of Spring Training, made the Opening Day lineup and went on to win Rookie of the Year honors. Howe assigned Minor League coach Bob Robertson, a former first baseman, to tutor Bagwell.

"Because Bags was having such a great spring you could see he was a born hitter," Howe recalled. As the years progressed, he made four All-Star teams and became one of only six first basemen to drive in at least 1,500 runs and score at least 1,500 in a career. He also was one of only six at that position to hit at least 300 homers and steal at least 100 bases.

Bagwell collected a Gold Glove and three Silver Sluggers. Howe could see it coming in his very first Major League game in 1991. "Rob Dibble back then threw about 100 mph," remembered Howe. "Bags came up in the ninth inning and he threw a pitch—I don't know how he got out of the way of it. It was right at his head. Bags went down. He got back up and the next pitch he hit was a bullet. It almost took Dibble right off the mound. Right there I said, 'We've got a hitter here. We've got a player.' I'll never forget that. That just showed me he was not gonna be intimidated and he was ready for prime time."

Bagwell's recollection was, "I was just having fun, hanging out with Casey (Candaele) and Cammy (Ken Caminiti), getting some hits. I had a pretty big year that year, winning Rookie of the Year. I probably felt after that whole year that I could play. And then, of course, immediately I started struggling a little bit."

General Manager Bill Wood remembered the evolution of the Bagwell deal in the 1990 season. "Through the work of Stan Benjamin and Tom Mooney, who were responsible for scouting the Red Sox and had seen their system, they saw all the players that they tried to get us to take for Andersen," said Wood. "But it would have been a fair trade if I'd taken one of those other guys. They gave us the guy that we were holding out for.

And he turned out to be even better than we thought he was. We could say that we knew he was going to be that great a player—but hey, we were just trying to get the best player we could. We didn't know how good he was going to be. To be honest, I think we asked for a lefthanded pitcher and they said no. And then we went to Bagwell. How fortunate we were."

Bagwell was far from embracing the deal in the beginning. "Devastated," he said of the trade. "I was living at home. Double A. We were three games away from going to the playoffs. I was having a good year. So I was devastated. My dad picked me up the next day and as we were driving back he said, 'You know what? This is probably the best thing that's ever happened to you. You've got a shot with this club.' They had had a real bad year that year. Cammy had a bad year. He said, 'You never know what can happen.' So that's how the offseason started there."

When he got to Spring Training in 1991, Bagwell sized up his chances to make the club. "My dad said, 'You know what? Tucson's not bad,'" of Houston's Triple-A club. "Because Cammy went like 10 for his first 10! Then with 10 days left in Spring Training I get called in and thought I was being sent down. They said, 'Do you want to play first base in the big leagues or third base in Triple-A?' I went to Hartford, not Harvard, but I could figure that one out."

When the Astros moved from the Astrodome to Minute Maid Park (then Enron Field) in 2000, Bagwell ripped 47 home runs to set the club's single season record. With six of the club's top 10 home run marks in history, he piled up three of those in the more hitter-friendly new ballpark. He set single season marks for runs (152), RBI (135), average (.368), walks (149), slugging percentage (.750) and total bases (363). His last playing days were in the 2005 World Series with a damaged right shoulder that cut short his career.

Bagwell's career on-base plus slugging percentage (OPS) figure of .948 ranks 10th among righthanded hitters in Major League history. He's one of nine players with 1,500 RBI, 1,500 runs and 200 steals and the only first baseman in NL history to reach the 30-30 club for home runs and stolen bases.

"I think that's one reason why I'm....I won't say beloved... in Houston but they appreciate me because I brought them Bagwell," Andersen joked years later. "I still need security when I go to Boston."

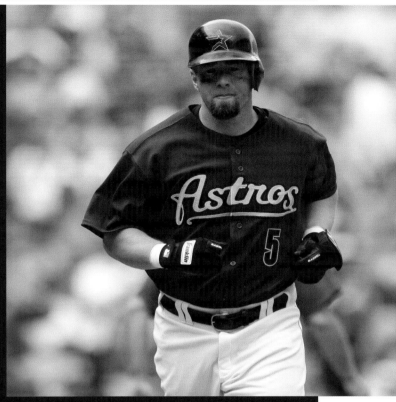

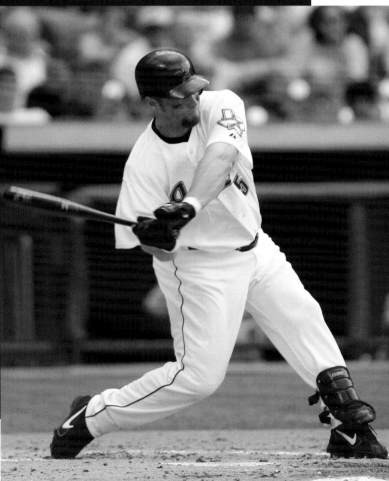

CRAIG BIGGIO

Craig Biggio's 20-year career took him from catcher to second base to the outfield and back to second base, a unique path in baseball history. He was drafted in the first round in 1987 from Seton Hall University, and his versatility allowed the club to make use of his tremendous offensive talents.

Biggio became a seven-time All Star, four-time Gold Glove winner and five-time Silver Slugger recipient. His approach to hitting was uncompromising. "The one constant which never really changed was where I stood on the plate," he said. "I really wasn't a big fan of the outside pitch but I could hit the inside pitch. It didn't matter where you threw it, I could hit it. I could get to it. So my theory was that I always wanted to stand on the inside part of the plate but know my weakness and then I'll go from there. So obviously, if you're going to come in, and it's too far in, you're probably going to hit me."

He is the all-time club leader in hits (3,060), runs (1,844), total bases (4,711), doubles (668), games (2,850) and at-bats (10,876). He finished his career with 414 stolen bases, second on the Astros all-time list. He was hit by a pitch 285 times, the most by a player in modern history. He set the National League record for leadoff home runs with 53. He and Cal Ripken Jr. are the only middle infielders in history to collect 3,000 or more hits and 1,000 or more extra base hits.

Biggio summed up his attitude about the conversion from catcher to second base. "The single motivation after I made my mind up was probably 85-90 percent of the people said there's no way you're going to be able to do it," he said. "And there's no way he's going to be able to go from there to there. And I used that motivation to be my

driving force. Saying I'm going to go out and make this work and we're going to be as good as we can be. And we're going to work, work, work like we did and we ended up at the All-Star Game the next year."

Infield coach Matt Galante, a close friend of Biggio's and a fellow New Yorker, was with Craig every step of the way. Galante spent countless hours hitting grounders to Biggio and working with him on the double play pivot.

"Offensively he was at the tip of the iceberg, because, as you saw through the years, he could steal bases with anybody," said Manager Art Howe. "He had great speed but catching wore him down. Bidge was maybe 165 pounds back then. I could picture Dave Parker coming home and putting him in the nickel seats somewhere, and I knew how good he could be offensively."

General Manager Bill Wood remembered Biggio's reaction to the proposed move. "When we first approached him about it he was not tuned to the idea at all," said Wood. "But it was not from a personal standpoint; it was because Billy Doran was at second base. And Billy was a guy he really looked up to. And he did not want to do anything to disrupt that. So we traded Billy and that made the transition much smoother. Matt Galante deserves a small niche on the side of Biggio's Hall of Fame plaque for all the work that he put in making him an outstanding second baseman."

The conversion began late in the 1990 season. Biggio wanted to keep it a secret, but "You're talking about these teammates and friends and you can kinda hear about it, see the writing on the wall, people speculating about it," said Biggio.

"So one day we laugh about it, but I felt horrible at the time. Billy (Doran) was in L.A. with us and we went out early with Matt Galante one day. So I said, 'Matty, OK, you guys are going to make me do this. So I want to work when nobody's around.' So we got there real early and then Billy came in, saw us working out. He went up to his locker, he got his glove, and he goes, 'If you're going to take my position, you might as well take my glove too.' And he threw it at me. He did it not to get at me, but more because he was mad at management at the

time. And that's OK. Yet, that same guy flew in in the offseason during the rodeo and we went over to the Astrodome when there was no field. In dirt we drew out the field and he says, 'Listen, if you're going to play second base, I'm going to teach you how to play it the right way.' And we spent two days there together. And to me that was probably one of the coolest things, the nicest things. And that's who Billy Doran was. He was just a great guy. A great team guy. And I'll never forget it."

"That's one of the proudest things I've done," Galante said of his contribution to the transformation. "The thing about it was it was almost like having your first child and he doesn't know how to walk so you teach him everything. We finally got him convinced to do this. I don't think anybody remembers this but prior to that, the year before, we started talking to him about it, he wasn't crazy about it. But it was down toward the end of the season and we were playing in San Francisco. Neither club was going to make the playoffs. So we felt this was a good time to try this. So he agreed to go out there. And the first ground ball to him went right through his legs. He never touched it with the leather. I looked at Artie (Howe) and I said, 'We're done. He'll never do this.'

"But in the wintertime he and I went over to Seton Hall University and they had an area of dirt indoors and we started the transformation. I told him I had a glove for him. Actually, it was…I had seen something like it…but I had a piece of foam that my wife cut out in a circle, sewed on this little pad for the fingers, and it was a homemade thing and it wasn't pretty. I showed it to Bidge and he said, 'I'm not using that.' I said, 'Yeah, you are.'

"We went on this back field and got out there and spent hours. I give him a lot of credit because he spent hours. Then he said to me, 'Okay, I'm ready to use this glove in a game.' And I said, 'You cannot use this glove in a game.' I remember Artie saying to me almost every day (and we were getting close to playing games), 'When can I put him in there?' Finally I said, 'Artie, he's ready to go.' And we put him out there every day.

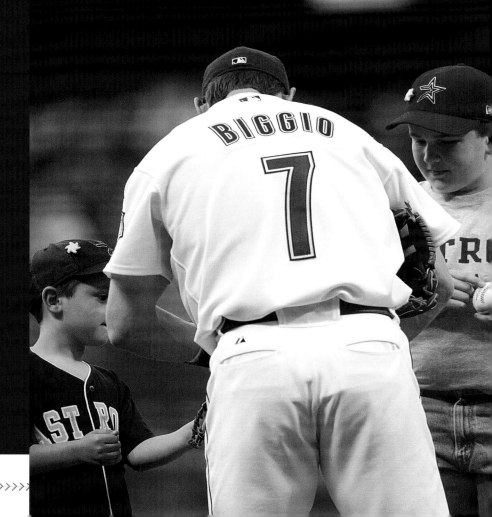

"He told me, 'We're going to do this. Don't tell me the good things because I know what I'm doing good. Tell me what I'm doing bad. The second part of this thing is, if we're going to do this, we need to win a Gold Glove.' I said, 'That's great.' And he won four of them. It was a proud moment for me when he gave me one of them, probably the best thing anybody's ever given me."

Biggio gave the fans a great memory with his 3,000th hit June 28, 2007 off Aaron Cook of the Colorado Rockies. His third hit of a five-hit night was an RBI single to right center field, tying the game 1-1. He was thrown out at second trying for a double. With his wife Patti and their three children on the field, he pulled former teammate Jeff Bagwell across the foul line to join in the celebration.

In the final weekend of his final season in 2007, Biggio collected four hits in his last three games against Atlanta. In his final game, he finished the day 1-for-4 in a 3-0 Houston win. It was fitting that his final Major League hit was a double, number 668 of his career. He finished fifth on the all-time doubles list and was the top right-handed hitter on the list. Another distinction for him was becoming the first player since Tris Speaker to collect 50 or more doubles and 50 or more steals in a season (1998).

Biggio later became the coach of the St. Thomas High School Eagles, leading the team to the TAPPS 4A State Championships in 2010 and 2011 with sons Conor and Cavan playing key roles. Before stepping into a new role as special assistant to the general manager, he received the Roberto Clemente Award for his longtime involvement with the Sunshine Kids and other charitable endeavors. He was voted to the All-time Astros 25-Man Roster in 2012. He served on the committee to select the Astros manager for 2013, Bo Porter.

KEN CAMINITI

The rifle arm of Ken Caminiti was one of his biggest assets. Scouts, players and longtime observers marveled over the arm strength and the diving plays on the highlight reel of the former San Jose State star, drafted in 1984. Only Doug Rader played more games for the Astros at third base than Caminiti, whose two stays in Houston totaled 10 years.

"I had seen Ken in the Minor Leagues," said Astros Manager Terry Collins. "You saw the skills. When I got the job here I did not know the mentality. No tougher guy have I ever been around than this guy. He was the silent leader on the ball club. With Cammy, Bidge and Baggy, with the way they played the game, if you didn't play as hard as they did, Caminiti had something to say. He didn't hold a team meeting. Just walked over to you, asked if you had a second, took you over to the weight room or in a private little place, looked you in the eye, and said, 'Look, this is how we're going to play here. If you can't do it, go in and see the manager and you need to get out of here.' Very quietly. And to me that was a leader. We had some standards here, and he's the guy who upheld those standards."

A switch-hitting power threat, Caminiti enjoyed his best RBI year for the Astros in 1991 with 80. He was traded to San Diego after the 1994 season, but returned to the Astros in 1999 and 2000. He was the National League MVP for San Diego in 1996, belting 40 homers and driving in 130 runs. He was a three-time All-Star and won three Gold Gloves.

Larry Dierker said, "Cammy was the ultimate warrior. His instincts on the field were always right on. With men on first and third and one out, he would often go for the double play even when it seemed unlikely that we could get it. But it seemed like we always got it, many times by an eyelash. And you know, he was the first player I ever saw do a stand up slide after rounding first and going full bore for second when a routine play would nail him."

In 2004, Caminiti's life tragically ended in New York. He was 41.

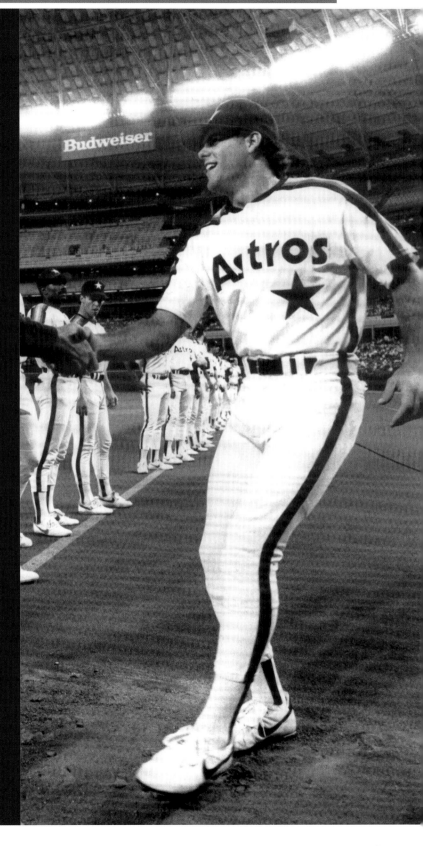

SHANE REYNOLDS

Shane Reynolds became one of the most consistent pitchers in Houston history, finishing with 103 wins with the Astros from 1992 to 2002. He was the Opening Day starter five times in a row from 1996 to 2000, winning 19 games in 1998. Reynolds was a durable and consistent starter who made 274 appearances in 11 years. He walked only 358 in 1622 career innings for Houston.

After being drafted in the third round in 1989, Reynolds was a marginal minor league pitcher until a major makeover in winter ball. "For me it was in Venezuela in '91," he said. "I had just finished my second year in AA and Rick Sweet was our manager and he was going to manage the Venezuelan club and Brent Strom was our AAA pitching coach and he was going to be our pitching coach. I think I got lucky as a AA player to be invited and then Strommy just completely changed me. He watched me throw a couple of games and he asked me the question, 'Do you want to spend 10 years in the minors or one year in the big leagues?' I said, 'One year in the big leagues.' He said, 'We need to do this. Let's try this.' He completely changed my windup, gave me a sinker, more control over the curveball and taught me the split-finger. I have to give him all the credit. I don't think I ever would have made it to the big leagues if that hadn't happened."

Reynolds finished in the club's all-time top 10 in wins, innings, starts and strikeouts. He was inducted into the Walk of Fame at Minute Maid Park in 2012. He also was named to the All-Time Astros 25-Man Roster.

DARRYL KILE

Darryl Kile was a part of the Astros' youth movement in 1991. Control issues dogged him. Terry Collins was faced with sending him to the minor leagues.

"One night he had a bad outing," remembered Collins. "Bob Watson called me on the phone and said, 'Your starting pitcher is out throwing the ball against the center field wall.' That was kind of the point when we said, 'Oh no, we've got to deal with this.' I walked out there, and sure enough he was throwing rockets against the center field wall an hour and a half after he came out of the baseball game. I was worried about injury more than anything. We decided after that to send him out and get his confidence back."

Kile threw a no-hitter against the New York Mets on Sept. 8, 1993 in a 7-1 win at the Astrodome. Diving plays by Ken Caminiti and Andujar Cedeno in the seventh inning supported his effort. Kile was from Southern California. He was drafted in the 30th round. His crackling fastball and knee-buckling curve combined to overpower hitters many times. He retired the final 17 in a row, walking only one in the game and fanning nine. After the game, in a radio interview with Larry Dierker, he said, "Well, at first I threw mostly fastballs. But after I started getting my curveball over, I threw it a lot."

Dierker said he had to ask about 20 or 30 questions to get through the interview because Kile didn't like to talk about himself. Dierker added, "He really didn't like to talk about his successes, but was hard on himself when he failed." Kile had been an All-Star earlier that year.

Through the struggles, he was a fierce competitor who stood up for his teammates. Craig Biggio remembers May 19, 1995 as a good example of Kile's loyalty. Pitching against Montreal in Houston, Kile was paired with Pedro Martinez. Two batters after Jeff Bagwell homered for a 3-1 Houston lead, Martinez

hit Luis Gonzalez with a pitch. Biggio and Bagwell, wanting Kile to be the winning pitcher, said, "Just get through the fifth inning. Then do whatever you want to do after that. Don't worry about it. Darryl just sat there. He listened. Then he went out and then with his first pitch of the fourth inning he drilled Roberto Kelly right in the middle of the back. And he just put his head down and walked off the mound at the Astrodome after he was ejected. Baggy and I couldn't wait for the inning to be over, because the minute it was over we ran into the clubhouse. 'We could rip you for doing it, but if there's anything you ever need we've got your back,'" the two told Kile. The Astros won the game 10-2.

On the final day of the 1996 season, Larry Dierker was saying his farewells in the clubhouse. He and Kile were chatting, and Kile asked what he could do during the offseason to improve. Dierker advised him to play a lot of golf.

"Here's the deal. Playing 18 holes has all the challenges you face on the mound. You need power shots and finesse shots. You need to spin the ball to make it curve the way you want it to go. And most of all, you have to maintain your composure. If you make a double bogey, you have to put it behind you immediately. Don't bogey the next hole because you're mad."

In 1997, he put together a brilliant season. His 19-7 record and 2.57 ERA was by far his best in a Houston uniform. It set him up well for free agency, and he moved to Colorado at the end of the season after pitching extremely well in a playoff loss to Atlanta. His 71-65 Houston record does not describe the esteem in which he was held by his teammates.

Kile then moved on to the St. Louis Cardinals. He won 20 games for them in 2000. In 2001, when the Astros and Cardinals battled to the final day of the season for the division title, Biggio homered off Kile in St. Louis. The long ball snapped a 2-2 tie and sent

the Astros on to a 4-2 win. Biggio was told after he rounded the bases that Kile was yelling at him as he came around second.

Biggio was puzzled at Kile's response, but nothing was mentioned between the two of them. "Two weeks before Christmas he calls me and says, 'Hey, I want to apologize,'" said Biggio. "'I should never, never have said the things I said to you as you ran around the bases.' I told him, 'I love you to death and we're going to do a lot of things together, but don't ever bother me with something silly like this again.' He said, 'You guys treated me super nice and you helped me get through some tough times. I should never, ever have done that to you.' And that's the typical person that he was."

Kile died of heart problems in June 2002. That night, Bagwell made a game-winning pinch hit, and players mobbed him on the field. Some of his former teammates traveled to his memorial service in St. Louis, returning to play in Houston that night. Kile's number "57" is represented in a circle on the wall at Minute Maid Park and his jersey was hanging in the Houston and St. Louis dugouts in the days following his death.

In honor of Kile's friendly personality, the Houston chapter of the Baseball Writers Association of America votes on an annual winner of the Darryl Kile "Good Guy" Award. Jeff Bagwell was the winner the first year it was awarded. The St. Louis Cardinals also award a Darryl Kile Award every year. Kile's spirit lives on each year with these awards.

The surprise choice of Larry Dierker as manager for the 1997 season caught many Houston media observers off guard. His knowledge of the game was evident in his broadcasting work, and his pitching career qualified him to work with the most important aspect of the game. But many had never thought of him as a manager. He led the Astros to four playoff berths in a five-year span, unparalleled success in club history.

The Astros won at a .553 clip under Dierker, with 448 wins and 362 losses from 1997 through 2001. That's the best winning percentage for any fulltime manager in club history. His laissez-faire approach to the offense put the players in the driver's seat. His influence on the pitching staff was evident in the reliance on starting pitchers to carry the load. His feel for using setup relievers more than one inning sometimes ran counter to that of many of his opposing skippers.

The Astros held off the Pittsburgh Pirates in 1997 to clinch their first playoff berth since 1986, with Mike Hampton pitching a complete game and Brad Ausmus belting a three-run homer in the clinching game.

Many longtime Houston baseball followers regard the 1998 team as the best in the team's history. Houston's best regular season record of 102-60 led to high hopes for this playoff series against San Diego. The high powered "Killer Bees" offense led by Biggio, Bagwell, Moises Alou, Ken Caminiti, Carl Everett, Derek Bell, Sean Berry and others scored 874 runs to set a club record to that point. Larry Dierker was named Manager of the Year.

Just seconds before the trading deadline July 31, 1998, General Manager Gerry Hunsicker pulled the trigger on a blockbuster trade for towering lefthanded pitcher Randy Johnson of Seattle. Parting with top prospects Freddy Garcia and Carlos Guillen along with John Halama, Hunsicker acquired a pitcher who went 10-1 with a 1.28 ERA for Houston.

Johnson delivered two more excellent outings in the Division Series. But Kevin Brown outpitched him 2-1 in the opener. Brown allowed just two hits in eight innings. He fanned 16 at the Astrodome, buzzing high 90s sinkers past a predominantly righthanded lineup of Killer Bees.

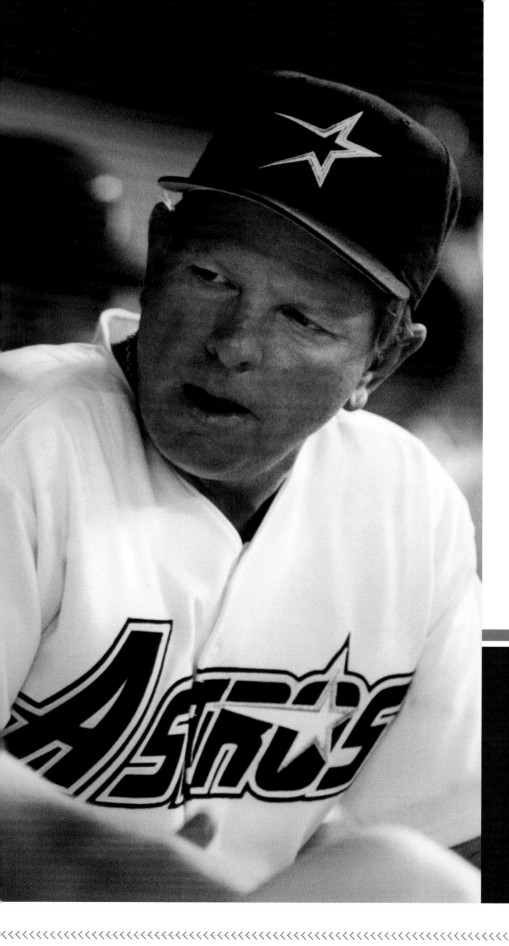

1997
NLDS

Atlanta swept Houston in three games, 2-1, 13-3 and 4-1 in the 1997 playoffs. Greg Maddux, Tom Glavine and John Smoltz held the Astros to a .167 batting average and eliminated the Astros after Houston ended its 11-year playoff drought by winning its first-ever National League Central Division title.

Maddux went the distance in the opener at Atlanta to shade Darryl Kile, 2-1 with RBI from Chipper Jones and Ryan Klesko. The Braves won with only two hits. Glavine was backed with an early explosion in the second game. The Braves worked Mike Hampton for eight walks in 4.2 innings. Smoltz closed out the series with a second Braves' complete game in the series, allowing just three hits and fanning 11. Jones added another homer.

DIERKER
1998

MANAGER OF THE YEAR

Moises Alou said, "The way he was, was great. You could joke with Larry. I remember telling him once, 'Larry, go out and argue with the umpire.' We were like friends. It wasn't like he was our manager."

ADDING JOHNSON
TO THE MIX

*"I thought it was even more important to do
something like the Johnson trade on a team
that looked like it had a chance to get to the
postseason because of what I call the 'piling
on effect,'" said Gerry Hunsicker. "I had all the
confidence in the world that that team would
get to the postseason. But to advance in the
postseason, to add somebody like Randy Johnson
to an already talented rotation gave us that much
more of an opportunity to really go deep into
the postseason. So the message that something
like that sends to your clubhouse is extremely
important and I remember how excited the players
were. That was probably the most important thing
to me—to continue to try to motivate them. But to
see the excitement that this brought to the city of
Houston was something that I'll never forget."*

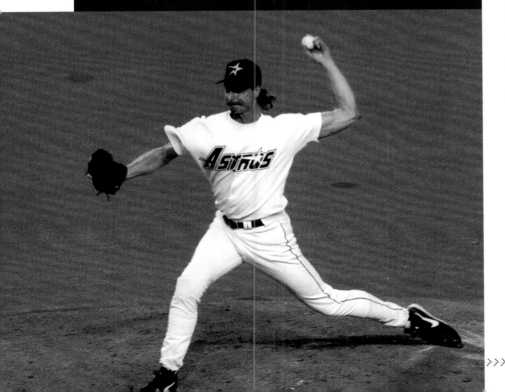

Jose Lima and Mike Hampton formed the core of the 1999 pitching staff that relied on closer Billy Wagner and setup man Scott Elarton to nail down wins. For the only time in club history, the Astros had two 20-game winners. Hampton set a club record with 22 wins and Lima added 21.

The single-game home record attendance of 54,037 for the September 28, 1999 game with Cincinnati brought Astrodome fans more of that electric experience. Not even a club record 12-game winning streak in September could add more than a game to Houston's lead over tenacious Cincinnati.

In 1999 post-season play, again it was the Braves winning the playoff series 3-1. Shane Reynolds downed Greg Maddux in the opener 6-1 with long balls from Caminiti and Daryle Ward. A Kevin Millwood one-hit 5-1 verdict evened the series. Then the pivotal Game Three brought a memorable play that decided the series.

Atlanta's Walt Weiss, the smooth-fielding shortstop, robbed Tony Eusebio of a game-winning hit in the 10th with the bases loaded. With the Braves playing at halfway depth up the middle for a double play on Eusebio, John Rocker gave up a sizzling ground ball up the middle that would have been a game-winning hit on most occasions. But Weiss nimbly dived to his left to snag the ball. With Ken Caminiti barreling home, Weiss sprang to his feet. But he didn't have time to get his feet established under him. With his body leaning toward third base, he snapped off a throw to catcher Eddie Perez. Perez had to stretch toward third base to grab the throw. He braced for a collision with Caminiti that never came. Caminiti tripped over his extended leg and went into a forward roll.

Ricky Gutierrez struck out to end the inning. Brian Jordan won the game 5-3 with a 12th inning double. Mike Hampton, who started for Houston, and Russ Springer, who relieved for Atlanta, moved on to other teams after that 1999 game.

John Smoltz turned out the lights on the Astros in Game Four, beating Reynolds. Caminiti hit his third playoff homer to give him the most powerful postseason series by an Astro to that point.

The Braves limited the Astros to 15 runs in the four games, with a .340 slugging percentage. The recurring theme was wearing on Astros fans. For the third straight year, some of the best pitchers in the game stopped their attack.

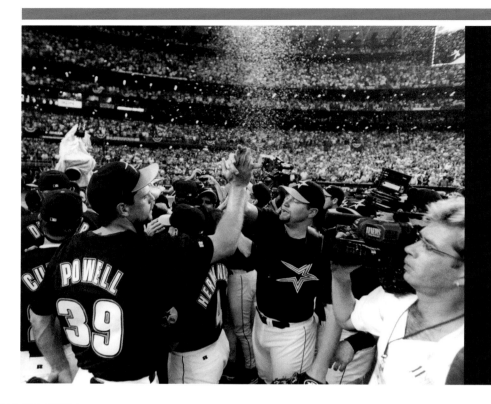

CLOSING OUT THE DOME

Fans saw an exciting race decided on the final day of the season in 1999. Closing out the Dome experience with a 50-32 home record, the Astros whipped the Dodgers 9-4 in the final game with 50,033 enjoying the big day. Many former Astros players returned for the final regular season game. They were treated to a division-clinching celebration after the game as confetti showered down on the players and closing ceremonies brought back memories.

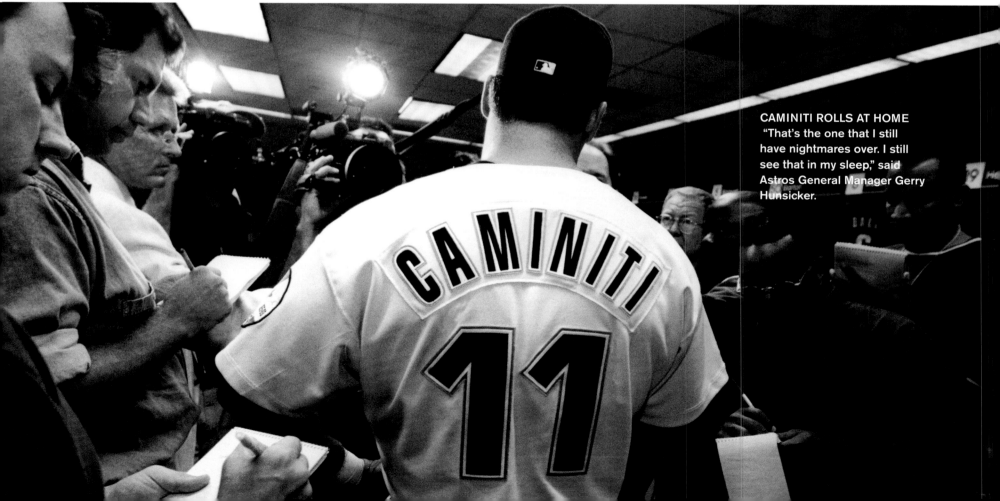

CAMINITI ROLLS AT HOME
"That's the one that I still have nightmares over. I still see that in my sleep," said Astros General Manager Gerry Hunsicker.

JOSE LIMA

Jose Lima was the perfect Astrodome pitcher. He struggled for success in other stadiums, but the Astrodome was his palace. He thrived on challenging hitters and fed off allowing 375-foot fly-ball outs. Time after time his outfielders caught fly balls on the warning track with men on base. He parlayed good control, showmanship that seemed to get his opponents so keyed up to blast the ball that they just missed it, and good offensive support to a 21-10 record in 1999. His ERA was 3.58 that year. He walked only 44 in 246 innings.

When he pitched, it was "Lima time." In his career he pitched 54 games at the Astrodome, going 18-11 with a 2.90 ERA. Outside the Dome, he was 71-91 with a 5.76 ERA. "I don't think you can find a better example," Manager Larry Dierker said of Lima's home field advantage. "Lima pitched pretty well on the road in those years. And I think one of the reasons he pitched well on the road is that he had a lot of confidence because he pitched well at home."

Lima arrived with catcher Brad Ausmus and others in a multiplayer trade with Detroit following the 1996 season. He was 46-42 in five years with Houston. Ever the entertainer, he performed in a salsa band. Once he entertained at Enron Field after getting ripped on the mound in that night's game. He passed away in 2010.

MIKE**HAMPTON**

Nicknamed "The Bulldog," Mike Hampton arrived in a deal with Seattle for Eric Anthony prior to the 1994 season. Used in relief that first season, he moved into the rotation in 1995. Mastering an effective changeup to combine with his fastball and sharp breaking pitch, Hampton strung together five straight 200-inning campaigns (four with Houston).

He was an aggressive competitor who was a Gold Glove winner and also made room for five Silver Slugger awards as the NL's best hitting pitcher. These talents helped Hampton compile a 76-50 mark during his seven Houston years.

Hampton really blossomed in 1997. "I remember the season not starting out the way I wanted it to," he said. "Dierker and I talked about it and I started throwing a lot more sinkers and got on a hot streak in the second half and that really catapulted my career. Then pitching that '97 win to clinch gave us a chance to go to the playoffs for the first time in 11 years. That was a great year for me, a great memory in my career."

Hampton set the club record for wins in a season with 22 in 1999. "That's a special place in my career," he said. "It's nice to have a record with a team—a positive record and 22 wins. There have been so many great Astros pitchers, and to be honest, the win total was pretty special.

In 1999, Hampton won the final regular season game in the Astrodome and the victory clinched a playoff berth. "There was plenty of pressure in the game itself," he said. "You try not to focus on that. You try to focus on the task at hand. That was winning that game and putting us in the playoffs. It was a special year for me, winning 22 games, and I think one of the things I remember most about that is getting a hit in my final at-bat to hit .300 as well. So that was pretty cool."

Brad Ausmus brought a Dartmouth education into his catcher's mask and was known by his batterymates as a Phi Beta Kappa-caliber game caller. He won three Gold Gloves to show for his acumen behind the plate and was an All-Star in 1999.

Ausmus caught Houston games for 10 years over two separate stints. He hit one of the biggest home runs in club history in 2005 in the ninth inning in Game 4 of the NLDS with Atlanta to tie the game the Astros won in the 18th inning.

Ausmus, when asked to rank that memory, said, "It's one of my most cherished memories. But Chris Burke's home run might be right in front of it as far as my favorite home run as an Astro. We had gone 18 innings. We were starting to get extremely tired. We wanted the game to end. We were running out of pitching. Rocket comes out of the bullpen and goes three innings. So that was one of those 'games for the ages.' Chris Burke's home run allowed us to let the air out."

Ausmus played all 18 innings of the playoff game, moving to first base for a few innings and then returning to catcher. He admitted it was exhausting. "It was, but I actually went to first for awhile and Raul Chavez came in and caught, I think for three innings," he said. "Then when Rocket came in the game I went back behind the plate and Chamo went to first. I didn't actually catch all 18 innings."

Ausmus loved Minute Maid Park, but also has fond memories of the Astrodome. "I actually always liked the Dome," he said. "Hitting in the Dome, playing there 81 games, is an advantage because it takes you a day to get used to the lighting in there. I always thought it was an advantage for us." He also ripped a three-run homer in the 1997 clincher at the Dome against the Cubs.

Craig Biggio remembers, "I sat next to him on the airplane and he did his homework. He went through all the scouting reports, wrote it all down. Manager's best friend, because he'd do all the work for you.

MOISES ALOU

One of the most respected clutch hitters of his era, Moises Alou joined the Astros in 1998 and set one of the highest standards of any player who played for the club for three years or more. He hit .331, clubbed 95 longballs and drove in 346 runs, often providing game-changing hits in the late innings. His OPS for those three years was a whopping .988.

Alou, whose uncle Jesus played for the Astros from 1969 to 1973, paid immediate dividends after being acquired in a trade with Florida in 1997 by making 1998 one of his six All-Star years, even though he was upset at being traded shortly after Florida won the World Series. He was known as a hitter who could get results against the top pitchers in baseball and one who was at his best in pressure situations.

Alou explained, "Playing with good players makes you better," he said. "I'm a competitor. Baseball is a competitive game. It's a team game, but you want to compete. I'm a competitor. I don't want to lose at anything. The same thing happens when you play with good players. You want to play as good or better than them. I was surrounded by great players on the Houston team. That made me a lot better. I learned a lot and I had the desire, had the drive. Plus I was 31 or 32 years old, and I remember my Dad telling me, 'This is the prime of your career.'"

Larry Dierker said, "Moises was fearless. He stood up close to the plate and never moved an inch. As a baseball athlete, he was slim but strong, lithe and fluid. In other words, perfect.

Along with Paul Molitor, he was the only batter I've ever seen who had no trigger mechanism in his swing. He attacked the ball directly from where his hands were in his stance." Dierker added, "And he was quietly defiant. He was the guy I wanted up there with the game on the line in the ninth inning, which is saying something with Biggio and Bagwell on the team."

Alou said, "I used to visualize about hitting in those situations a lot because I wanted to be in those situations. Because I always thought I had nothing to lose. It was a win-win situation. If you don't come through, so what, you know? There's a lot of failure in baseball. But if you come through, you're a hero. But you have to want it. I wanted to be in those situations.

"If you do it three out of 10 times you're successful. If you do it four out of 10 you're the best. I was a good fastball hitter and that helps. Whenever you're a good fastball hitter late in the game you're facing a guy who throws hard most of the time. Every at-bat they'll give you one fastball."

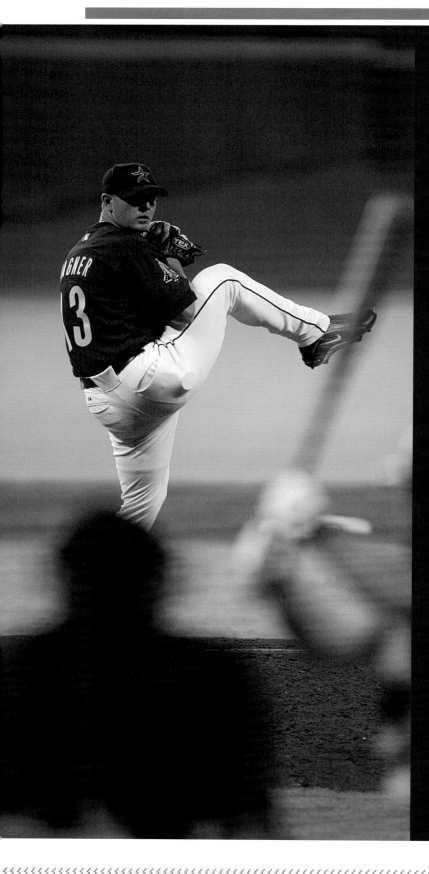

BILLY WAGNER

When Billy Wagner was growing up in Virginia, early on he demonstrated the qualities he would need in his ultimate baseball destination as a closer—one of the best of his era. A splintered family life made for a difficult childhood that found him living with different relatives, and through playing sports, he developed a feistiness. He learned to throw by hurling a baseball at a strike zone etched into the cement wall of a dairy on his uncle's farm. Wagner was so determined to keep playing that, when he was about five, he switched from throwing right-handed to left-handed because he had a broken right arm.

By the end of his career in 2010, he had become the all-time strikeout leader among left-handed relief pitchers. And with 422 saves, he fell two short of John Franco's record for a southpaw. He defied the odds at every turn. Excelling at tiny Ferrum College in Virginia, he set the Division III record for strikeouts in a career with 327 in 182.1 innings.

His crackling fastball helped him achieve first-round draft status in 1993. The Astros used the 12th overall pick to acknowledge his promise. Yet, he remembered in a Sports Illustrated article in 2010, "When I got drafted out of college by the Astros I went to Houston and met Drayton McLane. He looks at me and says, 'I thought you'd be bigger.'" Wagner stood about 5'10" and weighed in around 180 pounds. He remembered all the perceived slights throughout his career and used them as incentive to prove himself.

Arriving in the majors at the end of the 1995 season after three years of professional baseball, he made the conversion from starter to reliever. "I wasn't very good, either," he summarized. "My stats said I was good but I didn't have a good breaking ball, didn't have a changeup. I had no idea where I was throwing the ball. Most of my success was due to terror. You know, one at your head, two on the corner, throw a terrible breaking ball, bounce it 50 feet, fastball behind you. It was a constant battle. I didn't know. Then when I got called up in '96 and I was supposed to start. I didn't have that mentality to be a starter. I'm aggressive. I want to pitch every day.

Plus I didn't have the repertoire to go out and be a starter. I couldn't pitch in the big leagues with what I had.

"They go, 'All right, Wags. Go get 'em.' They didn't say 'This is what a closer's supposed to have. This is what he's supposed to throw.' They said, 'Go get 'em.' And that was it. My first save opportunity was three innings. And being naïve and dumb to the situation, I didn't know better. I just went out there and kept pitching because they said, 'Go play.'"

In 1998 he reached the 30-save plateau for the first time in his career. He had a scary night in Arizona on July 15 when Kelly Stinnett lined a ball off the left side of his head behind the ear. Wagner was carried off the field on a stretcher. He suffered a concussion and was placed on the disabled list. He was able to return in August and make a contribution to the 102-victory club that set a club record for wins in a season.

In 1999 Wagner set the club record for saves with 39, which he tied in 2001. He became the first Houston closer to win the prestigious Rolaids Relief Man Award. He was an All-Star in both of those seasons. In 2000, he missed the final three-and-a-half months with a partially torn flexor tendon that required surgery. But Wagner returned to top form in 2001 with 39 saves in 41 chances.

In 2003 one of the best Houston bullpens of all time featured Brad Lidge, Octavio Dotel and Wagner. Together for this one season, they gave the Astros a shutdown trio that could assure wins a high percentage of the time with leads after six innings. Wagner agreed that was the best group of relievers including him in his 16-year career.

"Yes, I think as far as complete control, dominating, yes," said Wagner. "You couldn't find any three guys who could complement each other as much as we did. It was as dominating as it could be. I know that guys still mention how awesome that was."

By the time Wagner was traded to the Philadelphia Phillies after the 2003 season, he had moved atop the club's all-time save list with 225, surpassing Dave Smith's mark of 199. His 2.53 ERA was third best by an Astro for a career. And his explosive fastball rocketing from a small, compact frame provided Houston fans with lasting memories of overpowering outs at the end of games.

After being a first round draft choice from Rice University in 1997, it didn't take long for Lance Berkman to breeze through the minors. The Texas native broke in as an outfielder in the Astrodome in 1999. Scouted by Ralph Bratton, he was surprised to be drafted by the Astros with the 16th choice overall in the first round because he had not seen Astros scouts at Rice games.

"I always kept in the background," said Bratton. "It was a different time then. We always tried to be last in the house. I had known Lance Berkman since he was 12 or 13. I thought he would be long gone by 16. He was in our top four or five. I had called Lance a week or 10 days before the draft. I asked, 'Are you going to give me any trouble signing?' He said, 'No, sir.' But he asked, 'You've got Jeff Bagwell at first base. What are your plans for me?' I told him I knew he could play the outfield. My main job was to convince the Astros that he could play outfield."

During his 10-year stay before being traded to the Yankees in 2010, the man who gave himself the nickname "Big Puma" on a morning talk show soared to the top, or near the top, of several offensive categories in club history and made it to the top 10 in many more. With a career Houston average of .296 with 326 homers and 1090 RBI, Berkman added a .549 slugging percentage that stood atop the list when he departed the club. He also scored 1008 runs.

Moving to first base after Jeff Bagwell retired, Berkman was a big part of the club's postseason success with six postseason home runs including an important grand slam against Atlanta in Game 4 of the 2005 NLDS.

"As I was going to the plate I thought to myself, 'This is the game,'" recalled Berkman. "'If I can do something here, we're in this game. If I don't, it's over. We're going to go back to Atlanta (for a deciding Game 5).' I distinctly remember having

hat thought as I was being announced to come up to hit. And then I remember (Braves reliever Kyle Farnsworth) threw me a first pitch fastball kind of away. He was throwing hard. It got the outer half. I took it. I thought, 'You should have swung at that pitch. If you see another one like that, you'd better not let it go by.' And sure enough don't know if it was the next pitch or the one after that, out pretty quickly thereafter he threw the exact same pitch and I hit a line drive into the Crawford seats (that rallied the Astros to within 6-5). As soon as that happened thought, 'We have a real chance.' And of course the building went absolutely nuts."

When his Astros career is put in context, his postseason hitting makes a high mark. "I think that's where you want to produce," said Berkman. "If you're ever going to do good that's where you want to do good, in the postseason because that's what everybody likes to say Can a guy get it done in the postseason?' Fortunately I've had good postseason experiences with the exception of the very first one in '01. I don't think that went particularly well. But having said that, I am pleased with the way I've been able to play and produce in the postseason."

Berkman counts his three-run homer off St. Louis' Chris Carpenter in Game 5 of the 2005 NLCS as his most memorable home run as an Astro. "I thought it was going to put us in the World Series, but Albert Pujols hit his three-run homer in the top of the ninth," he told The Sporting News.

Berkman ranks this hit high among his Astros memories because "Carp won the Cy Young that year and was one of the best, if not the best, pitchers in the game at that point. We were down a run, and Houston had never been to a World Series. That was the greatest moment of my career to that point. I hit that home run and circled the bases on air, like they say, and then Albert did me in, as only he can do."

From the time he successfully negotiated with Dr. John McMullen, Drayton McLane's forceful personality took hold with the players. As the team improved, success on the field and management's reputation spread to players on other teams. Over the years of his ownership, McLane attracted other free agents such as Roger Clemens, Andy Pettitte, Jeff Kent and Carlos Lee. Additionally, he spent major sums to retain the building blocks who had been with

the organization for their entire careers: Jeff Bagwell, Craig Biggio, Lance Berkman and Roy Oswalt. The team made the playoffs six times in McLane's first 13 years as owner.

When McLane passed the ownership torch to Jim Crane in November 2011, Commissioner Bud Selig praised the long-time owner's work with the team and the new ball park and credited him with stabilizing the franchise.

McLANE'S
LASTING LEGACY

In a 2010 Houston Chronicle *Tal Smith* called it: *"Drayton's ownership was very stable—lots of accomplishments, lots of success and a good overall record."*

Larry Dierker, who managed under McLane, praised his boss compared to other Astros owners: "He has been the best by far."

Commissioner Bud Selig said, "He came in and stabilized the franchise. Drayton should have a wonderful legacy of what he did with the Astros. He got a new ballpark built. He sure left a much better franchise than when he came in. He deserves all the credit in the world for that."

The Houston Astros, 2011

50 YEARS OF GLOVES & BATS

For any Major Leaguer, the fielding gloves and bats are the most important tools on the field. Craig Biggio, the franchise leader in career hits with 3,060, had a partiality to the Louisville Slugger H176 model bat. Perhaps no bats in the history of the Houston Astros were as carefully prepared as the ones used by Biggio in his 20-year career with the club. Biggio himself handled the carefully wrapped handles, and many saw a good amount of pine tar below the barrel. His 3,000th hit in 2007 came off of the M9 (maple) version of the H176 model.

Moving Downtown

A
S HOUSTON ENTERED THE 21ST CENTURY, IT BUILT A STATE-OF-THE-ART BALL-park downtown. The design of Enron Field featured brick and limestone as two of its primary materials. Anchored by Union Station, which had been used as a hub for rail passengers since 1911, the dynamic ballpark gave Houston fans their first outdoor Major League experience in 36 years.

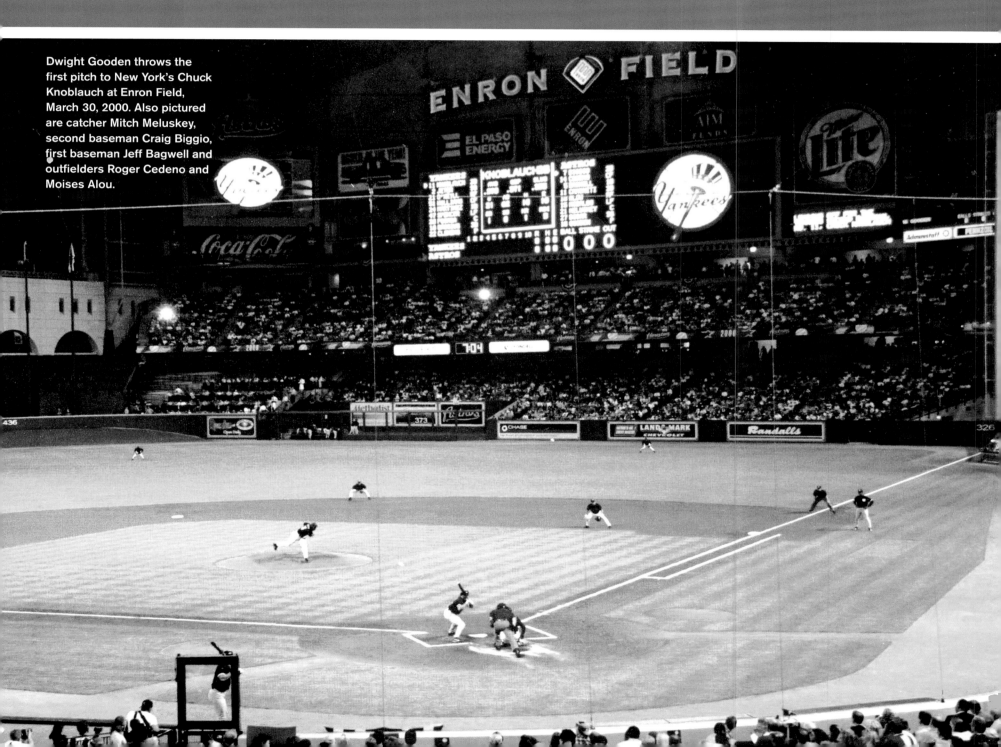

Dwight Gooden throws the first pitch to New York's Chuck Knoblauch at Enron Field, March 30, 2000. Also pictured are catcher Mitch Meluskey, second baseman Craig Biggio, first baseman Jeff Bagwell and outfielders Roger Cedeno and Moises Alou.

ENRON FIELD
MINUTE MAID PARK

As it had been with the development of the Astrodome, Houston was at the forefront of modern technology with the first retractable roof that moved completely off the ballpark. The presence of Union Station created a footprint for the stadium that made for some of the longest and shortest dimensions in the game.

The roof has a dimension of 589 by 242 feet and a weight of 3,810 metric tons. It moves on 36-inch forged steel wheels. On the left field side, 50,000 square feet of glass allows light in from the west wall. The windows give fans a view of the skyline, even when the roof is in the closed position. Combining the latest technology and amenities with a rich traditional style provides fans such combinations as air-conditioned luxury suites and the latest in restaurant fare with a hand-operated scoreboard near the left field line. The playing field is unique, with a distance of only 315 feet down the left field line topped by the 19-foot scoreboard in the left field wall, and Landry's Crawford Boxes sitting atop the wall in a home run friendly section of seats.

The monstrous center field of 436 feet is the deepest in baseball, fronted by a terraced section of ground named Tal's Hill because Tal Smith suggested this feature. The stadium's name was changed from Enron Field to Minute Maid Park in 2002 under a new naming rights agreement.

The downtown stadium opened March 30, 2000. The first visiting team, the New York Yankees, returned for an exhibition game 35 years after opening the Astrodome. Ricky Ledee belted the first home run in the new building off Astro Dwight Gooden. As in 1965, the Astros beat the Yankees, by a 6-5 score this time on a night when the gleaming lights blazed through the Houston sky on the eastern edge of downtown with the roof open. Jeff Bagwell was the first to get a hit; it came off Houston resident Roger Clemens in the game attended by former President George H.W. Bush, who would become a mainstay at Astros home games with former First Lady Barbara Bush.

When the Philadelphia Phillies paid a visit to provide the official NL Opener at Enron Field, Randy Wolf claimed the win with home run support from Scott Rolen in the 4-1 Phillies triumph. Craig Biggio picked up the first Houston hit. Octavio Dotel lasted seven innings, taking the loss. The Phillies' first base coach, Brad Mills, became the Astros' manager in 2010.

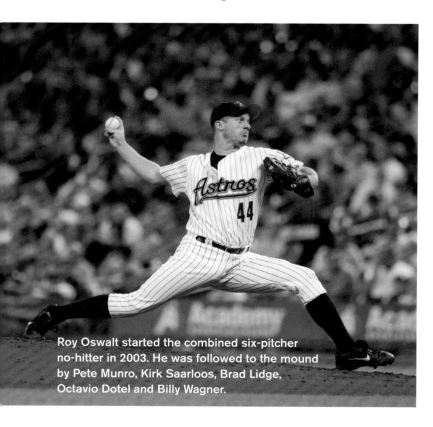

Roy Oswalt started the combined six-pitcher no-hitter in 2003. He was followed to the mound by Pete Munro, Kirk Saarloos, Brad Lidge, Octavio Dotel and Billy Wagner.

2001 NLDS

Shane Reynolds beat Darryl Kile and the Cardinals on the last day of the season 9-2 as they finished the regular season tied with the Cardinals with the same won/lost record at 93-69. The Astros were declared the division winner because of a better head-to-head record with the Redbirds.

In the 2001 NLDS, the Atlanta Braves again delivered the knockout punch on the Astros, sweeping the three games. Greg Maddux and Wade Miller started Game 1. Chipper Jones' eighth inning home run off Mike Jackson sent the Braves to a 7-4 win in Houston. Tom Glavine and John Smoltz collaborated on a 1-0 win over Dave Mlicki in Game 2. John Burkett sent the Braves on in the playoffs by winning Game 3 in Atlanta, beating Shane Reynolds.

THE SIX-PITCHER NO-HITTER

The Astros pieced together one of the most unusual no-hitters in baseball history with six pitchers in a game at Yankee Stadium. Roy Oswalt started and left two pitches into the second inning with aggravation of a groin strain that had forced him onto the 15-day disabled list prior to the June 11 game. Pete Munro took over and worked 2.2 innings. He was followed by Kirk Saarloos, Brad Lidge, Octavio Dotel and Billy Wagner. Dotel fanned four Yankees in his one inning.

It was the first regular season no-hitter at Yankee Stadium since 1952 and the 10th no-hitter in franchise history.

JEFF
KENT

In December of 2002, at age 35, Jeff Kent signed a two-year contract to join the Astros. The California native left the San Francisco Giants after six consecutive seasons with at least 100 RBI. Kent brought four years of playoff experience to Houston. The three-time All-Star hit three World Series home runs in 2002. He began his Astros experience with a home run in his first at-bat.

As Kent settled in at second base alongside shortstop Adam Everett, he began a two-year run with the Astros that included 49 homers and 200 RBI. He became an All-Star in 2004 for the game at Minute Maid Park. He put together a 25-game hitting streak that year from May 14 to June 11 to set a club record at that time.

Kent's dramatic three-run blast won Game 5 of the 2004 NLCS in the last of the ninth and gave the Astros a 3-2 lead in the series. Kent said, "There were pictures taken of me coming from third base to home plate, and I don't know if I've ever been so excited in my entire baseball career—even in the World Series—than at that moment." He became the all-time home run leader among second basemen in his final regular season game with the Astros.

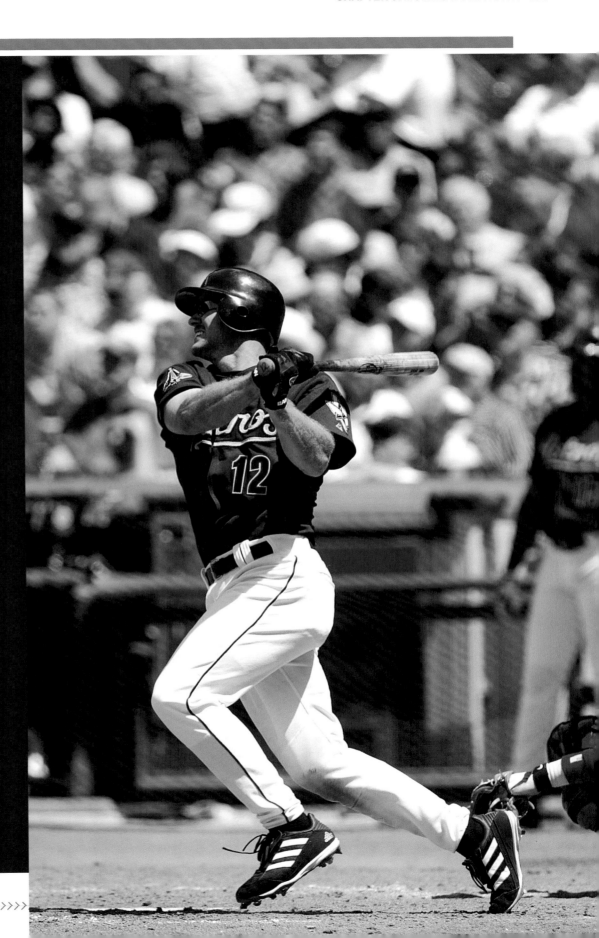

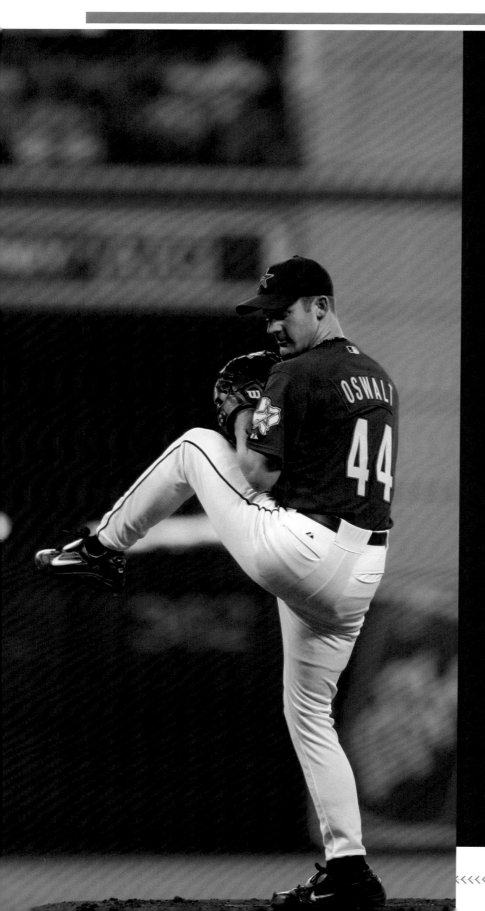

ROY OSWALT

James Farrar, the same scout who followed the amateur development of J.R. Richard, was following Roy Oswalt's development in Weir, Mississippi. Roy's grandfather, appropriately named Houston, had worked as a logger until retiring to become a watermelon farmer. During the summer months, Roy and his brother helped hoe weeds in the watermelon patch. Just as they were preparing the soil for the growth of watermelons, the weeds had to be cleared for Roy's growth into a Major Leaguer. There were obstacles. One was his size. He was a 6' right-hander, slender, who didn't throw all that hard. He was in a graduating high school class of 30.

Oswalt was a 23rd round draft choice in 1996, the year Billy Wagner made his big league debut. Drafted as a "draft and follow" choice, he showed sufficient progress to get a contract offer before the next year's draft when he was a sophomore at Holmes Community College in Mississippi. He caught the eye of Nolan Ryan at Round Rock with his composure and his competitiveness. And he learned from his pitching coach. " I felt like I had good enough stuff," said Oswalt. "I've always had a good fastball, but I knew I was going to have to sharpen my other pitches up. I learned how to pitch on both sides of the plate and started learning how to pitch in. I really put it together a lot more when I got to Double A and Mike Maddux the pitching coach was there. He's always been a contact pitcher, where I was always trying to avoid it. I tried to take as much as I could from him and tried to keep my pitch count down to get deeper into games and win games."

There was some head-butting with the front office as Oswalt learned his craft. "I remember one time—in Double A, maybe—Tim Purpura came down and told me that it was mandatory for me to throw 20 percent changeups during the game. And I remember thinking, 'If I keep putting up zeroes you have to move me, but if I don't put up zeroes you don't have to move me.' They made it mandatory I had to throw 20

percent changeups. I remember the next game I threw 20 changeups to start the game. So they told me they didn't want it like that. They wanted it throughout the game. So I didn't really learn one. I threw it occasionally through the years, but I had good enough velocity and a good enough curveball where I could rely on those two pitches." After that season, Oswalt played on the gold medal USA Olympic team.

By 2001 Oswalt burst upon the Major League scene with a 14-3 rookie record and a 2.73 ERA, fanning 144 in 141.2 innings. Roy was soaking it all in. "I felt like the biggest thing in the big leagues is being able to throw all your pitches for strikes when you want to and to control the bottom part of the zone." said Oswalt. "My first year no one really knew me. And I knew that with the curveball and the fastball velocity I had, the speed difference was going to trick a lot of people. And then as the year progressed I had to learn how to change speeds on my curve ball and learn a slider a little bit better. Actually I didn't learn a changeup until 2009."

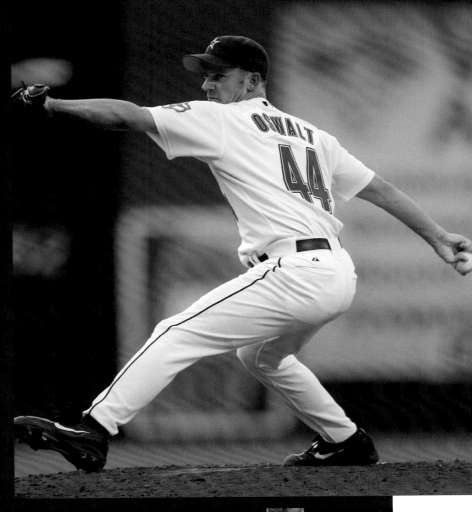

In 2002 he became a 19-game winner who piled up 233 innings. A groin injury in 2003 limited him to 21 starts. But by 2004, when the Astros had assembled a playoff team, Oswalt was ready to lead the way. He put together the first of his two consecutive 20-win seasons, working 237 innings and finishing third in the Cy Young Award voting. He was 12-3 down the stretch for a torrid second-half team. He was the first Astro since Joe Niekro to have back-to-back 20-win seasons. He also won the clinching game in the Division Series triumph over the Atlanta Braves—the first postseason series win in club history.

After working 241 innings during the regular season, Oswalt beat Atlanta again in the NLDS in Game 3. He also knocked off St. Louis in Game 2 of the NLCS. But when Albert Pujols won Game 5 in Houston with his momentous home run, Oswalt had to face the Redbirds again in Game 6 in St. Louis, with the Astros leading 3-2. Before the game, he was approached by Drayton McLane.

"Drayton's always been upbeat," said Oswalt. "It doesn't matter what the situation is. It could be one of the worst days

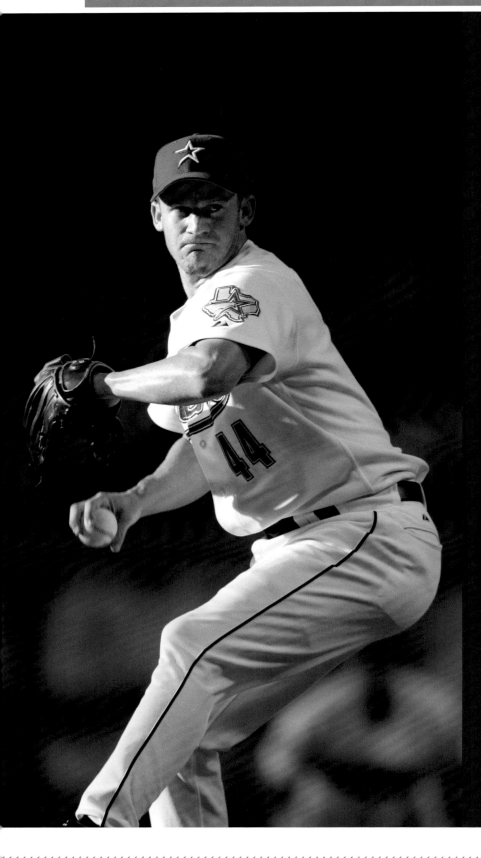

in the United States. He's upbeat. I was watching some of the Cardinals on video from the first time I pitched against them and I'm trying to make some adjustments on some guys who got hits. The conversation started, 'Are we going to win tonight? Are we going be a champion tonight?' Then he noticed that I was locked into the video. I was answering him, but I was watching the video too. He had to do something to get my attention.

"We'd been talking about this bulldozer that he owned, about my buying it from him at the end of the season. Sitting there, he told me that if I won the game that night and got us into the World Series he would give it to me. So I heard that pretty well," laughed Oswalt. "I told him I was going to hold him to it. I remember walking off the field after the seventh inning. He was sitting beside the dugout family group, and I thought, 'I'm going to call you this offseason looking for that bulldozer.'"

That night in St. Louis, in the final game of Busch Stadium before it was demolished, Oswalt returned to basics and used the approach that was successful early in his professional career. "I felt like that night I could throw pretty much the fastball where I wanted to. It had enough life on it where I felt like I could overpower most of the guys. It was just one of those nights where it clicked in and you felt like you couldn't get hit."

In July 2010, at Oswalt's request, he was traded to Philadelphia. At the time of the trade, he was one win short of tying Joe Niekro's club record for career wins with 144. They still rank as the top two. Did one of Houston's best pitchers in club history regret not breaking the record? "It would have been nice," said Oswalt. "I wanted to break it, and I knew it was coming down to the last few starts, but my number one goal from day one was to win a World Series. I didn't want a record to hold me back from what I started to do."

WORLD 05 SERIES

Astros

50 YEARS OF CLEATS & BASES

The cleats of Jeff Bagwell, one of the best base runners in Astros history, show the wear and tear of a 15-year career trekking around the dirt infields of Major League Baseball. In 2004 Roger Clemens had a limited edition of 22 pairs of cleats. The bases used during the final regular season home game at the Astrodome (upper left) were switched out every half inning. The home plate used during 2004-2005 (top, middle) is where Craig Biggio scored the first World Series run in Texas. Other special bases—ones used during the '05 World Series and the 50th Anniversary celebration in 2012 (upper right)—remain some of the most memorable.

57

5

ALL-STAR ROCKET

RC RC

A New Tradition

IN PURSUIT OF BOMBERS

AFTER FINISHING SECOND IN BOTH 2002 and 2003 under Jimy Williams with records of 84-78 and 87-75, the Astros went shopping for difference makers to get them back to the postseason. After two years of missing the playoffs, the 2004 season shaped up with much potential. During the offseason, McLane and GM Gerry Hunsicker had made a major effort to sign free agent lefty Andy Pettitte of Deer Park, a Houston suburb. Pettitte had gone from Deer Park High School to San Jacinto College.

Pettitte had compiled a 149-78 record with the Yankees and had pitched in the postseason for nine straight years. When they discovered Pettitte was receptive to leaving the Yankees, the opportunity to land a big game pitcher was too attractive to refuse. Joining a rotation with Roy Oswalt, Wade Miller and Tim Redding, Pettitte was a tough competitor who was schooled in excelling at the highest level.

A month later, Pettitte's Yankee teammate Roger Clemens, another top caliber pitcher with local roots, joined the club as a free agent. He brought a 310-160 record for his years with Boston, Toronto and New York. Like Pettitte, he was attracted by the opportunity to stay at home. He had attended Spring Woods High School, San Jacinto College and the University of Texas. Topping the free agent signings of Drabek and Swindell before the 1993 season, McLane had landed two of the best in baseball.

ANDY PETTITTE

Andy Pettitte was 37-26 with a 3.38 earned run average during his three years with the Astros. His Houston years began with an injury to his left elbow sustained in his very first start on a checked swing in his first time at-bat as an Astro. A torn flexor tendon forced him to make three trips to the disabled list and ultimately he underwent surgery in August, which kept him out of postseason play in 2004.

Nonetheless, Pettitte rebounded in 2005 to finish 17-9 with a 2.39 ERA, with another win in the Division Series adding to his postseason aura. After his three-year Houston stint, he returned to the Yankees. In 14 postseasons, Pettitte compiled a glittering 19-10 record.

When Pettitte joined the Astros, he had just come off the 2003 World Series. Combined with the other seasoned performers who were striving to attain what was part of a normal season for Pettitte, he brought the Astros to their top level of achievement. Playing alongside his longtime companions, Derek Jeter, Jorge Posada and others, Pettitte trained each winter with the World Series as part of his plan.

ROGER CLEMENS

In 2004, Roger Clemens had a 2.98 ERA and won his final six decisions on the way to an 18-4 record for the Astros. His winning percentage of .818 was the best in the majors and was the best ever for a pitcher older than 40. His seventh Cy Young Award was waiting for him at the end of the season

He followed that with a league best 1.87 ERA in 2005, winding up 13-8 because of a lack of run support. He also led the league in strikeouts that year with 226. In 2006 he made 19 starts. Clemens was 38-18 with the Astros with a 2.40 earned run average. He was an All-Star in 2004 and 2005. Like Pettitte, he returned to the Yankees after his Houston years.

Clemens finished his career with 354-184 record and a 3.12 ERA. Remembering his time in Houston he said, "The three years that I had here were very special, to have the opportunity to come home and pitch, to work alongside Baggy and Bidge and Andy. For a short period of time we took football off the map down here."

Earlier in the 2004 season, Hunsicker had moved swiftly, trading a slump-ridden outfielder Richard Hidalgo to the New York Mets for reliever David Weathers and a minor leaguer. Then he packaged closer Octavio Dotel with Minor League catcher John Buck in a three-way deal with Kansas City and Oakland. The prized return was 27-year-old centerfielder Carlos Beltran.

With Dotel gone, Brad Lidge was promoted to closer and there was a search for setup stability. Dan Miceli became the eighth-inning setup man and Weathers joined the other members of the bullpen crew. But Wade Miller left the rotation in late June with shoulder problems.

Beltran joined the Astros in Arlington. At the time, he joined a team with a 38-34 record. He provided an immediate upgrade in center field, allowing Jimy Williams to move Craig Biggio to left field. Beltran compiled a season that propelled him into the national spotlight as one of the top five talents in the game, with 38 homers and 42 steals.

From Aug. 15 to the end of the regular season, the 36-10 finish was the hot topic in the National League. It was the second-best finishing kick over that span of time in the National League in 55 years. Only the 1951 Giants had done it better. From Aug. 27 through Sept. 8, a 12-game winning streak got the attention of baseball observers everywhere. The end result was a one-game margin over San Francisco, with Chicago falling three lengths behind.

On the final day of the season, Brandon Backe dialed up a gem when Clemens was too sick to pitch and the Astros clinched a playoff spot. Brad Lidge struck out the final four, making him the National League's all-time single season strikeout leader among relievers with 157, breaking Dick Selma's record set in 1970. When Lidge whiffed Colorado's Aaron Miles for the final out of the final game of the regular season, the Astros mobbed each other on the field while the fans went delirious.

Houston beat Atlanta in the 2004 NLDS, giving the Astros their first playoff series win. They avenged losses to the Braves in three earlier playoff series.

Brandon Backe won Game 3 after the teams divided the first two encounters.

Back in Atlanta for Game 5, an emotional Houston team took the field after mourning the death of Ken Caminiti. Carlos Beltran stepped up in the decisive game, clubbing two homers and driving in five in a 12-3 rout. Beltran was voted series MVP. A weary Jeff Bagwell said, "It's great to move on. Finally."

HOME RUN DERBY (BERKMAN VS. TEJADA)

One of the most memorable moments of the 2004 All-Star experience in Houston was the Home Run Derby. Lance Berkman, an All-Star for the third time, reached the final round and finished second to Miguel Tejada. Batting righthanded, the switch hitting Berkman locked his swing into a powerful groove and sent balls soaring over the Landry's Crawford Boxes time after time. Tejada also was into that sort of rhythm. It made for quite a show of eye-popping power. Tejada won 5-4 in the final round, finishing with 27 in all rounds combined. The American League hit Roger Clemens with a six-run first inning and won the 2004 All-Star Game at Minute Maid Park 9-4. Clemens, who also started the 1986 All-Star Game in Houston for the American League, allowed first-inning homers to Manny Ramirez and Alfonso Soriano. Soriano, who played for the Texas Rangers at the time, was named the game's Most Valuable Player.

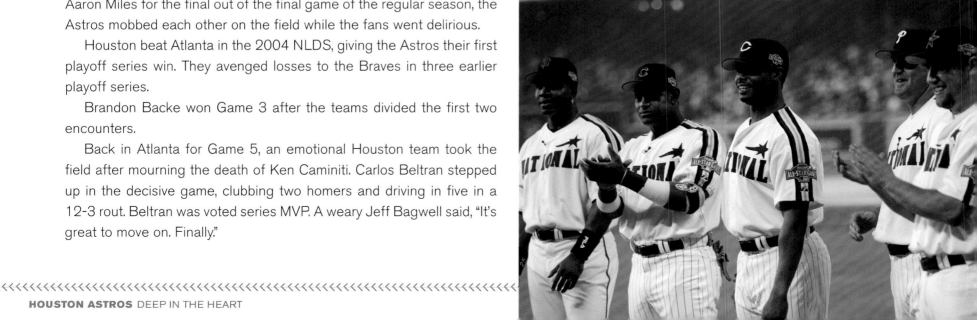

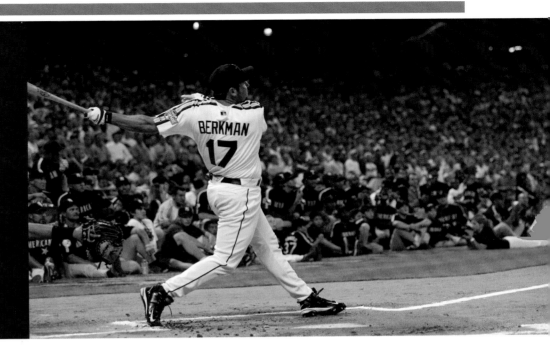

UNBEATABLE

Berkman hit .354 in August and September combined with 13 homers and 41 RBI. "It just seemed like every one of those games coming down the stretch was a playoff game," he said. "I think that actually played in our favor because once we got to the postseason it was really like well, here we are, it's just another game like we've been playing. Especially in '04 in this building. No one could beat us."

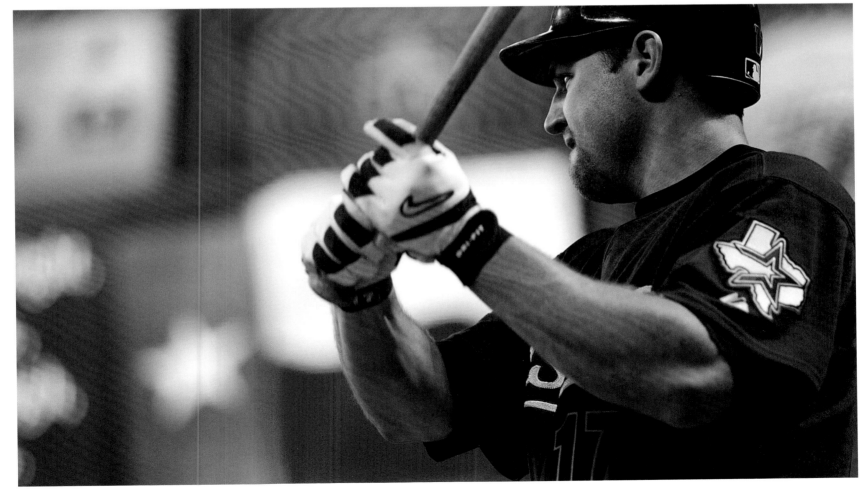

2004
NLCS

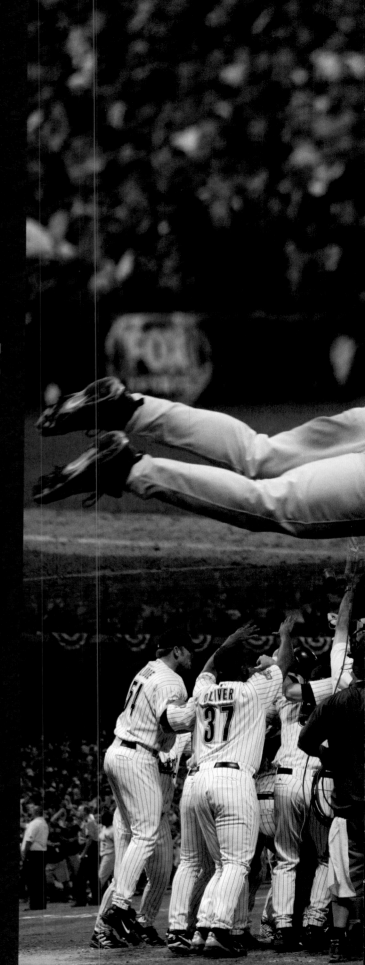

In **Game 3,** with the Cardinals up 2-0 in games, Clemens faced Jeff Suppan, his former Red Sox teammate, for the fourth time in 2004. Kent ripped a two-run homer, just as he had in the last game that Suppan had pitched in Houston. Clemens fired 111 pitches, fanning seven and allowing two runs on just four hits in seven innings. He maintained the slim 3-2 lead from the third inning until he left the game to a rousing cheer. Beltran tied a Major League record by ripping a homer in his fourth straight postseason game in the eighth off Danny Haren. Berkman destroyed a Ray King pitch in their second consecutive encounter in this series for a third Houston homer accounting for the game's final run in the 5-2 win.

Beltran's slugging crusade continued in **Game 4,** taking him to Major League record proportions with his eighth postseason home run. He also singled, walked and scored three times in the Astros' come-from-behind 6-5 victory. Beltran golfed a 2-2 slider for the game-winning homer with one out in the seventh. It was his fifth homer in five games, breaking a postseason mark. He went 7-for-13 in the NLCS.

Beltran's eighth playoff home run in nine games tied Barry Bonds' postseason record of eight in 17 games in 2002. In 32 playoff at-bats, Carlos was hitting .469 with 13 RBI, 14 runs scored, with an on-base average of .553 and a slugging percentage of 1.219.

Game 5 found Brandon Backe and Woody Williams at their best. With the crowd of 42,000 at a fever pitch, Backe retired the first 13 batters on his way to eight innings of one-hit, shutout ball. With the game still scoreless, Beltran lined a single to the gap in right center leading off the home ninth and stole second as the count went to 2-2 on Berkman. Berkman walked. The double play was in order as Kent came to the plate. He smacked the first pitch from Cardinal closer Jason Isringhausen for a game-winning three-run homer off the façade above the Landry's Crawford Boxes. It was a cut fastball over the plate.

An animated, smiling Kent pointed to the bench on his way to first base with the crowd erupting. When he got close to home, he tossed his helmet away, jumped in the air and joined the happy throng at home plate. He had a look of pure joy on his face. When the game started, he had more playoff strikeouts than hits. "I learned when I was with San Francisco to

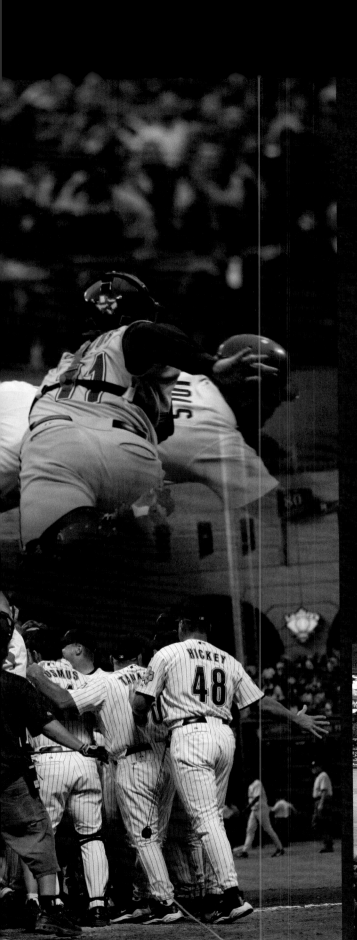

count down to my at bat," said Kent. "The leadoff guy gets on, he probably steals, base open for Barry Bonds, they walk Barry. So, you count down and kind of figure it. I was ready for it. That's probably as happy as I've felt, ever, in my career, on a walk-off home run. It was a heck of a moment." Lidge was the winner, entering in the top of the ninth and throwing just a few pitches in the 3-0 thriller.

In **Game 6,** Jim Edmonds clobbered the 344th pitch of the game—a high fastball-into the bullpen in right to send the 52,144 into pandemonium with a 6-4 Cardinal win. Then, it was **Game 7.** The numbers told the story of a series that not only came down to one game, it came down to two teams which had played on statistically even terms through the first six. Both teams were hitting .246 in this series. Both scored 29 runs. Both had 4.80 ERAs. Records had been set by Beltran for runs scored in a single postseason with 20 and a LCS series with 11. Albert Pujols had set a record for total bases. The teams had combined for 23 homers, tying a NLCS record.

The fired-up Cardinal crowd was quieted on the fourth pitch with a Biggio leadoff homer. Houston had two on and one out in the second when Brad Ausmus smoked a 3-1 pitch to left center. Edmonds, playing shallow, raced into the gap and made a headfirst diving catch which sent the crowd into a frenzy.

"To me that was the whole series," said Berkman. "Obviously there were other things that happened. But Edmonds almost singlehandedly won those last two games. He hit the walkoff home run in **Game 6** and then came back in **Game 7.** If he doesn't catch that ball, that's two runs and Ausmus is on second base. We probably end up winning that and going on to the World Series."

In the third, Beltran created a run for a 2-0 Houston lead. In the sixth, Pujols tied the game with a double and Scott Rolen followed with a two-run homer. Kiko Calero entered in the seventh with a 4-2 lead. The Cardinals clinched a World Series berth 5-2 and went on to meet the Red Sox in the World Series, losing four straight. The disappointment in Houston was acute after yet another exciting near miss.

After coming within one win of reaching the 2004 World Series, the Astros found the magic formula in 2005. For the second straight season, they sent baseball historians paging through the record books to research teams who rose from the ashes like the mythical phoenix. With high expectations, the Astros sank to a 15-30 start, going 10-19 in May to tie the worst club mark for that month.

They were written off by the *Houston Chronicle* in a May article with tombstone artwork. By the time the playoffs arrived, the Astros had joined the 1914 Miracle Boston Braves as the only teams to soar from 15 games under .500 to reach the playoffs.

The 2005 club featured some new faces. Carlos Beltran had signed with the Mets, alienating the fans in Houston, and Jeff Kent had signed with the Dodgers through free agency, opening second base for Craig Biggio's return. The entire outfield changed, with Luke Scott winning the left field job for Opening Day, Willy Taveras in center and Jason Lane in right. Lance Berkman was not in the lineup for the Opener, sidelined by right-knee surgery. When Berkman returned, he was quickly shifted to first base after Jeff Bagwell decided to have surgery on his right shoulder, sidelining him for most of the regular season.

General Manager Tim Purpura said, *"We'd walk around the clubhouse and talk to staff and players and kinda look at each other and say, 'Are we this bad?' And I don't think anybody felt that way. I don't think anybody gave up on the talent early. And we certainly didn't either. A lot of people wanted us to tear the club apart but we stuck to our guns. No. We're gonna go with this group and see what they can accomplish. We just decided not to try to tinker too much and go with what we had."*

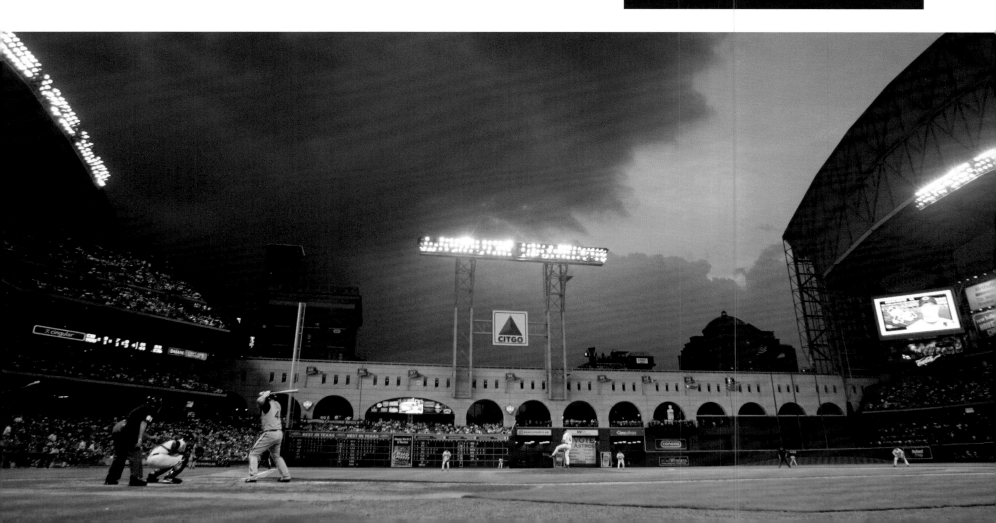

2005 DIVISION SERIES

Astros vs. Braves

The Braves had won the regular season series decisively, 5-1. It was a part of their 14th consecutive division title—the longest run in the history of team sports.

In **Game 1,** Andy Pettitte joined Atlanta's John Smoltz atop the all-time postseason win list with his 14th at Atlanta. Morgan Ensberg had a five RBI day. The Astros exploded with a five-run eighth to win 10-5.

John Smoltz pitched with precision and power in **Game 2,** claiming his 15th career postseason win and stopping the Astros after a first-inning Jason Lane RBI single. Roger Clemens was tagged for five runs in five innings. He made a mistake on a 2-0 fastball over the plate to rookie catcher Brian McCann, who was born in 1984, the year Clemens made his Major League debut. McCann ripped a three-run homer in the second. Adam LaRoche tagged a two-run double in the third to give Smoltz plenty of support.

Back in Houston for **Game 3,** the Astros took a 2-0 first inning lead against Jorge Sosa in Sosa's first postseason appearance. Oswalt kept the Braves off the scoreboard after surrendering two early runs. Mike Lamb blasted a long ball to right field in the third. The game stayed 3-2 until the seventh, when Houston tacked on four. Again the Braves' bullpen imploded.

The 7-6 win in 18 innings was the longest game in postseason Major League Baseball history in both the number of innings played and the length of time it took—five hours and 50 minutes. It was also one of the best postseason games in baseball history.

Brandon Backe walked two and hit a batter in the third, setting the table for a grand slam by Adam LaRoche. LaRoche's blast quieted the energetic crowd. Tim Hudson kept the crowd at bay with a strong seven innings. Backe stayed in until the fifth, when Houston skipper Phil Garner made his first call to the bullpen. Little did the unsuspecting crowd of 43,413 realize that Garner would summon a total of eight pitchers in the 18-inning marathon, using his entire relief corps and then moving on to venerable Roger Clemens in the 16th inning. The relievers would combine to work 13 and two-thirds innings, allowing just one run.

THE GREATEST GAME IN ASTROS HISTORY

"MIRACLE AT MINUTE MAID"

Game Four

OCTOBER 9

Houston 7, Atlanta 6 (18)

Winning Pitcher -
CLEMENS
Losing Pitcher -
DEVINE

On a 2-1 pitch in the eighth, Berkman ripped a line drive to the second row of the box seats in left field, drawing the Astros within a run, 6-5. The crowd erupted as the Astros' first extra-base hit of the game reached fan Shaun Dean's glove. Dean had never sat in the Landry's Crawford Boxes before. He had a souvenir of the biggest homer of Berkman's career. He also had caught the second grand slam ball of the game, a postseason record.

Ausmus, batting with two outs in the ninth, had hit only three home runs during the regular season. He ripped a fastball from Kyle Farnsworth perhaps an inch above the left center field wall, 404 feet away. The fans exploded as the game was tied. The Astros had overcome a 6-1 deficit and had all the momentum and the home field advantage. It was to be only the second time in baseball history that a team overcame a five-run deficit to win a postseason game.

About the 13th inning, Clemens went to Garner and said, "Skip I've got my spikes on." Garner replied: "I'm not worried about your feet. I'm worried about your arm. Are you OK?" Clemens responded: "Skip, I'll do whatever it takes." Garner didn't find out until some time later that Clemens had already thrown for perhaps 30 minutes in the cage to his son Koby and both were drenched in perspiration. Prior to that, Clemens had run on the treadmill and lifted weights. He was not about to bring that up to Garner. When he was waiting in the bullpen, he called the Astros' bench on the bullpen phone and asked for strength and conditioning coach Gene Coleman, who was surprised to get a phone call during the game. Clemens was requesting some bananas because he was famished.

"My favorite all-time vision I have of managing is looking at the bullpen…the stands are going crazy and the only guy I see in the bullpen is Clemens," Garner said years later. "He is sitting out there, somewhat somber, and taking it all in." He actually entered the game as a pinch hitter for Wheeler and executed a sacrifice bunt in the 15th.

In his three innings, his first relief appearance since 1984, Clemens allowed only a double to pinch hitter Brian Jordan in the 17th. Then, with one out in the home 18th, Chris Burke worked the count to 2-0. He had one at-bat the first three games—a pinch double in **Game 2.**

"People thought Rocket was going to win the game for us," said Burke. "On the 2-0 pitch my eyes had been moved toward the inside corner of the plate. Devine runs a 2-0 pitch and…he threw the pitch right where my eyes were. I got the barrel right there, and the rest is history."

Burke smacked it to the second row of the Crawford Boxes. The same fan who caught Berkman's slam—Shaun Dean—also grabbed Burke's game winner as the fans came unglued with emotion. Burke hit the 553rd pitch of the game into the left field seats. Ausmus, who had averaged one home run per 150 plate appearances in 2005, struck a blow for the ages in club history. Burke had the sixth home run in Major League history to end a playoff series. His bat was on its way to Cooperstown.

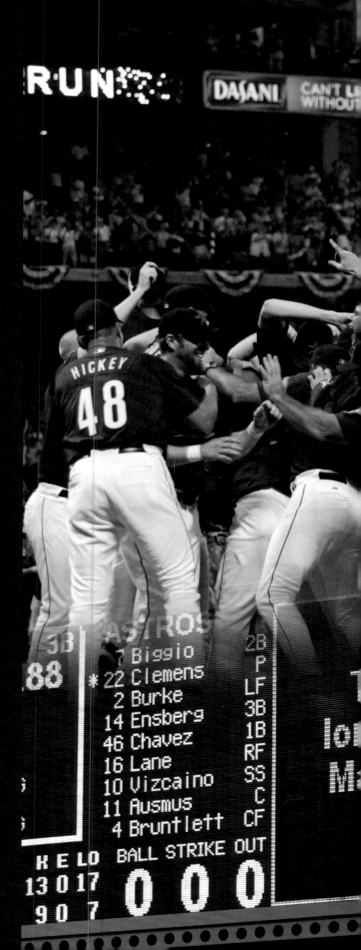

Burke jumped high as he joined his teammates at home plate for the winning celebration. "I just remember the adrenaline rush of the team being there. At that moment there is no thought of legacy or history or anything other than just pure emotion for a group of guys who just gutted out a six-hour win over an unbelievable opponent and now get to play for an opportunity to play for it all," said Burke. "I'm not a big memorabilia guy. Matter of fact, the bat that I hit the home run with just sits in my closet, but that is a picture that I have framed right there. What I love about it is the joy on the looks of my teammates. You can see that picture, you can see all the smiles, all the excitement on their faces. That's what it's all about."

In Astros' history, this game vaulted ahead of the 1986 **Game 6** NLCS loss to the Mets in 16 innings. The 2005 win went a long way toward blurring the vivid memories of playoff losses in the past.

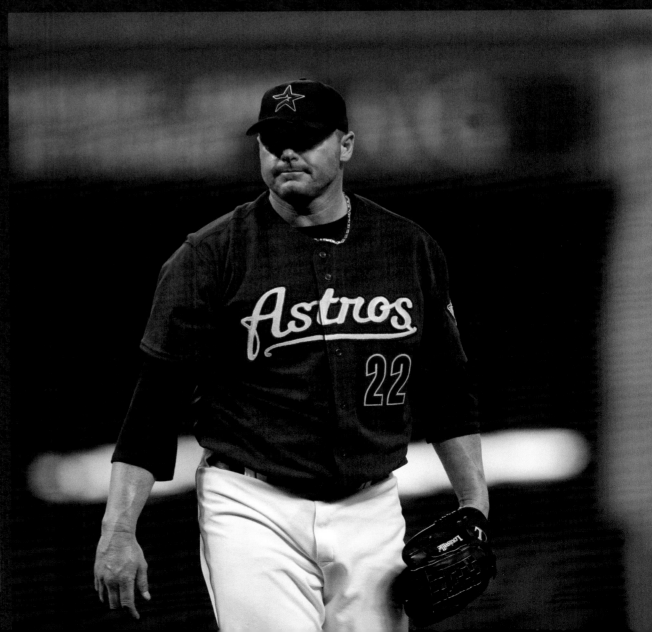

Baseball Bulletin: oday's game is the gest playoff game in or League Baseball history.

2005 NLCS

Astros vs. Cardinals

The story of **Game 1** was that the best pitcher in the National League in the second half of the season, Andy Pettitte, was hit on the right knee by a Roy Oswalt-batted ball during batting practice. Pettitte was running from second to third and saw the ball and tried to jump over it. His right knee swelled and he needed an injection to take the mound. St. Louis won, 5-3.

Roy Oswalt pitched one of the finest games of his career in **Game 2,** keeping his lively fastball low in the strike zone and mixing in some baffling sliders. His most important pitch came to Jim Edmonds in the seventh with two on, leading 2-1. Edmonds grounded the slider to first base to end the threat.

Some 42,823 packed into Minute Maid Park for **Game 3** and cheered loudly as the Astros grabbed a 2-1 lead in the NLCS. Roger Clemens struggled without command of his split-fingered fastball, throwing a liberal dosage of fastballs. In the fourth, Morgan Ensberg drew a leadoff walk and Mike Lamb blasted a fastball into the Landry's Crawford Boxes in left field for a 2-0 lead. John Mabry's pinch double in the ninth off Brad Lidge kept the Redbirds alive, but Lidge retired David Eckstein for the final out of the 4-3 win with the crowd noise rivaling the decibel level on a runway at George Bush Intercontinental Airport.

Phil Garner shocked everybody by giving his starting pitcher a quick hook in **Game 4.** All of his relief pitching decisions worked. A pinch runner scored the winning run on a shallow sacrifice fly. Two defensive substitutes made game-saving plays.

In the Houston seventh, two walks and an error led to pinch-runner Willy Taveras scoring from third on a sacrifice fly by Ensberg for a 2-1 lead.

When Lidge came in for the ninth, so did Eric Bruntlett at second base for Biggio. Lidge was shaky, allowing hits to Pujols and Larry Walker. The Redbirds had runners at first and third with no outs. With one out, Lidge got a slow roller to Bruntlett's left from Mabry. Garner, who had just moved his middle infielders in two steps, yelled for Bruntlett to throw home.

Bruntlett didn't know if he had time for a double play, but his quick footwork allowed him to get the ball to Adam Everett, who went airborne over a hard-sliding Reggie Sanders and fired to Berkman a quarter-step ahead of Mabry's arrival for the double play. Minute Maid Park erupted.

Albert Pujols drove a dagger into the hearts of Houston fans with his two-out three-run homer in the ninth in a 5-4 St. Louis win in **Game 5.** Lidge got the first two outs quickly in the ninth with the fans partying early, anticipating a World Series celebration.

Lidge hung a slider on 0-1 and Pujols ripped it over the railroad tracks high above the left field wall to put the Cardinals ahead. Berkman's three-run homer in the seventh had sent the crowd into eruptions of joy. Just as in 1980, the Astros were unable to clinch with a final win.

Many underestimated the competitor in Roy Oswalt. By the end of **Game 6,** he walked away with the MVP award for the NLCS and sent the Cardinal crowd home from Busch Stadium for the final time before it was demolished. With his three-hit work over seven innings, he tore down their hopes to repeat as NL Champs.

Pitching coach Jim Hickey remembered, "That very first inning when he struck out Pujols on that fastball that rode up and in on him like a sawblade, I just knew right that instant that there was no chance he was going to lose that ball game. I think he would probably agree that that was his finest hour."

The Astros had their first World Series berth. They closed down Busch Stadium in a classy way.

2005 WORLD SERIES

Of the 50 players on the two teams' rosters, 41 were appearing in their first World Series. Craig Biggio was about to play in his first after 2,564 games in his career—the all-time record for a player in his first Series. Jeff Bagwell was third on that list with 2,150 games.

When the lineups were announced, Lamb was playing first base and Bagwell was the DH. Bagwell missed 115 games that year with a bad shoulder. "Here's the issue," Garner said later. "In a short season, people of his character will do what they always do and they'll figure out how to win. I had no hesitation believing that if the Series went four, five, seven games, Bagwell would have played great. And I feel that he did."

Chicago White Sox righthander Jose Contreras gave up the first Houston World Series homer in Game 1. Mike Lamb connected in his first at-bat in the second. "Rocket had a long bottom of the first inning," remembered Lamb. "I was leading off the next inning and when I hit the ball I was just hoping Aaron Rowand didn't catch it."

Clemens, who was 3-0 with a 1.90 World Series ERA before this game, left with a strained hamstring. Wandy Rodriguez entered the game in relief and stayed in for 3⅓ innings. The Astros tied it 3-3 in the third on a clutch two-out double by Lance Berkman. The Sox added a run in the eighth in a 5-3 victory.

On a chilly, rainy night in Chicago for Game 2, Ensberg homered in the second off Mark Buehrle. Ensberg, after 36 regular-season long balls, was at the peak of his Major League career at age 30. Few could have foreseen that after 2008 he would be out of the game.

The Astros built a 4-2 edge through 6 ½ with Berkman driving in three. Pettitte left with the lead after throwing 98 pitches and stiffness setting in. At that point, the Houston bullpen failed. Chad Qualls came in with the bases full and Paul Konerko jerked his first pitch for a grand slam, sending the Sox ahead 6-4.

The Astros tied the game in the ninth on a two-out pinch single by Jose Vizcaino off Bobby Jenks. But in the last of the ninth, Scott Podsednik hit a 1-2 fastball from Lidge for his first homer of 2005 to win the game 7-6. Podsednik had more than 500 at-bats during the regular season without a long ball. He joined Kirk Gibson, Joe Carter, Bill Mazeroski,

Baseball Bulletin: Tonight's game is the longest game in World Series history.

Dusty Rhodes and others who had won World Series games with homers. Now the Sox had a 2-0 lead heading to Houston.

In **Game 3,** the first ever World Series game in the state of Texas, the Astros played their second marathon of the playoffs, lasting 5:41 with the Sox winning 7-5 in 14 innings. Oswalt was handed a 4-0 lead after 4. Lane homered in the fourth off Jon Garland. But after that, the Astros managed only one hit in the final 10 innings.

In the 14th, former Astro Geoff Blum ripped a go-ahead home run off Ezequiel Astacio. For Blum, it was only his second at-bat of the postseason. Ozzie Guillen called upon **Game 2** starter Buehrle for the save in the 14th.

The game was the longest by time in Series history. The 14 innings tied a 1918 game for the longest. Babe Ruth had thrown all 14 for Boston then.

The Sox clinched their first World Series title since 1917 with a brilliantly pitched 1-0 gem in **Game 4.** Former Astro farmhand Freddy Garcia, traded to Seattle in 1998 in the Randy Johnson deal, came back to haunt Houston. He also became the first Venezuelan-born starter to win a World Series game. Brandon Backe, traded for Blum in 2002, matched him with seven scoreless innings and for the second straight year pitched a fantastic game in his final home playoff effort.

In the eighth, Lidge entered the game and surrendered a leadoff single to pinch hitter Willie Harris, batting for Garcia. Jermaine Dye's two-out single drove in Harris with the only run.

Houston's first World Series appearance had been all too brief.

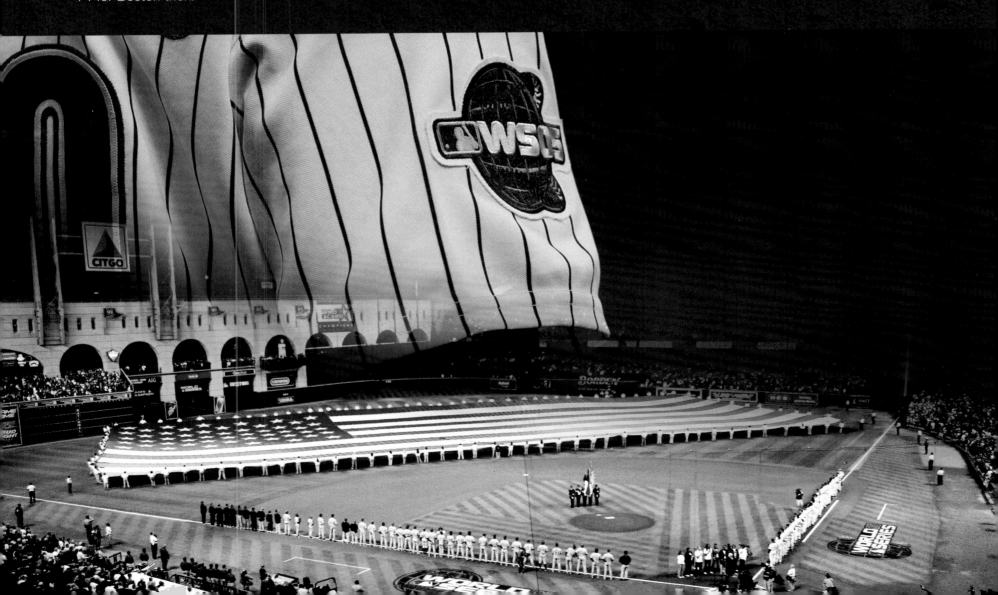

BRAD LIDGE

Brad Lidge was the Astros' first pick in the 1998 draft. He battled a long list of injuries as he moved through the farm system. Right shoulder and elbow problems dogged him early in his career. A broken right ulna followed…then right elbow surgery…then a sprained ligament.

Lidge persevered through the five-year test to reach the majors in 2002. "I spent the majority of the Minor Leagues watching baseball and not participating in it," said Lidge. "That was really hard. There were four surgeries I had in three years and finally getting to the big leagues in Houston felt like a big achievement. I was thrilled."

His first full Major League season of 2003 established him as one of the top late-inning relievers in the majors. He was a setup man for Billy Wagner that year. With 78 appearances, he tied the club's rookie record. His 85 innings were dotted with 97 strikeouts. Hitters were challenged by upper-90s velocity with a hard, sharply biting slider. The slider came at Minor League pitching coordinator Dewey Robinson's suggestion.

"It was just really hard for me," Lidge said. "I threw a curve ball and it was more over the top. When I started hurting my arm a couple of times, Dewey Robinson, moved my hand away from my head a little bit and introduced me to a slider. It was obviously one of the best pieces of advice anyone's given me. It really helped me stay healthy and helped me develop my best pitch."

In 2004, after Billy Wagner was traded to the Phillies and Octavio Dotel was dealt in the Beltran deal, Lidge moved into the closer role and responded

with 29 saves. Lidge recalled his response to the promotion, "I felt like that was the role I was born to do and I felt once I get that opportunity I'm going to put on the accelerator. I'm not going to put on the brakes. It's different for everyone. But I had so much adrenaline, so much excitement and energy when I came out for that inning, it was an incredible opportunity. I just wanted to prove to them that I am the man and they made the right decision."

Lidge set a National League record with strikeouts by a reliever with 157 in his 80 appearances. The next year he reeled off 42 saves. Over one stretch he made good on 50 of 54 save opportunities. In 2006 he added his third straight year of triple-digit strikeouts. When he was traded to Philadelphia for a package of players including Michael Bourn, Lidge left Houston with 123 saves, ranking him third on the club's all-time list. With the nickname "Lights Out," Lidge left many darkened areas behind him and put many hitters in black moods.

Seeking more offense, the Astros signed Carlos Lee as a free agent after the 2005 World Series. In his five-and-a-half seasons in Houston, El Caballo delivered 533 RBI with an .817 OPS in 815 games. He was traded to Miami in 2012 in the final year of his six-year contract. He set the club record with seven grand slams.

On June 17, 2009, Ivan "Pudge" Rodriguez set a Major League record for most games caught, while wearing a Houston uniform at Rangers Ballpark in Arlington. Rodriguez passed Carlton Fisk by catching his 2227th game. Earlier that season he belted his 300th homer May 17 at Wrigley Field off Rich Harden. He joined Carlos Lee and Lance Berkman that year as the first trio of teammates in history to reach 300 homers in the same season.

RYAN 34

Happy St. Patrick's Day 43

CABELL 23

CRUZ 25

50 YEARS OF JERSEYS

Since 1962 there have been many great players that have worn the Houston uniform. The Astros did not add names to the back of jerseys until the 1971 season. There have been twenty-nine combined variations of home and road jersey lettering since 1962. Over the years the fabric has included flannel, double knit, polyester, rayon and today's cool base material. Many of the earlier flannel jerseys were damaged while in storage at the Astrodome in the late 70s, making those that remain some of the rarest jerseys in existence.

BAGWELL 5

DIERKER 49

DOTEL 41

CLEMENS 22

BIGGIO 7

CRANE GROUP USHERS IN THE FUTURE

O VER THE WINTER BEFORE THE 2011 season, Drayton McLane put the Astros up for sale. In May, an agreement was reached to sell the team to a group led by Houston businessman Jim Crane.

Crane brought new fan initiatives to Minute Maid Park in 2012, allowing fans to bring food and water into the ballpark and reducing ticket prices. He attended meetings with season ticket holders and gauged their interests on a number of issues. He spoke to many groups and was constantly sampling opinions and explaining his plans. He was clear from the beginning about his goals, which include providing Astros fans with an outstanding experience. He has emphasized player development, setting up plans to create sustained success through a top-notch farm system.

He pioneered the Community Leaders program to refurbish, renovate and revitalize youth baseball and softball fields in the Houston area. At his initiative, a gift of $18 million will be committed through contributions from several companies to create a total of 12 parks in the program.

JIM CRANE

Crane was a pitcher in college at the University of Central Missouri. He had a 21-8 record and was a small college Honorable Mention All-American twice. In the first round of the 1974 Division II College World Series he struck out 18 against Ohio Northern, a number that remains the school strikeout mark. He founded two successful companies, EGL and Crane Worldwide Logistics.

Crane began his business career with $10,000 borrowed from his sister in 1984 to start Eagle USA Airfreight. He handled the loading and trucking himself in the beginning. He built it into an organization of more than 10,000 employees in 139 countries.

"Baseball teaches you a lot of values, and I tried to use those values, especially in how we ran the business," he said. "We try to operate as a team. We weren't afraid to work harder, harder than the other guys, and we stay persistent. The harder you work, the luckier you get."

"First and foremost, the Astros' fans come first. You are the customer. Our team will work hard to deliver a superior product and a great experience for the fans. I believe in running a first-class franchise, and everything we do will be built around building a championship team."

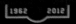

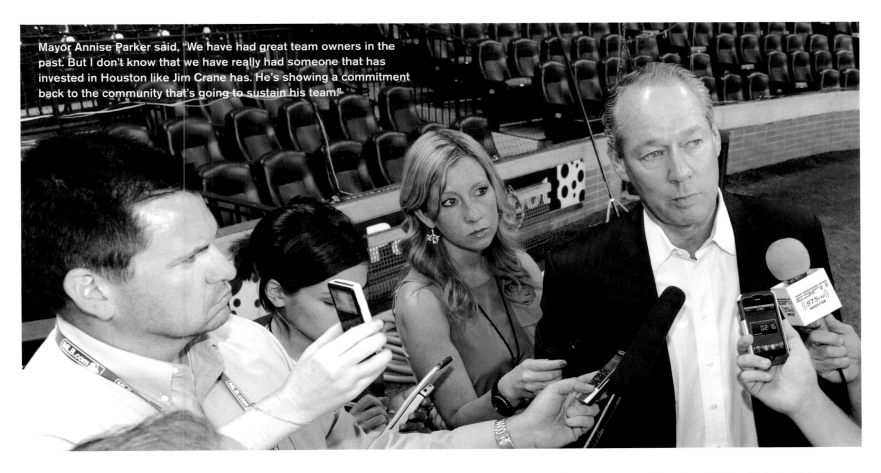

Mayor Annise Parker said, "We have had great team owners in the past. But I don't know that we have really had someone that has invested in Houston like Jim Crane has. He's showing a commitment back to the community that's going to sustain his team."

In July 2011 trades, General Manager Ed Wade obtained a total of 10 minor leaguers for Jeff Keppinger (who was traded to San Francisco), Hunter Pence (to Philadelphia) and Michael Bourn (to Atlanta). First baseman Jonathan Singleton, pitchers Jarred Cosart and Josh Zeid and outfielder Domingo Santana came from the Phillies for Pence. The Bourn deal reaped pitchers Brett Oberholtzer, Juan Abreu and Paul Clemens. Additionally, center fielder Jordan Schafer came to Houston in the deal to become the Astros' starter at that position.

General Manager Jeff Luhnow took over in December of 2011 as the architect of the Astros, leaving the St. Louis Cardinals after serving as their farm director and amateur scouting director as well as their vice president of scouting and player development. Luhnow earned his MBA from Northwestern University.

Luhnow moved swiftly, trading Mark Melancon to Boston for Kyle Weiland and Jed Lowrie in his first week on the job. He also made many changes in the front office as 2012 unfolded. He continued to restructure the organization with five deals in July 2012.

Luhnow dealt Carlos Lee to Miami in July 2012 for third baseman Matt Dominguez and pitcher Rob Rasmussen. Dominguez took over at third base late in the 2012 season. He added deals with Toronto, the White Sox, Pittsburgh and Arizona. By the time the dust had settled from Luhnow's deals, he had exchanged seven Houston players with Major League experience for 15 Minor League players and two Major League players. The Houston farm system was infused with many prospects who changed the landscape of the Astros for the future.

Under Luhnow's direction, Quinton McCracken became the new farm director. New scouting director Mike Elias took over at age 29 to run the draft and scout for talent. International signings, including outfielder Ariel Ovando of the Dominican Republic, have been emphasized in recent years. Oz Ocampo was named Director of International in 2012. Kevin Goldstein became the new pro scouting coordinator.

In late September, Bo Porter was named the new manager of the Astros for 2013. He came from a coaching background at Florida, Arizona and Washington after a brief career as a Major League player.

After the close of the 2012 season, Minute Maid Park underwent a facelift. New colors and a new logo and uniforms were prepared. The Astros positioned top draft choices such as Jason Castro (2008), Jiovanni Mier (2009), Delino DeShields (2010), George Springer (2011) and Carlos Correa (2012) for advancement as their performance dictated.

REBUILDING CONSISTENT COMPETITIVENESS

After the 2012 season Luhnow said, "We're judging the season on how close we're sticking to and accomplishing our plan of getting this organization back to consistent competitiveness. On the metrics we're grading ourselves on, we've had quite a successful season." The Astros' Minor League system jumped from last to first in winning percentage involving domestic farm clubs. "We're just really excited that we have people in the right spots and that we're all aligned around the same vision, which is to get Houston back to where it belongs."

YOUNG TALENT

Venezuelan-born Jose Altuve ascended quickly up the Minor League ladder in 2011, starting at Class A Lancaster. The young second baseman, listed at 5'5", tied the Astros' record by hitting safely in his first seven Major League games. When he was promoted from Corpus Christi, Altuve was hitting .389 in his Minor League games to lead all players. After being elevated to the big league club July 19, Altuve broke a 2-2 tie at St. Louis July 27 with what proved to be the game-winning hit in the ninth inning. Two weeks removed from playing in the All-Star Futures Game in Phoenix, Altuve made an immediate impression with his hustle and determination. Altuve picked up another game-winning hit in the 10th in a 4-3 win over Cincinnati Aug. 1.

By the end of August, he was hitting .313. He was named the Astros' Minor League Player of the Year for 2011. Altuve wound up collecting 200 hits as a professional in 2011.

In 2012, Altuve continued his excellent progress and was named a Major League All-Star, ranking among the top performers in the sport at his position. He led the club in several offensive departments in 2012 and was named team MVP.

Jordan Lyles (#41) was the youngest player in the majors when he made his debut in Chicago May 31, 2011 at age 20. Despite being winless in his first 11 starts in the majors, Lyles showed uncommon poise for his age and reached the winner's circle August 3 against Cincinnati.

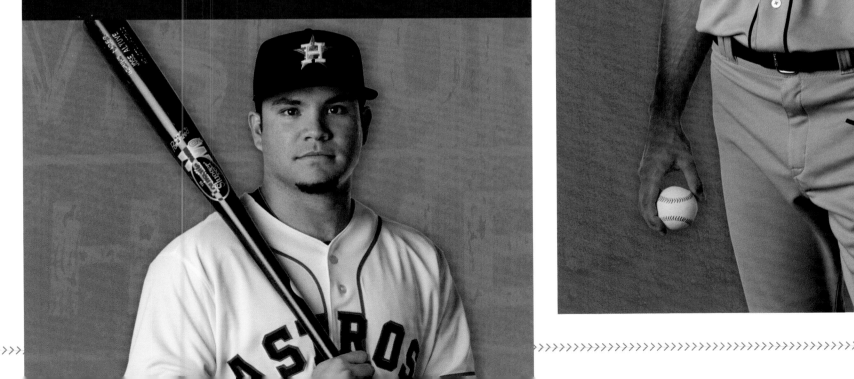

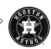

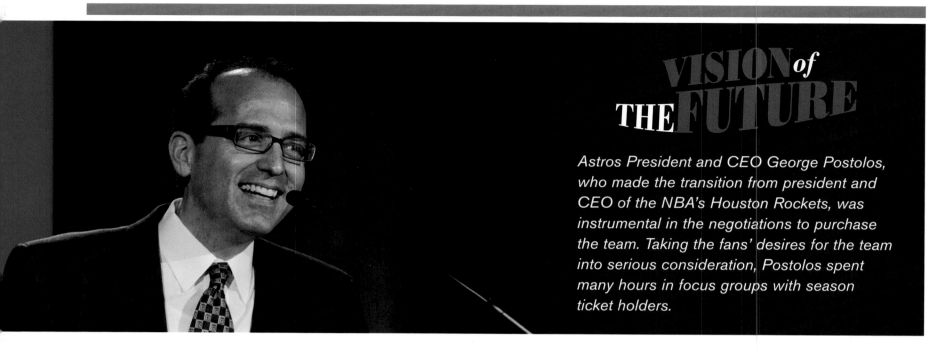

VISION of THE FUTURE

Astros President and CEO George Postolos, who made the transition from president and CEO of the NBA's Houston Rockets, was instrumental in the negotiations to purchase the team. Taking the fans' desires for the team into serious consideration, Postolos spent many hours in focus groups with season ticket holders.

As the Astros position themselves for the next chapter in the team's history, a strong base of young talent is pushing hard to make their mark on the books.

In its first 50 years, Astros baseball has been important to the Houston community in many ways. The name "Houston" appears on the sports pages every day. Rival teams and their fans travel to the Bayou City, occupy hotel rooms, drive rental cars, frequent restaurants and purchase gifts. Baseball has been the impetus for the construction of three new stadiums, which brought increased stature and many jobs to the community. Houston's reputation as an innovative city has been enhanced by the state-of-the-art designs of the Astrodome and Minute Maid Park.

Baseball's impact on Houston goes beyond the numbers and touches the spirit of the city. After retiring from their playing days, many players have made Houston their home for life, participating in countless charitable endeavors and contributing their strengths as dedicated community members. Exciting pennant races and post-season years have energized and united the city. As generations of Houstonians have headed out to the ballgame, they have passed along stories of favorite players and memorable games, creating many hours of enjoyment over a shared passion.

For one fan, Astros baseball provides an opportunity to teach the game to a son or grandson, a daughter or a granddaughter.

For another, it creates an opportunity to sit with friends and have an unhurried conversation while watching some of the world's best athletes compete at a high level. Yet another fan comes to entertain out-of-town business clients in a private suite or host a party for a special occasion.

Over 50 years of memories have been stamped indelibly on Houstonians, and they are revisited in sports bars, at kitchen tables, in restaurants, schools, offices and dens, wherever fans gather.

Whether the recollection involves Bob Bruce pitching a masterpiece at Colt Stadium, Jimmy Wynn hitting a tape measure home run at the Astrodome or a winning 18-inning playoff game for the ages at Minute Maid Park, the first half-century has been packed with stories.

Through 51 seasons, 8,138 games, nine playoff appearances, five National League Championship Series and Texas' first World Series, the Colt .45s and Astros have kept their fans entertained. Nine players' numbers have been retired and fans have been treated to three All-Star Games. Now a new group of standout players arrives. As they rack up hits, throw shutouts and keep the scoreboard at Minute Maid Park clicking, they'll be creating new memories for the next generation of Houston baseball fans. As this ever-innovative team moves into an exciting future, remember the Astrodome! History is happening every day when the Astros take the field.

YOUNG TALENT

Venezuelan-born Jose Altuve ascended quickly up the Minor League ladder in 2011, starting at Class A Lancaster. The young second baseman, listed at 5'5", tied the Astros' record by hitting safely in his first seven Major League games. When he was promoted from Corpus Christi, Altuve was hitting .389 in his Minor League games to lead all players. After being elevated to the big league club July 19, Altuve broke a 2-2 tie at St. Louis July 27 with what proved to be the game-winning hit in the ninth inning. Two weeks removed from playing in the All-Star Futures Game in Phoenix, Altuve made an immediate impression with his hustle and determination. Altuve picked up another game-winning hit in the 10th in a 4-3 win over Cincinnati Aug. 1.

By the end of August, he was hitting .313. He was named the Astros' Minor League Player of the Year for 2011. Altuve wound up collecting 200 hits as a professional in 2011.

In 2012, Altuve continued his excellent progress and was named a Major League All-Star, ranking among the top performers in the sport at his position. He led the club in several offensive departments in 2012 and was named team MVP.

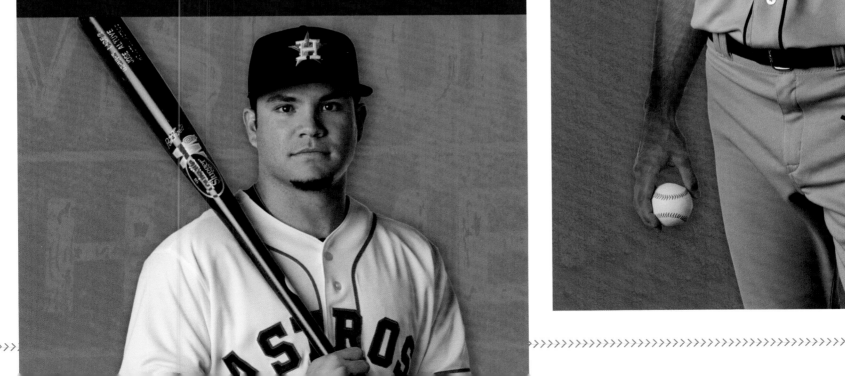

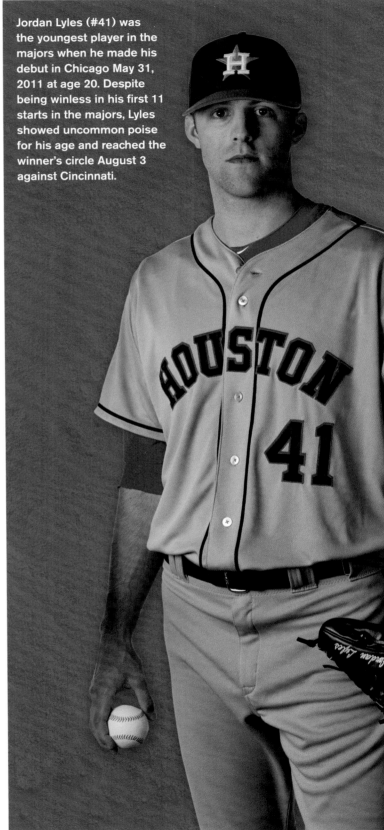

Jordan Lyles (#41) was the youngest player in the majors when he made his debut in Chicago May 31, 2011 at age 20. Despite being winless in his first 11 starts in the majors, Lyles showed uncommon poise for his age and reached the winner's circle August 3 against Cincinnati.

VISION of THE FUTURE

Astros President and CEO George Postolos, who made the transition from president and CEO of the NBA's Houston Rockets, was instrumental in the negotiations to purchase the team. Taking the fans' desires for the team into serious consideration, Postolos spent many hours in focus groups with season ticket holders.

As the Astros position themselves for the next chapter in the team's history, a strong base of young talent is pushing hard to make their mark on the books.

In its first 50 years, Astros baseball has been important to the Houston community in many ways. The name "Houston" appears on the sports pages every day. Rival teams and their fans travel to the Bayou City, occupy hotel rooms, drive rental cars, frequent restaurants and purchase gifts. Baseball has been the impetus for the construction of three new stadiums, which brought increased stature and many jobs to the community. Houston's reputation as an innovative city has been enhanced by the state-of-the-art designs of the Astrodome and Minute Maid Park.

Baseball's impact on Houston goes beyond the numbers and touches the spirit of the city. After retiring from their playing days, many players have made Houston their home for life, participating in countless charitable endeavors and contributing their strengths as dedicated community members. Exciting pennant races and post-season years have energized and united the city. As generations of Houstonians have headed out to the ballgame, they have passed along stories of favorite players and memorable games, creating many hours of enjoyment over a shared passion.

For one fan, Astros baseball provides an opportunity to teach the game to a son or grandson, a daughter or a granddaughter.

For another, it creates an opportunity to sit with friends and have an unhurried conversation while watching some of the world's best athletes compete at a high level. Yet another fan comes to entertain out-of-town business clients in a private suite or host a party for a special occasion.

Over 50 years of memories have been stamped indelibly on Houstonians, and they are revisited in sports bars, at kitchen tables, in restaurants, schools, offices and dens, wherever fans gather.

Whether the recollection involves Bob Bruce pitching a master-piece at Colt Stadium, Jimmy Wynn hitting a tape measure home run at the Astrodome or a winning 18-inning playoff game for the ages at Minute Maid Park, the first half-century has been packed with stories.

Through 51 seasons, 8,138 games, nine playoff appearances, five National League Championship Series and Texas' first World Series, the Colt .45s and Astros have kept their fans entertained. Nine players' numbers have been retired and fans have been treated to three All-Star Games. Now a new group of standout players arrives. As they rack up hits, throw shutouts and keep the scoreboard at Minute Maid Park clicking, they'll be creating new memories for the next generation of Houston baseball fans. As this ever-innovative team moves into an exciting future, remember the Astrodome! History is happening every day when the Astros take the field.

Doug "Red Rooster" Rader
HIT HOME RUN
4-3-70

Jim "Toy Cannon" Wynn
HIT HOME RUN
4-12-70

50 YEARS OF MEMORABILIA

In addition to the caps, jerseys, bats, gloves and baseballs that were used in actual games, other artifacts such as Astrodome seat backs and old ticket stubs also tell the story of the Astros. Many Astros fans have a special piece of memorabilia that connects them to a favorite moment or player. These items tell the stories, honor the legends and teach new generations of Houston fans just how much heart the home team has.

ACKNOWLEDGEMENTS

Bright Sky Press had a great reputation before this book, and that attracted the Astros to this partnership. The team, of editor Lucy Chambers and design artists Ellen Cregan and Marla Garcia, has attacked the project with gusto and created a special look for Astros fans.

Mike Acosta rounded up more than 1,000 photos and provided the outline for the book. He oversaw the use of the photos and their arrangement, as well as giving advice on how each era should be treated.

Richard Korczynski took the photos of the first pitches in Colt Stadium, the Astrodome and Enron Field. He graciously donated their use in this project.

The National Aeronautics and Space Administration granted permission for use of the photo of the space shuttle Endeavor being transported on a NASA 747 over the skies of downtown Houston. Many thanks to Librarian/researcher Mike Gentry and Ed Fein for expediting that approval.

Bob Hulsey provided a steady and attentive editor's look at the manuscript. A volunteer team of editors joined his efforts. Gene Duffey, Alyson Footer, Tim Gregg, Tal Smith, Bill Gilbert, Bill McCurdy and Greg Lucas offered advice and suggested topics of interest. They also corrected some misimpressions and caught some omissions.

Chris Garcia offered key advice on design elements. Gene Dias, Steve Grande, Dena Propis, Scott Wakeman and Phil Boudreaux all got involved in the process of making decisions and reviewing material. Carl Warwick offered the use of his photos.

Jim Crane made the decision to bring the book to Astros fans.

All were immensely helpful in getting the book to you.